Simon Schama is Old Dominion Professor of the Humanities at Columbia University, and author of *Patriots and Liberators*, *The Embarrassment of Riches*, *Citizens*, winner of the NCR Prize and *Dead Certainties*: *Unwarranted Speculations*.

LANDSCAPE AND MEMORY

LANDSCAPE
AND
MEMORY

SIMON SCHAMA

FontanaPress
An Imprint of HarperCollinsPublishers

Fontana Press
An imprint of HarperCollins*Publishers*
77–85 Fulham Palace Road,
Hammersmith, London W6 8JB

Published by Fontana Press 1996
1 3 5 7 9 8 6 4 2

First published in Great Britain by
HarperCollins*Publishers* 1995

ISBN 0 00 686348 5

Set in Galliard

Printed in Great Britain by
The Bath Press, Lower Road, Bath

FOR CHLOË AND GABRIEL

It is in vain to dream of a wildness
distant from ourselves. There is none such.
It is the bog in our brains and bowels, the
primitive vigor of Nature in us, that inspires
that dream. I shall never find in the wilds of
Labrador any greater wildness than in some recess
of Concord, i.e. than I import into it.

<div align="right">

HENRY DAVID THOREAU,
Journal, August 30, 1856

</div>

Contents

Color plates follow pages 18, 82, 114, 210, 338, and 530.

LANDSCAPE AND MEMORY

Introduction

It was only when I got to secondary school that I realized I wasn't supposed to like Rudyard Kipling. This was a blow. Not that I much minded leaving Kim and Mowgli behind. But *Puck of Pook's Hill* was a different story—my favorite story, in fact, ever since I had been given the book for my eighth birthday. For a small boy with his head in the past, Kipling's fantasy was potent magic. Apparently, there were some places in England where, if you were a child (in this case Dan or Una), people who had stood on the same spot centuries before would suddenly and inexplicably materialize. With Puck's help you could time-travel by standing still. On Pook's Hill, lucky Dan and Una got to chat with Viking warriors, Roman centurions, Norman knights, and then went home for tea.

I had no hill, but I did have the Thames. It was not the upstream river that the poets in my Palgrave claimed burbled betwixt mossy banks. Nor was it even the wide, olive-drab road dividing London. It was the low, gull-swept estuary, the marriage bed of salt and fresh water, stretching as far as I could see from my northern Essex bank, toward a thin black horizon on the other side. That would be Kent, the sinister enemy who always seemed to beat us in the County Cricket Championship. On most days the winds brought us a mixed draught

3

of aroma, olfactory messages from both the city and the sea: heavy traffic and fresh fish. And between them hung the smell of the old man himself: sharp and moldy as if it exuded from some vast subfluvial fungus growing in the primeval sludge.

Ten miles further downstream was the gloriously lurid seaside town of Southend, developed at the end of the last century as "the lungs of London." The pier was strung with colored lights and loud with the blare of band music, cracklingly amplified over the black water. The promenades were littered with flaccid, vinegar-saturated chips and you could, literally, get your teeth stuck into cylinders of Day-Glo-pink rock candy, the letters bleeding as you gnawed optimistically through the stick. Closer to home, the little port of Leigh still had shrimp boats in its harbor and cockle sheds on the dock. In St. Clements were buried its fishy fathers: not merely Richard Haddock (died 1453) but Robert Salmon (died 1641), whose epitaph claimed he was the "restorer of English navigation." Beyond the sheds, grimy sand, littered with discarded mussel shells and hard strings of black-blistered seaweed, stretched down to the gray water. When the tide went out, exposing an expanse of rusty mud, I could walk for what seemed miles from the shore, testing the depth of the ooze, paddling my feet among the scuttling crabs and the winkles, and staring intensely at the exact point where, I imagined, the river met the sea.

For it was there that my maritime Puck, perhaps an imp of Mercury, would meet me. He filled the horizon of my boyish imagination with yards of canvas and creaking timber; rope and tar and anchors and pigtails. Broad galleys entered the river with rows of grunting oarsmen. Long boats with dragon heads at the prow and dull iron shields nailed to the side slid menacingly upstream. Galliots and caravels gently rose and fell with the estuary tides, sporting on their bowsprits beaming cherubs or turbaned corsairs with goggling eyes and dangerous whiskers. Great tea clippers, their sails billowing like sheets on our washing line, beat their way before the breeze to the London docks. In my watery daydreams the shoreline itself mysteriously dissolved its ratty pubs and rusting cranes into a somber riverbank woodland where the tops of trees emerged from an ancient, funereal fog. When I took a boat trip with my father from Gravesend to Tower Bridge, the docks at Wapping and Rotherhithe still had big cargo ships at berth rather than upmarket grillrooms and corporate headquarters. But my mind's eye saw the generations of the wharves, bristling with masts and cranes as if in a print by Hollar, the bridges top-heavy and overhung across their whole span with rickety timber houses, alive with the great antswarm of the imperial city.

I had not yet read the opening pages of *Heart of Darkness,* and years would pass before I discovered that Joseph Conrad had anticipated this Thames-side vision of English history bobbing on the roadstead tides. When I did eventually encounter Charlie Marlow and his somber colleagues aboard the yawl *Nel-*

lie, moored in the estuary, the "venerable stream" bathed in "the august light of abiding memories," I was as much reassured as disappointed. For it seemed that the idea of the Thames as a line of time as well as space was itself a shared tradition. Had I reached back further in the literature of river argosies, I would have discovered that Conrad's imperial stream, the road of commercial penetration that ends in disorientation, dementia, and death, was an ancient obsession. Before the Victorian steamboats pushed their way through the scummy waterweed of the Upper Nile and the Gambia, there had been Spanish, Elizabethan, and even German craft, adrift up the Orinoco basin, pulled by the tantalizing mirage of El Dorado, the golden paradise, just around the next bend.

Tragic futility, though, has a hard time lodging in the imagination of boys in short trousers. I had never seen the light over the Essex marshes as the "gauzy and radiant fabric" of Conrad's description, nor perceived the air upriver "condensed into a mournful gloom." To go upstream was, I knew, to go backward: from metropolitan din to ancient silence; westward toward the source of the waters, the beginnings of Britain in the Celtic limestone. But I would have been hard put to share Marlow's ominous vision of the ancient Thames, with proconsuls in togas shivering in the fearful damp, out at the very end of the world: "one of the dark places of the earth." I was too busy watching the ships move purposefully out to sea toward all those places colored pink on our wall map at school, where bales of kapok or sisal or cocoa beans waited on some tropical dock so that the Commonwealth (as we had been told to call it) might pretend to live up to its name. After the coronation of the young queen we were told that we were all "new Elizabethans." So it seemed right to daydream of our connections with the original version: with Drake and Frobisher at Greenwich, and with the Virgin Queen herself (looking amazingly like Dame Flora Robson) smiting her armored breast at the Tilbury encampment and rallying the troops against the Armada. Without a trace of Conradian blackness on my horizon, I wrote "A History of the Royal Navy" in twelve pages, illustrated with cigarette cards of galleons and dreadnoughts, courtesy of the Imperial Tobacco Corporation.

Though lines of imperial power have always flowed along rivers, watercourses are not the only landscape to carry the freight of history. When not paddling in the currents of time, I was gumming small green leaves to a paper tree pinned to the wall of my *cheder*, the Hebrew school. Every sixpence collected for the blue and white box of the Jewish National Fund merited another leaf. When the tree was throttled with foliage the whole box was sent off, and a sapling, we were promised, would be dug into the Galilean soil, the name of our class stapled to one of its green twigs. All over north London, paper trees burst into leaf to the sound of jingling sixpences, and the forests of Zion thickened in happy response. The trees were our proxy immigrants, the forests our implantation. And while we assumed that a pinewood was more beautiful than

a hill denuded by grazing flocks of goats and sheep, we were never exactly sure what all the trees were *for*. What we did know was that a rooted forest was the opposite landscape to a place of drifting sand, of exposed rock and red dirt blown by the winds. The diaspora was sand. So what should Israel be, if not a forest, fixed and tall? No one bothered to tell us which trees we had sponsored. But we thought cedar, Solomonic cedar: the fragrance of the timbered temple.

Every year the tempo of leaf-gumming accelerated furiously toward Tu bi-Shevat, the fifteenth of the month of Shevat: the New Year for Trees. The festival had originated in an arbitrarily established date that separated one year's tithed fruit from the next—an oddly pleasing way to celebrate the end of a tax year. In Israel, though, it had been wholly reinvented as a Zionist Arbor Day, complete with trowel-wielding children planting the botanical equivalent of themselves in cheerful, obedient rows. It was an innocent ritual. But behind it lay a long, rich, and pagan tradition that imagined forests as the primal birth-place of nations; the beginning of habitation. Paradoxically, as we shall see, this was a tradition that had prospered in the very cultures that had stigmatized the Jews as an alien growth and had periodically undertaken campaigns of mur-derous uprooting. But we knew even less about J. G. Frazer's *Golden Bough*, with its mythic connections between sacrifice and renewal, than we did of Con-radian fatalism. Nor did it occur to us that the biblical Hebrews, like all the pas-toral tribes of the ancient Near East, were certain to have contributed to the denuding of the Levantine hillsides. And even had we known, it wouldn't have mattered. All we knew was that to create a Jewish forest was to go back to the beginning of our place in the world, the nursery of the nation.

Once rooted, the irresistible cycle of vegetation, where death merely com-posted the process of rebirth, seemed to promise true national immortality. Even the fires that could strike the wooded hillsides (as they did south of Mount Carmel a few years ago), while superficially devastating, actually pro-moted the natural cycle of renewal. No wonder some of the very first trees to be planted in the pioneer settlements of coastal Palestine were imported euca-lypts that not only fixed the drifting dunes but sent down deep subterranean ligno-tubers, which not only withstood fire but were actually made more robust and vigorous by the surface conflagration. Beneath the ashy crust, we knew, there would always be blessed vitality.[1]

So we recited blessings over our paper tree as the sprouted descendant of the Tree of Life, guarded in the Garden of Eden, so the Scripture said, by an angel with a flaming sword. Our sixpenny-worth of arboriculture was re-creating that garden in the new Zion. And if a child's vision of nature can already be loaded with complicating memories, myths, and meanings, how much more elabo-rately wrought is the frame through which our adult eyes survey the landscape. For although we are accustomed to separate nature and human perception into two realms, they are, in fact, indivisible. Before it can ever be a repose for the

senses, landscape is the work of the mind. Its scenery is built up as much from strata of memory as from layers of rock.

Objectively, of course, the various ecosystems that sustain life on the planet proceed independently of human agency, just as they operated before the hectic ascendancy of *Homo sapiens*. But it is also true that it is difficult to think of a single such natural system that has not, for better or worse, been substantially modified by human culture. Nor is this simply the work of the industrial centuries. It has been happening since the days of ancient Mesopotamia. It is coeval with writing, with the entirety of our social existence. And it is this irreversibly modified world, from the polar caps to the equatorial forests, that is all the nature we have.

The founding fathers of modern environmentalism, Henry David Thoreau and John Muir, promised that "in wildness is the preservation of the world." The presumption was that the wilderness was out there, somewhere, in the western heart of America, awaiting discovery, and that it would be the antidote for the poisons of industrial society. But of course the healing wilderness was as much the product of culture's craving and culture's framing as any other imagined garden. Take the first and most famous American Eden: Yosemite. Though the parking is almost as big as the park and there are bears rooting among the McDonald's cartons, we still imagine Yosemite the way Albert Bierstadt painted it or Carleton Watkins and Ansel Adams photographed it: with no trace of human presence. But of course the very act of identifying (not to mention photographing) the place presupposes our presence, and along with us all the heavy cultural backpacks that we lug with us on the trail.

The wilderness, after all, does not locate itself, does not name itself. It was an act of Congress in 1864 that established Yosemite Valley as a place of sacred significance for the nation, during the war which marked the moment of Fall in the American Garden.[2] Nor could the wilderness venerate itself. It needed hallowing visitations from New England preachers like Thomas Starr King, photographers like Leander Weed, Eadwaerd Muybridge, and Carleton Watkins, painters in oil like Bierstadt and Thomas Moran, and painters in prose like John Muir to represent it as the holy park of the West; the site of a new birth; a redemption for the national agony; an American re-creation. The strangely unearthly topography of the place, with brilliant meadows carpeting the valley flush to the sheer cliff walls of Cathedral Rock, the Merced River winding through the tall grass, lent itself perfectly to this vision of a democratic terrestrial paradise. And the fact that visitors had to *descend* to the valley floor only emphasized the religious sensation of entering a walled sanctuary.

Like all gardens, Yosemite presupposed barriers against the beastly. But its protectors reversed conventions by keeping the animals in and the humans out. So both the mining companies who had first penetrated this area of the Sierra Nevada and the expelled Ahwahneechee Indians were carefully and forcibly

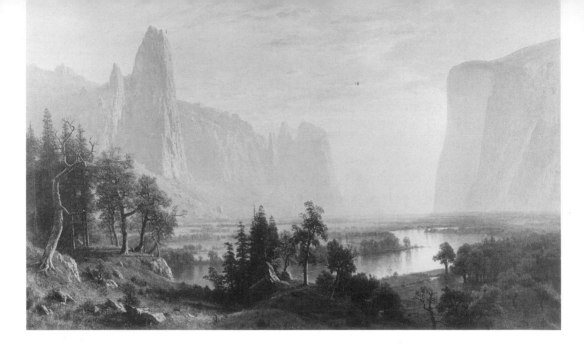

edited out of the idyll. It was John Muir, the prophet of wilderness, who actually characterized Yosemite as a "park valley" and celebrated its resemblance to an "artificial landscape-garden . . . with charming groves and meadows and thickets of blooming bushes." The mountains that rose above the "park" had "feet set in pine-groves and gay emerald meadows, their brows in the sky; bathed in light, bathed in floods of singing water, while snow-clouds avalanche and the winds shine and surge and wreathe about them as the years go by, as

Albert Bierstadt, *The Yosemite Valley*, 1868.

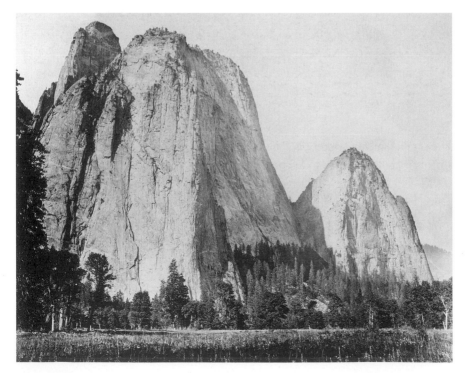

Carleton Watkins, *Cathedral Rock*, 2,600 feet, Yosemite.

if into these mountain mansions Nature had taken pains to gather her choicest treasures to draw her lovers into close and confiding communion with her."[3]

But of course nature does no such thing. We do. Ansel Adams, who admired and quoted Muir, and did his best to translate his reverence into spectacular nature-icons, explained to the director of the National Park Service, in 1952, that he photographed Yosemite in the way he did to sanctify "a religious idea" and to "inquire of my own soul just what the primeval scene really signifies." "In the last analysis," he wrote, "Half Dome is just a piece of rock. . . . There is some deep personal distillation of spirit and concept which moulds these earthly facts into some transcendental emotional and spiritual experience." To protect

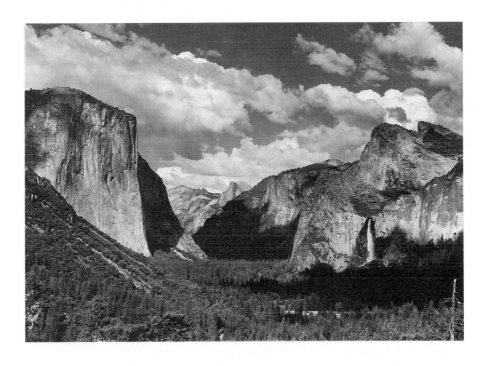

Ansel Adams, *Valley View from Tunnel Esplanade*, Yosemite National Park.

Yosemite's "spiritual potential," he believed, meant keeping the wilderness pure; "unfortunately, in order to keep it pure we have to occupy it."[4]

There is nothing inherently shameful about that occupation. Even the landscapes that we suppose to be most free of our culture may turn out, on closer inspection, to be its product. And it is the argument of *Landscape and Memory* that this is a cause not for guilt and sorrow but celebration. Would we rather that Yosemite, for all its overpopulation and overrepresentation, had *never* been identified, mapped, emparked? The brilliant meadow-floor which suggested to its first eulogists a pristine Eden was in fact the result of regular fire-clearances by its Ahwahneechee Indian occupants. So while we acknowledge (as we must) that the impact of humanity of the earth's ecology has not

been an unmixed blessing, neither has the long relationship between nature and culture been an unrelieved and predetermined calamity. At the very least, it seems right to acknowledge that it is our shaping perception that makes the difference between raw matter and landscape.

The word itself tells us as much. It entered the English language, along with herring and bleached linen, as a Dutch import at the end of the sixteenth century. And *landschap*, like its Germanic root, *Landschaft*, signified a unit of human occupation, indeed a jurisdiction, as much as anything that might be a pleasing object of depiction.[5] So it was surely not accidental that in the Netherlandish flood-fields, itself the site of formidable human engineering, a community developed the idea of a *landschap*, which in the colloquial English of the time became a *landskip*. Its Italian equivalents, the pastoral idyll of brooks and

Henry Peacham, *Rura Mihi et Silentium*, from *Minerva Britannia*, 1612.

wheat-gold hills, were known as *parerga*, and were the auxiliary settings for the familiar motifs of classical myth and sacred scripture. But in the Netherlands the human design and use of the landscape—implied by the fishermen, cattle drovers, and ordinary walkers and riders who dotted the paintings of Esaias van de Velde, for example—*was* the story, startlingly sufficient unto itself.

With the vogue for Dutch landskips established in England, the scholar-artist Henry Peacham included in his drawing manual, *Graphice*, the first practical advice to his compatriots on how to compose one. But lest anyone suppose that all they had to do was somehow translate the objects of their gaze into two-dimensional form, Peacham's book of emblems, *Minerva Britannia*, published the same year, set them right.[6] Positioned beside an image of the British arca-

dia, Peacham's emblem *Rura Mihi et Silentium* made it clear that the rustic life was to be valued as a moral corrective to the ills of court and city; for the medicinal properties of its plants; for the Christian associations of herbs and flowers; and above all for its proclamation of the stupendous benevolence of the Creator. What his emblem was supposed to invoke was the quintessentially English scene: "Some shadie grove upon the *Thames* faire side / Such as we may neere princely Richmond see."[7] But the woodcut that the drawing master supplied as illustration looks a lot more like the poetic arcadia than the Thames valley. It is an inventory of the standard features of the humanist happy valley: rolling hills safely grazed by fleecy flocks and cooled by zephyrs moist and sweet. It supplied the prototypical image that was reproduced in countless paintings, engravings, postcards, railway train photographs, and war posters, which

Frank Newbould, World War II civilian-effort poster.

merely had to be executed in order to summon up loyalty to the temperate, blessed isle.

The framed border of Peacham's woodcut is strikingly elaborate, as such printed emblems often were. They acted as a kind of visual prompt to the attentive that the truth of the image was to be thought of as poetic rather than literal; that a whole world of associations and sentiments enclosed and gave meaning to the scene. The most extreme example of such deliberate framing was the so-called Claude-glass, recommended in the eighteenth century to both artists and tourists of "picturesque" scenery. A small, portable mirror backed with dark foil, it was named for the French painter who most perfectly harmonized classical architecture, leafy groves, and distant water. If the view in

the mirror approximated to this Claudian ideal, it was judged sufficiently "picturesque" to be appreciated or even drawn. Later variations tinted the glass with the light of a radiant dawn or a roseate sunset. But it was always the inherited tradition, reaching back to the myths of Arcadia, Pan's fertile realm populated with nymphs and satyrs, that made *landscape* out of mere geology and vegetation.

"This is how we see the world," René Magritte argued in a 1938 lecture explaining his version of *La Condition humaine* (color illus. 2) in which a painting has been superimposed over the view it depicts so that the two are continuous and indistinguishable. "We see it as being outside ourselves even though it is only a mental representation of what we experience on the inside."[8] What lies beyond the windowpane of our apprehension, says Magritte, needs a design before we can properly discern its form, let alone derive pleasure from its perception. And it is culture, convention, and cognition that makes that design; that invests a retinal impression with the quality we experience as beauty.

It is exactly this kind of presumption that many contemporary landscapists find so offensive. So instead of having pictorial tradition dictate to nature, they have tried hard to dissolve the artistic ego within natural process.[9] Their aim is to produce an anti-landscape where the intervention of the artist is reduced to the most minimal and transient mark on the earth. The British artists Andy Goldsworthy and David Nash, for example, have made works that invoke nature without forcing it into museum-ready shape: "found" sculptures from shoreline driftwood or naturally charred tree limbs; cairns made from beach pebbles; or balls of leaves and snow bound with thorns and twigs and sited so as to decompose or metamorphose with the natural processes of the seasons (color illus. 3). But while much of this minimalist landscape is always stirring and often very beautiful, it seldom escapes from the condition it implicitly criticizes. Quite as much as with Carleton Watkins or Ansel Adams, the camera is required to capture the natural moment. So the organizing move of the artist is merely displaced from the hand on the paintbrush to the finger on the shutter. And in that split instant of framing, the old culture-creatures re-emerge from their lair, trailing the memories of generations behind them.[10]

In the same chastened spirit, environmental historians have also lamented the annexation of nature by culture. While not denying the landscape may indeed be a text on which generations write their recurring obsessions, they are not about to rejoice in the fact. The arcadian idyll, for example, seems just another pretty lie told by propertied aristocracies (from slave-owning Athens to slave-owning Virginia) to disguise the ecological consequences of their greed. And they have made it a point of honor to restore a distinction between landscape and manscape, and to see if a history could not be written that might not assume the earth and its diverse species were created for the express and exclusive pleasure of what Muir witheringly called "Lord Man."

Especially in the United States (where the interplay of men and habitat has long been at the heart of national history), the best environmental histories have brilliantly realized that ambition. Whether chronicling the ice-world of Antarctica, the fiery Australian bush, the ecological transformation of New England, or the water-wars of the American West, writers like Stephen Pyne, William Cronon, and Donald Worster have accomplished the feat of making inanimate topography into historical agents in their own right.[11] Restoring to the land and climate the kind of creative unpredictability conventionally reserved for human actors, these writers have created histories in which man is not the be-all and end-all of the story.

But though environmental history offers some of the most original and challenging history now being written, it inevitably tells the same dismal tale: of land taken, exploited, exhausted; of traditional cultures said to have lived in a relation of sacred reverence with the soil displaced by the reckless individualist, the capitalist aggressor. And while the mood of these histories is understandably penitential, they differ as to when the Western fall from grace took place. For some historians it was the Renaissance and the scientific revolutions of the sixteenth and seventeenth centuries that doomed the earth to be treated by the West as a machine that would never break, however hard it was used and abused.[12] For Lynn White, Jr., it was the invention, in the seventh century A.D., of a fixed-harnessed plow that sealed the earth's fate. The "knife" of the new implement "attacked the land"; farming became ecological war. "Formerly man had been part of nature; now he was the exploiter of nature."[13]

Intensive agriculture, then, is said to have made possible all manner of modern evils. It gouged the earth to feed populations whose demands (whether for necessities or luxuries) provoked yet further technological innovations, which in turn exhausted natural resources, spinning the mad cycle of exploitation at ever more frantic revolutions, on and on through the whole history of the West.

And perhaps not even the West. Perhaps, say the most severe critics, the entire history of settled (rather than nomadic) society, from the irrigation-mad Chinese to the irrigation-mad Sumerians, is contaminated by the brutal manipulation of nature. Only the Paleolithic cave-dwellers, who left us their cave paintings as evidence of their integration with, rather than dominion over, nature, are exempted from this original sin of civilization. Once the archaic cosmology in which the whole earth was held to be sacred, and man but a single link in the long chain of creation, was broken, it was all over, give or take a few millennia. Ancient Mesopotamia, all unknowing, begat, global warming. What we need, says one such impassioned critic, Max Oelschlaeger, are new "creation myths" to repair the damage done by our recklessly mechanical abuse of nature and to restore the balance between man and the rest of the organisms with which he shares the planet.[14]

It is not to deny the seriousness of our ecological predicament, nor to dismiss the urgency with which it needs repair and redress, to wonder whether, in fact, a new set of myths are what the doctor should order as a cure for our ills. What about the old ones? For notwithstanding the assumption, commonly asserted in these texts, that Western culture has evolved by sloughing off its nature myths, they have, in fact, never gone away. For if, as we have seen, our entire landscape tradition is the product of shared culture, it is by the same token a tradition built from a rich deposit of myths, memories, and obsessions. The cults which we are told to seek in other native cultures—of the primitive forest, of the river of life, of the sacred mountain—are in fact alive and well and all about us if only we know where to look for them.

And that is what *Landscape and Memory* tries to be: a way of looking; of rediscovering what we already have, but which somehow eludes our recognition and our appreciation. Instead of being yet another explanation of what we have lost, it is an exploration of what we may yet find.

In offering this alternative way of looking, I am aware that more is at stake than an academic quibble. For if the entire history of landscape in the West is indeed just a mindless race toward a machine-driven universe, uncomplicated by myth, metaphor, and allegory, where measurement, not memory, is the absolute arbiter of value, where our ingenuity is our tragedy, then we are indeed trapped in the engine of our self-destruction.

At the heart of this book is the stubborn belief that this is not, in fact, the whole story. The conviction is not born from any wishful thinking about our past or our prospects. For what it is worth, I unequivocally share the dismay at the ongoing degradation of the planet, and much of the foreboding about the possibilities of its restoration to good health. The point of *Landscape and Memory* is not to contest the reality of this crisis. It is, rather, by revealing the richness, antiquity, and complexity of our landscape tradition, to show just how much we stand to lose. Instead of assuming the mutually exclusive character of Western culture and nature, I want to suggest the strength of the links that have bound them together.

That strength is often hidden beneath layers of the commonplace. So *Landscape and Memory* is constructed as an excavation below our conventional sight-level to recover the veins of myth and memory that lie beneath the surface.

The "cathedral grove," for example, is a common tourist cliché. "Words of veneration describe this land of *ahs*," says one particularly breathless book on the old growth forests of the Pacific Northwest.[15] But beneath the commonplace is a long, rich, and significant history of associations between the pagan primitive grove and its tree idolatry, and the distinctive forms of Gothic architecture. The evolution from Nordic tree worship through the Christian iconography of the Tree of Life and the wooden cross to images like Caspar

David Friedrich's explicit association between the evergreen fir and the architecture of resurrection (color illus. 1) may seem esoteric. But in fact it goes directly to the heart of one of our most powerful yearnings: the craving to find in nature a consolation for our mortality. It is why groves of trees, with their annual promise of spring awakening, are thought to be a fitting décor for our earthly remains. So the mystery behind this commonplace turns out to be eloquent on the deepest relationships between natural form and human design.

Whether such relationships are, in fact, habitual, at least as habitual as the urge toward domination of nature, said to be the signature of the West, I will leave the reader to judge. Jung evidently believed that the universality of nature myths testified to their psychological indispensability in dealing with interior terrors and cravings. And the anthropologist of religion Mircea Eliade assumed them to have survived, fully operational, in modern, as well as traditional, cultures.

My own view is necessarily more historical, and by that token much less confidently universal. Not all cultures embrace nature and landscape myths with equal ardor, and those that do, go through periods of greater or lesser enthusiasm. What the myths of ancient forest mean for one European national tradition may translate into something entirely different in another. In Germany, for example, the forest primeval was the site of tribal self-assertion against the Roman empire of stone and law. In England the greenwood was the place where the king disported his power in the royal hunt yet redressed the injustices of his officers.

I have tried not to let these important differences in space and time be swallowed up in the long history of landscape metaphors sketched in this book. But while allowing for these variations, it is clear that inherited landscape myths and memories share two common characteristics: their surprising endurance through the centuries and their power to shape institutions that we still live with. National identity, to take just the most obvious example, would lose much of its ferocious enchantment without the mystique of a particular landscape tradition: its topography mapped, elaborated, and enriched as a homeland.[16] The poetic tradition of *la douce France*—"sweet France"—describes a geography as much as a history, the sweetness of a classically well-ordered place where rivers, cultivated fields, orchards, vineyards, and woods are all in harmonious balance with each other. The famous eulogy of the "sceptred isle," which Shakespeare puts in the mouth of the dying John of Gaunt, invokes cliff-girt insularity as patriotic identity, whereas the heroic destiny of the New World is identified as continental expansiveness in the landscape lyrics of "America the Beautiful." And landscapes can be self-consciously designed to express the virtues of a particular political or social community. The scale of the Mount Rushmore monument, as we shall see, was crucial to its sculptor's ambition to proclaim the continental magnitude of America as the bulwark of its democ-

racy. And on a much more intimate level, nineteenth-century advocates of the
American suburban idyll, like Frank Jesup Scott, prescribed carpets of front-
yard lawns, undivided by fences, as an expression of social solidarity and com-
munity, the imagined antidote to metropolitan alienation.

The designation of the suburban yard as a cure for the afflictions of city life
marks the greensward as a remnant of an old pastoral dream, even though its
goatherds and threshers have been replaced by tanks of pesticide and industrial-
strength mowing machines. And it is just because ancient places are constantly
being given the topdressings of modernity (the forest primeval, for example,
turning into the "wilderness park") that the antiquity of the myths at their
core is sometimes hard to make out. It is there, all the same. Driving at night
along Interstate 84, through the relic of what was once "the brass capital of
America," Waterbury, Connecticut, a creamy glow radiates from the top of a
hill overlooking the freeway. A bend in the road suddenly reveals the light
source as a neon cross, thirty feet tall—virtually all that remains of "Holy
Land, USA," built by a local lawyer in the 1960s. Familiar as we are with reli-
gious theme parks, Holy Land seems immediately classifiable as a Catholic
answer to Disneyland. But its siting as a hill pilgrimage, its devotional mis-
sion, and its conscientious if clumsy attempts to reproduce the topography
of the Passion in southern New England mark it as the last *sacro monte*, the
artificial Calvaries whose origins date back to the Italian Franciscans of the
fifteenth century.

To see the ghostly outline of an old landscape beneath the superficial cov-
ering of the contemporary is to be made vividly aware of the endurance of core
myths. As I write, *The New York Times* reports an ancient ash tree at El Esco-
rial, near Madrid, where the Virgin makes herself known to a retired cleaning
lady on the first Saturday of each month, much to the chagrin of the local social-
ist mayor.[17] Behind the tree is of course the monastery-palace of the Most
Catholic King of Spain, Philip II. But behind both are centuries of associations,
cherished particularly by the Franciscans and Jesuits, of apparitions of the Vir-
gin seated in a tree whose Eastertide renewal of foliage symbolized the Resur-
rection. And behind *that* tradition were even more ancient pagan myths that
described old and hollowed trees as the tomb of gods slaughtered on the
boughs and encased within the bark to await a new cycle of life.

Landscape and Memory has been built around such moments of recogni-
tion as this, when a place suddenly exposes its connections to an ancient and
peculiar vision of the forest, the mountain, or the river. A curious excavator of
traditions stumbles over something protruding above the surface of the com-
monplaces of contemporary life. He scratches away, discovering bits and pieces
of a cultural design that seems to elude coherent reconstruction but which leads
him deeper into the past. Each of the chapters that follow might be thought of
as an excavation, beginning with the familiar, digging down through layers of

memories and representations toward the primary bedrock, laid down centuries or even millennia ago, and then working up again toward the light of contemporary recognition.

My own burrows through time only follow, of course, where many other conscientious moles have already dug, throwing up tracers for the historian as they push through obscurity. Many of the stories told in the book celebrate their perseverance and passion as they recount their labors. Some of these zealous guardians of landscape memory—like Julius von Brincken, Tsar Nicholas I's warden of the Polish primeval forest of Białowieża, or Claude François Denecourt, who invented the romantic hike in the woods of Fontainebleau—became so rooted in a particular landscape that they became its *genius loci*, the "spirit of the place." Others appointed themselves the custodians of an ancient tradition—like the prolific Jesuit Athanasius Kircher, who undertook to decode the hieroglyphs of Egyptian obelisks for the popes of Baroque Rome so that their transplantation could be seen as the pagan Nile baptized by Christian Rome, or Sir James Hall, who tied willow rods together in a primitive arch to prove that the pointed Gothic style had begun with the interlaced boughs of trees.

Colorful as many of these devotees of nature myths were, they were emphatically not just a motley collection of eccentrics rambling down memory lane. Each one believed that an understanding of landscape's past traditions was a source of illumination for the present and future. That conviction made them less antiquarians than historians, or even prophets and politicians. They waxed passionate about their favorite places because they believed they could redeem the hollowness of contemporary life. And I have followed them into the wild woods, upstream along the rivers of life and death, up into the high mountains, not in the spirit of a cultural camper but because so many of our modern concerns—empire, nation, freedom, enterprise, and dictatorship—have invoked topography to give their ruling ideas a natural form.

Joel Barlow, American poet, commercial agent, diplomat, and mythographer, was but one of these explorers who linked the passions of their own time to ancient obsessions of nature. He sought the origins of the Liberty Tree in the ancient Egyptian myth of Osiris's resurrection because he wanted to root the most important emblem of freedom in both the American and French revolutions in a cult of nature. That seemed to him to make the urge to liberty not just a modern notion but an ancient, irresistible instinct, a truly *natural* right.

Barlow was following what, a century later, the great art historian and iconographer Aby Warburg would call the path of "social memory" (*sozialen Gedächtnisses*).[18] As one might expect from a scholar trained in his tradition, Warburg was primarily concerned with the recurrence of ancient motifs and expressive body gestures in the later classical art of the Renaissance and Baroque. But he had read as deeply in anthropology and early social psychol-

ogy as in art history. So his inquiries took him well beyond the purely formal issue of the survival of particular gestures and conventions in painting and sculpture. For Warburg those were merely the indicators pointing to something profoundly surprising and even troubling about the evolution of Western society. Beneath its pretensions to have built a culture grounded in reason, he believed, lay a powerful residue of mythic unreason. Just as Clio, the Muse of history, owed her beginnings to her mother, Mnemosyne, a more instinctual and primal persona, so the reasoned culture of the West, with its graceful designs of nature, was somehow vulnerable to the dark demiurges of irrational myths of death, sacrifice, and fertility.

None of this means that when we, too, set off on the trail of "social memory" we will inevitably end up in places where, in a century of horror, we would rather not go, places that represent a reinforcement of, rather than an escape from, public tragedy. But acknowledging the ambiguous legacy of nature myths does at least require us to recognize that landscapes will not always be simple "places of delight"—scenery as sedative, topography so arranged to feast the eye. For those eyes, as we will discover, are seldom clarified of the promptings of memory. And the memories are not all of pastoral picnics.

For that matter, a striking number of those who have been the most determined investigators of nature myths, like Nietzsche and Jung, have not been among the most warmhearted enthusiasts of pluralist democracy. And even today, the most zealous friends of the earth become understandably impatient with the shuffles and scuffles, compromises and bargains of politics when the "death of nature" is said to be imminent, and the alternatives presented as a bleak choice between redemption and extinction. It is at this point, when environmental imperatives are invested with a sacred, mythic quality, which is said to demand a dedication purer and more uncompromising than the habits of humanity usually supply, that memory may help to redress the balance. For what I have tried to show in *Landscape and Memory* is that the cultural habits of humanity have always made room for the sacredness of nature. All our landscapes, from the city park to the mountain hike, are imprinted with our tenacious, inescapable obsessions. So that to take the many and several ills of the environment seriously does not, I think, require that we trade in our cultural legacy or its posterity. It asks instead that we simply see it for what it has truly been: not the repudiation, but the veneration, of nature.

Landscape and Memory is not meant as facile consolation for ecological disaster. Nor does it make any claim to solve the profound problems that still beset any democracy wanting both to repair environmental abuse and to preserve liberty. Like all histories, this is less a recipe for action than an invitation to reflection, and is meant as a contribution to self-knowledge rather than a strategy for ecological rescue. But if by suggesting that over the centuries cultural habits have formed which have done something with nature other than merely work

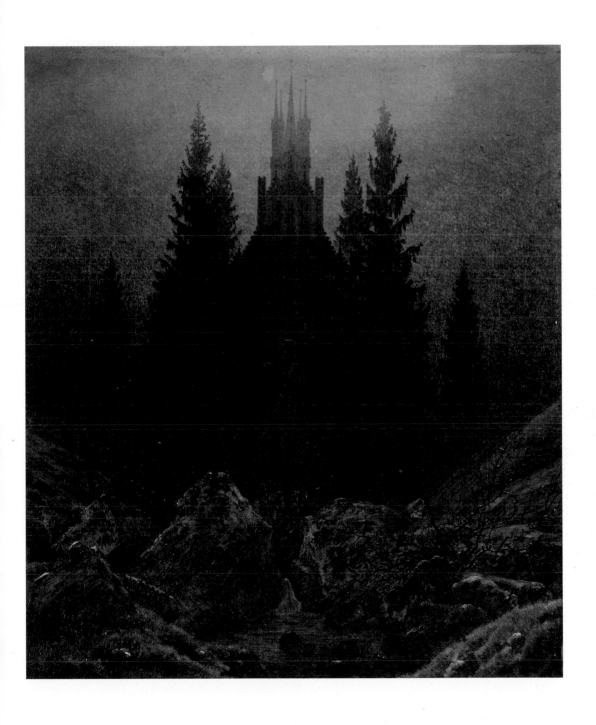

1. Caspar David Friedrich, *The Cross and Cathedral in the Mountains*, ca. 1812.

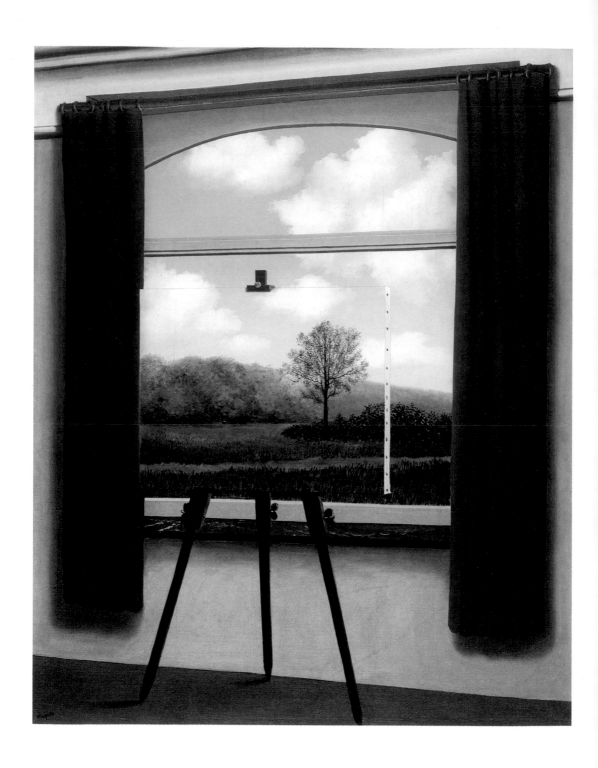

2. René Magritte, *La Condition humaine*, 1933.

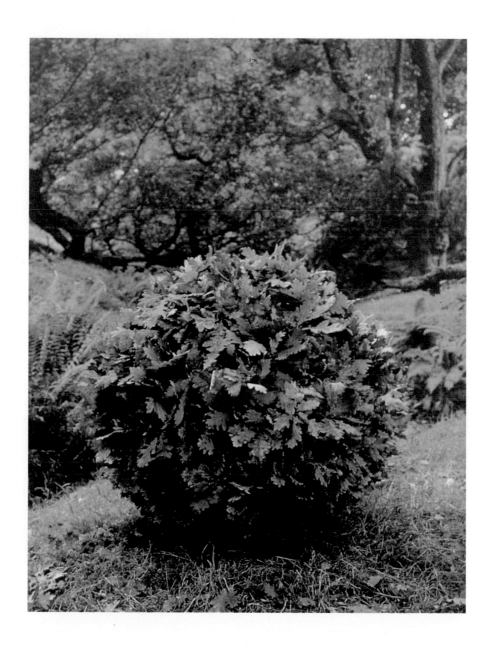

3. Andy Goldsworthy, *Wind, cloud, sun, rain,* 1985.

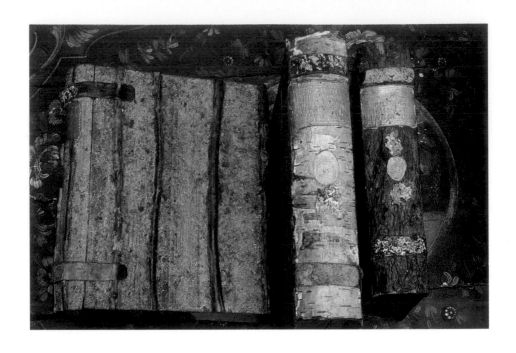

4. Xylothèque, Franeker, the Netherlands (photo: Rosamund Purcell).

5. Anselm Kiefer, *The Cauterization of the Rural District of Buchen*, 1974.

it to death, that help for our ills can come from within, rather than outside, our shared mental world, this book may not entirely have wasted good wood pulp.

Shelve it between optimism and pessimism—represented, as it happens, by two other kinds of wood-books. The volumes of the *xylothèque*, the "wooden library," are the product of a time when scientific inquiry and poetical sensibility seemed effortlessly and wittily married: the Enlightenment of the eighteenth century (color illus. 4). In the German culture where modern forestry began, some enthusiast thought to go one better than the botanical volumes that merely illustrated the taxonomy of trees. Instead the books themselves were to be fabricated from their subject matter, so that the volume on *Fagus*, for example, the common European beech, would be bound in the bark of that tree. Its interior would contain samples of beech nuts and seeds; and its pages would literally be its leaves, the folios its *feuilles*. But the wooden books were not pure caprice, a nice pun on the meaning of cultivation. By paying homage to the vegetable matter from which it, and all literature, was constituted, the wooden library made a dazzling statement about the necessary union of culture and nature.

Two and a half centuries later, after the sunny confidence of the Enlightenment had been engulfed in catastrophe, after landscapes picturesque and sublime had been chewed up by war and fertilized by the bones and blood of the unnumbered dead, another German created a different kind of wooden book (color illus. 5). But on the pages of Anselm Kiefer's book, history is written in letters of fire, and the optimism of the eighteenth century's culture of nature is consumed in smoke. The leaves of the volume, called by the artist *Cauterization of the Rural District of Buchen* (the district named for the beeches), are scorched by the conflagrations of total war, of the consummation of nature in atrocity.

We cannot help but think of fire as the element of annihilation. But both mythographers and natural historians know better: that from the pyre rises the phoenix, that through a mantle of ash can emerge a shoot of restored life. So if this is a book of memories, it is not meant as a lament at the cremation of our hope. Rather, it is a journey through spaces and places, eyes wide open, that may help us keep faith with a future on this tough, lovely old planet.

PART ONE

WOOD

YELENA *(to Astrov)* *You're still a young man. You*
 look about thirty-six or thirty-seven.
 I don't suppose it's as interesting as
 you say. Forest, forest, forest . . .
 monotonous, I should have thought.

SONIA *No. It's tremendously interesting.*
 Every year, the doctor plants new
 trees and they've sent him a bronze
 medal and a diploma already.

ANTON CHEKHOV
Uncle Vanya, act 1

The Detour

It took the mound at Giby to make me grasp just what was meant by "landscape and memory."

At first glance, when it flashed by the window of the ancient Mercedes, it looked nondescript, just a scrubby hill on which someone had planted a makeshift cross; another parochial fetish in a place still agitated with piety. But something about it snagged my attention, made me feel uneasy, required I take another look. We turned the car round.

We had been driving through the northeastern corner of Poland, a country where frontiers march back and forth to the abrupt commands of history. The same fields of wheat and rye moving in slow waves with the rhythm of the breeze had been Lithuanian, German, Russian, Polish. And as the car ate up the kilometers between the old boating resort of Augustów and the medieval church town of Sejny, we seemed to be moving backward in time. Plows were drawn by horses. The same horses—big, lumbering, high-cruppered chestnuts and bays—pulled carts packed with sunburned farm children along rutted roads and paths. The air smelled of cattle. A wide white early-evening sky was neither troubled by the scream of jets nor punctured by pylons. Beside chimney pots,

storks stood sentinel at their monstrously overbuilt nests, untidy citadels of twigs and branches. Every so often pairs of the birds, mates for life, would engage in noisy bouts of conjugal fencing, their lurid pink bills clacking against each other. Off to the east, a dark wall of forest, the most ancient in Europe, rose adamantly against the horizon.

I had come to Poland to see this forest. See what, exactly, I wasn't sure. Historians are supposed to reach the past always through texts, occasionally through images; things that are safely caught in the bell jar of academic convention; look but don't touch. But one of my best-loved teachers, an intellectual hell-raiser and a writer of eccentric courage, had always insisted on directly experiencing "a sense of place," of using "the archive of the feet." My subject was landscape myth and memory, and this woodland wilderness, the *puszcza*, stretching all the way along the borderland that Poland shared with Belarus and Lithuania, was the "native realm" of writers of our time like Czesław Miłosz and Tadeusz Konwicki; or past time like Adam Mickiewicz.[1] Generation after generation, such writers had created a consolatory myth of a sylvan countryside that would endure uncontaminated whatever disasters befell the Polish state. And with a swerve of logic that only connoisseurs of Polish history can appreciate, this sempiternal homeland was celebrated (in Polish) as "Lithuania."

> *O Lithuania, my country, thou*
> *Art like good health, I never knew till now*
> *How precious, till I lost thee.*[2]

"Just imagine," said a friend, "you Americans singing 'Canada the Beautiful.'"

Unstable identities are history's prey. There was, I knew, blood beneath the verdure and tombs in the deep glades of oak and fir. The fields and forests and rivers had seen war and terror, elation and desperation; death and resurrection; Lithuanian kings and Teutonic knights, partisans and Jews; Nazi Gestapo and Stalinist NKVD. It is haunted land where greatcoat buttons from six generations of fallen soldiers can be discovered lying amidst the woodland ferns.

The Mercedes pulled up outside the porch of a handsome wooden Lithuanian church, its timbers the color of burnt umber, the roof surmounted by an onion-shaped cupola covered in gray slate. A brown garland of wheat hung slackly over the door. Families were beginning to arrive for evensong beneath flights of racing swallows. Small boys dragged their feet while their mothers pulled them into the church, holding bunches of blue meadow flowers—lupines and cornflowers—in their spare hand.

A hundred yards up the road, and set back from it on a steeply rising embankment, was the wooden cross, backlit by the six o'clock sunshine like a

painting by Caspar David Friedrich. Skeptical pilgrims in a land notorious for instant martyrologies, we approached the cross up a grassy slope, dotted with boulders, hundreds of them, standing on end like a congregation or a battalion guarding a holy way. Halfway to the top we could read script on a small notice pinned to the cross telling us that in early 1945, here, at Giby, hundreds of men and women accused of supporting the Polish Home Army were taken to their death by the NKVD, Stalin's security police. The little hill had been given a fresh crown of yellow sand on which rested roughhewn slabs of polished granite. The stones were engraved with perhaps five hundred names, listed alphabetically from *A* to *Z*, then beginning again with *A* names, as though someone, late at night, had clapped his hand to his head and said, "Jesus Maria, what about Stefan and Jan and Marta?" and people for whom there was no last name and people for whom there was no first name, for both kinds appeared on these gray slabs. A single stone, at a remove from the rest, lay on its side amidst the boulders, declaring "they died because they were Poles."

Post-Communist Poland is full of such places, raw, chafing histories torn from decades of official silence yet still imperfectly recovered; markers freshly dug or posted. But the real shock waited at the top of the mound. For beyond the cross the ground fell sharply away to reveal a landscape of unanticipated beauty. A fringe of bright young trees marked the horizon floor, but at their back, like giants holding the hands of children, stood the black-green phalanx of the primeval forest. In the mid-ground a silver ribbon of river, one of the many lakes and streams feeding into the course of the Niemen, wound through reedy marshes and fields of green corn. The windows of isolated timber cottages caught the sunset beside the edge of quiet ponds where geese stood doing nothing very much. "Behold," one could hear Mickiewicz declaim in his grandest rhetorical manner: "Lithuania." For this, surely, was the picture that filled his mind's eye in his Parisian exile.

> *. . . bear off my yearning soul to roam*
> *Those little wooded hills, those fields beside*
> *The azure Niemen, spreading green and wide,*
> *The vari-painted cornfields like a quilt,*
> *The silver of the rye, the wheatfields' gilt.*[3]

What filled my own field of vision formed the shape of a window or a painting, a rectangular space, composed of horizontally layered scenery. Here was the homeland for which the people of Giby had died and to which, in the shape of their memorial hummock, they had now been added. Their memory had now assumed the form of the landscape itself. A metaphor had become a reality; an absence had become a presence.

Such grassy swellings—tumuli—were the first marks that man made upon the European landscape. Within such burial barrows the bodies of the honored dead would be united with the earth that had produced them, freeing their spirits for the journey to another abode. Lithuania was the last pagan nation to be converted to Christianity as late as the fourteenth century. And the ancient native tradition has endured by memorializing the nation's martyrs and heroes in the form of a *kopiec*—a grassy mound sometimes built from the ground up, sometimes added to the crown of a naturally standing hill. On the outskirts of the ancient Polish capital of Kraków, another patriot son of Lithuania, Tadeusz Kościuszko, fallen in a doomed revolutionary struggle against Russia in the 1790s, is enshrined by just such a hill, unnaturally conical, constructed from soil said to have been carted from the hero's battlefields.[4] Now it is a terraced beauty spot from which hand-holding lovers can survey the elegant old city wheezing in polluted fumes from the Nowa Huta steelworks on its smoggy horizon. At the foot of the mound, Kościuszko's sacred relics—a coat and a sword—hang in a shrine-like space within a toy fortress built by the Austrians.

Beneath the rocks of Giby, though, there is nothing but dirt. Some months earlier, in the nearby forest of Augustowska, a mass grave had been found, surmised to be the place where the NKVD had executed this entire village for supporting the Polish Home Army rather than the Communists. Bodies were exhumed but badges and buckles and boots had shown them to be German soldiers; death's-head insignia appearing amidst the bones; murderers murdered.

So the five hundred of Giby are still ghosts in transit; dragged who knows where, disposed of in some Arctic ice-hole along with millions of other victims. But the village was determined to go through with its act of repatriation. The yellow sand at the foot of the little hill marking a track had been freshly added in preparation for a ceremony in a few weeks. And as survivors' memories released more names, they too would be added to the granite slabs. There would, somehow, be a homecoming.

There was another population that once had also belonged to this landscape for whom homecomings were out of the question. For Poland's Jews en route to the charnel house, a view of the countryside had been blotted out by the shutters and nailed-down slats of transport wagons clattering relentlessly toward the death camps. In our mind's eye we are accustomed to think of the Holocaust as having no landscape—or at best one emptied of features and color, shrouded in night and fog, blanketed by perpetual winter, collapsed into shades of dun and gray; the gray of smoke, of ash, of pulverized bones, of quicklime. It is shocking, then, to realize that Treblinka, too, belongs to a brilliantly vivid countryside; the riverland of the Bug and the Vistula; rolling, gentle land, lined by avenues of poplar and aspen. Its numberless graves, like the memorial at Giby, are marked by unworked standing stones.

I had always thought of the Jews of the Alte Land as essentially urban types, even when they lived in villages: tradesmen and artisans; tailors and carpenters and butchers and bakers; with the rebbe as the lord of the shtetl; microcosms of the great swarming communities of Wilno and Białystok and Minsk. And so it often was, but the villages we walked through, these picture-perfect rustic cottages with their slanting timber eaves and crook-fenced gardens, had once been Jewish houses. "Seventy percent, eighty percent of the people here and here and here," said Tadeusz, "—all Jews." So even if they had not worked the earth with their hands or cut hay in the fields, these Jews had been country people, no less than the villagers of the Cotswolds or the peasants of the Auvergne. And one group among them, people known to everyone in the border country of Poland and Lithuania, had even been people of the forest, the wilderness *puszcza*.

Among them, somewhere, was my family. My mother's father, Mark, who did become a butcher, left this region along with three brothers, at the turn of the century, driven by the horseback terror of the Cossack pogroms. But his father, Eli, like many other Jews, made his living cutting timber from the great primeval forests, hauling it to the tributaries that fed the Niemen and floating the logs north to the sawmills of Grodno or, even farther downstream, all the way to the old provincial city of Kowno. The waters were full of these Jewish river rats, sometimes spending weeks at a time on the rafts, sleeping in crude cabins constructed from logs propped on end in the company of chickens and each other. During the brutal Lithuanian winters when the rivers were frozen, he would transport the timber on long sleds driven by big Polish farm horses or teams of oxen. From Kowno or Wilno on the river Viliya the lumber would be sold to the Russian railway companies for ties, or freight wagons, or shipped further downstream in rafts of a thousand or more logs, to the Baltic for export, usually handled by other and grander Jewish timber companies.

Somewhere, beside a Lithuanian river, with a primeval forest all about it, stood my great-grandfather Eli's house; itself made of roughly fashioned timber with a cladding of plaster, surrounded by a stone wall to announce its social pretensions. My mother, who was born and grew up in the yeasty clamor of London's Jewish East End, retains just the scraps and shreds of her father's and uncle's memories of this landscape: tales of brothers fending off wolves from the sleds (a standard brag of the woodland taverns); of the dreamy youngest brother, Hyman, falling asleep at the loading depot and rudely woken by being tied to a log and heaved into the river. Was this family as improbable as the Yiddishe woodsmen of Ruthenia I had seen in an old Roman Vishniac photo, poling logs in their sidelocks and homburgs; lumberjacks *mit tzitzis*?

And just where, *exactly*, was this place, this house, this world of stubby yellow cigarettes, fortifying pulls from grimy vodka bottles, Hassidic songs bellowed through the piny *Poylishe velder*? "Where was it?" I pressed my mother while we sat eating salad in a West End hotel. For the first time in my life I badly

needed to know. "Kowno gubernia, outside Kowno, that's all we ever knew." She shrugged her shoulders and went back to the lettuce.

The history of the country only deepens the uncertainty. For "Lithuania" is not coterminous with the present borders of the shrunken Baltic republic; still less with its language and religion. For centuries it covered an immense expanse of territory stretching all the way from the Black Sea in the south to the Bug river in the west to the Baltic in the north. In 1386 its hunter-king Jagiełło married the Polish queen Jadwiga, creating by their union the Great Polish realm. Over time the cultural identity of the south and west of the country was colonized by Poland. Its landowning gentry came to speak and write Polish and call themselves by the Polish name of *szlachta*. In the late eighteenth

Jewish lumbermen, Ruthenia (photo: Roman Vishniac).

century Poland was brutally and cynically partitioned and the pieces devoured by its neighbors—the Prussians, the Russians, and the Austrians. The Lithuanian heartland became Russian, and its Polish-speaking poets came to think of it as the captive homeland.

With no formal frontiers to cross, itinerant Jewish traders migrated within the Russian Empire as family connections or economic incentives beckoned, north from the Ukraine or Byelorussia, south from Latvia, magnetized by the great center of piety and cultural passion in Wilno. My great-grandfather and his four boys, like so many other wood-shleppers, were outriders of this Judeo-Lithuanian world, by Yiddish standards, real backwoodsmen, as at home with horses and dogs and two-handled saws as with prayer books and shabbos candles. We drove further north from Giby, past synagogues with drunkenly undu-

lating gables and whitewashed walls (the wooden structures having all been burned by the SS and their local collaborators), cutting through darker woodland dominated by spruce and fir. I remembered someone in a Cambridge common room pestering the self-designated "non-Jewish Jew" and Marxist historian Isaac Deutscher, himself a native of this country, about his roots. "Trees have roots," he shot back, scornfully, "Jews have legs." And I thought, as yet another metaphor collapsed into ironic literalism, Well, *some* Jews have both and branches and stems too.

So when Mickiewicz hails "ye trees of Lithuania" as if they belonged only to the gentry and their serfs, foresters, and gamekeepers, I could in our family's memory lay some claim to those thick groves of larch, hornbeam, and oak. I dare say that even the lime tree, worshipped by pagan Germans and Lithuanians as the abode of living spirits, lay on Eli Sztajnberg's sleds and carts waiting to be turned into the clogs and sandals worn everywhere in the Lithuanian villages.

Notoriously, Jews and Gentiles did not share the Lithuanian woods as happy neighbors. From the time they arrived in the forest region in the mid seventeenth century, fleeing from the slaughter inflicted by Bogdan Chmielnicki's murderous Cossacks in the Ukraine, relations have been always paradoxical, sometimes painful.[5] Though Great Poland had been home to the Jews for much longer, perhaps as far back as the twelfth century, they had always constituted an irreducibly distinctive presence in the kingdom, what Aleksander Hertz has defined as a caste.[6] And though their economic value was recognized, neither the intense, often primitive fervor of Polish Catholicism nor the mysticism of Slavic Christian Orthodoxy was auspicious for humanizing the Jewish presence. And to these two kinds of dangerous ecstasies, Judaism added its own, in the form of Hassidism, invented at precisely the time that Poland was in the process of being torn to shreds by the partitioning powers. So Polish Jews became themselves doubly flayed by history: martyrs' martyrs. Though the first Polish pogrom took place in Warsaw in 1794 while the nation was in its terminal throes, the riot remained an isolated incident and its leaders were punished, rather than celebrated, by the national government. Somehow, the worlds of the Jews and the Poles, anxious and often affronted by each other, were too thoroughly shaken together for the poison of demonization to work its way through the bloodstream of the nineteenth-century nation.

So should we be surprised to discover the Polish super-patriot Adam Mickiewicz, whose great statue dominates the market square of Kraków, not merely ambivalent about the Jews, but uncomfortably, undeniably, *related* to them?

Of his intimate familiarity there can be no doubt. His mother was herself from a family of Jewish converts, but her uncle with whom Adam spent his childhood country holidays was uncompromising and unbaptized. So that, unlike many young Poles of his generation, Mickiewicz grew up with Jews in his sights

and for that matter in his blood. According to one of his friends, Antoni Odyniec, the boy Mickiewicz stayed with a Jewish merchant on his first visit to Wilno and listened raptly to the old man's Yiddish stories.[7] In this world, where the Lithuanian towns spilled into the muddy countryside, it was impossible *not* to collide with rabbis and peddlers and carters and tailors and millers and horse traders and *schnorrers,* though some in Mickiewicz's class moved swiftly through the swishing coat-hems and the prodding fingers with their eyes averted and noses in the air. But Mickiewicz's lawyer father had no such qualms. He lodged the family in Zydowska Street (Jew Street) and took their cases even when it meant arguing against the Mother Superior of a Basilian order of nuns.

When Mickiewicz became a teacher he moved southwest to the second great city of Lithuania, Kowno, where the medieval alleys hummed with Jewish commotion. With his penchant for expeditions to rural backwaters, especially the dusty, ill-shod world of the river rafters, hunters, and foresters, it seems inconceivable that the young poet did not explore the rural districts along the west bank of the Niemen. So I shall claim him for a *Landsmann.*

Such kinships have their complications. Mickiewicz, part Catholic, part Jew, part convert, part messianist, was neither consistently philo-semitic nor anti-semitic (though he was capable of expressions of both). It was rather that where so many of his contemporaries saw the history of the two nations as necessarily alien to each other, Mickiewicz the poet from the beginning saw just how snarled up they were in each other's fate. In 1832, following the collapse of the November uprising against the tsar—the great catastrophe of his life— he wrote a gospel of national religion explicitly associating Poland's martyrdom with the Passion of Christ: *The Books of the Polish Pilgrim.* Book 15 features a Christian forester who declines a highwayman's invitation to pillage a local Jewish inn and kill its occupants and instead turns on the robber. Bleeding from his wounds, he goes to the Jews and asks their help in making sure the thief is put out of action. To his amazement (and though they give him brandy and tend his wounds) the Jews are full of querulous skepticism—dubious about the story, fearful the forester may demand payment for his protection, protesting it was not their job to clear the forest of robbers. Unable to make them comprehend his altruism, the forester walks off, groaning with pain, into the woods:

> The Jews knew that he was grievously wounded but they felt that they
> had done ill and they wished to persuade themselves that they had done
> no ill. So they talked loudly, that they might deafen their consciences.[8]

Mickiewicz's little parable is a classic item of Polish anti-semitism, neither better nor worse than the ancient Catholic tradition from which it so obviously descended.[9] Its Jews are stereotyped as callous, mean-minded unbelievers,

impervious to the meaning of disinterested sacrifice and ignobly timorous into the bargain. Above all, these Hebrews, huddled in their inn somewhere, are made to appear out of place in their surroundings, a scenic anomaly.

All of which makes the presentation of the Jew in *Pan Tadeusz* just two years later, in 1834, all the more astonishing. For although Jankiel (the name of his old Yiddish host in Wilno) is also an innkeeper, he is as much in his element in the countryside as the feudal barons, foresters, and peasants who populate Mickiewicz's story of Old Lithuania on the brink of the modern world. The same fox-fur hat and long coat which in other stories make the Jew conspicuously different now actually seem to be made from native fabric and intricately embroidered and ornamented with precious stones and metals. The drink he brews is a miraculously potent and mysteriously delectable honeymead. The inn itself is exotically picturesque, "turned up roof of lath and straw askew/ . . . crooked as the torn cap of a Jew." Yet somehow it belongs absolutely to the native landscape:

> *A style of architecture quite unknown*
> *To foreigners and now become our own . . .*
> *This inn was like a temple from behind*
> *The oblong front, like Noah's ark designed.*[10]

But what really naturalizes Jankiel is his music. Music is so important in *Pan Tadeusz* that it might as well have been a tone poem. It is as elaborately and as passionately described as the Lithuanian landscape and it is always meant to speak of a native feeling so powerful, so ancient, and so instinctive that it can hardly be communicated in any other form. At the center of the story of two feuding dynasties is a great woodland hunt during which one of the many officials of the retinue, the "seneschal," plays on a bison horn, a call that echoes over and over again throughout the forest; a sound to which Mickiewicz gives a feral tone, bonding together the men and the beasts, the hunters and their quarry, in a kind of primitive sylvan companionship.

At the very end of *Pan Tadeusz* the warring Soplicowo and Horeszko families are abruptly reconciled by the sudden appearance of a Russian threat, and their reconciliation is crowned by the marriage of Tadeusz to Zosia, uniting the clans. And it is at this point that Jankiel is asked by the bride to take out his zembalo—the old Polish dulcimer—and play for the wedding. At first he refuses, but then is sweet-talked by Zosia into consenting:

> *He sat and, taking up the instrument,*
> *He looked at it with pride and deep content;*
> *As when a veteran hears his country's call,*

Whose grandsons take his sword down from the wall,
And laughs: it's long since he has held the blade,
But yet he feels it will not be betrayed.[11]

The Jew's dulcimer thus becomes a musical weapon, unsheathed to turn a wedding party into a patriotic communion. And Jankiel's performance becomes a musical history of Poland's sorrows and defiance: beginning with the polonaise of May 3; the anthem of Kościuszko's revolution of 1794; changing to a violent dissonance recalling the betrayal of the revolution at Targowica and the Russian intervention, finally closing with the Dąbrowski mazurka adopted by the Polish legions fighting with the Napoleonic armies in the hope of a national resurrection:

That all the strings like brazen trumpets blared,
And from the trumpets to the heavens sped
That march of triumph: Poland is not dead! [12]

Jankiel finishes, exhausted by this patriotic consummation; "His floating beard majestically tipped;/Upon his cheeks two strange red circles showed,/And in his eye a youthful ardour glowed." With tears in his eyes, he greets General Dąbrowski as if he were the awaited Messiah.

He sobbed, the honest Jew,
He loved our country like a patriot true.
Dąbrowski gave the Jew his hand to kiss,
And thanked him kindly for his courtesies.

It is difficult to imagine a more complete transformation. Once an alien presence in the native land, the Jew has become its ancestral embodiment, as natural a figure in the landscape as hunters and woodsmen.

The idea of the Yiddish polonaise strummed on the zembalo by Jankiel the patriot is not quite as bizarre as it seems. For when Kościuszko's troops faced the Russians in their hopeless resistance in 1794, the Warsaw National Guard included a Jewish legion commanded by Berek Joselewicz, the first Jewish company under arms since the Dispersion, something undreamed of by the French Revolution.[13]

For Mickiewicz, dwelling amidst the Polish Diaspora in Paris, and becoming possessed by spiritual and messianic visions, the Jewish and Polish experiences of exile and suffering were directly analogous, even providentially related. It must have seemed to him a mysterious union of blood, not merely of nations but of sexes, for the male Polish Lithuanian Mickiewiczes seemed destined to marry not just Jewish women, but Jewish women from the ranks of the Frankist

sect that had believed in the appearance of the Messiah in the eighteenth century. In the same year that *Pan Tadeusz* was published Adam married Celina Szymanowska, the granddaughter of one of the most ardent Frankists in Poland.[14] Some literary historians, embarrassed by Mickiewicz's plunge into the cult of "Towianist" messianism that prophesied the convergence of Christianity and Judaism, have argued that it was his wife's passions (she was clinically unstable, they have implied, since she ended her life in a home for the insane) that swayed him. But the truth was much more obviously the other way about. By the time he met Celina, Mickiewicz was already stirred by what seemed to be the ordained union of the fate of both tribes. In 1842 he would tell his students at the Collège de France (in tones of divine election reminiscent of Michelet's threnodies for the Chosen of republican France) that

> it was not accidental that this people [the Jews] chose Poland for their fatherland. The most spiritual of all people, they are capable of grasping the highest values of humanity. But halted by their development, unable to see the end promised to them by Providence, they scattered the powers of their spirit in earthly ways and thus became contaminated. And yet it is only they who have not ceased to await the Messiah and this faith of theirs has undoubtedly influenced the character of Polish Messianism.[15]

Jewish emancipation and Jewish conversion, then, were part of the same historical process that would usher in a new era. In this new sacred epoch the converted Jews would take their place alongside their fellow Poles in a doubly redeemed homeland.

One of his closest friends was Armand Lévy, a Polish Catholic of Jewish descent who became guardian of Mickiewicz's children after the poet's death in 1855 and who himself returned to his old faith. In 1845 Lévy and Mickiewicz went together to the synagogue in the rue Neuve Saint-Laurent, on Tisha B'Av, the fast day that commemorates the destruction of the Jerusalem temple by the Babylonians in 586 B.C. and the Romans in 70 A.D. And it was with Lévy that Mickiewicz seems to have dreamed up the fantastic enterprise of the "Hussars of Israel."

It was the Crimean War that gave him his opportunity. In this most serious war of the mid nineteenth century, British and French troops came to the defense of the Ottoman Empire against Russia. On the principle that my enemy's enemy is my friend, the Polish émigrés planned to recruit a "Cossack" regiment to fight with the Ottoman army commanded by one Sadik Pasha, formerly the Ukrainian nobleman Michał Czajkowski. It was Mickiewicz's gloriously harebrained notion to expand this legion to include an explicitly "Hebraic" regiment recruited partly from Polish Jews who had been forced to

serve in the Russian army and had been taken prisoner by the Turks and partly from Ottoman Jewish volunteers themselves.

It was an extravagantly Polish fantasy, this dream of the Jewish-Polish-Turkish-Cossack, a thousand cavalrymen astride shiny black mounts, brilliantly kitted out in gold braid and shakoes, brandishing their sabers at the Russian hordes. Yet it was not, perhaps, any more lunatic than the visions that the Viennese Theodor Herzl would have, forty years later, of equestrian pioneers, Zionists on Lippizaners surveying the Galilean *fellahin*.

The Hussars of Israel were not a success. Though there were a handful of Jewish volunteers among the "Cossack" regiment, their commander, Sadik Pasha/Czajkowski, continued to refer to "scurvy Jews," and the Turks themselves (not for the last time) imagined the Hussars to be the first step in an international Jewish conspiracy to take Palestine. The enterprise would become envenomed in loathing and ridicule and Mickiewicz would himself collapse and die in Constantinople of a strange and unidentifiable agony of the gut, perhaps poisoned for the eccentricity of his visions. A Jewish midwife had brought him into the world, and Lévy, the reborn Jew, would pass a hand over his expiring brow.

A few months before the sorry demise of the dream and the dreamer, on a sultry Sabbath day in September 1855, the two friends in Israel-Lithuania, Mickiewicz and Lévy, went to another synagogue. This time the temple was in Izmir, the port city that the rest of the world knew as Smyrna. With an interpreter they went to see the local haham and attended Sabbath services. Again the poet was profoundly moved. Black silk gowns and candlelight flickering against the walls transported him at once to his lost, beloved Lithuania. The Sefardi melodies, the food stuffed with dried figs and apricots and perfumed with cinnamon and rosewater, the divans covered with silk and tapestry made no difference at all. Izmir was, he said, the image of a Jewish Lithuanian town, Kowno-in-Levant.

Quite mad, of course, except that my father's father's family lived in Izmir while my mother's father's family lived in Kowno. As far as I know, none of the Schamas or the Steinbergs became Cossacks, though my mother swears we had a circus rider who also tamed wild horses, though never on the shabbos.

I had been to Izmir many years ago, but never to Kowno. But now it is Kaunas, not the "Lithuania" of Mickiewicz's *patria* but the Baltic Lithuanian republic, with its own non-Slavic tongue. Though my visa was for Poland it might be possible, I thought, to cross the frontier. But we were cautioned that getting back was an altogether different proposition, taking our place in the three-day line waiting to migrate through Poland and westward on to the flesh-pots of EC capitalism. I had to be in Kraków in two days.

Kowno itself would have to remain a tantalizing distance away. But to be in my grandfather's landscape—timbered Lithuania—I did not need to cross

any borders at all. When I stood on the mound at Giby I was already there. But still I hungered for some familiar name, scanned the map of the frontier country for something that echoed. At its very northeastern tip, two miles from the border itself, was a place marked "Punsk." What was it my mother had said about the place the brothers went for the logs as she fretted about ancient enemies lurking in the woods—Cossacks, Poles, Nazis, NKVD—a place the brothers went to fetch logs . . . Pinsk? Too far south. Something like that.

It would be a detour, but then this whole expedition to a Poland that was once a Lithuania had been a detour. I had always liked that word, *meandering,* its snaking run of syllables flowing who knows where?

We pointed the Mercedes back north and the countryside opened up into rolling hills, cultivated fields, the forest still pursuing us darkly at the skyline.

Whatever it had once been, Punsk is now a Lithuanian town; Polish spoken to strangers, the Baltic tongue among its people. When Vilnius was being intimidated into temporary submission by Soviet troops in 1990, an office of the Lithuanian independence movement Sajudis was established there, and the overgrown village became a main transit point for donations of food, clothes, even money crossing the border. Some of the children, hurrying to their confirmation service at the twin-spired church, were dressed in the standard East European miniature ball-gowns and bridal dresses. But others wore ethnic Lithuanian costume, with green and red embroidered pillbox hats and short green jackets.

We asked and there was neither embarrassment or hesitation. "Over there," said a stout man in front of the church, pointing to a row of solid cottages with overhanging gables and fenced yards lining the main street, "all Jewish properties; not now, no Jews now."

There had to be, I knew, a Jewish cemetery and there was. Hands waved us in the general direction, but we drove out of the village (more than once), vainly searching the streets before we realized it must have been sited much further off. The Mercedes followed a street until it became a dirt road, then a farm track. We found ourselves at the edge of a wheat field, the car's wheels spinning crazily in a deep tractor-tread rut. Bogdan, the driver, gunned the engine savagely and careened through the field to descend again to a metalled path. We got out and, beyond the snarling and the smoke of scorched rubber, there it was: a crumbling gray stone wall attempting to contain an acre or so of trees and long-unmowed grass. Behind the wall the ground rose in a gentle slope. It was a burial mound.

Inside the enclosure what had looked like grass turned out to be a solid carpet of dandelions, packed so thickly that they formed a rippling, deep-pile meadow, perhaps a foot and a half tall, catching the light through the trees in dancing speckled patterns. It took a while to see any sign of stones at all, but close to the top of the little hill, one or two stuck out from the undergrowth

at crazy angles. Was this all? Were these the generations of Jewish Punsk? Had the Nazis ripped out the stones as they had throughout Poland? Or had the Lithuanians done it themselves?

It was only by crushing the dandelions underfoot that I could feel something other than soft-packed dirt. I knelt down and parted the stalks and leaves, brushed away the fuzz of their seedballs. Two inches of grizzled stone appeared, the Hebrew lettering virtually obliterated by heavy growths of tawny and mustard-colored lichen. I could just make out a name, Tet, Bet Yud, Hay, Tevye, Tovye? I sat and swept my arms about in the dandelions like a child making a snow-angel. Another stone appeared and another. Digging down a few inches brought another up from the netherworld. I could have spent a day with a shovel and shears and exposed an entire world, the subterranean universe of the Jews of Punsk.

But to what end? I thought of my father, looking stoically out at Hampstead Heath and reverting to cricket metaphors before he died: "When you've had your innings, you've had your innings." The tombs themselves were being buried, sliding gently and irrevocably into their companionable mound as verdant Lithuania rose to reclaim them. The headstones that had been lovingly cut and carved were losing any sign that human hands had wrought them. They were becoming a geological layer.

I lay down and stared through the branches at the blue beyond, listened to the elms and the poplars saying an indistinct Kaddish, and thought, Well, once there was a Lithuania and no Jews and for that matter no Christians either. Then there were Jews and some of them lived about the wood and took it to the rivers and the towns, and now there are no Jews again and the forest stands there.

Perhaps Deutscher was right, I thought. Trees have roots; Jews have legs. So I walked away from the mound at Punsk.

In the Realm of the Lithuanian Bison

i The Royal Beasts of Białowieża

Please, try the bison," said Tadeusz. "Really, it's very good."

So I did, and had to admit that it tasted better than it looked—crimson and stringy—arranged vividly on the "huntsman's platter" between the wild boar and the elk venison. In fact it tasted like nothing I'd ever eaten before: a strange sweetness lurking beneath its cheesy pungency. I might even have got greedy had I not seen the blocky chestnut-brown animals that same afternoon happily tearing and mashing the pasture of their ancestral habitat, the great primeval forest of Białowieża. I knew that every season there was a modest cull from the wild herd and that American millionaires who could put down a cool five thousand dollars had the chance to shoot one for the pedantic pleasure of pointing out to guests in Oregon or California or Texas that, no, the head over the wet bar was not an American buffalo but a Lithuanian bison. But I was also mindful that there were no more than two hundred and forty of the animals here, another two hundred in a state park in the south of the country, a pair here and there in zoos, and that was the entirety of the European bison.

So I took my time with the garish red meat and thought about the German soldiers freezing in the forest in the winter of 1918, butchering the bison

with their artillery. I thought about King Stanislas Augustus Poniatowski, the last king of Poland, sending boxes of smoked bison to his mistress, the Russian empress Catherine the Great, even as she whetted her appetite for Poland itself. I thought of Julius von Brincken, Tsar Nicholas I's chief forester, tracking the chocolate-brown animals through the winter snow, inking their numbers on his census.[1] But most of all I thought of Mikołaj Hussowski.

🦋 🦋 🦋

IMAGINE A YOUNG POLE in Michelangelo's Rome, soberly attired in scholar's cap, but affecting the floor-length coat, trimmed with sable, and the thigh-high boots that had become the favored style of the Polish gentry. This dress was supposed to proclaim their descent from the ancient warrior race of the rivers and woods of northeast Europe, identified by Tacitus as "Sarmatian."[2] But while the Roman historian had disparaged the Sarmatians as little better than forest brigands, exhibiting a "degraded aspect" and "living in wagons and on horseback," Polish chronicler-historians of the Renaissance made them a horseback nobility, equal before each other and invincible to foreigners. Some of these early national histories, it is true, preferred a more sedentary myth of origins, insisting that the western Slavs had always dwelled between the Niemen, Vistula, and Bug rivers. But the "Sarmatian costume" recorded in early Polish portraits, with its emphasis on hide and fur, came closer to the probable truth: an ori-

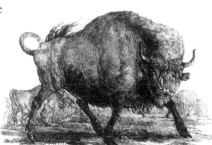

The Lithuanian Bison, engraving from J. von Brincken, *La Forêt Impériale de Bialowieza*, 1828.

gin from the nomadic tribes of the northern Carpathians.[3] Perhaps our scholar Hussowski was bold enough to sport the long whiskers of his countrymen, for he was, after all, the son of a Master of the Hunt. Though his origins were modest, he had been given a thorough humanist education, comprising both sacred devotion and classical learning at the Jagiellonian University of Kraków, then in its glory days. Sometime before 1520 he had been brought to Rome in the retinue of Erasmus Ciolek, the bishop of Polotsk, virtually the easternmost see of the Roman church.[4] And it was there that the promising young hunter-poet penned the first, indeed the only, full-length ode to the Lithuanian bison: *Carmen de Statura, Feritate ac Venatione Bisontis,* one thousand and seventy lines of the most grandiloquent Latin verse.

Though the sources are fragmentary, it seems that Hussowski, whom we should now translate into his Roman dignity as Nicolaus Hussovianus, composed the poem expressly for Pope Leo X, a notoriously passionate hunter. Certainly it also answered to what was then a huge curiosity about exotic beasts,

stoked by the voyages of discovery and the transport to Rome and other European courts of shiploads of rhinoceros, tapirs, and gangling apes.

Hussovianus was the northern forest's answer to the boosters of tropical exotica: a celebrant of the monstrous splendor of the bison—tight-curled above, shaggy beneath, the brute of the Scythian wastes. It was a great pity that he was not given the opportunity to recite it formally before the pope, so that he could roll his Polish accent around his bisonic verse-melodies:

> *Barba riget late pendentibus horrida villis,*
> *Lumina terrorum plena furore rubent*
> *Terribilisque iubae collo funduntur in armos*
> *Et genua et frontem et pectoris ima tegunt.*[5]

> *[A bristling beard hanging in shaggy lengths,*
> *Its eyes, shining with a fearful red rage*
> *And a terrible mane spreading from its neck*
> *And covering shoulders and knees and breast.]*

But Leo died in December 1521 and the new pope, the Dutch Hadrian VI, may have had a more conventionally pastoral attitude to ungulates. At any rate, Hussovianus seems to have languished and it was only when he returned to Kraków in 1523, with his great bison ode rededicated to the Polish queen Bona, that he saw it published in octavo by the Bibliotheca Zalusciana.

It is, by any standards, a strange and marvellous work: eccentric and erudite, scientific and fantastic, solemn and gossipy. Though Hussovianus paid proper tribute to those like Aristotle and Pliny who had preceded him in identifying the animal, being the scrupulous humanist that he was, he also enjoyed correcting the errors and fallacies of earlier writers. The true bison was not the shaggy, maned *bonasus* described by Aristotle dwelling on the borders of Macedonia, whose skin "when stretched covers a seven-seat dining room," and which gave birth within a high rampart of dung and defended itself by a copious voiding of scorching turds which it then kicked at its aggressors (a tactic more faithfully represented in Roeland Savery's 1610 painting than the anatomy of the beast itself).[6] Nor was it the wild "auroch," or "ur-oxen" as Caesar called them, roaming the endless Hercynian forest of Germany whose slaughter, he imagined, battle-hardened that country's young warriors.[7] Other medieval and Renaissance chroniclers like the German Conrad Celtis had described the "glittering eye" and "inward curving horns" of the *belua vasta* (huge monster).[8] But no writer before Hussovianus was so anatomically exhaustive—from the head, somewhat resembling an aged lion, to the tufted tail, horizontally erected whenever the animal was frightened or provoked. He goes on to describe its feeding and rutting habits, its longevity (about forty

years for the male), its notoriously mercurial temperament, and the phenome-
nal speed and strength of its charges. And Hussovianus concludes with a long
section on the traditions of the great bison hunts of the Sarmatian princes,
thousands of liveried beaters pressing the animals toward a preassigned enclo-
sure where royal hunters would dispatch the beasts before pavilions of applaud-
ing onlookers to the sound of the *mort* blown through a hunting horn.

De Bisonte was as much a work of ethnography as natural history. Husso-
vianus was at pains to present the awesome beast as a symbol of the heroic
tenacity of his native land and landscape. Even in the first century Pliny had
noted that the bison had retreated in the face of colonization to the depths of
the great Hercynian forest that marked the eastern border between ancient
"Germania" and the unknown and unconquered barbarian wilderness of

Roeland Savery,
*Bison Attacked
by Hounds,*
1610.

Scythia. Now, Hussowski claimed, the bison was to be found only in the
Lithuanian forest "and no other place in the world." The survival of the ancient
bison in the primeval woodland of the Polish-Lithuanian realm somehow
seemed a sign of its elect historical destiny. So as much as Mikołaj Hussowski
was anxious to present himself at Rome as the learned and pious Hussovianus,
the representative of a true Polish-Catholic Renaissance, his poem celebrated
the raw ungovernability of the Lithuanian forest world.

The paradox is explained by the moment in Polish history at which Hus-
sowski was writing. For a century and a half Poland had been ruled by the
Lithuanian dynasty of the Jagiellons. In 1386 Iogaila, the last pagan grand duke
of Lithuania, had married the twelve-year-old Jadwiga of Anjou and Poland,
uniting their realms under his freshly baptized kingship. And while Lithuania

and Poland preserved their respective identities under the union, it was natural for the first generation of history-chroniclers in the sixteenth century to add to the ancestral history and geography of lowland Poland the sylvan world of the Lithuanian warrior aristocracy.

The bison was as important to the Lithuanian-Polish cult of knighthood as the bull was for the Spanish warrior caste at the other end of Christianity's frontiers.[9] It was a one-ton prodigy, exhibiting the primitive ferocity of the frontier wilderness. "Here in the wildest forest of Lithuania," Hussowski wrote, echoing Albertus Magnus's *De animalia,* "may be found an animal so mighty that three men may be seated between his two horns"; a beast of dark savagery comparable to nothing else; the pendulous shaggy dewlap descending from throat and belly to the ground; the short but wiry mane and beard; the great muscled hump set on its back; the bulbous purplish-blue tongue; the peculiar transverse pupils of the black eyes set in black or dark red cornea; the unearthly honking call of distress to other animals in the herd; the phenomenal displays of strength, as when two beasts in the hunt of King Alexander in the early sixteenth century smashed into the pavilion holding his wife, Helena, and her courtiers, crushing the structure and nearly killing the queen.[10]

In Hussowski's prototype of Polish bison lore (and in the many accounts which followed over the next century), like that of Ritter Sigismund von Herberstein, the Austrian ambassador to Muscovy,[11] the animal was depicted as a miraculous relic of a presocial, even prehistoric past—a tribal, arboreal world of hunters and gatherers, at the same time frightening and admirable. The bison became a talisman of survival. For as long as the beast and its succoring forest habitat endured, it was implied, so would the nation's martial vigor. Its very brutishness operated as a test of strength and justice. The animal featured in ordeals imposed by primitive courts like that of the fifteenth-century prince of Lithuania Zygmunt the Great, who punished a criminal of his own court by dressing him in brilliant red and letting him be torn to pieces by enraged bison. And prowess in the bison hunts became woven into the legends of all those princes who had defended the marcher realm against Teutons from the west and Tatars from the east. Prince Witold was said to have practiced capturing young bison single-handed as an exercise in martial preparation. His cousin, the king, known since his conversion as Władisław, was said to have hunted at the lodge of Białowieża—literally, the White Tower—before his messianic battle with the Order of the Teutonic Knights at Grünwald. Mountainous piles of animal carcasses that could supply both smoked meat and hide shields for his soldiers were sent by raft along the Narew river. First kill the bison, then the Germans.

The heroic savagery of the provoked beast—the Latin term *belua,* or "monster," is often used in the literature—became associated with the immensity, darkness, and depth of its original habitat. That it dwelled in the deep woods and in small "families," rather than on the open grasslands in large,

slowly moving herds, was important for bison lore. The animals came to be seen as fugitive, unpredictable: peaceful until provoked, elusive until attacked, deadly when enraged. They were, in short, very much like those other occupants of woodland literature and history—outlaws and partisans—both of whom were to feature very heavily in the romantic history of Polish resistance. By retreating to the realm of the bison, the depths of the primeval forest, those later survivors of national disaster in the nineteenth and twentieth centuries would find asylum, succor, the promise of re-emergence.

For two centuries Great Poland had been able to boast that it was the most territorially extensive, if by no means institutionally strongest, state in Europe. Until the end of the seventeenth century it profited from the weakness of its neighbors, with Muscovy to the east still juvenile and chaotic, the German states to the west and Bohemia to the south torn apart and depopulated by devastating wars of religion. Poland occupied an indeterminate space in between, and gloried in its incoherence. Its aristocracy and gentry, the *szlachta,* sold their huge grain harvests to canny Dutch traders who arrived in Danzig Memel boasting (with good reason) of the gold pieces in their wagons; enough to fund the most grandiose pretensions of the Sarmatian aristocracy. Elaborate Baroque houses and formal parks, designed by Italian or French landscape architects, began to appear in the countryside east and south of Warsaw or among the fields and meadows that had been cleared from the Lithuanian woods. The great magnate dynasties—the Radziwiłłs, Lubomirskis, Ogińskys, Potockis, Tarnowskis, Zamoyskis—who housed themselves in this way continued to think of themselves as a free and independent equestrian class; altogether different from, and preferable to, the crushed fops of Versailles and Whitehall.[12] Uniquely in Baroque Europe, their votes elected the monarch; and no law could be legitimate should just one of them dissent. Bizarrely anomalous though this "Polish anarchy" came to seem in a world of states increasingly governed by centralized bureaucracies and managed legislatures, it was of a piece with the Polish nobles' view of themselves as cultivated editions of the warrior hordes. And when in September 1683 their king, Jan Sobieski, led the Catholic armies that liberated Vienna from the Turkish siege, the cult of the feudal horseback levy seemed to have been brilliantly vindicated.

The climactic moment of the battle was the headlong charge of the Polish hussars, swooping down from the Vienna woods against the encampment of the Ottoman sultan and his grand vizier. The understandably elated king wrote to his wife of a rout of three hundred thousand Turks, a force at least four times the size of his own army. And since the Ottoman army had included the horseback soldiers of the Tatar khan, Sobieski could claim to have preserved Christian Europe from the heathen horde. Its barbarism seemed to him exemplified by the wanton slaughter of "a mass of innocent local Austrian people," not to mention an ostrich looted from the Habsburg emperor's menagerie.

However spectacular, the victory at Vienna represented not the perpetuation but the end of Polish-Lithuanian chivalric power. The Lithuanian prince Sapieha had, in fact, detained the arrival of his horsemen until after the battle had been fought, and shortly after took them off in expeditions of anarchic marauding. Sobieski slogged on with further wars against the Turks as his power crumbled at home, and eventually retired to the elegant little palace he had built at Wilanów, outside Warsaw. With its formal park and grandiose collection of paintings and sculpture, it became the prototype for the Baroque country estates that rapidly became fashionable in eighteenth-century Poland.

Though the Polish nobility began to ape the manners and dwellings of their Western counterparts, in their hunting lodges they still sustained the illusion that Sarmatian blood coursed through their veins; that they remained the worthy heirs of the warriors who had vanquished the Teutonic knights, the Tatar hordes, and the Turkish janissaries. In fact the Masters of the Hunts prided themselves on ignoring the increasingly elaborate rules and regulations that affected hunting in Western Europe. Instead, as Baron von Brincken noted, the customs of blood sports remained unapologetically primitive: "The hunter pursues his game as he pleases without submitting to any rules whatsoever; his equipment consisting solely of a poor gun which he loads, as he wishes with shot or with bullets; a game-bag and a hunting horn made from juniper wood. For the chase he uses only hunting hounds that come from a stock so strong and so brave that they will attack wolves and even bears. Mastiffs that might well be of use in hunting big game are never used and the many species of tracking dogs [like spaniels] are hardly known."[13]

Białowieża, the White Tower, home of the *żubr*, was one of the most spectacular of these resorts of illusion; and in the eighteenth century no one enjoyed the place more than the electors of Saxony, after they had been promoted to the Polish throne. When Augustus II or Augustus III came to the primeval forest to hunt bison, elk, bear, wolf, wild boar, and lynx, they could indeed imagine themselves following the trails of Władysław Jagiełło, Zygmunt, and Alexander. At the top of the little hill overlooking the banks of the little Narewka river, an area was cleared to make a park with a handsome and curious hunting lodge at its center. It was constructed of timber—to preserve the sense of the hunt-primitive—though the interior apartments were provided with enough tapestries and oak furniture to give the place an air of sophistication.

On the twenty-seventh of September 1752 the assembly yard in front of the lodge was filled with an immense pack of horses, hounds, foresters, and riders dressed in gray hunting coats, trimmed in green velvet. King Augustus III (who seldom condescended to venture into Poland at all) had come with his queen Maria Józefa and his two sons, Xavier and Karl, to hunt bison and elk. In their train were marshals and officers of the Polish court—Hetman Branicki

(who had, doubtless to the king's chagrin, built a spectacular palace, already called "the Polish Versailles" at nearby Białystok), Wielopolski, Wilcewszki, Poniatowski, and the Saxon Grand Master of the Hunt, Graf Wollersdorff.[14] And though the pretense was of primitive improvisation, elaborate advance planning, amounting almost to a small military campaign, had ensured that the day would not be wasted. This was just as well since the king was enormously fat, frequently drunk, and, unlike his grandfather Augustus the Strong, who sired three hundred illegitimate children, not much given to sustained exertion.

Though its stock of game could hardly be rivalled, either in quantity or diversity, Białowieża in some respects was no place for a halfhearted hunter. There was, after all, a good reason why this green ark of mammals had survived. Since the *puszcza* wilderness had never been cleared, it presented (and still does) formidable obstacles to penetration by riders, let alone an easy shot. Tree roots of fallen oaks, many hundreds of years old, rise like brutally spiked ramparts, twenty feet high, from the forest floor. Carpets of brilliant green algae suddenly part to reveal the black brackish water of deep bogs beneath. And though there are clearings where elk and deer and bison like to graze, by the time hunters have appeared on the spot, their quarries have more than enough notice to flee. Which is why deep winter, when snow could muffle the sound of pursuit and when the animals could be tempted with strategically placed offerings of hay, became a favorite hunting season.

But Augustus and family had planned the hunt for the autumn, before the climate became too severe to enjoy their stay. So before their arrival an advance party of tracker-hunters had staked out an area of the woods within which they would enclose the bison, using the usual thousand-strong army of beaters. The idea was that the line of beaters, making as much noise as possible, would gradually form a closing semicircle as it pressed the game toward a custom-designed enclosure in the woods, complete with ornate pavilion where the royal family would take their shots. The gorgeously dressed courtiers had little more to do than load the royal guns and hand them over.

Even by the standards of the venery-crazed Saxons it was a good day. The queen, obviously no mean shot (though a trapped bison must offer a substantial target even to the most trembling fingers and myopic eye), dispatched twenty bison, almost half the total bag of forty-two, a massed fanfare sounding the *mort* each time one of the enormous animals came crashing down. In between blasting away at the doomed *żubre*, Maria Józefa, evidently a more studious soul than her husband, amused herself by reading, the octavo held high in her long, kid-gloved hands.[15] Thirteen elk and two roebuck were shot to make up a grand total of fifty-seven, all of which were, as custom required, duly arrayed on the ground for the inspection of the king, according to size and grandeur. Each of the carcasses was then weighed and distributed, minus heads, antlers, and whatever other parts may have been prized as trophies, to the beat-

ers as pay. Augustus was so pleased with the day's work that he had an obelisk erected by the riverbank recording for posterity the numbers, weight, and type of the kill. It is still there, bragging in golden limestone of so many bulls, cows, and calves, facing trees carved with the initials of Polish tourists.

The electors of Saxony, all of Europe knew, had only been made kings of Poland by grace of the Russian Empire, formidably increased in territory and military strength. And since true Polish sovereignty had already become a pious fiction by the mid eighteenth century, it was not surprising when Catherine the Great effectively imposed her discarded lover, Stanislas Poniatowski, on the Polish parliament, the Sejm. What *was* a surprise, not least to the empress, who was banking on his lassitude, was the degree of energy, enthusiasm, and intelligence that Poniatowski brought to the job.

In Stanislas's Białowieża, the slaughter of the bison stopped. This was less from any acknowledgement on his part of the symbolic aura of the animal than from his relative indifference to the hunt and the traditional protection accorded to the bison and the lynx as "royal beasts." But what the last king of Poland lacked in venery, he more than made up for in scientific curiosity. A typical product of the Age of Reason, what Stanislas really enjoyed hunting, were facts.

So the Enlightenment came to the Lithuanian woods, especially in the person of the treasurer-general of Lithuania, Antoni Tyzenhaus. He was the first official custodian of the forest not to see it simply as a place where otherwise impotent kings could play the Sarmatian warrior at the expense of the elk, but as a unique ecological and economic resource. Tyzenhaus was first and foremost an aggressive political economist, anxious to *do* something productive with Lithuania's vast potential. Because of their sacred place in the theology of the royal hunt, the ancient frontier forests had been spared the kind of industries that elsewhere in Europe, from England to Brandenburg, had cut huge slices out of their acreage. There were no breweries, no glassworks, no tanneries, no iron forges, not even charcoal burners in Białowieża. Virtually the only commercial activities had been the ancient occupation of wild apiculture: delectable honey gathered by the foresters from specially tended woodland beehives, and the blond, spongy bark stripped from linden trees to make their sandals and clogs.

Beyond the core of the royal game reserve, though, the sleeping forests were being roughly wakened by the kiss of modernity. Unlike western states where vast tracts were reserved to royal protection (or exploitation), the Polish-Lithuanian forest had, over centuries, been alienated to the same aristocratic magnates who dominated the political system. Whether they owned the land outright or not mattered little since use-right leases were so vaguely defined that the noble houses treated their woods as their exclusive property. As the Polish commonwealth became weaker, the Radziwiłłs, Tyszkiewiczes,

Lubomirskis, and the rest began to support their neo-feudal pretensions with aggressive business. The forests were suddenly seen as an immense capital asset. They stood at the hydrological divide between rivers that flowed either south toward the Black Sea or north to the Baltic. With the help of freshly cut canals, linking the Bug, the Vistula, and the Niemen, harvested timber could be sent to ports like Danzig.

And then there was potash. By the middle of the eighteenth century, a traveller to Lithuania might smell the Radziwiłł forests before he saw them, the smoke clouds from potash pits hanging over vast areas of cleared alders. And beneath the fumes alert nostrils could distinguish a peculiar mixture of odors: the sulfurous potash residue fouling the air with the smell of rotting eggs overlaid with the cloying scent of boiling birch tar and pine pitch. At the eastern end of Białowieża, the Tyszkiewicz family, which owned large tracts of the woods, were beginning to establish glassworks.

Finally, there was the perennial obsession with the international grain trade. Sharply rising population throughout Europe was driving prices upward and liberalized markets were sending them even higher. To a Branicki or a Potocki, eager to exchange his old costume of a whiskery Sarmatian squire for the latest edition of a refined, Francophone, international "gentleman," complete with rococo palace, Meissen porcelain, ormolu furniture, pseudo-Fragonards, residential theater, ballet, and orchestra, a park lavishly supplied with fountains, it was easy to agree with the steward who would whisper delightfully in his ear: slash and burn; plant and earn.

Like his Prussian neighbor Frederick the Great, King Stanislas wanted to ensure that the royal state got its share of all this busy good fortune. So he summoned lawyers versed in ancient customs and contracts to look over traditional leases and see if they could not be turned into something more aggressively profitable. Bureaucrats like Tyzenhaus, with armies of clerks and scribes, were turned loose on the forests to verify what was the king's share, and to see what enterprises might be initiated. Serious men in perruques, short dark coats, and pince-nez descended on the *puszcza* villages. The sound of goose quills scratching vellum and barking German instructions began to be commonplace in the local inns.

Karol Radziwiłł and his neighbors were not delighted with this interference. Poniatowski they thought an upstart who owed his throne to his tour of duty in Catherine's bed (admittedly a demanding service). By 1772 their disaffection had turned into outright revolt. For Stanislas, the price of crushing the rebellion with the help of Russian troops was brutal: the cession of large areas of the country, east, south, and west, respectively, to Russia, Austria, and Prussia.

Paradoxically, the humiliation of the first partition spurred Stanislas and his counsellors to more strenuous efforts at reform. The choice seemed starkly

clear: a new Poland or no Poland at all. Taxation, education, the economy, and finally the political system itself all became targets of radical change.

In Lithuania Tyzenhaus pressed on busily, carrying out the first statistical survey of the royal forests, instituting what were proudly advertised as scientific plans for timber cuts and replanting, dredging clogged rivers so that the lumber could be rafted to ports on the Baltic. Needless to say, his activism earned him the hatred of all the major aristocratic proprietors of the region. Eventually they made enough fuss to be rid of him, but his determination that Poland's forests should be a concern of the state remained. In fact forestry experts were sprouting like suckers in a coppice. Where once magnates with cultural pretensions had competed for the best dancing master or string orchestra, they now liked to show off their residential forester: earnest figures who could stride through the woods and impress courtiers from Warsaw with long lectures on grafting and the binomial classification of rare fungi.

Some aristocrats went even further, rolled up their muslin sleeves and became their own foresters, publishing the results of their estate management. The most impressive of all these works was written by the first published woman forester in Europe, Anna Jabłonowska Sapieha. Other lords of the trees, like the archbishop of Gniezno, established their own elaborate woodland administration. Sylvanomaniacs in silk breeches got into fierce arguments about whether timber should be felled before complete maturity, on the prudence of drastic thinning, on the timetables for replanting, whether burning for potash and charcoal should be restricted or even prohibited outright.[16]

This burst of rationalism went the way of the rest of the Polish reforms under Stanislas Augustus. The more serious they became, the less the Russians liked it, until, in 1792, Catherine felt threatened enough by a newly promulgated constitution to lead a coalition of the other two partition powers that carved further enormous slices out of Poland. Two years later, in 1794, and in defiance of the coalition powers, the Lithuanian-born veteran of the American Revolution Tadeusz Kościuszko announced a Polish insurrection from the market square of the old Jagiellonian capital, Kraków. After courageous but hopeless resistance (a constant theme in its history), the last remnant of Poland disappeared down the gullets of its neighbors. And Białowieża along with other Lithuanian *puszcza* to the north—Knyszynska and Augustowska—finally became Russian.[17]

There was a brief rush of fools' euphoria when the apparently invincible success of Napoleonic arms created a "Duchy of Warsaw" and the forest returned to the Poles. Regiments of the ninety thousand Polish troops that made up by far the largest foreign contingent of the Grande Armée bivouacked beneath the alders and birches of Białowieża en route to Russia in the late spring of 1812. In *Pan Tadeusz* Mickiewicz has a cannonball land in the depths of the forest at the very feet of an amazed bison "in his mossy lair"—"a twirling,

whirling, hissing shell/ That went off with a roar; the first time then/ He was afraid and sought a deeper den." His compatriots were bolder. Lithuanian Light Horse, sporting the red four-cornered hats that Kościuszko's peasant soldiers had worn in 1794, were the first across "their" river Niemen on June 24, riding into the old Grand Duchy. In December what was left of them returned. Of the thirty thousand troops that had made up the Fifth Polish Corps, just one hundred and twenty-six survived the successive horrors of Borodino, the burning of Moscow, the bitter retreat, and the nightmare crossing of the icy Berezina river. Four-fifths of the entire Polish division of the Grande Armée had perished in a single campaign.

Białowieża was retaken by Russian troops in 1813 and would remain the personal domain of the tsars for another century. Although the Congress of Vienna established a pseudo-autonomous "Kingdom of Poland," ruled indirectly by the Russian monarch, virtually all of Lithuania disappeared into Russia proper. And it was precisely on the borderland of the ancient forest that the frontier of the Russian Empire was extended to encompass the Niemen cities of Grodno and Kowno, as well as Białystok farther south. It may be that hunting had something to do with these border changes. Alexander I's ancestor the tsarina Elizabeth had been sent a present of two bison by the king of Prussia, and the reputation of Białowieża as a huntsman's paradise was certainly known in Moscow. Oddly enough (and not for the last time), care of the forest was entrusted not to Russians but to Baltic Germans. The governor of Lithuania, Baron von Bennigsen, perhaps mindful that forestry had already become an established discipline in the courts of eighteenth-century Germany, appointed men with names like Plater and Henke to senior posts in the forest administration. They in turn hired graduates of a new forestry school established in Warsaw in 1820. For the first time a periodical, predictably called *Sylwan,* published their proceedings. And while its pages were filled mostly with sober technical information, the care of the *puszcza* became more than pure arboriculture. Deprived of any more direct means of political self-expression, natural history had to substitute for national history as a way of nurturing the Polish-Lithuanian heritage. When shaded with the Romantic cult of nature, the scientific zeal to record and classify the flora and fauna of forest topography acted as a stealthy way to celebrate the glories of the native homeland.

In September 1820 one of these conscientious Balts, Julius von Brincken, German by origin but Polish by upbringing (and thus a one-man combination of scientific vigor and poetic enthusiasm), came to Białowieża. Experienced though he was in the lore of the great forests, he was thunderstruck by what he saw there. It was, he wrote in his *Mémoire,* the very picture of ancient Sarmatia: a sylvan arcadia that had long vanished from even the wilder regions of Prussia and Saxony. As civilization had steadily moved eastward, whole species—elk and lynx and bison—had retreated before it into the most inaccessible forests.

Arcady of old, so Greek writers like Pausanias had said, had been a place of dense brutishness, running with wild swine, where the people of the forest were more like animals than men.

Was Białowieża the Lithuanian arcady? The human specimens he observed certainly seemed like mysteriously preserved relics. For the forest people with their nut-brown weather-beaten faces and short fustian coats were evidently not true serfs, whatever their official legal status. They conspicuously disdained the drudgery of the fields for an arcadian life of hunting and gathering, much the same, he supposed, as their pagan Lithuanian ancestors. Their dwellings, sometimes deep within the woods, were log cabins of weathered larch, thatched with rye. And their arcane knowledge of the ancient forest was so intimate and so intricate, it allowed them to subsist handsomely on the most succulent wild mushrooms, on the intensely fragrant tiny bog cranberries that they boiled into preserves and stored in stone pots, aromatic wild woodland honey, broad leaves of sorrel and bulbs of wild garlic. In return for a paltry sum paid each year to the government, the foresters, gamekeepers, and beaters attached to the royal hunt were allowed to take any game they wanted within their district (excepting elk and bison). So their larders were stuffed with venison: wild boar, reindeer, hare, and bear. Pelts from the otter, badger, ermine, beaver, and marten, sold to itinerant merchants, or carted by themselves to Hajnowka or even Grodno, more than paid for their licenses and supplies of the velvety vodka, flavored with the marzipan-like "bison grass" (*Hierochloe odorata*).

The longer von Brincken stayed at Białowieża, the deeper grew his inner turmoil. His whole personality and intellect had been shaped by the Enlightenment's cult of reason. His profession as official forester, not to mention the academic literature and the prosperity of the tsar's great imperium, positively *required* him to divest all sentimentality, all cloudy romanticism. What Białowieża and places like it—who knew how many—in Lithuania represented was revenue, latent productivity, enterprise. What they needed, undeniably, was the firm smack of scientific management. The Russian government had already done away with the outrageous *starosties* by which any backwoods squire could do what he wanted with land and woods and pocket the proceeds. But matters had to be put on a more orderly footing. The state should see to it that potash and pitchworks were situated in regulated sites; that timber should be cut according to proper principles of *jardinage* and in areas that made sense for their transportation by road or river. And the woodsmen themselves should no longer be able to help themselves to anything that moved for the price of a few roubles and kopecks, an incentive to destroy entire stocks of game altogether. Instead they should be obliged to sell their pelts only to the forestry officials themselves and be paid per pelt, indeed rationed to so many pelts per animal per year. Discipline had to supplant chaos.

And then there was the primeval forest itself: a thing of glory and terror. Von Brincken had never seen anything like it. Where were the beech trees? For there was *everything* else: ash, aspen, maple, oak, linden, willow, birch, elm, hornbeams and spindle trees, pine and fir, all growing in a crazed jumble, amidst a vast botanical charnel house of rotting trunks, roots, and limbs. The irregularity was dreadful, sublime, perfectly imperfect. What was needed, of course, set out in the appendix to his book, was a methodical forestry that would, over time—and, given the size and wildness of the place, a very *long* time, perhaps a century and a half—bring it into some kind of proper hierarchy. Varieties would be massed together so that those most suitable for one purpose, like shipbuilding, could be efficiently harvested at the allotted time, while timber more suitable for building materials would be cultivated elsewhere. In this ideal regime, the trees would be graduated in age, so that foresters would not need to wander all through the woods looking for trees of maximum maturity or whatever the designated age might be for the job. Specimens of a like variety and maturity would present themselves in tidy battalions ready for their marching orders.

No one could accuse him, then, of not doing his duty, of not considering with the utmost scrupulousness what the science of forestry economics demanded.

But there was another von Brincken, one who listened to the wind rushing through the trees as he lay in his little bedroom in the wooden lodge on the hill, who marvelled at the immense girth of the great elms and birches, who counted with stupefaction eight hundred and fifteen rings on an ancient linden tree and saw in his mind's eye the grisly sacrificial offerings of pagan Lithuanians that he had read about in the old chronicles, ribbons of flesh appended to its boughs as propitiation to the tree-gods.[18] When storms ripped through the dells, von Brincken heard the villagers invoke the name of the heathen oak-deity Perkunas, the lord of the thunderclap and the lightning bolt. Yet for all the Gothic savagery of the old forest, he could not help but imagine himself its high priest and protector.

For the *żubr* he felt only love, an ardor that even the dryly official prose of his *Mémoire* fails to conceal. Even when hunting, he pursued them with an admirer's passion. When he ate them, savoring the special delicacy of smoked bison's lung, or the musky bouillon made from their bones, he did so with pleasure and gratitude. But what he liked to do best was to count them.

The task had to wait for the first snows. The bison were creatures of habit, and when their foraging needs took them from one site to the next in the freezing dawn sunshine, searching for the wild hazelnut, spindle tree, and hornbeam saplings they favored in winter, the canniest foresters would know their route. Using posts, von Brincken marked out a dependable crossing point from one sector of the woods to the other and then calculated the traffic from their hoofprints. Sometimes he even saw families on their morning march, their coats

changed to a dark chocolate for the winter. And though he was under no illusion that his counting method was rigorously scientific, he was confident enough to publish the number for 1828 of seven hundred and thirty-two, including ninety-three calves, more than twice the depleted numbers that had survived the comings and goings of the Napoleonic wars.

Von Brincken respected the stubborn resolution of the creatures and sympathized with their seasonal irritability. During winter a bull bison planted across a forest path was simply immovable. To approach it at closer than twenty paces invited a thirty-mile-an-hour charge. Far from being shy of humans, much less panicked by them, it stood, coolly indifferent to carts or walkers, often turning its great rear in sheer contempt. There was nothing for it but to wait until it trudged off into the woods, or else make an enormous detour around the obstacle. Their densely packed mass of muscle and bone was, he thought, awesome, remembering the seven-year-old bull, shot at twenty paces through the breast, that had needed sixty men to load it onto the game cart; and the day when huntsmen's horses, reined in an enclosure, had suddenly been faced with a bison herd and had galloped off in panic, smashing the enclosure to escape.

When another young adult bull was killed von Brincken reserved it for meticulous anatomical description. Using calipers, he measured precisely the distance from the base of the horns to the base of the tail, from the base of the horns to the tip of the muzzle; the circumference at breast and belly; the width of its nostrils, the length of large and small intestines (fifty-five and one hundred and twenty-eight feet, respectively). Anything that could be enumerated was. But, for von Brincken it was as much a matter of honor as science. Some authorities, reporting on the American buffalo, had casually indicated it to be of superior size to the European bison, without bothering to compare it to the latter's awesome dimensions. Now he would put them right.

This was not the worst of it. The two titans of Enlightenment natural history, Linnaeus and Buffon, who agreed on virtually nothing, were, in this case, of one opinion that the bison was merely a wild variant of domestic cattle, that its beard and belly-mane were not true characteristics but merely features that were associated with particular climates and habitats. The bison, they both opined, was not in fact a distinctive species at all. Von Brincken was contemptuous of their taxonomic dogma, based on no direct observation. When they imagined they were describing the bison, they were in fact, he pointed out, describing the wild ox, or auroch, the shaggy animal found once, but no more, in the woods of eastern Germany as well as Lithuania and Russia. Polish vernacular, he wrote, understood the distinction better than these august zoologists; for the auroch was a *tur*, the bison always a *żubr*. That there was nothing remotely domestic about the bison had been proved by the history of an orphaned female which the foresters had tried to persuade to nurse from a cow,

and then from a goat. The bison calf had pushed the barnyard animals away in powerful disgust, preferring to take a cereal pap from a dish held by humans. And when, some years later, attempts were made to mate the female with a prize bull, the bison had responded to the courtship by charging the bull. So much for its domestic lineage.

The more he saw, the more he wrote, the more von Brincken was committed to the peculiarity of the bison and its one home in the primeval forest of Lithuania. When the Prussians occupied the area around Białystok, he reported (with undisguised pleasure), they had made attempts to coax the animals out of Białowieża, but without any success. Under the Saxon kings, animals that had been transported to Germany invariably failed to reproduce. What they needed, he concluded, was the unique ecology the ancient forest offered, species of herbs and grasses that could be found nowhere else: the *parzydolo,* Queen of the Meadows; or the *zaraza,* the bitter buttercup that was not only repugnant but harmful to domestic cattle; the mixture of ash bark and linden seeds with which they spiced their diet.

Against all his training, the Baron von Brincken, *conservateur-en-chef* of the national forest of the Kingdom of Poland, chevalier of the Order of St. Stanislas (Second Class), was in danger of becoming a Romantic.

It wasn't just the bison. For centuries the forest had been a shelter for species that, to the west, had failed to hold their own against human settlement and colonization. The great elk, for example, in von Brincken's description figures as the Romantic animal par excellence, worshipped by the pagans as divine and, in its obstinate solitude and "melancholy," shunning even the bison as too gregarious. Since the High Middle Ages, they had disappeared from the German forests, retreating eastward. For a while they had been threatened by the tsar Paul's characteristically eccentric determination to outfit his Russian cavalry in elk-skin breeches. Happily for the elk, the ape-like tsar's cranium had been staved in with a malachite paperweight by the palace guard. So the big animals could once again graze in reclusive security among the aspens and ash trees of Białowieża.

The forest was different and its denizens were different. Its wolves and black bears and the lynx that lived in the hollows of tree stumps, its predatory birds, eagles and owls, were bigger and wilder than in Germany and Bohemia. Instead of the paragon of Enlightenment animals, an industrious and exacting hydraulic engineer, the Lithuanian beaver was a sloven, simply depositing crude piles of twigs and branches beside a river, rather than bothering with carefully constructed dams and lodges. It was, wrote von Brincken, ever generous to the local mammals, the fault of civilization, hunting and harrying the beaver until he was reduced to a rudimentary shack.

We shall never know if the baron was in danger of going native and imitating the Lithuanian beaver: of relapsing into a life of woodland improvisation.

The relentlessly confident plans for the economic organization of the region appended to his book suggest otherwise. Whatever the temptations, the starch-collar imperial bureaucrat ultimately prevailed over the loose-blouse Romantic conservationist. In the second half of the nineteenth century von Brincken's vision of a wild forest disciplined into a productive timber plantation would come dangerously close to realization. But precisely because he had also been so eloquent on the mystique of the *puszcza* as a sacred preserve of the arboreal past, the core of Białowieża was left alone. The hunting lodge on the hill was rebuilt to somewhat grander specifications, the villagers given regular jobs as foresters and gamekeepers. But although, for a century and more, the rulers of Russian empires, from Tsar Nicholas I to General Secretary Nikita Khrushchev, liked to show off their royal hunt, there was, at the same time, something about the heart of the forest that remained irreducibly alien; impenetrable, resistant.

ii The Last Foray

On the nineteenth of November 1830, revolution broke out in Warsaw, Polish style. One group of insurrectionaries forced their way into the Belvedere Palace in an attempt to assassinate the tsar's brother and regent, the grand duke Constantine. Another group tried to storm the Russian barracks in Łazienki Park. Both efforts were botched but the city arsenal yielded enough weapons for Warsaw to evict the Russians in an explosion of patriotic anger. Much of the country followed and, as usual in such circumstances, attempts at mediation died between obdurate reaction (in Moscow) and revolutionary passion (in Poland). In January 1831 the tsar was formally deposed as king of Poland, an act of bravura that was followed by nine months of desperate warfare against a relentlessly augmenting Russian army. After some initial victories, the battle of Ostrolenka broke the main body of the Polish army, and a noose tightened around Warsaw. Driven to extremity, the last rebel troops commanded by the wooden-legged General Sowiński fell back to the cemetery at Wola, where they died literally heaped on the graves of their ancestors.

The failed gamble exacted a dreadful price. The "Kingdom of Poland" established by the Congress of Vienna ceased to exist, even as a Russian protectorate. Hundreds were executed in the ferocious repression that followed.

Thousands of the old Polish and Lithuanian nobility were dispossessed of their manors and sent on brutally vindictive forced marches into remote Siberian exile. In the forest region of Podlasia partisans retreated to the deep woods, among them Emilie Plater, the woman soldier whose family had provided forestry officials earlier in the century. But in the open countryside, between fields of ripening rye, bodies hung from gallows, shredded by the busy crows.

The poet Adam Mickiewicz was in Rome when the November rising erupted, completing his verses "To the Polish Mother":

> vanquished his tombstone will be the scaffold's wood
> His only glory the weeping of a woman
> And the long night-talks of his compatriots.[19]

Though he had spent much of his young life wrapped in such laments, he did not leap into the next mail coach travelling northeast. In all likelihood Mickiewicz understood only too well what agonies lay ahead, for when he did make his move, it was to Paris to rally support and prepare a relief committee. Only then did he travel eastward to Prussian Posen (once Polish Poznań) in time to greet his own brother Francis among bands of demoralized refugees fleeing from the disaster. He was hardly a shirker, but not unreasonably, the poet may have felt he had already had more than his due share of calamity. In 1823, while teaching at Kowno, he had been arrested as one of a group of self-designated "Philomaths"; nothing much more than the standard Romantic reading clubs, full of students sweaty with secret patriotic excitement and vodka-soaked vows of sacrifice. Six months in prison and six months' house arrest was followed by a sentence of exile in Russia. This did not mean a penal colony in the tundra. Mickiewicz and his friends parted after a farewell banquet of songs and tear-stained embraces. But for the next six years he lived, successively, in St. Petersburg, Moscow, and Odessa, fairly lionized by writers like Pushkin and Bestuzhev, themselves leading uneasy lives snooped at by absurd and sinister tsarist spies conspicuously skulking amidst café smoke, reading rooms, and opera boxes.

Then, unpredictably, in 1829 Mickiewicz was given his freedom to travel. He went south to Italy, where there were already colonies of Polish exiles, perpetually grieving for their country during bouts of heavy drinking and late-night mazurkas danced slowly before laughing, uncomprehending Romans. At Madame Khlustine's salon Mickiewicz met James Fenimore Cooper, already America's most famous writer on the strength of his first two *Leather-Stocking Tales: The Pioneer* and *The Last of the Mohicans*. Together the bard of Lithuania and the scribe of Westchester went riding in the *campagna*. More than likely they talked of the most famous writer of all, whom they both passionately admired, Walter Scott.[20]

Mickiewicz, of course, had an already-formed and strongly individual literary identity. His Lithuania would never be mistaken for the Scottish Borders or the Adirondacks. The long poems he wrote in the grievous aftermath of the failed uprising drew on all his native obsessions: the endurance of Lithuania's pagan spirit cults in *Forefathers' Eve* and the providentially designed Christian martyrdom and redemption in *The Books of the Polish Pilgrim*. Yet there is a great deal of Scott in Mickiewicz's wonderful medieval epic, *Konrad Wallenrod*, not least in its exploration of shifting allegiance in a continuing borderland war. The poem has a Lithuanian child abducted and brought up by the Teutonic knights, rising to become the Grand Master of the Order, only to lead them deliberately to disaster in his homeland, an elaborate exercise in suicidal revenge. Its tragic themes of enforced exile, ingratiation and infiltration, the assumption of a mask—all, of course, directly reflected Mickiewicz's own experience in Russia and his complicated relationship with the brutal chastisement of the tsar-*batiushka*, the father-emperor. Back in Warsaw, new generations of students circulated *Wallenrod* as historical allegory and recited it silently in their humiliated heads.

Adam
Mickiewicz
(photo: Nadar).

Settled in his Parisian exile, Mickiewicz met up with James Fenimore Cooper again. The American had come to see his own work as a declaration of frontier independence against his father's Whiggish cultivation. Cooper Senior had given his name to Cooperstown by hacking back the wilderness and creating settlement. Cooper Junior would invent Natty Bumppo as the forest sage and adept, capable of wisdoms denied to the bearers of civilization.[21] It is not surprising, then, that the Pole and the American saw each other as kindred spirits. Cooper went to work in Paris, helped by Lafayette, organizing a Committee for Poland, while Mickiewicz (with perhaps Pushkin's bouncing musical rhymes echoing in his head as well) composed his own masterpiece of woodland nativism: *Pan Tadeusz*.

Both the *Leather-Stocking Tales* and *Pan Tadeusz* celebrate worlds their authors knew to be already extinct. But they also both hoped that the spirit embodied in their works of communion with the landscape—an enduring code of brotherhood, of wrongs redressed through selfless action—might somehow be transmitted to the national future. Even if the wild woods were reduced to dreary rows of obedient saplings, grown only to be industrially harvested for the wants of the city, even if the great forest were to be cleared altogether, the memory of sylvan virtue could be preserved in their literature as the hidden heart of national identity.

The temporal structure of *Pan Tadeusz* is its most complicated feature: a twisted braid of memory and anticipation that ends on a passionately optimistic note, but at a historical juncture—1812—that all its readers would know finished in disaster. Mickiewicz's childhood around Nowogródek and his years as student and teacher in Wilno and Kowno provided him with the landscapes and society that were woven into the luminous fabric of his poetically remembered Lithuania. But the young gentry at the center of the poem—the Frenchified Count Horeszko and Tadeusz himself of the enemy clan of the Soplica—are themselves bound to a historically determined destiny; to ancient memories of mutual wrongs, personal, dynastic, and national. Tadeusz is the son of Jacek Soplica, whose courtship of the Horeszko lord's daughter was ritually rejected by the presentation of a dish of sour black soup. To avenge the wound, he joins the Russians in the Kościuszko wars and kills Horeszko. To atone for his treason, he spends the rest of his life as a patriotic warrior with the French, appearing in the action of the poem disguised as a Bernardine monk. His son Tadeusz is named for the general—Kościuszko—he betrayed.

The story of *Pan Tadeusz,* then, is a war of memories. The family feud, feeding off bitter memories, boils over into an all-out battle, a "foray," or military expedition, of one clan against another. Incapable of forgetting or forgiving the Soplica treason, Gerwazy, the grizzled retainer of the Horeszko family, leads an attack on Tadeusz's house. Just as the manor is about to fall before the onslaught, both families are suddenly overwhelmed by the intrusion of a greater feud—that of Pole against Russian.

Like other great Romantic historical writers of his time—Scott and Hugo, for example—Mickiewicz set his story in a building that itself carried memory in its crumbling stones. The old manor house of his uncle Judge Soplica to which Tadeusz returns at the beginning of the story is warped by jealousy; the ruined castle whose disputed possession sets the two clans at each other's throats. But most powerfully of all, the poet makes the landscape itself the carrier of memory: things that are buried but will not stay interred; a nature that proceeds, season to season, birth to death to birth, indifferent to the revolutions of state and the bickering of dynasts.

The truly heroic historians of the drama are trees. Their great antiquity gives them an authority that spans the generations of Polish history, and they shelter

within their woodland recesses the values that keep Lithuania—an idea as much as a place—alive. Mickiewicz addresses them familiarly as ancestors, kin, friends, but also reverentially as the pillars of an unwritten, organic constitution:

> *Comrades of Lithuanian kings, ye trees*
> *Of Świteź, Kuszelewo, Białowieża,*
> *Whose shadow once the crownèd heads did cover*
> . . .
> *Ye woods! the last to hunt among you there*
> *Was the last king great Witold's cap to wear,*
> *Last happy warrior of Jagiełło's race,*
> *Last Lithuanian monarch of the chase.*
> *Trees of my fatherland! if heaven will*
> *That I return there, shall I find you still?*
> *My friends of old, are you alive today?*
> *Among whom as a child I used to play;*
> *And is the great Baublis living found*
> *By ages hollowed out, in whose wide round*
> *A dozen folk could sup as in a room?*[22]

Such trees embodied *both* freedom and legitimacy. The "last king" to wear "great Witold's cap" was Zygmunt August (1548–1572), who was ritually made duke of Lithuania as well as king of Poland by wearing the *kołpak*, the ancestral fur hat. And sometimes the trees acted as priestly guardian and instructor in the immemorial continuity of this history. The "great Baublis" was an immense oak on the Paszkiewicz estate, venerated in ancient Lithuania as a sacred tree. Its hollow interior had been scooped out to display a cabinet of Lithuanian antiquities, so that it was, at the same time, a place of festivity, where "a dozen folk could sup," and a museum of national memory. Even today, visitors to the national park in Białowieża can pay their respects to oaks that are officially designated "national monuments." They are named for the lost kings of Poland—Alexander, Jan Sobieski, Stanislas Augustus, and the like—but the affinity is closer than battleships named for admirals and generals since the five- and six-hundred-year-old trees are, in effect, the contemporaries of the monarchs, their kin in place and time.

In the forest glades allegiances and identities become sharpened and resolved. The rustic company at Tadeusz's uncle's house goes mushrooming in the woods, hunting expertly for orange and fly agaric. Two of the party are not much interested in collecting fungi—the pretty-boy count and the aging sophisticate Telimena, who is attempting instead to hunt Tadeusz. To show off their distinction from the bumpkin squires, they begin to talk of Italy—"Ye classic waterfalls of Tivoli/ . . . Pity our sad lot!/ . . . in Soplicowo raised."

And so they started talking of blue sky,
Of murmuring seas, sweet airs and mountains high,
As travellers do, mingling from time to time
Contempt and laughter for their native clime.
Yet all around in solemn splendour stood
The glory of the Lithuanian wood![23]

Tadeusz's gallantry abruptly shifts from the coquette to the vegetation as he springs to the defense of his native realm. Yes, he said, he too had seen such southern trees in the botanical gardens at Wilno—the overrated cypress and the "dwarfish lemon with its golden ball/And lacquered leaves, in shape so short and stumpy/Like a small woman, ugly, rich and dumpy"; how could it compare with an "honest birch, a fairer one,/That's like a peasant weeping for her son." Telimena, grasping the point only too accurately, retorts, "Soplicas, it's well known, have this disease,/No country but their fatherland can please."[24]

But all this is mere skirmishing on the edge of the woods. The heart of the poem unfolds in the heart of the forest. It is, necessarily, a hunt: the Lithuanian drama of sacred violence, the measure of fitness for battle. No writer before Mickiewicz had described the etiology of the ancient forest with such a keen eye, or worked harder to convey its shifting zones of light and darkness. Even today, forests like Białowieża are marvels of variety. It is only second growth and plantation woodland that is monotonous, relentless dense stands of conifers. Uncleared old growth forest produces its own natural zones of wild-grass clearings. Beaver-felling and consumption of saplings by red deer and bison thin out areas to produce glades where the grazing animals can further browse before the vegetation closes in again. Even within the heart of the forest, the death of a giant oak creates a temporary hole in the hundred-foot-high hardwood canopy to allow sunlight to speckle the woodland floor, itself textured with fern and moss and layers of leaves but here and there decorated with minute gold and white flowers. Much of the woods lie under water. Fallen trunks lying across the course of streams create black ponds, twenty feet deep, and odorous peat-swamps filled with frogs and thunderfish and covered with a gray coating of algae from which, during spring and summer, blades of iris and marsh marigold sprout, like tufts of hair on a bald man's pate.

And there never yet has been a nature writer who, confronted with primitive forest, has not resorted to the vocabulary of architecture. Indeed, since it has been impossible to visualize or verbalize nature in terms free of cultural association, the woodland interior has been habitually conceived of as a living space, a vaulted chamber. The trees of the Lithuanian primeval forest are present in every conceivable state of growth and decomposition, their vertical columns everywhere intersected by horizontal fallen trunks; curved and bent

boughs and branches suggesting arched portals to some grandiose vaulted hall. Burls and stumps take the shape of exuberantly carved bosses and finials: improbable and fantastic forms that became the passion of Romantic painting from the Hudson Valley to Scandinavia. But, as Mickiewicz noticed, the architecture often seems to be in ruins:

> *A fallen oak thrusts branches to the sky,*
> *Like a huge building, from which overgrown*
> *Protrude the broken shafts and walls o'erthrown.*[25]

The poem climbs over this debris of wrecked arches and vaults, explosively shattered timber, splintered and shredded. And as it penetrates deeper into the woods, the vocabulary becomes military: the timber forming itself into "ramparts" and "barricades," jagged-edged palisades pointing at the intruder beyond which "the forest lords dwell, boar and wolf and bear." And at the threshold of this primeval no-man's-land it stops, the light dying, the silence absolute, broken only by the woodpeckers (which in Białowieża have the violence and echo of gunshot), and the hurried scampering of a squirrel, like a civilian scrambling for safety amidst the wreckage, before the shooting begins.

Late for the hunt, Tadeusz joins it, with the monk, his disguised father, following to keep a watchful eye, heading directly for the deep *puszcza*. Mickiewicz suddenly abandons his lyrical description to evoke a different and terrifying world, the "innermost recess," a place of death and darkness. Anthills, hornets' nests, vicious thorns and brambles protect a terrain that the poet presents as deformed: ". . . stunted, worm-like trees/Are reft of leaves and bark by foul disease./With branches tangled up in mossy knots,/And humpbacked trunks and beards of fungus clots . . ."

These barriers culminate in a dense fog beyond which, "fables so declare," is a kind of primitive paradise: an ark of species, animal and vegetable; some of every kind. "Midmost the emperors of the forest hold/Their court, the Bison, Bear and Buffalo old." Their progeny are sent beyond this secret cradle-world, called "Motherland" by the huntsmen, but the archetypal animals remain in a zoological utopia:

> *They say the beasts in this metropolis*
> *Do rule themselves and thence good order is;*
> *No civilising human custom spoils,*
> *No law of property their world embroils;*
> *They know no duels nor in battles strive.*
> *In their ancestral paradise they live,*
> *The wild beast with the tame lives as a brother,*
> *Nor either ever bites or butts the other.*

E'en though a man should go there all unarmed,
He would pass through the midst of them unharmed.[26]

The same courtesies are not, alas, reciprocated. A bear, drawn by the temptation of woodland honey, strays beyond the barrier and becomes the huntsmen's quarry. The two young men—the count and Tadeusz—fire and miss the charging animal. He is about to scalp the count's blond hair with his paw when three of the older generation, servants and officers to the two warring families, appear and fire off what seem to be the fatal shots. The "seneschal" then sounds the *mort* on his bison horn. The music amplified, multiplied, and echoed by the whole forest relates the prowess of the seneschal's youth; sounding on and on, it becomes a virtual history of this hunt and all others: the summons to the hounds, the sharp yelping and baying, the thunder of shot and the dying fall. For unlike some modern ecological sensibilities, the old epics of the forest were not squeamish about the kill, experiencing it as a consummation, not a desecration, of woodland nature.

With the bear expiring bloodily on the grass, the old men (for these are Poles) proceed to quarrel about whose bullet stopped the animal, an argument settled by Gerwazy, who

drew his knife and cut the snout in twain
And, carving up the lobules of the brain,
Took out the bullet, wiped it on his frock
And measured it against his own flint-lock.

The bullet turns out to have come from his musket, but too scared to fire it off, he had given it to the monk. Only one man, declares Gerwazy, could shoot that well and that was the banished, villainous Jacek Soplica, Tadeusz's father. Before more direct comparisons can be made the monk disappears into the undergrowth, leaving the company to celebrate with gold-flecked Gdańsk vodka and the traditional *bigos:* the stew of sauerkraut, vegetables, sausages, and smoked meats, "parboiled till the heat draws out/The living juices from the cauldron's spout,/And all the air is fragrant with the smell."[27]

Such a royal *bigos* is, of course, the famished dream of an exile, sitting in a Paris apartment, pulling the damp Seine air through his nostrils and trying instead to savour the aroma of venison and boar and bison smothered in juicy sauerkraut, working to complete the olfactory memory with background notes of leafmold, boletus, gunpowder, and bear-musk. Such a woodland, too, is a landscape of memory, seen through a lead-pane window: gray houses metamorphosing into timber ruins; the streets invaded by the forest primeval; an unattainable Lithuania governed by bison, a commonwealth of perfect justice and peace, impregnable behind palisades of splintered hornbeam.

iii Mortality, Immortality

Landscapes are culture before they are nature; constructs of the imagination projected onto wood and water and rock. So goes the argument of this book. But it should also be acknowledged that once a certain idea of landscape, a myth, a vision, establishes itself in an actual place, it has a peculiar way of muddling categories, of making metaphors more real than their referents; of becoming, in fact, part of the scenery.

Mickiewicz imagined the forest depths as a naturally fortified shelter, where the Polish-Lithuanian nation had begun and to which, harried on all sides, it would finally retreat. In the primitive darkness, they would be reinforced by native wood-fauns, the blue-blooded, green-eyed, green-whiskered *Leshy*, who would lead their enemies astray, take them captive, and release them only after humiliation of ritual inversions. The chastened pursuers would have to exchange their right and left shoes, wear their tunics backward, and be sent packing from the forest.

But even without the help of the *Leshy*, rebel soldiers, defeated in the open field, were well aware that the forests that still covered a third of Poland's land surface in 1831 could provide tactical refuge against the Cossack cavalry of the tsar. So it was that Białowieża, as well as Augustowska to the north and Swietokryszka to the south, became strongholds of resistance for months, if not years, after the main body of nationalist insurrection had disintegrated.

The pattern of 1831–32 repeated itself thirty years later. As with so many revolutions, that of the 1860s began with memory. For it was when the Russian government attempted to ban demonstrations commemorating the thirtieth anniversary of the November uprising that the cycle of repression and resistance began that culminated in another round of desperate and hopeless revolt in January 1863. And once again, a makeshift army destroyed by the sheer weight of Russian numbers, besieged in the cities, turned to the ancient woods for safety and succor.

Defiance of the Russian bear from the realm of the Lithuanian bison and the wolf, though, *was* in the end a Romantic illusion. The cover of the forest sharply contracted in winter as the need for food, fuel, and family took the partisans, irresistibly, toward the villages where the Cossack patrols were waiting. So the forest idyll became a forest prison; the cradle of primitive freedom, a sylvan graveyard, dotted with wooden crosses and piles of stones. The cult of

Białowieża's local heroes became a cult of futile martyrdom; vengeance against the foe, a matter of desultory skirmishing; a "Muscovite" patrol shot while watering their horses; their throats cut while sleeping in their tents or drinking beer in a woodland inn. In return, captured partisans were spread-eagled against trees and smeared with wild honey for red ants and the savage mosquitoes of Białowieża to enjoy, a light entertainment for the Cossacks before the shooting began.

No writer has conveyed this sense of directionless chagrin better than the modern Polish writer Tadeusz Konwicki. Himself an errant soul who strayed in and out of Communism, Konwicki's *Kompleks Polski* (The Polish Complex) has its own narrator adrift in the time continuum, moving without warning back and forth between Polish disasters, from the end of the Second World War to the wobbly bravura of 1863. A platoon of rebel soldiers raises the flag of the white eagle of Lithuania in the heart of the forest, but as he wanders in the wilderness, stranded somewhere between life and death, the captain prays, with increasing desperation, for at least a small victory, a respite from humiliation. It is not to be. On the edge of the forest the Cossack commander gives the order to move out, reciting lines from Mickiewicz's friend Pushkin:

> *Once again our standards have broken through*
> *the breaches of Warsaw fallen once again:*
> *And Poland like a regiment in flight*
> *flings its bloody banner to the dust. . . .*

You turned your head around in a senseless desire to see the woodsman's cottage, and the encouraging sight of bright smoke streaming straight up into the spring blue of the sky. You saw the woodsman who had turned you in. He was looking at your ill-treated body, your legs spread shamefully like those of a gutted boar. . . . He whispered something. . . . His eyes were moist, there was an uncertainty in his voice as he moved his numb lips, but you, my brother across these eighty years, read on the woodsman's twitching lips that question which is always with us:

"Was it worth it?"[28]

But Konwicki's ironic fatalism is a twentieth-century version of the Polish predicament. The tragic romance of the Lithuanian forest somehow survived even the second abundant helping of disaster in 1863–64, when the Poles were robbed of any illusion that the great powers of Europe cared enough for their fate to hold Russia accountable for its repression. Before the censor and his police moved into their Warsaw offices with new and more formidable powers, Artur Grottger produced his three cycles of history prints—*Polonia, Warszawa,* and *Litwa*—chronicling in darkly operatic scenes the martyrology of Poland's

failed revolutions. The Lithuanian cycle opens with the figure of death flying over the black and terrifying *puszcza,* yawning tomb-like bogs guarded not by the stoical bison but by a snarling lynx. A forester receives the call to arms, leaves his wife and child, only to die beneath the trees in the company of his fellow woodsmen and hunting dogs, defiantly brandishing the banner of Lithuania. Two further scenes of obligatory patriotic piety complete the cycle: the forester's ghost appears unseen to the young widow and her crying infant. Finally, in front of an open grave a vision of the crowned Virgin and child appears to suggest, none too subtly, the celestial rewards of sacrifice.

Artur Grottger, lithograph from *Litwa*.

For many years, Grottger's consolatory art was available only far from the sites of its topography. In the 1870s a Pole wanting to acquire "Lithuania" would have to go to Kraków in the much more liberal region of Austrian Galicia to buy it. Under the influence of artists and architects congregating around the village of Zakopane, fifty miles south of Kraków, the cult of patriotic landscape was transported from the Lithuanian forests to the Tatra mountains in the extreme southeastern corner of old Poland.[29] To this new generation of Romantics, it was the rocks and lakes of the south, rather than the ancient woodland, that enclosed the heart of ancient and future Poland.

The fate of the Lithuanian forest in the aftermath of the second defeat was once again grim. Another wave of dispossessions took place, as it had in the 1830s. Many thousands of *szlachta* were exiled to the remote Russian interior; others still more unfortunate swung again from the gibbets erected by the very same specialist in repression, Muravyev, who had been responsible for the terror thirty years before. More confiscated land was transferred to officers of the

Russian army who had participated in the campaign as well as others favored by the government. Poland was now known as "the Vistula province" and Lithuania divided into the districts of Wilno, Kowno, and Grodno.

Białowieża became once more the personal hunting preserve of the tsar and a railway line was built all the way from Moscow to transport the parties of grand dukes and generals of the imperial staff who flocked to the forest in the summer and autumn. A new and much grander "château" was built in the 1880s, three stories high beneath ornately decorated Belarussian timber gables and a fantastic, spired tower at the end of one wing. There was a sunken Roman bath and imperial bed to accommodate Alexander III, as well as lodges and stables scattered about the park. The forestry school at Warsaw, which had been, even more than other academic institutions, a hotbed of patriotic enthusiasm, had been swiftly abolished in 1832, and the "imperial woodlands" were now administered directly from St. Petersburg. But whether in the hands of the state or those of private landowners, the object in the latter part of the nineteenth century was to wring as much profit out of the forests as they could possibly yield.

Increasingly, too, the story, like much else in the tsarist economy, was one of German demand and Russian supply, with a phantom Poland lying in between as a minor inconvenience. Prussia extended so far to the east that it was a logical market for whatever the old Polish provinces could supply. Huge areas were deforested and turned over to grain. And since hardwoods grew on the richer soils, it was disproportionately those that were felled, leaving conifers standing or replanted in relentless rows on the poorer ground. With the arrival of the railroads, the lumber industry became even more important with contract agents (like my great-grandfather) supplying timber for wagons and ties. A classic turn-of-the-century hysteria about finite supplies sent lumber prices into orbital inflation, driving the engine of deforestation even further. Half of all the wood imported into Germany in the thirty years before World War I came from the Niemen forests.[30] And as the great border forests lost more and more acreage to the sawmills and pulp factories that began to crowd the country towns, slowly but surely, woodland Lithuania was turning into an economic fief of the Second Reich.

Not far behind the dark gray suits and homburgs were the field-gray uniforms and spiked helmets. For if the First World War was not a direct consequence of economic competition, there remains compelling evidence that once it had begun, the imperial German government and General Staff saw occupation of land to the east as one solution to the (largely imaginary) crises of overpopulation and undersupply. The territories in question stretched from the Ukraine in the south, rich in both grain and minerals, to the timberlands of the Baltic in the north. Whether this enormous belt of land was to be directly colonized or merely brought inescapably within a zone of German economic arbitration was of little importance. The end result would be the same. Lithuania, Poland, the Ukraine would exist to service the Greater German Reich.[31]

Both strategically and logistically, the northeastern corner of Europe, then, could not escape the brunt of the conflict. During the very first month of the war, August 1914, the Russian imperial armies advanced into East Prussia along a line that corresponded exactly with the Lithuanian forests from Gumbinnen to Augustów. On August 31, at Tannenberg, where in 1410 the Teutonic knights had been annihilated by the Lithuanian army, the whole Russian Second Army was destroyed. A week later the Masurian lakeland on the borders of East Prussia and Lithuania saw the Russian line buckle, fold, and collapse. Heavy artillery turned the hills and meadows into smoking craters, the late summer woodlands into walls of fire.

And when the smoke cleared, to reveal a charred landscape of black stumps and gray ash, the German divisions had passed through the whole of Poland and Lithuania, and stood on a line well east of Wilno and Grodno. Yet another pseudo-Poland was established, this time under German protection. At Białowieża, the eagles of the Hohenzollerns replaced those of the Romanovs in the state bedroom. Lumbermen—engineers and entrepreneurs—settled in for a lengthy, lucrative stay at Hajnowka, at the western edge of the forest. Unemployed laborers were drafted from Prussia to man the sawmills that worked round the clock, in time with the loggers clearing huge areas of the woods. The cool air filled with the scent of pine resin and the sour rawness of fresh-cut oak. Before the war was over, the forest had lost a full 5 percent of its area. Five million cubic meters of wood had been shipped directly to Germany.

The trees of Lithuania were not the only hostages of the occupation. Camped in the park, German troops helped themselves indiscriminately to its animals. A whiskery major from Hanover or a stout *Oberleutnant* from Hessen who had scarcely ever frightened a pheasant could fancy himself the equal of the mastiff classes of Prussia, gunning down elk and stag with his artillery. And there were creatures these men remembered only from their childhood: the chocolate-brown shaggy *wisents* seen on a Sunday afternoon at Hagenbeck's Tierpark near Hamburg or grazing the pasture of their ditched enclosure at the Berlin zoo. For along with all the other tributes to the imperial economy, Białowieża's bison had been exported, some as purchases, some as gifts, westward to Germany. In fact the animals were so well established in German zoos that an international register of the *wisents* was kept in Berlin. In the same year that German armor smashed its way through the woods, Lorenz Hagenbeck (the son of the great animal trader, Carl Hagenbeck) sent three of the Polish bison to Stockholm in exchange for two hundred Swedish plow-horses for the use of German farmers.[32]

But as the conditions of the war deteriorated, the bison (along with almost everything else that moved on four legs) came to be seen as so much standing meat. The herd had already suffered serious attrition from the intensive

exploitation of the forest in the years leading up to the war, as well as from the tsar's trigger-happy hunting parties. It might have been even worse had the Russians followed the example of the Austrian archduke Franz Ferdinand, whose idea of an afternoon's sport was to machine-gun the animals with the latest product of the imperial munitions factory at Steyr. But between capitalists and hunters the number of bison halved, from eight hundred to four hundred and sixty in 1914. When things began to go badly, in the winter of 1918, anything on legs was butchered to feed the famished troops. Hunger was kept at bay with a lordly diet of venison, boar, and hare. By the time the conscripts were down to polecat and weasel, the bison were doomed. Some sources claim that they were eliminated altogether, an unknown corporal devouring the last slice of a musky haunch. Others maintain that a number in single digits survived (the most often cited number is four), the last dying of natural causes in 1921.

In Stanislas Czyz's *Dream Book for Our Times* a character roams the fields and woods after the war and finds abandoned trenches covered with barbed wire, beneath which wild strawberries are growing. Resurrected as a free state by the Versailles conference, the Polish republic, with the pianist and Chopin-virtuoso Ignace Paderewski as its prime minister, drew on a dense grove of national memory for its patriotic solidarity. Though a separate ethnic Lithuanian republic had been established on the Baltic with its capital in Kowno, rebaptized Kaunas, most of the great urban centers of the old Grand Duchy—Wilno, Grodno, and Mickiewicz's hometown of Nowogródek—were all returned to Poland. Józef Piłsudski, its generalissimo, was himself a Lithuanian Pole who almost destroyed his country in a war against the Soviet Union by gambling on a campaign that would have extended the northeast frontier all the way to the Dnieper river.

And the *puszcza* remained, as always, an emblem of national immortality, of the certainty of resurrection. In 1926 Stefan Żeromski published his own contribution to the genre, *Puszcza Jodłowa,* swimming in mystical allusions to a sacred past and a sylvan destiny. Though the wildernesses of Żeromski's own world were the southern forests of Lysica and Nida, the songs he sings and the scenes he paints are the same: of wilderness chapels in which repose the rotting remains of medieval knights becoming one with their hunting grounds; of hacked-about martyrs of 1863 who come to lie with them in the humus; bear and wolf taking the spirit of freedom into their lair; "white towers in the woodland valleys, carpeted with violets. . . . Who knows whether men won't come to cut the forest in the name of some business or some profit, but whatever their law might be, whosoever they should be, I would call to the barbarians, 'I forbid you to do this. . . . This is the forest of kings, bishops, princes, peasants. . . . It belongs neither to you or me. It belongs only to God. It is a Holy Land.' "[33]

But short of God disclosing a way to make the zloty convertible without hard currency reserves, the sacred space of the *puszcza* was likely to have to sur-

render to the profane needs of the Polish economy. Railroad lines that had been torn up, and cities scarred by shellfire, had lumber merchants cracking their knuckles in anticipation. So, predictably, Białowieża simply exchanged the German companies that had dominated before and during the war for a different contractor: the British lumber company Century, which managed to do more comprehensive damage to the forest during its five-year lease between 1924 and 1929 than the entire German military occupation.

In the same year the British departed, the *żubre* returned to their ancestral home. A biologist, Jan Stolczman, had made it his mission to re-create a breeding stock and turned to the very zoos of Europe that before the war had imported bison from Lithuania. So Białowieża received its reparations in the kind it valued most: *żubre*. Back they came from Hamburg and Berlin, even from Stockholm, where Hagenbeck had made the trade for plow-horses in 1915. Some cows were shipped up from a small herd that had somehow remained safe in the south of the country throughout the war. And in the summer of 1929, with enough time for the notoriously decorous quadrupeds to build up to their autumn rutting, the repatriated bulls were uncrated in the palace park. A photograph in the natural history museum records the moment of patriotic jubilation: beaming soldiers with their four-cornered caps, astride the open boxes while the big animals, their heads already lowered sniffing the grass, take bloodshot stock of the woodland meadow like landlords inspecting their house after the eviction of particularly disagreeable tenants.

Under the impact of a series of natural disasters—plagues of voracious insects, fungal blights, and in 1928–29 a brutally severe winter that resulted in the destruction of many of the forest's oldest oaks and firs forest conservation suddenly came to be taken seriously by the Polish state. In the early 1930s the Piłsudski government established the League for Nature Conservation and designated Białowieża as one of the country's first three national parks. What really needed protecting, however, was Poland itself.

It was with this in mind that in the summer of 1934, the Polish ambassador in Berlin, Józef Lipski, invited Germany's most compulsive hunter to Białowieża. Everything about Hermann Göring would have been preposterous had he also not been so dangerous. In 1934 he was forty-one, already running to the corpulence that would turn him into the monstrous, jewel-encrusted hippopotamus of the Third Reich. The essence of Göring's personality was sensual appetite and in this he perfectly complemented Hitler, whose ecstasies were ideological. Hitler the nut-cutlet vegetarian was offset by Göring the sensualist, who liked to sink his teeth into broad slabs of bleeding meat. There was something of the child playing Pasha about Göring; the acquisition of brutal despotism in order to reach out and grab whatever his fat little heart desired without fear of opposition: a pot of diamonds carried round with him by a spe-

cially hired servant lest he feel a sudden urge to trawl his hands through the brilliant rocks; the obsession with jewelled daggers; the biggest model railway in the world, fitted into a custom-built room at the Carinhalle, a vast lakeside estate east of Berlin constructed around a mausoleum for his first wife.

In his prime, Göring adored hunting opponents, rivals, and heavily antlered stags, the difference being that he had a healthy respect for the quadrupeds. Earlier in 1934 he had enacted a Reich Game Law, drafted with the help of his chief forester, Ulrich Scherping, whose ancestors had been gamekeepers to the kings of Prussia. The law made Göring himself the first Reichsjägermeister (entitling him to dress up like an extra from *Der Freischütz*) and provided capital punishment for anyone with the temerity to kill an eagle. Vivisection was prohibited on pain of deportation or of being dispatched to a concentration camp where the medical staff was less fussy about operating on humans than hounds.

And then there were Göring's own bison. For what to the Poles was Lithuania's talismanic beast, for Göring was the symbol of hairy Teutonic bullishness. He too was supplied with breeding bulls by the Berlin zoo (along with Scandinavian elk) and planned to begin populating his Schorf Heide estate, east of Berlin, with progeny produced, according to

Hermann Göring at Białowieża.

the best veterinary eugenic advice, from mating with hybrid cows. On June 10, 1934, Göring appeared on the grounds of the Carinhalle in a spectacularly ill-matched outfit of von Richthofen aviator's rubber, billowing Barrymore sleeves, high boots, and hunting knife stuck in his bulging belt. Massed, green-liveried foresters roared their admiration. Diplomats reached deep within their training to mask titters behind expressions of charmed admiration. Göring then ceremoniously introduced a bison bull to his intended mate. But both parties, as a reading of Hussovianus or von Brincken would have predicted, trotted off in inconvenient disgust. The Reichsjägermeister was not to be denied, how-ever, and had more of the animals shipped to his immense hunting estate at Rominten at the very border of Lithuania and the northeasternmost tip of Prus-sia. Almost at home, they flourished in the company of Teutonic wolves and any stags who managed to escape Göring's constant artillery in rutting season.

Needless to say, Göring cast a glittering and covetous eye on Białowieża. He slept in the tsar's bed, vast enough to accommodate his frightening bulk, and wallowed like a hog in the marble sunken bath. After his initial visit he made sure that not a year went by without a visit to the primeval forest in Lithuania, and as the years passed, his foreign policy and his hunting habits gratifyingly converged. The Poles were understandably apprehensive about German intentions to their east and for some years were given smiling reassurances by Göring, as battalions of boar and deer dropped to his gun, that the foreign interests of the two states in fact coincided; that Germany had no designs on the Danzig corridor. He went so far as to insinuate that the Poles and the Germans might together carve up adjoining territories, the former annexing part of the Ukraine while the Reich moved up the Baltic. These barefaced lies continued even while Germany was negotiating the non-aggression pact with the Soviet Union that provided for a joint invasion and partition of Poland. But if the Poles had their suspicions, they were regularly disarmed by the glad-handing jocularity of the hunter. Until almost the very end they had no idea they were to be the prey.

When war broke out in September 1939, the *Blitzkrieg* was so savage and so swift that the German army reached Białowieża in a matter of weeks. While Polish cities lay in cinders from bombing raids, a single plane from Göring's Luftwaffe scored a direct hit on the local church, much to the distress of foresters who were unable to credit the Reichsjägermeister with such casual barbarism. Under the agreement with the Soviets, the Germans withdrew to a line on the Bug river. For two years Białowieża became Russian once more; but the commissars were less interested in hunting than enforcing sound ideological principles in the local population.

On June 22, 1941, Hitler launched Operation Barbarossa against the Soviet Union. Exactly five days later there was a swastika flying over Alexander's "palace" in Białowieża. While the SS would dearly have liked to have flame-torched the forest to purge it of any possible shelter for partisans, the animal-loving Reichsmarschall took it as his personal property. He even obliged a delegation of foresters that had come to Berlin to see him, dressed in their overpressed Sunday suits, to implore him, on bended knee, to restore the damaged church. As for the primeval forest, it was a *heiliger Hain,* a "sacred grove." Not a leaf was to suffer hurt. Fur and feathers were to be strictly protected. For the elk and bison were now his elk and bison—German elk and bison—members of a big family that included his own pet lion. Someday the Reichs-jägermeister would return to the lair of Władysław Jagiełło and Witold and with the sound of the hallali ringing over the carcass of a great stag, the Teutonic knight, reborn for the ages, would wipe out the shame of Grünwald.

If the creatures of the woods lived undisturbed under the regime of Ulrich Scherping's German forest guards, the same protection was not extended to

the local population. During their brief occupation in September 1939, the German army had already given Białowieża a sample of the terror they would inflict on the area two years later. The innkeeper of the Żubr tavern, Michał Zdankiewicz, who was reckless enough to make free with his opinions of the occupiers, first had dogs set on him, then was shot standing over the grave he had just dug.[34] In the summer of 1941 open season was declared on the Jews who made up about 12 percent of Białowieża's population. The procedure was routine, not just for the SS but for the regular troops of the German army; in this case Battalion 322 of General Fedor von Bock's Army Division of the Center. The five hundred and fifty Jews were lined up in the forecourt of the hunting palace, the women and children separated from men and boys over sixteen. The next day the males were taken into the deep forest and somewhere amidst the old oaks and lindens were shot beside their mass grave. Their families were deported to the ghetto at Pruzhany and ended up in the extermination ovens of Treblinka, where massed freestanding stones mark their monument.

But if Jews were to be erased altogether from the southern Lithuanian woodland villages, the landscape itself was to be decisively altered so that it would become what Göring and other enthusiasts of the Teutonic *Heimat* like the Reichskommissar for the Affirmation of German Culture, Heinrich Himmler, believed it should have been all along: an unbroken extension of East Prussia. As soon as the German occupation of Poland was completed by the end of September 1939, Himmler commissioned a team led by SS Oberführer Konrad Meyer, who had been Professor of Agriculture at Berlin University, to plan a colonization program that would make over the alien landscape into something unmistakably German. Poles were to be deported, along with Jews, shipped further east, or else reduced to the status of barnyard animals that could be stabled or slaughtered as the freshly reclaimed landscape required. Their cottages, regarded as primitive dwellings, symptomatic of the semi-evolved, were to be obliterated and replaced by houses appropriate to a truly German countryside.[35]

By the summer of 1941 this program of physical and human alteration had already been well advanced in the "General Gouvernement" and areas directly annexed to the Reich. Now that the German army also occupied the eastern, ex-Soviet zones, the plans of Germanization could be extended all the way to the ancient Lithuanian forests. In his capacity as Master of the German Forests (Reichsforstmeister), Göring had created a special government department for conservation, the Reichsstelle für Naturschutz, with Walther Schönichen as its director, a figure who in the 1920s had complained bitterly in print about the loss of Germany's African colonies that contained tracts of primeval rain forest. Now he was able, with Göring's eager assistance, to contemplate creating a huge protected forest zone, expanding outward from Białowieża itself, to an area more than six times the original acreage of the Polish National Park.[36]

The first task toward realizing this "total landscape plan," as it was designated, was to empty villages. Between late June and mid August 1941 thousands of farmers and foresters from the old, timbered villages on the edge of the forest were deported out of the area; trudging along the roads with a battered bag, their houses in flames behind them, their animals wasted in the burning barns. Around the village of Narew, northwest of Białowieża, Battalion 322 behaved with characteristically brisk cruelty, rounding up the population on the pretext of checking papers, then driving the men off into the *puszcza* Ladzka nearby and shooting about a hundred after the usual excavation of a forest pit by the prisoners. One or two of the men managed to escape by feigning death. And when the news passed round, villagers returned to the site at night, dug amidst the mass grave for their family members, and brought them back clandestinely to Narew for burial in the local cemetery. Similar scenes were repeated throughout the area. At least nine hundred villagers (not counting the Jewish deportees) were murdered in this way.

The flamboyant hunting lodges of Białowieża became home to the different divisions of the Nazi terror. The commander of Battalion 322, Kobylinski, took up residence in the tsar's hunting apartments while the rest of the palace was filled up with officers, Göring's specially deputed forester Ulrich Scherping and his staff, and some units of German airmen, known locally as "Fligs." Down the hill a little way, the gendarmerie and Gestapo occupied the brick annexes that had served as post office and "town hall." From these headquarters, the army, police, and forest guards for three years carried out a policy of merciless brutality that, as elsewhere in occupied Europe, specialized in public hangings, a dozen or so at a time with the villagers obliged to be spectators or join the next line on the swinging gibbets. On at least one occasion, a group of young teenagers were rounded up for some act of courageous, childish misbehavior and were sentenced to execution. The commander's idea of clemency was to accept the offer of a group of septuagenarians to be hanged in their place.[37]

Two ideas of the primeval forest were at war in occupied Białowieża. The goal of the German terror, once Jews had been eliminated from the scenery, was to use violence (mauling by retrained hunting hounds became a routine punishment) to dissuade the local population from taking to the woods as partisans or aiding and abetting those who might already be there. The woods became instead *their* colony of death, a place of mass executions, dispatched close to the roadside perimeter of the dark forest; a dirty business of hasty entries and exits. Once its humans had been made docile, the forest could be prepared by dependable German foresters for its proper role as the Greater Reich's most splendid hunting ground. With its Polish-Lithuanian identity completely wiped out, it could be presented as a great, living laboratory of purely Teutonic species: eagles, elk, and wolves. And since a painting of a bison

hung on Göring's wall at the Carinhalle (presented to him by the finance minister of the 1930s, Hjalmar Schacht), the most famous of the forest animals could, at last, be definitively reclassified as zoologically Aryan.

But the local tyrants of the Third Reich were ultimately unsuccessful in their attempt to dispossess Polish Lithuania of its memory of the *puszcza*. The seneschal's bison horn and Jankiel's dulcimer, played from the heart of the forest, still echoed. And as they had done generation after generation, partisan bands gathered in the deep woods. More remarkable still, from the spring of 1943 Jewish escapees from the ghettos in Białystok, Kowno, and Wilno found their way to the forests, especially the Augustowska. By November that year there were at least four hundred such woodland Jewish fighters.[38] It was true, as one of them admitted, that "life is no safer in the forest than the Ghetto; every day means a rendezvous with death."[39] But at the very least it was a world at exactly the opposite pole from the false security of the ghetto walls. In place of its wretched and ultimately murderous hierarchies, partisans like Chaim Yellin from Kowno established what they imagined, like so many generations before, to be a primitive community of equals, living in pits covered with branches and moss, or abandoned woodsmen's huts. "In the forest," Yellin told Avraham Tory, the Jews "entered a new world. Even people whom they had known assumed a different appearance in the forest camp. There, even one's speech was different, the way one walked was different, one's thoughts were different." Calling themselves "wolves," the veterans went on nocturnal forays out from their pits to the woodland villages to try to procure oil, soap, candles. When there was none to be had, they "borrowed" horses and stole altar candles from the churches. Of all the generations of *puszcza* fighters, they were the most desperate: hated by the Lithuanian militias who collaborated with the Germans, despised or ignored by the Soviet partisans from whom they tried to scrounge supplies dropped from Russian planes.

Yet where and when they could, they fought as bravely and bitterly as the Polish and Soviet forest resistance. Combat was unpredictable and murderous, and it did not stop with the German retreat. For when the NKVD terror replaced the Nazis', brutal forest fighting took place between Communist and Home Army troops, the latter beneath the hornbeams, the leafmold turned yet again to accommodate fresh graves—Catholic, Jewish, Orthodox, atheist— beside the stone piles and wooden crosses of 1831 and 1864.

With the Germans gone, one might have expected Stalin, as the latest tsar, to repossess their greatest hunt. And with Poland's borders moved westward and Lithuania an annexed province of the Soviet Empire, nothing would have been easier. Perhaps, though, stalking the wolf and the bison was the one blood sport in which Stalin showed little interest. Perhaps he was vexed by the total failure of the Moscow State Circus to train the bison to perform tricks, or to do anything at all except horn the walls of their cages. At any rate he agreed to

keep the most ancient tract of forest on the Polish side of the border with Byelorussia. Within the pudgy frame of the Ukrainian peasant-dictator Nikita Khrushchev, on the other hand, was an ardent and sly hunter. In the late 1950s he abruptly decided that a new hunting lodge was required to impress foreign grandees and senior members of the *nomenklatura* who would nervously stand around in fur hats as foresters obligingly drove the game their way. (Some of the Białowieża foresters claim the animals were drugged to make them an easy hit for even the most vodka-saturated magnates of the Party.) Like much of his decision-making, Khrushchev's order came without any warning and with an impossible deadline attached. And like countless other buildings in the Soviet Empire, its concrete and wood went up at frantic speed and then fell down immediately before it could be used.[40]

But for the Soviet state, like many of its predecessors, forestry was a branch of state security. During the forty years of Communist rule, the border between the Byelorussian republic and Poland ran right through the center of the forest. Students at the forestry school in Białowieża became accustomed to a steady droning noise that sounded through the woods and which came from an immense and unwieldy mowing device used by the Soviet border guards. A forty-foot-wide strip had been cleared, right in the middle of the woods, and a vast growling machine—Big Mower—was used to keep it clean-shaven and visible from the guard towers. For the woods had a way of invading the route-map of the police state with their undergrowth, creating botanically sheltered places of sedition. No doubt about it, the woods were reactionary accomplices in the chauvinist conspiracy to undermine People's Democracy.

Big Mower has fallen silent now and the guardhouse was deserted the day I saw it. The barrier poles remain but the green and yellow flag of Belarus has replaced the red banner of the Soviets. Every day tattered convoys of Belarussian cars line up at other, unforested checkpoints on the Polish frontier. "We are their West," said my photographer friend Tadeusz with characteristically grim irony.

If the forest survived the Third Reich, the little palace of the Saxon kings and of Stanislas Augustus and the tsars did not. The last of the royal hunters, Göring, who never did return to his favorite preserve, ordered it burned to the ground as the Germans retreated. The same fires consumed his other hunting lodges, at Rominten on the Lithuanian border and on the Schorf Heide, an elaborately planned *Götterdämmerung* of the big game, thoroughly in keeping with the Nazi preference for collective suicide over collective shame. So the reindeer and the elk and Göring's favorite raccoons went up in flames along with his fantasies of the Teutonic woods.

On the foundations of the old palace the Communist Park Service built a little hotel of poured concrete. In the late spring it is overrun by battalions of excited schoolchildren on field trips. In one of the small rooms overlooking the

park I was woken up at 2 a.m. by an orgy of door-slamming and shouted German hilarity. Sleep came fitfully, interrupted predictably by nightmares of deportation while storks clacked their red bills from rooftop guardnests.

We rose to see the dawn from inside the forest, hoping to catch some of the wild bison herd on the move before they settled for the day in a remote and inaccessible woodland pasture. The bison failed to materialize, and an immense stillness mantled the woods, with only the tapping of woodpeckers and the push of the breeze through the treetops to fill the silence. Inside the forest darkness I made my way over fallen logs decorated with plate-size shaggy mushrooms of magenta and gold, toward wooden crosses and stones, graves unmarked on the tourist maps, unknown bodies beneath the leafmold.

The day before, our forester-guide Włodek, whose startling blue eyes smiled from a face the color of tree bark, had given us his landscape memories: of the woodlands east of Minsk where he grew up; of the borderlands of Hungary where he was caught by Soviet troops fleeing from the debacle of 1939; of the Arctic *gulag* where he watched friends die of hunger and exposure, a prisoner with a fever of 103° forced to sit with his feet in a bucket of ice water for six hours as a penalty for "malingering"; the arid landscape of northern Iran through which he trudged with the rest of the "Anders" army of Poles, released once Hitler attacked Stalin, on its way to British-held Iraq; the tropical landscape of the African coast where he caught malaria en route to Durban and the troop ships; the rolling meadows of Essex where he trained as a pilot in the exiled Polish Air Force; the burned-out shells of German cities where he threw bars of chocolate to small children; the desperate women whom he and his mates called "Dutch" when they wanted a night of illegal fraternization.

And all the time he had hung on to his memories of the Lithuanian woods as if they were the parachute cords of his identity. He had remembered the dark smell of the bison and the almond-sweet fragrance of the bison-grass vodka. "I don't care about the state," he said when I asked him about the Great Alteration from communism to democracy. "This is my state"—he smiled, waving airily at the trees—"nature; you understand: the state of nature."

Der Holzweg: *The Track Through the Woods*

i The Hunt for Germania

1878 The naturalist Franz Lichterfeld visits Białowieża. In the pages of the popular journal *Die Natur* he sides with Aristotle and Buffon, authoritatively pronouncing the bison, the *wisent,* to be identical with the Teutonic wild ox, the *auroch.* As for the forest itself, it is *ein Bild der altgermanischen Waldungen von Cäsar und Tacitus erzählt* (the very picture of the ancient woods as described by Caesar and Tacitus).[1]

AUTUMN 1943

A detachment of SS winds its way up the mountain road west of Ancona tracing a black line in the autumn gold: crows in the corn. Clouds of chalky dust rise from the road while the exhaust from the armored cars shakes the unharvested wheat. Ten miles down, on the Adriatic coast, Ancona waits in frantic terror for an Allied bombing raid. Already it chokes on the brown dust of dis-

aster while the iron and stone wreckage of its port crumbles into the tepid turquoise sea. Italy spins in turmoil. The last days of July had seen the end of Mussolini's dictatorship. Now, his Roman Empire is open to barbarian occupation, the Germans obeying Hitler's orders not to relinquish an inch of the Apennine center and north; the Anglo-Saxon allies advancing slowly and bloodily from the south. Released from formal military obligations, the remnant of the Italian army disintegrates, spilling thousands into the countryside, where, as Fascist *squadri* and partisan *bande,* they fight like snarling dogs over the bones of the fallen dictatorship.

South of Iesi, the medieval hill-town where the most Italian of German emperors, Frederick II, had been born, the little column turns into a rutted carriage road and halts in front of a grandly Palladian nineteenth-century palazzo.[2] Its pilastered columns speak authority but the visitors are famous for their contempt for such outworn pretensions. Fascist militiamen hammer melodramatically on the door while the German officers scrutinize the house, their boots crunching on the weedy gravel. It is open season in the Marche, when the hills crack with gunshot and *uccellati,* "little birds," drop from the sky to be spitted between layers of roasting mushrooms. But these hunters have other quarry, not partisans, not even Jews. They have come for the birth certificate of the German race.

According to scholars who staffed the SS's special research division of classics and antiquity, the Ahnenerbe (Race Ancestry), this had been supplied by the Roman historian Cornelius Tacitus.[3] His *Germania; or, On the Origin and Situation of the Germans* had been written around the year 98, with Trajan's armies still embattled with the Teutonic tribes, and was a backhanded tribute from civilization to barbarism. The Roman legions had been attempting to subdue the Germans, Tacitus ruefully conceded, for two hundred and ten years and "between the beginning and end of that long period . . . neither Sammite nor Carthaginian, neither Spain nor Gaul . . . [has] taught us more lessons." There was a reason for the Germans proving such obdurate foes. Unlike Tacitus's own contemporaries in imperial Rome, they had managed to remain, in all essentials, children of nature. Of course, that nature, *in universum tamen silvis horrida aut paludibus foeda,* "for the most part bristling forests and foul bogs,"[4] was decidedly unappealing to Roman taste. But it had to be conceded that this daunting and gloomy landscape, where even the short-horned cattle were undersized, had nurtured a warrior race of formidable toughness, a people that does "no business, private or public, without arms in their hands."[5] "Should it happen that the community where they are born is drugged with long years of peace and quiet, many of the high-born youth voluntarily seek those tribes which are at the time engaged in some war; for rest is unwelcome to the race."[6]

Tacitus's Germans, clad in the skins of wild beasts or, according to the first-century geographer Pomponius Mela, in a garment made from tree bark, vir-

tually defined the Latin understanding of "uncivilized." Yet had any Roman-ized Germans ever read their first ethnography, they might still have been flat-tered rather than insulted by their characterization as dwellers in swamps and woods. For though Tacitus makes them ferocious primitives, he also invests them with natural nobility through their instinctive indifference to the vices that had corrupted Rome: luxury, secrecy, property, sensuality, slavery. They were, in strong contrast to the Romans, bereft of wine and letters, a "people without craft or cunning."[7]

By counter-example, then, Tacitus's text was as much concerned with what it was to be truly Roman as with what it was to be truly German. So it was inevitable that it came to be a shared possession, coveted and contested between author and subject, Rome and Germany. The manuscript itself trav-elled back and forth across the Alps in the luggage of whichever of the two cul-tures claimed to be its principal guardian. In 852 the monk Rudolf of Fulda cited Tacitus as the authority for a reference to the river Weser, so that it seems probable that a manuscript copy of the *Germania* lay in that Benedictine monastery's famous library.[8] But it would take another six hundred years before an authentic text would come to light. And it would, inevitably, be Italian humanists who would unearth it.[9]

In 1425 the most resourceful and tireless of all the manuscript hunters, Poggio Bracciolini, wrote to his friend Niccolò Niccoli that the *Germania* was indeed in a German monastery. Two decades later, another dogged retriever of antique texts, Enoch of Ascoli, was dispatched to Germany by Pope Nicholas V, to bring back as many Greek and Latin manuscripts as he could lay his hands on. By the time he returned, in 1455, the pope was dead, but among his haul was a codex from the abbey at Hersfeld, close to Fulda both geographically and in the training of scribes. Deprived of his patron, Enoch initially failed to find a buyer for his hoard. But two years later just such an enthusiast showed up in Rome in the person of the chancellor of Perugia, Stefano Guarnieri. By the end of the decade Guarnieri had brought back to his library at Iesi a compilation of three manuscripts: a ninth-century script of another of Tacitus's works, the *Agricola,* quite probably a fragment from the great Hersfeld codex itself; a fourth-century account of the Trojan War; and a version of the *Germania,* copied in his own hand, possibly directly from the German manuscript, but equally possibly from an intermediary source (color illus. 10).

Copying such treasures was not a casual recording exercise. Guarnieri took great pains to emulate the Caroline ninth-century script of the *Agricola* so that his "Tacito" would in every respect feel close to the original. In 1470, at the border of the Latin and Germanic worlds in Venice, the *Germania* became the very first of Tacitus's works to be printed. Three years later it was published in Nuremberg, and with the first vernacular translation, published in Leipzig in 1496, it came to lodge permanently in the bloodstream of German culture.[10]

Once printed, the *Germania* took on a life of its own and the Guarnieri manuscript slipped back into drowsy obscurity in the palazzo library in the hills back of Ancona. Revolution arrived in the 1790s and the male line of the Guarnieri disappeared. The chancellor's legacy, however, lived on through a marriage alliance to the dynasty of the Marche family of the counts Balleani, who inherited the palazzi and the great library that went with them. These Balleanis, moreover, embraced the modern century with gusto while other equally venerable families were content to expire in a haze of provincial *dolce far niente*. Trading their hose for spats, they became aristocratic entrepreneurs, built a spanking new Palladian palazzo at Fontedamo, and established a modern, mechanized silk-weaving manufacture close by. They grew rich on high rents and busy markets and the Academy of Rome awarded them prizes for the quality of Fontedamo silk. Even the catastrophe of the pébrine epidemic that wiped out the industrious worms failed to do much damage to either the riches or the reputation of the Balleanis as the grandest of notables in the otherwise backward province of the Marche.

At the end of this busy, prospering century, the family fortune ended up in the hands of Count Aurelio, whose investments bore fruit while, alas, his loins did not. So *vecchio* Aurelio turned to his sister's considerable brood for an heir and chose the seventh of her nine children for no other reason (though a good one) than that he had been given the same name.

So, at six years old, *piccolo* Aurelio—"Lelo" to his family—inherited three palazzi and a serious fortune. And after the Great War, he crossed the Atlantic to the one place where he could most enjoy it. In New York he did a little of this and that on Wall Street; met and married Silvia Palermo, thus adding the Banco Siciliano to the family assets, which may have helped cut his losses during the Crash. He cut a figure in Manhattan, acquiring a nice Charleston kickstep that he took pleasure in showing off well into his eighties. Whenever possible he lunched at Giovanni's, in midtown, where herds of zebra roamed the crimson wallpaper but the pasta tasted *paisan*.

At home, the Fascist government took a sudden, unhealthy interest in the Balleani "Tacito." In 1902 the *professore* of classics at the local high school, Cesare Annibaldi, had "discovered" what was now called the Codex Aesinas lat. 8 (after the Latin name for Osimo, the third of the Balleani palazzi) and established it as the closest surviving link with the original. Before and after the First World War an entire cottage industry of German philologists, obsessed with the tribal origins of their new Reich, made it their business to comb through the manuscript folio by folio. For in the 1920s it came to be seen, in the decisive phrase of Eduard Norden, as their *Urgeschichte*, and some of his most avid readers hungered to have it return to its "natural homeland." Among them were Alfred Rosenberg, the Party's principal ideologue; Heinrich Himmler, who prided himself on his classical cultivation; and not least, Adolf Hitler.

In 1936 Mussolini visited Berlin, and the führer took the opportunity, by way of expressing his enthusiasm for the historical relationship between Rome and Germany, to ask if the Codex Aesinas might not be brought back to the Reich.[11] No philologist, the Duce obliged his host and, when told by his advisers that it belonged to a notorious anti-Fascist, the count Balleani, may have been still more delighted to dispossess him. On the other hand, Mussolini was also a great snob and the self-appointed guardian of the Roman imperial legacy (Tacitus included). So when a storm of protest greeted the suggestion that the Codex Aesinas leave Italy, Mussolini reneged on his offer.

Doubtless this did not please Hitler. But nor did he care so very much about the manuscript that he would make special exertions to seize it from his ally. Heinrich Himmler, on the other hand, cared very much indeed. Did not Tacitus, in chapter 4, expressly endorse "the opinions of those who hold that in the peoples of Germany there has been given to the world a race unmixed by intermarriage with other races, a peculiar people and pure [*propriam et sinceram*], like no one but themselves"?[12] And while it seems odd (even obscene) to think of the SS as a cultural institution, Himmler's pretensions to ideological integrity were demonstrably serious. It was for the SA to indulge in mindless violence; his kind would be mindful. It was the task of National Socialist scholarship to demonstrate the historical as well as the biological basis of Aryan supremacy, and in the invincible ancient Germanic tribes, the Semnones (with their partiality for human sacrifice) and the martial Cherusci, Himmler believed he could find just such vindication. Guided by his cultural mentor Hermann Wirth, he founded the Ahnenerbe in 1935 as an academic organization that under the aegis of the SS would promote and pursue research into Germanic antiquity and racial identity conceived in its broadest sense. Thus there would not only be archaeologists and classical historians in blackshirts, but also philologists, ethnographers, and biologists.[13] To have had the Aesinas *Germania* return to the Fatherland in 1936 would thus have been a crowning victory, every bit as important for Himmler as the Berlin Olympics and the reoccupation of the Rhineland.

Through the war years the frustration of this act of philological repatriation was evidently not forgotten. Through the good offices of the German ambassador in Rome, Hans Georg von Mackensen, one of the most enthusiastic Latinists of the Ahnenerbe, Dr. Rudolph Till, had managed to secure access to the codex. A photographic facsimile was made in Berlin, and then, presumably in deference to the sensibilities of an ally, the codex went back to Italy. But once Mussolini had been overthrown, the Reich no longer had to bother with such courtesies. And in 1943 Till published his new "authoritative" edition, complete with a foreword by SS Reichsführer Himmler (to the effect that the future would only be granted to those who understood the stock of their ancestry).[14] The timing could not possibly have been acciden-

tal. Himmler's foreword was, in effect, the warrant for the seizure of the codex.

Which is why the SS were parked on the grass in front of the palazzo Balleani at Fontedamo. They had come to make good on Mussolini's reckless gesture—to repatriate the *Germania* to the Fatherland after a millennium of exile.

They were to be denied again. Once they had smashed in the door, the SS stood in the empty, echoing vestibule of Fontedamo with no one to answer their barked commands. With the help of the local Fascists, they then proceeded to take the house apart. The manuscript was not, of course, in the library; nor did there seem to be any alcoves, swinging doors, or secret closets that might be concealing the prize. And as room after room declared itself barren, what began as a systematic search turned into a violent festival of vindictive malice. Frescoes were scraped to the bare plaster, smeared with obscenities; paintings slashed; furniture ripped apart; mosaic floors smashed to shivers and ground into colored powder with the butt end of machine guns.

And while one Balleani house was being demolished from the inside out, another at Osimo, the hill-town to the southeast, was sheltering the family in its deep cellars. For Count Aurelio had been served well by his expansive brand of dynastic paternalism. Barroom gossip, doubtless falling from the slack tongue of a local Fascist, had tipped off the count's driver in advance on the German excursion to Fontedamo. And even before he had let the family know, he had transported clothes and food to Osimo, enough to keep the count and his family hidden for weeks. And that house had been built, in the sixteenth-century fashion, to withstand assault: a fortress-like structure dominating one side of a piazza and opening onto the street from a single, inhospitable doorway. Still more helpfully, the Guarnieris had constructed deep below the house a labyrinth of cellars that ran below the square and connected with other noble palazzi. So where this subterranean Machiavellian architecture had once lodged wine and muskets and swordsmen, it now concealed Aurelio and Silvia and their two children, Lodovico and the little girl Francesca, who still remembers hearing violent, angry beating sounds far above of thwarted soldiers.

And all this time, the codex itself lay peacefully in the one place the SS failed to search, perhaps because it appeared to be the most obviously open and uninhabited. For there was, in fact, yet a *third* Balleani palazzo, in the very center of Iesi itself. The soldiers had looked, but they had found only empty rooms, an abandoned place. They had not looked hard enough. At the side of the square where the infant Frederick Hohenstaufen had been snatched from the bloody birth canal of his mother, in full public view, and shown to the citizenry in a demonstration of irrefutable imperial succession; behind the rococo facade of the palazzo with the Madonna and child lodged in a niche above the

door; beneath the *sala grande* with its spectacularly coffered ceiling and portraits of the Guarnieris and the Balleanis hanging on the crimson walls; deep in a little kitchen cellar, inside a tin-lined trunk, was the manuscript that began in capitals of red and black DE ORIGINE ET SITU GERMANORUM.

Perhaps, in the place of his extraordinary birth, the emperor, who like Countess Balleani grew up Sicilian, and kept company with racially impure Semites, Arabs and Jews alike, was, in the end upholding *his* version of the Reich against theirs. And if Frederick II was indeed the *genius loci* of Iesi, it was certainly not his fault that in 1966, in the vaults of the Banco Siciliano in Florence, the invading floodwaters of the Arno succeeded, where the SS had failed, in briefly taking hostage of Chancellor Guarnieri's "Tacito."[15]

ii Blood in the Forest

The fruitless quest by the cultural storm troops of the Third Reich for Codex Aesinas lat. 8 must represent one of the most tenacious examples of the obsession with a myth of origins. It was ironic, of course, that while the hunt was driven by a need for an ancestral memory of woodland warriors, the writer who provided the pedigree was thinking as much of his own (Roman) history as that of his adversaries. For as curious as Tacitus was about the Germans in their own right, his picture of the topography, manners, and religious rituals of the barbarian tribes is, in all essential respects, that of a not-Rome.

Nowhere is this more evident than in his description of the German habitat. The very first lines of the *Germania* proclaim its separation from Latinized Gaul by daunting barriers of water and rock as well as by "mutual misgivings" (*mutuo metu*). And when Tacitus writes of *informem terris* he uses a word that meant, simultaneously, "shapeless" *and* "dismal." For a Roman, the sign of a pleasing landscape was necessarily that which had been formed, upon which man had left his civilizing and fructifying mark. But according to Tacitus, the Germans were not disposed to work their land; they would rather take their subsistence from hunting, gathering, and the spoils of war. So even though much of the country was, in fact, fertile enough to support a fairly dense population, Tacitus paints a landscape of Germania in tones of dun and darkness: a cold, damp place, inured to a "bitter climate," "pleasant neither to live in nor to look upon unless it be one's fatherland."[16]

But it was this uncompromising ruggedness of the ancestral, forested Germany that most recommended it to the antiquarian warriors of the Ahnenerbe.[17] One of their most eager enthusiasts was the Reichsminister of Agriculture, Rudolf Darré, who had coined the term *Blut und Boden* (Blood and Soil) as a Nazi motto,[18] and who pushed for a policy of *Naturschutz* (protection of nature) as a state priority. Darré was one of many Nazi pedigreehunters who seized on the connection made by Tacitus between the formidable barriers of German topography and the apparently indigenous nature of the race, only "very slightly blended with new arrivals."[19] Even more rewarding for this racial genealogy was the Roman's description of the ancient myth-hymns of the Germans that extolled the primal deity Tuisto, *deum terra editum*, who had literally issued from the soil. Tuisto had given birth to Mannus, the first man, who in his turn had produced three sons, each the ancestral forefather of a German tribe. Beyond all other peoples, Tacitus seemed to be saying, the Germans were true indigens, sprung from the black earth of their native land, for

> personally I associate myself with the opinions of those who hold that in the peoples of Germany there has been given to the world a race unmixed by intermarriage with other races, a peculiar people and pure, like no-one but themselves, whence it comes that their physique, so far as can be said with their vast numbers, is identical: fierce blue eyes, red hair, tall frames, powerful.[20]

This, of course, was just what the eugenic historians of the Reich, even if they did not have blue eyes and red hair, wanted to read. Never mind that for Tacitus and his Roman readers, racial purity, bred up from the *informem terris,* was not an unmixed virtue. In the ancient polarization between culture and nature, it was clear (not least from the radically deforested Italian peninsula) where their allegiance lay. In fact it is not too much to say that classical civilization has always defined itself against the primeval woods. In the first Mesopotamian epic the warrior Gilgamesh claims his right to rule by journeying to the center of the Cedar Forest and slaying its guardian, Humbaba—"Kill him, grind him up, pulverize him," urges Gilgamesh's companion Enkidu.[21] Pulp the wild man of the woods and make his timber into fine buildings, into towns. Rome, too, tested its legitimacy against the boundaries of the wild wood. Livy's history of early Rome described the Ciminian forest of Etruria as "even more impassable and appalling" than the German woods. After their defeat at the hands of the Romans in 310 B.C. the Etruscans retreated into this fastness. To general amazement the consul Marcus Fabius, who spoke Etruscan, decided to reconnoiter the enemy position by penetrating the woods. But he took care to disguise himself as a wild man, dressed in skins, with a herdsman's billhook as his only weapon.[22]

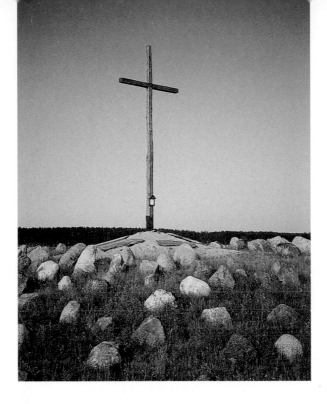

6. The cross at Giby.

7. Giby: view from the mound (photo: Tadeusz Rolke).

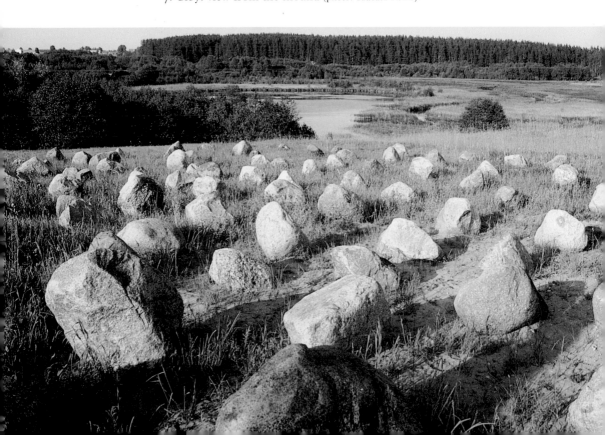

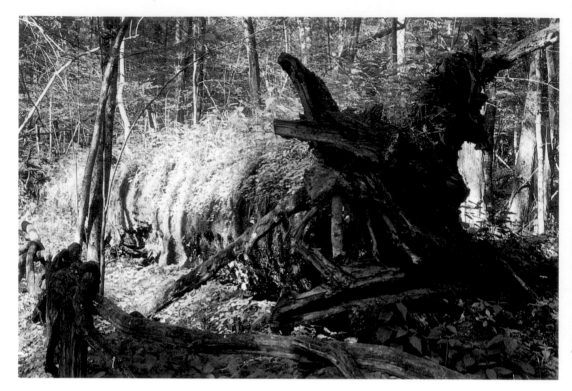

8. Puszca Białowieża (photo: Tadeusz Rolke).

9. Punsk: the Jewish cemetery (photo: Tadeusz Rolke).

10. The Codex Aesinas, First Folio, Tacitus's *Germania*.

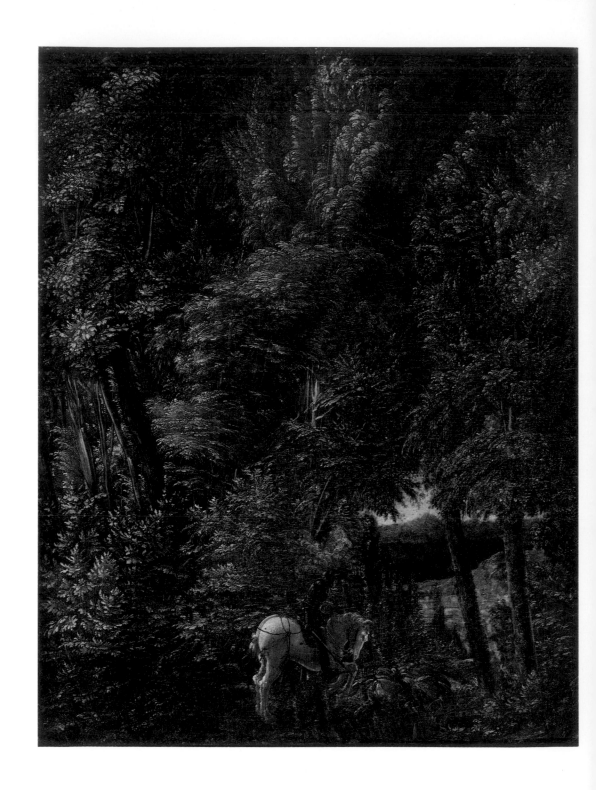

11. Albrecht Altdorfer, *St. George and the Dragon*, 1510.

12. Roeland Savery, *The Bohemian Husbandman*, ca. 1616.

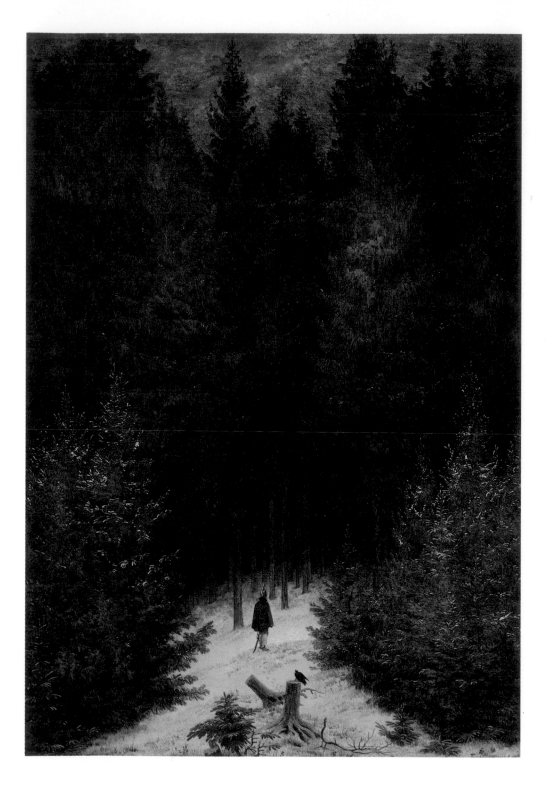

13. Caspar David Friedrich, *The "Chasseur" in the Forest*, 1813.

14. Album, *Hermannsdenkmal*, Detmold, 1875.

15. Anselm Kiefer, *Tree with Palette*, 1978.

But in the first century A.D., when Tacitus was writing, the alien forest was German, specifically the immense Hercynian forest that extended in different belts, west to east, all the way from the Rhine across the Danube perhaps as far as the Elbe. At least one map of Roman roads, attributed to Castorius, showed "Allemania" at the perimeter of the known world, terminating in a barrier of trees. In its densest areas the Hercynian forest was said to take nine days to cross north to south. But this was a mere excursion, compared to a journey west to east. Caesar, whose *De bello Gallico* had actually initiated many of the features of the collective German portrait, including their chastity, their martial wildness, and their common property,[23] recorded the common opinion that unencumbered travellers had journeyed *sixty* days eastward without ever seeing its edge.[24] On their return they told stories of strange and various kinds of wild beasts long extinct elsewhere—flat-antlered elks that used the valonia oaks as their "couch"; hairy aurochs with red-black eyes and fearsome curving horns and, according to Pliny, strange birds whose plumage shone like fire in the depths of the night.[25] Most important the Hercynian forest was unimaginably ancient, literally prehistoric according to Tacitus's friend Pliny, "intacta aevis et congenita mundo prope immortali sorte miracula excedit" (coeval with the world, which surpasses all marvels by its almost immortal destiny).[26]

There is in this description a note of awestruck admiration as well as repugnance that exactly reflected Rome's mixed feelings about the forest. On the one hand, it was a place which, by definition, was "outside" (*foris*) the writ of their law and the governance of their state. On the other hand, their own founding myths were sylvan. Classical Greece had venerated groves sacred to Artemis and Apollo and their cults of fertility, the hunt, and the tree-oracle had been transferred to Rome. Arcadia was imagined in both cultures as a wooded, rocky place, the haunt of satyrs, the realm of Pan. According to Virgil, the city itself had sprung from the motherwood Rhea Silvia, where wildmen and giants issued from the trunks of oaks. The fig tree beneath which Romulus and Remus were said to have been suckled by the she-wolf had been removed to the forum, where it too was an active devotional site. And by the time of Tacitus and Pliny it had become commonplace to contrast the mythic simplicity of an archaic "timbered" Rome, when the first Senate was no more than a rustic hut, with what moralists complained was the gilded decadence of the empire.

Tacitus's wooded Germania, then, was in some ways desirably, as well as deplorably, primitive. The "creatures" who "when not at war spend time in hunting but more in idleness . . . sleeping and eating" recalled the arcadian portrait of arboreal man given by Lucretius in his *De rerum natura,* living in contentment beneath the tall trees, his hunger satisfied by acorn-laden oaks, nuts, and berries and his thirst slaked by the rushing brook. Tacitus's Germans are, for sure, less idyllic and more barbaric, but the barely worked fabric of their

dwellings proclaimed their closeness to brute nature. Not only did they eschew stone; they "have not even learned to use quarry-stone or tiles: the timber they use for all purposes is unshaped, and stops short of all ornament or attraction." In winter some of them hibernated like beasts, gouging out pits in the ground and roofing it over with dung.[27]

The essence of their social simplicity was summed up by Tacitus's observation that "nullas Germanorum populis urbes habitari" (none of the German tribes live in [walled] cities).[28] Not only this but their houses are not even contiguous with each other, let alone joined in streets and terraces. "They live separated and scattered, according as spring-water, meadow or grove appeals to

each man. . . . Everyone keeps a clear space around his house." And that separation preserves them from an overbearing collective authority; protects their instinctive liberty.

Living as they did either in the depths of the forest or beside the reedy swamp, the Germans had managed, more by natural intuition than considered judgement, to preserve a world of timbered virtue. At its heart was a natural religion that believed it degrading to confine worship within masonry walls or to represent gods with human faces. Instead veneration of divinities that lodged within, and were indivisible from, natural phenomena like great oaks, was practiced in the open in holy groves.

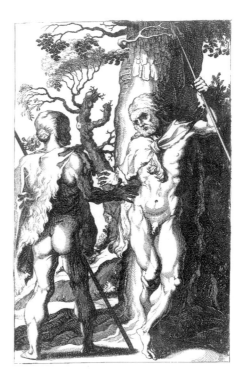

Engraving from Philip Cluverius, *Germaniae Antiquae*, 1616.

Tacitus reserves his most dismayed description for the Semnones—the "oldest and best born of the Swabian tribes"—who convene their annual assemblies in the sacred forest grove. It is there, he tells us, "initia gentis" (where the race first arose), as if uncoiling, fern-like, from the dark and spongy humus. Their mark of remembrance of this woodland tribal birth is to offer a human sacrifice and display the corpse on a tree trunk, "here where dwells the god who is lord of all things."[29] It seems possible that the grisly rite was a re-enactment of the self-sacrifice of the Teutonic god Wotan, who hanged himself on the boughs of the cosmic ash tree Yggdrasil (the Nordic symbol of the universe) for nine

days and nights, in a ritual of death and resurrection.[30] Waiting in vain for suc-
cor, Wotan saw beneath the great tree a vast pile of stone runes, which he suc-
ceeded in raising through the force of his supernatural will. Standing erect, the
runes liberated Wotan from his arboreal ordeal and into a new, rejuvenated life
of unprecedented power and strength.

The woodland sacrifice, then, is likely to have been a ritual of collective
tribal rebirth. But Tacitus saw only an act of horrifying barbarism. And he was
not much more attracted by the Semnones' convention of binding the hands
and feet of laymen with cords before they are permitted to enter the inner sanc-
tum of the woods. The humiliation is meant to signify their prostration before
the presiding divinity of the tribal birthplace. Should any devotee stumble, he
is not to be helped to his feet but has to writhe and squirm his way from under
the trees like so much mortal vermin.[31] And it is these morbid associations,
described by a not altogether neutral Latin commentator, between blood sac-
rifice, prostrate servitude, primitive woodland freedom,
and a myth of ethnic origins that would cast the
longest and darkest shadow over the fate of German
nationality.

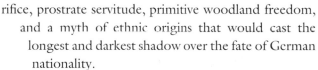

From Sebastian
Münster,
Cosmographey,
1570 edition.

Obviously this kind of primitive indignity
arouses only revulsion in the sardonic patrician
Tacitus. But the inversion of Roman values in the
Teutonic woods is not without its redeeming
features. Since their territories, as far as he knows,
have no mines bearing silver or gold, the Germans
have been spared this corrupting luxury, forgoing
ornament both in their simple dwellings and on
their bodies. For dress they wear nothing but sim-
ple cloaks fastened sometimes with a thorn or else
the skins and pelts of wild animals. Only the very
richest among them affect undergarments as a badge of status. But though the
women go about with their arms and much of their upper body bare, "the mar-
riage tie with them is strict. . . . They are almost the only barbarians who are
content with one wife apiece," and so (in marked contrast to the mores of Tac-
itus's Rome) "their life is one of fenced-in chastity." There is no arena with its
seductions: no opulent dinners to corrupt and debauch them, no exchange of
secret letters, hardly any adultery at all. The result of all this rugged self-denial
is to produce specimens of formidable toughness and stature. The hallmark of
the innocent vitality of the Germans is that their mothers suckle their own
infants rather than pass them on to wet nurses, so that children grow "up amid
nakedness and squalor into that girth of limb and frame which is to our peo-
ple a marvel."[32]

This portrait of Germania as a not-Rome is completed by its relative indifference to property and elaborate distinctions of rank, and its marked preference for spontaneous forms of community: communal feasting and hospitality. "To close the door against any human being is a crime." Their diet is peculiarly simple—wild fruit, game, curdled milk—and they drink a strange amber concoction of fermented barley or other grains, frequently in legendary amounts, so that days and nights run together. At their tribal assemblies artless (if overmuscular) candor is valued over verbal sophistry and those convicted of serious crimes meet with swift, rough justice. Sentences are administered by the landscape itself: traitors and deserters are hanged from trees, while the more infamous "cowards and poor fighters and sexual deviants" are "plunged in the mud of marshes with a hurdle on their heads" so that the vileness of their transgression will be swallowed in the morass.[33] And when they come to the end of this life of instinctual habit they are buried in a mound with the utmost simplicity. Even tribal nobles are cremated with specially designated kinds of wood—oak, beech, pine, or juniper—reaffirming to the last their bond with the forest.[34]

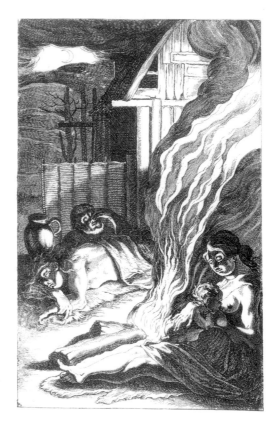

Engraving from Philip Cluverius, *Germaniae Antiquae,* 1616.

There is something like a theory of social geography lurking in the *Germania,* drawn from earlier sources, now lost, like the *Histories* of the Greek philosopher Posidonius.[35] For it is the German closeness to their natural habitat that contrasts so markedly with Rome and which gave some of its later moralizing writers like the Stoic Seneca the occasion for a lament on decadence.

Consider the peoples beyond the limits of the Roman empire. I speak of the Germans and all those vagrant tribes one meets beyond the

Danube. Living on sterile soil they must bear a perpetual winter and a gloomy sky. A mere thatched roof protects them against the rain. . . . They nourish themselves on the wild beasts which they hunt in the forests. Are they unhappy? No, there is no unhappiness in that which has become natural through habit; what has become necessity soon becomes pleasure. . . . Thus what you would regard as misery is the natural way of life of many peoples.[36]

The armies of the Caesars may have fought the battles but it was the prose of Tacitus that ordained the conflict, for generations, for centuries to come, on and on: wood against marble; iron against gold; fur against silk; brutal seriousness against elegant irony; bloody-minded tribalism against legalistic universalism. No wonder the Axis was a disaster; no wonder that with the Duce swinging from a lamppost, the SS had come to transport Tacitus back where they thought he belonged, north of the Alps.

He had, after all, given them more than their tribal identity. He had also given them their *Urheld*, their original hero: Arminius, prince of the Cherusci, who inhabited the extensive forested regions on either bank of the river Weser. Arminius was the superhero of the tribes, the Roman citizen who had rediscovered his blood loyalty and become conqueror of three Roman legions: Hermann the German. He appears in the *Annals*, written twenty years after the *Germania* and which are Tacitus's enduring masterpiece. The chronicle of the Roman Empire beginning with the death of Augustus and presumably ending with the suicide of Nero (for the last part has been lost) is one long exercise in ironic contemplation of the discrepancy between lofty purposes and base practices. At the heart of the first three books is the murderous war between Rome and the German tribes; the fight to the death between the two authentic heroes, Arminius and the emperor Tiberius's nephew Germanicus. That conflict was even more sharply defined by the fact that Arminius was the son of a captured German chief who, like many such captives, had made a military career in the Roman armies, commanding Cheruscan auxiliary troops. But it was only when Arminius returned to his ancient tribal identity, raising the rebellion against the empire that culminated in the slaughter of a whole Roman army in the Teutoburg Forest in 9 A.D., that Tacitus paradoxically grants him the qualities of a true hero: the custodian of extinct ideals: audacious, patriotically single-minded, and energetic, the antithesis of the public world with which Tacitus was himself intimate and which he evidently despised as lethargic, cynical, and weak. Germany, and the terror of its woods and marshes, is designed in his history as the ordeal of empire—the place where it would discover just what it was made of, what it was worth.

✦　✦　✦

ALAS FOR PUBLIUS QUINTILIUS VARUS!—remembered only as one of European history's most ignominious losers, on a par with "the unhappy General Mack" (as Tolstoy presents him), the Austrian commander routed at Austerlitz, or the General Staff of the French army in 1940. There is something especially humiliating (for the one side) and gratifying (for the other) about a catastrophic ambush, especially when the general failed to heed the warnings. Alas for Publius Quintilius Varus, the Custer of the Teutoburger Wald; Custer in many ways, since Velleius Paterculus, the one and only surviving source, pays particular attention to Varus's racial and cultural arrogance, despising the Germans as "having nothing human about them but voice and limbs."[37] To Varus, then, they were benighted savages, living in trees and bogs, brutes that required civilizing, not by the sword but by the omnipotent force of Roman law.

In Velleius's account, Varus courts hubris precisely because he is a specimen of everything that was wrong with the Roman Empire of Tiberius. (Velleius's grandfather had fought with Brutus and Cassius, so he may well have had a long republican animus against the pretensions of the imperial line.) Varus, he implies, had been ripened and softened by his years in North Africa and Syria, where he had been pampered by voluptuaries and corrupted by Levantine indolence. Posted to Germany, he turns into a petty oriental despot, levying excessive taxes and personally presiding over legal tribunals and "fancying himself a city praetor dispensing justice in the forum instead of the commander of an army in the middle of Germany." Varus is a hothouse plant, fated to perish beneath the dull iron skies of the north.

Arminius, on the other hand, is a tough nut of the beechwoods. The very fact that (like so many other rebels) he had served in the Roman armies only pointed up the exactly drawn opposition between incarnations of decadence and those of martial vigor. Arminius the veteran knew Rome; Varus the intruder was ignorant of Germany. While the Roman patronizingly imagined the Germans as children—uncultivated, fearful, and naively incapable of dissimulation—Arminius was in fact highly intelligent, fearless, and lethally skilled in subterfuge.

What was evidently the classic history of the disaster in the Teutoburger Wald, written by Pliny the Elder, has been lost. But from Velleius's brief history, the stark outlines of a catastrophe are clear enough. In the late summer of the year 9 A.D. Varus marched his army, numbering twenty-five thousand in all and comprising three legions and six auxiliary regiments, from their summer quarters on the river Weser toward more protected winter quarters on the Rhine. At some point on the march—the precise site is still unforgivingly disputed by archaeologists—the route ran between treacherous swamps and impenetrable forest, precisely (indeed suspiciously) the German scenery summarily characterized by Tacitus in the opening of the *Germania*. And it was there, in the tribal heartland, with no room for maneuver, that the legions were

suddenly confronted by a huge force of Cheruscan spearmen rushing from the forest and falling on the encumbered Romans. To retreat meant becoming helplessly bogged down in the swamp. To cut their way through the loose Cheruscan ranks, which seemed to come and go with mercurial swiftness, meant penetrating the terrible woods in an effort to root them out. For three days, under rains of javelins, the Romans attempted to hold their ground, more of them cut down with each sally of the Cheruscan spear-warriors. A bare remnant managed to survive and reach the Roman camp on the Rhine to report the slaughter. Varus himself, surveying the bloody fiasco, fell on his sword.

The *Annals* of Tacitus only begin after the magnitude of the disaster has been realized in Rome. His account of what then followed in the long and brutal campaign for vindication is presented as a trial of Roman fortitude. The hapless Varus is replaced by his antitype, the relentlessly virtuous Germanicus, the son of the emperor Tiberius's brother, Drusus, and thus the grandson of Augustus. Not only does Germanicus more than make up for Varus's defects, he is sketched by Tacitus as in every way a match for Arminius, fully his equal in strategic cunning, ruthless bloodthirstiness, and military charisma. Needless to say, the doppelgängers are too good to survive, both falling prey to treachery among their own people rather than each other.

Writing at the end of the first century A.D., when Germany was by no means pacified, Tacitus had a healthy respect for the barbarians as the social equivalent of a force of nature. He projected some of the same mixture of disgust and awed trepidation onto Germanicus himself, making his narrative of the campaign of the years 15–17 A.D. a terrifying tour de force of exorcism and vindication. Tacitus makes it clear from the start that the campaign is all about effacing the stain of military humiliation; that Tiberius was determined to penetrate the German heartland where his predecessor the shrewd Augustus would have been content to give it a wide berth. Having put down a mutiny among the understandably apprehensive troops, Germanicus deliberately leads them directly across the Rhine and through a deep forest where (like Hercules) he has to choose between alternative woodland paths. His first military action is a surprise raid as a German religious festival is being celebrated: "Neither age nor sex inspired pity: places sacred and profane were razed indifferently to the ground," including a holy grove, "the most noted religious centre of these tribes."[38]

As the campaign takes him deeper into Westphalia, Germanicus grows obsessed with avenging Varus's ghost, almost to the point of vicariously reliving the trauma. He leads his soldiers right to the Teutoburger Wald, throwing causeways over flooded swamps as they approach the forest "hideous to sight and memory." Six years after the disaster, its debris remained scattered around the site like a museum of calamity. Shreds and marks of Varus's camp, all tidily measured according to the regulation intervals for officers and men, were still

visible, as were the broken walls and ditches where fugitive soldiers had pathetically tried to take cover. The patterned distribution of bleached bones described the way the soldiers had died: heaped up like little backward-curving waves where they had stood their ground; randomly strewn about where they had fled.

Still more gruesome sights appeared in the forest itself: skulls nailed to tree trunks; woodland altars where captive tribunes and centurions had been slaughtered. And as Germanicus's soldiers began to gather up the bones for interment in a great burial mound, surviving veterans elaborated on the horror; of torture pits and unspeakable insults that desecrated the Roman eagles and standards. Gradually a great natural ossuary rose on the field, between the bogs and the woods; soldiers carrying bones in their cloaks, "no man [knowing] whether he consigned to earth the remains of a stranger or a kinsman, but all thought of all as friends and members of one family, and, with anger rising against the enemy, mourned at once and hated."[39] Much to Tiberius's displeasure Germanicus then broke the convention that forbade commanders from associating with the dead lest they pollute their authority: he threw the first dirt on the mass grave and conducted the funeral solemnities.

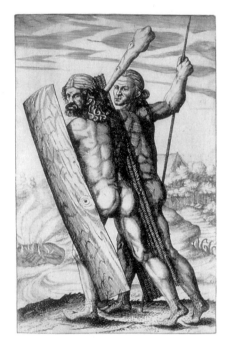

Engraving from Philip Cluverius, *Germaniae Antiquae*, 1616.

Military exorcism was not so easily accomplished. After an initial engagement, Arminius's troops retreated into the woods where, with perverse disregard for precedent, the Roman soldiers followed. Not surprisingly, they were suddenly faced with the enemy wheeling about in a charge beneath the trees. A rout was only avoided by the rapid reinforcement of fresh legions. Worse was to follow. Germanicus divided the army, evacuating part of it himself along the river Ems, leaving his veteran general Caecina to face Arminius. For days the Roman troops flounder about in the marshes, attempting to hold their own against hit-and-run attacks by the Cherusci soldiers camped on the high ground in the woods. One night the Roman camp is kept awake by German tribal chants and ululations coming from the forest and Caecina dreams that Quintilius Varus rises from the swamp, horribly bloodied, calling to him and stretching out a

gory arm to drag the general in. The next day the Germans fall on the mired Roman troops, mutilated horses slithering in the mud before collapsing on their own riders.[40]

It was only in the following year, 16 A.D., that Germanicus's army was able to achieve a victory solid enough to allow the Romans to retire from Germany with some semblance of honor. As Tacitus describes it, it was accomplished by Germanicus taking a leaf, as it were, from Arminius's own book of forest-fighting. First he disguises himself as a Cheruscan tribesman in a wild-animal's pelt to spy out the enemy's positions in one of their sacred groves. Then he does his best to dispel the Roman troops' terror of woodland combat. There is no need, he argued, to assume that the Germans will always prevail in the forest. Used intelligently, Roman weapons might actually prove superior. Short-swords could slash at the enemy's unprotected faces, causing enough chaos for them to become encumbered in the thick vegetation with their unwieldy spears and long wickerwork shields.[41]

A series of battles followed, some on a narrow plain from which the defeated Cherusci flee to the safety of the forest, pursued by Romans who fell trees holding enemy soldiers trying to hide among the branches. At the climax, huge numbers of Germans pack into a woodland space so tightly that, as Germanicus had predicted, they lose all possibility of free maneuver. The forest fortress becomes a deathtrap of hopelessly flailing lances and discarded shields, Germanicus ordering his men to take no prisoners, for "nothing but the extermination of the race would end the war."[42]

Finally, then, Germanicus had exorcised Varus's ghost by annihilating the tree-worshipping barbarians inside their own woodland lair, indeed in a grove specially dedicated to Thor. It had become something of a test to see whether an urban and imperial state could in fact impose its will on barbarian wilderness. Tacitus had been evenhanded enough in his distribution of vices and virtues to allow *both* Latins and Germans to claim him as their vindicator. And although the documentary trail of the *Germania* peters out into an indistinct track for much of the Middle Ages, when Tacitus himself was all but forgotten, two facts concerning the fate of manuscript copies remain incontestable: first, that they lay in German monastery libraries; second, that the Italians meant to repatriate them.

Few cared more to succeed in this enterprise than the first Italian commentator to specifically cite the *Germania* in a letter, dated 1458. Enea Silvio de'Piccolomini, the humanist cleric who subsequently became Pope Pius II, took a typically Roman view of its significance. The text, he wrote, merely showed how far the Germans had come since their rude beginnings. But they still had some way to go before being decently integrated into the civilization of Roman Christendom.[43] One of Enea Silvio's correspondents, the poet Giovanni Campano, attending the diet of German princes at Regensburg in 1471

(a year after the *Germania* was first published in Venice), pretended to flatter his hosts by producing a eulogy of German history, the better to persuade them to take up arms against the Turks. But his real view of the barbarians was revealed in private letters to his Italian friends in which he bitterly complained about the filthy food, appalling climate, and the stink of decaying corpses.[44]

It was exactly this kind of habitual condescension that ignited the patriotic fire of the poet, scholar, and orator Conrad Celtis, who more than any other Renaissance humanist was responsible for reclaiming the *Germania* for the Germans. Describing himself as having been born "in the middle of the Hercynian forest," Celtis was altogether an extraordinary figure. The son of a peasant winemaker from Wipfeld in Franconia, he was determined enough to exchange viticulture for humanist culture to escape from home on a lumber raft down the river Main. The epitome of the wandering poet-scholar, he studied in Heidelberg, Leipzig, and Rostock before reaching Kraków in 1489, where he had a sensually ecstatic affair with Hasilina Ryztonic, the wife of a Polish nobleman. "How happy I was in that hour amid kisses and embraces holding Hasa's soft breasts in my hands and

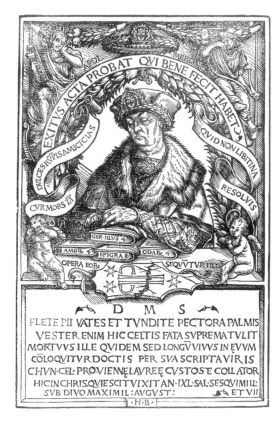

Hans Burgkmair, epitaph portrait of Conrad Celtis, woodcut.

burying myself in her sweet thighs."[45] Celtis strayed far enough into the Polish countryside to hunt bison, but his view of Poland as a place hopelessly sunk in drunken squalor may have been colored by his rejection at the hands of the passionate but unpredictable Hasa. In his later *Liber Amorum* she was decisively annexed as one of the four corners of Germany, the others being represented by Ursula of Mainz, Elsula of Nuremberg, and Barbara of Lübeck.[46]

Was it his Polish experience that led Celtis, in an oration delivered in 1492 at the University of Ingolstadt, where he had been appointed to the faculty, to differentiate the Germans as sharply as he could from the truly barbarous and nomadic Scythians and Sarmatians, "as uncivilised and brutal as beasts of prey

wandering over wild untrodden deserts like cattle"? In extricating the history of the ancient Germans from the monopoly of Italian interpretation, Celtis played a decisive role in pushing Germany away from the domination of papal Rome. Attacks on the decadence of the Roman church had been increasingly given voice in the second half of the fifteenth century. And though he nowhere mentions Tacitus by name in the oration, Celtis evidently meant to persuade his German audience to understand their own history in decidedly non-Italian terms. Though he begins by conceding to conventional Latin prejudices, saying that he was "born in the midst of barbarians and drunkards," and although he sometimes deplores the lawlessness that infested his native countryside, Celtis's real purpose at Ingolstadt was to stir in his German audience a powerful sense of their own natural nobility, and especially the grandeur of their antiquity. Invoking the shade of Arminius, he urged his countrymen to "assume, O men of Germany, that ancient spirit of yours with which you so often confounded and terrified the Romans and turn your eyes to the frontiers of Germany; collect her torn and broken territories. Let us be ashamed, ashamed, I say, to have placed upon our nation the yoke of slavery. . . . O free and powerful people, O noble and valiant race." So even while much of the speech is devoted to Celtis's appeals to his countrymen to shake off their reputation for philistinism by cultivating arts and learning, he presents it as a kind of revolt against Italian culture: the oppressive decadence of urban Rome.

> To such an extent are we corrupted by Italian sensuality and by fierce cruelty in extracting filthy lucre that it would have been far more holy and reverent for us to practice that rude and rustic life of old, living within the bounds of self-control, than to have imported the paraphernalia of sensuality and greed which are never sated, and to have adopted foreign customs.[47]

Celtis's debt to Tacitus was unmistakable, both in his account of Arminius's victory over the legions and his evocation of the sylvan simplicity of ancient Germany. Where Tacitus himself had used his ethnography to make a subtle criticism of Rome, Celtis and contemporaries like the Strasbourger Jacob Wimpheling, whose *Teutschland* (Germany) appeared in 1501, made forceful contrasts between the diseased south and the healthy north. Latin Europe offered the rounded arch, Roman statute law, syphilis, and, as Michael Baxandall characterizes this view, "a rather flashy way of standing with the feet together, one leg carrying the weight, the other elegantly bent."[48] In the north, though much invaded and corrupted by Italian ways, were to be seen the relics of a free and pure life: Germanic common law, civic liberty, domestic piety, and the pointed Gothic architecture of cathedrals like Strasbourg that Wimpheling eulogized as the most perfect and most natural form of sacred building.

For a while this aggressive attack on Romanism was useful to the imperial cause. In Vienna Maximilian I, who had been crowned emperor in 1493, authorized Celtis to create a Poets' College at the university and there he lectured expressly on Tacitus, as a way of further disseminating his message about a reborn Germany, to be nourished by a return to ancient virtues and revitalized learning. Celtis's own edition of the *Germania* appeared in Vienna in 1500.[49] During this campaign it was always the pope of Rome, his bishops, and his courtiers that were the targets of Tacitean polemics—not the Holy Roman *Emperor*, the German Habsburg Maximilian. Emperor and pope had quarreled for centuries over the

Painting on parchment after Erhard von Etzlaub, *Nuremberg and the Forests of St. Lorenz and St. Sebaldus,* 1516.

governance of Christian Europe. And such was the venomous hostility between pope and emperor at this time that any attack on Italian, papal domination was bound to be construed as a gesture of solidarity with the emperor. But whether the emperor would turn out to be the champion or enemy of the *Germania nova,* the "new Germany," would depend on the assertiveness with which he would prosecute the reform of the church. Celtis himself was reluctant to turn his rhetoric against the emperor. But following his death in 1508, there was nothing to stop militant apostles, impatient with the pace and radicalism of reform, from turning Celtis's reading of the *Germania* into an attack on *both* emperor and pope.

This is precisely what happened in the famous case of Ulrich von Hutten. Another wandering poet-scholar, von Hutten (who, unlike Celtis, also turned soldier) initially looked to Maximilian to become the new Arminius and take the war to Rome itself. But by the time he came to write his own dialogue, *Arminius,* Martin Luther had already begun his own dramatic assault on the authority of the church of Rome. Indeed it may well have been Luther who first insisted on stripping the national hero of his Romanized name and rebaptizing him with his vernacular war-moniker, Hermann, literally the "man of the army."[50] Increasingly disappointed in the failure of the new emperor, Charles V, to support the Lutheran position, Hutten hoisted the standard of Arminius in the camp of the Reformation. By the time he committed himself to outright rebellion against both the Roman church and the Holy Roman Emperor, von Hutten had himself become Hermann, "the father of the nation." There even seemed to be analogies with the original Arminius, once obedient to the commands of Rome but finally driven to revolt and ethnic self-discovery by the plight of his people.

It was not just German history that was being reborn in the first decades of the sixteenth century, but German geography. For along with the rediscovery of Hermann, the national father, came the mapping of a Fatherland. Perhaps Celtis's most creative legacy was the project he planned but never accomplished for a *Germania Illustrata:* a great compendium of topographical description and historical chronicle. Once again he imagined it as a German response to a genre that had already been established in the Latin world by an *Italia Illustrata,* and which was modeled on the books of the Greek geographer Strabo. But from his outline, *Germania generalis,* it also seems likely that he wanted to specifically answer the standard reproaches that southerners made of the beastliness, ugliness, and inclement quality of German cities and countryside. His description of the city and region of Nuremberg, the Norimberga, went out of its way to extol the virtues of German woods, above all, of course, the remaining tracts of the *Urwald* itself, the Hercynian forest, a place haunted by Druid groves of "murmuring leaves" and "dark valleys where sonorous torrents plunged through rocks."[51]

As Christopher Wood has pointed out in his rich study on Altdorfer's landscapes, by the time the German forest was being identified as the authentically native German scenery, much of it was fast disappearing under the axe.[52] So the geographers who wanted to celebrate the organically living world of the German woods (and by implication dispose of the dead world of Roman masonry) needed to replant it with their literary and visual imagination. To accomplish this cultural reafforestation, they relied on two strategies, apparently in contradiction, but which nevertheless somehow managed to complement each other in the reawakened German imagination.

The first approach, adopted by a number of Conrad Celtis's pupils, was to make a virtue of the changes that had so visibly altered the density of the German woods. The geographer Johannes Rauw, for example, while paying tribute to the

original grandeur of the ancient forests, dismissed its demonization as the home of barbarism as so much Italian slander, and praised instead the more compact forests like the Odenwald and the Thüringer Wald into which it had been divided. Likewise, the Black Forest ought to be thought of not as barren wilderness but as the place where the finest beef cattle, exceeding even those of Bohemia, Hungary, and Poland, were raised.[53] Such forests were now reimagined as domesticated woodlands, intersected by arable land and orchards, and living in easy relationship with the cities they surrounded, like Nuremberg and Würzburg. The

The Black Forest, "part of the Hercynian Forest," engraving from Sebastian Münster, *Cosmographey.*

woods ought no longer, then, to be thought of as brutal wildernesses but rather as places of health and wealth. Sebastian Münster's *Cosmographey* praised the Black Forest for its "wonderful and copious cold and warm springs to bathe in" and painted word pictures of the great rafts of building timber floating down the Rhine toward Strasbourg bringing back *gros gelt* each year for the forest people.[54] And the very first regional botany of any kind was the *Silva Hercynia* of Joachim Camerarius the Younger, published at Frankfurt am Main in 1588.[55]

At the same time that they presented their woods as a more populous and humane landscape, the patriotic topographers of the German Renaissance did not want to lose the connection, taken from Tacitus, between their forest home and their immunity to the seductions of city life Italian style. Ten years ago, in a brilliant article, Larry Silver argued that the renewed interest in Tacitus's portrait of the ancient Germans had changed the image of the "wild man" from a brute into a noble savage. Albrecht Altdorfer's *Family of Satyrs*, with a golden-

haired mother and sturdy infant, is thought to represent this better-groomed version of wildness.[56] For much of the Middle Ages, hairy, cannibalistic, sexually omnivorous wild men and women had represented the antithesis of the civilized Christian.[57] But beginning in the later part of the fifteenth century—the same period that saw the reappearance of the *Germania*—wild men were made over into exemplars of the virtuous and natural life. Theologians like the Strasbourg cleric Geiler von Kaiserberg associated them with incontestably holy hairy

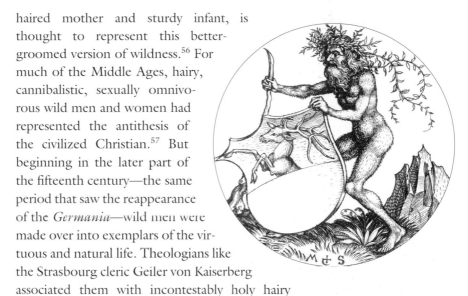

Martin Schongauer, *Wild Man Supporting Emblazoned Shield*, ca. 1480-90.

men: the anchorite saints and hermits of early Christianity. And over the next century wild men turned into conspicuously gentler creatures. To characterize them as *natural* beings no longer required images of bestiality. The old stereotypes of wild men munching on infants or doing unpleasant things with animals were replaced by paragons of family life: a hairy hand-holding between demure couples, or snub-nosed little wild-things having their heads patted by their proud parents. The woodland idylls even presented the oxymoronic spectacle of wild but willing men diligently tending to flocks or even tilling fields.

In other words, the wild men and the ancient Germans had merged together in the imagined woodland home. Their adversary, after all, was the same: the court and city culture of the Latin south. And it was a complaint against the vices of that world that the Nuremberg poet Hans Sachs put into the mouth of his wild family in the "Lament of the Wild Forest-Folk about the Perfidious World." Though the couple are still hirsute, their nakedness is now becomingly concealed by generous wreaths of foliage. The husband has a tree branch as a staff with which to fulfil the protective duties of *pater familias*. And while his wife's left hand clasps the vine that signifies her fertility, her right hand

Hans Leonhart Schäufelein, *Wild Man and Wild Woman*.

rests benevolently upon the fruit of her womb. Even the dog (known to the ancient Romans as domesticated by the Germans and even, on occasion, buried with them) appears as an emblem of natural faithfulness in a fickle world.

Echoing Celtis's own contrast between "the woods [which] are pleasing to the muses" and the "city, hateful to poets,"[58] the couple announce their return to the native German forest, the seat of ancestral virtue:

> *And so we left our worldly goods*
> *To make our home in these deep woods*
> *With our little ones protected*
> *From that falsehood we rejected*
> *We feed ourselves on native fruits*
> *And from the earth dig tender roots*
> *For drink pure springs are plentiful*
> *For garments grass and leaves we make*
> *Our homes are made of caves of stone*
> *And no-one takes what's not his own. . . .*
>
> *When all the world will see the light*
> *And every man live true, upright,*
> *In equal, unconniving good,*
> *It's then we'll gladly leave the wood.*[59]

Before long an entire genre of sentimental ethnography developed, especially in southern Germany, in which it was increasingly difficult to distinguish between the cleaned-up wild men and the various ancestral Germans embellished from Tacitus, who were now thought to have dwelled in a sylvan arcadia. Johannes Bohemus, for example, who lived in Aub, near Würzburg, and who published a work in 1520 comparing the manners and mores of different peoples, developed an idyllic portrait of the first Germans. They had, he insisted, called each other *Bruder* and dwelled in a sylvan arcadia where

> no-one . . . strove for earthly riches for each was satisfied with what nature accorded him: to find a soft place under some shady tree to serve him and his wife and dear children as a refuge; to obtain honest nourishment from the fruits of the field and the milk of the animals; to clothe their nakedness with the broad leaves of trees.[60]

To do justice to the German woods, to their tribal ancestors and their modern descendants, then, required as much subtlety as determination. Their inhabitants had to be wild enough to be distinguished from the effete Italian townsmen, but not so wild as to incur the old accusations of brutishness. It was

the astounding achievement of Albrecht Altdorfer, in particular, to make the forest *itself* the natural protagonist of this German difference. And in his drawings, woodcuts, and paintings, Altdorfer managed exactly to produce images of German trees and woods that in their startlingly dense and writhing forms proclaimed an unmistakable difference from anything attempted in Italian art.

Altdorfer's hometown of Regensburg, on the Danube, was an important center of exactly the kind of patriotic humanism represented by Celtis and his followers' fascination with German antiquity and topography. But he also belonged to a religious world where sculptors and architects had, from the middle of the fifteenth century onward, ornamented church interiors with living bowers, the columns and vaults sprouting tendrils and leaves. In some of the most elaborately organic examples in south Germany, twists of boughs and branches, bursting with foliage, rose into a living, naturally canopied tabernacle.[61] So although some of Altdorfer's trees seem wilfully and fantastically stylized, they are evidently meant as the supports of both a verdant sanctuary tabernacle and a tribal dwelling place.

There is one astonishing painting, executed by Altdorfer around 1510, that not merely visualizes but actually seems to *grow* this vegetable world of holy heroism (color illus. 11). Within its modest frame a creeping, luxuriant forest of ferns, evergreens, and oaks takes possession of almost the entire surface of the parchment sheet, glued to a limewood panel. (*Linde*, the early High German word for "limewood," Michael Baxandall reminds us, signified a sacred grove as well as the lime tree.)[62] Only a mean little space at bottom right is torn open so that a mountain prospect can provide an intelligible sense of depth and distance.

The ostensible subject of the painting is St. George not so much slaying as apparently paying his compliments to the dragon. And though he is conventionally represented as the epitome of the *miles Christianus,* the knight confronting the forces of hell, the toy-like miniaturization of the action (in an already small work) strengthens the impression that the real hero of the piece is as much the Teutonic forest as the Christian warrior. If he is a George, then, he is also a quasi-Hermann. The panel constitutes a true revolution in landscape painting, not least because of the extraordinary care Altdorfer has taken to transcribe the conventions of ornamental church foliage directly to the painting, thereby creating a consecrated space. This did not mean, however, that Altdorfer's foliage is unrecognizably stylized. Quite the contrary, in fact. He has evidently drawn with the scientific rigor of Dürer and Leonardo, but the painting transcends mere naturalistic accumulation by producing a startling sensation of the engulfing totality of the woodland, as if the beholder were being smothered and blindfolded with leaves. And by interposing itself between us and our expectations of visual depth, the curtain of greenery virtually obliterates the possibility of narrative, of storytelling. Confined *in front* of a corner of the leaf-wall, George and the dragon are no more the dramatic protagonists of

the scene than an introductory chorus before a proscenium curtain. The story, we begin to understand as the leaves emit light onto yet more leaves, piling up and overlapping in densely embroidered frond-like panels, *is* the forest. This German wood is not "the setting"; it is the history itself.[63]

Almost a century later the connections between ancient Germany, utopian primitivism, and the woodlands were revived at the Frankenthal court of the elector palatine Frederick III and the Prague court of the mystically inclined Emperor Rudolf II. Artists of the "Frankenthal circle" like Gillis Coninxloo and Roeland Savery were actually from the Netherlands or the Rhineland frontier of Germany. But the cavernous woodland interiors in which vegetation swallows up isolated parties of hunters faithfully reproduced the kind of sylvan arcadias that had become an established taste in Germany and Danubian Austria. Savery, in particular, had been commissioned by Rudolf to paint a number of mountain scenes in the Tyrol and around the Bohemian Woods that were yet another extension of the "Hercynian forest." In the first decade of the seventeenth century he painted the definitive image of the Bohemian forester (color illus. 12), clad, shod, and hatted in fustian and hides, the ancient, hirsute wild man evolved into a wholly sympathetic *Waldmann*—the man of the woods. To represent the world of nature rather than the world of culture, he is posed against the pathetic ruins of antiquity irreversibly invaded by greenery. He is everything the ideal of the Roman classical hero is not: rustic to the point of seeming a denizen of the woods rather than its sovereign. And Savery's little triumph of the rustic over the classical is at exactly the opposite pole of taste from contemporary Italian pastorals, where the landscape is devised as a setting for architecture or figures from an antique frieze. And compared with the refined herdsmen, transported from the Greek and Roman lyric traditions of music and poetry, Savery's bearded *Waldmann* seems made from the elements he inhabits: earth and timber. Nectar being in short supply in the German woods, he makes do with wild honey and strong ale. His music is made by the rustic sackbut and the hurdy-gurdy, not the flute and lute.

iii Arminius Redivivus

For all the hopes and passions of its advocates, the *Germania nova* did not come into being. If the sheer number of editions of Tacitus's text could alone

have guaranteed its vitality, the reborn Germany ought to have been the wonder of the Baroque age. But by the conclusion of the Thirty Years' War in 1648, there had been twenty-six editions of the *Germania* and Germany lay in shattered fragments. Its only power was the Holy Roman Empire, once again tied inseparably to the Roman church militant. Its landscape, which had given such cheer to the humanists of Conrad Celtis's generation, was a destitute ruin: depopulated and burnt-over; a wilderness traipsed by pathetic caravans of destitute vagrants and brutalized by marauders.

At the end of the eighteenth century the German Romantics would complain that a kind of Baroque despotism, overlaid with banal classical courtliness, had atrophied the national culture. The pugnacious Hermann, released by the sixteenth-century humanists from his Latin servitude, had reverted to classical decorum. Likewise, the instinctively native pleasure in the homely, with all its knobbly Gothic irregularities and woodland wanderings, was again frowned on as regrettable coarseness. What had taken its place in the world of the German courts, the Romantics argued, had been an international, Francophone culture of reason, dominated by the revival of the Latin classics and the passion for scientific inquiry. But in their indignation against the supremacy of reason, they almost certainly exaggerated the degree to which Enlightenment universalism actually suffocated an interest in native Germanism. Commentaries on Tacitus with vivid illustrations of the mores of the ancient Germans were widely available throughout the seventeenth century. Even when commentators like Philip Cluverius, who from his chair in the stronghold of classicism at Leiden University wanted to emphasize the savagery, rather than the virtue, of the woodland tribes, the spectacular engravings included in the volume undercut the criticism by playing up the austere dignity of warriors and primitive families.

Engraving from Philip Cluverius, *Germaniae, Antiquae,* 1616.

It was the survival, rather than the disappearance, of the cult of Arminius and of the woodland *Heimat,* even at a time when German political fortunes

were at their lowest ebb, that enabled a later generation to revitalize the ancient myths and traditions. The reality of German eighteenth-century forestry bore very little resemblance to the nostalgic yearning for the ancient broadleaf forests of the tribes. For what little of the mixed hardwood stands had survived the Thirty Years' War and the Wars of the North at the end of the seventeenth century had been laid waste by greedy and prodigal princelings, eager to cash in on the demands for naval timber from the Atlantic and Baltic powers, England, France, and the Dutch republic. And when the oak and beech were gone, the replanting was generally in quickly maturing conifers, according to the prescription of the first German forestry manuals published in the mid eighteenth century. But even as prolific forests of fir and larch rose in the heartland of the old German woods, the cultural imagination of Germany was being intensely reseeded with the oak groves of yore.

For by the middle of the eighteenth century the ancient mystique of rustic innocence, martial virility, and woodland nativism had all converged to create a fresh generation of patriots, steeped in Tacitus and the cult of the Teutoburger Wald. In the 1760s the poet and dramatist Friedrich Gottlieb Klopstock published his epic trilogy of plays based on the life and death of Arminius/Hermann. They were written, moreover, in the self-consciously archaic "bardic" style purportedly derived from the dialects said to have survived in the oral traditions of the common *Volk*.[64] And while the cultural enemy in the sixteenth century had been Italy, now it was the new international language of classicism—French—that was held to have debased native German manners and speech. And to the extent that French culture, and the notorious French partiality for rational discourse and skeptical inquiry, dominated the culture of the court elites, so it was held to account by this latest generation of "Arminians" as amoral and cosmopolitan. Redemption was to be found by fleeing this Frenchified world of court and city fashions and returning, once more, to the authentic Germania of the villages, uncontaminated by modernity. In a climactic scene in the Klopstock drama, immediately before the battle a Druid apostrophizes the oaks of Germany as the abode of their gods, the natural embodiment of the Fatherland: ancient, strong, and indestructible.[65]

To root German culture once more in its native soil was the consuming ambition of the most eloquent and influential of these custodians of folkmemory: Johann Gottfried Herder. In a series of essays Herder attacked the universalist claims of aesthetes like the scholar Winckelmann, who, from his post as secretary and librarian to a Roman cardinal, insisted on the unarguable supremacy of (especially Greek) classicism. Instead of this displaced cosmopolitanism, Herder, the heir of Celtis, argued for a culture organically rooted in the topography, customs, and communities of the local native tradition. Authentic native culture, he insisted, embodying the flesh and blood of true German history, had to be sought not in the idealized forms of Greek

nudes but in the unapologetically vernacular arts: folklore, ballads, fairy tales, and popular poetry.[66] Instead of Greek and Roman history, Herder promoted the importance of the very epoch most aggressively despised by the international and Francophone philosophes of the Enlightenment: the Middle Ages. Where they wrote it off as a period of unalloyed barbarism and superstition, a midnight of the classical soul, Herder and his followers celebrated it as the best of all German times: sacred, communal, and heroic. In their imagination, too, they saw not only a medieval German world peopled with the carolling balladeers, the *minnesänger*, but an as yet unspoiled native landscape—run by boar and wild ox, a great realm of the forest prolific in treasures for lord and churl alike.

It was hardly surprising, then, that these medieval inspirations sent the early generation of German Romantics to the woods. In 1772, for example, a group of students at Göttingen University, under the spell of Klopstock's tribal Druids, spent a night beneath the moon and stars in what was said to be an ancient oak grove. With their hands linked by garlands made of oak leaves, they swore eternal friendship and fraternity and constituted themselves a *Hain-Bund*, literally a "Grove-League," from which their druidical odes would seek to rejuvenate their Fatherland.[67] Enormous oak trees began to figure again in elaborately allegorical paintings, as the emblem of Germania itself. Another favorite theme was the withered tree that was prophesied to become green once more when the medieval emperor Frederick Barbarossa, scourge of the Italians, would return from his centuries-long slumber in the mountain tomb of the Kyffhäuser. When the great day came, he would unwind his beard (which had grown three times about the stone table within the mountain) and emerge from his rock, resurrected like Wotan and Christ, and hang his great shield on the boughs of the oak, green with the vigor of new German life.[68]

The promised triumph of German greenery over Latin masonry produced a virtual oak-fetish in the art and literature of the late eighteenth and early nineteenth centuries. One of the most startlingly original of all German graphic artists of this period, Karl Wilhelm Kolbe, acquired the nickname of "Eichen-Kolbe" (Oaken Kolbe) and used his long rambles in the woods near Dessau as a starting point for etchings that recalled the woodland scenes of the sixteenth century by the zeal with which they suffocated classical figures in gigantic, all-enveloping vegetation. More conventional landscapists like the Braunschweig painter Pascha Weitsch, obviously swayed by Klopstock's evocation of the "tallest, oldest, holiest oaks," began to paint the woods of pollarded oaks at Querum, not as conventionally pastoral scenery but as a patriotic tabernacle. In the most powerful of his many oakwood studies Weitsch painted himself, sketchbook on his lap, while a brilliant light illuminates trees that display both the battering of ancient history and the luxuriant growth of a new age.[69]

Karl Wilhelm Kolbe, *Thicket with Antique Figures,* ca. 1800.

The wars against Napoleon provided more opportunities to cast the battle between Roma and Germania—city and forest, the olive and the oak—in still sharper contrasts. Heinrich von Kleist's *Hermannsschlacht,* described by its author as his "gift to the Germans," expressly cast itself as a bond between past and posterity, calling on the native warriors for freedom to rededicate themselves in the groves of their ancestors. When Georg Friedrich Kersting wanted to paint a memorial to three friends who had been killed in the war, he portrayed them in the floppy-hatted *altdeutsch* uniform of the Lutzow Freikorps

Pascha Weitsch, *Oak Forest. Near Querum with self-portrait,* 1800.

in the thick of an oakwood. This was expressly meant to be a volunteer *Home Guard*, and Kersting's trio (who were in fact killed at different times and in different places of battle) have become allegorical incarnations of the patriotic volunteer. They are posed in complementary attitudes, the upright and vigilant figure balanced by another figure at rest (but only after the insignia of the iron cross has given proof of his valor in combat). Paradoxically, the most famous of the three, Theodor Körner, the young Saxon poet who had written stirring calls to arms and who had been killed early on in the fighting, in March 1813, is shown in the glades, pensive and melancholy as if meditating the heavy price of patriotic sacrifice. Predictably, Körner's memorial was sited beneath a massive and ancient oak. A pendant, painted in 1815, poses a mourning maiden, deep in the bowers of a dense grove, weaving a garland of oak leaves meant as a poignant signifier of both victory and death.[70]

Georg Friedrich Kersting, *On Sentry Duty*, 1815.

The Kerstings were shown in an exhibition of patriotic painting at Dresden in 1814 alongside a painting that became the most enduring of all the icons of the *Freiheitskrieg:* Caspar David Friedrich's *"Chasseur" in the Forest* (color illus. 13). Contemporary critics had no difficulty in recognizing the heavy load of patriotic symbols carried by the painting: the raven, perched on the felled fir stumps (signifying martyred soldiers), singing its song of death to the isolated French *chasseur.* But Friedrich's composition was much more than a mechanical inventory of such inspirational emblems. It might almost be considered as a bookend to the Altdorfer *St. George.* Both panels are dominated by a forbidding screen of foliage that sharply encloses the space within which their histories may be read. In both cases, too, the forest itself acts German, but there the similarities end. For while the leaves of Altdorfer's *Silva Hercynia* are lit with the illumination of a sacred triumph, in Friedrich's fir forest they are edged with the snow of death. The Christian-German warrior George is seen in heroic profile, whereas the French soldier, serving Napoleon—the new emperor and, by virtue of his conquests, the king of Italy, too—is seen from the rear, as if to emphasize his vulnerability. Whereas the woodland solitude seems to be the ally of St. George, it is evidently the adversary of the new "Latin" invader. Even his helmet, accurately described from the French military, seems strangely Roman, as if borrowed from one of Varus's lost centurions. Perhaps there were even echoes in their respective weapons, for while the ancient Germans carried javelins and spears not much different from the lance that pierces the dragon, the Romans used swords, represented in Friedrich's paintings by the weapon trailing clumsily beneath the *chasseur*'s cape. And while St. George is set parallel to the plane of the forest, as if in consort with it, the hapless *chasseur* faces it dead-on, pulled into its interior by the relentlessly commanding path leading nowhere good. For where, in the Altdorfer, the vegetation is pierced by light, exposing a space beyond, in the Friedrich there is only blackness. Like Varus's centurions, the *chasseur* is surrounded and dwarfed by the impenetrable line of evergreens, the massed troops of the reborn Germania.

One year earlier, 1813, the year of the victories of the Austrian and Prussian monarchs over Napoleon at Leipzig, the brothers Grimm had begun to publish their *Altdeutsche Wälder* (Old German Forests): anthologies of medieval poetry; legends and fables; anecdotes, jokes, proverbs, and songs; even guides to the folklore of plants and flowers.[71] They had been gathering this material for some years at the request of the poet Brentano, who had two publishing projects in mind: the folk-song collection *Das Knaben Wunderhorn* and a book of folktales. Since they were (with some cause) nervous that Brentano would turn the folk material into embellished romances, the Grimms retained copies for themselves. This was just as well since, taking the careless manner of the Romantic poet rather too far, Brentano managed to lose the manuscripts in a church cloister in Alsace, no doubt while transported in a

medieval reverie. From their own material the Grimms then began publishing the fables and fairy tales in 1812 as the volumes known as *Kinder- und Hausmärchen*, the anthologies that have come down to us as the "Tales of the Brothers Grimm."[72] Their suspicions of Brentano had always arisen from his inability to understand the stories as the fulfilment of Herder's call for a rediscovery of German authenticity. And they fretted lest his poetic inventions smother the essential documentation of German culture that they believed to be embedded in the tales. Both their journal, the "Old German Forests," and the "Tales" were, then, at heart another patriotic weapon to throw in the teeth of the Corsico-Gallic New Roman Empire.

It is virtually impossible, as Jack Zipes and many others have noticed, to think of the Grimm tales without immediately conjuring up a forest.[73] And it is always a northern Germanic wood: a place of firs and beeches and monstrously deformed oaks, gnarled and twisted like Kolbe's devouring vegetable monsters; or the child-destroying "elf-king" of the alders of Goethe's stunning poem "Erlkönig." It is also a place where Hansels and Lisels and Franzls, not to mention tailors and soldiers, face the perils of being robbed, murdered, eaten, or physically altered, or any or all of the above. But if the forest is a place of terror it is also the great adjudicator. Roman rules do not apply: social station and the force of conventional law disappear down the dwindling path. Instead a form of primitive and absolute redress takes place. An ungrateful girl who spurns the elves who brought her strawberries from the snow is severely punished. Toads, not words, drop from her mouth when she tries to speak. The woodland robber who wanted to rob, dismember, and salt his bride gets his comeuppance at the bridal banquet; the princess separated from her twelve brothers at birth is reunited. Ordeal precedes resurrection.

Religion and patriotism, antiquity and the future—all came together in the Teutonic romance of the woods. Figures asleep for centuries might stir into life, not least Germania herself. For the three hundredth anniversary of Ulrich von Hutten's Knights' Rebellion in 1823, Friedrich produced a painting that anthologized all these themes. The figure who stands over Ulrich von Hutten's forest tomb wears a peculiar combination of nineteenth-century trousers and *altdeutsch* pseudo-Renaissance hat and coat. He is, and is not, of his own time. The historically hybrid dress is supposed to be the costume worn by the citizen volunteers of the wars of liberation against Napoleon: self-consciously archaic, as if the fabric of the older generation of patriot humanists of the age of Celtis and Luther would literally rub off on their spiritual descendants. About the pilgrim (who may be a representation of Friedrich himself) are the graves of modern heroes of the German wars of liberation, bringing together the most recent *Liberatores Germaniae* with the most ancient, Arminius himself, and von Hutten's chosen historical doppelgänger. And if the connection between ancient and modern Germania were not already sufficiently indicated, a livid blood-red

dawn light illuminates a young German oak rising from the tomb and a tall fir tree that provides the canopy of the sepulchre: the images, respectively, of national and spiritual resurrection.

These images were not, of course, politically neutral. In post-Napoleonic Europe, dominated by archconservative absolutist monarchies in the German states, even a muted summons to arms was not excused by its patriotic use of history. But if the figure of Arminius/Hermann could somehow be associated with the ambitions of the very same princes, the campaign for national revival could be made more acceptably state-sponsored. And as the domination of the Austrian Habsburgs began to falter, in the fourth decade of the nineteenth century, more projects for the celebration of the Hermann-spirit were made public. In 1839, for example, the most creative of Germany's neoclassical architects, Karl-Friedrich Schinkel, made a drawing for a monument of Hermann, to be

Caspar David Friedrich, *Ulrich von Hutten's Tomb*, 1823.

Karl-Friedrich Schinkel, drawing for the *Hermanns-denkmal*.

set on the site of his victory in the region that, since the seventeenth century, had been known as the Teutoburger Wald. It explicitly followed Friedrich in bringing together elements of the native landscape with its mythic history. For Hermann, leaning on his sword, was to be mounted on a pedestal of unfashioned rock, the whole statue emerging, supernaturally, from the treetops of the oakwoods that surrounded it.

A *Hermannsdenkmal* would eventually be built at the Teutoburger Wald but it would not be to Schinkel's design.[74] Proposals for some sort of heroic statue went back all the way to the humanist theologian and student of Celtis, the Saxon Georg Spalatin, in the late fifteenth century, who had actually made a public pilgrimage to what he thought was the site of the battle in the Teutoburger Wald.[75] And in the aftermath of the devastating wars of the seventeenth century, the largely mythical figure of the Saxon hero Irminsul was repeatedly

suggested as a suitable model for a pan-Teutonic monument. In the 1780s there were at least two projects for landscaped pyramids, one of them produced for the Landgrave of Hesse-Homburg by his friend the *Hermann*-dramatist Klopstock. But the most inventive (and fashionable) design was an entire memorial park created on the estate of the Graf von Bruhl at Seifersdorfer Tal near Dresden. His wife, Christine, in particular, was of the generation that worshiped Rousseau, and may well have known and seen René de Girardin's landscaped park at Ermenonville, the center of which was Rousseau's tomb on an isle of poplars.[76] The Seifersdorfer Tal version creatively Germanized the program to feature a stone altar set in the woods with a shield and banner suspended from a "Hermanns-oak" both converting the wood into a Teutonic sacred grove and invoking the allied tradition of the hero-god who sleeps within the oak.

Kaiser Wilhelm I visits von Bandel's studio.

In the end, a site just south of Detmold, near Bielefeld, between the Ems and Weser rivers, prevailed over its competitors, though there were (and still are) disputes as to the exact location of the battle. Tacitus had unhelpfully merely located the *saltus Teutoburgiensis* between the Rhine and the Elbe. The sculptor who offered himself for the work was the Bavarian Joseph Ernst von Bandel, whose two years of academic study in Rome had not dimmed his German ardor. Von Bandel's version was in every way more prosaic and predictable than Schinkel's and altogether more to the official taste of the German courts.[77] The roughcast pedestal (which von Bandel had retained in his early sketches) was now replaced by a circular temple made of sandstone bricks with ten columns foliated at the capitals in a fanciful pseudo-Teutonic order and surmounted by a blind "cyclopean" or monopteroid cupola on which the hero stood. At the base of the temple a flight of steps would draw the pilgrim-visitor into a reverent darkness from which he could look out onto the dense German woods.

Instead of Schinkel's brooding warrior resting on his sword, von Bandel's Hermann brandished it aloft rather like a heldentenor in a Wagner opera. But in the light of Bismarck's military road to unification, the sword took on enormous emblematic significance in the eventual project. Bartholdi's Statue of Liberty

would have the torch of freedom; Bandel's Hermann would have Nothung, the mystical and omnipotent sword of the Nibelungen, steeled for heroes. Not slow to make a point, the sculptured version, duly inscribed with martial epithets that equated the kaiser Wilhelm with Hermann, was supplied by the Krupp armaments company, which had done very well hammering plowshares into swords.

Von Bandel slogged away at the project for nearly forty years. Rejected by the Bavarian monarchy, he moved his workshop to the site of the Groteburg hill just south of Detmold, officially working for the Landgrave of Hesse but perpetually delayed by the divisive politics of nineteenth-century Germany and also by the steeply rising cost. The idea was for all the states of Germany, including Austria, to make contributions, and so they did, though unevenly and not

Workshop for the *Hermanns-denkmal,* New Ulm, Minnesota.

always in proportion to their size or wealth. Stirred by the project, German patriotic enthusiasts from Chicago to Buckingham Palace (where Prince Albert eagerly chipped in) dutifully made contributions. But it was only when the issue of German national leadership had been settled, in the crushing defeat inflicted by Prussia and its allies on Austria and the south German Catholic states in 1866, that von Bandel saw a new opportunity. Though he was Bavarian, he had done a good deal of work in Berlin, not least a statue of King Frederick William IV for the university. And now he would shamelessly promote the identification of the triumphant king (soon to be kaiser) William I as the new Arminius. In 1869 he was gratified by a visit from the king himself to inspect the work in progress in von Bandel's atelier, where he lingered in admiration over the heroic features of his ancient predecessor in the vast, helmeted head.

And there was always another Rome to vanquish. In 1870 Napoleon III's empire perished on the battlefields of Sedan and Metz, crushed by the Prussian army. In Louis XIV's Hall of Mirrors at Versailles, a new German Reich was ceremonially brought into being. The defeated French state had been merely the latest edition of a "Roman Empire" against which Germania was defined on the field of battle, and reunited in triumph. Virtually every sketch of a *Hermannsdenkmal* had included as an obligatory feature the fasces and/or eagles of Rome trampled under the feet of the hero, and now the detail seemed especially satisfying.

So, in 1875, the fifth year of the Second Reich, the monument was finished. To mark the event, an official book of colored lithographs and gushing poems of praise was published, duly identifying Wilhelm I as the successor of Arminius, indomitable war-chief, bringer of unity and national freedom[78] (color illus. 14). In mid-August the count of Lippe had his hour of glory playing host to the kaiser for the official opening. It was orchestrated as a stupendous imperial triumph, with hundreds of banners and pennants flying the imperial colors and the arms of the now elaborately obsequious dependent princes of the empire. The Arminius Redivivus, Kaiser Wilhelm I, sat in an immense pseudo-medieval pavilion at the top of the Groteburg listening to a Lutheran preacher fulminate passionately on German destiny. Three actors got up in Romano-Teutonic costume impersonated the hero, their swords held aloft in the August sunshine. The vast crowd could buy little replicas of Hermann done in plaster or alabaster. Beer foamed; champagne bottles stood at attention in silver buckets; military brass oompahed over the hill and the summer air grew heavy with jubilation and the blue smoke that issued from thousands of "Hermann" cigars.[79]

Von Bandel may not have been the most flamboyantly inspired of monumental sculptors but he evidently knew his public. He provided it with exactly the image of the Wagnerian hero it expected: whiskery, wing-helmeted, flourishing the invincibly tempered Nothung in the skies, a repatriated version of Tacitus's Arminius as "the liberator of Germany."[80] And it was an image that literally went round the Germanic world, on Porto Rico tobacco tins; on the masthead of the *Sons of Hermann News* in Texas; and not least in the monument, one hundred and two feet tall, created by Julius Berndt for the patriotic Sons of Hermann in New Ulm, Minnesota.[81]

Von Bandel was rewarded for his perseverance by being portrayed in the memorial book as the human essence of Teutonic simplicity, creating the figure of the Cheruscan hero while living in a rustic *Hütte* quaintly decorated in the local peasant style, listening to "birdsong, year in, year out." He was a paragon, in fact, of the ancient virtues that Germany's sociologist of "field and forest"—Wilhelm Heinrich Riehl—extolled in his *Natural History of the German People*.[82]

Riehl's intellectual self-discovery ran parallel to his nation's. He was born in 1823, the year of the von Hutten tercentenary, but his family background was classically Enlightened. Grandpa Riehl was devoutly Lutheran and doggedly loyal to the House of Nassau, for whom he was a minor official. Papa Riehl, born in 1789, saw the light of liberty and became infatuated with the Napoleonic brand of *raison d'état,* residing for long periods in Paris and only returning to Wiesbaden with great reluctance. Perhaps he never got over Waterloo, for though (like so many bureaucrats) he managed to transfer his loyalty back to the old dynasty, he fell prey to deep depressions that ended with his suicide in 1839. Riehl was sixteen when his father died, but he went ahead with an education designed for his entry into the church. At Marburg University the lectures of the historian Friedrich Dahlmann and the grand old man of patriotic poetry, Ernst Moritz Arndt, prompted him to change course. He became instead a Man of Letters, with a bent for the more theoretical side of politics and literature.

Establishing himself in the genre of learned journalism (not an oxymoron in Germany then or now), Riehl returned to Wiesbaden, where he edited the *Nassauische Allegemeine Zeitung.* During the failed revolutions of 1848–49 he embraced a cautious political liberalism but was adamantly opposed to any kind of social radicalism. The spectre of social revolution, however fleeting and insubstantial, proved to be a crucial turning point for Riehl, as for so many others in German intellectual life. Unlike Marx, with whom he has sometimes been compared, not wholly absurdly, Riehl became a great deal less, rather than more, radical. But his conservatism, which had been Romantic and instinctive before the revolution, was now self-consciously given the weight of social science. What he shared with the sociologists of the left was a bitter hostility to industrial capitalism and metropolitan life, seeing both as corrosive of the moral solidarity he thought inherent in traditional work and community. Riehl was, then, the first to elaborate what a later and much better known sociologist, Karl Tonnies, would define as the opposition between *Gemeinschaft* (an organically bonded community) and *Gesellschaft* (an aggregate of individuals connected only by material interests).

In his horror at the prospect of a society dominated by the religions of materialism and individualism, Riehl clearly belonged in the company of Thoreau, Ruskin, and Carlyle, all of whom were fierce critics of contemporary capitalism. But he was more than simply their German counterpart, for he was always enough of Arndt's student to have *Heimat* at the very core of his theory. And that *Heimat* is for him much more than a patriotic sentiment: it is a physical topography with specific customs and idioms, in short the memories particular to Germany, embedded in its soil. His collective title for the three books published between 1851 and 1855, *The Natural History of the German People,* was quite apt, for it represented an attempt to invent a

sociology of habitat in that country, but in a language that was strikingly poetic.

The second of Riehl's volumes was called *Land und Leute* (Land and People). It was organized around a series of oppositions between those aspects of the land shaped by the engine of the market and those which had escaped its force. The "road" connected producers and consumers while the "path" connected villagers and citizens. The most sharply opposed countryside worlds were those of the open field and the forest—respectively, commercialized agriculture and the wilderness. They even produced different rural types. Foresters and woodcutters might statistically rank as the more impoverished of the two populations. But it was the field-villagers who, according to Riehl, constituted a true "proletariat" since they felt themselves exploited and turned into "heartless skinflints." Having to live on their wits, the woodlanders were more mentally spry than the "heavy-jowled" villagers, and while they were coarser, they were also better-humored. The forests were "the heartland of [German] folk culture . . . so that a village without a forest is like a town without any historical buildings, theater or art galleries. Forests are games fields for the young, feasting-places for the old."[83] They were, in short, the home of community; the absolute opposite of a Germany made over into one vast overupholstered, department-store-manufactured bourgeois parlor. If, in this scheme, the rootless Jew was the purveyor of this corrupted, citified society, the forester was his antithesis—the embodiment of ethnic authenticity, rooted like his trees in the ancient earth of the Fatherland.

A great deal of this, of course, belongs more in the fabulous realm of the brothers Grimm than the gritty social science Riehl was supposed to profess. But not all of his observations lacked historical substance. When he boasted that Germany had somehow preserved large areas of woodland that elsewhere had gone under the axe, he knew very well that this miracle was a direct result of the country's relative economic and social retardation. Indeed he rejoiced in the good fortune of backwardness. Renaissance princes like Duke Albert V of Bavaria had, in the mid sixteenth century, established elaborate forest regulations, complete with a personnel answerable directly to the court and backed up with savage penalties for infringements.[84] And these same laws, designed to protect the princely hunting preserves, had stayed on the statute books right through to the nineteenth century. Germany's fragmentation into countless principalities, he knew, had also helped to maintain these splendid anachronisms from more rational and economically driven plans that might have been imposed by a great-state bureaucracy. And it had been spared the voracious demands for naval timber which in the eighteenth century had denuded whole regions of France and England. Germany's impotence, then, had been its forests' boon.

This unearned good fortune, Riehl knew, was unlikely to last. Already, substantial tracts of forests, especially those which had formerly belonged to the

Catholic bishops and nobles of southwestern Germany, had been invaded by light industry in the shape of glass factories. And when he looked at Westphalia where the Teutoburger Wald itself was supposed to be located, and the suddenly burgeoning Ruhr, he saw the remnant of woodland Germany in dire peril, a superb anomaly about to be consumed by the smelting furnace.

Somehow he needed to show that their preservation was not simply a matter of patriotic sentimentality but functionally important for the life of the nation. And he was under no illusion that he alone would save the woodlands or the kind of traditional social solidarity he thought they sheltered. But he aimed to write something that would bring past and present enthusiasms for the forest together so that its protection would come to be seen as a priority of state. And he saw ways in which government might be induced to act, if necessary against private and market interests, as the protector of the landscape patrimony. Paradoxically, the most traditional and authoritarian institutions—like the hunting prerogatives of dynasts—might be redefined as a modern form of social paternalism designed to uphold public rights against the invasive absolutism of private property. Thus (as in so many other areas of nineteenth-century German life) feudalism shaded into welfare statism, and the Landgrave of Hesse's ordinances governing birch-branch-gleaning and the prohibition on woodland hogs could now be made over as modern Forest Law. On the subject of common rights to gather firewood from the forest floor, his views were indeed identical with those of Karl Marx, who, in 1842, had published a fierce polemic on the subject in the *Rheinische Zeitung*.[85] And Riehl rejoiced when the government of Anhalt-Dessau in 1852 decreed that all oaks, whether on public or private land, were the property of the sovereign and fell within the domain of "forest." Thus even solitary and ancient trees (of the kind whose execution Thoreau mourned so bitterly in Concord) could be declared legal "forest" and protected accordingly.[86]

Riehl was phenomenally successful, partly in ways that he could never have anticipated. *The Natural History* went through twelve editions, with many of its axioms, including its anti-semitism, forming the core of a whole array of anti-urban and anti-modernist ideologies.[87] Riehl himself became an intellectual grandee, first at the court of the Wittelsbach kings of Bavaria in Munich, where he moved in the 1850s as press adviser to King Maximilian, with a professorship at the university attached to the post. Embraced with equal fervor by the rest of Germany, he was elevated to the knightly *Ritterschaft* and even became a privy councillor at the court of the kaiser. More specifically his influence helped establish forestry as a serious academic and scientific discipline at Munich University, where in 1878 no fewer than five chairs were created in all aspects of the subject.[88]

By the time he died in 1897, covered with imperial honors and oak garlands, the *Holzweg* that Riehl had cut through the forest had forked into two distinct paths, the practical and the mystical. One track had been marked out in the eigh-

teenth century by forbidding pedagogues of state forestry like Gottfried Moser, whose *Grundsätze der Forstökonomie* taught budding German silviculturalists to treat the woods like a laboratory. Generations of dutiful students followed, turning topping and lopping and dibbling and grafting into a high science, rising to the ultimate German eminence of a university chair at Giessen or Munich. By 1827 Herr Professor Johann Christian Hundeshagen could deliver himself of an entire encyclopedia of the new science, bristling with tables, diagrams, charts, cross sections.[89] So when the new Reich came into being in 1870, it could be greeted with an expanding empire of German forestry, boasting learned journals, scientific communications on botanical diseases, arboreta, experimental nurseries, and training programs for serious bark-scratchers clad in green coats and hats.

The highnesses of the imperial forestry—Adam Schwappach at Eberswald, Kurt Michaelis at Bramwald, and Heinrich Mayr at Munich—not only combined historical erudition with practical learning; they also were instrumental in committing the national and provincial governments to accept responsibilities for woodland management. Every tree felled to create yet another of their formidable tomes could be considered an investment in political education. Considerable areas that had been arbitrarily cleared depending on the vagaries of the timber market were now maintained as "forest stock" by the state and in some cases replanted with oak and beech as well as the more commercially versatile conifers. This was nothing that Green politics would now recognize as the ancestor of "deep ecology," that is to say, the *supersession* of economic by ecological criteria of forest maintenance, and it was quite unsentimental about old and mixed growths. But it had succeeded in persuading the state that the German woods were more than simply an economic resource: they were in some mysteriously indeterminate way an essential element of the national character; they were, as Riehl put it, "what made Germany German."

Sometimes that woodland ethnicity surfaced even beyond the formal borders of the Reich. In 1873 the painter Edmund Kanoldt discovered, to his horror, that the ancient oakwood of La Serpentara at Olevano, east of Rome, was doomed to be felled. Ever since it had been discovered by Joseph Anton Koch, the grove had been virtually annexed by generations of German painters in Rome, as their forest home-away-from-home. Kanoldt himself had sketched and painted there, and such was his indignation at its fate that he recruited the German ambassador in Rome for its preservation. With the heavy guns of officialdom weighing in, enough money was raised to buy the wood outright and it was presented to the kaiser, who established it in perpetuity as the "Estate of German Artists." In appreciation for the patronage, a *Kaiser-Eiche* was planted at La Serpentara to mark Wilhelm I's ninetieth birthday. To this day the property remains the summer resort of the German Academy in Rome. Though barely ninety oak trees survive, they still constitute a little outcrop of the German woods, in the very heart of the Latin state.

The second path took *Deutschtum*—Germanness—into darker and less innocent glades—though it would also be a mistake to assume that every forest tramper in lederhosen was a recruit for the Reich to come. The Wandervogel youth movement and the Ramblers who communed, Siegfried style, around bonfires on forested hills, attracted not just those who saw themselves as the new generation of *Hermannskinder,* but also some on the left, not least the young Walter Benjamin.[90] Left and right, after all, shared the contempt for bourgeois urban materialism proclaimed by Riehl and were prepared to follow him in extolling nature, and especially the sublime German portion of it, as of transcendent value. The craving was for some ideal-

Celebrants at the *Hermanns-denkmal.*

ized, immutable rural community that had not been prostituted by industrial modernity.[91]

Ultimately, though there may have been some leftist stragglers on the way, the trail through the beechwoods led to terrible rehearsals of the *Hermannsschlacht.* This time the enemy was not just the legions of the hapless Varus but the entire Enlightenment tradition of humane liberalism. In August 1925, the fiftieth anniversary of the *Hermannsdenkmal* became an opportunity for fifty thousand ultranationalists, organized in the Jungdeutschenordnen (Order of Young Germans) and the paramilitary Stahlhelm (Steel Helmet) brigades, dressed in a variety of historical costumes, to march on the Detmold monument in the woods as though they were marching on Weimar's democracy. Some evidently imagined themselves already as a new order of Teutonic knights whose black-on-white cross banner they waved from beneath von Bandel's

Germanic pillars.[92] The bonfires of the forest camps would, before long, come to the center of town and their fuel would not be birch bark.

Tacitus's observation that their isolated habitat had made the Germans the least mixed of all European peoples would of course become the lethal obsession of the Nazi tyranny. *Germanentum*—the idea of a biologically pure and inviolate race, as "natural" to its terrain as indigenous species of trees and flowers—featured in much of the archaeological and prehistorical literature both before and after the First World War. The catastrophe of defeat in 1918 seemed only to make this hunger for tribal reassertion more desperate. The linguist and ancient historian Gustav Kossinna, for example, in 1921 published his archaeological work (in which the German tribes were given an ominously expansive territory) as *German Prehistory: A Pre-eminently National Discipline*. And not surprisingly, Riehl's complaint that Jews were disproportionately represented in the commercial, urban, and cosmopolitan *Gesellschaft* that he believed was eating away at the true Germany was adopted as prophetic by the founding fathers of Nazi ideology like Alfred Rosenberg. And though it seems unlikely that Riehl would have welcomed their embrace any more than Nietzsche, Riehl was honored by the Nazis as one of their progenitors, a fate which has guaranteed his subsequent total eclipse. But his imitators and vulgarizers multiplied like toadstools in the autumn rain, whether, like Otto Freucht, they insisted on the redemptive uniqueness of woodland society, or, like Kurt Hueck, issued ringing calls to defend the integrity of the woodland ecosystem.[93]

After 1933, forest themes invaded virtually every realm of art and politics. The nineteenth-century novels of Adalbert Stifter, which evoked woodland and mountain landscape with extraordinary immediacy and musical force, were vulgarly reinterpreted as catechisms against liberal modernity. Even modern writers like Alfred Döblin, exiled and alienated from the new dictatorship, consciously engaged with the legacy of Romantic nature writing in their radically modern reinterpretations of the woodland.[94] Books that attributed German racial and national distinctiveness to its woodland heritage, like Karl Rebel's 1934 *Der Wald in der deutschen Kultur* (The Forest in German Culture) and Julius Kober's 1935 *Deutscher Wald, Deutsches Volk* (German Forest, German People), kept the presses busy and filled the bookstores. Music, film (and of course the first act of *Die Walküre,* where the fate of the hero Siegmund is sealed by his pulling Nothung from the heart of an ash)— all ensured that the *Heimat* had never seemed so leafy. Whenever possible, Hitler, the Reichsforstmeister Göring, and Himmler were photographed in sylvan settings. And in 1934 Walther Schönichen, who was to occupy high office in the forestry and landscape administration of the Reich, published his album of the German primeval forests, where fir trees were made, once again, to resemble soldiers. In one of the most extraordinary of Schönichen's pho-

tographs, an oak and a beech were locked together in the kind of apparent copulation that was usually reserved for Nazi kitsch. Arguably, no German government had ever taken the protection of the German forests more seriously than the Third Reich and its Reichsforstminister Göring. Reluctant eleven-year-olds were turned into expert leaf-peepers through programs on forest ecology introduced into schools and were shown how the woodlands demonstrated the laws of biological competition and survival from the earwig to the eagle. Conservation was institutionalized through the creation of an entire administration run by the likes of Schönichen (who lectured on the subject at Berlin University from 1934 to 1936).[95]

It is, of course, painful to acknowledge how ecologically conscientious the most barbaric regime in modern history actually was. Exterminating millions of lives was not at all incompatible with passionate protection for millions of trees. This is not to make an obscene syllogism: to imply in any way that modern environmentalism has any kind of historical kinship with totalitarianism. The American experience, as we shall see, demonstrates how, in a different culture, wilderness could be taken as an emblem of democracy rather than its enemy (though even that history would expose deep and still unresolved conflicts about the kind of role the state should play as protector of the forest and the degree of its authority).[96]

The long, undeniable connections between the mythic memory of the forest and militant nationalism have created a zone of great moral angst in Germany. Since the war a distinctively right-wing nostalgic political ecology has appeared only in Austria, German Green politics being a virtual monopoly of the left. But the fierce divisions between more and less militant wings of the movement represent a painful argument about the price to be paid by the environment for accepting the normal processes of representative democracy. The more militant wing, in Germany as elsewhere, see their cause as a revolutionary contestation with bourgeois capitalism for the fate of the earth, and crave the authority to impose salutary solutions for what they present as a crisis of paramount importance. Those who seek more modestly to avert and correct its greatest damage are more uneasy about abridging individual liberties in the name of the earth and much less sure of the inherence of rights in nonhuman organisms.

Above all, though, Green politics is sited in the present and the future, with only the very remote past (at least in Europe) invoked as a sacred ancestor. There are merely peremptory and nervously embarrassed glances over the shoulder at the myth and memory of the German landscape, as if to take the forest trail, the *Holzweg,* back through time, is to necessarily become disoriented, lost in its darkness. The very term *Holzweg* in German carries that secondary meaning: a lure for the unwary ending in front of Hansel and Gretel's gingerbread cottage.

Yet there have been, in postwar Germany, those who have been willing to re-enter the forest of German history, not as innocent scouts but as woodland exorcists, determined to track down the ogres of myth in their own lair. And of these woodsmen none has been more single-minded in his pursuit of landscape memory than Anselm Kiefer.

iv *Waldsterben*

By the time Anselm Kiefer moved there in 1971 not much was left of the Hercynian forest. He had come to live in the Odenwald, the handsome country between the Main and the Neckar that Sebastian Münster and the Renaissance geographers had identified as the southwestern bloc of the great pan-Germanic woodland. In the early Middle Ages the Odenwald, resting on its crumbly sandstone bed, had resisted the kind of clearance and settlement that had already affected much of the woodlands in the rest of northwest Europe. For centuries its only inhabitants practiced primitive slash-and-burn culture, and when monasteries like the great Benedictine establishment at Lorsch finally set about clearing some of the woods, they created a landscape in which there was an unusually abrupt boundary between the cultivated field and the dense forest.[97]

Since then the broadleaf hardwoods of the Odenwald had surrendered to farmland, which was restocked in the nineteenth century with commercial conifers. Though it would not be until the 1980s that the German government would begin to take systematic scientific surveys of the damage done by sulfur dioxide emissions, and for the term *Waldsterben*—forest-death—to become the common coin of Green environmentalism, it was already apparent that the Odenwald, like other areas of the ancient *silva Hercynia* (notably the Harz, the Bayerischer Wald, and the Schwarzwald), had suffered dreadfully during the heyday of uncontrolled industrialism.[98] But even if there was precious little of the sylvan piety of the early German monks about the Odenwald of the 1970s, Kiefer, who evidently had a thing about arboreal myth, certainly knew something of its ancient and medieval history. Newly married, he moved with his wife into an old schoolhouse in the village of Hornbach, about forty miles south of Frankfurt, and converted its timbered attic space for his studio.[99] Beyond the village the woodlands were broken by broad stretches of agricultural land, orchards, and gently rolling hills and meadows.

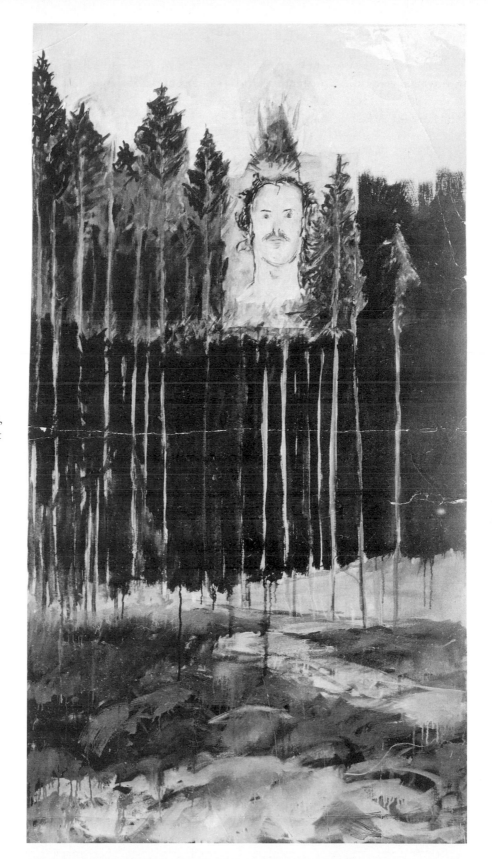

Anselm Kiefer,
Untitled, right
half, 1971.

Did Kiefer take the morbidity of the trees to heart? He had grown up in Donaueschingen, close to the Black Forest, and now the closest town of any size was Buchen: "the beeches." He also had a weakness for puns which made him *die Kiefer*, the "pine tree." One of his first Odenwald paintings has his own head inserted at the top of a fir forest crowned with a nimbus of sacred fire. Another, *Man in the Forest* (1971), had him in generically mysticoreligious robes, holding aloft a torch; yet another lying prone with a tree sprouting from his loins like the medieval Jesses from whom grew the tree of the Passion. Flirting with sacrilege, he was St. Anselm; a herald of resurrection; an evergreen in the beechwood. But in its masculine form, *der Kiefer* becomes something else, the "maxilla": the jawbone instrument of speech. Kiefer was casting himself not just as the mustachioed messiah of the woods but as the carrier of the jawbone: Samson among the Philistines, the riddling speaker in the land of the mute.

Caspar David Friedrich, *Traveller Looking Over a Sea of Fog*.

Kiefer was born in March 1945, as Allied troops were discovering another beechwood—Buchenwald—and Allied warplanes were reducing the cities and the landscape of the Third Reich to ashes. But Kiefer has vehemently denied that there ever was meaning to what the Germans called "Ground Zero." The caesura, he has said, was a cultural convenience, like the sudden onset of collective amnesia. "In 1945, after the 'accident' as it is so emphatically put, people thought now we start from scratch. The past was taboo, [my] dragging it up only caused repulsion and distaste."[100] He was committed to becoming a cultural nuisance, worrying away at the scabs of memory until they revealed open and livid wounds again.

Kiefer's first exhibited work consisted of a series of photographs of himself in boots and breeches making the Nazi *Sieg heil* salute on different European sites. The title, *Occupations,* was unsubtle but it made its point, half parody, half sermon. If this was clowning around by a sixties dropout law student, the

corners of the clown's mouth were turned down. And behind the posturing there was a studious, even bookish intellect, acutely aware of the continuities of German myths and icons. One of the locations for *Occupations* was a rocky shore, quoted from the Romantic painter Caspar David Friedrich with Kiefer's absurdly solitary Nazi substituted for Friedrich's mystical sea-gazer seen from the rear. At the core of this strategy of embarrassment was an obstinate determination to force together culturally acceptable elements of the German heroic and mythic tradition with its unacceptable historical consequences. The next effort along these lines was a terrifying album of images of *The Flooding of Heidelberg:* the citadel of traditional German culture engulfed through an act of wilful lunatic destruction. The overflowing of the banks of the Rhine was a *Götterdämmerung* that could only remind Kiefer's parents' generation of their own historical version of the catastrophe.

Anselm Kiefer, *Besetzungen* (*Occupations*), 1969.

Kiefer was provocative, even brazen about his challenge to conventional decorum, confessing that to understand fascism he needed to some degree to re-enact its megalomania. The stance was perverse, threatening, daring to be misunderstood, which it certainly was. But he was saved from obscene tomfoolery about the crematoria by his aggressive historicism, born, I believe, from an authentic determination to explore the modern fate of landscape myth. Early in the 1970s he was encouraged by the most creative and aggressively confrontational of Germany's postmodernist artists, Joseph Beuys, who in his manifold (and less ambiguous) fashion was forcing his countrymen to face the reality of their historical experience. In the same year that Kiefer had come to the Odenwald, Beuys had staged a theatrical (and brilliantly successful) demonstration in the Grafenberger Wald outside Düsseldorf against a proposed conversion of part of the woods into country-club tennis courts. Together with fifty students and disciples Beuys swept the woods with birch brooms in a kind of ritual exorcism of the bourgeoisie, painting crosses and rings on the threatened trees as if he were

affirming the ancient Teutonic religion of wood-spirits. "If anyone ever tries to cut down these trees," he warned, "we shall sit in the branches." Later he would run, flamboyantly and unsuccessfully, as a Green candidate for the European Parliament in Strasbourg, Germania yet again challenging the hegemony of (the Treaty of) Rome.[101] But Beuys was as uncomfortable with the pragmatic processes of politics as he was with the conventions of modern art. Instead he sought, especially toward the end of his life, to take some sort of civic and historical action that would have direct public significance well beyond the norms of artistic communication. So his contribution to the "Documenta 7" show at Kassel in 1982 took the form of the characteristically ambitious project of "Seven Thousand Oaks" to be planted in the center of German cities. He wanted, so he said, to practice *Verwaldung*: afforestation as redemption. "It suggests making the world a big forest, making towns and environments forest-like."[102] At his death in 1986 more than five thousand had been planted, and a year later his son Wenzel planted the last of the trees by way of memorial.[103]

Kulturlandschaft versus tennis; living oak against dead concrete. How could Kiefer resist this invitation to rediscover the organic materiality of German art? Like his guru (in this case, not too extravagant a term), Kiefer saw himself in revolt against what he took to be the bourgeois pabulum of commercial culture. And also like Beuys, he meant to reject the a historical and cosmopolitan modernism of the art coming out of New York. In fact, of course, Pop Art was the obvious child of American urban history and culture, but along with other versions of the avant-garde, like color-field painting, it was seen by Beuys and Kiefer as uprooted from narratives of time and place. What they minded most of all was the narcissism of the avant-garde, its insistence that the only interesting subject left for art was art. Hence the increasingly precious and reflexive variations on the venerable modernist theme of the uncoupling of painterly process and its ostensible objects, the endless pirouettes around the holy of holies: representation theory.

As he announced in a series of self-consciously grandiose paintings, the *Bilderstreit* (The Dispute of Paintings), Kiefer had more weighty things on his mind than silk-screened Marilyns. And to express those things, he needed a reinvention of traditional forms; above all, landscape and history painting. What he did was to collapse the one into the other, exactly reversing abstraction's metaphysical obligations to push the implications of painting beyond and through the picture. Where Piet Mondrian had launched himself from the representation of a tree toward abstract essence, Kiefer returned to materiality, in one of the *Bilderstreit* paintings literally nailing his palette to an enormously magnified trunk whose texture fills and overwhelms the whole picture surface (color illus. 15). Where Mondrian had transformed a tree into a grid whose lines extended toward infinity, Kiefer designed his paintings to

Joseph Beuys,
"Seven
Thousand
Oaks," 1984.

return those compositional lines back to their narrative function, a rebuttal he crudely overadvertised in *Piet Mondrian—Hermannsschlacht.* Abstraction prized lightness, flatness, the airy, and the cerebral. Very well, Kiefer turned back to German expressionism, for the raw texture, the gritty materiality, of historical truth. Modernism upended the picture plane dead-on to the beholder, rejoicing in the integrity of flatness. But Kiefer was concerned with a different kind of integrity: that of the undisguised storyteller, the orchestrator of a visual *Gesamtkunstwerk:* a total experience, at once operatic, poetic, and epic. So he pushed the plane back down, using aggressively deep perspective to create the big operatic spaces in which his histories could be enacted.

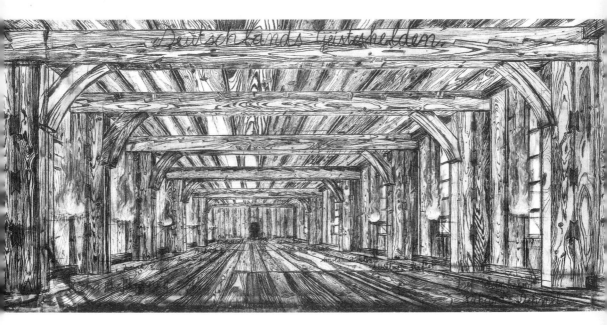

At the outset those histories operated at the tangent of myth and gospel. A path through a naked winter forest marked out by the body of a snake ends celestially beyond the frame at the steps to Kiefer's wooden attic; the empty wooden space holds Siegmund's fateful sword, Nothung, bloodied and stuck into the floorboards. That same space is opened up to the impossibly monumental dimensions of a timber hall of the "spiritual heroes" of Germany, their names (including Wagner, Beuys, and the Romantic "nature" novelist Adalbert Stifter) all in danger of immolation from the torches burning fiercely in the wooden chamber. As a work from 1974 made explicit (*Malen=Verbrennen* [Painting=Burning]), Kiefer came to think of his painting as an aggressive reenactment of historical destruction, literally as a "burning." So where Romantic art reiterated the sentimental celebration of native landscapes, his art did

what history did: it burned them. (Later he would literally burn books in *Cauterization of the Rural District of Buchen*, where the *Buchen* beech leaves and the leaves of the book share, as indeed they did under National Socialism, the same catastrophic fate.)

The tree-lined hills of Pomerania can be glimpsed at the top of a painting whose surface is filled with a black-scorched field, flecked with red flame and white ash. The Brandenburg heathland is turned into a drab, barren waste relieved only by a pathetic group of silver birch, the walking wounded of war, staring down an interminable path that marks the perspective line of the painting, through to the vanishing point and even beyond, a route march through the Brandenburg March of unutterable desolation.

Germany was not yet out of the woods, and neither was Anselm Kiefer. In 1974 he drew on the national reverence for both wood carving and woodcut engraving to produce a series of prints in which "Germany's facial types" were seen barely emerging from the grain of timber. And at the same time, his title *Charcoal for Two Thousand Years* suggested yet again that the racial archetypes that were proclaimed by the Third Reich to endure for two millennia would do so only as burned and blackened sacrifices.

Two years later the artist made another, decisive engagement with the myth and memory of the German past.[104] In *Varus* (color illus. 16) the line of perspective leads the beholder along a wintry, blood-stained path, where the dirty snow seems mixed with ashes, into the depths of the Teutoburger Wald, made dark and sinister. Kiefer had invoked Caspar David Friedrich before, almost parodically substituting himself for Friedrich's own persona, seen from the rear, the *Rückenfigur*. Now he quoted him again, specifically *The "Chasseur" in the Forest*. But instead of the solitary French soldier, the generic imperialist lost in the Teutonic woods, Kiefer has scrawled in the Roman's name in burnt-charcoal black. And in place of the overpowering, sacred fir forest, the emblem of national resurrection, Kiefer has scraggly, weather-beaten trees, their tops invisible, their lower trunks scarred and denuded by the toils of war; a forest filled with the filth of death like Dante's sanguinary, suicidal trees, a forest that is itself in the tormented throes of *Waldsterben*. Spiked upper branches form an archway of spears, literally a mock triumph, like an honor guard of soldiers at a wedding. This, however, is a consummation of slaughter, followed by a momentous birth: the historical beginning of *Deutschtum*, of Germanness. Hermann and his wife, Thusnelda, lie in wait along the *Holzweg*. They too are unable to escape the blotchy spills of blood, for they too would perish in the tangle of tribal and family hatreds, Thusnelda's father, Segestes, allying with the Romans to destroy his son-in-law.

The hapless Varus, inscribed in deathly black, faces down the path of *Schicksal*, his historical fate. He is there in name, not person, because his adoption into the founding myth of Germany requires that an actual historical actor

Anselm Kiefer,
*Germany's
Spiritual Heroes,*
1973.

be stripped down to a symbolic essence—a sign, in this case, that Roman imperial hubris is about to meet its comeuppance at the hands of woodland freedom. Other names, important makers of the Arminius myth, hang from the branches or are attached to the battleground by white tendrils of memory. There too, perched in the tree or tied to the battleground by white tendrils of memory, are all the memorialists and decorators of the primal myth: the bards of the *Hermanns-Schlacht,* Klopstock and Kleist; von Eichendorff, Grabbe, and Schlegel. So the path down which Kiefer leads us is the track of time. It is not, however, open-ended. Another tree trunk marks its closure at the vanishing point. Just as decisively as in the hall of "spiritual heroes," we are made to feel enclosed, trapped in a timbered vault; a forest cul-de-sac, a *Holzweg* for Varus, for Hermann, and for Germany.[105]

Anselm Kiefer, *Paths of the Wisdom of the World, Hermann's Battle,* 1978–80.

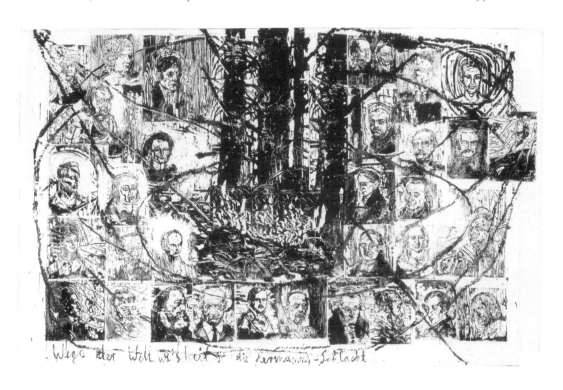

For a while Kiefer himself seemed, like Varus (rather than Arminius), trapped in the Teutoburger Wald's forest of myth, returning again and again to the *Hermanns-Schlacht* as the primal symbol of Germany's cultural identity. In three more versions of the *Wege der Weltweisheit—die Hermannsschlacht* (Ways of Worldly Wisdom—Arminius's Battle), the forest battle-site has receded into the background, where the base of the trees becomes a funeral pyre of burning logs. In the Amsterdam version snake-like roots coil from the logs, entwining themselves about figures who now include the engineers of

German's military myths—von Clausewitz and von Schlieffen—along with its cultural mythmakers like Schleiermacher and Fichte. "I chose these personages because power abused them," he has said.[106] For the version now in Chicago this family tree of corrupted idealism becomes more literally wooden. Kiefer used the print-form most associated with native Germanic identity, the woodcut (which had been self-consciously re-created by expressionists such as Kirchner and Nolde),[107] to create his pantheon. Unlike other pantheons, though, the figures memorialized are not unmixed heroes. For alongside philosophers of the German Enlightenment like Immanuel Kant and poets like Hölderlin are to be discovered artists of death like the armaments magnate Alfred Krupp and the architect of Prussian military supremacy, Helmuth von Moltke.

In one way or another many of the figures are, like Kiefer himself, cultural foresters: Adalbert Stifter, for example, the lyrical novelist of the *Hochwald*, and Carl Maria von Weber, whose opera *Der Freischütz*, populated with hunters and woodlanders, sent Richard Wagner into ecstasies over the Fatherland.[108] And an almost obligatory presence is the philosopher Martin Heidegger, whose inaugural address as rector of the University of Freiburg in 1934 was an infamous vindication of many of the Third Reich's most cherished dogma on will and the state. After the war Heidegger, whose deep engagement in the ambiguities that lie between language and act marked him out as the link between Nietzsche and modern phenomenology, retreated to the depths of the Black Forest. There, for some years, he affected a kind of sylvan hermitage, still implacably alienated from the technological twentieth century and addressing the local villagers in what was purported to be the ancient "Alemannic" German dialect. It was there, too, that Heidegger published his own ruminations under the title *Holzwege:* the paths through the forest that led to a historical dead end. And it is in just such a wooden blankness, the darkest grove of history, that Kiefer has his block-heads emerge from the grain of German timber.

For better or worse, Kiefer's compression of form and narrative is hard for a historian to resist. But it also sustains an expressly German tradition, going all the way back to Altdorfer's parchment on limewood in which the organic material of the art is referred back to the landscape from which it has been cut and which it now re-presents. Nowhere is this more dramatically embodied than in Kiefer's *Hermanns-Schlacht* book, completed in 1977. Removing it from its standard museum case in the Boston Museum of Fine Arts on a hot summer day was like freeing an unkempt forest animal from its hutch, for the thing is self-consciously coarse, mounted and printed on rag paper. On a hot summer's day, the dark ink glowed stickily as if made of pine tar and the curator had trouble in safely drawing back the protective interleaves. "It never dries," she said, and it did indeed look more coagulated than completed, the pages scarred and torn where they had obstinately stuck.

Anselm Kiefer,
*Die Hermanns-
Schlacht*, 1977.

To "read" the Boston *Hermanns-Schlacht* is to be led by Kiefer's iron grip down the *Holzweg*. It opens with a black-and-white photograph, taken by the artist, of the edge of Varus's forest: a screen of white birches, thin and cage-like, barring the entrance (and the exit). In front is a grass verge with a single Kersting-like felled stump; behind the line of birches, an infinity of blackness. To turn the page is to enter the interior; the vertical proportions reversed,

Anselm Kiefer,
Die Hermanns-Schlacht, 1977.

immense and forbidding black trunks separated only by fragile columns of light pressing themselves against the sight. Kiefer seems to have printed these with whole planks so that not only the grain but the knots and wrinkles of the trees seem to rise from the knubbly surface of the page. Page after page follows in the same way, claustrophobically enclosing the reader, and when, at last, the forest seems to admit some light it does so to reveal yet again not the bodies of

Anselm Kiefer,
*Die Hermanns-
Schlacht*, 1977.

centurions but the graveyard of German heroic idealism. The forest becomes another portrait gallery of the physiognomy of national destiny, beginning with Arminius himself, moving through figures like the political philosopher Fichte, whose "Addresses to the German Nation" in 1809, at the nadir of national fortunes in the Napoleonic wars, was meant as a summons to cultural revival, and drawing in Heidegger, whose compromised public rhetoric signified the wretched end of that long enterprise. What they all share is a fateful implication in national, tribal myth: a force hard to resist, but which leads up the forest path, to a wooden grave.

Evidently, Kiefer did not share the view, popular among empirical historians in the 1960s, that the Third Reich was a historical aberration that owed little or nothing to long traditions of German militarist authoritarianism. It would be convenient, of course, if the violent myths of blood and soil could be safely pigeonholed as peculiarly Nazi, and leave it at that. But Kiefer is too conscientious a cultural historian to tolerate such tidy classifications. Democracy, he seems to say, averts its face from these myths at its peril. To exorcise their spell means, to some extent, understanding their potency at close quarters, even, perhaps, within contamination range.

Needless to say, Kiefer's unseemly willingness to play with fire has brought on him the accusation of being the eager arsonist. In Germany he is still regarded with distasteful suspicion and a travelling exhibition in the United States in 1988–89 was not greeted with unmixed rapture, Arthur Danto going so far as to accuse him of disingenuousness, of wallowing in a kind of crackpot Wagnerian cultism, propagating the very mystique of "blood and soil" he professes to deplore.[109]

Anselm Kiefer is not, I am convinced, a closet fascist (or any other kind). But it is easy to see, notwithstanding all the awards bestowed in Jerusalem and Tel Aviv, how the suspicion arises. For it has attached to countless artists and anthropologists who have parted company with Enlightenment skepticism about the cultural force of myth and magic and who have seen in their complicated symbolic elaboration something more than a hoax perpetrated on the naive by the unscrupulous. To be sure, myths are seductive things. A truly disconcerting number of those who have spent their lives codifying, narrating, and explicating them have not gone unbewitched by their spell. The two modern careers of Mircea Eliade and Joseph Campbell are alarming cautionary tales. Campbell, the best-known mythographer in America thanks to public television, was, it now seems, not only a student but a devotee of heroic archetypes and decidedly impatient with the quotidian littleness of democracy.[110] Eliade, without question the most distinguished scholarly interpreter of myth, turns out to have been damningly implicated in the most brutal authoritarian politics in his native Romania.[111] And behind them, of course, stretches a long line of devotees of archetypes, from Carl Jung to Friedrich Nietzsche (the latter

conspicuously missing from Kiefer's wooden pantheon), whose embrace of myth fired their hostility to natural-rights individualism, and the democratic politics that protects it.

Carlo Ginzburg, a fearsome prosecutor in these matters, has recently uncovered the cautionary case of the French anthropologist Georges Dumézil, whose book on German myths was published in 1939.[112] Even though Dumézil explicitly connected the institutions and cultural fantasies of the Third Reich with the tradition of Germanic warrior cultures and failed to make a clear critical distance between himself and his subject, the book was praised in reviews by sociologists and historians including the Jewish founder of the Annales, Marc Bloch, who joined the Resistance and whose life ended in a concentration camp.

So how much myth is good for us? And how can we measure the dosage? Should we avoid the stuff altogether for fear of contamination or dismiss it out of hand as sinister and irrational esoterica that belong only in the unsavory margins of "real" (to wit, our own) history? Or do we have to ensure that a *cordon sanitaire* of protective irony is always securely in place when discussing such matters? Should certifications of ideological purity be published attesting under oath that we are not doing dirty business with the Devil under the pretense of learned work, to pre-empt a working-over from Arthur Danto or Carlo Ginzburg?

The real problem—what we might call the Kiefer syndrome—is whether it is possible to take myth seriously on its own terms, and to respect its coherence and complexity, without becoming morally blinded by its poetic power. This is only a variation, after all, of the habitual and insoluble dilemma of the anthropologist (or for that matter the historian, though not many of us like to own up to it): of how to reproduce the "other," separated from us by space, time, or cultural customs, without either losing ourselves altogether in total immersion or else rendering the subject "safe" by the usual eviscerations of Western empirical analysis.

Of one thing at least I am certain: that not to take myth seriously in the life of an ostensibly "disenchanted" culture like our own is actually to impoverish our understanding of our shared world. And it is also to concede the subject by default to those who have no critical distance from it at all, who apprehend myth not as a historical phenomenon but as an unchallengeable perennial mystery. As the great Talmudist Saul Lieberman said when he introduced Gershom Scholem's lectures on the Kabbalah that became *Major Trends in Jewish Mysticism:* "Nonsense (when all is said and done) is still nonsense. But the study of nonsense, that is science."[113]

The Liberties of the Greenwood

i Green Men

During the reign of the Stuarts, when gentility might be surmised from the elaborate dip and flutter of a deep bow, there dwelled in Dorset one Henry Hastings, second son of the earl of Huntingdon.[1] Though his family had been painted by van Dyck, Hastings was technically, not culturally, a cavalier. A stranger to frills and furbelows, he was one of the keepers of the New Forest, his jurisdiction being the "walk" of Christchurch. While others may have taken their duties with aristocratic carelessness, everything that is known about Henry Hastings suggests he took his *walk* seriously.

Hastings's house in Dorset was called, aptly enough, Woodlands. (He was also the landlord of a farm at Little Piddle near Combe Deverel in the same county.)[2] He made a point of dressing only in green broadcloth, and entertained guests in a chamber that had been built for him in the hollow of an oak. Should any of his company have ventured inside the house, they might well have wished they were back in the tree. Stepping into the great hall of Woodlands meant grinding the heel of one's boot on a carpet of half-gnawed marrowbones, while the evil-smelling chamber itself was filled with an inconceivable number of hunting, pointing, and retrieving dogs—spaniels, ter-

riers, and hounds of every description. Hawks and falcons roosted from the sconces set in the panelled walls, spattering the floor with their droppings. At the upper end of the room hung two seasons' worth of fox-skins with the occasional polecat pelt mixed in among them.

With his brick-red face and unkempt straw-colored hair, Henry Hastings must have looked as though he had more in common with the feral creatures of the woods than with an ancient noble line. He was also notorious for emulating their rutting, "there being not a woman in all his walks of the degree of a yeoman's wife and under the age of forty but it was her own fault if he was not intimately acquainted with her." This "made him very popular," John Hutchins, the eighteenth-century antiquarian of Dorset, implausibly claimed, "always speaking to the husband, brother and father who was very welcome to his house."[3]

In respect of its moldy beastliness, the parlor at Woodlands was not much of an improvement on the hall. Litters of cats lay in the great chairs and supped with their master, only occasionally batted away by a fourteen-inch white wand so "that he might defend such meat that he had no mind to part with to them." Most often their dainties were oysters, carted in from the fishing port of Poole twice a day for Hastings's dinner (at three) and supper (at eight). But they were always supplemented with whatever he had killed and hung to an acceptable degree of decomposing ripeness: venison, hare, or woodcock; roast, stewed or stuffed into pasties and pies. And should he still be peckish, he could walk to the end of the room, through a maze of little tables and desks overflowing with hawks' hoods, fowling poles, ancient guns, hats with their crowns stoved in to make a nest for the eggs of plover and partridge, past the chaos of dice and cards and ancient, grimy pipes, black and green with crusted smoke, past the cobwebbed books of martyrs and a single mildewed Bible, through a closet filled with bottles of ale and wine and the syrup of gillyflower with which he flavored his sack, and out the other side into his chapel. There, waiting for him in an old, intricately carved pulpit that had not heard a sermon for many years, would be a mighty chine of beef, a welcoming rosy side of gammon, or, most toothsome of all, a great crown of apple pie sweating sweet and spicy juices within its thick crust, "extremely baked."

Though he was given to yelling, "calling his servants Bastards and Cuckoldry knaves (in which he often spoke truth to his own knowledge)," Henry Hastings thought himself a moderate, sober sort of fellow. He never drank more than a glass or two of wine with his meals, preferring his small beer flavored with rosemary. "He lived to be a hundred," wrote William Gilpin admiringly, "and never lost his eye-sight nor used spectacles. He got on horseback and rode to the death of the stag till he was past fourscore."[4]

It is virtually impossible to disentangle myth from reality in this portrait of Henry Hastings. A century after his death, the squire of the New Forest had become as much folklore as history: an emblem of English incorrigibility,

bloody-minded, freely fornicating earthiness, in all likelihood the model for Addison and Steele's Sir Roger de Coverley and Fielding's Squire Western. But Gilpin, who occupied the New Forest parsonage of Boldre, celebrated Hastings in the pages of his *Remarks on Forest Scenery* because he had become an emblem of the English greenwood: a survivor of an ancient forest knighthood; virtually a living extrusion of the verdure; a piggy truffle-grubber; a specimen of the tradition of wild men of the woods; an Arcadian prince of Pan-ic, goatish and greedy. And though the Claudes and Poussins which supplied Gilpin with his definition of *picturesque* generally featured more comely types of herders and hunters, the filthy *terribilitas* of a Hastings, all crazed and blasted, a type in which ruined splendor and homely charm mixed in equal degrees, satisfied the picturesque's demand for irregularity. Besides, Hastings exuded a kind of warty rustic integrity that was at the opposite extreme from Gilpin's smooth aristocratic neighbors in the New Forest, with their obsessive interest in landscape "improvements": broad avenues of elms and oaks or ornamental fishponds made from the damming of perfectly good streams. Some, like Mr. Welbore Ellis at Paulton, who passed for a man of good taste, had even compounded these affectations with the abomination of a Chinese arched bridge. It was Sir William Chambers, whose *Designs of Chinese Buildings* had been published in 1757, whom he held accountable for such abominations. "Above all ornaments," wrote Gilpin with his literary handkerchief to his nose, "we are disgusted with the Chinese."[5]

Chinese fences and bridges had no more business in the New Forest, thought Gilpin, than pagodas (which had arrived at Kew) replacing his own church at Boldre. For the forest was much more than his own parish. To Parson Gilpin (also the high priest of the picturesque), it was the essential England—not just the abode of ancient oaks and wild ponies but the seat of English liberty and its long resistance to despotism. That was why he rejoiced in the splendidly horrible anachronism of Henry Hastings, who held the king's office of keeper of the forest but who was so unlike the sinecure-holders who took the perquisites and kept clear of the woods. That was also why Gilpin was proud to confess that he had befriended an ex-poacher who had confided to him in elaborate detail how he had taken (on average) a hundred bucks a year from right under the nose of the royal gamekeepers.[6] With considerable ingenuity, which Gilpin obviously admired, the poacher had constructed a special gun that could be unscrewed into three parts and concealed beneath his coat as he walked about the forest with the underkeepers, locating the best game. At night he would remove his kill to a secret storeroom he had built behind a false wall in his house and, when it was safe, would sell it to marketmen who were happy enough to observe the old forest adage *Non est inquirendum unde venit venison.*

As another exemplary forest type, Gilpin recounted the story of an "ancient" widow, living like many of the poor woodlanders in a tumbledown

cottage in the trees, much harassed by the forest officers who tried to remove them as "encroachers." When the Whig duke of Bedford had been lord warden of the New Forest he had tried to have such folk cleared out wholesale. But when faced with the determined resistance of two hundred of the woodsmen, he had reluctantly backed away from using force. The widow's husband had died young, leaving her with two small sons and an infant daughter but also with a carefully planted orchard at the back of the cottage and a garden at the front. And though her old age was "oppressed with infirmity . . . and various [unnamed] afflictions in her family," she was nonetheless pious and good-hearted, and her "little tenement . . . the habitation of innocence and industry." It was, in fact, very much the kind of cottage Gainsborough liked to paint, standing "sweetly in a dell on the edge of a forest," the family subsisting modestly through virtuous labor. Such a place, though technically illegal, Gilpin thought, could hardly be considered an "injury," producing as it did so much happiness and utility from a "petty trespass on waste."[7]

"New Forest Scenery," from William Gilpin, *Remarks on Forest Scenery*, 1808.

The wondrous-crazy lord of Woodlands and keeper of the forest, the bold and ingenious poacher, and the innocent trespasser were all prime specimens of what Gilpin believed to be English freedom set in the truest and most picturesque of English scenery: forest scenery. Yet he closed his long and superb account "with a sigh" because he did not think its unkempt splendors would be likely to survive the apparently insatiable demand for naval timber that was leading to acre after acre being felled, or the threat of mistaken embellishment in aristocratic parks.

His pessimism would prove, in some respects, unfounded. The nineteenth-century change in the construction of naval vessels from wood to iron, and the replacement of wood by coal for industrial processes, was to be the salvation of the royal forests. The market price for timber dropped steeply, reducing the incentive for subcontractors to lease off areas of old forest for commercial exploitation. But in any case, Gilpin believed that his own advocacy of the picturesque might ultimately affect official and fashionable views

of what landscapes were worth preserving. What he was looking for was some sort of grand patron who would share such a view. And it was not even completely out of the question that England had such a prince in its reigning monarch.

For on June 25, 1789, while Louis XVI and his ministers were plotting an armed march on insurrectionary Paris, George III arrived at the lodge of his lord warden of the New Forest at Lyndhurst.[8] It was meant to be nothing more than a brief stop en route to the new sea-bathing resort of Weymouth. But the king, who was the first monarch since Charles II to visit the most famous, ancient, and beautiful of all his royal forests, was so taken with what he saw that he stayed five days, along with Queen Charlotte and three of the royal princesses. In the same week that the Bourbons were putting up padlocks in Versailles, the farmer king and his daughters dined at the Lyndhurst lodge with the windows thrown open, or at wooden tables on the lawn before a cheering (though railed-off) public. It was a scene of spontaneous and disorderly merriment, right from the sketchbook of Thomas Rowlandson, and only slightly marred when "the populace became rather riotous in their joy [and] there was a necessity to exclude them."[9]

As the vicar of Boldre, no less than the advocate of unadorned Britain, Gilpin rejoiced at seeing George III galloping around the New Forest villages, doffing his hat as he was huzzahed on his way, the very picture of the bluff patriot king come among his loyal woodlander subjects. But then Gilpin had inherited a long memory of the forest as a place where history and geography met: the seat of greenwood liberty, a patrimony shared by both the polite and the common sort. If he had been able to suspend all disbelief, he could have shown friends and visitors the very tree off which, it was said, the arrow of Walter Tyrrell glanced before entering the body of King William II, Rufus, in the year 1100.

IN THE LORE of the free greenwood, Rufus, the son of William the Conqueror, was a chief and singular villain inheriting his father's lust for venery and his contempt for the traditional common woodland rights of grazing and gleaning. To nourish the hart and the hind, it was said, whole parishes had disappeared into the arbitrary jurisdiction of the new royal forests, their "vert and venison" (the trees and the beasts) protected by the most despotic institutions ever seen in Old England. But those who had committed this assault on the liberties of the greenwood would not go unpunished. So the arrow intended for a red deer, loosed by an especially worthless sycophant, was somehow providentially deflected in flight toward the body of the Norman despot. Indeed the whole dynasty of the Conqueror seemed to have been cursed for their crimes against greenwood liberty, for another of William I's sons, Richard, was also

killed in the New Forest, as was a grandson (also called Richard), his brother Duke Robert died with an arrow in his neck, and *his* son hanged from an oak by his hair, a Norman Absalom.[10]

The eleventh-century monk Oderic, of Saxon stock, was quite certain that Rufus had died unshriven amidst the oaks as punishment for his brutal and ungodly rule, and reported that the prelates and doctors of theology had decreed he should remain unabsolved because of his "filthy life and shameful deeds."[11] The monk Eadmer similarly believed him justly killed for falsely accusing fifty men of taking the king's deer. Though they had been condemned to the ordeal of the hot iron, he added, God had preserved their innocent hands from any scorching.[12] According to this pious tradition, it would be another century before the true justice of the greenwood returned embodied in the Charta de Foresta, signed just two years after the Magna Carta in 1217, and in the myth of sylvan liberties, every bit as important.

The legend of ravening Norman despotism annihilating whole villages and parishes to create the private hunting reserve of the New Forest was based on the claims of medieval clerics like Oderic and Walter Map, archdeacon of Oxford, who wrote that "the Conqueror took away much land from God and men and converted it for the use of wild beasts and the sport of his dogs for which he demolished thirty-six churches and exterminated the inhabitants."[13] Passed on through the generations as far as the eighteenth century, it evolved into the farfetched claim (found, for example, in Voltaire) that the Conqueror and his heirs had been so determined to swathe Old England in woods populated only by boar and by buck that they had gone to the length of planting good arable fields with trees. Gilpin rejected this assertion as transparently absurd and was skeptical about the magnitude of parish destruction claimed in the canonical history of the New Forest.

Pruned of its most important features, though, the mythic memory of greenwood freedom survived into the nineteenth century as material for the historical novel, not least, of course, Scott's *Ivanhoe*. Before the Norman tyranny, it was supposed, Britain had been mantled with the greenwood, a habitat where lord and peasant, thane and churl co-existed in pre-feudal reciprocity—the one exercising his hunting rights with moderation, the other allowed the freedom of the woods to pasture his swine and collect the wood for his wattle and hearth. The forests of England—Arden (Eardene, north of Worcester) and Sherwood, Dean and Epping—entered the popular imagination in a quite different style from the primeval woods of Polish Lithuania or the German *silva Hercynia*. There, the hunt was the expression of tribal community. In the idyll of the English greenwood, though, the hunt was an alien despotism, the hoofs of its horses trampling primitive liberties embodied, it was said, in the Saxon assembly, the witengamot, or the Scottish midsummer assembly at Glen Taner, where tribal chiefs met in their clan games.

There were perhaps some links with the Germanic tradition of martial wood-land *Gemeinschaft.* The Celtic king Caractacus was said to have made his last stand against the Romans from Clun Forest. But in the English greenwood, the blood pact turned into mere bloody-mindedness: overbearing authority corrected by acts of anarchic justice, the true law executed by the out-law.

Greenwood was not, then, like Dante's *selva oscura,* the darkling forest where one lost oneself at the entrance to hell. It was something like the exact opposite: the place where one found oneself. In the Arden of *As You Like It,* Shakespeare has the banished Duke Senior discard the vanities and corruption of court life in favor of woodland authenticity. "They say," Charles tells Oliver, "he is already in the forest of Arden, and a many merry men with him; and there they live like the old Robin Hood of England. They say many young gentlemen flock to him every day, and fleet the time carelessly, as they did in the golden world." Greenwood, then, is the upside-down world of the Renaissance court: a place where the conventions of gender and rank are *temporarily* reversed in the interest of discovering truth, love, freedom, and, above all, justice. "You have said," remarks Touchstone, "but whether wisely or no, let the forest judge." And so the forest does. At the very end of the play the usurping Duke Frederick—the urban condottiere—

> *hearing how that every day*
> *Men of great worth resorted to this forest,*
> *Address'd a mighty power, which were on foot*
> *In his own conduct, purposely to take*
> *His brother here, and put him to the sword;*
> *And to the skirts of this wild wood he came;*
> *Where, meeting with an old religious man,*
> *After some question with him, was converted*
> *Both from his enterprise and from the world,*
> *His crown bequeathing to his banish'd brother,*
> *And all their lands restor'd to them again.*[14]

The "old religious man" so abruptly and conveniently introduced by Shakespeare functions as both priest and judge of the ancient forest: a wood-land magus. So too the trees of Birnam Wood march relentlessly toward the usurper Macbeth in an act of justice and redress. This being England, the greenwood generally votes conservative. Its reversals of rank and sex are always temporary and its sentiments incurably loyal and royal. The grim slaughters of Białowieża and the Teutoburgwald are unthinkable in the sylvan habitat of Merrie England: there it is forever green, always summer. The nightingales sing, the ale is heady, and masters and men are brought together in fellowship by the lord of the jest: Robin Hood.

ii Living in the Woods: Laws and Outlaws

Behind this fantasy there was a real place. But it hardly resembled the unbroken summery-sylvan idyll of the greenwood. To imagine early medieval England blanketed with vast and immemorially ancient deciduous forests, broken only by stretches of scrubby moor and precarious patches of grainfields and pasture, is to get things the wrong way round. By the time William the Conqueror arrived on the Sussex coast, no more than 15 percent of English territory would have been wooded.[15] According to Oliver Rackham, even the Romans, whom Joseph Conrad and others imagined shivering with fear at the dark British woods as they did at the German and Etruscan forests, would not have encountered a country uniformly dominated by woodland. Of the original primeval wildwood there was nothing at all left except perhaps a small acreage at the very center of the New Forest. Well before the arrival of the Romans, Britain's earliest settled cultures, principally Celtic, had undertaken major clearances. The sophisticated demands of Roman town life, not least for heated water in the chill and foggy climate of Britain, certainly accelerated the denuding of the woods. Extensive wood-fired iron smelting carried the process further and faster.

By the time of Anglo-Saxon kings, then, the essential familiar pattern of the English countryside—broad tracts of cultivated field and pasture punctuated with copses and limited stands of trees—had already been established. There were still substantial areas of woodland in counties like Middlesex and Warwickshire, but from the fifth to the eleventh century they were steadily shrinking as clay soils were taken for farming. By the time of the Domesday Book in 1086, areas whose very names signified woodland, like the Kentish Weald, had been converted into pasture, orchard, and arable.[16]

And it would be equally mistaken to imagine the medieval English forests as vast green tanks of silence: dense, impenetrable, and deserted places populated only by bandits and hermits. The *expectation* that there ought to be hermits in the woods was such that King Stephen went to the length of setting one up in a customized rustic cell in Writtle Forest.[17] The forest as the opposite of court, town, and village—the sylvan remnant of arcady, or what Shakespeare called the "golden world"—was an idea that would lodge tenaciously in the poetic and the pious imagination. But in England (and in much of France as well) the reality was different.[18]

For there were people in the woods: settled, active, making a livelihood out of its resources, a robust society with its own seasonal rhythms of movement, communication, religion, work, and pleasure. Even the broadest forests were laced with cart tracks, footpaths, and trails which to its adepts were as familiar as Roman roads. The network of tracks ran through a landscape in which town dwellers might become quickly disoriented, but to those who lived there it was mapped by distinctive landmarks: rocky outcrops wrapped in liverwort; ancient lightning-blasted trees; trunks and roots fallen and decayed into shapes suggestive enough to earn nicknames; winding brooks, ponds, and bogs; hummocks and slopes; the ruins of older hearths and walls; the rubble of fugitives; the cinders of charcoal burners.

And the trees themselves were not all of a sameness, either in maturity or density (let alone species). Much of the forest, even in the early Middle Ages, was already being managed as a special kind of micro-economy for its inhabitants. Hardwoods were cut at regular twelve-year intervals four to six feet from the ground, sufficiently high to prevent deer from eating the new shoots. The base "stool" would then be left to regenerate itself rapidly into the kind of light timber that could be used to meet all manner of essential needs: fencing, wattling, tools and implements. The result was the underwood, or coppice, that was the distinctive mark of the medieval forest and which in a very few locations, like Hatfield and Hadley Chase, can still be seen in England.[19] In contrast to the most ancient forests of Germany and Poland and to the conifer woods of the Scottish Highlands and the oak forests of the English aristocratic estates—all products of the eighteenth- and nineteenth-century crazes for picturesque and Romantic "improvements"—these ancient woodlands seem thinner and almost patchy, with swathes of grassy meadow and wild flowers blooming between pollarded and truncated broadleaf trees. The exact opposite of what is now considered to be the ideal norm of a forest habitat—the untended wilderness—they have light and space and variety: a working room for an authentic woodland culture.

And the wild animals of the chase often shared the woods with the domestic livestock pastured by the cottagers. Cattle, horses, sheep, and even goats (though they were voraciously destructive of saplings and young coppice shoots) grazed the underwood and any clearings caused naturally by the fall of old trees. But the real lords of the woods were pigs, especially in the "pannage" season from Michaelmas to Martinmas, when they gorged themselves on acorns and beech mast. In the eighteenth century the silviculturalist William Ellis claimed that a peck a day of acorns would increase hog weight by a pound a day (though he also thought the digestive sickness of "garget" could be prevented by swinging a piss-pot over piles of heaped-up acorns!).[20] If the elegant tapestries depicting medieval forests had been closer to the common truth (which was not, of course, their point), they would have woven flocks of con-

tented porkers rooting about, together with the elegant fallow deer and decorative unicorn. For the pig was a typical feature of the forest landscape and the mainstay of the woodsmen's household economy. Medieval Frankish law devoted no less than nineteen of its articles to pigs, carefully classified into subgroups. We know, for example, that the herd belonging to the monastic domain of St. Remi at Longeville numbered four hundred and fifteen, and comprised one hundred and forty "young pigs," ten "great boars," one hundred and sixty-five sows, and one hundred geldings.

Autumn through to late November, when the fattened pigs would be slaughtered, was the busiest time in the woodland societies. As well as pork-curing, dead and fallen wood would be gathered and corded for fuel. Animals, illegal as well as legal, were turned into smoked sausage for the lean winter months. Fruit and berries were dried, honey was harvested from the wild hives, and the chestnuts that were one of the staples of medieval diet (mashed into porridge, ground into meal for primitive loaves) were carefully collected and stored.

The mark of these western woodland societies was not their separation from, but their connection with, the rest of the world.[21] Within the forest perimeter, charcoal was burned that would fire primitive ironworks. Bark was stripped for tanning, fuel drawn for glassworks and breweries, tall timber felled for beams and supports of town houses.

The greenwood, then, was not an imaginary utopia; it was a vigorous working society. And it was just because the English woods were home to all this busy social and economic activity that the imposition of the Norman concept of the forest seemed so brutal. For even given the exaggerations of medieval chroniclers, there is no doubt that, institutionally, the imposition of forest law was a violent shock. Its fundamental principle, originating in Frankish custom, was the creation of huge areas of special jurisdiction, policed at the king's pleasure and by his direct appointment, for the preservation of game. The nomenclature "forest" that now replaced the older Latin terms of *saltus* or *silva* was in all probability derived from *foris,* or "outside." It signified not a particular kind of topography but a particular kind of administration, cut off from the regular codes of Roman and common law. Such "forests" could and were imposed on large areas of the English countryside, including the entire county of Essex, that were not wooded at all, and which included tracts of pasture, meadow, cultivated farmland, and even towns.[22] For the first century of Norman rule these "forests" made up something like a quarter of the entire territory of the realm, and during this period the kings, especially Henry II, seemed eager to "afforest" lands at will.

At this distance it is hard to imagine how vast areas of the country could have been annexed simply to protect royal recreation—"the unspeakable in pursuit of the inedible," as Siegfried Sassoon put it. But for a warrior state, the royal

hunt was always more than a pastime, however compulsively pursued. Outside of war itself, it was the most important blood ritual through which the hierarchy of status and honor around the king was ordered. It may not be too much to characterize it as an alternative court where, free of the clerical domination of regular administration, clans of nobles could compete for proximity to the king. Not surprisingly, the offices of Masters of the Horse and Hunt were fiercely competed for and jealously preserved within the family. And since the dominant weapon of Norman arms was the mounted knight, the hunt served as an apprenticeship in martial equestrianism for young nobles. Since the very first treatise on hunting, Xenophon's *Cynegeticus* (Hunting Man), riding to hunt had been the recommended way for aspirant knights to win their spurs.[23] But this was more than an exercise in physical prowess. Observing the initiation rites of the hunt required an elaborate display of learning, from the formal presentation of the "fewmets," or deer feces, to the prince, evidence of the magnificence of the pursued stag, to the complicated and minutely prescribed ceremonies of evisceration, or gralloching.[24] The hunter performing this work was expected to know to whom specific parts of the kill should be formally presented. Woe betide anyone mistakenly offering, say, the rectum of the stag to anyone other than a high-ranked lord, or omitting to give the brisket to the hunter who had driven the deer from hiding. From beginning to end, then, the hunt was not merely a kill that gave potency and authority to the aura of the royal warlord, it was also a ritual demonstration of the discipline and order of his court. No wonder it became a form of treason to spoil the king's aim.

Not that this made forest law any more acceptable to many contemporaries, especially the churchmen forbidden from hunting and therefore excluded from the king's mounted retinue. Its arbitrariness and the draconian penalties specified for offenses against "venison" (the game animals) or "vert" (the woods that sheltered them) were the object of many popular complaints. *The Anglo-Saxon Chronicle*, for example, expressed what was probably a common view of William the Conqueror, that

> *He made great protection for the game*
> *And imposed laws for the same*
> *That who so slew hart or hind*
> *Should be made blind. . . .*

> *He preserved the harts and boars*
> *And loved stags as much*
> *As if he were their father.*[25]

The Normans put in place the essential elements of the regime: the lord wardens of each royal forest, with their keepers and "garçons" appointed to

apprehend malefactors against the vert and the venison; the "eyre" court that heard serious cases and "swanimote" courts that heard the relatively more trivial; and the "verderers" and "regarders" (inspectors) elected every four years from among the local magnates.[26] But it was under the Angevin kings that the forests reached their greatest extent territorially and their laws were most seriously enforced. To read the digest of laws published at the end of the sixteenth century by the improbably named Lincoln's Inn barrister Sir John Manwood is to have the impression of a systematic tyranny: a state within a state whose unaccountable petty officials exercised justice by mutilation. The penalty, for example, for illegally killing a deer was the removal of both sets of soft organs: eyes and testicles.[27]

The bizarre system, codified in Manwood, at once petty and harsh, was exemplified by the elaborate instructions for expedition, or "lawing." This practice, originating in the reign of the Saxon king Edward the Confessor, involved the declawing of mastiffs and hounds belonging to forest dwellers, disabling them from attacking the royal bucks and does. The expedition code prescribed with loving detail the precise size of the block of wood (eight inches thick, one inch square) that was to be used, together with a mallet and chisel (two inches broad). Even the places at which the lawing was to be done were specified as the only sites traditionally authorized for the job. "Mastiffs" came to mean any large hounds, but those that could wriggle through specially constructed iron stirrups like the one still preserved at Lyndhurst in the New Forest were excused as only a minor threat to game. Unlucky dogs, on the other hand, had their forepaws set firmly on the aforesaid regulation-size block, claws out, where the sergeant would "with one blow smite them clean off."[28] Any mastiff found within the forest limits who had not been altered in the legally decreed way would incur for his owner a stiff fine.[29]

Taken as a literal document of greenwood police, Manwood's forestry statutes virtually presuppose a counter-force, a forest resistance, a Robin Hood. In fact, however, much of Manwood's text describes a system that existed only on paper. Writing in the last years of Queen Elizabeth, he assumed that in centuries gone by the provisions of the forest laws had been rigorously enforced and only recently fallen into neglect. But the records of the eyre courts, where they survive, tell a completely different story: of a system that was less an out-and-out tyranny and more of an officious interference in the busy world of the woods. The penalties recorded in their books far more commonly list fines than mutilation or the gibbet.[30]

What we know of the social reality of the regime in the New Forest, for example, suggests that its practices were much less indiscriminate and arbitrary than a mere catalogue of grisly penalties would indicate.[31] And, contrary to the assertion of some contemporary commentaries like Richard Fitznigel's late twelfth-century *Dialogue of the Exchequer* (uncritically repeated by Manwood),

forest law did not supersede but supplemented common law. Offenses against "vert" like the illegal chopping of brushwood were almost always punished by fines and those were very often made proportionate to the offender's means. Taking the king's deer was more serious and could indeed get the poacher hanged for a repeated conviction. To be caught "red-handed" meant, literally, with hands still blood-stained from an illicit evisceration. But the penalties, savage though they were, were neither more nor less harsh than those for comparable property crimes *outside* the forest. At any rate there is no doubt that however draconian the stipulated penalties, they failed to act as a deterrent, for poaching was endemic throughout each and every one of the royal forests. Given the long intervals between the eyre courts and the modest manpower available for the forest police, the odds on getting away with shooting the smaller animals in particular—fallow deer, rabbits, and birds—must have been very high.

This is not to say that there were not some dramatic and violent confrontations between poachers and foresters which often ended in the death of the latter. Sometimes the illegal hunters organized themselves in a large gang, Hood style, as in the New Forest in 1270, when on St. Margaret's Eve a small regiment of around sixty men armed with bows and arrows and accompanied by hounds entered the forest and succeeded in taking fifteen hart and about the same number of hind, then broke their way into the grange at Beaulieu for the night and drank and ate their way through its provisions before taking their leave.[32]

But the sheer brazenness of this kind of quasi-military expedition strongly suggests that the outlaws were not rags-and-tatters woodsmen taking the odd rabbit or pheasant along with wattle-sticks and faggots when the need arose. Rather, these were forest *bravos:* delinquent soldiers from a baronial retinue, or, as was often the case, led by a yeoman or even someone of noble birth.

This is important, for much of the angriest hostility against the royal forest regime, especially under the Angevin monarchs, came not from the common people, who somehow improvised ways and means of living with it, but from the propertied elite. It was the nobility and the church that were most indignant at having their privileges and power subjected to the arbitrary extension of "forest" that, as far as they were concerned, represented the unlimited power of the king and his current gang of favorites. At its heart, then, the argument about the liberty of the greenwood was as much political as social. And it was further complicated by the fact that, all along, the Norman and Angevin kings had permitted the existence of islands of private property *within* the area of the royal forests. The reason, of course, was money. In exchange for a substantial fee that dropped straight into the royal treasury, the holders of these "assarts" could do anything they wanted within its bounds. In practice this invariably meant exploitation: clearing the land for farming, establishing tenants in hamlets and villages and taking the usual feudal rents.

The quarrel that culminated in the Magna Carta of the woods—the Charta de Foresta of 1217 and 1225—was not a simple matter of greenwood liberty defying sylvan despotism. It would be better thought of as a competition between two parties, *each* of which wanted to exploit the woods in their own way. And what decided its outcome, once again, was war. The dynastic marriage alliance in 1152 between Eleanor of Aquitaine and King Henry II which had created the enormous Angevin realm had also embroiled it in endless wars, from the Holy Land crusade to the Marcher frontiers of Wales. Money was always short. Needs were either urgent or desperate. So that "afforestation"—the extension of the forest jurisdiction well beyond anything that could remotely be thought suitable for hunting—turned into another license for extortion. The forest courts were now expected to be revenue enhancers for the king's exchequer: fining away and trying to trap institutional or noble offenders, since their penalties could be especially lucrative. The law was now a business. And its businessmen were creative in coming up with all kinds of ways to raise more money. For example, "pardons" might be issued (even to woodsmen who were unaware they had done anything wrong) allowing, for a fat fee, the grazing of animals in a specified area. Or customary practices, such as the taking of fallen wood, might be "leased" back, for a hefty price, to those who had always freely exercised them.[33]

Increasingly, then, the royal forests were managed for business, not pleasure. But the business was run indirectly, not by farming the produce of the forests, but by taking a cut for "protection" through the courts. It seems like sylvan gangsterism, and it was. Some of the most enthusiastic enforcers of this business, like the Neville family, who ran the courts for King John, were businessmen of the most grimly uncompromising kind. So when the barons had a chance to press their grievances on his successor, the nine-year-old Henry III, as a condition of their allegiance, they leapt at it. The Charta de Foresta of 1217 rolled back the "afforestations"—the limits of these special jurisdictions—to what they had been before the reign of Richard and John's father, Henry II, a century earlier. It made the courts more accountable and regular. But it also took care not to do away with the system altogether.

For, after all, today's disaffected woodland baron might be tomorrow's officer. The verderers, who heard cases of forest "nuisances," and the regarders, who inspected the woodland domain, were themselves drawn from the same class as the aggrieved. And as England became a more developed economy in the thirteenth century, the gentry and nobility began to see ways in which they, too, could make the forests pay. A lease from the Crown could be made lucrative by establishing iron forges using timber fuel, or subletting to charcoal burners, tanners, and glassmakers. So that by the time of the Plantagenet Edwards, in the fourteenth century, the forest, legal and topographical, had come to mean

two glaringly contradictory things in English culture. As royal greenwood it was governed sternly but impartially for the hunt. (The most comprehensive manual of hunting would be written by the duke of York as late as the fifteenth century.) But the legal forest was also a place of profit for noble entrepreneurs whose decision about whether to work with, or against, the royal system was governed essentially by hard economic calculation.

Royal penury was their opportunity. The military restlessness of the Plantagenets, exercised against the French or each other in the Wars of the Roses, became an expensive addiction. The relentless need to pay for their soldiers dictated the sale of enormous areas of forest, especially in the north of England. The sales were leasehold so that the Crown allowed itself the illusion of future recovery. But to make the deals attractive to buyers, the leases were framed to ignore old customs and "liberties" of pasture, and wood-gleaning: the practices which had sustained the whole forest world. Now run by the newer and tougher regime of the buying barons, the eyre courts—the travelling high courts of forest justice—began to pick up rhythm again, extending their jurisdiction into deer parks that were more efficiently policed than under the old direct royal administration.

And so it was that in 1308, at Wakefield in Yorkshire, one Robert Hood was obliged to make payment for wood he had gathered in the earl's forest.

We may have no clear idea who the model for Robin Hood actually was. But we certainly know his enemy. It is not the king (usually called "Edward," not Richard, in the early ballads), but the usurpers of his good name. These include not just sheriffs, foresters, and their men but all the institutional types—unscrupulous officeholders, corrupt abbots, encroachers and enclosers—who had deformed the original idea of the forest and come between the direct administration of royal justice and its subjects. It is this usurpation that entitles Robin to take the king's deer as and when he pleases. Better the official rogue than the unofficial rogues who abuse royal authority to line their pockets! From the moment it appears, Robin's greenwood is an elegy for a world of liberty and justice that had never existed: one where the relation between leader and led is of unsullied reciprocity and where the purest form of fellowship is the open-air forest feast.

It can hardly be an accident that the first cluster of printed editions of the *Lytell Geste of Robyn Hode,* including one published by the printer Wynkyn de Worde, appear at a disastrous moment in English history: the Wars of the Roses in the late fifteenth century. Though the printed ballads and "speakynges" can be traced back to an earlier fourteenth-century manuscript, the Hood phenomenon remains a product of a time of usurpation and chronic rebellion. J. C. Holt, who has written incomparably the best study of the literature, legend, and history of Robin Hood, believes that it originated within the ranks of the late feudal military retinues, was sung by minstrels first at the castle-courts

of the great barons, and then was transferred to the markets and fairs, where it entered the stream of popular culture. In other words, it started high-class, ended low-class. In all of the earliest versions, however, Robin is that perfectly intermedi-ate figure: the yeoman. And though

Thomas Bewick, woodcut illustration to Joseph Ritson, *Robin Hood: A Collection of All the Ancient Poems, Songs and Ballads,* 1795.

he may be an outlaw, he is no rebel. In fact he is a passionate and nostalgic con-servative who yearns for the restoration of a just, personal monarchy and who wants a social order dislocated by rogues and parvenus to be set right in its proper ranks, stations, and portions.

Those whom Robin aids with the proceeds of his outlawry are themselves the victims of illegitimate dispossession or persecution. Sir Richard-at-Lee, the poor knight who figures in all the early editions of the *Geste,* has been forced to mortgage his estate to a rapacious abbot in order to come up with bail for his son, unjustly (it is implied) accused of murder. Robin provides him with the wherewithal that the knight then throws at the abbot at the appointed hour, quite ruining the cleric's happy anticipation of eviction. And behind Robin the Righteous there were other medieval outlaw stories, some mythical, some mere embellishment on real histories, but all of which featured men bent on redress. Hereward the Wake, for example, in the reigns of Edward the Confessor and William the Conqueror, pursued his guerrilla campaign from the Isle of Ely to repair his disinheritance. Though his grievances were personal, and began before 1066, the late medieval stories of Hereward present him as a one-man English resistance against the Norman invaders. Fulk Fitz-Warin resorted to the forest when, during the reign of John around 1200, he lost a suit to keep his estate of Whittington. In one of the prose romances written about Fitz-Warin's exploits he captures the king while disguised in the charcoal burner's blackface, and by enticing him into the deep woods with the prospect of a stag. The king's ransom for his freedom is, of course, the restoration of Fitz-Warin's rightful estate.[34] Similar tales, especially in the north of England, where the royal forests had been most extensively (and therefore most damagingly) alien-ated, circulated around other legendary figures like the Monk Eustace. Eustace was yet another figure represented in the tales and ballads as a victim-turned-outlaw. The son of a knightly family, he had quit his monastery in the 1190s to avenge the murder of his father and the expropriation of his land. In the shel-ter of the forest he turned outlaw, taking captive his enemy the Count of Boulogne, as Fulk Fitz-Warin was said to have taken King John. Later Eustace seems to have turned pirate in the Channel, and eventually, like many of the outlaw types, was betrayed and beheaded.

Robin himself is no radical. He venerates the Virgin. He is elaborately chivalrous to women; and his archery with the yew longbow celebrates the most traditionally English weapon of war at the dawn of the gunpowder age. Above all else, Robin is a starry-eyed royalist. Guy of Gisborne and the infamous sheriff are his enemies precisely because they have desecrated the holy aura of kingship by perverting it to their own interests. Pending the appearance of the king himself, Robin serves as a surrogate monarch or at least a loyal deputy for the prince in absentia who can exercise redress and primitive justice under the oaks. A standard element of the greenwood plot in all the early versions has King Edward show up in the forest in heavy disguise (sometimes as a monk), where he observes the virtues of an ideal realm. Loyalty, honor, chivalry, brotherhood, magnanimity, hospitality, ceremony, courage, and even sometimes a brusque kind of Franciscan piety are all practiced in the greenwood, in painful contrast to their disappearance from the modern world of court and state. In a later version (ca. 1600), *The Greenwood Tree*, which nonetheless preserves many of the elements of the original *Geste,* Robin takes King Edward's horse and insists he abide for a while, for

> *We be yeomen of this Forest*
> *Under the Greenwood Tree*
> *We live by the King's decree*
> *Other shift have not wee*
> *And ye have churches and rents both and good full plenty*
> *Give us some of your spending*
> *for Saint Charitie.*

and a little later:

> *Today shalt thou dine with me*
> *For the love of our King*
> *Under the trusty tree.*[35]

The king then partakes of his own deer, provided for him by his most faithful follower. And this almost sacramental re-enactment of the bond between monarch and subject is reinforced by a contest, sometimes quarterslaves, sometimes wrestling, but always lost by Robin (who otherwise is invariably victorious against his social equals or superiors). After the beating the king reveals his identity, the outlaws fall to their knees, are pardoned, and taken into his service. And no wonder, for it has not escaped the king that Robin's relation to his men represents all the qualities that have been banished from the unscrupulous Renaissance court.

Here is a wonder seemly sight
Me thinketh me by Gods
His men are more at his bidding
Than my men be at mine
Full hastily was their dinner dight
And thereto can they gone. . . .
They served our King with all their might
With Robin and Little John.[36]

It should not surprise us, then, to discover that by the reign of Henry VIII, Robin Hood had become a wholly acceptable part of official Tudor culture, rewritten by the king's antiquary John Leland. He and his greenwood, where liberty and loyalty somehow contrived a perfect fit, had also established themselves in the repertoire of Maytime plays, performed on village greens to greet the spring and featuring the exploits of legendary heroes like St. George.[37] In their gallant company Robin struts as the Lord of Misrule in the counter-realm of the forest: the bringer of healing havoc. But he poses no serious threat to the established order, for he is the arbiter of a world turned temporarily upside down, the better to consolidate it right side up.[38] Robin's Maytime is a kind of outlaw Eastertide, a game of renewal: the Resurrection of justice. His Lincoln green is the color of Christian hope. In the texts of the *Geste* he even holds out the particular hope of a righteous conversion for the sheriff himself. Obliged by Robin to spend the night in the forest, the sheriff is stripped of his clothes like St. Francis at the moment of his spiritual rebirth, and garbed instead in Lincoln green, the cloth of the arboreal cloister, as if he were a novice preparing for his vows. Needless to say, the conversion is purely temporary.

Thomas Bewick, woodcut illustration to Joseph Ritson, *Robin Hood: A Collection of All the Ancient Poems, Songs and Ballads,* 1795.

With all these themes of reinstated loyalty, sacred allegiance, and royal justice in England's resurrected Maytime, it is not surprising to find the young Henry VIII himself participating in Robin Hood festivities in 1515. Two hundred archers dressed in green shot at butts under the leadership of Robin, who invited the king and queen to come into the greenwood to keep fellowship with the outlaws:

> The King demanded of the Queen and her ladies, if they durst adventure to go into the wood with so many outlaws. Then the Queen said, that if it pleased him, she was content. Then the horns blew till they came to the wood under Shooters Hill, and there was an arbour made of boughs, with a hall and a great chamber and an inner chamber very

well made and covered with flowers and sweet herbs, which the King much praised. Then said Robyn hood, Sir, outlaws' breakfast is venison, and therefore you must be content with such fare as we use. Then the King and Queen sat down, and were served with venison and wine by Robyn hood and his men, to their great contentation.[39]

A recurring feature of the artificial greenwood arbors in which the king sat was a "trystel tree": an adaptation of the Maypole that stood for fecundity: the passage from spring to summer and the resurrection of the fertile golden age.[40] But it had also come to signify a tryst, or covenant: a pact between the sovereign and his subjects sealed in the English wood. And during the Tudor sixteenth century, as the Robin Hood tales became more richly elaborate and filled Sherwood with the cast of characters familiar to us today—Marian; the renegade friar; the minstrel Alan-a-dale—a portrait of an idealized, chivalrous, hospitable merry greenwood England came into being. It was a place where the venison never wanted for a company of free fellows whose thieving was, in the end, an expression of loyalty to their sovereign and protector.

iii Hearts of Oak and Bulwarks of Liberty?

The greenwood was a useful fantasy; the English forest was serious business. At the same time that the Crown presented itself as the custodian of the old, free greenwood, it was busy realizing its economic assets. Under the Tudors, freed by the Protestant Reformation from any residual allegiance to Rome, England began to envision itself as an empire. It was at this time, in the first half of the sixteenth century, that court historians began to develop a literature of the "origins of Britain" and to emphasize the autonomous, peculiarly insular destiny of its history. Wholly mythical or semimythical figures like the Trojan "Brutus" and King Arthur began to feature prominently in such chronicles.

"England-as-Empire" was thus self-consciously conceived against the claims of other empires: Holy Roman and Papal Roman. But to make that ambition more substantial than empty court propaganda, iron was needed for the arsenals of the realm and timber for its shipyards. Counsellors to the throne advised that a truly independent realm ought not to rely on imports of these strategic commodities, especially when they abounded in the forests. A whole

range of industries would make the kingdom prosperous if only the woodland "wastes" were open to development. Nor did England lack for gentlemen to step forward as entrepreneurs. They would be, gracious majesty permitting, the lords of the blast furnace, iron barons in doublet and hose. Henry VIII's dissolution of the monasteries provided them with the opportunity to buy choice land with both mineral wealth and the timber to process it. Thus the great woods of Robertsbridge Abbey in Sussex, for example, made Sir William Sidney, the grandfather of the poet, one of the richest ironmasters of the kingdom.[41]

In 1580 William Harrison lamented that he could ride for twenty miles and encounter virtually no woodland at all "except where the inhabitants have planted a few elms, oaks, hazels or ashes about their dwellings" to protect them from the wind.[42] Whole populations were transformed from habitual users and gatherers of the woods into dispossessed consumers, required to purchase firewood at market prices. The whole business seemed gratifyingly (or, depending on one's point of view, disastrously) self-propelling. Imperial politics generated industrial demand. Demand fuelled the rise in timber prices. Rosy prospects for large profits encouraged men for whom the greenwood was just so much minstrelsy nonsense to move in with the axe. And the perpetual indebtedness of the Crown made it expedient to grant them space in the forests in return for immediate cash.

So, just at the time when Robin Hood's Sherwood was appearing in children's literature, stage drama, and poetic ballads, the greenwood idyll was disappearing into house beams, dye vats, ship timbers, and iron forges. Stimulated further by a rapidly expanding population, the urban economy of England generated a new level of industrial need for timber. While trying to serve (and indeed profit from) that demand, Tudor and Stuart governments still pretended to stand as guardians of the woodland patrimony. This was, of course, but another early instance of the debate over the forest that would repeat itself over and again in the history of the early modern state. Because of the crucial and urgent role played by timber in both the logistics and weapons of war, and the more general sense, developing at this time, that a powerful and growing economy was essential to military success, the forester-king was bound to be torn between exploitation and conservation. Arguments over the true responsibility of a national forestry have not changed much since that time. The bitter arguments between John Muir and Gifford Pinchot over the fate of American forests at the beginning of the twentieth century, the continuing soul-searching in the Pacific Northwest over the meaning of "sustainable resources" in the forest, are only the latest edition of debates that have been continuing for five centuries.

For the Tudor monarchy, the issue was the transformation of an ancient personal claim to the forest as a specially protected domain for the beasts of the royal hunt into a more impersonal state-stewardship of the national patrimony.

Was the government to act merely as the managing director of Imperial English Enterprises, Inc., husbanding those resources so that enterprising gentlemen might exploit them for their, and by extension the country's, good? Or ought the Crown to take a loftier view of its role as guardian, protecting the timber as long-term naval inventory, the "wooden walls" of the kingdom, as the earl of Coventry would put it in the seventeenth century.[43] And as *pater patriae*, the "father of his nation," the king also had a duty to see to it that the common people did not suffer from a dearth of fuel, and the price inflation that went with it.

What was a conscientious monarch to do? Statutes for the protection of timber could be enacted, and were. Lessees could be required to provide fences and ditches to keep animals off saplings, and to set aside a reserve of a royal dozen for every hundred they felled. But this was official piety. Reality was Edward Seymour, earl of Somerset, who became Lord Protector to his nephew, the child king Edward VI. As steward of the greenwood, Somerset held inquiries into the riots that accompanied the wasting of the southern woodlands. But as Seymour the ironmaster of the forges of the Kentish forests of the Weald, the same man was, at least indirectly, responsible for the troubles he was investigating!

By 1600 both conservationists and developers could invoke the fundamental interests of the realm—prosperity, security, and liberty—to support *both* their respective positions. Under the first item, developers argued that the conversion of forest to farmland would make the lot of the common people more bearable by increasing the supply, and thus lowering the price, of food. Conservationists retorted that that would be offset by the shortage of firewood. As for the strength of the realm, developers believed that a strong industrial economy would make for a strong Protestant England, capable of standing alone, if need be, against the Catholic empire of Spain. Conservationists replied that nothing would avail an England whose navy had foundered for lack of ship timber. And when the sacred myth of greenwood liberty was raised, the baronial entrepreneurs had no hesitation in depicting the reassertion of royal authority as some sort of attempt to reinstitute the "Norman" despotism of the forest. Royal counsellors responded by giving credence to the story that, in the wreckage of the flagship of the Spanish Armada, a note had been found in King Philip's hand ordering the destruction of the Forest of Dean. Would the despoilers now do his work for him and put the liberties of England to the axe by tearing out its Heart of Oak?[44]

Such was the strength of the royalist romance of the greenwood that even when the monarchs themselves seemed to have abdicated direct responsibility for their forests, self-appointed champions of the English oakwoods would undertake to remind them of their patrimony. Arthur Standish, for example, gentleman knight living in south Lincolnshire, was one such self-appointed

campaigner. In 1611 Standish addressed his *Commons' Complaint* directly to King James I. The premise of all such appeals was that the king had been misled by poor or wicked counsel, that *he* could not possibly be indifferent to the fate of his timber. And Standish obligingly supplied the king with arguments to refute those who claimed England would be better off with more arable and less woodland. Such assumptions, he insisted, had ignored the dung factor. Robbed of local firewood, poor cottagers had had to burn straw or dung to see them through the winter. With the muck gone up in smoke, the fertility of the fields had been reduced, thus pushing food prices up. It was an argument bizarre enough to appeal to James, who allowed the royal imprimatur to cover Standish's second publication, *New Directions for the Planting of Wood*, in which a "General Plantation" was urged to forestall the evil day when England's timber reserves would be entirely exhausted.[45]

The response of the Stuart kings was all affectation and no substance. At the very same time that Charles I had van Dyck depict him as the new St. George, mounted beneath a great umbrageous oak of the realm, he was busy selling off vast tracts of the royal forests to noble entrepreneurs like the earls of Pembroke and Warwick, who then cut them down. Whatever the rhetoric of royal protection, it was always set aside by the next threat of state bankruptcy. The Stuart genius for alienating virtually everyone reached right into the greenwood. For once he had realized funds from the first wave of sales Charles actually went into reverse and *reafforested* some areas, even reviving the old forest courts. The point of this, though, was not to extend the royal shield over the woods, but simply to confine sales and leases to a clientele of his own choosing.[46]

Anthony van Dyck, *Charles I on Horseback*, 1635–40.

No family profited more from this dithering than the Winters of Lydney. They had started well, Sir William Winter rising to be an admiral in the fleet of Queen Elizabeth. But the next generation remained defiantly Catholic, Thomas Winter being among the conspirators who attempted to blow up Parliament in 1605. Not all their improprieties were acts of faith. Edward Winter was removed from his post as lord warden of the forest for cutting and carting thousands more mature timber trees than his official allowance. But the Winters always came back like suckers on a pollard. They knew their Stuarts well, and felt certain that the extravagance of the court would make their offers of cash advances for forest leases irresistible. They were right. By the end of the 1620s Edward's son John had enlarged the ironworks at Lydney in Gloucestershire and had become the dominating contractor of the Crown in the Royal Forest of Dean.

Though he had been instructed to use only "dotards"—the superannuated trees that were useless for naval timber—for industrial charcoal, Winter immediately embarked on wholesale enclosures and clearances. Monopolizing all supplies in the greatest of all the royal forests, Winter was thus in a position to

force woodland villagers (and even his own miners) to buy wood at exorbitant prices. The predictable result was a series of violent riots.[47] Though Crown policy was capable of putting the brakes on wholesale exploitation when the peace and good order of the realm was seriously jeopardized, the halt was never more than a temporary palliative. During the years of Charles I's "personal rule," when Parliament had been suspended, in the 1630s, more and more acreage was sold off. The piecemeal liquidation of the royal greenwood culminated in an auction for the Forest of Dean itself, which, to nobody's surprise, went to the deep-pocketed and timber-hungry Sir John Winter for eighteen thousand pounds. Within one year he had managed to fell a third of the entire forest, including its choicest and most ancient hardwoods.

To those who noticed these things (and toward the end of Charles's reign their numbers were growing fast), it could not possibly be fortuitous that Winter was secretary to Queen Henrietta Maria and, like her, an obstinate Catholic! Was his apparently insatiable appetite actually a subterfuge for stripping the nation of the timber needed for its navy, thus realizing the ambition of the Spanish kings to restore the Catholic obedience that had prevailed when Queen Mary Tudor had been on the throne and her husband had been King Philip II? The liberties of freeborn Englishmen, such alarmists argued, were falling with the greenwood. In 1642, with the authority of the king collapsing, Winter was finally removed from his office in the forest, and his contract repudiated as "of evil fame and disaffected to the public peace and prosperity of the Kingdom."

To his credit, Winter did not shrink from the coming confrontation. Arrested and thrown into the Tower in 1643, he was no sooner set free than he raised an army on the Welsh borders for the king and used his own ironworks to turn the house at Lydney into an armed camp. With the king's main armies vanquished, Winter would still not admit defeat, carrying on an extraordinary guerrilla campaign from the heart of *his* forest. When all seemed finally lost and his back was literally to the Severn, he eluded capture by clambering down a two-hundred-foot cliff at Tidenham and jumping into a boat waiting for him on the river. In 1648 his estates were confiscated. Time and again he was given the chance to "compound" for them—paying a penal fine for their restoration. But evidently Winter did not care to pay for his own property, still less to make a penitent "submission" to Parliament, followed by safe conduct to exile. Instead he chose the Tower, and it was only in 1653 that the Commonwealth government first allowed him the "liberty of the Tower" and then a residence anywhere within thirty miles of London.

The Civil War merely substituted the spoliation of the many for the spoliation of the few. The immediate result of the wholesale abolition of the royal forests during the Civil War was sylvan anarchy. After so many years of being fenced off by contractors, whether parliamentarian or royalist, the woods were simply invaded by great armies of the common people who whacked and

hacked at anything they could find. Brushwood, standing timber, fallen limbs and boughs—anything and everything was taken before the next-door neighbor or the next village could get to it. The chaos was so serious that Parliament inherited all of the dilemmas, and all the expedients of its royal predecessor. Once again sober regulation was followed in short order by sales to anyone and everyone who could guarantee advances of money, ships, and guns.

So the scene that John Evelyn surveyed when he presented *Silva, or A Discourse of Forest-Trees* to the restored Charles II in February 1664 was of unparalleled desolation. The book had originated in a request to the Royal Society from the Crown commissioners of the navy for a fresh plan for replanting timber trees. Evelyn was one of four Fellows of the Society approached for ideas, and asked to make a digest of all their proposals along with his own. The learned editor, however, quickly turned author.[48] For Evelyn, it was a perfect assignment. Already middle-aged, he had spent his prime publishing unrepentantly royalist pamphlets and representing Charles I's interests in France. The more hopeless the cause became, the more tenacious was his loyalty. When the royalist court at Oxford dissolved, Evelyn served Charles's embassy in Paris, where his fidelity was at least rewarded with a bride in the person of Mary Browne, the daughter of the king's ambassador. And Evelyn compensated for political adversity with encyclopedic intellectual curiosity. Like Francis Bacon (beside whose mighty intellectual torch Evelyn was, in truth, but an elegant candle), there was no subject on which he felt disqualified from offering an opinion. Returned to England in the waning years of the Commonwealth, he quickly produced books on children's education and the art and history of engraving. But it was in designs for the land that Evelyn always expressed his most acutely felt passions and principles. In 1658 he published *The French Gardener* and a year later had sent to the physicist Robert Boyle plans for the establishment of a collegiate retreat, conceived as a self-sufficient Roman villa.

In 1662 John Evelyn stared, heartsick, at whole woods cut clear to the ground, great timber trees uprooted altogether; acres of scarred, mutilated, and burned underwood. For the sentimental royalist there could be no more terrible emblem of revolution than the stand of venerable elms on the royal walk at St. James's amputated down to raw and grimy stumps. So *Silva* was conceived not just as a learned work on the techniques of arboriculture but also as an act of reparation and consolation: a walk through the ancient groves, a shower of acorns for posterity.

Silva may still be the greatest of all forestry books ever published in English, and its author revelled in its immediate success. When the second edition was published in 1669, he boasted to Charles II that "more than a thousand copies [had been] bought up of the first impression . . . in much less time than two years." According to the booksellers, this "was a very extraordinary thing in volumes of this bulk."[49] Ten years later, however, he grumbled that "I am

only vexed that it proving so popular as in so few years to pass so many impressions and (as I hear) gratify the avaricious printers with some hundreds of pounds, there had not been some cause in it for the benefit of our society."[50]

Part of the lasting appeal of *Silva* is its marriage of the practical and the fantastic. Graft a pruner's manual to *The Golden Bough* and you have a version of *Silva*. Every page makes it clear that it was a labor of love for the polymathic Evelyn. Evelyn's first chapters are full of meticulous technical advice on soil composition, sowing, dibbling, germinating, pruning, lopping, grafting, and trimming; on the cultivation of each of the major species of hardwood and conifers; on the different techniques needed to produce stands of mature timber trees, pollarded coppices, prolific nut and fruit orchards, or garden shrubs. In everything there should be the principle of carefully understood taxonomic appropriateness: each variety treated after its own character.

Scientific precision did not preclude poetry. Evelyn's friend Abraham Cowley supplied a preface that mused, "We nowhere greater art do see/ Than when we graft or bud a tree." And when Evelyn himself came to the hornbeams sheltering saplings of orange and myrtle in Brompton Park, his prose turned into an arcadian lyric.

> During the increasing heat of summer they are so ranged, disposed as to adorn a noble area of a most magnificent paradisian dining room— to the top of Hortulan pomp and bliss, superior to all the artificial furniture of the greatest princes' court—the golden fruit, the apples of the Hesperides together with the delicious ananas gratify the taste while the cheerful ditties of canorous birds recording their innocent amours to the murmurs of the bubbling fountain delight the ear. At the same time the charming accents of the fair and virtuous sex, preferable to all the admired composures of the most skilful musicians, join in concert with hymns and hallelujahs to the bountiful and glorious Creator.[51]

But *Silva* was meant to be neither a botanical rhapsody nor a mere handbook of husbandry. Like Standish before him, Evelyn had a higher political and national purpose in mind. Chapter 7, he immodestly insisted, "should constitute part of the political catechism of all Statesmen" (advice that was taken more seriously across the Channel by the ministers of Louis XIV). The restoration of the king, he argued, should also announce the restoration of the forests, so he addressed Charles as Cyrus, the restorer of the Temple, and Hiram, the king of the cedars of Lebanon, the prince who "by cultivating our decaying woods will contribute to your Power as to our Wealth and Safety."[52] Who better, after all, to effect this than the monarch whose life and reign was owed to the oak in which he sheltered after the defeat of the Battle of Worcester? Evelyn included

lines from the Cavalier poets Waller and Cowley that made the association between the "phoenix-king" and the British oak even more emphatic, the trees depicted as faithful subjects in a country that had spurned its rightful sovereign.

> *The loyal Tree its willing boughs inclin'd,*
> *Well to receive the climbing Royal Guest,*
> *(In Trees more pity than in Men we find)*
> *And in thick leaves into an arbour press'd.*

> *A rugged Seat of Wood became a Throne,*
> *Th' obsequious Boughs his Canopy of State,*
> *With bowing Tops the Tree their King did own,*
> *And silently ador'd him as he sate.*[53]

He even exploited the fashion, begun under the early Stuarts, of imagining the Druids in their oak groves as the ancestors of modern Britons, with himself perhaps as a chief Druid, wise and holy man of the sacred arbor. Quoting Cowley, Evelyn established the tree-priest as a royalist and patriot, the absolute opposite of the pagan sorcerer Comus, whom John Milton, the Puritan and regicide, presented as a lord of wickedness. The masque *Comus* had turned the forest into a place of heathen and "barbarous dissonance" populated by the wizard's "rout of monsters," howling "Like Stabled wolves or tigers at their prey,/Doing abhorred rites to Hecate."[54] In Cowley and Evelyn's words, though,

> *Our British Druids not with vain intent*
> *Or without Providence did the Oak frequent,*
> *That Albion did that Tree so much advance*
> *Nor superstition was, nor ignorance*
> *Those priest divining even then bespoke*
> *The Mighty Triumph of the Royal Oak.*[55]

Evelyn's hope was that by identifying the policy of spoliation with the Commonwealth, Charles would wholeheartedly embrace the idealized tradition of the royal forester that his father and grandfather had betrayed. Evelyn dwelled on the damage that the confiscators and random vandalism had wrought, condemning "the improvident wretches who gloried in the destruction of those goodly forests" to "their proper scorpions and the vengeance of the Druids." But it was the masters of the forges and furnaces who were the greatest villains of all, for they "had set steel in the bowels of their Mother, Old England."[56]

Evelyn later told the king that his book "has been the sole occasion of furnishing your almost exhausted dominion with more . . . than two millions of timber trees," a meaningless figure that he reduced to a mere million in the preface to the third edition in 1679. In his old age he later embroidered the story even further, telling the countess of Sunderland that the king *himself* had complimented him that "by that book alone" he had "incited a world of planters to repair their broken estates and woods which the greedy rebels had wasted and made such havoc of."[57]

In point of fact, it was the fifth edition, published in 1776, long after Evelyn's death, which, as we shall see, would truly revolutionize British sensibilities about the woodlands. For all the erudition, eloquence, and careful science that went into the book, it had no more immediate success than Standish's chimerical projects at converting the Stuarts into patrons of the greenwood. By 1668 that nemesis of the hardwoods, Sir John Winter, was back in the Forest of Dean stripping it of oaks at a faster rate than ever before.

In theory, it ought to have been possible to inaugurate a serious debate about the husbanding of the nation's timber, as Charles II's reign also marked a decisive shift toward an aggressive naval and colonial policy. England's most formidable rival on the seas was the Dutch republic. It was rich enough to monopolize supplies of Baltic timber by buying the production of entire Norwegian forests, years in advance, and economically ingenious enough to produce vessels through an extraordinary system of prefabricated construction. When the hulls, masts, and sails had all been assembled in the Amsterdam dockyards, Dutch ships had cost a third of the price of their English equivalents and had been built in half the time. And while the first round of hostilities in the 1650s had caught the Dutch relatively lightly armed, the second war, between 1664 and 1667, was an unmitigated disaster for the English, ending in the Dutch navy penetrating the Medway, burning the fleet, and carrying away *The Royal Charles* as prize to Amsterdam.

The humiliation only made the architects of maritime power more determined. But their emphasis, given the acute desire for revenge and reassertion, was on speed, convenience, and effectiveness of supply for the royal dockyards. This in turn meant relying more on the aristocratic landowners who would supply the navy (and the growing merchant marine) directly, or work through long-term contracts from the royal forests.[58]

By the end of the seventeenth century France had replaced the Dutch republic as Britain's principal colonial and naval competitor. And it may have been awareness of the measures enacted by Louis XIV's great minister Jean-Baptiste Colbert, for the strategic preservation of French forests, that prompted some belated action on the other side of the Channel. In 1698 King William III introduced in the royal forests (now much shrunken) the power of "rolling enclosure," by which two hundred acres of the New Forest, for exam-

ple, were to be set aside each year as a nursery for timber oaks. When six thousand acres had matured sufficiently to survive animal grazing, they could be opened to game and a new area closed off for more restocking. But in an age when enumerating national assets was the chief obsession of the "political arithmeticians" of the Treasury and the Admiralty, little comfort would have been drawn from comparing the eighth of the British land surface that remained wooded with the quarter of France said still to be covered by forest.

As if this gloomy prognosis were not enough, nature made its own brutal intervention. On November 26, 1703, a monstrously violent storm, described by some contemporaries as a "hurricane," devastated the forests of southern England. In a later edition of *Silva*, Evelyn reported that no less than three thousand great timber oaks had been uprooted in the Forest of Dean, and four thousand in the New Forest. He himself had some two thousand blown down, "several of which, torn up by their fall, raised mounds of earth near twenty feet high with great stones intangled among the roots and rubbish and this almost within sight of my dwelling."[59] The tragedy—for so it seemed to Evelyn, two years before his own death—was as much national as personal and led him instinctively to use political and even military language to describe its magnitude. In the first year of the renewed war against the Sun King it was as though the country had suffered a terrible defeat before the troops of the tyrant of Versailles.

> Sure I am that I still feel the dismal groans of our forests; that late dreadful hurricane having subverted so many thousand of goodly oaks prostrating the trees laying them in ghastly postures like whole regiments fallen in battle by the sword of the Conqueror crushing all that grew beneath them.[60]

The damage from the gale of 1703 set off another round of dirges for the disappearance of the oaks of old England. Now that the enemy was absolutist, Catholic France, the trees became fetishized as more than simply the construction fabric of the navy. In countless eighteenth-century broadsides, pamphlets, ballads, inn signs, and allegorical engravings, the "Heart of Oak" became the bulwark of liberty, all that stood between freeborn Englishmen and Catholic slavery and idolatry. At the victorious conclusion of the war against Louis XIV, Alexander Pope, who had written Windsor-Forest as a sylvan history of English freedom, had Father Thames confidently proclaim:

> *"Thy Trees, fair Windsor! now shall leave their woods,*
> *And half thy Forests rush into my Floods,*
> *Bear Britain's Thunder and her Cross display,*
> *To the bright Regions of the rising Day . . ."*[61]

In 1743 James Wheeler, botanist and gardener, published *The Modern Druid* with a frontispiece drawn and engraved by a friend of Gainsborough and Hogarth and drawing master to Frederick, Prince of Wales, John Joshua Kirby. No allegorical masterpiece, Kirby's design nonetheless graphically anthologized these perennial anxieties. Britannia is shown seated, holding a twig of the sacred national oak, beside both a broken stump and a tree thick with acorns. In the middle distance, the fruit of prudent silviculture, in the shape of fleets, martial and mercantile, sail beneath the reassuring Latin motto *Britanniae Decus et Tutamen* (The Glory and Protection of Britain).

Repeated analogies were made between the character of the timber and the character of the nation. The "heart" of oak, the core of the tree, was its hardest and stoutest wood, the most defiantly resistant to the worst natural infirmities: fungal dry rot within, teredine boring molluscs without. Even the quirkiness of *Quercus robur,* with its crooked, angular pieces crucial for the construction of hulls, was contrasted with more predictably uniform "foreign" timber. The fact that Italian oaks were even more prone to produce crooked limbs was neither here nor there beside the fact that the English oak was thus characterized as the arboreal kingdom's individualist: stag-headed, undisciplined, glo-

Frontispiece to James Wheeler, *The Modern Druid,* 1747.

rying in its irregularity. "It is a striking but well-known fact," John Charnock, the historian of naval architecture, insisted, that "the oak of other countries, though lying under precisely the same latitude with Britain, has been invariably found less serviceable than that of the latter, as though Nature herself, were it possible to indulge so romantic an idea, had forbad that the national character of a British ship should be suffered to undergo a species of degradation by being built of materials not indigenous to it."[62]

Batty Langley's *Sure Method of Improving Estates by Plantations of Oak,* published in 1728, was meant to reconcile a reform in landscape architecture with patriotic self-preservation. Unless something was done, he predicted that in sixty years England's timber would disappear altogether.

Indeed at this juncture we have very little building timber in our woods and forests to boast of and are already much obligd to foreigners for great quantities of our civil uses. But should we ever happen (which God forbid) to be obligd to purchase some of their timber for our Shipping (by want thereof at Home) 'tis to be feared that this glorious Nation that governs the Seas must submit to every Invasion that's made, for want of its wooden Walls of defence.[63]

The real problem, many observers felt, was less purely silvicultural than social. Though all surveyors agreed on the shrunken acreage of great timber oaks, some, like Daniel Defoe, insisted that there were more than enough remaining trees to supply the country's naval needs for the foreseeable future. Near Southampton he saw "gentlemen's estates . . . so overgrown, with their woods so full of full-grown timber that it seemed as if they wanted sale for it." Instead of missing old trees, private forests were suffocating with them, rotting as they stood, "ancient oaks of many hundred years standing perishing with their wither'd tops advanced up in the air that could never get the favor of being cut down and made serviceable to their country."[64]

These arboreal graveyards had come about either through negligence or by the selfish design of landowners deliberately limiting supply to sustain high prices. In either case, it was the want of public and patriotic spirit in the propertied classes that accounted for the oak famine. But how might they be made more responsible? During the first half of the eighteenth century a regulating role for the Crown seemed out of the question. The Glorious Revolution of 1688 had, after all, established a parliamentary monarchy presumed to support, rather than infringe on, the interests of the propertied aristocracy. The very offices that had procurement power in the forests—the Treasury and the Admiralty—were the sinecures of the Hanoverian magnates on which this constitutional regime rested. So it was extremely unlikely that the state would act in such a way as to inconvenience its landowners. Should such a temptation arise, it would invariably be greeted with cries of "Stuart despotism."

Parliamentary statutes were much more likely to reinforce, than to weaken, the property rights of the Whig aristocracy, who had, after all, become the heirs of the Norman and Angevin forester-hunters—their mastery of the county hunts symbolizing their political and social supremacy. Instead of medieval forest law, new parliamentary statutes imposed what on paper were draconian capital penalties for poaching. In turn a new generation of outlaws, described in the punitive statute of 1722 as "wicked and evil-disposed persons," continued to thieve the Whig grandees' deer and resist the final extinction of common use rights. In some of the most bitterly contested areas like Waltham Forest in Hampshire, a virtual woodland war broke out, fought between armed gamekeepers and gangs of poachers disguised in the charcoal blackface of rebellion.[65]

It was only the next wave of anxiety for Britain's naval future that persuaded a new generation to pass a series of acts for the "encouragement and better preservation of timber." Ironically, this sense of crisis followed directly on the brilliant string of naval victories against the French during the Seven Years' War (1756–1763). For though the Royal Navy had triumphed, it had also sustained heavy losses, and by the end of the war it was scrambling to find import substitutes for both hull and mast timber. Hard on the heels of victory came the galling sense that the most recent generation of ships was probably already obsolescent, superseded by even bigger, more heavily armed men-of-war. Whatever the eventual design of that next generation, no one doubted that its ships would consume even more oak than the last.

If the imperial dream was to stay afloat, something had to be done (so patriotic souls thought) to revive the public spirit of the oligarchs. "Let each gentleman . . . reflect upon horses and dogs, wine and women, cards and folly and then upon planting. Will not the last engross his whole mind and appear worthy of employing all his attention?" asked William Hanbury, the rector of Church Langton in Oxfordshire in his 1758 *Essay on Planting*. Apparently not, since "those increasing funds for future shipping [were] totally sunk," a spectacle that "must sensibly affect every English heart who knows that his nation's safety consists in her wooden walls."[66]

Engraving from William Boutcher, *A Treatise on Forest-Trees*, 1775.

Five years later, at the end of the war, the Liverpool shipwright Roger Fisher confirmed the gloomy prognosis. Testifying before a parliamentary committee of inquiry on the oak shortage (a report that was published in 1763 as *Heart of Oak: The British Bulwark*), Fisher set out an entire historical theory in which empires rose and fell depending on their prudent or reckless forestry. What gave his arguments unusual force was his detailed personal research. He had inquired from thirty-one timber dealers and shipwrights around the country (including Scotland) on the price and availability of naval timber. And his conclusion was that the outlook for the liberties of Old England was indeed desolate.[67] The gentry and nobles of Hanoverian Britain had pillaged their woods to provide for "horses and dogs, wine and women, cards and folly" with-

out a thought for posterity. "We are preying on our very vitals yet the bulk of the nation is insensible to it and quite easily swimming in plenty, giving laws to the world yet careless of our own inward security."

Fisher also noticed that while they were at this, they were also destroying the ancestral topography of Britain. The hedgerow and the underwood were being cut and uprooted, dooming entire species of British birds like the linnet. Fisher's lament was colored by a sociological as well as an ornithological romanticism. In earlier and happier times, he claimed (not very accurately), noblemen had cleared only a narrow perimeter between their houses and the woods,

> so that, properly speaking, they appeared at a distance in the midst of a wood and were only to be seen through the avenues leading to them. Thus situated they were sheltered from storms and tempests and had the pleasure of viewing from every apartment the progress of their labours still keeping in view the grand design, the naval power of Britain.

Shaded by their leafy canopies, these gentry had lived a life of bosky patri-otism, the cares of man and bird alike soothed away by the pleasures of their little greenwood arcadia.

> When a little cloyed with enjoyment, or to retire from business or for the sake of meditation, a walk for the space of a furlong or little more leads the wealthy inhabitant into a spacious wood. The variety of the scene revives his drooping spirits. On the branch of a full-topt oak, at a small distance, the blackbird and thrush warble forth their notes, and as it were bless their benefactor. Variety of changes draw on the pleas-ing hour amongst the massy bodies of the full-grown oaks and thriv-ing plants. The prospects of his country's good warms his heart. He returns and beholds his little offspring round his board satiated with the views of the provision made for their defence in the thriving nurs-eries all around. He enjoys it a while and in good old age lies down and dies in peace.[68]

Such Arden-Edens, Fisher regretted, had all but disappeared, replaced by the "new-built palaces and country seats of our grandees" who deemed it "unhealthful to live near a wood." Who was to blame? Foreigners, of course, and those impressionable gentlemen who had had their good oaken British common sense knocked out of them on their Grand Tours. So the Messieurs and the Italianized architects between them had severed the nobility from their own better nature, from their past, and, worse, from the precious preservation

of native freedom. "Down with the oaks from the front and wings is the modern cry," and down with them, thought Fisher, would come the British constitution.

What could be done to remedy this dangerous situation? Even before the war, in 1755, a memoir by Edward Wade proposing a mass planting program had been presented to the recently established Royal Society for the Encouragement of the Arts. And three years later the first prizes were offered to those proprietors, aristocrat and commoner alike, who had sown the most acorns, or had planted other trees (like Spanish chestnut, elm, and Scots fir) deemed use-

Thomas Gainsborough, *John Plampin*, ca. 1755.

ful for the navy. Acres of ducal property were immediately studded with acorns, and fir saplings by the hundreds of thousands began to sprout across the country. In 1761, for example, the duke of Bedford claimed the society's silver medal for planting eleven acres of acorns at Woburn, and in 1763, for sixteen thousand firs on his estate at Millbrook. This was nothing, though, compared to William Beckford's gold for 61,800 Scotch firs at Fonthill or William Mellish's 101,600 spruce and 475,000 larch on his estates at Blyth, Nottinghamshire. (The all-time six-medal winner, late in the century, must have been the lord lieutenant of Cardiganshire, Colonel Thomas Johnes, an enthusiast of the picturesque, who between 1795 and 1801 planted over two million trees, and raised, according to his claim, 922,000 oaks.)[69] So the massively spreading oaks

that became almost an obligatory feature of the portraits painted by Gainsborough now advertised not merely the substance but the patriotism of the sitters.

Some of the propagandists of the new planting looked to the new king for patronage and support. When the physician Dr. Alexander Hunter published a new edition of John Evelyn's *Silva* in 1776, he flattered George III (just as Evelyn had prematurely flattered Charles II) by emphasizing the royal "munificence" by which the king had ordered twenty acres of the Forest of Knaresborough in Yorkshire to be set aside as an oak nursery, to supply *both* the coppicing needs of the local poor as well as the timber needs of the navy. And it seemed auspicious that in 1770 the prime minister, Lord North, had appointed a professional forester, Andrew Emmerich (born in Hanau but naturalized British), *Forstmeister* to Frederick II of Prussia, as the deputy surveyor-general of the royal forests, chases, and parks.[70]

Besides being the founder of the York Lunatic Asylum in 1772, Hunter was the author of *Georgical Essays,* tracts on the curability of consumption; an *Illustration of the Analogy Between Vegetable and Animal Parturition;* and the *Culina Fomulatrix Medicinae,* possibly the first (but not the last) medical cookbook. Irrepressibly public-spirited, Hunter evidently thought of the republication of *Silva* as a political as much as a botanical event. (Indeed his tough Scottish Enlightenment temper made him impatient with Evelyn's interminable and "unnecessary digressions" on subjects like the tree species that constituted the timber of the cross. "A superstitious Monk might be allowed to waste his time in investigations of this nature, but a serious and practical Christian . . . will despise such ridiculous fooleries.")[71] Though Hunter looked to the Crown to rouse what was left of the spirit of patriotic planting, he was also enough of a pragmatist to realize that the fate of the British woods would be decided not by the king but by his aristocracy. "The loss of timber would not have operated so severely," he lamented, "had the principal nobility and gentry been as solicitous to plant as to cut down their woods."[72] So he must have been gratified by the subscription list (at two guineas a copy), dominated as it was by the greatest and grandest among the Whig nobility. The duke of Portland, whose gardener, William Speechly, was Hunter's principal source for new techniques of intensive acorn-sowing, bought two copies, and the marquis of Rockingham, usually associated with the opposition Whigs, proclaimed *his* oaken patriotism by ordering no fewer than five. Among the other subscribers were not only James Boswell and the Anglo-Dutch banker James Hope but the dukes of Argyll, Atholl, Buccleuch, Beaufort, Grafton, and Devonshire and the earls of Egremont, Cholmondeley, Radnor, and Pembroke. Obviously, subscription to the Hunterian *Silva* was a requirement of fashion. But among this roll call of landed magnates and political grandees were many who, as the Royal Society of Arts' prize lists indicate, had already become the pioneers of planting programs on their estates.[73]

As Evelyn's faithful disciple, Hunter repeated the author's boast that the effect of the first edition had been to inaugurate a wave of oak-planting, "and there is reason to believe that many of our ships, which in the last war gave laws to the whole world, were constructed from Oaks planted at that time."[74] "I flatter myself," he added, "that the present republication will be a means of raising the same virtuous and patriotic spirit."[75] Evelyn's original instructions about planting the great hardwoods were now supplemented by Hunter's up-to-date intelligence about modern methods of silviculture. Advice was given on raising stands of alternative hardwoods (Spanish chestnut as a substitute for oak, American Weymouth pine instead of the fir). Every chapter was illustrated by spectacular engravings of leaves, seeds, and keys, hand-colored in specially commissioned volumes (color illus. 17).

And sewn in among the paragraphs of briskly practical prose were plates calculated to stir wonder and sentiment: engravings of the Methuselahs of the British woods. These were blasted patriarchs like the Greendale oak at Welbeck (that spread almost fifty feet from the bole) and the Cowthorpe oak on Lady Stourton's estate, sesquicentenarians that were vegetable proclamations of British immortality. A horseman, riding through one such heroically ruined trunk, came to seem like a personification of the greenwood gentry, framed by the triumphal arch of English immortality. Fifteen years on from the Hunterian plates, the poet William Cowper, his own mind much blasted by "raving melancholy," would see in the equally venerable and ruined Yardley oak an entire history of the British constitution, from its beginnings in the druidical woods, through great days of state, to its present forlorn state, eaten by corruption and hacked about by the greedy. Even thus, he pictures the oak limbless but not lifeless, for deep in the crumbling mold Cowper discovers the renewal of life.

A. Rooker after S. H. Grimm, "A North West View of the Greendale Oak near Welbeck," from John Evelyn, *Silva*, 1775.

> Embowell'd now, and of thy ancient self
> Possessing nought but the scoop'd rind, that seems
> An huge throat calling to the clouds for drink . . .
> Yet is thy root sincere, sound as the rock,
> A quarry of stout spurs and knotted fangs,
> Which, crook'd into a thousand whimsies, clasp
> The stubborn soil, and hold thee still erect.
> So stands a kingdom, whose foundations yet
> Fail not, in virtue and in wisdom laid,
> Though all the superstructure, by the tooth
> Pulveriz'd of venality, a shell
> Stands now, and semblance only of itself. . . .
> Yet life still lingers in thee, and puts forth
> Proof not contemptible of what she can,
> Even where death predominates. The spring

Thee finds not less alive to her sweet force
Than yonder upstarts of the neighbour wood.[76]

Poetic license aside, was the Hunterian *Silva* an elegy or a call to action? Had the rebirth of sylvan patriotism happened too late? The fact that it was published in 1776 was not, of course, accidental. The choice nightmare of the greenwood pessimists featured an unholy union between French absolutism and colonial rebellion, the *Marine royale* and the Minutemen: the oaken hulls of Brittany sporting the pine masts of New England, a true chastisement for generations of improvidence.

To the clear-sighted, though, it was apparent that the worst damage to the navy had been done not by the guns of French or American warships, but by

William Burgh, "A Winter View of the Cowthorpe Oak," from John Evelyn, *Silva*, 1775.

fungi, specifically the great leathery growths of *Xylostroma giganteum* or the smelly, slimy white fistula of the *Boletus hybridus* that luxuriated inside ships' timber. No sea lord of the Admiralty feared John Paul Jones half as much as he feared a rotting bottom.

As early as 1742 William Ellis had warned against using "Norway oak" for anything except elbow-pieces, the acutely bent timbers needed for the curved, lower sides of the hull. Like other foreign and "exotic" (meaning American) oaks, he claimed, its proportion of sap to wood was much higher, nourishing worm and encouraging rot and blight. Truly native English oak, on the other hand, was (like the population in general) tight-pored and tough-grained, inhospitable to pests, phenomenally watertight and long-lived.[77] But naval procurement had become desperate. According to William Marshall, writing at the

end of the eighteenth century, a seventy-four-gun ship of the line needed one hundred and fifty feet of elm (in twenty-five-foot lengths) for the keel alone, and would consume two thousand mature oaks of around two tons each.[78] And the oak panic had been further aggravated by the pine and fir neurosis. Doomsayers thought that the independent United States might well deny Britain the supplies of precious hundred-foot softwood logs from which masts for the great thirty-foot ships of the line were fashioned. In extremis the Royal Navy might have to resort to masts made from four or five pieces of inferior pine, connected by iron rings. These pieced-together masts compromised maneuverability in battle by slowing the time needed to furl or unfurl sails, extra caution being needed to move rope over the joints. The advantage the British had enjoyed over the French thus shrank even further. It was not surprising, then, that in the frantic atmosphere of Anglo-French competition following the American war, there was the temptation to cut corners and use whatever timber the royal yards could lay their hands on, no questions asked about provenance.

Some of these lots were greener than they should have been. Predictably, and to the huge satisfaction of the prophets of arboreal doom, disasters followed. None was more spectacular than the fate that befell the hundred-gun *Royal George* in 1782. "Heeled over" for some minor repairs in Portsmouth Harbour, the timbers of the vessel failed to take the strain and its entire bottom fell out, sinking the huge ship immediately and drowning scores of the crew, including a full admiral.[79] Other vessels were so rotten from attacks of fungus blight or shipworm molluscs that by the time they were ready for commissioning, the hull and keel needed rebuilding all over again. The *Queen Charlotte*, originally built at Deptford in 1810 from Canada oak and pitch pine, had had warming stoves set in its hull to hurry the seasoning of the green wood, with the result that within a year it was covered in growths of boletus. By the time it had been retimbered a third time, the ship had cost the staggering sum of £287,837.[80]

No wonder that whenever Admiral Collingwood took shore leave he went about with his breeches pockets full of acorns, from which handfuls would be surreptitiously strewn on his hosts' land. Nor that one of the most eloquent propagandists for a consistent government policy of conservation and planting was Horatio Nelson, who, in 1803, visited the Forest of Dean and saw rotting dotards, or stands cut before maturity so that the men who ran the "timber rings" could take a quick profit, while in the clearings "vast droves" of hogs and sheep tore the shoots of saplings. Even as he grieved over the landscape of desolation, Nelson imagined the creation of a wholly new corps of foresters: incorruptible, zealous, and knowledgeable. The "guardian of the support of our Navy must be an intelligent honest man who will give up his time to his employment. . . . He must live in the Forest, have a house, a small farm and an adequate salary."[81]

Pending this happy reformation, there were other short-term answers to the timber famine, the most economic of which was copiously supplied by Nelson himself, in the shape of captured French ships. Thus it was that the oak of the Pays Basque and the pines of the Pyrenees were refitted to fly the white ensign of the Royal Navy. But even while celebrating their triumphs and recycling their spoils, jeering at the froggies puffed up with pride or sunk in destitution, the sea lords were still nervously aware that it was much easier (so they thought) for the French state, whether Bourbon, Jacobin, or Bonapartist, simply to requisition naval timber by official fiat. Many had taken the diligence south on the Grand Tour, and had travelled through the forests of Lower Burgundy or even seen the endless pinewoods of the Gascon *landes,* Provence, and the Pyrenees. They knew that the masters of the French forestry corps could simply designate stands of forest for the service of the nation almost as if they were conscripting militia. And, not unnaturally, this sweeping authority made those, like Sir Charles Middleton, trying to establish a more rational procurement system in England, wish occasionally that the greenwood were not quite so hedged with liberties. What were such rights but the right of extortion freely practiced by the magnates of the Timber Trust? Under such warrant, men like William Bowsher and John Larkin, who had managed to lock up the market, dictated outrageously low prices to the Crown.[82] And Friends of the Oak, conscientiously building a library of silviculture, could not help but notice that their German volumes were now matched by an increasing number of titles in French. No self-respecting forestry buff could be content with *Silva* if he did not also have the six volumes of Duhamel du Monceau alongside.

Which is not to say that an upstanding, beef-eating, bloody-minded, free born Englishman would ever publicly envy the craven, mincing French anything, least of all their trees. All the same, it did give one pause over the port.

iv The Pillars of Gaul

Had an English oak-fancier smuggled himself into a French forest on a day of *martelage,* his anxieties would not have been much assuaged. It all looked so impressive, so orderly. There was even something decisive about the silver hatchet, the *marteau,* for which the day was named, with its blade shaped like a fleur-de-lys, to mark the timber for the king. On the appointed date a little

procession would make its way into the woods. At its head would be the officers of the royal forestry corps, the *maîtrise,* dressed in blue velvet *surtout* coats with gold vests and frogging, cocked hats on their carefully bewigged heads. Behind them would follow the forest guards whose first responsibility was to see that the great timber trees reserved to the crown, the *grande futaie,* were allowed to grow to their proper hundred-year maturity without being surreptitiously lopped or felled by unscrupulous local merchants or desperate woodlanders. Behind the guards in proper order would be notables and officers of the local municipality and, bringing up the rear, the day laborers hired for authorized contract-logging.

Using an official survey of the forest, the *garde-marteau* would mark the designated young trunk with the royal sign, declaring it a ward of the crown until, as a great centenarian, it would make its contribution to the glory of the French Empire. These rites of adoption would then be followed by a celebratory woodland dinner for the officers and their ladies: game pies and white wine cooled in silver basins. At a respectful distance, a table of social inferiors would share (up to a point) the festivities, a country air sung by one of the girls competing with the wood pigeons and thrushes.[83]

This was how things were supposed to be, at least since the great "reformation" of the forest administration in the 1660s. The direction taken by the French monarchy to ensure its maritime future was exactly the reverse of its rival across the Channel. In England the medieval administration of the royal forests had, over the centuries of the Tudors and Stuarts, effectively abdicated real economic power to contractors and aristocratic landowners. As the tonnage of the navy quadrupled between the reigns of Charles II and George III, it was these private individuals, rather than the Crown, who controlled supply, and took the profit. But if the policy of the British crown in the seventeenth and eighteenth centuries was a pragmatic abdication of the control of the state, its French counterpart was determined to assert its authority. In late medieval and Renaissance France, it had seemed on paper to be an imposing royal forest administration. But in reality it had been the creature of the noble families who dominated the provinces and perpetuated civil war. The great forests of Compiègne and Fontainebleau had been carefully preserved for the pleasure of the royal hunt while oak and beechwoods up and down the country were plundered by the same officers who were supposed to be guarding them for the king. The devastation of the forests during the long religious wars of the sixteenth century had been so severe that well-meaning officers of the crown drew up new statutes of protection and even attempted some light enforcement. But at precisely the same time that the English crown was conceding effective power to the aristocracy, the French crown was taking it back. The oracular warning issued by Jean-Baptiste Colbert to Louis XIV, "La France périra, faute de bois [France will perish for want of wood]," was no different from John Eve-

lyn's lament to Charles II. The difference lay in that the Bourbon king listened more attentively than the Stuart, and that his minister was given formidable powers to do something about the crisis.[84]

In carrying out his timber "reformation," Colbert could draw on a long tradition of arboreal classicism. A century before, in 1567, the architect Philibert de l'Orme had encapsulated its axiom by drawing a classical column in its rudimentary form as a tree trunk. He was, to be sure, only illustrating the famous passage on the arboreal origins of building in the second book of Vitruvius's *De architectura*.[85] But de l'Orme's treatise is imprinted with French classicism's axiom that nature should be made orderly and functional, and that the forests of France were to be lined up awaiting their proper service to the state. Fifteen years earlier, the Valois king Henri II had ordered his subjects to plant elms alongside the highways of his kingdom. His design was as much military as aesthetic, for they were supposed to provide timber for wagons and artillery mounts.[86] And it seems unlikely that the peasantry were massively mobilized in a campaign of elm-planting. But eventually the great columnar avenues of elms and poplars alongside the roads of France did become established like so many guards of honor for a royal progress.

Philibert de l'Orme, tree-column from *Le Premier Tome de l'Architecture*, 1567.

Colbert certainly expected the officers of the royal forestry to stand to attention. While the young king's martial dreams took the form of military descents on Flanders or the Rhineland, Colbert understood (as much as John Evelyn) that the kingdom's imperial fate would be decided on the ocean. Despite all the waste of past centuries, France still boasted great forests that covered, according to his surveyors, 25 percent of its territory. The woods of Normandy, Picardy, and (aside from Fontainebleau and the nearby forest of Sénart) the Ile de France had been much reduced. But there were still immense reserves in the eastern and central regions of Burgundy, Champagne, and the Auvergne. The softwood pine forests of the Pyrenees had hardly been touched. And Louis XIV's "War of Devolution" waged on the eastern frontier of the kingdom in 1667 had already added the thickly wooded hills and mountains of the Franche-Comté to the inventory. Before long the forested hills of the Vosges would be added to the realm.

After an initial period when Colbert allowed the incumbent masters and grand masters of the royal forests the illusion that they would be allowed to reform themselves, the minister launched his inquisition. The inquisitors were his own men, sometimes indeed his own relatives. Their loyalty was unquestioned and they descended on the offices and tribunals of the forestry—the *maîtrises*—with no concern for rank or antiquity. What they found appalled Colbert: officers who routinely looted the woods they were appointed to protect; bishops who felled anything they wanted if the price was right; local counts who treated the forest of the king as if it were their own private domain. Oaks that were supposed to be left to mature into tall timber were harvested every few years by merchants operating with illicit contracts.

A ruthless purge followed. The *maître* of the Champagne forests, Charles Fasnier, was condemned to death; others, especially in the west, where Colbert's brother was a particularly zealous inquisitor, were subjected to massive fines, evicted from their posts, and sometimes banished from the region or even the kingdom. In Poitiers the delinquent officer did public penance along with his subordinates, a rope about his neck, holding the torch of contrition in a procession to the city gate. Accompanied by the hooded public executioner, the malefactor was required to make full confession of all his crimes "rashly and fraudulently and malevolently committed [thereby] causing the ruin of His Majesty's Forests for which [he] humbly beseeches pardon of God, the King and his Justice."[87]

However traumatic, even this humiliation was probably envied by guards and sergeants convicted of illegal sales who might receive sentences of brutal flogging or even the galleys. But the culpable masters and grand masters were all themselves nobles for whom the treatment meted out by Colbert's tribunals amounted to social death. Anything remotely comparable in England would, without question, have provoked cries of the return of Norman despotism and have precipitated another revolution.

But matters were different in France, where the power of the crown was unrestrained by parliamentary claims of a share in legislative sovereignty. The extraordinary tribunals that would have been demonized in England as tyrannical were accepted in France as the proper arms of absolutist authority. After the annihilation of the old service Colbert installed his own men, recruited, he hoped, for competence as well as integrity. An ambitious survey was conducted of the entire area of woodland France. As well as royal forests, the "communal woods" attached to villages and towns, and even private tracts, were surveyed when their proximity to rivers marked them down as potentially useful to the state. Carriage-loads of men in long wigs and long coats, carrying surveying rods and spools of horsehair twine, descended on the forests of Normandy, Lower Burgundy, and the Ile de France. By the end of the 1660s Colbert had the data he needed to act.

The object, as always in Cartesian France, was to bring order to chaos. Colbert thought of the kingdom of trees much as he thought of the kingdom of men: divided into distinctive orders, each with their own rank and use. At the top were the noble oak and beech, on whose strength and longevity the defense of the realm rested. Beneath them were the softwood conifers, the vegetable bourgeoisie, monotonous in their culture but indispensable for certain tasks. Even the artisans of the woods—ash and lime, hornbeam and chestnut—had their proper function. But just as an ill-tended forest concealed so much human *canaille*—brigands and smugglers and vagrants—so it sheltered the scraggly, misshapen good-for-nothing growths of willow and bog alder, and white birch.

The regime of classical forestry designed to replace this monstrous jumble was encoded in the great ordinance of 1669: five hundred articles, a hundred pages, the Bible of French forestry until, and even beyond, the Revolution. In place of the random cropping of wood as need arose, the forests were to be divided into two strictly separated resources: the *taillis composé*, grown deliberately for regular harvesting, and the *grande futaie*, the great stands of timber trees planted in waves of successive maturity. Space for these regiments would be created by clear-cutting everything down to stumps and then protecting the acorn-grown saplings from animals (and men) by a series of defensive palings, earthworks, and fences that would have done credit to Vauban, Louis XIV's expert at fortification.

Some of the articles of the Code Colbert were merely vexing, like the requirement to bell animals so that illegal strays in the forest could be tracked from their telltale tinkle. Others, like the obligation to set aside a full quarter of all communal woods for protected timber, were a bitter blow to French peasants already struggling to survive in the woods. What did they know of the king's ships, built in some far-off port at the mouth of the Loire? And what did they care? They needed acorns for their pigs and chestnuts for themselves to get through the winter. Most of all they needed firewood. Now, with the scramble for what was left becoming desperate and the merchants opportunistically raising prices, they would have to pay dearly to keep warm, to cook, to live.

The colonnaded forest, neatly ordered by rank and purpose, was the dream of a bureaucrat. But even the most rigidly scrupulous officials found it impossible to ignore human reality. The predictable result was that after Colbert's death, his code remained a paper monument to sylvan paternalism. The brutal winters of the "little ice age" in the early years of the eighteenth century persuaded officials to allow peasants to ignore the king's *quart* if their survival was at stake. Villages and timber merchants colluded to disguise illicit felling, set mysterious fires that reduced timber trees to "waste," or, if nothing else worked, confronted the officers with violence. Whole regions of the French forests in the 1730s were plunged into endemic woodland warfare.[88] The royal

service decided to cut its losses, confining its serious attempts at enforcement to areas deemed strategically indispensable and leaving its foresters elsewhere to put up a good show on the days of the little hatchet with the fleur-de-lys.

If local resistance cut one swathe through Colbert's code, business cut another. As in Britain, the acceleration of industrial development during the eighteenth century created a booming market for timber, both as fuel and construction material. Their compliance eased with shares of the profits; forestry officials often looked the other way while reserves set aside for the state were harvested and shipped to the saltworks of the Jura, the Paris lumberyards on the Seine, or the iron forges of the north and east. Just how tempting this business was may be judged from the fact that the most famous botanist in Europe, Buffon, the author of a comprehensive treatise on silviculture, was also the master of the ironworks of Montbard. And though the co-existence of industrialist and botanist in one personality may shock our modern sensibility, Buffon actually rejoiced in the reconciliation of silviculture and metallurgy. His workers at the forge near Dijon in Burgundy were housed in model farm cottages, and in his view the whole enterprise was a single great chain of productive energy, using the treasures of earth, forest, and water that God had so bountifully provided.[89]

v In Extremis

On the eve of the Revolution, and from apparently opposite corners, the French and British forestry states were in fact converging. For although the monarchy seemed to be in control in France, and the landowning class in England, the battles being fought on both sides of the Channel for the posterity of their forests were virtually identical. In the oakwoods of Sussex or the forests of the Morvan and the Vosges, a triangular (and unequal) contest for precious timber was under way. At one corner were those—merchants, contractors, stewards, tenant farmers—who had shrewdly bought up a piece of woodland and who looked on the trees as so much standing capital, to be realized or reinvested as the market dictated. At the other corner were the landless poor whose survival depended on the defense, violent if necessary, of traditional rights to gleaning, gathering, and cropping. And at the apex of the triangle were the officials of the state, increasingly desperate about the shortage of ship timber and

suffering from nightmares of the last pine and the last oak snatched by the Other Side.

These were the realities of the timber empires. But the French Revolution was less concerned with realities than with justice and retribution. Though the agents of misery were more likely to be the woodland entrepreneurs than the officers of the royal forest corps, it was the men in blue coats who bore the brunt of popular fury in 1789. Except for a few paragons who actually heeded the Constituent Assembly's request that they remain at their post while a new administration was organized, most of the vulnerable personnel quietly slipped off their uniform and melted into the citizenry. In the forests there was a general and joyous slaughter of game while herds of cows and flocks of pigs turned the preciously guarded reserves into a great green feeding trough. And now that the Revolution had abolished the right of woodland owners to kill any goats that strayed among the trees, the southern half of France saw armies of goats, their numbers phenomenally multiplied, advancing on the woods, nibbling and grinding their way through the saplings.[90]

And while liberty trees—a political adaptation (via America) of the traditional Maypole symbols of fertility and rebirth—were going up all over France, Colbert's precious *grande futaie* was coming down. Liberated from the custody of the masters and grand masters of the Eaux et Forêts, the forests were virtually open to all comers; and facing winters at the end of the eighteenth century that were at least as brutal as those at the beginning, the poor of the French woodlands helped themselves. "They take wood as though it were cabbages in their garden," complained one local official. But the winters of the Revolution were winters of the wolf (and for the first time in many years the wolf-bounties of the old regime were restored in earnest). Humanity and prudence dictated the blind eye. Great holes appeared in the dense forests where desperate gangs with axes and mattocks had hauled away everything they could, green or dry. What use was freedom, what use was *bread,* to the frozen?

Even before Britain and France went to war in 1793, the revolutionary government, horrified at what had befallen the forests, determined to reinstate the state supervision that had collapsed in 1789. (In this chastened demotion of liberty to authority, they exactly repeated the experience of the English government of Oliver Cromwell's Commonwealth.) And with each ship of the line blown out of the water by the enemy's broadsides, British lords of the Admiralty and Jacobin citizen commissioners searched desperately for the next two thousand oaks (complete with elbows or *tortillards*) that could replace it.

From Brest and La Rochelle, provisioning agents made for the Basque coast; Marseilles and Toulon (once Bonaparte had ejected the British fleet), Tuscany, Calabria, and his own native home of Corsica were scoured for good timber. Whole ranges of hills in Corsica were denuded to provide for the navy of the Republic (and have never been reforested). Resourceful French agents

even fetched up in Ottoman Albania as soon as they heard there might be oak to buy.[91] At the same time, their British competitors were combing the empire for supplies to make up the shortfall in native forests. Before the crisis of the 1790s the huge expense of shipping timber from the dense Canadian forests of Nova Scotia and New Brunswick had seemed prohibitive. But such was the desperation of the wartime navy that they were now prepared to swallow the price. Sources even further afield were considered. Some claimed that brazilwood was as hard and as watertight as the best English oak, or Cape stinkwood or New Zealand kauri or Sierra Leone teak.

There was, though, a source of timber much closer than these remote colonial rain forests. Where the great rivers of northeast Europe—the Oder and the Niemen—flowed into the Baltic, in port cities like Riga, Danzig, and Memel, English and Scots factors had established agencies, some of them going as far back as the seventeenth century. With prices skyrocketing, these little colonies of enterprise, run by canny, unforgiving men like William Moir or the firm of Thomson and Pierson, cashed in. Living in timber houses washed with northern stucco painted the colors of rhubarb or pistachio creams, speaking broken but serviceable German or even Polish, their guts marinaded by years of vodka, they knew exactly how to milk their windfall. Their operational system was already perfectly in place. They would first contract with the navy (preferably the British, but they were not above doing business with Bonaparte's agents if the price was right) for gross lots of mast and sometimes hull timber. Then they would meet with the heads of the Jewish families—the Kaletzkys, the Simonowitzes, the Bontchewskys—men who carried with them an aroma of piety and very old wool, and who offered them a price for guaranteed delivery of prime Lithuanian or Podolian hardwoods and softwoods, floated downstream or sledded across the snow. Sometimes, too, they could come to an arrangement with the hard-pressed steward of one of the great Lithuanian noble estates, though there, too, it would be for the Jewish timber-men to deliver the lumber.[92]

If the need was critical, emissaries would even be sent all the way from London or Portsmouth, on shabby little buss-boats awash in vinegar and putrid with herring, or endlessly overland through the dun wastes of the Brandenburg plains and the Pripet marshes to finish, somehow, on the granite quays of the Baltic dockyards. And there, in the dominions of the Prussian and Russian despots, with the sea wind slicing their cheeks raw, hard-boiled Scotsmen in freshly powdered wigs haggled with Polish Jews in sable-rimmed hats, corkscrew side-curls, and long black coats over the price of oak and fir.

So while my mother's ancestors (blessed be their memory) were settling the fate of English liberty, Major Heyman Rooke of the 100th Regiment of Foot (retd.) was prematurely grieving over its loss. Inspecting the ancient royal forests, he noted, gloomily, that it was Sherwood that had suffered most griev-

ously between the time of the surveys of 1608 and 1783. In King James I's day, it had still numbered some 23,370 oaks; in King George III's time, they had shrunk to a mere 1,368. Rooke's *Sketch of the Ancient and Present State of Sherwood in the County of Nottingham* was a requiem for the greenwood.

But Rooke was determined to reseed the torn greenwood with fables. Even as he wandered among the stumps, he speculated on the forest wanderings of Robin Hood. Published along with his survey, the acorns of his mythical geography took sturdy root. No one worked harder in the plantation of greenwood myth, though, than the antiquarian Joseph Ritson. In 1795, he published his two-volume *Robin Hood: A Collection of All the Ancient Poems, Songs, and Ballads,* illustrated with woodcuts by Thomas Bewick and purporting to be an exhaustive anthology of all the many versions of the *Geste.* Walter Scott, who freely used the collection for *Ivanhoe,* both admired its compendiousness and scorned Ritson's naiveté as an editor. "The last volume," he wrote, "is a notable illustration of the excellence and defects of Ritson's system. Every extant allusion to Robin Hood is printed and explained, but Ritson's superstitious scrupulosity led him to publish many valueless versions of the same ballad and to print indiscriminately all the spurious trash that had accumulated about his name."[93]

Thomas Bewick, woodcut from Joseph Ritson, *Robin Hood: A Collection of All the Ancient Poems, Songs and Ballads,* 1795.

But Ritson was no mere credulous antiquary. He was determined to be the enduring memorialist of the greenwood, and he was even more determined to make it, for the future, a vegetable democracy. He had begun his career as a Jacobite, a fanatic for monarchy, and would end it as a Jacobin, a zealous supporter of the revolutionary French Republic. He plainly thought of himself as a literary outlaw committed to rescuing humble folk ballads and rhymes from oblivion. Since the language itself had been purloined by the mighty, he would revolutionize its spelling. Unhappily the phonetics he used were so peculiar that no one else could follow its conventions. Disillusioned with revolutionary France, he planted his last banner in the kingdom of plants, becoming a militant vegetarian and evicting family members who refused to follow his orders to abandon meat. Just before his sanity gave out altogether, from what was described as "paralysis of the brain," feeling desolate and suffocated by the vast foilage of manuscripts with which he had surrounded himself, Ritson attempted a rebel's fate. He barricaded himself in his room at Gray's Inn, piled his papers high, and set light to them. Only a determined effort by a steward prevented Ritson from being incinerated along with his rhymes.

Those ashes merely fertilized the myths that Ritson and Bewick had already planted in word and image. Robin Hood, that arch-royalist, was turned into a radical and an egalitarian: the champion of the poor. The greenwood became the forest of English fellowship where English class magically dissolved into the moss. Skeptical though he was of his working methods, Walter Scott took good care to summon Ritson to his house in 1800, three years before Ritson's death, and extract from the bad-tempered eccentric the essence of Hood the rebel.

In Ritson's uncompromising woodland hero, the Romantics had found their man and their place. Countless verse meditations on the lost and haunted greenwood found their way to the literary reviews. In February 1818, John Hamilton Reynolds produced his version, later published in *The Yellow Dwarf*, in the form of a long rhetorical question.

> *The trees in Sherwood forest are old and good*
> *The grass beneath them now is dimly green;*
> *Are they deserted all? Is no young mien*
> *With loose-slung bugle, met within the wood;—*
> *No arrow found, foil'd of its antler'd food,*
> *Stuck in the oak's rude side . . . ?*[94]

"Foil'd of its antler'd food": Reynolds's friend, John Keats, professed to like that, and was kind enough to say so in a letter thanking him for the poetic "filberts" he had sent. But Keats was in a Hood temper, determined to have done with the overbearing influence of contemporaries such as Wordsworth and Leigh Hunt. Away with them, he told Reynolds. Let's to the old greenwood of our tradition instead, to Shakespeare and to the gest of Robin Hood. So in a response, meant kindly but devastating in its superiority to Reynolds's own effort, Keats sent back what he called "some catkins," playful in their emulation of seventeenth-century seven-syllable couplets but somber in their refusal of sentimentality. Reynolds had answered his own question with a Romantic *yes*. Keats replied with an adamant negative. If it ever had been, his England was greenwood no longer. Better clear off the deadwood, burn the brush, see things as they truly were. Enough of the mead.

> *No! those days are gone away,*
> *And their hours are old and gray,*
> *And their minutes buried all*
> *Under the down-trodden pall*
> *Of the leaves of many years*
> *Many times have winter's shears,*
> *Frozen North, and chilling East,*
> *Sounded tempests to the feast*

Of the forest's whispering fleeces,
Since men knew nor rent nor leases

No, the bugle sounds no more,
And the twanging bow no more;
Silent is the ivory shrill
Past the heath and up the hill;
. . . .

Gone, the merry morris dinl;
Gone the song of Gamelyn;
Gone, the tough-belted outlaw,
Idling in the "grene shaw";
All are gone away and past!
And if Robin should be cast
Sudden from his turfed grave,
And if Marian should have
Once again her forest days,
She would weep, and he would craze:
He would swear, for all his oaks,
Fall'n beneath the dockyard strokes,
Have rotted on the briny seas;
She would weep that her wild bees
Sang not to her—strange! that honey
Can't be got without hard money . . .[95]

The Verdant Cross

i Grizzlies

It was Augustus T. Dowd's big joke. On a spring morning in 1852 he had been after a wounded grizzly, meaning to finish the brute off and provide the men of the Union Water Company with fried bear for the rest of the week. That was his job. As he was tracking the animal through the woods of sugar pine and ponderosa, the flickering light dimmed. Without any warning Dowd abruptly came face to face with a monster. It was maybe fifty feet round and, as close as he could guess, near three hundred feet high. It was a tree.

Of course no one at Murphy's Camp would believe him. They were more likely to credit a giant bear than a giant tree, he supposed. And so he told them the next day that the biggest grizzly there ever was was lurking right there, deep in the woods. And when he took them right up to the strange thing, a cinnamon-brown tower etched with deep furrows up its whole length, cavities a man's arm could disappear into, not a branch below fifty feet and its crown invisible, he could point and jump about and crow and laugh: "Boys, do you now believe my big tree story? That's the grizzly I wanted you to see. Now do you believe my yarn?"[1]

They did, and were quick, too, to figure out some way to profit from it. For the magnitude of what they beheld was not lost on a gang of laborers stuck

out in the foothills of the western Sierra Nevada, digging canals and ditches for the mining camps of the Mariposa Estate. No one in Yosemite Valley in 1852 was there for the scenery; of that we can be sure. The miners who peopled the shacks and cabins that straggled over the hillsides were forty-niners whose dreams had soured. Panning the streams in the drenching days of spring, they survived by working for the soldier-explorer John C. Frémont, whose mill-machines smashed quantities of quartz at the western end of the valley in the hope of extracting gold. It was not all high-altitude craziness. Some mines like Princeton and Pine-Josephine gave up real riches, for a few years at any rate. The Frémont workers would take the extracted ore, set it with quicksilver into bricks, and then transport them (with all due caution and security) to the bank vaults in San Francisco. From there they ended up, duly assayed, in the U.S. Mint.

Not much of this good fortune trickled down to the scrambling, violent crowd of Italians, Chinese, Mexicans, and Germans inhabiting the shacks and tents of the Mariposa. Along with the miners were the usual camp followers and hangers-on: hunters, loggers, ditchdiggers, cooks, and whores, many of them practicing more than one trade. But if their life was precarious it was nothing compared to the Ahwahneechee Indians. As tribal cultures went, the Ahwahneechee were relatively sedentary (and therefore particularly despised by the Europeans), subsisting on black oak acorns, grubs, and the trout scooped from the river, belly up, after they had poisoned the water with soapweed. The dazzling meadow-floor of the valley which they called (in the Miwok tongue) *Ahwahnee,* or "gaping mouth," and which its white eulogists, like John Muir, supposed to be untouched and Edenic, actually looked the way it did because of the Indians' repeated set-fires, which cleared it of brush and opened the space for grazing.[2] The Indians hunted a little, too, and driven from their food sources by the guns of the mining camps, they resorted to periodic raids to get some of it back, and liquor and weapons as well, if they could. Sometimes there was shooting and cutting. After one of these affrays, Major James D. Savage's Mariposa Battalion would thunder off after them, guided by Mono Indian pursuers, hounding the wretched Ahwahneechee from valley to valley until there were no more to be seen. The few who survived dispossession and dislocation called their tormentors *Yo-che-ma-te:* "some among them are killers."

Naturally, a more picturesque account of the etymology of the valley's name was needed. So the soldiers imagined that it derived from a Miwok term for "grizzly bear": *uzumati.* And the Big Trees in what became known as the Calaveras Grove were almost immediately treated as trophy: skinned, mounted, and displayed for bragging and for cash. In the summer of 1854 another ex-miner, George Gale, who saw gold in wood, rather than water or rock, picked out the biggest specimen he could find, ninety feet round at its base and known

as the Mother of the Forest. No sentimental respecter of maternity, Gale stripped the tree of its fragrant, dark-ridged bark to a height of a hundred and sixteen feet and shipped the pieces east, where they were stitched back together and the hollow giant shown as a botanical marvel.[3] But a public already skeptical about P. T. Barnum assumed this, too, to be a crude hoax, along the lines of mermaids constituted from the head of a manatee and the tail of a salmon. The lines at the box office shrank and George Gale's fortune turned to fool's gold. Transcendentalists were delighted.

While jaded, cynical New York was refusing to suspend its disbelief, the learned botanical community knew better. The discovery of the Big Trees, originally reported in the *Sonora Herald,* was reprinted in the London *Athenaeum* and the English *Gardeners' Chronicle.*[4] Lectures were given in short order at the Royal Society and the Société Botanique in Paris, British and French botanists (as usual) competing with each other to see who could come up with the clinching classification and nomenclature. The English, naturally, thought *Wellingtonia gigantea* would be fitting. But the French botanist Decaisne, believing it to be related to the California coastal redwood, the *Sequoia sempervirens,* decided instead on *Sequoia gigantea* for the giant of the Sierra. In actuality, the relationship is less close than might be supposed from casual observation. After it gets to two hundred feet the Big Tree begins to expand its girth more than its height, while the redwood keeps on going well beyond an average three hundred feet. The former's needles are blue-green scaly spikes; the latter's are marked with white bands beneath. In fact "sequoia" was an eccentrically inappropriate label for either species, being the name of a half-blood Alabama Cherokee (a.k.a. George Guess) who had invented a written language for the tribe. Its adoption by Asa Gray, the founder of Harvard's botanical garden, and his New York colleague John Turrell, however, was of more than purely taxonomic significance. As the author of the official state *Yosemite Book* explained in 1868:

> It is to the happy accident of the generic agreement of the Big Tree with the redwood that we owe it that we are *not* now obliged to call the largest and most interesting tree in America after an *English* military hero.[5]

The Big Trees were thus seen as the botanical correlate of America's heroic nationalism at a time when the Republic was suffering its most divisive crisis since the Revolution. To a skeptical Englishman who refused to believe that the bark he saw at the Crystal Palace at Sydenham was from a single tree, an American visitor took pleasure in "assuring the Englishman that he had stood in the grove . . . that there were even larger trees in it than this one, that in spite of the fact that the bark had been completely removed to the height of a hundred feet the tree was as green as any of the majestic fraternity." (It would not remain

that way for very long.) "The Englishman gave one look of rage," the Ameri-
can tourist reported, "and bolted from the neighborhood."[6]

The phenomenal size of the sequoias proclaimed a manifest destiny that
had been primordially planted; something which altogether dwarfed the
timetables of conventional European and even classical history. They were,
their first observers thought (wrongly, again, for the less imposing bristle-cone
pines of the Sierras had not yet been dated), the oldest living things on earth.
Even Horace Greeley, who saw them in 1859 and tried hard not to be
impressed, was startled by the thought that they had stood upright "when
David danced before the Ark; when Theseus ruled Athens; when Aeneas fled
from the burning wreck of Troy."[7]

In the first instance, though, it was the commerce of novelty, not the cult
of antiquity, that took up the "Mammoth Trees." By the time James Mason
Hutchings, the English-born publisher of *Hutchings' California Magazine*,
took the first party of tourists to the Calaveras Grove in 1855, the botanical

freak show was already well established. Iron pump augers were used to drill
holes in trunks selected for felling, though even after they had been severed
from the base, a further series of wedges levered the tree away from its upright,
suspended position. The whole process could take five men three weeks (two
and a half days alone for toppling). "In our estimation," commented Hutch-
ings without much conviction, "it was a sacrilegious act." But at the end was a
half-million feet of lumber and an instantaneous amusement park. A two-lane
bowling alley was built (complete with protecting shed) along a planed-down
surface of a trunk; and the stump of a felled sequoia was made into a dance floor
for tourists where, Hutchings tells us, "on the 4th of July, thirty-two persons
were engaged in dancing four sets of cotillion at one time, without suffering
any inconvenience whatever."[8]

By the end of the decade, Hutchings had supplied the operational appara-
tus of scenic tourism in the Calaveras Grove.[9] Travellers could get from San
Francisco to Stockton either by a new railroad or by steamboat up the San
Joaquin River. From Stockton they would use coaches and wagons via Cop-

peropolis and Murphy's Camp. Hutchings could then accommodate them in the Mammoth Tree Cottage Hotel, a pretty building, five miles from the grove, boasting splashing fountains, a balustraded balcony, and appointments comfortable enough for the ladies, who were already beginning to visit the fabled woods.

Ironically, though, it was visitors (or, as they preferred to say, "pilgrims") from the East who transformed attitudes toward the sequoia groves, making them a place not just of curiosity but of veneration. The most important was the Boston Unitarian (and famous orator) Thomas Starr King, who in 1860 was dispatched to the Barbary Coast of California to minister to their First Church in San Francisco.[10] Starr King was a natural missionary and part of his vocation was to preach the virtues of the Union to Californians who might have been tempted by the demons of secession. But coming from the cradle of Transcendentalism in New England, he found the lure of the Sierra Nevada irresistible, being both the visible face of divinity and the purest American habitat. His sermon "Living Waters from Lake Tahoe," for example, proclaimed that "this purity of nature is part of the revelation to us of the sanctity of God. It is his character that is hinted at in the cleanness of the lake and its haste to reject all taint." Moreover, by the time Starr King took his vacation in the valley in the summer of 1860, a second and larger grove of Big Trees had been discovered, south of Calaveras, toward Mariposa itself, and Starr King along with his high-minded friends and colleagues determined that the "wretched drudgery of destruction" that had overtaken the Calaveras trees should not be visited on the second forest. "The Mariposa stands," he wrote in his articles to the *Boston Evening Transcript,* "as the Creator fashioned it, unprofaned except by fire."[11]

Charles C. Curtis, *Quadrille on Redwood Stump,* albumen print.

Thomas A. Ayres, *The Mammoth Tree Grove,* Calaveras County, tinted lithograph.

The Big Trees, in short, were sacred: America's own natural temple. "I think I shall see nothing else so beautiful till happily I stand within the gates of the Heavenly City," wrote Sydney Andrews in the Boston Daily Advertiser.[12] And while Starr King assigned pagan magic to the oak groves of Greece and Germany, "the evergreen," he noted, was "so much softer in their stock and far deeper and more serious in their music. . . . The evergreen is the Hebrew tree."[13] And the dizzying thought that their age could be measured in millennia, and thus literally be coeval with the whole Christian era, only reinforced

this sense of native holiness. "Tell me," Starr King imagined himself whispering to the Big Tree, "whether or not your birth belongs to the Christian centuries; whether we must write 'B.C.' or 'A.D.' against your infancy?"[14] And the correspondent of the Boston Daily Advertiser, in a rapture usually associated with tabernacle revival meetings (many of which, in mid-nineteenth-century New England, were being held in open-air groves), actually linked the nativity of the trees to the birth of the Savior:

> What lengths of days are here! His years are the years of the Christian era; perhaps in the hour when the angels saw the Star of Bethlehem standing in the East, this germ broke through the tender sod and came out into the air of the Upper World.[15]

The pious notion that the Big Trees were somehow contemporaries of Christ became a standard refrain in their hymns of praise. John Muir counted the rings on one martyr to the axe and discovered that "this tree was in its prime, swaying in the Sierra winds when Christ walked the earth." It was as if contemporaneity banished geographical distance; this immense botanical mystery was part of what Muir called the "Holy of Holies" in Yosemite. And like all things touched with divinity, the sequoias were immortal, never actually decaying as they stood, but falling only to the celestial forces of lightning-conducted fire, or the axes of infidel loggers. The crowns that had been stripped away by lightning were proof of the inconceivable antiquity that guaranteed that someday they would be struck by a bolt.[16]

It was one of these blasted patriarchs that filled the frame of one of Carleton Watkins's glass-plate stereographs. More than any other images, Watkins's heroic prints shaped American sensibilities toward Yosemite and the Big Trees.[17] They were not the first photographs of the valley. To drum up business, the ever-enterprising Hutchings had hired both a painter, Thomas Ayres, and a photographer, Charles Weed, whose work was then engraved as promotional lures in *Hutchings' California Magazine*. Watkins had been working as a carpenter in San Francisco but had become known as an amateur daguerreotypist and photographer of the Mariposa mines and landscape, which had also attracted pioneers of the new medium like Robert Vance and Eadwaerd Muybridge. In 1861 he visited Yosemite and, using a "mammoth frame," created the icons of the valley: Half Dome, Cathedral Rock, El Capitán, along with parties of gentlemen and ladies in hooped skirts (including the widow of the British Arctic explorer John Franklin), demurely dining off wooden tables in the great outdoors. His Big Tree stereographs posed tiny figures, probably including the Mariposa guide, Galen Clark, against the immense trunk and captured the heroically mutilated quality of the "Grizzly Giant," storm-racked but defiant and enduring; a perfect

emblem for the American Republic on the brink of the Civil War: a botanical Fort Sumter.

Watkins's pictures went on show at the Goupil Gallery in New York in 1862 and were a phenomenal success. Those who had ridiculed George Gale's pieces of bark were now converted to the stupendousness of the sequoias. Oliver Wendell Holmes, writing in the *Atlantic Monthly*, extolled the pictures as fully the equal of the greatest productions of Western art and their subjects, the authentic, living monuments of pristine America. Suddenly Yosemite became a symbol of a landscape that was beyond the reach of sectional conflict, a primordial place of such transcendent beauty that it proclaimed the gift of the Creator to his new Chosen People.

Only the sense that Yosemite and the Big Trees constituted an overpowering revelation of the uniqueness of the American Republic can explain Abraham Lincoln, in the midst of the Civil War, signing an unprecedented bill that on July 1, 1864, granted them to the State of California "for the benefit of the people, for their resort and recreation, to hold them inalienable for all time." The bill, creating the world's first wilderness park, had been introduced by California's senator John Conness, with the backing of Governor Frederick Low and the influential state geologist Josiah Whitney. And there is no doubt that the landscape architect Frederick Law Olmsted (then thwarted in his plans for Central Park and working as the superintendent-manager of the Mariposa Mines) also had an important hand in its promotion. Named to the Yosemite Commission along with Galen Clark and Whitney, Olmsted issued his first report in 1865, which still contains the clearest articulation of public, federal responsibility for denying areas of natural beauty to the fate of private enterprise.[18]

It was the aura of heroic sanctity, the sense that the grove of the Big Trees was some sort of living American monument, a botanical pantheon, that moved Lincoln and the Congress to act as they did. The impression of a pantheon was reinforced when the mightiest sequoias began to be baptized as "Daniel Webster," "Thomas Starr King" (who also rated a mountain), and "Andrew Jackson." ("General Sherman" is still with us, the biggest vegetable in America.) The sequoias seemed to vindicate the American national intuition that colossal grandeur spoke to the soul. It was precisely because the red columns of this sublimely American temple had not been constructed by the hand of man that they seemed providentially sited, growing inexorably ever more awesome until God's new Chosen People could discover them in the heart of the Promised West.

There was another reason the Big Trees seemed an American godsend. A generation earlier the forest had been represented in the popular imagination as the enemy. The eastern woods, after all, had been the habitat of the godless Indian. To make a godly settlement, then, required that both the wilderness and the wild men be comprehensively cleared. Beauty lay in clearance; danger

and horror lurked in the pagan woods. The clearances were so extensive and so indiscriminate, though, that even as early as 1818 James Madison was protesting the "injurious and excessive destruction" of timber.[19] To a generation reared on Fenimore Cooper's forest romances, the miraculous appearance of *western* woodlands seemed to be a sign of God's forbearance, a second chance for America to understand the divinity inscribed in its landscape.

It did not strike the artist Albert Bierstadt as particularly hypocritical to

Carleton Watkins, *The Grizzly Giant,* albumen print.

Carleton Watkins, *The Grizzly Giant,* albumen print, 1861, Mariposa, California. Galen Clark is the figure at the base.

paint the Big Trees as embodying *both* national magnitude and spiritual redemption[20] (color illus. 18). He had made his reputation as a landscapist largely as a result of having produced huge, grandstanding panoramas of the Rockies, based on sketches made on a western trip in 1859.[21] Some were exhibited at the Goupil Gallery, and it seems likely that it was Watkins's stereographs that influenced Bierstadt and the popular writer and lecturer Fitz Hugh Ludlow to make the trip to Yosemite in 1863. Ludlow's articles for the *Atlantic Monthly* perfectly reflect the quizzical easterner dryly scrutinizing Eden, but

then surrendering to transports of conversionary amazement. Describing the
sequoias, he begins with a mere statistical report of circumference but then
confesses that "we cannot realize time images as we can those of space by a ref-
erence to dimensions within experience, so that the age of these marvellous
trees still remains to me an incomprehensible fact." Accustomed as New Eng-
landers were to their own scaled-down version of heroic botany, some of the
Mammoth Trees "had fulfilled the lifetime of the late Charter Oak (at Hart-
ford) when Solomon called his master-masons to refreshment from the build-
ing of the Temple."[22] By the same token he thought it impossible for his fellow
travellers (Ludlow and Bierstadt were accompanied by two other painters, Vir-
gil Williams and Enoch Wood Perry) to convey anything but a pigmy repre-
sentation of the sequoias.

> The marvellous size does not go into gilt frames. You paint a Big Tree
> and it only looks like a common tree in a cramped coffin. To be sure
> you can put a live figure against the butt for comparison; but unless
> you take a canvas of the size of Haydon's your picture is likely to
> resemble Homunculus against an average tree and a large man against
> *Sequoia gigantea*.[23]

Perhaps it was these daunting technical problems which account for no
Bierstadt Big Tree paintings surviving from this first trip to Yosemite. But when
he returned from his second trip, 1871–73, he evidently felt that there would
be a market for grandiose icons of the veterans of the ancient American woods,
for at least six such paintings are known from this period.[24] His star as a fash-
ionable painter was, however, already dimming and every exhibition of new
work was met with a merciless fusillade from the critic of the *Tribune*, Clarence
Cook, who upbraided Bierstadt for his addiction to vulgar, flashy, and visually
meretricious effects. Directed at the immense light shows of Yosemite, the crit-
icism had much merit. But Bierstadt's Big Tree pictures were in fact aiming for
something other than sheer magnitude. The diminutive figure set against one
version of *The Grizzly Giant*, for example, obviously established the immensity
of the scale for the beholder. But the pose was taken directly from Carleton
Watkins's plates, reshot for the official Yosemite survey and guidebook, in
which Watkins posed Galen Clark in front of that particular tree.

Clark had been appointed "guardian" of the protected Mariposa Grove
under the terms of the 1864 California statute (and its niggardly budget of two
thousand dollars a year for the maintenance of the entire area of Yosemite). But
he had also become, in the writing of the period, a symbol of the idealized
affinities between American nature and American people: decent, hospitable,
enduring, hardy, but also hiding great nobility and wisdom behind a weather-
beaten exterior: Natty Bumppo with a library. Olmsted wrote admiringly that

he "looked like the wandering Jew but spoke like a professor of belles-lettres."[25] And Fitz Hugh Ludlow described him as

> one of the best informed men, one of the very best guides I ever met in the Californian or any other wilderness. He is a fine looking stalwart old grizzly-hunter, a miner of the '49 days, wears a noble full beard hued like his favorite game, but no head covering of any kind since he recovered from a head fever which left his head intolerant even of a slouch. He lives among folk near Mariposa in the winter and in the summer occupies a hermitage built by himself in one of the loveliest valleys of the Sierra. Here he gives travellers a surprise by the nicest poached eggs and rashers of bacon, homemade bread and wild strawberry sweetmeats which they will find in the State.[26]

Clark then was himself a grizzly, posed beneath the grizzly sequoia in the valley named for the grizzly bear. But the great column that towered above him, almost an extension of his own heroic American personality, was deep red rather than gray, and above all it spoke of an elemental chronology: not the chronology of classical European civilization, but the chronology of wild nature, America's own time scale, inherited directly from the Creator, without the supervening mediation of human pretensions. The truly *venerable* nature of American history, as the explorer Clarence King put it after seeing the Big Trees, could be measured in what he called, oxymoronically, "green old age."[27] Earlier in the century, writers like Charles Fenno Hoffman, travelling in the Mississippi Valley, seemed to shame the American tourists who thronged Rome and Paris by comparing "the temples which Roman robbers have reared" and "the towers in which feudal oppression has fortified itself" unfavorably with "the deep forests which the eye of God has alone pervaded and where Nature in her unviolated sanctuary has for ages laid her fruits and flowers on His altar!"[28] What was the Colosseum beside the immense and prehistoric Grizzly Giant, a nobler ruin than the Parthenon: the epitome of heroic endurance over millennia: scarred, burned, ravaged by time and decapitated by lightning. And unlike those heaps of stone, the Giant was yet alive with the vigorous green shoots of a new age. It exactly linked prehistorical antiquity to American posterity. No wonder, then, that Bierstadt chose to exhibit his version of *The Great Trees, Mariposa Grove* at the Centennial Exposition in Philadelphia, where it could proclaim that the first hundred years of the American Republic were but the political twinkling of an eye.

The Big Trees also proclaimed the sacredness of American time. And it is conceivable that Watkins's albumen print was not the only source for Bierstadt's heroic treatment of the ancient and weathered tree. For it is distinctly possible that he would have seen Caspar David Friedrich's *Oak Tree in Winter*

in the National Gallery in Berlin, which he had visited between the two trips to Yosemite. In fact Bierstadt might well have had an immediate understanding and particular sympathy for Friedrich's own versions of arboreal salvation. He himself had been born in Solingen, but had been taken to the United States as an infant and had grown up in the prosperous Massachusetts whaling port of New Bedford. But like others of his generation, in particular the Hudson Valley painter Worthington Whittredge, he had returned to Germany for his studies. The center of their training, it is true, was the Düsseldorf Academy,

which boasted the least Romantic and most studiously naturalistic techniques in landscape. But as Barbara Novak has argued very persuasively, it seems unlikely that the intensity of German Romantic idealism, still far from moribund, would not have rubbed off on a group of American artists who were, in any case, extremely prone to a kind of visual Transcendentalism.[29]

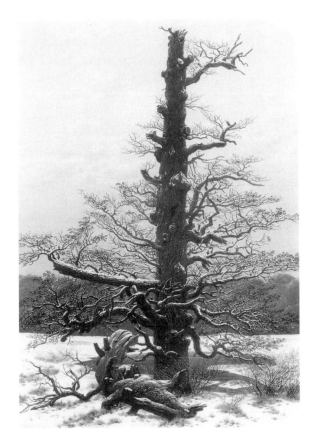

Caspar David Friedrich, *Oak Tree in Winter*, 1829.

Both Bierstadt and Whittredge, during their time in Germany in the 1850s, produced a number of landscapes in which great trees (usually oaks) figure as both heroic and spiritual actors in the scenery. And it was not long after his return that Whittredge painted one of the most successful and powerful of all his landscapes, *The Old Hunting Grounds* (color illus. 20). Backlit in exactly the Friedrichian manner, Whittredge's birches rise like fluted columns to the arched, darker foreground trees that frame the composition. The effect is obviously architectural, almost an illustration of the tradition which located the origin of Gothic pointed arches and vaults in the spontaneous interlacing of tree limbs. But the title of Whittredge's forest interior was not casually given, for the painting is also

loaded with the spiritual associations standard to the Hudson Valley painters. A ruined canoe eaten with decay lies in pond water as a memorial to the Indians, banished and vanished, whose "hunting grounds" these once were. The broken stump and the trembling birch leaves, emblems of death and new life, echo the canonical, anthem-like quality of the painting. Along with two other equally famous American forest interiors, Whittredge's painting became the literal visual expression of the pious cliché of the "cathedral grove."

In his own *Giant Redwood Trees of California* Bierstadt transposed this ecclesiastical reading of the primordial woods to a sequoia forest (color illus. 19). In fact, the trees look more like the *Sequoia sempervirens* of the coastal forests than the Big Trees, and the red light, reflecting off the bark, suggests the luminous dimness of the much denser, darker redwoods of Mendocino and Humboldt counties. But it reiterated all the standard motifs of sequoia iconography: antiquity, reverence, and magnitude. And instead of the sentimental, inanimate elegy for the vanished redwood redskin, Bierstadt includes three Indians, a brave with his son seated by the pool and a squaw returning with a basket on her back, a native American version of the Georgic idyll. Most crucially, the tepee-like triangular opening in the side of the foremost tree is evidently the Indians' dwelling place. It is the most literal translation of what John Muir (who himself underwent a kind of theophany in Yosemite) meant when he wrote of returning to the American woods as "going home." Bierstadt's painting is sylvan-domestic: the ancient residence of the *most* indigenous Americans.

Both Bierstadt's and Whittredge's paintings paid homage to the patriarch of all American forest interiors, Asher Durand. President of the National Academy of Design in New York, Durand was, in effect, the theologian of the second generation of the Hudson Valley school. By his lights, the whole point of landscape was expressive veneration. In 1840, during a trip to England, he had spoken of his decision not to become a minister of the church, "the better to indulge reflection unrestrained under the high canopy of heaven." His famous "Letters on Landscape Painting," published in *The Crayon*, had appeared in the same year that he exhibited *In the Woods*, which also featured birches bowed together in Gothic inclination. It was the exact illustration of the diluted Transcendentalism preached in his essays: American nature shaped as the archway to divinity.

> The external appearance of this our dwelling place, apart from its wondrous structure and functions that minister to our well-being, is fraught with lessons of high and holy meaning, only surpassed by the light of Revelation. It is impossible to contemplate . . . [them] without arriving at the conviction that the Great Designer of these glorious pictures has placed them before us as types of the Divine attributes.[30]

Asher Brown
Durand,
In the Woods,
1855.

Durand's most famous painting—a virtual manifesto of Hudson Valley sublimity—was *Kindred Spirits*, conceived as a memorial to Thomas Cole, the founding father of the school, who had died in 1848. A fictitious composite of two of Cole's favorite sites—the Kaaterskill Falls and the Catskill Clove, drenched in a radiant golden light—it was also a comprehensive inventory of its stock symbols and emblems. The broken tree in the foreground signified Cole's premature demise; the evergreens his immortality; the hanging rock-ledge the precariousness of life; the eagle flying toward the horizon the liberation of soul from body; the river the voyage of life, which Cole had himself made the theme of one of his most ambitious series of allegorical paintings. The very composition of the painting, a swooping circular route for the eye, some-what reminiscent of Bruegel, was surely a formal expression of the cycle of eternity. Standing on the ledge are Cole himself, holding palette and maulstick, and the poet William Cullen Bryant, who had delivered the funeral eulogy for the dead artist at the Church of the Messiah in New York and whose own work tes-

tified not merely to kinship between like-minded souls but to the essential *naturalness* of American identity.[31]

Bryant's poems (immensely popular in their day, almost unreadably plodding in ours) revealed the American forests as the birthplace of the nation. To repair to the woods was to be reminded of two features of the national personality: its liberty and its holiness. An anthology published a year after Cole's death had two important poems in which the primitive antiquity of the forests was presented as a corrective to the national passion for novelty. In "The Antiquity of Freedom" the poet stands amidst "old trees, tall oaks and gnarled pines . . . / . . . In these peaceful shades/Peaceful, unpruned, immeasurably old/ My thoughts go up the long dim path of years/ Back to the earliest days of liberty."[32] Freedom was not "as poets dream/A Fair young girl with light and delicate dreams," but a hoary warrior, "scarred with the tokens of old wars," in

Asher Brown
Durand,
Kindred Spirits,
1849.

fact, a grizzly; cut about, blasted, and shaken, but always with the power to throw out new life. The woods, then, proclaimed the true natural constitution of free America, beside which a manmade document was merely the sapling of philosophical invention.

Even more important, though, the forest supplied America with the visible form of the primitive church.

> *The groves were God's first temples. Ere man learned*
> *To hew the shaft and lay the architrave*
> *And spread the roof above them—ere he framed*
> *The lofty vault, to gather and roll back*
> *The sound of anthems; in the darkling wood*
> *Amidst the cool and silence, he knelt down,*
> *And offered to the Mightiest solemn thanks*
> *And supplication.*[33]

The idea of the "venerable columns" and the "verdant roof" supplying both the original place of worship and then suggesting the actual form of spiritual architecture in the Gothic already had a long tradition by the time Bryant got around to giving it an American accent.[34] But in the New World it had a

Frederick Edwin Church, *Hooker and Company Journeying Through the Wilderness from Plymouth to Hartford, 1636,* 1846.

special resonance. Fenimore Cooper begins one of his more successful *Leather-Stocking Tales, The Pathfinder,* with the reader suspended like an angel and looking west above the rolling canopy of the virgin forest: "an ocean of leaves glorious and rich in the varied but lively verdure . . . the elm with its graceful and weeping top; the rich varieties of the maple, most of the noble oaks of the American forest . . . forming one broad and seemingly interminable carpet of foliage that stretched away toward the setting sun until it bounded the horizon by blending with the clouds as the waves and the sky meet at the base of the vault of Heaven."[35]

It is from this primordial vegetable matter, celestially sanctified and unspoiled as yet by the touch of man, that America was born, so the writers and painters of the first native generation proclaim.[36] In so doing they self-consciously turned their back both on the classical contempt for woodland barbarism and the long Puritan legacy that equated the forest with pagan darkness and profanity. Instead, for his first important painting the young Frederick Edwin Church chose for his American Moses the Reverend Thomas Hooker, in 1636 leading a flock westward, away from the heavy hand of Old World authority represented by the Bay Colony government. And the Promised Land, it is apparent, is a dense woodland, not forbidding or packed with heathen terror, but a sanctuary in the literal sense of holy asylum. Its foliage trickles with sunlight; its waters run sweet and clear. It is the tabernacle of liberty, ventilated by the breeze of holy freedom and suffused with the golden radiance of providential benediction.

ii Vegetable Resurrection

Frederick Church, though, was only Elisha. The mantle he received (through their common patron, Daniel Wadsworth) had belonged for a whole generation to Thomas Cole. And throughout his life Thomas Cole had been one of nature's crusaders. Considering his background in Dissenter Lancashire, it seems very likely that as a child he would have been exposed to the kind of Improving Literature that saw "sermons in stones" and parables in every twig and brook. John Bunyan would remain one of the most powerful sources for his painting series that depicted life as a pilgrimage from innocence to experience to epiphany. Even the cycles of history that made up the vast subject of

his *Course of Empire* were inscribed in landscapes that evolved from primitive arcadia through the dynamism and decadence of civilizations before the verdure sprouted once more through the fallen masonry.

He must also have been familiar with the long European tradition of nature emblems. His *Landscape with Dead Tree*, for example, might almost have been painted as a direct homage to the same themes of death and rebirth in the landscapes of Jacob van Ruisdael and his more recent German interpreters. And although he could have had no premonition of his own death, it was entirely in keeping with Cole's restlessly evangelical character that images of the cross figured so prominently in his last years of work. Sometimes those images were, literally, seraphic visions, as in the Bunyanesque series *The Cross and the World*, unfinished at his death. But sometimes, too, the cross is cunningly integrated into the human and natural landscape. It appears surreptitiously in *Home in the Woods:* a painting where the destruction of the forest represented by broken logs and stumps in the foreground is made acceptable only by the rustic wooden virtue of the log cabin and its occupants. Significantly (for *everything* in Cole's woodland paintings is lumbered with significance), the vine that climbs over the face of the cabin, wreathing it with domestic virtue, is rooted at the base of a piece of fencing, angled to form the shape of the cross. With the vine winding about its stem, the crosspiece thus becomes both support and benediction.

Thomas Cole, *The Course of Empire: The Arcadian or Pastoral State*, 1833–36.

Thomas Cole, *The Course of Empire: Desolation*, 1833–36.

Thomas Cole, *Home in the Woods*, 1847, detail.

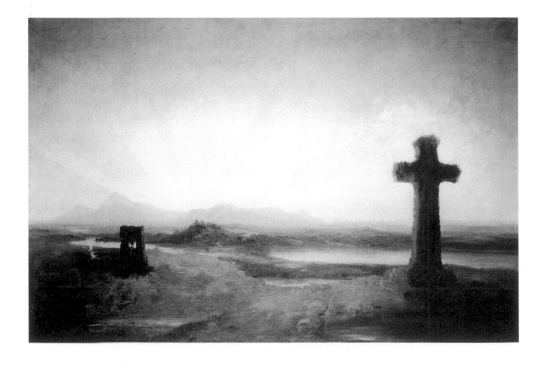

For someone like Cole, obsessed with vegetable theology, mortality could only be a prologue to a new life. So it is not surprising to discover that some of his valedictory crosses actually seem to be in a process of depetrification. Nowhere does this seem more explicit than in a pair of paintings done a year before his death, and from their identical formats, mountain horizons, and sunsets, evidently meant as pendants. In one, Cole sets a young tree growing from the stone ruins of a Gothic church so that the architectural form of sacred botany returns, as it were, to its true nature. In its pair, the huge cross dominating the foreground seems, even when its unfinished condition is taken into account, deliberately fuzzed and scumbled at its edges, as if invaded by some mossy, lichenous, irresistibly organic growth.[37]

Thomas Cole,
*Gothic Ruins
at Sunset,*
ca. 1844–48.

Two years earlier, at about the time he was beginning to sketch ideas for *The Cross and the World*, Cole painted what he called "one of my happiest productions," a circular composition "in defiance of one of the famous rules of Art, viz. that the light should never be exactly in the middle of the picture"[38] (color illus. 21). It was meant as a literal illustration of the sentimental verses of Mrs. Felicia Hemans that featured yet another mourning Indian brave seated before a hummock, "his arms folded in majestic gloom./ . . . His bow lay unstrung beneath the mound/Which sanctified the gorgeous waste around/For a pale cross above its greensward rose." Through his theatrical illumination, the unnaturally brilliant light shining directly on the hidden face of the cross, Cole has turned the grieving warrior into a pantheist (which he probably, in any case, was). But the garlanded stone seems not so much inserted as *planted* on its tussock, and, growing there, as much a piece of the wilderness landscape as the autumnal trees, the migrating birds, and the grieving warrior.

And it was, surely, that little painting that inspired Cole's only pupil, Frederick Edwin Church, to produce his own memorial in 1848, almost immediately after his teacher had unexpectedly died. Much less well known than Asher Durand's memorial tribute, and only recently rediscovered, Church's painting is nonetheless of a substantial size and grandeur (color illus. 22). Even more explicitly than *Kindred Spirits,* Church's *To the Memory of Cole* offers homage through reiteration, for all the sanctified Cole symbols are here, from the immortal evergreens to the river of life. At the center of the painting is a cross,

Thomas Cole,
Cross at Sunset,
ca. 1848.

strikingly similar to Cole's 1845 wilderness monument. But even more than in his master's painting, the student has made it appear unnaturally isolated from all possible human agency. No mason could seemingly have cut this object nor set it in such radiant meadow grass. Nor could the blooms that climb exuberantly from the pasture and twine themselves about the stone have possibly been planted. What we encounter in this unpeopled, brilliantly lit meadow is the theater of another miraculous depetrification in progress, the transformation of dusty death into the vital shoots of nature, a vegetable resurrection.

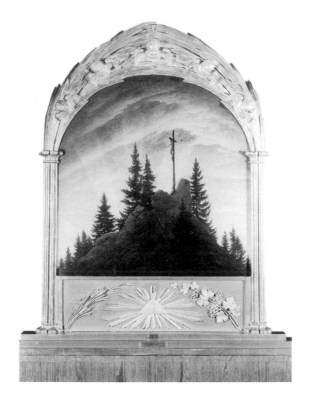

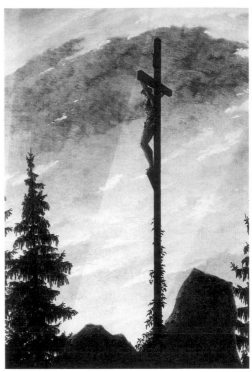

Caspar David
Friedrich,
*The Cross in
the Mountains,*
1808.

Caspar David
Friedrich,
*The Cross in
the Mountains,*
detail.

Caspar David
Friedrich,
*Procession at
Sunrise,* ca. 1805.

iii Pathfinders

HOW VERY UNORIGINAL, the vigilant art historian will object, this studied approximation of masonry and greenery. Next slide please. Here we have, beside Frederick Church's spontaneously blooming wreath, the tendrils of the vine curling about the limbs of the Savior in Caspar David Friedrich's famous *Cross in the Mountains*, the altarpiece that so provoked the anger of German critics by negating the difference between sacred art and landscape. Here, too, a dawn pilgrimage approaching the mystery of the verdant cross.

But originality is not the issue here; rather the opposite, in fact. For while American painters may have wanted to create something wholly fresh and radical, sparkling with the innocence of the Edenic New World, they were actually involuntary legatees, conscious or unconscious, of an ancient and persistent metaphorical tradition. And the veneration of native holy groves is all the more remarkable since many of those who put the woodland icons on their parlor walls were seldom wet-eyed sentimentalists. Patrons of Cole and Church like Luman Reed and Daniel Wadsworth doubtless prided themselves on their taste, but they were New York and New England merchants whose capital, invested in a thousand fruitful enterprises, was busy obliterating precisely the kind of woodland fetishes that they displayed on their walls. It was quite possible, though, for industrial capitalism and forest veneration to co-exist within the same personality. Bierstadt's vast elegy for the redwoods of the California coastal forest, complete with temple backlighting and Indian idyll, was commissioned to adorn the palatial residence of Zenas Crane, Massachusetts paper magnate and manufacturer of United States greenbacks.

American modernity, even in its most aggressively imperial forms, then, has been no more depleted of nature myth and memory than any other culture. Only blind obedience to the assumptions of the Enlightenment claims science and capitalism to be necessarily incompatible with natural religion. Two centuries of American culture in which both have flourished in a constant state of dynamic hostility—John Bunyan and Paul Bunyan lashed to the same steed —proves such assumptions unfounded. It is true, though, that at the beginning of this century the anthropologists busy codifying the ritual practices and symbols of "primitive" religion were profoundly divided on the issue that lies at the heart of this book: the persistence of myth. On the threshold of the age of sci-

ence, it was left to art historians and psychologists to take seriously the possi-
bility that myth and magic might obstinately make themselves felt, encoded in
symbolic forms, in a world where, as Rudolf Wittkower has put it, "our lives
are fenced in by rituals sunk to the level of conventions."[39] But a more domi-
nant and conventional view was the opposite: that the vitality and authority of
nature religions declined precisely to the degree that cultures were shaped by
scientific, empirically derived knowledge. And none believed this truism, inher-
ited from the Enlightenment, more categorically, even while he was laboring
in the forests of myth and magic, than the anthropologist Sir James Frazer.

A century after its original publication, it seems extraordinary that so few
noticed that the descriptive richness of *The Golden Bough*—the chaotic, fertile,
proliferating quality of the text—was at such complete odds with the philoso-
phy that underpinned it. In his brilliant biographical study of Frazer, Robert
Ackerman makes it clear that the Scottish rationalist was in
most respects an uncreative disciple of the sociologist
Spencer and the anthropologist Tylor. Like them,
he assumed that humanity's progressive evolu-
tion could be measured by the degree to
which it had cast off the myth and magic of
primitive religion.[40] The first volume of *The
Golden Bough* appeared in 1890, at the
apogee of imperialist confidence. And even
though he pitched his bivouac nowhere more
exotic than Trinity College, Cambridge,
Frazer approached "primitivism" as a relic of
prehistory. As far as he was concerned, the chal-
lenge of anthropological fieldwork lay in discovering
splendid anomalies that, at the end of the disenchanted
nineteenth century, had miraculously preserved, in darkest jungles or frosty
taiga, the living human reality of archaic cults.

Sir James Frazer.

It was not, of course, lost on Frazer, any more than on the great German
folklorist Mannhardt, on whom he depended for so much of his information
about tree worship and sacrificial cults, that elements of pagan animism had
indeed survived into Judeo-Christian theology. Indeed the demonstration of
such survivals was, for the ex-Calvinist rationalist, tantamount to discrediting
the creeds altogether. And here, as Ackerman argues so persuasively, Frazer dif-
fered (in his obtuseness, one is tempted to add) from the work of his friend and
mentor Robertson Smith. It was not just that Smith remained a believer
throughout his life. It was rather that his whole sensibility was open (in ways
that were closed to Frazer) to the possibility that the survival of myth actually
lent *greater,* not lesser, power to the core of religious belief. In this respect
Robertson Smith took exception to the British empiricism that dismissed out

of hand the idea that myths might be highly complex systems of understanding, with the power to generate and determine social behavior, rather than the other way about. For Frazer, on the other hand, they were simply "mistakes" that primitives make about their world (and especially the natural world), mistakes committed in the grip of ignorance and fear.

This unexamined rationalism was not actually a condition of Fellowship at Trinity. The great historian who became the college's master, G. M. Trevelyan, while presumably unfamiliar with the German and French traditions of cultural anthropology, nonetheless himself professed a nature religion that would have been wholly familiar to Coleridge and Friedrich von Schlegel, not to say Thoreau and John Muir.[41] And a philosopher as wholly analytical as Wittgenstein expressed his impatience at Frazer's crude positivism: his unreconstructed Enlightenment insistence that myths became elaborated only to help frightened savages cope with their incomprehension of natural process.

The oddest thing of all, as many readers and critics of *The Golden Bough* and some of Frazer's other books have noticed, is that the teeming compilation of information about sacrificial cults, drawn from cultures wholly disconnected in space and time, never seems to have led Frazer toward his desired conclusion. In fact, the quality of which he was so rightly proud—the descriptive vividness of his ethnography—actually pulls the reader in precisely the opposite direction from its author's intentions—toward the depths of the mythic forest, rather than the brightly mowed pasture of Frazer's intellect.

If indeed *The Golden Bough* has escaped from its creator, it may have migrated toward exactly the kind of cultural speculation that would have set Frazer's teeth on edge. For even before the war to end all wars had finally interred the Enlightenment in a muddy, bloody grave, there were those (Nietzsche, for example) who thought myth and modernity not at all irreconcilable. Some, indeed, like Carl Jung, who before the war dreamed dreams of vast oceans of blood engulfing the whole landmass of Europe up to the Alps, believed mythic archetypes to be necessarily imprinted on the deepest psychic structures of the human persona. To embrace myth and to readmit primitive religion in social behavior was not, for Jung, to flee modernity but to face up to it.

But not all those who acknowledged the fateful braiding together of myth and modernity were so satisfied with its consequences. For those made most anxious by its implications, like the great art historian Aby Warburg, a recognition of the limits, if not the impotence, of Enlightenment rationality was disquieting.[42] The predicament he got himself into, by taking myth as a serious vector of historical sensibility, was the obverse of Frazer's complacent cultural imperialism. For while the Scot seemed serenely untroubled by the fact that the *substance* of his empirical research was at odds with its theoretical rationale, Warburg came to agonize painfully over the fact that his greatest formal discoveries betrayed terrible truths. The most terrible of all was the truth that

brought him altogether too close to Nietzsche's beetling brows and unsparing, unstable imagination.

Beneath the smooth marble facade of classicism, there was, Warburg had discovered early in his career, a primal energy, periodically suppressed and controlled by rational discourse, but always capable of boiling up from its deep sources and engulfing civilization. In terms of the Greek myths, it was as though the troops of Dionysus, bloody and orgiastic, were constantly threatening to get the upper hand on the followers of the deity of music, poetry, and culture: Apollo. Even when that turbulent Dionysian energy had been converted into something like the musical delicacy of the fluttering drapery of Botticelli's and Ghirlandaio's nymphs, Warburg believed it was still driven by ancient urgings, *die ungebändigte Lebensfulle,* the unrestrained vitality of the earlier rites. So the nymph that seemed so decoratively insubstantial, he realized, was actually an "elemental sprite . . . a pagan goddess in exile."[43]

At Bonn University in 1886 Warburg had studied with the scholar Hermann Usener, who had made a career out of insisting on the survival of paganism into Christian ritual and theology. And during the early stages of his own scholarship on Botticelli, Warburg concerned himself with showing the comparable processes by which primitive myth and magic had evolved a symbolic repertoire expressed in Renaissance art and sculpture. But as time went on, the implications of these insights began to be more troubling. For the surviving pagan motifs all seemed to disrupt the smoothness of their integration into recognizably "civilized" works of art. The middle tier in the famous frescoes of the Palazzo Schifanoia in Ferrara, for example, appeared to be Greek, but Warburg recognized them instead as the time-demons of ancient Egyptian religion that had survived into the Renaissance in the form of astrological symbols. They would have been known to the patron of the work through the anthologies of pagan signs and emblems codified by such a scholar as Boccaccio.

Increasingly Warburg became possessed by his own time-demons, plunging more deeply into the social and psychological processes by which he thought the irrational and the primitive had become sublimated in art forms. If, after all, the merchant patricians of Florence had allowed the irrational and the archaic a place within their own ostensibly rational, humanist culture, was it not as likely that his own world, perhaps even his own Warburg *family* of merchant bankers, might harbor their own demons? Needless to say, Warburg was interested in Jung (though not in Freud). But it was from the social psychologist Richard Semon that he had taken the idea of an "engram": a conditioned nervous response to a particular, often alarming stimulus, biologically registered and transmitted but socially expressed in involuntary body language. (The instinctive, jerky extension of hands and legs made by frightened infants— now known as the Moro reflex—seems to be roughly what Semon had in mind.) For Warburg the cultural equivalents of these "engrams" were symbols:

17. *Quercus robur,* English oak, from John Evelyn, *Silva, or A Discourse of Forest-Trees.*

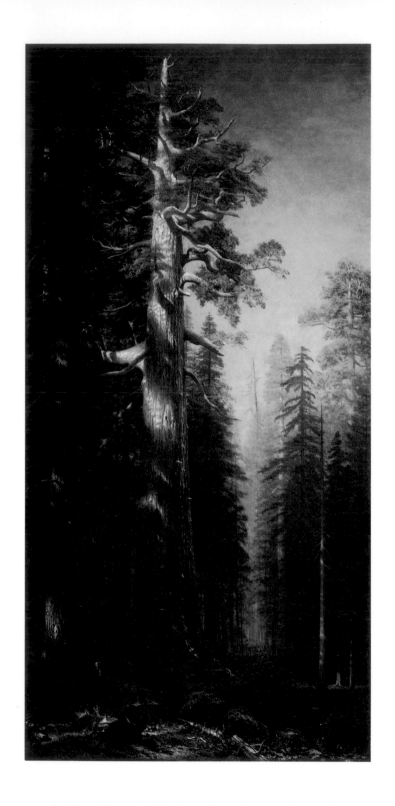

18. Albert Bierstadt, *The Great Trees, Mariposa Grove*, 1876.

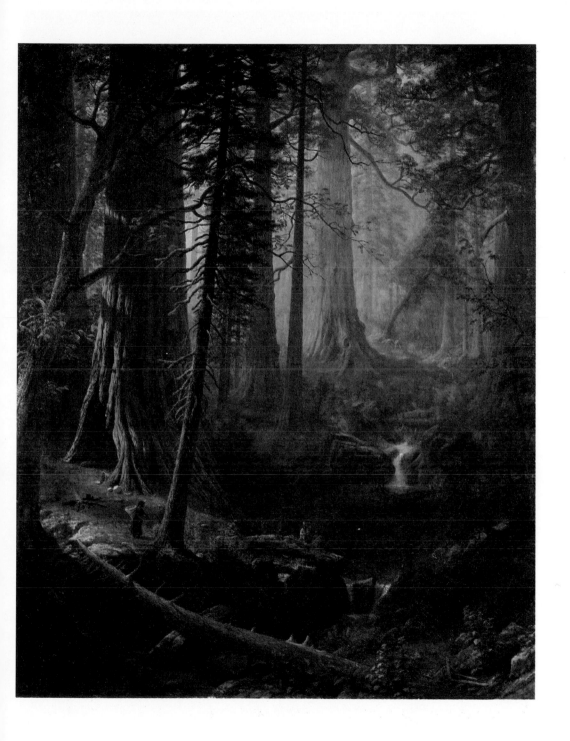

19. Albert Bierstadt, *Giant Redwood Trees of California*, 1874

20. Worthington Whittredge, *The Old Hunting Grounds*, ca. 1864.

21. Thomas Cole, *The Cross in the Wilderness,* ca. 1844.

22. Frederick E. Church, *To the Memory of Cole,* 1848.

23. Christ
on a tree-cross
between Mary
and John,
Ermengau
Master,
Breviary,
Toulouse,
1354.

24. Moses
before the
burning bush,
Lotharingian
Book of Hours,
late fifteenth
century.

25. Hendrick Goltzius, *Christ on the Tree of Life*, 1610.

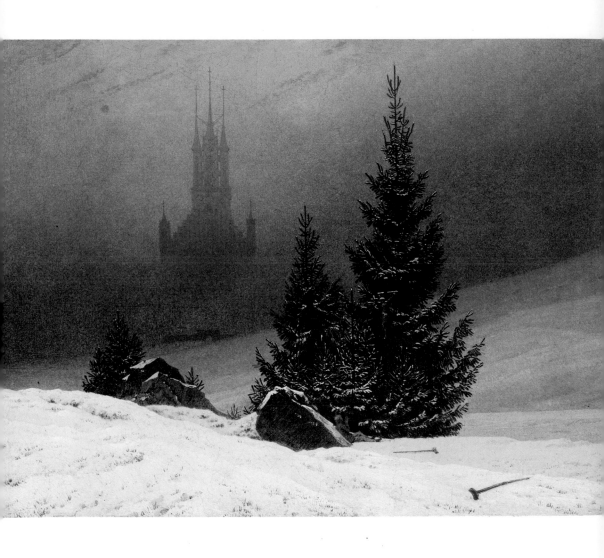

26. Caspar David Friedrich, *Winter Landscape*, ca. 1811.

devices that compressed within a visual shorthand ancient, indeed primeval beliefs and responses. So that what might to the incurious simply appear as stylized conventions would reveal themselves to the uninhibited archaeologist of culture as traces of terror or ecstasy. Warburg called such symbols *Leitfossils,* and when he stared at their delicately petrified imprint, he could conjure up, all too easily, the primordial monsters. To look hard at those symbols, to acknowledge their endurance, was, then, a risky business. For it was to unravel the sublimation of these Dionysian instincts embodied in the symbol itself. To give the symbol its real due, thus, meant going beyond the habits of the scholar, beyond classification and elucidation. It meant confronting, in their shapeless, frighteningly indeterminate form, the forces behind the device, all of which were necessarily unreasonable.

In pursuit of these imps, Warburg, in 1895, did something no self-respecting art historian of the Italian quattrocento would have dreamed of doing. He undertook an extraordinary journey into the desert of New Mexico to observe Hopi Indian rituals and ceremonies, especially the snake dances, in which the Indians, each August, threw live snakes at serpentine images of lightning to ensure the harvest rains.[44] And there in the sagebrush, with his Stetson on his head and his bandanna about his throat, Aby Warburg suddenly grasped the timeless universalism of the way symbols operate in our cultural consciousness. For the moment he dealt with the problem, like many of his contemporaries (not least Jung), in a relatively mechanical way, seeing them as devices that protected prescientific man from his fear of the inexplicable. But as time went on, Warburg began to lose this conventional confidence that knowledge could supersede symbol as a way of dealing with terror.

Increasingly incapable of adjudicating between the angels of thought and the demons of instinct, and prone at the best of times to fits of melancholy, Warburg gradually himself became a casualty of the unrelenting struggle. As Europe slid toward war, he, like Jung, began to have nightmares of the earth slopping in blood. This anguish, though, had not been preordained. As a young adult, Aby had had no trouble at all in identifying patriotically with the German Empire of Kaiser Wilhelm, serving as an officer-candidate in the army. Photographs survive of him posing before a fake equestrian landscape, improbably hoisted on a cavalry mount, his impeccable uniform completed by the pointed helmet. As Felix Gilbert has suggested, Warburg may even have seen the unapologetically martial state as an exemplar of the creative tensions between reason and unreason.[45] And when the conflict finally came in September 1914, he had no difficulty in viewing it as a struggle between the barbarian philistinism of the British and the saving civilization of the German Empire.

The problem was Italy. Ostensibly an ally, the Italian kingdom was flirting with defection to the Entente powers. Warburg was alarmed enough at this

possibility to propose the only contribution he could make: establishing a learned journal in the Italian language in Germany as a way of keeping the two cultures connected. A *Rivista* duly appeared under his editorship. But it was of no avail. Italy became an enemy in the spring of 1915 and Warburg, seething with a sense of personal betrayal, exclaimed, "It's a pity that one can't suddenly die from an attack of nausea. . . . Incidentally I will help annihilate Italy however and when I can."[46] It was as though the shades of Dionysus were determined to subvert his life's work, closing the German Institute in Florence, the institution that symbolized Warburg's efforts to reconcile "magic" and "logic."

As the war dragged on, Warburg's visions became sanguinary, as though all his pagan terrors had now sunk their fangs into the civilization he cherished. In 1918 the German military state was finally prostrated in defeat. Slaughter had consumed the world. And as Germany collapsed, so did Warburg, diving into a psychotic depression that landed him in a clinic for the mentally ill on the Swiss shore of Lake Constance for five dark years.[47] Paranoid that his research would be stolen, he would appear before his family in the sanatorium, his jacket pockets overflowing with manically scribbled notes on the pagan Furies.

And when his lucidity slowly came back, he proclaimed it by returning not to science but to magic, delivering a lecture in April 1923 before the inmates, clinical staff, and guests on the Hopi serpent rituals that he had studied almost thirty years before in New Mexico.[48] But while Warburg had gone to the southwestern desert in 1895 with conventional ethnographic views on primitivism, notions of the survival of "living relics" of the archaic past that were meat and drink to Frazer and

Aby Warburg.

his generation, his approach to the rituals after war and madness was quite different. Instead of stressing the *separation* between primitivism and the modern condition, he implied its connection through what he called, perhaps for the first time, "the archive of memory" (*Archiv des Gedächtsnisses*). The lecture must have been an astonishing moment: an affirmation to a clinic which presupposed the incommensurability of reason and unreason that they were, in fact, culturally inseparable. By declaring the permanence, the timelessness, of delirium, Warburg won his release from the asylum.

While he had been incarcerated his student Fritz Saxl had continued Warburg's work of accumulating the great library that would demonstrate the endurance and universalism of these symbolic types. The identification and classification of the symbols inherited from antiquity and transmitted through the generations of Western culture, safely summarized as the *Nachleben der Antike*, the "afterlife of classicism," became the official vocation of the "War-

burg school," first in Hamburg, later in London, where Mnemosyne, the goddess of memory, is literally inscribed over the doorway. At the level of social psychology, Warburg probably believed in the universality of a symbolic repertoire. But he was bored by the generalized banality of archetypes. He would not have been a believing Jungian. What interested him most was the eloquence of peculiarity. Which is why his famous epigram that "God lies in the details" was a carefully considered oxymoron. An unconventional metaphor, a strikingly strange and recurring motif (like a talking tree) could not be adequately accounted for by lazy invocations of "historical background" nor a dumbly mechanical dictionary of emblems. Tracking that motif from archaic sources through all the mutations and permutations of form and meaning over time would not only yield the deep connections between past and present; it would also reveal, somewhere along that road, its cultural and cognitive significance for human apprehension. This was not just art history, not even cultural history. It was the pursuit of truth, revealed not in some vast metaphysical Platonic design, but as a parti-colored mosaic of discrete pieces of our nature from which a coherent image might emerge.

It was, in fact, like a stamp album. Warburg loved postage stamps and was a passionate collector. And since he believed that nothing was too picayune to carry the imprint of an ancient motif, he was as likely to lecture on stamps (as well as heraldry, signs of the zodiac, pageants) as on the repository of his great stock of memory. Unlike Frazer, whose own contemporary culture was defined by the complete absence of primitivism, Warburg saw it lurking everywhere. Such was the sweetness of his wisdom that, like a boy who has decided not to outgrow his terrors, he chose as his last project, called *Mnemosyne,* what was in effect a gigantic vertical stamp album (though he called it an atlas): screens of photographs, organized by motif, and assembling (along with reproductions of paintings, prints, and drawings) travel posters, advertisements, and news photographs that struck him as bearing, wittingly or not, the memory of ancient lore. He would, I think, have hated the scholarly classification of such things as "ephemera," for in Warburg's mind, that was precisely what they were *not.* They were in fact evidence of longevity, of endurance, of an inescapable haunting. For where Frazer defined his own contemporary culture by the absence of the primitive, Warburg saw it everywhere. The last screen of *Mnemosyne* illustrated the survival of the orgiastic nymph, the maenad, with a photograph of a woman golfer following through with her nine iron.

Frazer wrote thousands of pages on the subjects of tree cults and rituals of sacrifice and resurrection, sited in the primitive grove. Warburg wrote, so far as I know, just one. But if I want to argue, against the grain of much environmental writing, that Western culture, even while it has been busy destroying forests, has been full, not drained, of such myths, it is the assimilated German Jew, exemplifying what another German philosopher of history, Wilhelm

Dilthey, called "the poetic imagination," rather than the unproblematically lapsed Scottish Calvinist, who had better be my guide. Had Frazer ever set eyes on the Big Trees of Mariposa and sampled the devotional literature that represented them as the pillars of a Christian temple, he would doubtless have attributed this to the peasant demography of American immigration. The verdant cross, on the other hand, a symbol of death proclaiming the vitality of organic life, would have been immediately recognizable to Aby Warburg as a felicitous oxymoron. We can assume as much, since the one page that he wrote on arboreal resurrection was, in fact, his last. He died of a heart attack at the age of sixty-three on October 26, 1929, in his house at Hamburg. When his wife, Mary, and his slavishly devoted assistant, secretary, and lover, Gertrud Bing, were going through his effects, they found a final entry in his diary, in verse, celebrating an apple tree in his garden which to all appearances had seemed dead, but which had, in the fall, suddenly burst into clouds of white blossom: Maytime in October, a mysterious resurrection.[49]

iv The Verdant Cross

In the fourth century A.D., in the Holy Sepulchre at Jerusalem, between the basilica and the rotunda, the emperor Theodosius I had erected a large golden cross, encrusted in gems and in the form of a burgeoning, flowering plant. And not long after, in fifth- and sixth-century Palestine, there appeared among pilgrims silver and terra-cotta ampoules supposedly containing drops of oil pressed from the "wood of life" that made up the Cross. Most of the examples that survive show the cross in the form of a living palm tree.

But the specifically palmate form of the tree-cross may also have a pagan source. The date palm, after all, was the very first fruit-bearing tree to be systematically cultivated five to six thousand years ago in ancient Sumeria and Mesopotamia. As the source of life in arid places, producing honey, bread, and even, according to Pliny, a kind of wine, it was venerated as exceptionally fecund.[50] (It does, in fact, have a long harvest period from July to November and can produce fruit for sixty or even eighty years.) Pliny also repeated one of the many stories of palms that perpetually revived themselves, new leaves constantly appearing at the site from which dead fronds had dropped. This gave the slender, prolific trees a magical aura of immortality. There was one such marvel

Holy oil
ampoule,
sixth century
Palestine.

that was shown to travellers as a witness to the birth of Apollo, much as the Mariposa Big Trees were said to have been contemporaries of the Christian nativity. And since the words for "palm" and "phoenix" were interchangeable in both Greek and Egyptian Coptic, it was possible for the creator of the early Christian mosaic in Santa Prassede in Rome to show the haloed bird actually perched on a palm bough, the light of his immortality illuminating the apostles below.[51]

Within the structure of the myth, then, it was neatly economical for the engravers of the ampoules to represent the adored Christ as a nimbused head atop a palm which becomes both his and the tree's trunk. Not surprisingly for an icon featuring a self-replenishing plant, the verso face usually represented the Resurrection.

The botanical cross was rapidly translated into the iconography of the Christian West, where it put out multiple shoots. But sometimes traces of pagan prototypes hung on the branches. A decorated capital *T* (for *Te Igitur*) in a ninth-century Metz breviary in which the cross is formed from vines also includes a pair of oxen at the base and twin sacrificial lambs at either end of the crosspiece.[52] Generally, this signified the victory of the new faith over the old, and in time classical icons like the oxen were replaced at the base of the cross by the serpent of Genesis.

The most austere and militant of the early church fathers were certainly aware that using trees and flowers to symbolize the death-that-is-no-death might come perilously close to outright idolatry. Formidable iconoclasts like St. Eligius, the bishop of Noyon, warned the faithful to obey scrupulously the commandment of Deuteronomy 12.2 to "utterly destroy all the places, wherein the nations which ye shall possess served their gods, upon the high mountains, and upon the hills, and under every green tree."[53] But tree cults were everywhere in barbarian Europe, from the Celtic shores of the Atlantic in Ireland and Brittany, and Nordic Scandinavia, all the way through to the Balkans in the southeast and

Breviary, ninth
century, Metz.

Lithuania on the Baltic. And since the latter province was thoroughly converted only in the fourteenth century, it is still possible to find startling "graveyards" where, instead of conventional crosses, wooden totems, their forms unaltered from paganism, crowd together in antic disorder.

A debate ensued between radical iconoclasts, intent on extirpating idolatry root and branch, and pragmatists. Among the latter was the formidable pope Gregory the Great, who at the very beginning of the seventh century wrote to the abbot Mellitus (then on a mission to heathen England) advising him to take a tolerant attitude toward pagan practices, since

> from obdurate minds it is undoubtedly impossible to cut out everything at once, just as he who strives to ascend to the highest place rises by degrees and not by leaps.[54]

Armed with this kind of authorization, many of the shrewder proselytizers grafted Christian theology onto pre-existing pagan cults of nature. In Ireland, for example, Lisa Bitel has discovered that monastic cells and hermitages were established on the ancient woodland pagan altars called *bili*. The idea was to graft, rather than uproot.[55] Pope Gregory explicitly counselled Mellitus to establish churches on the site of pagan groves.

> When this people see that their shrines are not destroyed, they will be able to banish error from their hearts and be more ready to come to the places they are familiar with, but now recognizing and worshipping the true God.[56]

In the Latin world, as Frazer reminded us, the ancient Roman cult of Atys may have helped, rather than obstructed, the work of evangelism. On the face of it, Atys does not seem promising conversion material. Driven by the jealous and vindictive Cybele to a madness that ends in self-castration, Atys (in one of those interventions that Jupiter so enjoyed) is transformed into a pine tree. But the cult, celebrated in imperial Rome with Dionysiac abandon, was a ritual of sacrifice and vegetable metamorphosis. Close to the spring equinox, dendrophors—ritual tree-carriers—were sent into the woods near Rome to cut a sacred pine. Garlanded with anemones signifying the blood of the slaughtered Atys, the tree became the fetish of festivities that also included flagellation and self-mutilation followed by a day of *hilaria*, or rejoicing, to greet the divine resurrection on the day of equinox itself. Pigs stood in for the martyr and their blood flowed to make the spring propitious. In some places the flesh and blood of Atys were consumed through the symbolic communion of bread and wine.[57] And throughout the whole area of the cult the death of Atys was associated with evergreen resurrection, celebrated in the season the Christians would call Easter.[58]

Even the most dramatic acts of evangelical tree surgery were ambiguous. None was more famous than that described in the monk Willibrord's life of St. Boniface. Relating the saint's mission to the Hessians in 723, he reported that "some were wont secretly, some openly, to sacrifice to trees and springs, some in secret and others openly." Boniface's response seemed unequivocal:

> With the advice and counsel of these last [converts] the saint attempted, in the place called Gaesmere (Geismar), while the servants of God stood by, to fell an oak of extraordinary size which is called by the old name of the pagan oak of Jupiter [almost certainly Wotan]. When, in the strength of his steadfast heart he had cut the lower notch, there was present a great multitude of pagans who in their souls were most earnestly cursing the enemy of their gods. But when the front of the tree was cut into only a little, suddenly the oak's vast bulk, driven by a divine blast from above, crashed to the ground, shivering its crown of branches as it fell, and as if by the gracious dispensation of the Most High, it was also burst into four parts and four trunks of huge size. . . . At this sight the pagans who had cursed, now believed and blessed the Lord and put away their reviling. Then, moreover, the holy bishop, after taking counsel with the brethren, built from the timber of the tree, a wooden oratory and dedicated it in honor of St. Peter the apostle.[59]

It is often said that the source of Boniface's determination was his own native landscape of Devon, dotted with obstinate tree cults, not least that of the Celtic yew, which still decorates Devonian churchyards as an emblem of immortality. But it's at least as plausible to offer an opposite interpretation, namely, that his familiarity with local animism may have given him a healthy respect for its power. After all, Willibrord's story, ostensibly a conversionary miracle, actually demonstrates the ways by which pagan beliefs could be turned to Christian ends. The "divine blast" that helped Boniface fell the oak is identical with the pagan lightning bolts which in Celtic and Germanic lore mark the tree as a tree of life. According to Pliny, the Druids believed mistletoe to grow in precisely those places where lightning, dispatched by the gods, had struck the oak. In related traditions its interior was thought to be the abode of the spirits of the dead. So Boniface's axe transformed rather than destroyed. The spiritually dead pagans were turned into living believers. The rotten (perhaps hollow) trunk of the idolatrous tree was turned inside out to reveal four perfect, clean timbers, from which a house of the reborn and eternally living Christ could then be constructed.

Sometimes the hijacking of pagan myths could be shameless. At Trier, where there had been a thriving Bacchic cult to go with its wine production,

Bishop Nicetius, in the middle of the sixth century, took the composite leaf-mask capitals from a nearby ruined Roman temple and set them on the piers of his new cathedral.[60]

Green Men like the Trier mask grin and grimace from so many bosses, vault ribs, and piers in European churches that they somehow manage to become invisible to the casual gaze. So we fail to register the grotesque incongruousness of fertility fetishes, vomiting greenstuff from their stretched mouths into the house of Christ. In Trier the church fathers may have become embarrassed by the intruders since the leaf-men were walled up in the twelfth century. But at exactly that time an even more spectacular example of tree idols appeared in the projections over the south portal at Chartres Cathedral. There, the foliate heads seem to have been chosen by Abbot Thierry with an eye to their suitability for Christian conversion. Thus the Bacchic vine, with bunches of grapes hanging from his mischievous whiskers, served as the pious sign of the eucharist; another head, disgorging acorn-loaded oak twigs, alluded to the Druid temple over which the church was said to have been built; and the frontal head of acanthus (the phoenix-plant of the Latins) represented yet another botanical icon of rebirth and resurrection.[61]

Why should Christianity have denied itself the irresistible analogy between the vegetable cycle and the theology of sacrifice and immortality? Had it been adamantly ascetic, Christianity would have been unique among the religions of the world in its rejection of arboreal symbolism. For there was no other cult in which holy trees did not function as symbols of renewal. Even a summary list would include the Persian Haoma, whose sap conferred eternal life; the Chinese hundred-thousand-cubit Tree of Life, the Kien-mou, growing on the slopes of the terrestrial paradise of Kuen-Luen; the Buddhist Tree of Wisdom, from whose four boughs the great rivers of life flow; the Muslim Lote tree, which marks the boundary between human understanding and the realm of divine mystery; the great Nordic ash tree Yggdrasil, which fastens the earth between underworld and heaven with its roots and trunk; Canaanite trees sacred to Astarte/Ashterah; the Greek oaks sacred to Zeus, the laurel to Apollo, the myrtle to Aphrodite, the olive to Athena, the fig tree beneath which Romulus and Remus were suckled by the she-wolf, and, of course, Frazer's fatal grove of Nemi, sacred to Diana, where the guardian priest padded nervously about the trees, awaiting the slayer from the darkness who would succeed him in an endless cycle of death and renewal.[62]

It was to be expected, then, that Christian theology, notwithstanding its official nervousness about pagan tree cults, would, in the end, go beyond the barely baptized Yggdrasil of a twelfth-century Flemish illumination where the boughs of the world-tree support paradise.[63] But it was only when the scriptural and apocryphal traditions of the Tree of Life were grafted onto the cult of the Cross that a genuinely independent Christian vegetable theology came into being.[64]

The original source was the text in Genesis 2.9 that specified not one but two trees in the Garden of Eden: the fatal Tree of the Knowledge of Good and Evil and the vital Tree of Life. When Adam and Eve are evicted for having sampled the fruit of the former, the Lord God "placed at the east of the garden of Eden Cherubims, and a flaming sword which turned every way, to keep the way of the tree of life."[65] From the very beginning, then, they are planted together as necessary opposites; the Tree of Life guarded so that, in the form of the Cross, it could redeem the Fall. In chapter 7 of the first-century apocryphal Gospel of Nicodemus, Christ enters hell to liberate the dead from Satan and, taking Adam's hand, announces:

> "Come with me all you who have suffered death through the tree which this man [Adam] touched. For behold I raise you all up again through the tree of the cross."

Sometimes the tree announced its own destiny as it did in Anglo-Saxon to the tenth-century writer of the *Dream of the Rood*. In his vision the forest tree describes its own physical fate—hacked, felled, and torn as if it were a surrogate for the torments of Christ. So when it receives the body of the Savior, the substance of the tree and the Messiah dissolve into each other in a single organism of death and redemption. Rightly could the tree say, "They pierced *me* with nails. . . . /They marked us together/I was all bedewed with blood."[66]

No taxonomist, the tree of the *Dream* unhelpfully fails to identify just what kind of tree it is. But perhaps this was just as well since an entire genre of literature developed in which the varieties (oak, ash, holly, and yew in the Frankish north; olive, cedar, fig, and cypress in the south) dispute their respective claims to have constituted all or part of the Cross. And the timber history of Christ— born in a wooden stable, mother married to a carpenter, crowned with thorns and crucified on the Cross—helped elaborate an astonishing iconography. As a source, scripture was supplemented with the various versions of the Legend of the True Cross. In a twelfth-century version Adam, nine hundred and thirty-two years old and (understandably) ailing, sends his son Seth to fetch a seed from one of the Edenic trees. Returning, the son then drops the seed in Father Adam's mouth, from where it sprouts into sacred history. It supplies a length for Noah's ark (a first redemption), the rod of Moses, a beam in Solomon's temple, a plank in Joseph's workshop, and finally the structure of the Cross itself.[67]

The image of the verdant cross, then, expressed with poetic conciseness the complicated theology by which the Crucifixion atoned for the Fall. And it imprinted itself on virtually every kind of sacred article through the Christian Middle Ages from a ninth-century breviary in the Benedictine abbey of Corvey, where the serpent snakes about the base of a palmate cross, through the great

mosaic in the apse of San Clemente in Rome, where the cross rises from a vast acanthus, to a fifteenth-century breviary by the Ermengau Master (color illus. 23), in which the bent boughs of the palmate cross rhyme with the mortified rib cage of the suffering Christ.[68]

There was more than one iconographic route to the vernal resurrection. In cathedral windows (at Chartres, for example), and in psalters, breviaries, and Books of Hours, a tree sprouts from the loins of Jesse and rises heavenward to the Passion, with the Father observing from its crown. So the wooden elevation rises from its carnal root to its celestial crown, from matter to spirit. Other holy plants were variations on the dead-and-alive theme. In a late medieval Lotharingian Book of Hours, for example, Moses witnesses not one but two botanical miracles (color illus. 24). The bush that burns and burns but is not consumed is host not merely to the commanding voice of God but to a riot of flowers that defeat the licking flames. But beside it is the emblem of paganism: an ancient, Germanic oak, eaten away with heathenism. Yet from the center of its dead trunk the May-blooms of resurrection rise in triumph; a spring blossoming that continues into the glorious paradise garden that decorates the margins of the page.

The miraculous transformation of dead into living wood supplied one of the most prolific motifs of the Christian tradition. The Tree of the Knowledge of Good and Evil, for example, dry since the Fall, was said to have developed green shoots at the time of the Resurrection. In Giovanni da Modena's *Mystery of the Fall and Redemption of Man* in the church of San Petronio in Bologna, Adam and Eve stand in contrite atonement on the thorny side of the tree cross while Mary, with a chalice to catch the vinous blood of the Savior, stands beneath its leafy branches with the apostles and fathers of the church.

Sacred plants and trees developed a reputation for blooming at Christmas and rapidly developed their own cult of veneration and pilgrimage. Not far from Nuremberg, according to a fifteenth-century writer, an apple tree revealed itself on Christmas Eve to be heavy with *both* blossom and fruit, a miracle at once botanical and theological.[69] A hawthorn tree that stood on a hill outside the town of Glastonbury in Somerset was said to have grown in the precise place where Joseph of Arimathea, on a mission to southwest England, had planted his staff. On the next day the staff had taken root and was in full blossom, and from then on was expected to repeat the miracle each Christmas. And though the iconoclastic Puritans deliberately destroyed the Glastonbury Thorn during the Civil War in their campaign to uproot idolatry, local royalists were said to have taken cuttings and replanted them elsewhere, ensuring both the survival of the tree and, no doubt, the survival of the line of Charles I, the martyr-monarch, who was said by pious loyalists to have inherited the Savior's crown of thorns. In 1752 the change from Julian

to Gregorian calendars decreed by the government caused great uncertainty at Glastonbury as to which Christmas, the old or the new, would be proclaimed legitimate by the blooming of the Thorn. On the twenty-fourth of December (new style), the tree's failure to bloom seemed to vindicate the suspicions of the calendrical conservatives that the change had been some sort of diabolical conspiracy. And when, on the fifth of January, the first little white flowers opened, the thousands of faithful who had gathered, holding lanterns and candles, determined to celebrate Christmas on the day consecrated by the tree.

Giovanni da Modena, *Mystery of the Fall and Redemption of Man.*

As long as Christian Europe remained relatively unified during the Middle Ages, dead-and-alive trees were rendered within a single image or ritual. In Piero della Francesca's *Resurrection* at San Sepolcro, for example, the risen Christ stands holding the blood-red cross banner between the dry and the green trees, wonderfully transplanted from Eden to Tuscany. But as the fissures in the *congregatio fidelium* began to open and gape, so the trees began to represent irreconcilable opposites: the Old and New Testaments; the synagogue and the church; sin and salvation; Satan and Christ; death and life. In Johannes von Zittau's version of the chastisement of disobedience, the two trees are still mysteriously braided together with the serpent. But Eve and the Virgin are counterpointed as sacred and profane fruit-pluckers. So while Mary presents the fruit of her womb on the left, Eve offers hers as a death's-head to a stubborn crowd of pointy-hatted Jews on the right.

In the Protestant art of the next generation, these divisions actually shape the formal composition of the paintings. Holbein and Cranach the Elder both

produced allegories of
the Fall and the Pas-
sion, bisected down
the center by a tree that
is dead on one side,
green on the other.
Almost nothing in the
engraving after a panel
from Cranach's work-
shop is without its sym-
bolic opposite. The
lamb, the wound, and
the Holy Spirit on the
"green" side are paired
with the Fall and the
descent into hell
(observed by the Jews)
on the other.

Piero della
Francesca,
Resurrection,
1463.

And for all the
Reformation's hatred
of Catholic icons, Lutheran printers were not above borrowing them for their
own theology. Heinrich Vogtherr's woodcut of 1524 is a good example of how
the old Pauline tradition of the "Tree of Faith" (a variation on both the Tree
of Jesse and the Ages of Man) could re-emerge from a great bath of Lutheran
wordiness as an impeccably orthodox Protestant image. The roots of the tree
are embedded in *Gottes Wort,* and, tended by apostolic gardeners, the tree
ascends directly (without any pruning or grafting by the clergy!), via faith (the

heart), to the mouth
of Understanding,
and higher still to
Christ crucified on
a palm tree sur-
mounted by the
Holy Spirit and
finally the Father.

It was the
Counter-Reforma-
tion's stroke of
genius, of course, to
brandish exactly the
signs, symbols, mys-
tery, and myths

Workshop of
Lucas Cranach,
engraving,
*Allegory of the
Fall and the
Passion.*

Heinrich
Vogtherr,
Glaubensbaum,
woodcut, 1524.

which Protestant asceticism had ordered obliterated. So in the century between 1550 and 1650, a great forest of holy trees and verdant crosses sprouted in churches, chapels, and wayside shrines. And though the Jesuits were the stage directors of the new devotional theater, it was Franciscan tradition that gave the church these sacred arbors. The *lignum vitae* had been the site of St. Bonaventure's meditations on the Tree of Life, and it reappeared in all manner of prints, paintings, and even sculptures. In the fourteenth century Taddeo Gaddi had painted a spectacular Passion for the refectory of Santa Croce in Florence, in which the cross appears as a twelve-branched tree (for the apostles), each laden with the fruit of the Gospels.

Nearly two centuries later the greatest graphic artist of the Catholic Baroque, Jacques Callot, etched two trees of the living dead. They are not usually associated with each other. The horrifying print from the *Petites misères de la guerre*, with its harvest of hanging corpses, has been read, long after Callot

Taddeo Gaddi, *The Tree of the Cross (The Tree of Life)*, mid-fourteenth century.

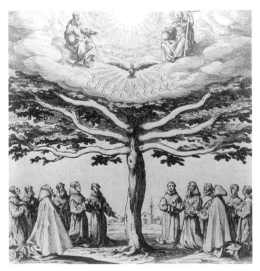

Jacques Callot, etching, *Tree of St. Francis*, ca. 1620.

Jacques Callot, *The Hanging Tree*, etching from *Les Petites misères de la guerre*, 1633–35.

was dead and forgotten, as a pacifist protest against the Thirty Years' War. But Callot was a devout and ardent Catholic and it is much more likely that the moral behind the whole series was one of Christian acceptance and stoicism rather than any kind of radical dissent. If we set it alongside his other tree, drawn and engraved at the same time, around 1635–36, their relationship seems to echo the ancient Christian traditions of dead and living trees; of the world and the spirit; of knowledge and life. Callot's *Tree of St. Francis* modifies the Franciscan piety of the Gaddi fresco to a more missionary form. Twelve apostles venerate the tree in which the Trinity is seated and where the holy flame of the evangel illuminates the gospel fruit. The figure of Christ himself has ostensibly disappeared, like some pagan divinity, back into the substance of the tree,

Jacopo Ligozzi, *The Beech Tree of the Madonna at La Verna*, 1607.

where, however, it is unmistakably present in the anthropomorphic trunk and branches.

Because of the saint's strong associations with Christianized nature worship, the Franciscans of the seventeenth century seem to have produced a particularly emphatic tradition of Savior-Trees. For his series of drawings of the mountain retreat of Monte Verna in Piedmont, the Florentine artist Jacopo Ligozzi drew *The Beech of the Bell*, where the tree trunk plainly echoes the twisted form of the crucified Savior. And in a still more startling image, a second cruciform beech not only seats a vision of the Virgin and child in its branches but uses a hollow cavity to suggest the tomb of the Resurrection, neatly incorporating all three elements—Nativity, Passion, and Resurrection—within a single vegetable form.

Verdant crosses were not the exclusive property of the Counter-Reformation. The most beautiful and startling example I know was painted by the great Dutch humanist Hendrik Goltzius toward the end of his life, in 1610 (color illus. 25). His whole career had uneasily straddled confessional allegiances, neither militantly Catholic nor formally Protestant. His teacher, the engraver and scholar Coornhert, had been Erasmus's student, and in many ways Goltzius's *Tree* is a typically Erasmian compilation of motifs ancient and modern, pious

and secular, devotional and poetic. The living cross on which the crucified Christ hangs is specifically an apple tree in fruit. But the textual source is from the Old Testament, chapter 2 of the Song of Songs:

> As the apple tree among the trees of the wood, so is my beloved among the sons. I sat down under his shadow with great delight, and his fruit was sweet to my taste.

Jesus is, of course, the fruit, the apple lying in Mary's lap. But he is also the fruit plucked by the flying, apple-cheeked cherub whose face, in the Mannerist idiom of the time, bears an expression of such calculated sweetness that it almost convinces the beholder that the Passion was, after all, worth the pain. The scene is all the more astonishing in that while Goltzius has given Christ the head of a human in the throes of torment, his body goes well beyond the twisting conventions of Mannerist modelling. The arms are muscled to follow the natural knots and swellings of the tree's branches; the torso clings and covers the trunk as if it had indeed become indivisible from the wood. And the line that projects forward following Christ's fluttering loincloth is extended backward along the leafy sprig of new growth.

Is it possible, too, that this anthem to suffering and rebirth was not merely a theological allegory? Frima Fox Hofrichter, who first commented on the painting in 1983, added the intriguing historical footnote that Haarlem, where Goltzius presided over the founding generation of northern Netherlands artists, had the *dorre boom,* the "burnt tree," as a civic emblem. In the siege and sack of the city in 1572–73, Spanish troops had burned its woods and outlying orchards. And Goltzius's patriotic sympathies are well known from his engravings. His own spectacular contribution to the verdant cross tradition might easily have functioned as a symbol of civic as well as spiritual resurrection.

The phoenix-tree had travelled a clear millennium from the crude little terra-cotta vessels of sixth-century Palestine to the leafy apple tree of Haarlem. But it still had some way to go.

v Tabernacles

Eden was a garden, not a forest. It had just two trees, both assigned, as we have seen, ominous destinies. And for all the burgeoning, sprouting, budding, and

leafing of the verdant crosses, they are seen either alone or with their evil twin, The Knowledge.

Could a whole *forest* be a Christian place? To read the fulminations of the fathers of the early church against heathen groves one would suppose not. And some, to be sure, had inherited the Roman and Jewish dread of the somber woodland depths. But as we have already seen, our impression of early medieval Europe as marked by abrupt boundaries between cleared and wooded space is an anachronism. There were all kinds of intermediate zones where a coppiced understory supported a busy society of men and animals. From at least the seventh century, then, many monasteries were established in woodlands not as retreats but to take advantage of the thriving natural economy, and left their marks on place names like Waldkirch and Klosterwald.[70]

Which is not to say that there were no true forest hermits. From Ireland to Bohemia, penitents fled from the temptations of the world into the woodland depths. In solitude they would deliver themselves to mystical transports or prevail over the ordeals that might come their way from the demonic powers lurking in the darkness. The indeterminate, boundless forest, then, was Europe's version of the Hebraic desert wilderness (to which it was often compared): a place where the faith of the true believer would be put to the severest tests. But it was also a site of miracles where stags would appear bearing the holy cross in their antlers, and the leprous and the lame could be suddenly cured with a root or a bough.[71]

Alas, it was not easy to protect holy seclusion. Once established in anchorite solitude, many hermits became so famous that they attracted throngs of pilgrims. A few attempted to shrug off this unfortunate popularity by retreating into still more remote sites. But others accepted their paradoxical fate by becoming charismatic preachers like Peter the Hermit, who, at the end of the eleventh century, delivered fiery sermons before vast crowds that urged a great crusade for the Holy Land. Others institutionalized collective seclusion by founding monasteries of penitents, trying, at least, to site them in the midst of marshes or atop inaccessible mountains.[72]

Ultimately, though, the gardeners prevailed over the hermits. The hagiographies are full of stories of sainted holy men like Ermelande turning his eighth-century monastery on a forested island of the Loire, "set in the densest and darkest woods," into a virtual paradise.[73] Such places had their wildness, barbarism, and paganism defanged so that savage beasts such as wolves, snakes, and bears became tame and even companionable and the grim habitat began to bloom with flowers and fruit.

It was only in the late Middle Ages, though, that paradise turned sylvan. For at the same time that Dante was perpetuating, in the very opening stanzas of the *Inferno,* the ancient Roman idea of the dark wood as a place where one lost one's way, the beckoning antechamber of hell, the architects and decora-

tors of Gothic churches in the north were busy creating a woodland version of
heaven. The nineteenth-century architect and advocate of Gothic restoration
Viollet-le-Duc seems to have been the first to notice that while early Gothic
botanical ornament contented itself with buds and scrolled leaf-shoots, later
centuries witnessed an extraordinary unfurling. In a magisterial essay the art
historian Karl Oettinger documented this profuse fifteenth-century sprouting
of arborescent and vegetable forms on porches, pulpits, choir stalls, mon-
strances, and screens. The proliferation of organic plant-forms—tendrils,
leaves, twigs, boughs, and arbors—was not, he argues, simply a matter of dis-
crete decoration but part of a coherent program to make the church over into
a paradise garden.[74] The wooden door to the castle church at Chemnitz, for
example, built around 1525, was actually fashioned to resemble tree branches
bent over to form a natural archway.[75] So at the same time that Conrad Celtis
and his followers were reclaiming Germany from Italian cultural domination by
reviving the traditions of the ancient woodland, the abbeys and churches of
Germany and Austria were, in effect, depetrifying themselves.

In both cases, the embowering was necessarily at the expense of classicism.
The great text on the origins of building, Vitruvius's *De architectura,* probably
written in the first century B.C., provided the earliest narrative of the way in
which architecture had evolved from the primitive hut. According to Vitruvius,
following the accidental discovery of fire, savage men gradually fashioned rudi-
mentary shelters from mud and leaves and twigs in imitation of the nests of
birds and beasts. He then cited tribes in Gaul and Spain which continued to
use whole tree trunks to create a structure which, in its essence, was a primitive
form of the constituents of classical architecture: columns, entablature, and
pediment. And as Joseph Rykwert, Alain Jouffroy, and others have noticed, it
probably is no coincidence that about the time that Vitruvius's book was first
being printed, Piero di Cosimo painted a series of panels illustrating the habi-
tat and mythology of primitive man. And in the background of *Vulcan and
Eole,* where fire is being harnessed to a forge, and an ancestral family group is
seated on a woven cloth, another group of men, naked except for loincloths,
hammers out just such a timber building.[76]

This fascination with the timbered origins of architecture is not to be con-
fused with nostalgia, though. A report written by a "pseudo-Raphael" for Pope
Leo X recycled Vitruvius's ur-history but also complained that the barbarian
cultures that had invaded Rome had vandalized classical buildings and replaced
them with versions of their primitive buildings.[77] These took the form of
bizarre and unsound structures, encrusted with crude and structurally mean-
ingless decorations of leaves and animals. Graceless and architecturally miscon-
ceived though such structures were, they owed their pointed arches to the
bowing together of uncut tree branches.[78] "In their buildings," wrote another
aggrieved classicist, Vasari, "which are so numerous that the whole earth is

infested with them, we see doors ornamented with slender columns, twisted like vines incapable of supporting even the lightest weight. On every face of these buildings has been placed such a swarm of little tabernacles. . . . May Heaven preserve every good country from following these detestable fancies whose ugliness forms so great a contrast with the beauty of our works that they do not deserve to be spoken of any more."[79]

This grudging interest in "arboreal Gothic" in the hands of contemporary German builders became a flamboyant boast. For whoever created the Sigmaringen Monstrance around 1505 or the arborescent rib-vaulting at Seefeld in the Tyrol proclaimed something like the opposite of classical theory. Instead of conceiving sacred space as a shelter closed off against the forest

Piero di Cosimo, *Vulcan and Eole,* ca. 1495–1500.

wilderness, it was meant to embody it. Of course, pointed arches, rib vaults, and trefoil windows had been in existence for centuries before this highly self-conscious turn toward a theory of origins. But the embrace, rather than the rejection, of sylvan nature, and the attempt to inscribe organicism into the features of the building itself, to dissolve the boundaries between nature and architecture, was, as Oettinger implies, truly revolutionary. It was, in fact, the culmination of the long process by which the ancient Germanic and Celtic pagan groves had become fully converted to Christian use. But what had happened here? Had the woods become subdued by the priesthood or had the cathedral gone green?

Had, for that matter, the female incarnations of the fecund earth—Gaia and Artemis—become absorbed into the fruitful Virgin? Even before the Reformation Marian iconography had often set the Virgin in the center of the paradise garden, surrounded by flowers, fruit, and leafy trees. But through the sixteenth and seventeenth centuries a true cult of rustic pilgrimage developed, often marked by wayside shrines and chapels. Those shrines held images of the Madonna and child carved from limewood and were sometimes themselves crudely fashioned out of the trunk of a tree.[80] In Bavaria and the forested region

of southern Germany and Austria, a whole chain of Marian pilgrimage churches and hermitages were built. Jakob Balde, a Jesuit poet, wrote an ode to one of them, the Tyrolean Maria Waldrast (the Forest Rest), as if the woods and the chapel were extensions of each other: benign, peaceful, a place where a foot-sore palmer could rest, undisturbed by the least hint of savagery from man or beast.[81]

So even during the period when Gothic architecture had fallen furthest from favor—from the mid seventeenth to the mid eighteenth century—sacred naturalism was preserved in the Baroque and rococo churches of Catholic Germany and Austria. Amidst flights of gilded cherubs, massed hosts of aerial saints, celestial swags, and scrolls and baskets laden with fruit, vine tendrils twine themselves about columns and delicate tree trunks reach for the dizzy ceilings. There is nothing of the gloomy groves about such places. They present instead a spectacle of enchantment, a radiantly lit tabernacle ventilated by gusts of spiritual good cheer. No wonder God's greenery in such places seems so irrepressibly fertile.

It was not a Bavarian monk, however, but a Whig bishop who provided the most powerful reinforcement for the connection between the forest and sacred architecture. In his 1751 edition of the works of Alexander Pope, Bishop Warburton chose Pope's "Epistle to Lord Burlington" as a prompt for an extraordinary digression on the origins of Gothic architecture. The choice of text was not arbitrary. Burlington had been the leading exponent of Palladian classicism in early eighteenth-century England. His villa at Chiswick was a slavish (if very beautiful) version of Palladio's Villa Rotonda at Verona, and his influence set the tone and taste of Georgian country-house building for an entire generation. So Warburton's history of the origins of Gothic architecture was more than an esoteric footnote. It was a pious dissent against the dictatorship of the classical temple. "Our Gothic ancestors had juster and manlier notions than modern mimics of Greek and Roman magnificence," for they were more concerned with spiritual exaltation than civic pomp.

Warburton went on to supply a fantastic history in which the Visigothic conquest of Spain, when brought into contact with Moorish arabesques and pointed arches, produced a wholly new kind of architecture. With its soaring verticality and slender columns, these new buildings were conscious imitations of the natural structure and appearance of the ancient Germanic groves. "Could the Arches be otherwise than pointed when the workman was to imitate that curve which branches make by their intersection with one another? Or could the columns be otherwise than split into distinct shafts when they were to represent the stems of a group of trees?" Likewise, stained glass was said to imitate the openings between leaves, "concurring to preserve that gloomy light inspiring religious horror." Even the warmest admirers of Palladio, Warburton remarks (to Burlington's shade), must concede that Gothic architecture, what-

ever its qualities, had a nobler origin than classical.[82] The Georgian in him came to the fore, however, when he concluded that the mark of the success of Gothic builders was that "no attentive observer ever viewed a regular avenue of well-grown trees, intermixing their branches overhead, but it presently put him in mind of the long Visto through a Gothic cathedral." A generation later, the merits of Gothic would rest on the reversal of those priorities!

Warburton was by no means the first to offer these observations. In 1724, for example, William Stukeley's *Itinerarium Curiosum* had cited the cloisters of what would be the bishop's own cathedral in Gloucester as suggesting the arboreal origins of Gothic. But after Warburton, decorated Gothic attracted a

Paul Decker, engraving from *Gothic Architecture Decorated*, 1759.

whole new generation of defenders, and even those who tried to create a new rustic form of building. In 1759, for example, Paul Decker's *Gothic Architecture Decorated* showed a "Hermitic Retirement Chiefly Composed with Rock Branches and the Roots of Trees," and we may owe the origins of the rustic garden bench to the same author.

Much of the interest, though, was confined to trifles and follies. Houses touted as Gothic, like Horace Walpole's Strawberry Hill, were nothing but an aggregate of decorative details superimposed on a conventionally classical pavilion. And as long as a complacent rationalism prevailed, the arboreal affinity would only reinforce the view that Gothic was the architecture of "supersti-

tion," which fully deserved ignominy and oblivion along with the rest of the rituals and theology of the Christian cult.

All this changed in the middle decades of the eighteenth century. In 1753 the ex-Jesuit Marc-Antoine Laugier published his *Essay on the Origins of Architecture*. Laugier recycled Vitruvius's account of the beginnings of human habitation but represented primitive man as using tree timber only after becoming dissatisfied with the darkness of the cave. Taking tree trunks for corners and columns, and inclined branches to form a sloping roof and pediment, was, then, a stage in human progress, a coming-into-the-light. Andperhaps it was Laugier's Jesuitical habits that led him to emphasize the correspondence between the natural and the architectural order. For he assumed that true classicism would, with the progress of civilization, have necessarily emerged from its wooden prototype. Jean-Jacques Rousseau's *Discourse on the Origins of Inequality,* on the other hand, published two years after Laugier's evocation of the primitive hut, was much more committed to recovering the natural from the classical; reversing modern conventions by departing the stone temple for the wooden cabin.[83]

Paul Decker, engraving from *Gothic Architecture Decorated*, 1759.

But while the theorists of the origins of classical architecture seldom went beyond the speculation of their texts and engravings, those who championed Gothic as embodying in its characteristic forms—pointed arches, clustered columns and vaults—the forest glade were prepared to try to offer practical demonstrations of their argument. And none among them was more determined or more literal in his passion than Sir James Hall.[84]

We all know someone like Hall. A walking repository of esoteric knowledge, he carries his learning with intense gravity. He is eager to impart his latest discovery and does his best to persuade everyone within hearing range,

especially over dinner, of its self-evident historical significance. He invariably has a theory that, if properly heeded, will make the world a different place. He is a tremendous bore but no one can bring himself to dislike him for very long. His air of sweet innocence precludes it.

In Scotland, in the second half of the eighteenth century, such a person would have been an antiquarian, his library crammed with enormous tomes purporting to be chronicles of local clans and dynasts. James Hall was not merely an antiquarian but also a geologist because nothing fascinated him more than prime causes and the lore of origins. To call such explorations "myths" would be to trivialize the seriousness with which such provincial gentlemen, all over Europe, took their inquiries.

It is a common misconception that the Enlightenment was exclusively, or even primarily, obsessed with novelty. Many of its most impatient enthusiasts were indeed devotees of modernity. But along with the prophets of the new came the connoisseurs of the antique, even the archaic. Far from thinking of themselves as musty antediluvians, such explorers of the mysteries of the remote past fully expected, with a kind of alchemical passion, to make some Great and General Discovery that would actually link past and future time and so truly astonish the universe. Geology was one such route to truths of cosmic significance, and astrology another. By the last third of the century such universal projectors would be flirting with Romanticism.

James Hall is seldom classified among the Romantics, not least because certified upholders of its truths, like Friedrich von Schlegel, thought he was an appalling booby; and though he went on to preside over the Royal Society of Scotland, he has never really recovered from their contempt. But no one who stumbled over the origins of the Gothic while contemplating the wine harvest in the Médoc should be so summarily dismissed.

It was 1785. Hall, who described the incident in his *Essay on the Origins, History and Principles of Gothic Architecture,* was then on the Grand Tour. Like everyone else with an interest in the subject, he had read Bishop Warburton and had duly noted that the resemblances between a Gothic nave and an "alley of trees" could not be fortuitous. (He remained skeptical, though, about the peculiar hybrid of the German grove and the Saracen arch that Warburton suggested as the starting point of Gothic.) Offended by Vasari's contemptuous dismissal of Gothic as "monstrous and barbarous, being void of all order and rather deserving the name of disorder and confusion," Hall appointed himself its vindicator.

His essay begins, interestingly, with a general defense of ornamentation that spontaneously imitated natural forms. As if to refute the convention that classical architecture cleaved to universally ideal forms while Gothic was local and particular, Hall chose to make his point with the decorative patterning on

Tahitian canoes and Peruvian gourd vases as well as Greek urns. But it was in France, where he was sent into raptures by the Gothic cathedrals, that he hit on a way to demonstrate, empirically, just how their forms had "naturally" evolved. As he watched the French vineyard laborers coming back from the *vendange* and bearing bunches of grapes on long poles,

> it occurred to me that a rustic dwelling might be constructed of such rods, bearing a resemblance to works of Gothic architecture and from which the peculiar forms of that style might have derived.[85]

Hall then went on a tour of Gothic churches in the north of England and Ireland to fortify his confidence before embarking on the experiment that would earn him, in rapid succession, renown and derision. While the rest of Europe was plunged into the turmoil of revolution and war, James Hall, assisted by a local cooper, methodically set about planting two facing rows of ash-tree rods in the ground, each about three inches in diameter. To the top of each rod Hall then attached pliable willow rods and bent two together to form a "natural arch." His conviction was not only that he was reconstructing the original building method of the first Gothic architects, but that his sticks would actually root and sprout leaves and stalks, thus creating a perfect union of wooden nature and organic architecture. A year after he performed the experiment he was happy to discover that some of the rods had indeed become rooted and that the places where they had begun to bud or rot or leaf corresponded to equivalent irregularities in Gothic forms.

Further tours of British Gothic churches and extensive antiquarian reading only reinforced the results of his experiment. At the church on St. Mary's

James Hall, engraving, from *Essay on the Origins, History and Principles of Gothic Architecture.*

Isle in Galway a rail made of fresh wood had actually struck roots, much like his own little structure. The gateway to Durham Cathedral's cloister he thought had obviously been made of rods and branches. Was it any wonder, then, that a Tree of Jesse was to be found in the interior? And were not the rituals of Palm Sunday, when green boughs were torn from trees together with their foliage and brought inside the church as decoration, a survival of the same sylvan building? The earliest church of all, Hall thought (and he supplied the illustration that is the magnificent crowning folly of his entire book), was an entire wickerwork cathedral, perhaps the kind of thing suggested in Dugdale's *Monasticon Anglicanum* built for the convert king Arviragus at Durham.

As far as he was concerned, Hall had demonstrated beyond all doubt the organic process by which "Gothic" (a label he disliked as irremediably pejorative) had evolved. "In all its parts," he concluded, it is "nearly connected with nature." "Greek" architecture, by contrast, was "much less flexible." While the rigid forms of classicism might be suitable as a habitation of the gods, a church was meant to house a congregation and "therefore requires much room within and a great deal of light whereas a temple has little need of either." Where there was Gothic form there was always light, Hall concluded. Take the Eddystone lighthouse, for instance, modelled on a great oak tree and a beacon in the darkness.

Ach, Lieber Gott! chorused the Germans when they were made aware of Hall's *Essay.* Confident though he was of his demonstration, Hall was not over-hasty in broadcasting the results. His first reading to the Royal Society of Scotland was five years after the first ash rods had been set, and it was another sixteen years before the *Essay* was published.

It was the vulgar functionalism of Hall's efforts to reproduce the original construction of Gothic that most offended critics like Friedrich von Schlegel. (Though he also unjustly ridiculed Hall for claiming to have made an original discovery—something Hall was actually at pains to disavow—it would not be unlike Schlegel to have written off the "Englishman" without having actually read him.) But one can understand his pain at discovering a treatise which substituted a woodenly literal view of the origins of Gothic for the Romantics' historical view, which located it in an expressly Germanic, sacred and tribal history. What was even worse was that the *affinities* between the sacred grove and Gothic form, apprehended by Goethe and other high minds like Hegel, Georg Forster, and the Schlegels, had been reduced to a clumsy exercise in botanical utilitarianism.

Twenty-two years before Hall had his inspiration in the vineyards, Goethe had stood before Strasbourg Cathedral in a transport of celestial illumination. It was also in that city that he met, for the first time, Johann Gottfried Herder, an encounter of profound significance for him.[86] Herder was by far the most

adamant and eloquent voice raised on behalf of the sacred and tribal continuities of *Deutschtum*. He had stood all the pieties of the Enlightenment on their head. Where the philosophes offered classical universalism and the triumph of rationalist modernity, Herder unapologetically countered with cultural nationalism and the sacred past. Indeed he had travelled from the far-eastern end of the German world in Riga to the extreme west in Alsace. By the time they met, Goethe had almost certainly read Herder's *Silvae Criticae* (*Kritischen Wälder*), published just the year before and which set out his beliefs on the organic development of distinctive tongues and idioms. The architectural style that best embodied such organic truths was of course medieval Gothic. And his influence may well have swayed the young Goethe, himself delicately poised between classicism and Romanticism, toward the latter. During Goethe's long life he would veer back many times in the other direction. But for the moment he became an apostle, even plunging into the collection of local folklore and ballads around Alsace in a burst of Herderian zeal.

In 1772 Goethe published his response to Strasbourg Cathedral (and reprinted it a year later in one of Herder's own anthologies). And two years after that he climbed the tower of the cathedral again to write a poem to Erwin, the architect who was said to be buried beneath its pavement. But it was the initial impact that drew from him the most emphatic rejection of the kind of mechanical functionalism represented in Laugier and Hall. It was not the dependence of walls on tree-trunk columns, but their freedom, that was the mark of exalted architecture. In his famous lines directed to a new generation of Gothic architects, Goethe wrote:

> Multiply, pierce the huge walls which you are to raise against the sky
> so that they shall ascend, like sublime, overspreading trees of God,
> whose thousand branches, millions of twigs and leaves . . . announce
> the beauty of the Lord, their master.[87]

Was it the popularity of this affinity, reproduced and vulgarized in countless versions, that prompted the architect Dauthé, in Leipzig, to rebuild the columns of the Nikolaikirche as if they were palm trees? If so, he missed the point, as much as Hall had. As if to correct these misconceptions, a great stream of volumes on the distinctiveness of German Gothic appeared in the decades that followed, virtually all of which stressed its organic connection with the sacred *Urwald*. The imperatives of primitive habitat were now decisively replaced by the *freedom* of German spirituality, the conscious choice of an architecture that embodied (rather than merely mimicked) the sublimity of vegetable creation.

Thus Goethe and Herder at Strasbourg were followed by Forster and Alexander von Humboldt in Cologne, where they remarked that "the group

of slender columns, in their tremendous height, stand like the trees of a primeval forest, splitting at their summit into a cluster of branches." And Forster's *Ansichten vom Niederrhein* in turn prompted a pilgrimage to Cologne by Friedrich von Schlegel, whose six-volume *Grundzüge der Gothischen Baukunst* was probably the most influential of all these vindications of Gothic sublimity. "The essence of Gothic," Schlegel declared, lay "in the power of creating like nature herself an infinite multiplicity of forms and flower-like decorations. Hence the inexhaustible and countless decorative details, hence the vegetable element."[88]

While the beds of this holy vegetation, during the sixteenth and seventeenth centuries, had been in the Catholic south of Germany, the Romantic search for the relics of timbered prototypes for Gothic took them north. The artist Johann Christian Dahl, for example, who himself was capable of producing paintings with storm-tossed heroic oaks at their center, was also an ethnographer and historian of folk-architecture in Scandinavia. His *Holzbaukunst* introduced a generation to the medieval Norwegian timber churches, of fantastic elaboration and protuberant towers and spires and hanging gables, that still survived from the eleventh and twelfth centuries.

And the artist who brought this entire history of verdant crosses, forest groves, evergreen resurrections, and Gothic masonry together was likewise a northerner. Caspar David Friedrich's roots were Baltic, his education principally Danish, and his chosen form of piety the nature evangelism preached by the Copenhagen pastor Kosegarten. Stung by public criticism that his 1808 altarpiece, *The Cross on the Mountains*, had presumptuously muddied the strict distinctions between landscape and religious art, Friedrich went on the counter-attack, supplying the explicit meanings of his symbols. We are left in no doubt, then, that in the ancient traditions of vegetable Christianity, his evergreen trees were meant to signify the eternal life granted by the Resurrection.

So it hardly seems loose guesswork to assume that the prominent firs in Friedrich's *Winter Landscape*, painted three years later, likewise stand for the resurrection of Christian hope from the dead of winter[89] (color illus. 26). The season is marked by another moment in the ancient Nordic and Germanic calendar, linking the pagan with the sacred past. It is the winter solstice, close to Christmas, the feast which had only been invented in its modern form in sixteenth-century Germany, as a baptized form of the pagan Yuletide feast of light. Death is present in the bleak cloak of winter. But in the midst of the snow cover stands the image of vernal resurrection: the evergreen (indeed the Christmas tree!). A traveller who from his staff we are meant to recognize as a pilgrim has hobbled before the cross. But leaning against the rock (a standard emblem of the church), he has discarded his crutches, as if some great thaumaturgic miracle is in process of healing his infirmity. And so exhaustive is Friedrich's recapitula-

tion of all the myths and symbols of the living cross that he has set a "dry tree," represented by a fir pole, strangely stripped of branches and needles, parallel to, and just to the left of, the cross itself. At the back of the painting, the house of paradise, the Gothic church, rises (indeed it does actually seem to levitate above the mist), its spires a precise linear echo of the shape of the fir trees. It is a moment when the year turns not merely from darkness to light but from death to life. Hope really does spring eternal and it is announced by something green, the tiniest blades of grass pushing through the snow.

It is hard to know why Friedrich in the years between 1811 and 1812 was evidently so obsessed by these themes of wintry despair and vernal rebirth. As we have already seen, he was an ardent German patriot and these years were precisely when the domination of Napoleonic imperialism seemed heaviest, the years before the springtime of the *Befreiungskrieg*. There may even be some suggestion of the wounds of battle in the traveller's crutches, as if war-scarred Germany were itself experiencing the turn from wintry death to spring awakening. But it would be crass to reduce Friedrich's deepest spiritual convictions to the timetables of war. Whether or not he had a presentiment of the national springtime to come, he turned the *Winter Landscape* into Easter with yet another variation on the same theme.

But it is not just the season that has changed. For Friedrich has turned the profile crosses of the Tetschen altarpiece and the *Winter Landscape* about, parallel to the picture plane, so that, together with the fir trees, they frontally face the beholder (color illus. 1). It is as if the vegetation and the cross constituted an altarpiece facing down the nave of a cathedral, the very cathedral indeed which Friedrich has interpellated *behind* the screen of trees. It is, in fact, its own altar and choir. And the anthem it sings is the concordance between nature and Gothic spirituality: a hymn of resurrection. Beneath the cross itself, and scattered about the massive rocks, is the dry wood of the Fall that reaches up toward the crucified Christ like a claw. But the water that gushes from the foot of the cross into a healing pool acts as the baptismal source of atonement and redemption. The snow which dominates the earlier painting is now reduced to the merest touches of white at the tips of rocks and twigs. And where the grass had been beginning its springtime comeback, it is now rapidly turning, especially at the left of the picture, from brown to green. Triumph is not merely pending as in the winter landscape. It is at hand, and within the cathedral the hallelujahs sound from the organic organ beyond. Its spires rise spikily like the thorns of Christ's crown, but also in fugal echo of the triumph of the evergreens, the death-that-is-no-death.

The painting is in the Kunstmuseum Düsseldorf, where, surely, a half century after it was painted, a group of young Americans, among them Worthington Whittredge, Albert Bierstadt, and Fitz Hugh Ludlow, stood stroking their chins and contemplating the mystery of the verdant cross.

vi Volvos at the Sepulchre

Easter, 1990. There was still snow on the ground back home in Massachusetts.
It was not the dry, fluffy stuff that bulb catalogues use as fetching backgrounds
for the "heralds of spring": snowdrops, chionodoxa, and crocus. This was what
we usually get in March and April: huge galumphing flakes, soggy with water,
crash-landing on the delicate flowers, crumpling their petals, and burying
hopes of resurrection.

What did we care? We were in northern California, visiting my mother-in-
law in a Mendocino valley that lay between hills dressed in the gorgeous green-
ery of their springtime. To the west and north stood the redwoods of the
coastal-range forests massed in stands that were far denser and, for all the log-
ging, still more populous than the Big Trees groves of the Sierras. Taller than
the Mariposa sequoias, their trunks seldom reached their titanic diameter. But
they were still big enough for tourist posts to boast the inevitable "Drive
Through Trees," advertised in one old poster as "Nature's Garage."

What was this thing my family seemed to have about forests? For while the
Steinbergs were logrolling in Lithuania, my mother-in-law's folk were felling
redwoods in the deep woods of northern California. The distance, in space and
culture, between the great conifers of the Niemen and Mendocino and the
worlds they sheltered seemed immeasurably remote. But if you look at the
cones of the sequoias they are, when compared to the size of their parent trees,
comically small—almost indistinguishable, in fact, from the cones of Baltic
pines. And, as it turned out, our forest families were historically closer than first
appearances suggested. For the homeland from which my mother-in-law's log-
ging family departed to make the immense journey, ending up on the wooded
shores of the Pacific, was Lithuania. It was not out of the question, then, that
while Catherine the Great was sampling imperial jerky—the smoked bison
dainties dispatched by her Polish lover—my in-laws were busy sawing down the
trees which the Hassidic lumbermen of my family floated downstream toward
the great gray Baltic.

It was high time, I thought, that my children were given a vision of at least
one of these woodland homes. So on a brilliant Eastertide morning we set off
for Montgomery Woods, at the southern end of the coastal redwoods, close to

the mineral waters of Orr Springs. The children were merry. Sandwiches were packed. As we passed the occasional truck, hundred-foot-long flatbeds packed with tawny-red logs, their grandmother chatted to them of the old logging days. A world returned in the back of the car, rugged and noisy, chattering with the sound of steam-donkeys and giant saws, but also with the music of fiddles and bad songs. The women seemed always to be bringing lemon seedcake and beer to the campsite and tending wounds and broken bones. The grim poverty, terrors, and loss of limb the children could learn about some other day in more bleakly exhaustive histories. In the meantime the beckoning forest seemed a playground for heroes.

"Nature's Garage" in the Redwoods.

From a hilly ridge the road descended steeply, winding through woods of Douglas fir, the greenery packing the road verges and closing in on the car as the road narrowed. The sun dimmed, flaring on and off through the car windows like a strobe, making the children wince and screw up their eyes. Then it disappeared altogether, leaving us driving through a deep tank of bottle-green gloom. It was as though we had entered a passageway, not merely of vegetation but of time.

The sensation of time warp in the vegetable kingdom became even more vivid when we arrived at Orr Springs. Parked outside the ramshackle little spa were Volvos and Volkswagens, bearing San Francisco license plates. Their bodies were gallantly scarred and bruised in the service of a thousand good causes, all of which were announced on bumper stickers, the heraldry of the counterculture. Past the timber gates, we explored, tentatively, the peeling whitewash and scrubbed gray planking of an empty kitchen where campers were invited, or rather instructed, to take their meals in common "in the spirit of our healing community." Kids with the stringy blond hair and unwiped noses that go with their assigned lot as children of nature emerged from behind tree trunks looking bored or wicked or both. At the end of pathways where pine needles had been trodden into the wet mud, making a natural forest bath-mat, were gray stone

tubs holding small pools of dark, faintly evil-smelling water. In some of them, a boulder or two had been set in a halfhearted attempt to suggest the healing cascades of arcadia.

A gentle singsong chatter rose from one of the unappealing troughs. And before we could take evasive action, large opal-colored forms rose from the waters, not saying or doing very much but turning on us disconcertingly inviting smiles as we tried to mask our discomfort. Broad buttocks, slickly glistening and globular breasts, like large pale fruit about to drop to the forest floor, were hospitably presented to us: the offerings of arcadia, to be followed, perhaps, by acorn hash in the communal kitchen.

We exited hastily into the sylvan darkness. It was now about noon and not only dark but seriously cold, as stone-chill as any Gothic cathedral. The children were coaxed onward into the forest with promises of stupendous tree-wonders to come. But when they suddenly saw the redwoods, these seemed more like monsters than marvels. Their vague discomfort and irritability turned into something like fear. For the sequoias—fragrant, feathery, and massive— are perhaps the most beautiful phenomena in all the vegetable kingdom. But for very small children, their trunks were the torsoes of dinosaurs and possibly of the devouring, rather than the grazing, variety. Only when I looked at my six-year-old daughter beside the immense, wrinkled girth of a burl did I realize that she could barely apprehend it as a tree at all. The great plumy green fronds that made up its needles and branches were so impossibly high above her that they might as well have been invisible. What the children felt was what was closest to them: the urgent life of the forest floor, primordially squishy-soft, packed with fungus and seething with the vast traffic of countless beetles, earwigs, and ants commuting this way and that, a ceaseless commotion of eating, warring, colonizing, populating. Even the great trunks that lay half-submerged in ripe-smelling brackish pools seemed to deter clambering. And though the obligatory "cathedral grove" lay directly ahead, the children were deaf to the swelling diapason of Gothic sublimity. They peered this way and that for a glimpse of light like prisoners caught in an endless chain of unlit caverns.

If this was the Pook's Hill of ancient America, my children were not about to stand in for Dan and Una. They wanted out of the reptilian tomb of prehistory. The Druids and wood nymphs of Haight Ashbury could be left to their woodland ablutions. So we found our way out from blackness to radiance and finished our sandwiches on a hilltop above the ramparts of the woods. Cooing to the deer and clutching meadow flowers in their hands, the children romped in the rinsing sunshine while we measured our distance from the forest primeval.

PART TWO

WATER

I was born in a country of brooks and rivers, in a corner of Champagne, called le Vallage for the great number of its valleys. The most beautiful of its places for me was the hollow of a valley by the side of fresh water, in the shade of willows. . . .

My pleasure still is to follow the stream, to walk along its banks in the right direction, in the direction of the flowing water, the water that leads life towards the next village. . . .

But our native country is less an expanse of territory than a substance; it's a rock or a soil or an aridity or a water or a light. It's the place where our dreams materialize; it's through that place that our dreams take on their proper form. . . . Dreaming beside the river, I gave my imagination to the water, the green, clear water, the water that makes the meadows green. I can't sit beside a brook without falling into a deep reverie, without seeing once again my happiness. . . . The stream doesn't have to be ours; the water doesn't have to be ours. The anonymous water knows all my secrets. And the same memory issues from every spring.

<div align="right">

GASTON BACHELARD,
*L'Eau et les Rêves. Essai
sur l'imagination de
la matière*

</div>

Streams of Consciousness

i The Flow of Myth

AUGUST 1797

How was the world governed? By machinery or by magic?

Resolve this, Joel Barlow supposed, as he sat out his quarantine in the Marseilles pesthouse, and you resolve everything: nature, revolution, freedom—everything.[1]

There were worse places than the *lazaret* to grapple with such weighty matters: a structure half sanitary, half military, but not, all things considered, disagreeable. In 1723 Marseilles had been the center of the last great outbreak of bubonic plague in Europe. When the tide of death had ebbed, the royal government had provided the port with the kind of installation usually reserved for siege defense. A double line of fifteen-foot-high walls ringed the compound, pierced only on the water-side to allow authorized cargo to be landed from lighters. Merchantmen, especially those arriving from Africa (and Barlow had come from Algiers), were required to dock at an inspection island farther out in the harbor while their crews and cargo were examined. The old regime, Bar-

low acknowledged, had known how to protect itself from everything but its own stupidity and brutality. Its walls, like the masonry of many vanished powers, would remain even when its sovereignty had perished. And the *lazaret*, he admitted readily enough, was a decided improvement on the verminous holes that passed for pesthouses he had seen on the Barbary Coast.

His purgatory was serene, the building cool and commodious, with ample room for a hundred residents (no women or children), housed in whitewashed rooms. Additional quarters were of course provided for servants. The institution adhered to an orderliness seldom seen in these chaotic years of revolutionary liberty and Barlow was secretly grateful for the discipline. The cooks of the establishment kept a sturdy Provençal kitchen that made few concessions to the broiling August heat. *Daubes* showed up frequently, rendered down to a turbid beef tea in which sour little black olives

rested unappealingly at the bottom of white earthenware bowls. But there were Spanish oranges and white cheeses and garnet-colored wine poured from glazed terra-cotta jugs. And if the wine went undrunk it could usefully spoil into the vinegar which was swabbed on anything that might harbor infection: breeches, boots, shifts, commodes. Even Barlow's letters, exiting the *lazaret* for Paris, were punctured and liberally sprinkled with the sanitizing potion. The first impression that his wife, Ruth, or James Monroe, the American minister to France, must have had of him when they broke the seal on his letters was of a strong marinade of *poulet au vinaigre*.

John Vanderlin, *Portrait of Joel Barlow*, 1798.

So he sat in his philosopher's cell, the shutters throwing blue shadows on the wall, and filled coarse rag-paper notebooks with reflections on everything and anything, the quill scratching away in time with the agitations of his restless mind. Speculations, refutations, investigations filled the pages. What were the mythological origins of the Swedish days of the week? Ought one to assent to Robert Boyle's claim that the mechanism of the eye of the bluebottle was superior to the whole anatomy of the human? Everything flowed toward one great riddle: the operation of nature and how man had apprehended it. In the iron stillness of the Provençal heat, his mind seemed to be drawn to moisture as if by divination. Was it not the first element of life? How had the great Xerxes

constructed his canal? What was the depth and form of the bed of the Hudson River, indeed of the great waters—the Ohio and the Susquehanna—that constituted the arteries of his country? How, for that matter, did all the fluvial systems of the world operate? He recalled reading, somewhere on his footslogging for democracy, the seventeenth-century treatise by Pierre Perrault on the origin of brooks and rivers.[2] Following a hypothesis first set out in antiquity, Perrault had argued that rivers were simply the product of evaporated seawater condensed into rain and collected between the porous surface of the earth and the impervious substrata of bedrock. Supersaturation produced springs issuing from these aquifers, which then descended from hills and mountains toward the sea.

Much as he admired the tidy, self-sustaining economy of this "hydrological cycle," Barlow could not bring himself to believe that the whole volume and regularity of rivers could be supplied entirely in this way. An alternative view had been suggested by the Elder Pliny, who asserted that the ocean penetrated crevices in rock-walls and was carried thence through a vast system of underground passages where it was filtered into fresh water before issuing again through the surface. Barlow knew that such a theory was discredited by the elementary laws of physics which ruled out the possibility of water flowing uphill, even in the vacuous tunnels of the earth. Suppose, though, that these subterranean bowels drew heat from fiery volcanic substrata, deep in the core, generating pressure that might indeed force water up and outward through cracks and fissures. He had read the *Mundus Subterraneus* of the seventeenth-century Jesuit Athanasius Kircher, who had let himself be lowered into the active crater of Vesuvius to explore just such terrestrial furnaces.[3] And perhaps it was from Kircher's engravings that Joel Barlow could indeed imagine subterranean steam pumps powerful enough to blow water clear through limestone or granite.

But there was another way in which he imagined the life of rivers. Were they not figured as *bodies* of water because, since antiquity, their flow was likened to the blood circulating through the body? Plato had believed the circle to be the perfect form, and imagined that nature and our bodies were constructed according to the same mysterious universal law of circulation that governed all forms of vitality. Barlow knew that to see a river was to be swept up in a great current of myths and memories that was strong enough to carry us back to the first watery element of our existence in the womb. And along that stream were borne some of the most intense of our social and animal passions: the mysterious transmutations of blood and water; the vitality and mortality of heroes, empires, nations, and gods.

None of these insights, snatched at and scribbled down, ever resolved themselves into anything remotely like a coherent theory of the ways in which human cultures imagined raw nature. Rather, they were flung down in brilliant

gobbets of erudition, as if Barlow had been dictating a pocket encyclopedia to his own right hand.

But then Joel Barlow was a chronic breaker-off.[4] The son of a Connecticut farmer, he had found schoolmastering too humdrum, Yale too sober; and a chaplaincy to a Massachusetts regiment of the line during the American Revolution had not survived his natural irreverence. To earn his bread, he had tried the law, but had needed to nourish his sensibility by writing poetry (some of it witty). Both callings proved too meager for his wants. On the eve of another revolution Barlow had arrived in France as an agent for an Ohio land company, but had failed to interest any of the Paris plutocracy in acres of densely forested upstream wilderness. In London he had been welcomed into the club of liberal, even democratic tempers organized around the Society for Constitutional Information, agitating for parliamentary reform. So it was predictable that Barlow's own naturally ardent spirits would catch light on returning to France in 1789.

The Revolution seemed to him (as to so many other Friends of Liberty) to be the fulfilment of a universal prophecy: the coming of the Age of Reason. All his tracts and treatises (most, alas, incomplete) were designed to demonstrate the necessary historical harmonies that linked the American and French revolutions; uniting, across the Atlantic, enlightenment and freedom. What Columbus had started, Mirabeau would consummate. So, along with John Paul Jones, Barlow appeared before the Constituent Assembly to offer the felicitations of a free America to a France liberated from the chains of despotism. Intoxicated with fraternal generosity, he rashly promised that his countrymen would supply the soldiers of France with a thousand pairs of shoes a month, the least they could do to pay their debt to Lafayette and Rochambeau. And while the lathes were turning in Boston and Philadelphia, he could put his busy pen to the service of France. Together with his friend Tom Paine, Barlow composed a sharp refutation of the criticism levelled by that erstwhile friend of liberty, Edmund Burke, against the new revolution.[5] And when war approached he hurled thunderbolts from his Anglophone press in the face of the presumptuous tyrants.

Powered by patriotism and paranoia, the frontiers of republican democracy were expanding, and Barlow did his best to push them further forward. In the autumn of 1792 he had accompanied the ex-abbé Henri Grégoire on a mission from the National Convention to persuade the people of Savoy that unimaginable happiness was theirs should they vote to "reunite" themselves with France. They did, but (alas) balked at expressing their gratitude to Barlow by electing him a deputy to the convention. And he had scarcely begun to enjoy his special status as "Citizen of Two Republics" when the Revolution turned feral. Under the Jacobin Terror in 1793, Tom Paine was taken before the revolutionary tribunal and imprisoned for nothing more than voicing tactless

reservations about the execution of Louis XVI. Barlow's English women friends, enthusiasts of republican liberty Helen Maria Williams and Mary Wollstonecraft, were hounded as suspects for their associations with the disgraced Girondins. To speak freely of universal liberty had until recently been a public duty. Now it could land one before the tribunals on a charge of adventurism. In the winter of 1793 Barlow retreated to a suburban villa at Meudon, where he did his best to resemble an inconspicuous *érudit,* barricaded from disaster by his books.

Living quietly in the republic of knowledge, he returned to his unfinished history of the American Revolution. Making sense of the calamity, though, meant attempting a different history, one that dealt directly with the events in France. But that, too, became a rock of Sisyphus which he regularly rolled up the slope of his distressed reason, only to have it tumble down about his head. For years after the Terror had ended, Barlow remained haunted by the failure of the French Revolution to realize all the blessings its beginnings had so expansively promised. The trouble, he thought, was that in its own way it had turned religious. It had ejected the old priests, only to ordain new ones in secular disguise who proved scarcely less dogmatic. Perhaps, who knows, they had all underestimated the tenacity of cults and myths on the imagination of mankind? They had imagined themselves inventors of a new world when in reality they were tied by nature to the relics of antiquity.

This was the question to which all his most thoughtful friends returned over and over again as they nervously emerged from beneath the ruins of the Jacobin republic. How could an edifice constructed according to the principles of pure reason crumble in irrationality and fearfulness? How could the arch-rationalist Robespierre turn into the High Priest of the Cult of the Supreme Being? Such questions were all the more acute because, before the Revolution, it had been assumed that myths and magic were the ways in which those ignorant of science apprehended the forces of nature. All religions thus could be thought of as defensive responses to natural phenomena. One of the savants Barlow most admired, the ex-aristocrat Constantin Volney, a deputy to the National Assembly, had published his *Ruins* precisely to demonstrate the truth of such assumptions. And when Thomas Jefferson, the American minister to France, found himself unable to take on the translation, Joel Barlow offered to complete it.[6]

In the aftermath of the Terror, the axiom that religion could be explained as the defective perception of nature seemed less self-evident. In common with the scientists and philosophers who made up the new republican academy of learning, the Institut, Barlow began to take myth more seriously as a complicated order of belief. He noticed that even Volney, who had spent four years in Egypt and Syria, and who had taught himself Coptic and Arabic, was at least half bewitched by the very mysteries he presented as specimens of blindness.

And as Barlow's own ruminations turned archaeological and oriental, he turned, as did all the members of the Institut, to the colossal peculiarity of Charles François Dupuis.

In 1794 Dupuis published his *Origine de tous les cultes; ou, La Religion universelle* (The Origin of All Faiths; or, The Universal Religion), one of the most extraordinary books of the entire revolutionary epoch.[7] Dupuis had made his reputation as a brilliant mathematician in a French generation rich in scientific genius. To all intents and purposes he had invented the telegraph and was its first user. But in the 1780s he had launched himself into astronomy and from there into an eccentric and ambitious project to understand the anthropological origin of religion in terms of human apprehension of the celestial bodies. But rather than dismiss such connections as so much foolishness, Dupuis actually offered them as if they represented some sort of fundamental truth about the rhythms of the universe. At the core of his account were the perceived relationships between the conjunctions of the stars and planets, and the cycle of seasons and vegetation, which Dupuis believed to be the starting point of mythical and religious explanations of the universe. Instead of assuming that a potent mind had cracked, Dupuis's friends and contemporaries began to re-examine their own beliefs about the world. Perhaps the universe was neither the lump of indifferent matter that the materialists saw when they looked at the stars nor the dumb toy of the Almighty, made in his image and manipulated according to his will, as the Christians had insisted. Perhaps divinity *was* Nature—its spirit self-embodied in natural forms like the greenery of the world and its running water?

This revelation turned the premise of the Enlightenment's mechanical explanation of the universe on its head. Instead of boasting of a radically new, disenchanted way of seeing the world, Dupuis's admirers (including Barlow) wanted to become reconnected to ancient cosmologies. All religions, they were convinced, had been (at their essence) natural religions. Learn enough and it should be possible to expose the core beliefs from which they were descended: for example, the celebration of resurrection in the springtime rebirth of the world; or the ancient analogy between the circulation of rivers and the bloodstream of the human body. Suppose, then, that the true fraternity of men lay not in some rationally articulated political formula requiring universal assent, but in an immense and venerable stock of responses to nature that had been culturally encoded as myth. Suppose also that a diligent investigator could uncover the connections between such myths across cultures and centuries. Would he not then be able to expose the fundamental unity of mankind? Was it conceivable, after all, that the world was *both* machinery and magic?

In the midst of such giddy speculation, Joel Barlow got sent to Algiers. It was not his idea. But Thomas Jefferson, while still minister in Paris, had become exercised about the fate of American captives taken from merchant ships in the

Mediterranean by the Algerian corsairs. It was known that they were shackled in filthy cells, along with hundreds of other European prisoners waiting in vain for their ransom to be paid. Even more Gothic stories circulated of torture and mutilation. For the dey of Algiers this was just business; the principal commerce, in fact, of the North African coast. Like his neighbors in Tripoli and Tunis, he lived by exacting protection tribute from vessels wanting to trade in the waters of the southern Mediterranean. Those who failed to pay up were seized, their cargo taken as prize and their crews as hostages for ransom. And since almost a quarter of all American exports at the time were shipped to the Mediterranean, their ships, unprotected by naval force, had become game for the corsairs. For the corsair princes it was an old pursuit, hallowed by time and certain understood conventions. For Thomas Jefferson it was an outrageous relic of oriental despotism that had no right to survive into the age of republican democracy.

On becoming secretary of state, Jefferson resolved to do something about it. Since 1785, when the first American hostages had been taken, emissaries had been sent to Algiers in predictably fruitless attempts to appeal to the dey's nonexistent humanity. And because American naval force was so thinly stretched, threats were largely empty. To surrender to extortion was an indignity which any republic must feel keenly, Jefferson thought. But to abandon American citizens was a worse betrayal. Jefferson had come to know Barlow well during the heady days of the Paris revolution, even liked his poetry and encouraged him in his efforts to write some grand history that would link the destinies of the French and American republics. As an experienced traveller, a practiced businessman, and, most important, a citizen of both America and France, Barlow seemed well qualified for the unenviable task of persuading the dey to release the captives, or at least of trying to beat down his price.

As expected, the mission to Algiers was no promenade. Every few weeks Barlow would be granted an audience with the dey and would be screamed at: "You are a liar, your government is a liar, and I will put you in chains in the marine and declare war."[8] Even bribery, the universal lubricant of Levantine diplomacy, was tricky. What the dey wanted, it transpired, was not only money for himself, his relatives, ministers, and hangers-on, but an entire naval arsenal: timber, powder, cannon, a fully equipped American frigate. It must have occurred to both Barlow and Jefferson that to accede (as they did) was to award the dey a prize, rather than a penalty, for his accomplished life of crime.

It took more than a year before Barlow managed to persuade the American government to satisfy the pirate prince's demands. Much of it he spent in a Moorish villa in the countryside outside the plague-infested port of Algiers. Beside a garden pool with a view of olive groves, his big taurine head covered with a silk cap, Barlow got back to his real work: penetrating the mysteries of the Orient.

As usual, he began with the practical and graduated to the marvellous. Nothing escaped his attention: the history of the Arab invasions; the progress and decay of the Ottoman Empire; the ease (unfair, compared to the bitter toil of New England) with which crops could be raised in the Maghreb sunshine; the peculiar mixture of prurience and possessiveness with which the Algerian men treated their women. But it was also in Algiers that the other face of the Orient began to captivate him: the rites and religion of Egyptian antiquity, especially the great epic of sacrifice and resurrection embodied in the myth of Isis and Osiris.

It was only when the business in Algiers was done with and he was back in France, confined to the white cell of the Marseilles *lazaret*, that Barlow seems to have had a sudden vision of how something as esoteric and remote as the myth of Osiris was alive as a cult of nature in his own time and place. In every square in the Republic, officials had planted "Liberty Trees" as emblems of the spring-like renewal of life in the Revolution. They were, in effect, politicized Maypoles, bearing a promise of fertility and freedom. Barlow's old colleague on his mission to Savoy, Grégoire, had already published a learned paper tracing their origin back to Celtic and Druid rituals of rebirth.[9] But with his Egyptian illumination still strong in his imagination, Barlow knew better. Liberty was indeed rooted in a cult of nature. But that cult had begun not in the oak-woods of the foggy north, but on the great river of the south, the mother of all civilizations, the Nile. The Druid groves parted. Beyond them lay the serpentine effluvium of the sacred Nile, and Barlow's imagination, inspired, let itself be carried along from the physical to the allegorical.

On one matter he was categorical. The Liberty Tree, in its remote origins, was the amputated penis of Osiris.

He began with the assumption that the dying of the sun in the autumn, "causing vegetation to cease," had given rise to the ancient "fable" of Osiris. Barlow had been reading Diodorus Siculus.[10] And he evidently had in mind the Greek version of the myth in which the king and demigod who abolished cannibalism, brought civilization to Egypt in the form of agriculture and wine, and invented writing and laws was murdered by his brother Set (known to the Greeks as Typhon). The wicked brother has a richly ornamented chest made, precisely to Osiris's measurements, and tricks him into trying it for size by promising the coffer to anyone it might fit. The chest instantly becomes his coffin, is sealed with molten lead and cast into the Nile. His widow (who is also his sister), Isis, then travels as far as the Phoenician shore at Byblos, where the coffin, washed ashore, has taken root and grown into a tamarisk tree. The tree has been made into a column supporting the house of the Phoenician king, with the dead hero still locked inside. And only after many more ordeals (involving a metamorphosis into a grieving swallow) is Isis able to return the

coffin to Egypt. There it is again seized by Set/Typhon, described by Barlow as the "power of darkness,"

> who cut the body in pieces and threw the genitals into the Nile. Isis . . . collected all parts of her husband's body except the precious fragment left in the river. To supply what was wanting she caused new genitals to be formed of wax and interred the body entire. But the genitals cast into the Nile communicated a fecundating power to that river which from that time became the source of life and vegetation to all Egypt. . . .
>
> To commemorate at once the tragical death of Osiris and the great benefits that resulted to mankind from the posthumous power of the organs of generation, a solemn feast was instituted in which the phallus in a posture of strong erection was carried in a procession.[11]

Barlow then borrowed from friends like Volney and Dupuis the diffusion theory that accounted for the core myth recurring in other cultures where sacrifice, dismemberment, and the fertility of vegetation were connected. And he listed exactly the related cults that James Frazer, a century later, would claim to be mere variations of a single, original archetype: the castrated Atys, the dismembered Adonis, Persian Mythras, and so on. Barlow went even further by exploiting a traditional Greek identification between Osiris and Dionysus. The rites of Bacchus—lord of wine and lust—he continued, commemorated "the generating powers," celebrated by carrying around a ceremonial phallus.

How, though, did the Bacchic-Osiriac phallus turn democratic? Ah well, Barlow went on, "from the freedom and licentiousness that reigned in these nocturnal assemblies the God acquired the name of Eleutheroi or Freedom and when these religious rites were carried to Rome Bacchus was known by the epithet *Liber* so that the phallus became the emblem of *Libertas*."

Through the centuries these ancient fertility rites evolved into celebrations of the coming of spring. "Men forgot the original object of the institution, the *Phallus,* [which] lost its *testicles* and has been for many centuries reduced to a simple pole." It amused Barlow no end to think that the villagers who danced about the Maypole had no inkling of the "antetype of this curious emblem." And equally he could proclaim the virility of independence by noting that

> when the Liberty Pole passed over to America it assumed a more venerable appearance; it grew to an *enormous mast* and without regard to any particular day it was planted in the ground as a solid emblem of *political liberty.*

From there it recrossed the Atlantic to extend its blessings to its native continent where it has [again] assumed the form of a tree. In this form it is now planted in the public places all over France, hung round with the three-colored ribbon, surmounted with the Cap of Liberty [which, of course, Barlow observed in an appendix, was "the head of the Penis"], inspiring enthusiasm in the host of heroes who swell the triumph of that victorious Republic.[12]

Was it serious, this priapic radicalism? Barlow was, after all, one of the "Hartford Wits" and the author not just of *The Conspiracy of the Kings* but of *The Hasty Pudding*. Yet there is nothing in the text that suggests a pornographic joke at the expense of his orientalist friends, nor anything else in the notebooks indicating Barlow in a teasing mood. By the 1790s, there was already a substantial literature—both pretentious and erotic—on the history of phallic cults. The antiquarian Baron d'Hancarville, whom Barlow had probably met in Paris in 1789, was the pioneer of the genre.[13] But it seems likely that Barlow's enthusiasm for the subject had been stirred by reading the *Discourse on the Worship of Priapus,* published in 1786 by D'Hancarville's patron, Richard Payne Knight, and scandalously well known among Barlow's liberal friends in London.[14] In Directoire Paris the modes were crotch-hugging breeches and gaping décolletage, and chairs and desks were sprouting sphinxes and harpies. The wife of Barlow's own banker, Récamier, had been duly enthroned as the reigning deity of Greco-Egyptian style. So perhaps a fantastic little piece of pedantry equating liberty and libertinism, and wrapping the whole speculation in a nature cult, was not so incongruous in the Year V of the Republic: when the Jacobin Reign of Virtue was just a queasy memory.

Of course Barlow's grasp of myth was seriously pre-Egyptological. He could not possibly have known that the deity most associated with the fertile inundation was Hapy rather than Osiris. And it was as sovereign-guardian of the dead rather than of living vegetation that Osiris seems to have played a dominant role in ancient Egyptian religion. But the associations that Barlow naively made between fertility cults and the sacrificed king-god of the Nile did, in fact, survive in some of the major works of Egyptology like E. A. Wallis Budge's *Gods of the Egyptians* and *Osiris and the Egyptian Resurrection*.[15]

᛭ ᛭ ᛭

AT THE VERY END of the princely library designed by Christopher Wren in Trinity College, Cambridge, is a substantial steel vault where J. G. Frazer's own collection of archaeological and folklore sources is housed.[16] It's just possible to step inside (as if peering into Osiris's tomb) and extract learned plunder: German, French, and English tomes of nineteenth-century epigraphy and

Egyptology, densely inscribed and reinscribed in Frazer's controlled little Scottish hand. From all these encyclopedic sources he produced *Adonis-Atys-Osiris*, which gathered together, as a single archetype, all the varieties of myths and rituals from Egypt, Greece, and Rome in which death and resurrection were symbolically linked to the calendar of nature.[17]

Joel Barlow of Hartford, Yale, and the rue Vaugirard would doubtless have felt vindicated by Frazer of Trinity. But, alas, *discredited*—the word that tolls the scholarly death knell—has been used in recent Egyptological writing to dismiss what remains of Frazer's hypothesis (though, to paraphrase a traveller to the Nile, Mark Twain, the death of the thesis may be slightly exaggerated, since Fifth Dynasty "Pyramid Texts" and other sources do now appear to attest to Osiris's identification with the fertilizing power of the "new waters").[18] But what is not in any doubt at all is the endurance and power of the Hellenized version of the Osiris myth for the posterity of Western culture. Doubtless the Ptolemies, the Hellenized rulers of Egypt, from the time of Alexander onward, embellished the myth precisely to make Egyptian and Greek traditions more compatible. "Sarapis" was invented as a pseudo-deity that would indeed seem a barely oriental version of Dionysus. And there is no dispute that the most prominent feature of Dionysian festivals was the display of an imposing ritual phallus.[19]

Once established, the revised myth was a lasting success. It seems to have colonized established cults of Osiris at Abydos and generated new temples, most famously at Philae, just below Aswân, at the boundary of Nubia and Lower Egypt, and one of the many sites claiming to be the last resting place of the god. Rituals were elaborated that associated Osiris-Sarapis with the inundations of the fertile river, and the associations were strong enough for Seneca, in the first century A.D., to attach significance to the fact that it was from the island of Philae, close to the two crags known as "the veins of the Nile," that the annual rise was first observed.[20] And with Seneca, Pliny, Plutarch, Strabo, and Diodorus, an entire genre of Nile literature—a rich slurry of myth, topography, and history—inaugurated the Western cult of the fertile, fatal river. Its power was such that even the austere Stoic Seneca could be swept away in its fantasy, giving credence to the belief that its fecundity could cure barren women; that its source and flood should be sought neither in the blast of the "Etesian winds" that Anaxagoras thought stopped its mouth nor yet in the melting of the Ethiopian snows, but rather in the veins and passages of underground caves and channels deep in the heart of Africa. Only on the Nile was it possible, thought Seneca, that fluvial gladiators—crocodiles from the south and dolphins from the north—could have engaged in massed mortal combat. Only on the meandering Nile could the canny dolphins, the animals of peace and wisdom, have prevailed by tearing the reptile underbellies with their dorsal fins, salt water and fresh; mud and blood; life and death, tinting the sacred stream.[21]

ii Circulation: Arteries and Mysteries

Had he known of a tomb effigy of Osiris in the Ptolemaic temple at Philae, Barlow would doubtless have felt wholly vindicated. For there, as one nineteenth-century Egyptologist reported, the god lay "on his bier in an attitude which indicates in the plainest way that even in *death* his generative virtue was not extinct but only suspended, ready to prove a source of life and fertility to the world when the opportunity should offer."[22] But even without this archaeological confirmation, he might have invoked the two most famous texts of the Osiris myth: the first book of Diodorus Siculus, probably written in the first century B.C. and based on his own travels through Egypt, and Plutarch's *De Iside et Osiride,* from the fifth book of the *Moralia,* also grounded in firsthand experience of the Nile valley. Though they disagreed on the precise number of parts into which Osiris had been dismembered by his wicked brother (Plutarch scoring fourteen, Diodorus sixteen), both writers agreed that, according to tradition, not only had the demigod's vital parts been cast into the Nile, but the *oxyrhynchus,* the "river pike," and the *phagrus,* the "sea bream," had eaten them, thus accounting for the dietary prohibition against those particular fish. The taboo on consuming bream was especially strict since, according to the Greek chronicler, it was the herald of resurrection, appearing in the Nile in late June as a "self-sent messenger . . . announcing to a happy people, the rise of the river."[23]

Mischievously elated to have traced the history of the emblem of republican liberty to the (literally) seminal fable of Osiris, Barlow overlooked altogether the essence of Plutarch's rich and beautiful account, in which the physical behavior of the Nile was tied to the narrative of the myth. Indeed their interpretations were divided by more than the centuries. For while Barlow treated the myth as an allegory of nature, Plutarch, though affecting the voice of a skeptic, actually moves from physical to metaphysical matters. Following a famous passage in Plato's *Timaeus,* Plutarch claims that the workings of the natural universe were so marvellously self-contained and interlocking that they must necessarily be the visible embodiment of divinely originating principles of perfection.[24]

But if the world was a perfectly harmonized and self-replenishing organism, the intelligibility of its operation was not at all simple. And nowhere were

the springs of its machinery more teasingly mysterious than on the Nile. Since Herodotus in the fifth century B.C., geographers had been perplexed by the two defining features of the great river.[25] First, its mysterious source was evidently somewhere in the "Ethiopian" *south* (though Egyptian religious practices held it to gush from the "caves of Hapy" or the First Cataract). For the Greeks it seemed singular that it should thus flow from a more, to a less, torrid zone, rather than follow the universal rule of beginning in a cooler mountain zone and ending in a hot plain or delta. And it was likewise peculiar that its seasonal inundation also reversed conventional expectations, being at its height in the parching summer, when all other known rivers were at their low point. Myths, Plutarch knew perfectly well, did not *explain* such natural marvels nor were explained *by* them. Rather, they were the poetic forms by which such mysteries were intricately symbolized. And that, to him, was almost as interesting as the topography itself.[26]

In such a metaphorical scheme, Plutarch tells us, Osiris functions as the personification of fecundity: "the whole source and faculty of creative moisture," and "the Nile . . . the effusion of Osiris." Conversely, Set/Typhon is his antithesis, the personification of drought and famine: "all that is dry, fiery and arid."[27] The sealing of Osiris in his coffin thus "means nothing less than the vanishing and disappearance of water." The elements mourned for the dead hero in all their qualities: the fading of daylight, the dying of the north winds, the retreat of vegetation. As the waters abated, penurious anxiety returned. With the Osirian resurrection (or at least reconstitution) in the late spring, hope, prosperity, and verdure returned to the basin of the Nile, born of the embrace between the moist Osiris and the earthy Isis. The fruit of their union, the child-god Horus, finally and conclusively dispatches Typhon, the destructive ocean, forcing it back to expose the alluvial silt that manures Egypt's crops. Death and sacrifice, then, are the preconditions of rebirth. Blood is miraculously transubstantiated into water (and indeed into wine, the vital fluid of Osiris-Sarapis-Dionysus). An Egyptian Book of the Dead hailed Osiris thus:

> The Nile appeareth at thy utterance, making men live through the effluxes that come forth from thy members, making all cultivated lands to be green by thy coming, great source of things which bloom, sap of crops and herbs, lord of millions of years, sustainer of wild animals, lord of cattle; the support of whatsoever is in the heavens is thine, what is in the waters is thine.[28]

The connection between sacrifice, propitiation, and fluvial abundance seems to have occurred in all the great river cultures of antiquity. Recent archaeological evidence suggests that Akkadian civilization perished not at the hands

of any invaders but when the Tigris and Euphrates desiccated. So it is not surprising to discover that the death and resurrection of the harvest god, Tammuz, in Mesopotamian mythology is virtually identical with the Osirian contract where fertility is the reward of martyrdom. It was also ritually reenacted. At the Babylonian New Year, a ram was ritually slaughtered, dismembered, its blood smeared on the temple walls and the torso and head thrown into the Euphrates. When the river waters finally rose, a wooden figure of the god was first launched in a funerary vessel that then sank to the fluvial underworld.[29]

Even the Greek primordial river myth, that of Acheloüs (who, according to Hesiod's *Theogony*, was the brother of Nilus, the progeny of Oceanus and Thetis),[30] preserved this fated connection between violence and prosperity. Fighting Hercules for the hand of Deianira, Acheloüs transforms himself, first into a serpent and then into a bull. Bested in the struggle, one of his horns is wrenched off and cast into the river by the nymphs. The vanquished Acheloüs then kills himself by drowning in the

Libation tables, Mendes, lower Egypt, second–third century A.D.

great river that henceforth carries his name. But the amputated horn, lying in the watery depths, begins to bear fabulous fruit as the Cornucopia: the Horn of Plenty.

All these fluvial myths embodied one of the governing principles of hydraulic societies: circulation. In the *Timaeus* Plato had decreed the circle to be the necessarily perfect shape for creation as it alone formed a line of complete containment.[31] The principle held good for the circulation of blood about the human body and for waters about the earth. So the rhythms of fluvial death and rebirth, the transmutability of water, blood, and wine, described a cycle that, provided the proper remembrances were observed, would be self-regulating. Which is why, in Plato's dialogue, Critias describes the Nile as a "savior" river, rather than a destroyer, its waters gradually rising from below, unlike the Greek torrents which crashed down from a mountainous height, threaten-

ing cities like Athens with destruction. This consistency of behavior, Critias continues, was *the* essential reason why the temples and monuments of Egypt were better preserved than anywhere else; what made the Nile, in fact, the river of longevity, of memory.[32]

On the Nile the life-assuring obligations of reverence were ritually fulfilled by priests at stone libation tables, sited by the riverbanks. Eighteen of these chiselled tables from the region of Mendes survive, and have been carefully discussed by Vivian Hibbs.[33] Displaying an ingenious symbolic economy, the wine ceremonially offered to Osiris or Hapy or Sarapis flowed through winding gutters carved into the stone in imitation of the course of the sacred river. Depending on whether the wine was poured from above or from the table, it could be made either to "inundate" a central basin or else flow serenely through the meandering "maze" pattern of the relief. Many of the tables featured emblems of fertility—ears of corn, lotus pods, or bunches of grapes—as well as sacred fauna of the Nile, like crocodiles, dolphins, and lions. The meander itself, which we take for granted as a purely decorative border, had been named by the Greeks for the river Maeander, sacred to the Phrygians in Asia Minor, and then generalized as a motif of fluvial benevolence, turning this way and that, enclosing within its bends and angles the produce of the flood basin. It suited the Hellenized rulers of Egypt, the Ptolemies, to propagate an emblem of the winding river, dedicated to Nilus or to Sarapis, the pseudo-Osiris, attesting to the benevolence of their rule. Even the color of the wine flowing through the stone runnels celebrated the time just before inundation (in the third week of July), when the river in Lower Egypt took on a reddish hue as the clay sediment of the White Nile mixed with the waters of the Blue Nile.[34] And though the Book of Exodus reversed the meaning of this change of hue from blessing to curse, the original sense of the sanguine river as life-enhancing rather than life-destroying somehow survived. In 1610, for example, George Sandys, the traveller and translator of Ovid who journeyed up the Nile in his early twenties, tasted Nile water from his own libation cup and concluded that it "cureth the dolor of the reines [kidneys]" for

> the waters thereof there is none more sweet being not unpleasantly cold and of all others offers the most wholesome [draught]. So much it nourisheth, that the inhabitants think that it forthwith converteth into blood retaining that property ever since thereunto metamorphosed by Moses.[35]

The meandering libation table, with its offering to the fruitful wine-water of the alluvial river, symbolized the benign version of the Nile's consistency. But the Nilometer gauges (dutifully visited by every traveller from Strabo to Florence Nightingale) represented the opposite, anxious aspect of the great

stream. For while the rivers of the ancient world brought the principle of cir-
culation to settled societies—the Osirian gifts of harvests, exchange, law, and
empire—they were, at the same time, seen as the carriers of havoc and death.
The Nilometers at Cairo and Elephantine were only auspicious if they regis-
tered exactly the right number of cubits (sixteen, the same number of parts into
which Osiris had been sliced) as the river rose to its summer crest. Too little,
and one of Typhon's curses, drought, would visit the valley, bringing with it
half the plagues of Old Egypt: the starvation of livestock, depletion of seed
reserves, settled populations of agriculturalists transformed into beggarly
nomads.

A whole literature of "lamentation" dating from the end of the third and
beginning of the second millennium B.C. coincided with one such prolonged
period of low water.[36] Over two centuries the marshlands of the Delta dried
out. The dunes of the desert advanced on areas of intensive settlement and
fierce *khamsin* winds brought sandstorms to croplands. The lamentations speak
of bodies rotting in the Nile, devoured by crocodiles; of suicides and cannibal-
ism; of the looting of burial grounds and a time of anarchy and brigandage.[37]

But Typhon's other curse, high water, would bring yet other plagues in its
wake. Severe floods could break the transverse dikes that were used to augment
and distribute irrigation along the valley. Seed stocks would be saturated. Blight
and parasite populations would grow to catastrophic proportions; granaries and
food stores would have to be destroyed. And even sacred sites like the great
temple at Karnak would be invaded by the flood. No wonder, then, that one
of the Nilometers calibrated not just the measure of the water but its correlates
in human fortune and misfortune. Twelve cubits, it decreed, denoted famine;
thirteen, hunger; fourteen, cheerfulness; fifteen, security; and sixteen, at last,
delight.[38]

Egypt's fluvial myth, of the death and rebirth of waters, promised, above
all, regularity. But insofar as archaeologists have been able to reconstruct
ancient hydraulic history, the Nile could behave with alarming unpredictabil-
ity, varying the amount of alluvium deposited on the banks of the basin and the
Delta by as much as 30 percent over the course of a century.[39] A prolonged fail-
ure of the prevailing cosmology to perform according to expectations almost
certainly had serious political consequences, and seems to have coincided with
ruptures in the orderly succession of the Pharaohs. What the river could autho-
rize, it could also take away.

For while Joel Barlow thought he had found the origins of the cult of lib-
erty in the myth of Osiris and Isis, a less eccentric view has tied together the
behavior of the Nile with the establishment of absolutism. A long tradition of
sociologists, from Karl Marx to Karl Wittfogel, have seen "hydraulic societies"
and despotism as functionally connected.[40] In naturally arid regions, they
argued, only an absolutely obedient, virtually enslaved regime could possibly

have mobilized the concentrations of labor needed to man and maintain the irrigation canals and dikes on which intensive agriculture depended. And Witt-fogel, who went from being a devout Marxist to an equally impassioned anti-Marxist, made no secret in the 1950s that he saw in the Chinese and Soviet regimes further evidence that it was as the arbiters of water that tyrannies anointed themselves as legitimate. The colossal dam and the hydroelectric power station as emblems of omnipotence were for modern despots what the Nile irrigation canals were for the Pharaohs. Steaming along the Volga-Don canal to which countless thousands of slave laborers had been sacrificed, Stalin could proclaim himself the master of the waters. Breasting his way down the Yangtze, at the head of regiments of the swimming proletariat, Mao Tse-tung could affirm (even as his master economic plan for China was foundering) that he was indeed the fluvial Emperor of the Masses: unsinkable, indestructible, immortal. And by pressing ahead with the titanic project of the Three Gorges Dam, flooding the most famous icon of all China's river landscapes, Deng Xiaoping tried to present himself in succession to the founder of the very first dynasty, around 2200 B.C., the semilegendary emperor Yu (the Chinese Osiris), whose authority was established on his mastery of the flood, and the establishment of intensive, irrigated agriculture.[41]

But the ideology professed by modern hydraulic despotisms—Marxist dialectical materialism—has been linear, not circular, pushing history relentlessly downstream. So if the self-regulating arterial course of the sacred river, akin to the bloodstream of men, has constituted one permanent image of the flow of life, the *line* of waters, from beginning to end, birth to death, source to issue, has been at least as important. It has, moreover, dominated the European and Western language of rivers: supplying imagery for the life and death of nations and empires and the fateful alternation between commerce and calamity. In classical Eastern and Near Eastern cultures, the great sacred rivers were seen as temporal and topographical loops. In the Roman West, from a very early date, rivers were conceived as roads: highways that could be made straight; that would carry traffic and, if necessary, armed men; that defined entrances and stations. The model for the well-behaved watercourse was the aqueduct: the highest achievement of Roman engineering. It was in Latin texts, too, that history was straightened out in linear development so that rivers—not least the Tiber—might also be imagined as lines of power and time carrying empires from source to expansive breadth. At the same time, though, Western writers often sensed a disturbing paradox about these fluvial boulevards. For while the sight of riverbanks seemed to assure a kind of security (the sort denied, for example, to mariners who lost sight of land), upstream explorers also appreciated that until they had mapped the course from end to end, they had little control over their destination. The currents might end up taking them to places where they would be the captives, rather than the masters, of the waters.

The urge, then, from the outset, was to penetrate directly to the source, to possess and to master the headwaters. And it was precisely the denial of this sovereign possession to Greeks, Romans, French, and British that made the Nile so tantalizing, so treacherous—in a word, so Cleopatran.

Cleopatra, "her baleful beauty painted up beyond measure: covered with the spoils of the Red Sea . . . her white breasts . . . revealed by the fabric of Sidon," presides over the classic encounter between a Western, linear determination to master the Nile and the circular artfulness of those who protected its mysteries. The writer is Lucan, the nephew of Seneca: mediocre as historian, epic poet, and conspirator (for he ended his life cutting his veins in a bath of warm water in obedience to Nero's sentence). But in book 10 of *The Civil War* Lucan paints a scene of gorgeous Egyptian doom, Caesar surrendering his vigilance to Cleopatra's recumbent cunning.[42] While "crystal ewers supplied Nile water for their hands" and "they drenched their hair with cinnamon," Caesar rouses himself enough to ask the high priest, Acoreus, the secret of the Nile's source, promising that he would even abandon his wars were he ever to set eyes on its springs.[43]

Acoreus is as serpentine as Caesar is direct. He begins by appearing to promise to reveal the secret of the river. But the further he sails upstream through the dark waters of astrology, fable, and hearsay, the more cryptic and priestly he becomes. "Certain waters," he explains,

> long after the world was created, burst forth in consequence of earthquakes, with no special purpose on the part of the deity; but certain others [like the Nile], at the very formation of the world, had their beginning along with the universe; and the latter the creator and artificer of all things restrains under a law of their own.[44]

In other words, the mysteries of the Nile's rise, fall, and source will remain perpetually unknowable and inexplicable. And Acoreus makes matters worse by reminding Caesar that before the Romans, the Persian and Macedonian kings were equally determined to possess the secrets of the river but were, in the end, "defeated by its native power of concealment." Quick to dismiss the speculations of other ancients like Herodotus, Acoreus will only acknowledge that the Nile rises "on the Equator, boldly raising its channel in the face of burning Cancer," thence meandering to and fro between Libya and Arabia until reaching the cataracts and springs at the gate of Egypt near Philae.

This vexing mixture of commonplaces and esoteric casuistry was unlikely to have satisfied Caesar. Certainly he was not persuaded to desist from his wars. He had asked for a map and had got a myth. He had planned on engineering and had been given poetry. He wanted a direct pathway through Nubia and Ethiopia, and had been fobbed off with meandering subterfuge. The secrets of

the Nile remained tantalizingly elusive. There would come a time, many centuries later, when a Roman ruler would set the Nile by the Tiber, but such an astonishing confluence would have to await the miraculous appearance of something quite unimaginable to Caesar or his imperial successors: Christian hydraulics.

iii Holy Confluences

It was odd, Father Felix Fabri thought, that the women of the Nile valley applied crocodile dung as a cosmetic, and swore that it smoothed the wrinkles from their skin.[45] But then Egypt, in the autumn of 1483, was full of marvels and monsters. He, and eighteen fellow pilgrims, who had plodded across the biblical wilderness on camels, had suffered much for their faith. They had been set upon by Bedouin brigands, stoned in the streets of Gaza by Saracen urchins, tormented by gray biting fleas the size of hazelnuts, frozen on the summit of Mount Sinai, and burned in the red ravines of southern Judea. In the "Midianite" desert, estimated by Fabri to be "bigger than all of Germany," they had lost their way and had wandered like the lost tribes as the whirling, wind-driven grit peppered their faces unmercifully. In such extremity the deacon of Mainz, Bernhard von Breitenbach, had lost his sight, and then his reason. In Cairo horrible, stinking sores appeared on their faces, but at least they were spared the plague which was carrying off untold thousands of victims every day. And on the Nile itself Fabri was terrified by the sight of wallowing hippos, lying in wait, he believed, to attack their boats and devour the passengers in their slick, pink maws.[46]

And yet, amidst such unholy terrors, Fabri managed to discover exotic pleasures, tentatively ventured, guiltily enjoyed: handfuls of figs plucked from the tree; stone flagons of black wine; the steaming waters of a Moorish bath (a habit only explicable, he thought, by the uniquely horrible odor given off by the Turks).

And then there was the great river itself, which, for all its anthropophagous hippos and fearsome serpents, he declared to be a true miracle of God's creation, blessing everything it washed with abundance, even in the midst of an arid wilderness.[47] While other, faster rivers tear at the land, "eviscerating them," he wrote, plagiarizing Seneca, "the Nile does not take but gives," supplying

solidity to the soil, manuring the fields. Unlike the floods of misery and destruction he had seen in Europe, the Nile's inundation was a "flood of joy." Even the horrid things dwelling in the river's muddy depths attested to its miraculous vitality. Nothing, for example, in all creation, could compare with the speed and magnitude of growth that increased the crocodile hatchling to the thirty-foot adult reptile.

Fabri's conversion of the Nile into a landscape of blessings was at odds with tradition. For many generations the sacred river of Christianity (as for Judaism) was, of course, the Jordan.[48] And as a site of redemption and deliverance the Jordan was defined as the Nile's opposite: a rushing, clear waterline, not a sluggish, turbid meander; a place of purity in the desert, not the viscous, sinuous lubricant of profane fleshpots. And the linear torrent was meant to carry the Chosen, or the Elect, from one historical epoch to the next: from slavery to freedom, paganism to theism, damnation to redemption. These were waters that would not turn back on themselves.[49]

The Jordan's source in the snowy high Lebanon and its issue into the abysmal Dead Sea fed the sense of its providential direction. It had slaked the thirst of hermits, evangelists, prophets, men who shunned the common clay of humanity and their vices, while the Nile had pandered to luxury and vanity. The whole epic of Hebraic deliverance as described in Exodus had been a flight from the Nile to the Jordan; an idolatrous and enslaved past drowned with Pharaoh's chariots, a new life of freedom and holiness consecrated with the crossing of the Judean river. These were Jehovah's waters, not Osiris's: fast, wrathful, cleansing, the waters of the desert hills and the cascade. Anyone who has visited the remote sites of the Essene cult near Qumrân, from which early Christian belief seems to have been descended, can see the fastidious obsession with ablution rituals. On the shores of the Dead Sea, walled in by the crimson ravines of the desert of Edom and Moab, channels of bleached stone were constructed to run waste (of food and body) into the saltwater basin where it would be marinaded into saline white nothingness. Not surprisingly, the earliest fathers of the Egyptian church, notably St. Anthony, turned their back on the luxurious Nile and established their monasteries in the bitter, arid desert wastes between the Gulf of Suez and the Sinai peninsula.

It was the typology of the Jordan torrent, not the Nile, then, that probably supplied the rudimentary rituals of cleansing and redemption that evolved into baptism. But the distinction ought not to be too neat. The pilgrim Anthony of Plaisance saw the rituals of the Feast of the Epiphany outside Jerusalem take the form of a blessing of the waters of the Jordan. At the precise site from which water was drawn for baptisms, a wooden obelisk had been planted in the river surmounted by a cross.[50] But what seems, on the face of it, to be a ritual proclaiming the advent of a new life actually retained potent con-

nections with the old. For the obelisk was the traditional Egyptian emblem of the rays of the sun; and by its being surmounted by a cross, Christ as *Sol Invictus,* the victor over death, became a peculiarly hybrid deity: water and light, old and new, Egyptian and Judean.

Just as the official Christian policy of uprooting pagan tree cults was belied by the pragmatic grafting practiced by missionaries like St. Boniface, so, too, ancient pagan traditions of the sacred stream, a site of death and resurrection, often diluted the severity of the early church fathers. Scholars like Jean Daniélou, E. O. James, and Per Lundberg have suggested that the conferring of immortality through baptismal immersion must have owed something to pagan Near Eastern myths identifying the holy rivers of the Nile and the Tigris as the abode of the dead, ruled by a lord, Tammuz or Osiris, inhabiting an ambiguous zone between mortals and immortals, and vested with the power of resurrection.[51] The cult of Isis was widespread throughout areas of Latin Europe where Christian converts were being made.[52] And since we know that, at the temple of Isis in Pompeii, for example, the sprinkling of water on the heads of devotees was a regular afternoon practice, the approximation of pagan and Christian water rituals does not seem too improbable. Seneca had reported the common belief that drinking Nile water could make barren women fertile, and throughout late antiquity and the early medieval period, phials of the muddy solution were purveyed as miracle draughts.[53]

The early fathers of the Near Eastern churches were certainly aware of the continuing potency of pagan river myths. Felix Fabri recalled the story of the eager iconoclast Emperor Theodosius and his patriarch Theophilus, who in the year 391 ordered the destruction of the "Serapeum" of Alexandria and the burning of statues of the god. But at the same time he conceded the stubbornness of pagan belief that connected the annual inundations to the offerings made to the deities of the river: Hapy, Nilus, and Sarapis. When the Nile floods failed, there was predictable consternation that it was a punishment for the emperor's destruction of the temples and desecration of traditional sites. Theodosius is said to have replied that it was the pollutions of idolatry that were to blame for the misfortune. But suicides and sacrifices thrown into the Nile continued in desperate attempts to appease the offended fluvial gods.[54] As late as the sixth century, the emperor Justinian, who prohibited paganism throughout the Roman Empire, was forced to tolerate the continuance of obeisances to Isis and Osiris at Philae.

Without specific associations with the Nile, quasi-pagan customs of propitiation and sacrifice persisted along riverbanks throughout Europe well into the late Middle Ages. On St. John's Day, 1333, for example, Petrarch watched women at Cologne rinsing their arms and hands in the Rhine "so that the threatening calamities of the coming year might be washed away by bathing in

the river. Those who dwell by Father Rhine are indeed fortunate if he washes away their misfortunes"; he added, "I fear that neither Po nor Tiber could ever free us of ours."[55]

For much of the Middle Ages, the Muslim conquest of Egypt put serious obstacles in the way of those who still wanted to penetrate the mysteries of the Nile. Even the more adventurous pilgrims confined themselves to the traditional Holy Land sites of the Scriptures. But with the waning of the Crusades, and the reopening of trade routes in the Levant in the fourteenth and fifteenth centuries, some hardy souls, like the Flemish nobleman Josse van Ghistele, did stray south toward the Red Sea and the Nile.

And what was striking about the narratives of that generation of travellers was their obstinate conviction that the waters of the Nile flowed, ultimately, from paradise. Van Ghistele, for example, was sure that it was the river "Gihon" mentioned in Genesis 2.13, one of the four streams into which the primal river of Eden divided as it left the garden. And Felix Fabri went much further in constructing an entire fabulous geography that, in effect, made the Jordan and the Nile one single sacred stream. What allowed him to have this vision of a holy confluence was the destruction of Sodom and Gomorrah. Since they were sited in the deepest basin of the Dead Sea rift, Fabri imagined the apocalypse as a kind of saline earthquake in which the rocks gaped open, plunging the cities into the depression and creating the Dead Sea as their pool of chastisement. Before this convulsion, he believed, the whole of the valley of Palestine from Galilee to Aqaba had been as verdant and fertile as the Nile; the Dead Sea had not existed at all, and the Jordan followed a stately course through to a junction with the great river of Egypt.[56] (Strangely enough, in *geological* rather than theological time, he was correct in assuming the Dead Sea as the northernmost extension of the Nile rift.)

Now Fabri's own Dominican monastery at Ulm was sited at the junction of the Iller and Danube rivers. So perhaps he had meditated on the spiritual significance of confluence. But his topographical speculations (while fantastic) brought together more than two otherwise remote and antithetical landscapes. They also revived Platonic theories of the cosmic unities by insisting that, ultimately, all the great waters of the region could be traced back to the single stream that rose from the base of the Tree of Life within the paradise garden. Pious Dominican though he was, Fabri was not above recycling the ancient tradition of fluvial topography that supposed the waters of paradise to have reached the remotest parts of the earth through subterranean passages and conduits, from which they surfaced as the great rivers of Greece, India, and Africa. In Fabri's mental map, they were all part of one vast, interconnected drain of waters. And both the Nile and the Jordan were fed by two of the four rivers expressly mentioned in Genesis, the Jordan by the Tigris. The Nile (even more improbably) was ultimately fed by the Ganges, thought to be "Pison," the first-

mentioned of the streams leaving Eden. So in their origin, the Nile and Jordan were, in fact, issues of the same primal stream, "and one may conclude, then, that pilgrims who have drunk from the Jordan and the Nile have drunk the waters of the four rivers of Paradise . . . which is no vain title of glory."[57]

Of one thing we can be sure. Fabri was no original. In his caravan he brought a pack of myths and fables about the shape of the world, ancient and modern, that at the end of the fifteenth century were commonplace. Like many other travellers of his generation, he pieced together his cosmology from oral traditions; fragments of classical texts, often garbled (like Herodotus and Diodorus Siculus); Ptolemaic geography; and the fantastic assertions of late medieval explorers. In such visions there was no clear distinction between astronomy and astrology, and both played a part in Fabri's consideration of the seasonal rise and fall of the Nile beneath the signs of Leo and Virgo. And his apparently untroubled assimilation of pagan and sacred texts certainly owed something to the popular anthologies of classical myth and lore exemplified by Boccaccio's *De genealogia deorum*.[58]

In these crazy-quilt cosmologies, two essential features stood out. The first, ultimately derived from Plato, was the fundamental unity of the world, both in time and space. Whereas the early fathers of the church had been at pains to stress the severance of Christian from pagan worldviews, the antiquarians of the early Renaissance effectively brought them together again. And though pagan myth was heavily mined for motifs that seemed to prefigure Christian mysteries, it often succeeded in breaking through the pious patterning, to establish an authority and coherence of its own. So while for centuries the Nile had been perceived as the profane sister of the holy Jordan, by the Renaissance it was beginning once again to be invested with the imperial magnitude which classical scholars and artists found irresistible.

Secondly, the fluvial literature of the late fifteenth and early sixteenth centuries became obsessed with mystifying the Source. To return to primitive antiquity was, after all, to become bewitched with myths of creation, and the ultimate origin was represented as a fountainhead. A contemporary of Seneca, Philo Judaeus, commenting on the rivers of paradise, had described a *fons sapientiae:* the mystically revealed union of goodness, beauty, and wisdom, the closest thing that could be apprehended, even metaphysically, to the secrets of Creation. And from the early sixteenth century, this gush of esoteric illumination was conceived, visualized, and eventually, in the gardens and parks of Renaissance villas, actually designed as a basin of moving water.[59]

iv *Fons Sapientiae*

There was at least one place where the Nile, in full spate, seemed to flow toward the Tiber. About fifteen miles southeast of Rome, in the town of Palestrina (known to the Romans as Praeneste), stood the ruined temple of Fortuna Primigenia. Very often such temples were associated with the cult of Isis, and since the date of its foundation was obscure, the rites of her veneration may have been very ancient. Statues of the goddess that stood in these sanctuaries suggest a conscious effort to make a Greco-Roman version of the Nile deity. A surviving example in the Vatican Museum holds a vase in her left hand and the drapery falls in a cascade, modelled as rivulets at her belly, from breasts to feet. It was in the reigns of the emperors Hadrian and Septimius Severus, however, that the temple had been most elaborately embellished. Hadrian had spent more time in Egypt than any other Roman ruler, and it seems likely that it was under his authority that the two obelisks found amidst the ruins were brought to Praeneste.

Was it Hadrian, then, who had diverted the sacred waters of Egypt to flow through Latium? For on the floor of the Aula Absidiata of the temple was a spectacular mosaic of the inundation of the Nile, probably executed by Greco-Egyptian artists sometime around the end of the first century B.C.[60] Almost everything that Europeans had carried in their collective memory about the Nile was deposited in the swarming landscape: realistically depicted flora and fauna such as fearsome hippopotami and crocodiles as well as palms and lotus, monkeys and storks. Half-submerged rocks and trees suggest the rising flood, while little farms and meadows appear as islets in the overrunning stream. But the landscape may also be a topographical ideogram. For the highlands shown at the top of the mosaic with scenes of lion hunts atop extravagant crags resemble descriptions of the Nubian and Ethiopian highlands from which the river was supposed to rise. In the middle ground, left and right, are two genre scenes of figures, apparently gathered about a Hellenic temple, with obelisks (left) and a walled enclosure with giant statuary (right). The foot of the mosaic suggests the destination of the river before another temple. For it is there that the primal ceremony of the birth of life, with the sun's fire impregnating the waters, is ritually observed with a candle plunged into a fountain. In celebration, the

side of a great arch spanning the flood is festooned with flowers celebrating the resurrection of life in the teeming Nile.

From 1484 onward, the great mosaic of Praeneste was the responsibility of the young prince Francesco Colonna.[61] He had many reasons to take these responsibilities seriously. His noble family liked to boast of its purported

Isis-Fortuna,
Greco-Roman,
first century B.C.

descent from the Julian dynasty of the Roman emperors. So that made Francesco the heir of two Egyptophile Romans: Julius and Hadrian. More important, though, was his immediate legacy. He was the great-nephew of the humanist scholar and antiquarian Cardinal Prospero Colonna, a leading figure in the retinue of the popes Nicholas V and Pius II, both of whom were deeply engaged in exploring comparative religion and plumbing the mysteries of the birth of nature. But with Pius II's death a revolution of sorts took place at Rome under the auspices of the Borgias, and the Colonna fell out of favor. Francesco's father, Stefano, retired to Palestrina and, under the guidance of Leon Battista Alberti, began the work of restoring the ancient temple.

So it was as political exile, archaeologist, connoisseur of the esoteric, antiquarian, and poet that Francesco continued the Colonna restoration of Praeneste. He completed the work in 1493 and perhaps once again covered the great Nile mosaic with the film of water through which it was supposed to be seen, creating on site the illusion of the sacred stream. Without any doubt, he was also fascinated by the mystery of Egyptian hieroglyphs and had almost certainly read the *Hieroglyphica* of Horapollo, rediscovered in manuscript on the Greek island of Andros in 1418 and published toward the end of the fifteenth century. As the hybrid name suggests, this was a Greco-Egyptian treatise, possibly compiled as late as the fourth century A.D. Known in late antiquity and the early Middle Ages, it established the

Mosaic pavement of the Nile inundation, temple of Fortuna Primigenia (Palestrina) ca. 80 B.C.

mystique of hieroglyphs as a unique language, encoding in its symbols not merely the functional characteristics of things but their immaterial essence.[62] From Plotinus onward, neo-Platonists (without actually understanding anything authentically Egyptian) adopted hieroglyphs as the vehicle of transcendental apprehension, a language not simply deployed to describe the outward character of things but which embodied the inner Idea that Plato taught was their deep reality. To the initiate, open to intuitive and mystical apprehension, such symbols, opaque to those who relied on reason alone, would open the way to the secrets of Creation. Francesco's great-uncle Prospero, and Alberti himself, subscribed to this mystique, and wanted to create a synthetic language drawing not only on Egyptian but on Hebrew, Chaldean, and Greek to embody these cosmic verities.

Colonna probably understood even less of the authentic character of hieroglyphs than the many learned commentators on Horapollo. Yet as the likeliest author of *Hypnerotomachia Poliphili* (The Dream of Poliphilus), first published in Venice in 1499, he was eager to offer a rich array of impressively enigmatic and pseudo-Egyptian devices.[63] Prominent among them was an obelisk carried on the back of an elephant that drew water from its trunk to its mouth. In the esoteric tradition, this was meant as an elaborate allegory of the birth of life on earth. The obelisk stood (as indeed it had for the Egyptians) for the divine light of the sun; the elephant, by virtue of its mass, for the earth within

Woodcut, elephant and obelisk, from *Hypnerotomachia Poliphili*.

whose belly the dead lay entombed. As the elephant carried fluid to its body, so the dead seeds were brought to resurrection by the fertile union of light and water. It might have been a virtual commentary on the mosaic pavement of the Nile at Palestrina. All that was missing was the address to Osiris from the Book of the Dead. And along with the obelisks and elephants, Colonna included images and allusions to Hermes Trismegistus, the legendary magus, magical mason, and lawgiver of Egypt, whose reign was said to have antedated Moses and whose legacy was hidden within a code of symbols accessible only to his devotees and initiates.

No reader of the *Hypnerotomachia* would ever mistake Colonna for Dante, but the mediocrity of the text was compensated for by the haunting peculiarity of the woodcut illustrations, executed by an unknown artist. The emblems, along with images of Poliphilus on his pilgrimage toward Illumination through

Love, gave the text exactly the quality of esoteric strangeness that its author sought. Their effect is not, in any doggedly literal way, meant to be Egyptian, any more than the waters that play through the text were carried from the Nile. But they did bear the ancient associations of life, death, and transcendental wisdom that the Egyptian myths had passed to the West.

Like many other pilgrims for Truth and Beauty, Poliphilus is made to begin his journey, stumbling about in a sinister forest of gnarled oaks. Even without reading Dante it would be obvious that such a place represents, in the symbolic topography of Renaissance poetry, disorientation. And in precise contrast, it is flowing water that gives the dream-traveller direction. From the beginning, water takes over his experience. The crystalline brook from which he drinks after exiting the wood immediately sings to him "dorical melodies" and from thence he proceeds through a progress of waters, gushing from fountains, toward the yearned-for union with Love and Enlightenment.

In one episode he comes on a sleeping nymph "and out of the round breast did sprout out small streamings of pure and clear fresh water—from the right breast as if it had been a thread but from the left breast most vehemently" —the two rivulets joining to water a meadow bright with "fragrant herbs and spring flowers": tansey, oxeye, cowslips, and daisies. We will need to return to the idea of the female body as the *fons et origo* of verdant life. But Colonna's scene was evidently meant as another variation on Ovid's celebration of the

Woodcut, from *Hypnerotomachia Poliphili.*

return of the golden age. The narrator proceeds past fountains of harpies surmounted by the Graces (from whose breasts "water did spin out like silver twist"), golden-scaled dragons, pissing putti, through cryptically inscribed doors until he finally arrives at the temple of Venus. At this last fountain Poliphilus re-enacts a rite of Isis, extinguishing fire in the water. Fertility assured, he is at last permitted his consummation with the incarnation of truth and beauty: Polia herself.

It is difficult for modern readers, trudging along in the footsteps of the earnest Poliphilus, to grasp the impact that the work evidently had on contemporaries. This impact was delayed a generation, not least by the fact that Colonna's reputation as a virtuoso of pagan signs and symbols opened him to

Illustrations from *Hypnerotomachia Poliphili* (left: from the French edition, 1546).

ΠΑΝΤΩΝ ΤΟΚΑΔΙ

charges of heresy, brought by the Borgia pope, Alexander VI. Though acquitted, with the charges dismissed as calumny, it proved harder for him to have enforced the judgement of the court that restored his confiscated estates. Hardly had Francesco returned to Palestrina than a papal guard suddenly materialized to evict him. Expelled from the one place that meant most to his life, he spent his last years as a Dominican monk. Severed from his dreamworld of enchanted groves and dorical waters, Colonna's mythology nonetheless lived on through his book. For the fountains of the *Hypnerotomachia Poliphili* contrived an effect that was somehow both erotic and philosophical, animal and ethereal. And it was this irresistible combination that cast a spell on the landscape architects of the Roman and Tuscan villas of the mid and late sixteenth century.[64]

As in the *Hypnerotomachia*, fountains were conceived as stations en route to illumination, often connected by lines of water that mapped the progress of the visitor along a strictly predetermined and allegorically saturated path. That path was thus transformed into a river-road itself, navigated with the help of mythological and poetic references. At the Villa Lante at Bagnaia, built for the archbishop of Viterbo, for example, the Fountain of Rivers, personified in colossal reclining figures of the Tiber and Arno, was linked to the primal site of the Fountain of the Deluge by a "water-chain" down which water flowed through a channel of stone crayfish. At the Villa Farnese at Caprarola, the sides of the water-stair were shaped as interlaced dolphins, the talismanic beast for a safe and blessed journey across water, often from the mortal to the immortal realm.

River-road at Villa Lante, Bagnaia.

These were no places for casual strolls. The creators of the villa gardens assumed their visitors to be learned in all the indispensable texts— Ovid, Virgil, and even the popular anthologies of pagan myths compiled by learned antiquarians. Only then could they enter the enchanted universe of titans and gods, nymphs and heroes, that they confronted in the fountains, pools, and statues. A visitor to the Boboli Gardens of the Pitti Palace, for example, was meant to grasp immediately the relationship of Niccolò Tribolo and Giambologna's great fountain statue of Oceanus, the world-river, with the figures of the Ganges, Nile and Euphrates crouching beneath. And to participate fully in the experience designed by the landscape gardeners, the obedient walker was required to proceed from fountain to fountain, from watery births (such as Venus's) to watery deaths (such as Adonis's) in a particular order, sometimes moving from a wild to a "civilized" classical setting, sometimes the reverse.[65]

From the middle of the sixteenth century these carefully programmed progresses increasingly featured a journey toward a primal Source or (as at the

Villa Aldobrandini at Frascati) a Spring of Initiation, concealed in a cave or grotto. Such places were sited at the symbolic boundary between the visible and invisible worlds, and often guarded by grotesque or gigantic figures, frequently in the form of reclining river-gods. Within, the pilgrim would step over polished pebbles and experience the dim iridescence of an aqueous or submarine world. Walls of volcanic tufa would give the impression of penetrating inside the world's crust, and stucco surfaces would be set with mother-of-pearl,

Giovanni Bologna, fountain of Oceanus, Boboli Gardens, Florence, 1570–76.

shellwork, or strangely wrought enamel forms that seemed to have petrified from slithering amphibians. At the center, a fountain personification of bathing deities Venus or Diana would reveal themselves as the Source of Wisdom, the Fountainhead.

At Castello, built for Duke Cosimo de' Medici (Francesco Colonna's son Stefano was an adviser), the grotto brought the Praeneste mosaic into three dimensions, displaying a bestiary of Nile animals—camel, giraffe, and elephant

(as well as the inevitable croc and hippo)—all, according to Ovid, the original creatures of Creation. And while the initiate marvelled at these revelations, he would (like Poliphilus) hear strange and delicate music played by water organs concealed behind or beneath the statuary. At Pratolino, built for Duke Francesco de' Medici, the grotto even boasted moving automata that would complete the unearthly effect by making convincing sounds in the half-light.

All this, of course, required from the designers not merely easy familiarity with the grammar of hydro-mythology but also a whole new technology of ornamental hydraulics. This too was thought, inevitably, to have a Greco-Egyptian origin in the treatises of the School of Alexandria, said to date from the third century B.C. *Fontanieri* such as Tommaso Francini and Bernardo Buontalenti created the water marvels, automata, organ pipes, and *giocchi d'acqua* (water jokes) that would douse unsuspecting visitors who triggered its jets with an innocent footfall. Their new mechanics was built on a body of theorems said to have been proposed by Alexandrian physicists and mathematicians known to posterity as Ctesibius and Hero. These men had explored the expanding properties of water under heat and had experimented with the effects of air pressure and controlled vacuums. Mentioned by Vitruvius, their treatises were known during the Middle Ages from Latin and Arabic manuscripts and during the sixteenth century were published in Italian translations.[66]

Mastery of these complicated and interlocking arts seemed to require not just mechanical skill but profound philosophical learning. The title of "superintendent of rivers and waters," awarded to some of the most famous of the *fontanieri* like Buontalenti, was much more than a certificate of engineering. It signified true hydraulic virtuosity: the allied powers of physics and metaphysics. While the discipline began in Italy, it spread throughout Europe as the first generation of water virtuosi were commissioned by princes from England to Austria to divert rivers and build underground conduits that would debouch in spectacular sprays in their palace parks. Tommaso Francini, for example, who had worked for the Medici dukes, was exported to Henri IV in France to reproduce the grottoes, automata, river statuary, and cascades that awed visitors to the villas near Florence. And for the most ambitious of those rulers, there was the implicit hope not only that they would outdo their rivals in these water spectacles but that the polymathic *fontanieri* would use their art to reveal the deep and occult principles of creation. Absolute monarchs, after all, had a professional interest in the revelation of cosmic harmonies, the laws which disclosed the stable, self-regulating circularities governing the universe. Supposing the hydraulic philosophers were not charlatans or witches, they might provide the prince with the potent weapon of metaphysical knowledge.

It did no harm, of course, that hydraulics could also be shown to have practical virtues. Princes were supposed to care as much for the salubrity of their

subjects as for philosophical riddles. Bernard Palissy, the Huguenot enamellist
and potter patronized by Catherine de' Medici and who created the ultimate
grotto at Saint-Germain-en-Laye, studded with lustrous enamel crustaceans,
also devoted himself to applying the principles of Alexandrian hydraulics to the
urban supply of water. His book on rivers and fountains opens with an anec-
dote meant to declare his vocation. Travelling through a village in northern
France on a hot day, Palissy inquired of a peasant where he could find a foun-
tain to refresh himself,

> to which he replied that there was none in these parts and that the wells
> were all ruined because of the drought and that there was only a little
> brackish water at the bottom of those wells. What he said made me
> sorely angry and astonished at the hardship under which the inhabi-
> tants of the village labored through the want of water.[67]

Palissy's vocation was thus defined by the necessary transformation of stag-
nant, into flowing, water: the pond into the fountain; mortality into vitality.
But even when these conscientious engineers were necessarily preoccupied with
pipe corrosion or the design of a new generation of water mills, they ultimately
saw themselves as magi: wise men to whom it would be given to discover the
principles of universal kinetics, including, perhaps, perpetual motion. And it
may be that their very reputation as masters of cryptic arts made them appear
to flirt with heresy. To save his soul (and possibly his body), Francesco Colonna
had retreated to the safety of a Dominican monastery. But after his Medici
patroness died, the Protestant Palissy found himself incarcerated in the ultimate
anti-grotto, the Bastille, and never saw the light of day again.

These political perils failed to deter the most ambitious of the water magi
from attempting the impossible. None were more extravagant in their aims or
their practices than the Caus family, father and son, Salomon and Isaac.[68] Orig-
inating in northern France (pays de Caux), Salomon de Caus had worked under
Buontalenti at the stupendous garden at Pratolino. And though, like Palissy,
the family was Protestant, this seemed no impediment for Catholic patrons,
even those as committed as the Habsburg archduke Albert, viceroy of the Span-
ish Netherlands. Men as gifted as Caus were in short supply and the archduke
longed for a truly Medician water garden (as well as a dependable engine to
supply domestic water) for his palace near Brussels.

It was in the England of James I (who fancied himself the epitome of
Plato's philosopher-king) that Caus found a circle obviously congenial to his
expansive intellect. Caus swiftly built a reputation as the most ingenious of
water mechanics, pumping water from the Thames to feed the Parnassus he had
created for the earl of Arundel's gardens at Somerset House. At the base of the
artificial hill of the Muses, four figures representing the rivers of Britain held

vases from which water flowed into a central basin. Thus the Thames was, in King James's heavenly Albion, promoted to one of the rivers of paradise.

Caus gave lessons in mathematics and perspective to Henry, Prince of Wales, and his sister, Elizabeth, and emigrated with her to Heidelberg when she married Frederick, the elector palatine. There he created (as he had for Henry at Richmond) gardens of fantastic intricacy, featuring water parterres, river-roads and statuary, and the encrusted, luminous grottoes pioneered at Pratolino. But when the Protestant cause was destroyed at the Battle of the White Mountain in 1620, Caus moved to France, perhaps seeking the protection of the Queen Mother Marie de' Medici. This turned out to be a poor career move since the Queen Mother fell steeply from favor in the reign of her son Louis XIII. Caus was rumored to have been locked up by Cardinal Richelieu in the terrifying prison-madhouse of Bicêtre.

Anonymous portrait of Salomon de Caus.

Before he died, Caus managed to produce one of the most extraordinary works in the entire history of hydraulics, *Les Raisons des forces mouvantes,* which was reprinted after his death in an English edition by his son Isaac as an introduction to his own work at the earl of Pembroke's gardens at Wilton, and which was translated into virtually every European language before the middle of the seventeenth century. In his introduction Caus self-consciously places himself in the tradition of masters of the *fons sapientiae,* which begins with Plato and Aristotle and proceeds with the School of Alexandria through to the philosopher-artists of the Renaissance like Alberti and Leonardo. But the true wonder of the book is the collection of astonishing plates, many of them marvels of technical fountain design along the lines of Medician and Roman hydraulics. Caus is at pains to expose exactly the physical means (using steam pressure a century before James Watt) by which water might be made to behave in ostensibly "unnatural" ways. But in the most theatrical plates he commands light, fire, and water in the heart of rocky caverns where birds are made to warble, brilliant balls fly around on illuminated jets, and the secrets of elemental mechanics are mastered at the very fountainhead. No wonder he was thought dangerous, the Prospero of Heidelberg.

Engravings
from Salomon
de Caus,
*Les Raisons
des forces
mouvantes,*
1615.

v Nile Brought to Tiber

In 1512 a colossal reclining statue was discovered in the rubble of a late Roman temple of Isis on the Monte Cavallo.[69] In all respects it corresponded to the river-god types familiar from Greek statuary and Roman coins: bearded, mostly nude but with drapery that seemed to suggest the flowing waters, and, most important for the classical tradition, holding a cornucopia, the Horn of Plenty that had been torn off Acheloüs by Hercules. The fact that this particular statue group included the figures of Rom-

Reclining statue of the Tiber, Greco-Roman, first century B.C.

ulus and Remus suckled by the she-wolf clinched its identification as the Tiber. And it was in this auspicious guise that it was brought to the collection of antique statuary in the Vatican. By the sixteenth century the Tiber was notorious for its mercurial unpredictability. Though it snaked between papal and civic Rome, it was decidedly unlike the Nile in its raging floods and torrents, which had the habit of swamping the poor quarters of the Trastevere. Later in the century the Jesuit writer Giovanni Botero would contrast such Italian torrents (for the Arno was even worse) with the slow and sedimentary rivers of Flanders and northern Europe that, through solute density, were capable of carrying heavier traffic and thus comporting themselves as vehicles of prosperity.[70]

But for all its bad temper, the Tiber was still the quintessential imperial river. Virgil has the river itself welcome Aeneas to the place where he founds the new Troy—Rome—and (like the Thames and the Seine) it was revered as

the very bloodstream of the state. The following year, 1513, a second reclining river deity was found on the same site, also bearded but festooned with sixteen putti clambering over its torso. Readers of Pliny (and there were many) immediately identified these as the personifications of the sixteen cubits by which the Nile rose to its optimal flood-level. It seemed both logical and pleasing to popes like Julius II, who certainly had pretensions to establish a new spiritual empire in Rome, that the Nile should be brought together with the Tiber as emblems of imperial succession. And the Borgia pope, Alexander VI, was even absurdly flattered by Annius of Viterbo, who attempted to use Diodorus Siculus to prove that Alexander was actually descended, albeit remotely, from Osiris himself. Never one to shrink from comparisons with heroic divinity, Alexander had Pinturicchio celebrate the genealogy with a series of paintings commemorating the life and death of Osiris.[71] By that time, Michelangelo (who had sculpted

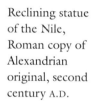

Reclining statue of the Nile, Roman copy of Alexandrian original, second century A.D.

figures of river-gods for the Medici tombs and planned a group of the four rivers of Hades) had designed a setting for the twinned river-gods of the Nile and Tiber at the base of the great staircase of the Campidoglio. And there they remain as guardian deities of fluvial empire.

The enthronement of the two rivers was more than just a gesture of casual classical nostalgia. It announced the claim of the Renaissance papacy to inherit not just the cultural legacy of Old Egypt but the specific Roman imperial title to its possession. And nothing signified that claim more dramatically than the extraordinary program embarked on by Sixtus V in his brief papacy in the 1580s, of re-erecting Egyptian obelisks on new, expressly Christian sites. The obelisks had been brought to Rome by a succession of emperors, beginning with Augustus himself and including Hadrian, who had travelled to Egypt and coveted its antiquities. The act of their removal, moreover, was meant to proclaim not appreciation (much less, reverence) for their antiquity or beauty but

triumphal appropriation, much like the parades of slaves and treasure that fol-
lowed a military victory. The Romans were aware that the obelisks were objects
of religious adoration for the Egyptians, rays of the sun symbolized by pointed
columns of stone. Most of them had been taken from temples at Thebes and
Heliopolis where they had stood in pairs at the entrance to temples dedicated
to Amun-Ra, the sun-god. It was relatively simple, then, for the Roman emper-
ors to transfer not only the obelisks themselves but their religious associations
to their own domestic cult of the sun, whose beams naturally irradiated their
own imperial divinity.

By the sixteenth century only one of the thirteen known obelisks still
stood upright at the *spina* of the Vatican Circus. And like many of the surviv-
ing Egyptian antiquities in and about Rome, it had been effectively baptized
into the Christian tradition through a combination of archaeological igno-
rance and rich local mythology. The Vatican obelisk, brought by Caligula from
the Julian Forum in Alexandria where Augustus had erected it, was said to
have witnessed the martyrdom of St. Peter himself. It thus embodied a per-
fect symbolic connection between pagan antiquity and Christian posterity, the
two histories of Rome. So it made inspired sense for Pope Sixtus V to move
the column to the site where the papacy's ambitions to create a new and glo-
rious Christian regnum were concentrated: the piazza in front of the Basilica
of St. Peter's.

The fact that daunting logistical obstacles stood in the way of the enter-
prise only whetted the pope's appetite. Doubtless he had read Pliny's famous
description of the spectacular mechanics of the emperors' transport of the
obelisks from Egypt to Rome. What better way to demonstrate the succession
from a pagan to a Christian empire than to carry out a comparable relocation.
It helped, of course, that in Domenico Fontana the pope had an engineer (in
fact a *hydraulic* engineer) of genius. Following some of Pliny's detailed account
of the original transportation of the columns, Fontana had a huge wooden cra-
dle constructed, along with an elaborate system of pulleys, to lower and then
move the column over a long road of wooden rollers toward its final resting
place. The spectacle could not have been better designed to rouse the *plebs
Romana,* notoriously greedy for excitement. Eighty-three feet and three hun-
dred and twenty-six tons of masonry trundling through the streets; the four
bronze crabs which had ornamented the Roman setting, in the rear, all the way
to St. Peter's; a miracle of urban logistics, wholly worthy of the magnitude of
Sixtus's ambitions. No wonder that in the superb volume Fontana published
to celebrate his work he congratulates himself for living up to his ancient
Roman predecessors.[72]

On September 26, 1586, the obelisk's conversion was completed when it
was surmounted by a cross and Sixtus's own emblem: the holy star. From then
on the pope became a compulsive obelisk-hauler. With Fontana repeating his

Engraving from
Domenico
Fontana, *Delle
Trasportazione
Dell' Obelisco
Vaticano,* 1590.

own mechanical system for transportation, three more columns were re-erected between 1587 and 1589. One had stood before the mausoleum of Augustus; a second, lying shattered beneath layers of rubble and masonry debris, had been brought by the son of Constantine to Rome, and had originally stood in the temple of Amun at Thebes. Over a hundred feet tall, it was hauled to San Giovanni in Laterano. And the last of the four also lay broken in the Circus Maximus and was set upright in the Piazza del Popolo in the spring of 1589.[73]

But Sixtus was not yet finished with his ambitions as the engineer, literally, of *renovatio*. Fontana belonged to the generation whose engineering credentials would have been incomplete without a profound knowledge of hydraulics. But for a Roman, the hydraulic tradition had a special significance. The ruins of great aqueducts throughout the Latin world had survived as a reminder of the imperial scale of Roman waterworks. But they were merely the visible fragment of a system that, according to Pliny, numbered seven hundred basins, five hundred fountains, one hundred and thirty reservoirs, and one hundred and seventy free public baths. Little wonder that he could boast:

> If we take into careful consideration the abundant supplies of water in public buildings, baths, pools, open channels, private houses, gardens and country estates near the city, if we consider the distances traversed by the water before it arrives; the raising of arches, the tunneling of mountains and the building of level routes across deep valleys, we shall readily admit that there has never been anything more remarkable in the whole world.[74]

In 1425 details of the construction and maintenance of the Roman system became available to the Renaissance engineers when Poggio Bracciolini (the tireless sleuth) discovered, in the monastery of Monte Cassino, Sextus Julius Frontinus's *De aquis urbis Romae*, written around A.D. 97.[75] Frontinus was commissioner for hydraulics under the emperors Nerva and Trajan and, from what can be gathered from scanty sources, was the model of a zealous public servant. By now it should not come as a surprise to learn that he acquired his skills in classical hydraulics from the School of Alexandria (though he boasted that in comparison with Roman aqueducts, the pyramids were an insignificant achievement). And perhaps just because the engineers of the Renaissance believed they were the heirs of the ancient arts of pressurized flow, the discrepancy between ancient and modern supply of water for the citizens of Rome seemed painfully glaring.

The renewal of pure, flowing water, at once a sacred and a civic duty, thus became an essential part of the program of papal reform. In 1453 Nicholas V inaugurated the work of repair and restoration of one of the eleven ancient ducts and rebaptized it the Acqua Virgo. The same year that Fontana moved

the Vatican obelisk he also supervised the restoration of a decayed portion of the old Acqua Alexandrina, which was also renamed as the Acqua Felice. Conscious of the kind of civic paternalism that Frontinus had described, Sixtus had grandiose ideas for the irrigation of a greater Rome that would flower under his pontificate. The Acqua Felice would allow the hills outside the city walls to become populated once more and connect them with a freshly cleansed city. And while the popes could hardly reproduce the three hundred bronze and marble statues and four hundred marble columns that Pliny describes as ornamenting the waterworks, Sixtus was determined to make at least some architectural expression of his claim to refresh the imperial tradition. On the hilltop terminus of the Acqua Felice, Fontana built a great monumental castellum,

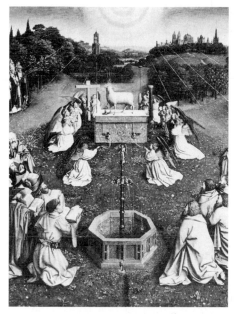

Detail, Jan and Hugo van Eyck, *Triptych of the Holy Lamb*, Cathedral of St. Bavo, Ghent, completed 1432.

embellished with fountains and statuary, that did recover something of the nobility of the Roman structures.

During the brief quinquennium of Sixtus's pontificate, ideas for Roman refreshment gushed from the Vatican—not just fountains and new pipes but public baths, mechanisms for waste disposal, troughs for the rinsing of wool, *anything* that could be piped, washed, flushed. And after his death the enthusiasm flowed on. Paul V repaired the old Acqua Trajana, which duly became the Acqua Paola, and had Jacopo della Porta build the most grandiose of all the monumental termini, resembling a triumphal arch more than a fountain. But the pope took good care to see that the elaborate relief sculptures that decorated it all alluded to the spiritual and biblical warrants for the watery renovation: Joshua at the Jordan; Aaron and Moses at the rock of Horeb.

For, quite apart from the imperial precedent for papal waterworks, fountains had come to feature very prominently in the iconography of the church militant.[76] If the Tree of Life figured as the archetypal ancestor of the cross, a river flowed from its roots into the world and was commonly represented in medieval illuminations as feeding the Well of Life. In this guise a fountain occupies a central position in the van Eyck brothers' famous triptych of the Sacred Lamb in Ghent. Very often, too, the fountain, or well of life, marked the gathering place of the nations, believers and unbelievers; almost as if it were the

waters that flowed, like the Nile, between pagan and Christian worlds. And the fluids that fed the fountain were, in keeping with the same ancient pre-Christian tradition, composed of the mutable liquids of blood, wine, and water. In the same Catholic city of Ghent the Flemish artist Horenbout, for example, produced an extraordinary altarpiece of multiple-tiered fountains. From Christ's body, posed very much like the antique statues of Oceanus, blood spurts copiously from his wounds into a chalice from which it overflows into

Gerard Horenbout, *Fountain of Life and Mercy*, Ghent, 1596.

the cups of the thirsty faithful, gathered about the well (while the acolytes of Dame World worship elsewhere).[77]

All the elements of a new sacred hydraulics were coming together: the Christianized memory of the Nile and its cult of vital fertility; the mystique of the Source of Creation, made visible through the miraculous mechanics of the School of Alexandria; the *renovatio* of the Roman tradition of flowing water.

Yet somehow the ensembles of stone, light, and water remained inert. Fontana and Della Porta's fountains sat importantly on their Roman hills, devoid of any real kinetic animation. The obelisk stood to attention before St. Peter's like a standard captured from the enemy. Together they all spoke of authority, not mystery; not the secrets of Egypt. What they needed was a magus. And in Gianlorenzo Bernini they would get one.

vi Bernini and the Four Rivers

The fountains of Versailles were in their infancy when Bernini told his French minder, Fréart de Chantelou, that all his life he had been "un amico dell'acqua."[78] He might have added that water was, as it were, in his blood, for in addition to a career as a mediocre sculptor, his father, Pietro, had been invested with the office of superintendent of the Acqua Vergine. From the outset, Bernini had wanted to liberate the kinetic qualities of light and water from the rather stolid forms in which the fountain sculptors of the High Renaissance had encased them. Where they had stressed the contrary properties of stone mass and running water, Bernini wanted to bring them together in one fluid, musical sequence. To succeed in dissolving these substances in a glorious run of light, sound, and motion seemed the great response to Michelangelo's challenge of *difficoltà*.

Bernini had already risen to that challenge in the carving of his namesake, San Lorenzo, writhing on the grill, licked by flames that seemed to transubstantiate themselves from stone to fire, just as the saint's body underwent the metamorphosis from agonized, charred flesh to the ecstatic, fragrant sweetness of martyrdom. And it was the *stupenda* of such early works that caught the attention of patrons like Sixtus V's nephew, Cardinal Montalto, who commissioned from him a Neptune with Tritons for his gardens. Bernini took one of the most familiar of Ovid's myths, the moment when Neptune relents from the primal flood and, to the sound of Triton's horn, the waters recede into the forms they took on the reborn earth: lakes, seas, and rivers. Bernini's genius was to combine *both* the violence of the original act of destruction and its compensatory moment of restoration. To do this he needed to break radically with the tradition of representing Neptune in relatively static or reclining poses, and to abandon the formality of figures posed erect standing in chalice fountains. Instead he coupled the figures against each other in a brutal, twisting *contrapposto;* the

enraged Neptune harrowing the waves with his trident while the Triton sounds the conch. Bernini already knew enough of the new pressure-driven hydraulics to force the water through the shell, as if it were the liquid equivalent of the sound, and down into a great cascade. Aside from fulfilling his obligation to represent the cardinal as the bringer of order from chaos, Bernini produced an unprecedentedly spectacular piece of water-theater: full of furious energy and mad, crashing noise.[79]

Bernini, Neptune and Triton, ca. 1620–21.

For his great patron and friend Maffeo Barberini, Pope Urban VIII, Bernini cultivated a less flamboyant style of fountain: more self-consciously cerebral, learned, and witty.[80] The Fountain of the Bee, completed in 1626, thus alluded to the ubiquitous emblem of the Barberini. Three years later Bernini inherited from his father the post of superintendent of the Acqua Vergine and planned a similar conceit as its terminus, at the entrance of the *Piazza di Spagna*. The form its basin took was that of a boat which, when filled, looks strangely half-submerged. But to appreciate the marriage of playfulness and gravitas that was uniquely Bernini's approach to water requires looking from the fountain up toward the Church of Santa Trinità on the hill that overlooks it. For even without the Spanish steps it seems likely that Bernini, who certainly knew the traditional metaphor of the Church as a ship, meant to have the fountain and the church echo each other at the summit and the base of the hill.

And when he returned to the subject of the Triton, in the center of the propietary Piazza Barberini, Bernini could hardly help but revert to his revolutionary inventiveness. In place of the conventional cup as a base for the figure, he opened a colossal

Bernini, Fountain of the Barcaccia, 1627–29, Piazza di Spagna, engraving by G. B. Falda.

shell, itself supported on the back of dolphins, decorated again with the Barberini bees and carrying the kneeling Triton. Thus, the emblem of security and *fortuna,* the dolphin, is surmounted by a figure symbolizing immortality won through art (for Urban VIII had serious pretensions as a poet); the whole celebration ecstatically extended through brilliant, pressurized jets shooting hydraulic hosannas into the Roman sky.

Art historians sometimes seem reluctant to take Bernini's fountains as seriously, which is to say, as *playfully,* as they deserve. Of Bernini's masterpiece, the

Bernini,
Fountain of
the Triton,
Piazza
Barberini,
Rome, 1642–43.

Fountain of the Four Rivers in the Piazza Navona, one of his biographers comments loftily that its overall effect is compromised by features "that belong more to a circus-act" than to a great monumental sculpture.[81] But the Fountain of the Four Rivers *does,* after all, stand in a circus, for the Piazza Navona preserves in its oval shape the stadium of the Agonale Circus, where, during the reign of the emperor Domitian, games were regularly held. From the late fifteenth century, the piazza was the site of a thriving Wednesday market, where hawkers sold all kinds of food, wine, household wares, and tools. And as was often the case with such places, it rapidly developed into a kind of street fair, too, with jugglers and quacks, street singers and actors of the *commedia dell'arte* jostling for space amidst the throng.[82] The Piazza Navona was also a marketplace of power where political ideas, gossip, and scandal could be traded between the stalls of fruit and cheese. And by the second half of the sixteenth century, palazzi of the Roman nobility looked onto the open space, so that important days in the holy calendar would be marked by the ostentatious presence of carriages and retinues of the Aldobrandini, Torres, Orsini, and Pamphilj.

Anonymous, Piazza Navona, ca. 1630, before the construction of Bernini's fountain.

Though one part of Bernini's personality was passionately devout and high-minded, another had the quality of an exuberant showman: the writer of satires and comedies, the composer and dramaturge. His uniqueness in the world of the Catholic Baroque was precisely the seamlessness of these qualities—his innocence that devotion and theatricality could ever be considered incompatible. And for all the sheer ingenuity and sophistication of both the concept and execution of his works, it is this adamant refusal to divide play and veneration that accounts for the humanity of so much of his sculpture.

In other words, Bernini took comedy seriously, even in the dramatic pieces he wrote for the theater of the Palazzo Barberini, which combined light, music, and startling effects in a conscious attempt to negate the boundary between audience and performance. In one play called *The Flooding of the Tiber* he went so far as to have water gush from the back of the stage toward the front rows, only to be diverted at the last moment by a canal, hidden from the public sight line.

For Bernini, then, the flow of the rivers contained its own powerful drama. And to channel that drama into a fountain that would somehow both symbolize and embody the sacred myths of the rivers was an irresistible challenge. To say that he met that challenge theatrically is, in the terms of the Baroque (or for that matter our own), to bestow on his achievement the highest accolade. For the Fountain of the Four Rivers is a masterpiece in the same way that Bernini's other great works of sacred theater, like the Cornaro Chapel or the *braccia* of St. Peter's, are masterpieces: in demanding the suspension of the

beholder's disbelief, the surrender to a vision of the world in which profound cosmic mysteries are given visible, sensuous expression. And it is also the place where all the currents of river mythology, Eastern and Western, Egyptian and Roman, pagan and Christian, flowed toward one great sacred stream.

That it came to pass at all was something of a miracle. With the death of Urban VIII in 1644, after a disastrous and petty local war, the cause of the Barberini collapsed in disgrace. The family clique of cardinals fled, pursued by creditors and enemies, and the reputation of their favored sculptor-architect suddenly passed beneath the darkest of clouds. Even his own works seemed to be conspiring against him. The first of the two campaniles he had built at St. Peter's had produced such serious cracks in the fabric of the masonry that by 1646 it was ordered demolished. And to add insult to injury, it was Bernini who had to bear the expense of the demolition.

It seemed an apt symbol of his abruptly overturned fortune. For more than a century the papacy had been a fiercely contested prize among the aristocratic clans of Rome, rich, landed, ferociously Machiavellian, and merciless to their foes. The pope who profited from Urban VIII's disgrace, Innocent X, was from the native Roman Pamphilj family and, although notoriously stingy (especially in comparison with the spectacularly prodigal Florentine Urban VIII), was considered the patron of Bernini's rivals, Alessandro Algardi and Francesco Borromini. The family palazzo stood beside the church that Innocent wanted Borromini to enlarge and which became Sant'Agnese. But in the age of sacred hydraulics, the way in which a papal dynasty effectively colonized a Roman piazza was by creating a new fountain. Since Bernini had been forced by Urban VIII's death to abandon work on the Trevi Fountain, at the end of the Acqua

Bernini and workshop, Fountain of the Four Rivers, Piazza Navona.

Felice, Innocent took the opportunity to upstage his predecessor by bringing the Acqua Vergine (once the charge of Pietro Bernini) all the way into the Piazza Navona, and completing it with a great show of stone and water. Borromini engineered the hydraulics that made this possible, and with Bernini pointedly excluded from the competition for the design, it seemed virtually certain that either he or Algardi would win the commission.

But for once in his life, that most inventive and unorthodox artist produced an uncharacteristically austere design, with water falling from scallop shells at the base of the obelisk that was to be the fountain's centerpiece. It may well be that Borromini had in mind a simple treatment that would emulate the undecorated setting of the St. Peter's obelisk.[83] If this was indeed the case, then Borromini mistook the pope's notoriously curmudgeonly temperament for aesthetic conservatism. In this case, it seems, Innocent (or perhaps his powerful sister-in-law, Olimpia Mondalchini) wanted a grand show. Two drawings by Algardi, in the Museo Correr in Venice and in the Louvre, suggest the evolving nature of the commission. Borrowing from his fellow Bolognese Giambologna's *Fountain of Neptune,* Algardi produced a multi-tiered structure, flamboyantly ornamented with lobate shellwork. In one version it was crowned with a reclining personification of the river Tiber, complete with Romulus and Remus and the she-wolf. In a

Bernini, self-portrait.

second drawing Algardi has four river deities surround the base (much as three monkeys were gathered about the base of another Giambologna fountain in the Boboli Gardens). And one of the river-gods, as Jennifer Montagu has astutely noticed, appears to gesticulate in the same exclamatory manner as Bernini's figure of the Río de la Plata.[84]

All of which suggests that many of the ideas that would coalesce in Bernini's fertile mind were, in various forms, already circulating in 1646–47, when the pope was coming to a decision about the fountain. Yet even if the eventual master-idea for the Fountain of the Four Rivers grew out of these initiatives, the end result was undoubtedly pure Bernini in its audacious improbability.

Just how he won the commission away from his competitors varies according to the source. One contemporary writer, Marini, claims that Bernini made

a model for the project in solid silver and presented it to the pope's formidable sister-in-law as a way of getting Innocent's attention. But the more popular version that has become a permanent part of Berniniana was supplied by the two biographies written by his son Domenico and by Filippo Baldinucci. It is a tale of cunning and impulsiveness, perfectly in keeping with Baroque Rome and, even if untrue, or at least exaggerated, *è ben trovato*. Sensing Innocent's uncertainty, Niccolò Ludovisi, the prince of Piombino and Venosa, a supporter of Bernini and married to Innocent's niece Constanza, intervened on the sculptor's behalf. Early in 1647 he encouraged Bernini to produce a drawing for the Fountain of the Four Rivers. It took the basic idea of the Triton fountain further by mounting a figure on top of an irregular structure, part stone, part shell, from which water would pour into a shallow basin. The figure (wonderfully

Diego Velázquez, *Portrait of Innocent X,* detail, 1659.

drawn by Bernini) was a variation on the standard bearded river deity, whose flowing whiskers, rather than drapery, suggested the water and whose arms held aloft the papal shields from which the obelisk arose.

A second drawing, now in Windsor Castle, moved the project along toward its eventual shape. In place of the single figure, river-gods, in the manner of Algardi's design, were now seated at the corners of the obelisk, and the encrusted shells on which they sat (above another layer of spouting dolphins) converged to create an irregular cavity through which light penetrated. A brilliant sheet of sketches shows Bernini teasing out this paradox by which a rocky mass could still appear porous, airy, and punctured with light: another exercise in the mastery of *difficoltà*. Bernini has now dispensed with the shells and dolphins altogether and concentrates on a great knot of rock-slabs, pushed and torn and pierced as though by some eruption of the earth's geological motion. One of the sketches (at top right) shows him playing with what would become the boldest idea of all, having the obelisk itself minimally supported so that it appeared to be hovering over the rock and the figures, rather than firmly grounded on any kind of pedestal.[85]

By the time he came to work up a model, presumably sometime in the early autumn of 1647, these basic components had come together (although the fig-

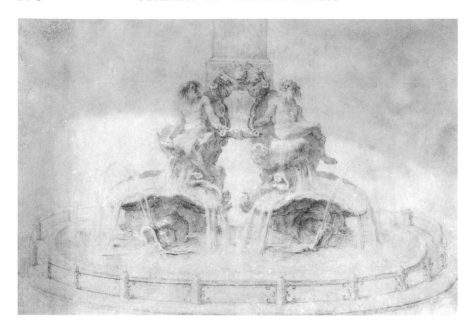

Bernini,
drawing for
Fountain of
the Four Rivers.

Bernini,
drawing studies
for Fountain of
the Four Rivers.

ures of the rivers themselves were still a long way from their eventual characterization). The rock from which the river-gods appeared almost naturally extruded, rather than posed, obviously owed much to the Mannerist rocks of the fountain grottoes, but it could as well invoke scriptural precedents: the rock of Horeb from which Moses struck water, as well as the traditional symbol of the Church as rock. At this point, according to the Domenico/Baldinucci version of events, Prince Ludovisi smuggled the model into the palace of Donna Olimpia when he knew the pope was being entertained there and set it at the end of a passage which led to the dining area. There Innocent must have suddenly seen it, a strange little thing sitting on its advertising table; the huge power of a great, living monument crowded with writhing animate forms. Immediately taken with the model, and guessing the identity of the artist, Innocent spent a good half an hour "quasi estatico," in

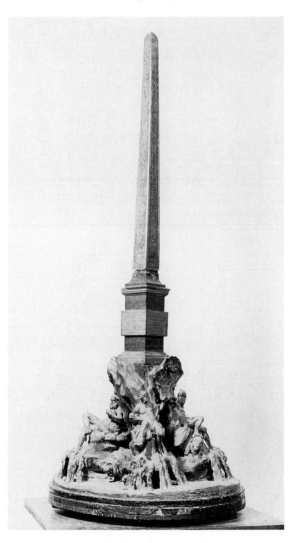

Bernini, terracotta model for the Fountain of the Four Rivers.

thrall to "the inventiveness, the nobility and the immensity" of the sculpture. Describing the coup as "a trick of Prince Ludovisi," he nonetheless capitulated to it, much to the legendary chagrin of Borromini. "Whoever does not wish to have Bernini's designs executed," the pope is said to have remarked, "had better not see his work."[86]

Of course these stories have an unmistakably self-congratulatory air about them. But apocrypha aside, Bernini triumphed because, in spite of the appar-

ent austerity of the pope, he wanted something more elaborately triumphal than Borromini's meager pedestal. What Innocent wanted was a glorification of the obelisk he was re-erecting in the Piazza Navona in time for the Holy Year of 1650. For these jubilees were occasions of conspicuous sacred display in a city packed with pilgrims; confraternities and even the poor eager to have the rich (for a change) wait on them. It was the chance for Innocent to make his own permanent mark on a Rome already vastly altered by the ambitions of the Baroque papacy.

Innocent needed, then, a setting that would be simultaneously imperial and papal. Just as Sixtus had invoked the ghosts of Augustus and Constantine to lend authority to his own works, Innocent saw himself as the heir to Domitian, who had had the obelisk brought to Rome and erected in the Agonale Circus, where the most spectacular games and theatricals had been staged. At some point in the reign of Maxentius the column had been removed and in the seventeenth century lay prostrate and broken on the Via Appia near the monument of Cecilia Metella. After going to see it in the spring of 1647, Innocent conceived its triumphal return and re-erection as a conversion ritual that would transform the pagan stadium into a sacred theater.[87] Borromini's projected Church of Sant'Agnese (converting the pagan *Agonale* into the Christian *Agnes*) as well as the construction of a great fountain, would complete this marriage between a princely Baroque *cour d'honneur* and a sacred open-air theater. So the ensemble of basilica-obelisk-fountain-palace would, in effect, constitute the site of a new papal *cathedra*, St. Peter's removed to the Piazza Navona.

Even by his own standards of inventiveness, Bernini's master-concept was phenomenally bold. It seemed to defy the conventions of matter, with Domitian's obelisk set atop a rock that was itself pierced on both axes, almost as if the column had erupted from the stone, cracking its mass as it emerged, but then, like a jet of water, leaving the realm of the crag altogether. At its tip, the obelisk was surmounted by a dove holding an olive branch that was simultaneously the emblem of the Pamphilj dynasty and the Holy Ghost. Thus the column of the sun, at once light and matter, began in exploding rock and ended in the heavens, with its corporeal substance dissolved into the mystery of Christian triumph.

As if this were not enough, Bernini turned conventional fountain design upside down, both conceptually and structurally. Where fountains were assumed to situate mass in a solid-block base with jets of water rising above it, Bernini concentrates all the kinetic energy in the elemental world of animals, plants, and water in his Edenic rock pool. Above it lie his allegorical rivers, continuing the motion in titanic twists and turns, gesticulations, and muscular exertions, like the great motions of the rivers they personify. And, as always with Bernini, the body language is not a mere dumb show. It is an act of a sacred

mystery, a response to *something,* and that something is the fixed, unyielding point in the whole tumultuous composition, the immutable obelisk; the ray of the sun, *Sol Invictus,* the godhead of Amun-Ra, the father of Osiris, the fountainhead of the whole Egypto-Romano-Christian tradition.

No other artist of the Baroque approached Bernini's intensely Catholic yearning for unity. Just as he was forever inventing new ways in which the unification of matter and spirit, body and soul, could be visualized and physically experienced, so, as Irving Lavin has memorably demonstrated, he orchestrated

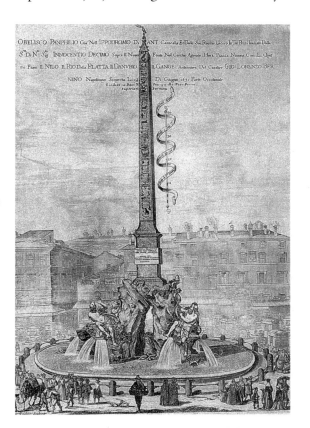

G. B. Falda, The Fountain of the Four Rivers.

his many skills in a unified performance; the nearest the Baroque came to a sacred *Gesamtkunstwerk.*[88] In his fountain in the Piazza Navona, the four rivers of paradise that divided the world are brought back to their single mysterious source: the rock of Creation. Art historians have argued back and forth as to whether Innocent X wanted an expression of the global triumph of *his* pontificate over the four continents and their pagan cults.[89] But this seems to sell short the subtlety and seriousness of the pope's governing idea for the monument.

It seems probable, for example, that Innocent, in common with many of his contemporaries, was versed in the new generation of Egyptology that had followed Sixtus V's obeliscomania. New finds of Pharaonic and Ptolemaic antiquities had been made at the end of the sixteenth century, and a modern generation of scholars, such as Mercati and Lorenzo Pignoria, had attempted to make distinctions between authentic Egyptian hieroglyphs and later, neo-Platonist reconstructions. Basing their work increasingly on true archaeology and some knowledge of Egyptian writing given by early church fathers, they were in the process of turning their back on the fanciful, mystical, allegorical interpretations of the *Hypnerotomachia* variety.[90]

To decode *his* obelisk, however, Innocent turned not to scholars working in this proto-Egyptological discipline, but to an unreconstructed neo-Platonist obsessed with hieroglyphs as an allegorical and esoteric crypt: Athanasius Kircher. At the time of Innocent's accession to the papacy, Kircher was a professor of mathematics at the University of Rome and an inexhaustible philologist and geologist. He had a genuine knowledge of Coptic and had published the first grammar of that language and believed he could extend this expertise into decoding the hieroglyphs on the Pamphilj obelisk. Kircher's *Obeliscus Pamphilius* was the first of a whole series of publications claiming to reveal, at last, the wisdoms of ancient Egyptian religion and philosophy through its writing.[91]

Erik Iversen has lamented the long tradition which has made Kircher "the whipping boy of Egyptology, his Egyptological lifework censured and ridiculed and he himself denounced as a fraud and a humbug."[92] And while his decoding has turned out to be spurious, it is quite true that in terms of his conviction that the hieroglyphs were a Hermetic symbolic code embodying certain cosmic relationships and affinities, his reading had its own inner coherence. Certainly it seemed persuasive to two popes (Alexander VII as well as Innocent X), to Bernini, and to a whole generation accustomed to believe that within Egyptian symbol and myth lay embedded universal, even sacred truths. For Kircher was certainly no relativist, but a Jesuit father, devoted to the supremacy of Catholic Christianity. Like Caus, the Huguenot, he did not have a crudely triumphalist view of the relationship between pagan cults and Christian mysteries. He was much more adamantly committed to the view that the eventual revelation and victory of Christianity had been prefigured by, and was immanent in, other systems of belief. Thus its dominant symbols could find meaningful matches in Greek, Egyptian, and even Zoroastrian iconography. The news that in 1618 another Jesuit father, Pedro Pais, had actually visited the source of the Nile with the emperor of Ethiopia, assumed to be a Coptic Christian, only added credibility to these assumptions about the global unity of a world faith. In such an ecumenical cosmology, though the waters of paradise had indeed divided the world, they retained, at their ultimate source, the *fons et origo,* an issue from a single indivisible divinity. In Kircher's world, then, sym-

Athanasius
Kircher.

Athanasius
Kircher, plate
from *Obeliscus
Pamphilius,*
1650.

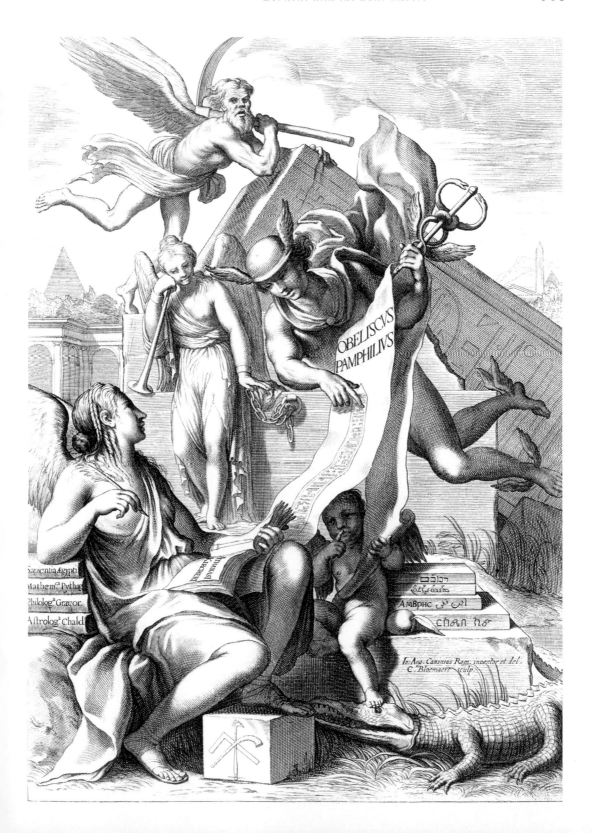

bolic codes disclosed the underlying harmonies that connected what would otherwise appear to be mere collections of unrelated things—suns, moons, animals, plants, gods. And though it is difficult to trace the exact degree of closeness between the sculptor and the Egyptologist, something like this belief—the revelation of divinely ordained unities, tying together the different elements of living creation—is surely the controlling concept behind Bernini's immense creation.

The disposition of the river personifications reflect these connections. So although the Danube carries with it the papal arms and the rushing horse, alluding to the alliance, during the Thirty Years' War, between the Church of Rome and the Holy Roman Empire (with its center in Habsburg Vienna), it can only be seen with either the Nile, the source of Kircher's Hermetic code, or the Río de la Plata, the site of the Counter-Reformation's latest mission of conversion. And since the four rivers symbolize the four continents of the world (as well as, perhaps, the four elements), Europe is thus situated between the ancient site of its wisdoms in Africa, and the new world of its proselytism in America.[93]

Bernini and workshop, Fountain of the Four Rivers, detail, Danube.

Although four of Bernini's assistants, Raggi, Fancelli, Claude Poussin, and Baratta, sculpted, respectively, the Danube, Nile, Ganges, and Río de la Plata, they were merely the faithful executors of Bernini's own designs, worked into models. In the year and a half that followed his first drawings, Bernini transformed his vision of the figures. They no longer followed the conventional reclining pose of the antique figures reproduced in most river-fountain sculptures, but instead responded dramatically to the ultimate source of creation: the finger of solar light radiating down the obelisk. The Nile's head remains veiled to emphasize the mystery of its, and the world's source, while its animal attributes, like the crocodile, paddle the water below. But both the Danube and the Río de

Bernini and workshop, Fountain of the Four Rivers, Nile.

Bernini and workshop, Fountain of the Four Rivers, Río de la Plata.

la Plata attest in their gestures to the irradiating brilliance of the light of faith. The head of the Río de la Plata is startlingly different from any fountain statuary that had gone before, and, while visibly negroid in some features, seems also to be a prototype for the bust of Constantine that Bernini would produce later. If this is in fact the case, the theme of conversion by the overpowering light of faith runs through both projects. As for the Ganges, the least animated of the group, the tradition credited by travellers like Felix Fabri made it one of the four rivers mentioned in Genesis, and thus connected through the Edenic source with the other sacred world streams.

Bernini was not content with a formal allegorical grouping. From the huge slabs of travertine, worked on site, he created a whole organic world, alive with light, water, and air and the forms of animals and plants: in effect, a grotto of the original source, turned inside out. Even the force of a rushing wind is present, blowing through the palm tree that, along with the crocodile, was one of the standard attributes of the Nile and which Bernini himself probably carved. As we have already

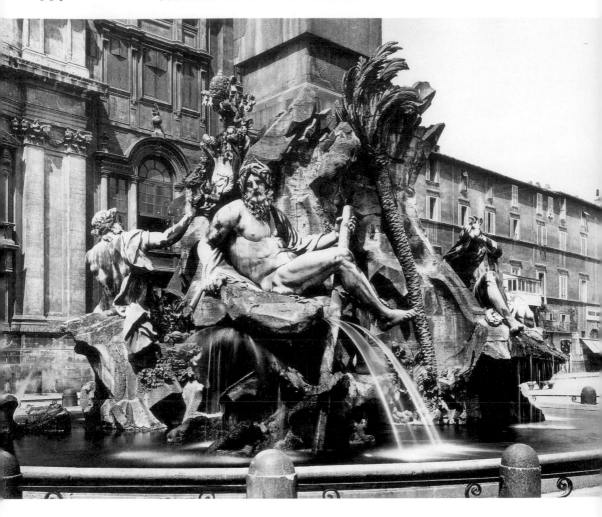

seen, a tradition handed down by Pliny among others made the date palm symbolically interchangeable with the phoenix, as a tree believed to be virtually immortal, an icon that was adopted by the early Christian Coptic, Syriac, and Egyptian churches as the primary form of the cross, the site of resurrection and renewal. At the rock-source, then, the Edenic grotto flowing with light, air, and water, the beholder witnessed less a scene of confessional triumph, courtesy of the Pamphilj pope, than a great synthesis of matter and spirit, nature and faith, pagan and Christian cults; the mysterious transmutation of one cosmology into another.

The construction of the Fountain of the Four Rivers continued through the Holy Year of 1650, with workmen busy not only carving but gilding the papal arms, coloring the palm tree and lilies. Shortly before its completion, the pope made an inspection along with a large retinue and asked Bernini if he

Bernini and workshop, Fountain of the Four Rivers, the Ganges and palm tree.

would turn on the water supply. Typically, the artist refused, claiming he had not been given enough notice, but as Innocent was about to leave, according to Baldinucci, "he heard a loud sound of water" and, turning round, saw it "gushing out in great abundance."

At that time it was surely the greatest water spectacle in any urban space in Europe: the ultimate consummation, not merely of papal Rome's hydraulic revival but of the entire tradition of fluvial vitality. Perhaps it was in the spirit of paternal refreshment that a year later, in 1652, Innocent inaugurated the custom of the *piazza allagata,* by opening the sluices at the base of the fountain in the burning, dusty month of August and allowing the waters of the Acqua Vergine to flood the square. It was, in the first place, a boon to the parched throats and bodies of the citizenry, but before long (and for two centuries) a ritual had been created by which the most splendid carriages of the Roman nobility would process through the waters, the horses splashing about the ancient stadium to the cheers of the crowds.

But when Innocent bid the waters rise in the long oval of the Piazza Navona, he was, in effect, finally baptizing the pagan Circo Agonale, creating a sacred river in the heart of Rome, a stone's throw from the Tiber bend.

And did he know that at almost the very same time, thousands of miles away, the Ottoman viceroys of Egypt were performing the ancient ceremony

Engraving of the Piazza Navona Allagata, Giuseppi Vasi, *Magnificenze di Roma antica e moderna,* 1752, vol. II.

of cutting the Nile dike at Cairo? It was a modern embankment, built to contain the rising waters until cultivation had prepared their fields to receive the floodwaters. A little truncated cone of earth, customarily known as "the bride of the earth," a miniature Isis pyramid, had been built beside the dike, and propitiatory offerings of millet and corn were strewn over it in offering to the goddess of fertility. Some traditions called for a virgin, bedecked in muslin and flowers, to be thrown into the river, to re-enact with her body the union of the fertile earth-goddess with Osiris. So while Bernini's waters played around the Piazza Navona, workmen arrived to slowly breach the last retaining dike of the Nile, and when only a final ridge remained, a boat with an officer aboard was propelled toward it, breaking the barrier. The little craft, like a waterborne coffin, carrying with it ancient mysteries of vitality and mortality, flood and abundance, descended with a sudden rush into the new irrigation canal. And as it passed his elaborately decorated barge, the viceroy of Cairo would toss a purse of gold while his servants tried to stop swimmers from drowning in an attempt to catch the glittering coin; wealth and death, blood and water commingling as they had forever in the human memory of the meandering river.

The *Neiloia* festival, from George Sandys, *Relation of a Journey Begun in 1610*.

Bloodstreams

i Sir Water Ralegh Loses His Drift

It was the flirting queen, much taken with her own wit, who called him "Water." So greedy was her thirst for Ralegh's company that his distracted rival at court, Christopher Hatton, was driven to communicate his despair in the form of a conceit. Three objects were presented to Elizabeth: a bucket, by which she was to understand her "water"; a book, within which Hatton declared his torment in a pleasing trill of desperation; and a bodkin, to use on his own breast should the queen persist in favoring Sir Walter Ralegh.[1]

So it pleased Her Majesty to relent, an economical note of tenderness sounding through the royal decree. Peace, Sir Christopher, she allowed, "there *shall* be no more destruction by water."

Self-destruction, though, was another matter. In the reign of James I, when Ralegh was confined in the Tower (for thirteen years), it was commonly agreed that it had been his abundance of sanguine, as much as the stratagems of the envious, that had been the ruin of him. For whatever view was offered on the poet-soldier-courtier, no one was likely to suggest that his humors were governed by bile or by phlegm. Of choler, Ralegh doubtless had an ample share, and if crossed, he could be transported with alarming rage. But it was

sanguine—the quality that made him by turns amiable, urgent, fanciful, eloquent, wilful, extravagant, reckless, infatuated, obstinate, mendacious, the sanguine that coursed about the tubes and runnels of his body—that commanded his action. That it stoked the heat of his energies was evident from the way his swarthy beard and mustachios curled of their own accord, like paper before a fire. So it was no surprise, however disagreeable, to view his face through a mask of dirty white smoke, as the Devil's leaf smouldered in his stinking pipe. Sanguine had landed the boy Ralegh in the Fleet and the Marshalsea for brawls and duels. It fuelled the grown man's notorious lust, burning in the bed of the queen's maid-in-waiting, Bess Throckmorton, with a heat that made ashes of Ralegh's place at court. But whenever disaster knocked him down, up he rose again, like the Phoenix of his own verse, borne aloft, his damnable optimism bubbling away in the blood.

Yet the queen's jest was nicer than she meant, for Ralegh's combustible personality was indeed the product of water touched by fire, just like the rites of Isis and Osiris, described in his copy of Plutarch's *Moralia*. And if his energies were steam-driven, like the hydraulic machines of Alexandria, it was along rivers that he propelled his fortunes. Had he not, following Plato, Seneca, and William Caxton's *Mirrour of the World*, pronounced on the natural correspondence between the channels that flowed about the body of man and those that watered the earth?

Anonymous, portrait of Sir Walter Ralegh.

Our "blood which disperseth itself by the branches or veins through all the body, may be resembled to these waters which are carried by brooks and rivers overall the earth."[2] And just as he believed history itself to be borne along the currents of rivers, so there was, he thought, a fluvial tide to his own fortunes.

Ralegh had grown up by the banks of the Devonian Ex, throwing stones with his half-brothers, the Gilberts, and his cousins, the Gorges. And he should have ended things peacefully in his park at Sherborne, where the little Yeo ran through grazing meadows like the brooks of old Arcady. But two other great floods had carried him off, as if in confluent conspiracy. It was in his turreted chamber in Durham House overlooking the Thames that he first envisioned the great project of the Guiana rivers, the water-road that would carry him

directly to El Dorado: a place where the riverbed danced in the ripple of gold light, and handsome fish caught the luster in their scales.[3]

In 1586 the Spanish governor of Patagonia, the explorer-conquistador Pedro Sarmiento de Gamboa, was captured by one of Ralegh's privateers. And while he sat in a bare chamber in Plymouth, stoically awaiting his repatriation, Sarmiento de Gamboa decided to put a spell on his captor. The spell was a story and here is how it ran.

Eighteen years earlier, the soldier Pedro Maraver de Silva had undertaken to find the land settled by fugitive Inca, somewhere east of the Cordillera and north of Peru. The journey was a stupendous undertaking covering many hundreds of miles of brutal terrain, the worst that mountain, forest, or dust plain could offer. Somewhere among the drain of tributaries that fed the upper Amazon in the grasslands of the *gran llano,* the expedition had finally come to grief, dividing its survivors into small bands of desperates. In one such company was a munitions man, like all his company from the badlands of Spanish Estremadura, and called Juan Martin de Albujar. When the powder remaining to his band exploded, leaving them without shot, he was punished for his negligence by being set adrift in a rotting skiff somewhere in southern Colombia. The river, thick with cayman and anaconda, took him north and east. With his boat beaten by tropical tempests, his plight became pitiful. On the verge of starving to death, Martin was captured by Indians. With a blindfold on his eyes, he was led mile upon mile farther upstream into the heart of the river forest. When his sight was restored to him, it was immediately blinded again by the radiance that shone out from the jungle gloom: gold on the skin of a great chief; gold on the glistening bodies of his warriors; gold glowing from the arms and legs and breasts of the Indians, from the temple vessels and statues; gold that seemed to throb from the rocks beneath his feet. He had found El Dorado.

The spell worked. Ralegh was bewitched, for the rest of his life, by what the Spanish themselves called *engaño,* the hot mist of hallucination that could swallow reality. The truth about Martin's fate was fantastic enough without embellishment. As the sole survivor of Maraver's expedition, he had lived for twenty years, clad only in red and black tribal daubs, had taken Indian wives, learned their tongue, their art of hunting, the secrets of their poisons and physics, and the dangerous caprices of their gods. But in the truly ensorcelled world of tribal, Habsburg Spain, Martin had to be assigned the more glamorously epic role of the Man Who Met El Dorado. For El Dorado was a person, not a place. He was, literally, "the Gilded One," the native prince whose body was anointed with oil and then rolled in the gold dust that carpeted his dominion.

Spanish fantasies of an auric Cockayne were as old as the Conquest itself, a mess of fables that confused Ovid's lost Age of Gold with the craving for bite-proven yellow metal. And since all the gold of the Inca seemed barely enough to satisfy a few hundred Spanish soldiers, convictions multiplied promising an

infinity of bullion. Any stories related by the Indians themselves of warriors crowned with parrot feathers or sporting golden pectorals were immediately taken as confirmation of the travellers' tales. And the discovery that the Guayana Caribs on the Caroni did indeed wear golden ornaments and would even trade some of the pieces, made the possibility of finding some great mine as the source of the ore virtually irresistible.[4] So whether El Dorado was a place, a person, or a mine gradually became immaterial. Over the mountains and up the rivers went expedition after expedition; Spanish, Flemish, and German (working for the banking house of the Welsers), each wrecked in its own way, some broken as they tried to ride the churning falls, others patiently roasted on the scalding aridity of the *llano,* others still smothered in velvet darkness as the creeping forest closed about them.[5]

In fact there had been enough disasters for a strain of skepticism to establish itself even in imperial Spain during the last third of the six-teenth century. But Ralegh, who had got much glory but little gold in his crusades against the Spanish, was deaf to dissuasion.

Thomas Hariot, map of "Manoa" and its lake, from L. Hulsius, *Travels,* 1599.

He knew that an old soldier, Antonio de Berrio, who had himself launched two expeditions up the Orinoco, had established a fort on the island of Trinidad, guarding the mouth of the river. Apparently, Berrio had been told by Caribs that there were men arrayed in crimson dwelling in the lake city called "Manoa," somewhere in the Guiana Highlands beyond the junction of the Orinoco with its tributary the Caroni. His conviction that he was within reach of the realm of gold had been so strong that on his second expedition Berrio had ordered the slaughter of all the troop's horses so that his men would have no exit except by water. But nothing yet had come of all this ferocious deter-mination. And the old man still sat and waited on his fever-ridden island, leashed to his poverty like a mad and hungry dog, ready to attack any who tres-passed on his route.[6]

In his tower study in Durham House, Ralegh pored over charts showing Manoa as a lake island (topography borrowed from Aztec Tenochtitlan, nomenclature from the Amazon region of Manaus), situated somewhere

between the Orinoco and the Amazon rivers. From his lofty vantage point on the north bank, where the Thames made a snaking, southern bend, Ralegh could survey the progress of empire: the dipping oars of the queen's state barge as it made its way from Greenwich to Sheen; bunched masts of pinnaces and carracks swaying at their berths; broad-sterned Dutch fly boats bouncing on the dock-tide; wherries taking passengers to the Southwark theaters; the whole humming business of the black river. But through the miry soup of refuse that slapped at his walls, Ralegh could see the waters of the Orinoco, as seductively nacreous as the pearl he wore on his ear. Perhaps he imagined himself victorious, vindicated, restored to favor, laying the tribute of El Dorado at the feet of Cynthia-Artemis-Isis-Elizabeth as if he were again playacting some ingratiating masque.

> *The seat for your disport shall be*
> *Over some river in a tree*
> *Where silver sand and pebbles sing*
> *Eternal ditties with the spring . . .*

> *Fa la la, la la*

But his venture would warrant anthems, hosannas. Beside the treasure of El Dorado all the marvels of the Virginia plantation would seem but paltry gardening. The potent Thames would embrace the fertile Orinoco, "a maydenhead never sackt," and its fruit would be a Great British Guyana.

Ralegh and his fellowship of geographers—Dr. Dee, Thomas Hariot, and the Balliol Latinist Laurence Keymis—had figured the Orinoco as a roadstead to fortune, an artery of power. To discover that it was, in fact, not a cornucopia-bearing Acheloüs, but Meander—a snaking beast of indirection—would produce unease, and then, in short order, disorientation followed by consternation.

Yet it was not as if he had set out for the journey ill-prepared. His captain, Jacob Whiddon, had returned from a reconnoitring trip to Trinidad confirming the truth of Berrio's fort, not least from the brisk attack he had received from its soldiers. And the papers of another Spanish river explorer who had claimed to have seen the very ramparts of El Dorado rising above the waters had also fallen into English hands. On arriving at Trinidad, in April 1595, Ralegh wasted no time doing what he did well: attacking the Spanish garrison and capturing its commander, the septuagenarian Berrio. Whether it was from exhausted resignation or (as Ralegh liked to suppose) because he responded to the knightly magnanimity of his captor, Berrio confirmed the location of "Manoa" upstream on the Caroni. Perhaps, too, Berrio's ostensible fatalism was seasoned by anticipation of the privations that would be Ralegh's lot, just as they had been his.

Trials there were in every imaginable form, so that the journey upstream became a kind of fluvial pilgrimage, led by the waterborne knight-errant: a Quixote in a shallop. Or at least so it appears from Ralegh's own account, published on his return as *The Discoverie of the large, rich and beautifull Empire of Guianna, with a relation of the great and golden citie of Manoa (which the Spaniards call El Dorado)*.[7] Of course he had discovered no such thing. Nor had he returned with treasures such as would guarantee the good graces of the queen. All that he had to show were some lumps of spar, bearing traces of gold, as proof that he had approached the very threshold of El Dorado.

Yet Ralegh's first journey to Guiana did indeed produce gold: not the clinking metal of his dreams, but a breathtaking narrative; the prototype of all imperial upstream epics. It was, of course, packed with lies, boasts, fables, and fancies, and Ralegh's decision to pass off stories of men whose heads grew beneath their shoulders was an instance of his poetic sanguine once more getting the better of him. But the power and persuasiveness of the epic lay in its candid recitation of ordeals, as well as breathless ejaculation at wonders. Though in some details and structure it may have been based as much on the Spanish account of one of Berrio's subalterns, Domingo de Vera, as Ralegh's actual experience, the poet-warrior gave the text a voice that was wholly his own. And for better or worse, it passed down time like driftwood, as the myth of thwarted imperial penetration, fetching up again in the imaginations of Alexander von Humboldt, Joseph Conrad, John Huston, and many many more pilots of delusion.

Like all great poetic myths, Ralegh's established definite stations of the journey. First is the barred highway; then (*station 2*) the treacherous byway. Surviving these ordeals, the company of knights arrives (*station 3*) at the gates of tropical arcadia and is nourished by native hospitality. But they are still barely at the gates of the Golden City, of which (*station 4*), through the rushing spray of impassable waterfalls, they barely attain a mocking glimpse as the rising, rushing waters bear them back to their starting point, clutching the talismans of their quest: the glinting rocks of spar.

Or so structuralist lit. crit. would have it. Within Ralegh's creeper-strangled, monster-bloated, erotically lubricated, filmy, floating world, things are altogether more marvellous. And what the discoverers discover, right away, is that the great river is not for their taking. Instead it takes them.

At its mouth, the captain beholds his first wonder: oysters growing on trees. No matter that these are mangroves with their tortuous roots planted in the water; such miracles augur wonders to come. Yet even before they have set off upstream, the conquerors are made to seem vulnerable. Reassuring comparisons between the estuary mouth and the breadth of the Thames at Woolwich are made. But the pilotage very soon proves a great deal trickier. For the draught of the Orinoco delta was so shallow that it precluded travelling in the

large vessels. The hundred men of Ralegh's band were thus distributed between five open boats, all powered by oars. The most imposing of the boats was a converted Spanish galley, but the commander himself took up position in a shallop that held only ten men. Yet even these little craft have difficulty in finding their way in the treacherous streams of the delta, navigating between sandbars and then through the mud-clogged, liana-choked waterways, hopelessly bewildered about the route to the Orinoco proper.

Provisions dwindle and rot in the suppurating heat. Occasionally the men let off some shot with their fowling pieces directed at the brilliant, taunting birds and shrieking, crested monkeys that dart about the immeasurably high branches of the trees. When heron and parrot are taken, they are gratefully and greedily devoured. But for the most part the men subsist on fish hauled from the rust-brown river. Though they are loath to swallow its waters, and their gullets gag at the effort, they must do so in their plight. And even as they cast their lines, they are shiveringly aware of the commonwealth of terrors mobilized beneath the surface: serpents thirty feet long; great toothed *lagartos* (alligators) and sharp snouted *guuians* (cayman) whose thrashing tails send the frail craft pitching wildly. On the banks from time to time appear strange beasts that they suppose to be part pig, part deer, part giant cony. Attempts to slay them are comical. The shot falls uselessly into the water and the tapir and coati and capybara either disappear abruptly behind the screen of vegetation or else raise a contemptuous gaze and return to lapping the water.

Sometimes it seems as if they are drowning in the very air; such is the weight of its saturation. A week into these cursed waters and they start to mold and stink like rancid whey. Their English broadcloth glues itself to their bodies, yet it is not stout enough armor against the stiletto-thrusts of voracious mosquitoes and the industrious burrowing of chiggers beneath their grimy dermis. Though the enclosing canopy chokes out the air, there is sun enough to scorch their necks and wrists so that their skin stripes with burns as if raked with martyrs' coals. They are too hot to tell if they have fever. But they all shake and tremble with the river-palsy, rowing blind, their lids and corneal jelly stinging with sweat. In their wretchedness, they are sustained by alternations of cursing and prayer. They piss into the river as if their waters might kill the malevolent Orinoco. And when the heat relents in the evening darkness, they evacuate their loathing and wrath in wild brawling, the oafish roaring answered antiphonally by the howling of monkeys and syncopated with the juddering flight of vampire bats.

Then, an apparition: a flash of paddles in the haze; a pursuit, a capture. Threatened, the Indian promises to take them to a village where they may get succor and thence to the true Orinoco. But he tells them they must divide their little fleet, for only the small boats will pass through the shallow, narrow passages. After hours of diligent rowing and poling through the viscid ooze, the

men suspect foul play, perhaps the plot of an upstream Spanish encampment. Ralegh would as good have hanged the native, as his men swore he should. But it was pitch-black night and the dread of the forest was worse than the fear of betrayal.

At the point of despair they are, of course, saved. The village is found; fire in the darkness. The English are well treated and provendered, and in the morning their eyes are blessed by a landscape of salvation, the open grassy plains of the *llano* stretching down to the riverbank:

> some of the most beautiful countrey that ever mine eyes beheld, and wherwithal that we had seen before was nothing but woods, prickles, bushes and thornes, here we beheld great plains of twenty miles in length, the grasse shorte and greene and in divers parts groves of trees by themselves as if they had been by all the art and labour in the world.[8]

Arrived at this equatorial arcadia, nature becomes suddenly less forbidding. Deer, as if charmed, approach their craft; the fish miraculously grow (or shrink) to edible proportions; enormous butterflies, as intensely blue as lapis lazuli, flit about their heads, dainty aerial masquers. Even the discovery that death is indeed also in Arcady, when one of their company is eaten by a *lagarto,* fails to affect their transformation from hapless orphans of the stream to sanguine-rich, dauntless voyagers. The further upriver they go, the more noble the natives appear, jadeite spleen stones plugging their upper lips, their torsoes less stunted, their spears and blowpipes more forbidding, as if in promise of a true warrior-aristocracy in the Manoan heartland. And it is not just the men but the women whom Ralegh, the fabled satyr, the love poet, caresses with his anthropology: "very young and excellently favored which came to us without deceit starke naked." And further on, lodged in the hut of a chief, he drowns in admiration of the man's wife:

> In all my life I have seldome seen a better favored woman. She was of good stature with black eyes, fat of body, of an excellent countenance, her hair almost as long as her selve, tied up again in prettie knots and seemed she stood not in awe of her husband as the rest for she spake and discoursed and dranke among the gentlemen and captaines and was very pleasant knowing her own comeliness and taking great pride therein. I have seen a lady in England so like her as but for the difference of colour I would have sworne might have been the same.[9]

What memories was Ralegh combing for such a comparison, seeing that his copper Amazon was, of course, naked? And in any event, the lover was deci-

sively curbed (so he tells us) by the responsibilities of the knight, the protector, the *Protestant*.

> Nothing got us more love than thus usage, for I suffered not anye man to take from any of the nations so much as a Pina [pineapple], or a Potato roote without giving them contentment, nor any man so much as to offer to touch any of their wives or daughters which course, so contrarie to the Spaniards (who tyrannize over them in all things), drew them to admire her Majestie whose commandment I told them it was and also wonderfully to honor our nation.[10]

What better pioneer of the repression of the British imperial libido than its most famous Elizabethan fornicator: the Great Lucifer commissioned to fight against Sin!

Strategic virtue seemed to pay off. At the junction of the Orinoco and the Caroni, Ralegh was presented with gold-plated gifts—pineapples and armadillo— by the old chief Topiawari, who appeared in a macaw-plumed crown, as though posing for an allegorical print of America. To Ralegh's delight, he delivered himself of a tirade against the cruelties of the Spanish and, still better, between much humming and clicking of his tongue and shaking of his head, spoke of an upstream people, crimson-caped and formidably armed, who had descended down the Caroni to conquer local tribes.

Thus El Dorado crooked his wicked finger in their direction, beckoning always upstream. Within sight of the Guiana Highlands, the landscape turned into the suburbs of Eden. Crane and flamingo rose from the water in dense clouds of carnation and white, "and every stone we stooped to take promised silver or gold."[11] Yet even as they were scrabbling amidst the pebbles and panning the waters with outspread fingers and palms, the river was beginning to mutiny against their good fortune. Rains of a torrential power crashed down on them like siege mortar. The river rose alarmingly, tossing the boats helplessly between needle-sharp rocks. And at the back of the din was a yet more monstrous clamor, "as if a thousand great belles were knoct against one another." Around a bend the campanile that tolled the death of their hope reared monstrously above them, "like a Church towre of exceeding height": a colossal waterfall dropping great curtains of foam down sheer walls of brutal black rock. It was the cascade of which old Berrio had spoken, the highest falls ever seen by man, a barrier that had defeated the concupiscent, larcenous Spanish and would inflict the same fate on the knights of the Virgin Queen. In its waters, Berrio had told Ralegh, were to be found diamonds and other precious gems. But none among the crew dared trust their lives to so rash a gamble.

The dispirited expedition returned downstream, its luggage heavier with stories than treasure. *The Discoverie,* together with the enticing maps drawn by

Thomas Hariot, was completed in record time, by November 1595. But though it was an immediate sensation, it did nothing to rouse the "blockish and slothfull" spirits who were no more prepared to credit Ralegh's claim that he had actually found El Dorado than his accompanying descriptions of Amazon warriors, as adamant in their habits as their Hellenic ancestors, though with their left breasts happily intact. As for the queen, her attention seemed elsewhere, indeed wherever the earl of Essex might also be. Undaunted by his indifferent reception, Ralegh sent Laurence Keymis off on a further exploratory voyage around the Guiana coast. But even his additional relation of the "Second Voyage to Guiana" failed to rally the opinion and, more important, the funds needed to sustain a major new expedition.

Before very long, Ralegh's prospects of realizing his fantastic dream disappeared into a prison cell. In 1603 Elizabeth died at Richmond, and Ralegh saw her coffin borne on the state barge to Whitehall. Her successor, James, lost no time in registering his displeasure at Ralegh's doting loyalty and, in the same year, managed to have him implicated in a treason plot. Evidence of any direct role in the Lady Arabella Stuart conspiracy was negligible, but, hungry for convictions, Lord Chief Justice Coke had ruthlessly extracted from one of the plotters, and an erstwhile friend of Ralegh's, Lord Cobham, a statement of incrimination. Panicky lies, and stuttering retractions from Ralegh's own mouth gave the suspicions weight where there had been only malevolent speculation. Condemned to execution and brought to the scaffold on Tower Green, Ralegh was reprieved at the last moment by the king's magnanimous clemency.

The view from Durham House was exchanged for a two-room apartment in the Bloody Tower. As incarcerations go, it could have been worse. Ralegh had the company and comfort of his wife, Bess, visits from his children, and servants (including his waterman) to bring him necessities. He also had a view of the river from his walk on St. Thomas's Tower, and though his temperament scarcely fitted him for a life of stoical immobility, he settled into an entirely new and reflective character. Slandered as an atheist, a diabolist, an accomplice of darkness, he began to don the persona of the magus; his prison a *Wunderkammer* of arts, both healing and philosophical; alembics, retorts, and tottering folio volumes lining the damp walls. From his empirical knowledge of the Orinoco basin—its roots, its minerals, its waters—Ralegh concocted a new physic, better than gold. There was a stone which, when clenched properly, could make a man piss blood and so relieve his costive sanguine. There was the Guiana Balsam, and above all there was the Great Cordial, said to have been brewed from forty substances that included ambergris, red coral, and powder of pearl. The potion became so renowned that Queen Anne herself sent from her little white house at Greenwich for a flask, and began to visit the man her husband had condemned as a traitor. Her son, Prince Henry, the flower of

Protestant chivalry and avid devotee of Learning, became an acolyte of Ralegh's until he died of a fever after swimming the Thames. In extremis, even the king consented to have the prince treated with the Guiana Balsam, though Ralegh warned that it would not prevail against any kind of poisoning.

But the association of the prince with the old Elizabethan lasted long enough to transform Ralegh's fortunes. In 1608 he even sponsored a new expedition to Guiana to re-establish contact with the Indians and to scout Spanish positions. Two years later he was among those supporting Thomas Roe's voyage to the eastern coast, venturing up the Wiapoco to see if there were not a back-door route to El Dorado. And while the map that he, Keymis, and Hariot had drawn was now laced with tributaries of the Amazon, as well as the Orinoco, running in every direction, Ralegh turned his mighty imagination to the great flow of time, nothing less than the History of the World entire.

Frontispiece
from Ralegh,
*Newes of Sir
Walter Ralegh,*
London, 1618.

Eight volumes took him only to 168 B.C., but this was enough, more than enough, to establish his Grand View: an extraordinary pottage of Aristotelian philosophy, Lucretian cosmology, learned scriptural exegesis, antiquarian ancient history (from Creation to the Punic Wars), and exacting geography. Its tone is both rational and fantastic, humanist and metaphysical. Ralegh can scoff at the foolish tradition that believed the river called Pison in Genesis to be the Ganges, but he can assert, as if self-evident, that the founder of Egypt, known as "Mizraim," from the Hebrew word for the country, was in fact Osiris, who in turn was descended from Noah through the line of Ham. Above all, he wants to give sacred topography the linear clarity of an explorer's map. Armed with one of these maps, a traveller could in fact find his way to the original Eden, somewhere, Ralegh was sure, in Mesopotamia. Of course, the garden had deteriorated since Adam's day, not to mention the universal Deluge. But Ralegh still provided his maps, laced with rivers, for it was still rivers—from the beauteous Indus to the Ethiopian Nile—that obsessed him.[12]

It was as though, between the Thames and the Orinoco, he finally understood how the waters of Eden had flowed through history, through the territory of humanity; how they had irrigated empires and flooded their ruins. He understood, too, the essential distinction between nature's circulation of

waters, running to the sea and thence back to the springs, and history's flow, where the currents were irreversibly linear. Civilization's course, he wrote, went *downstream,* away from the Edenic source, so that as it became less innocent and more tidal, the density of population and the majesty of state naturally increased. Thus it was with Babylon, thus with Nineveh, and with Egypt.

To fight a way upstream, he now realized, was to pursue a sacred mystery: to move back in time toward some sort of Edenic re-naissance. In Ralegh's own analogy between the bloodstream of the body and the waters of the world, such a voyage was to go to the very heart of the matter.

But it was, alas, as a different kind of philosopher that the king consented, in 1616, to Ralegh's release from the Tower, the kind that could magic something from nothing. What James required, as the price of Ralegh's liberty (though not his innocence, for no mention was made of setting aside his conviction), was the key to the realm of gold, or at the very least a prolific Mine Royal. Should Ralegh succeed, James was the richer; should he fail, the axe would at last rid the king of this ancient, stubborn inconvenience. Either way, there was much to profit and nothing to hazard. Still, it paid to be prudent. A busybody watch, accountable to the justices, was set to mind Ralegh wherever he went.

The old man's opportunity had only come about through the rise of a relatively anti-Spanish faction at court: the legacy of Henry, Prince of Wales, who had died at the age of eighteen, robbing his admirers of hopes of a brilliant succession. But James was not so alienated from his old sympathies toward Madrid as to challenge the Habsburg court outright. Pressed by Philip III's ambassador, the uninhibitedly fanatical count Gondomar, the king strictly forbade Ralegh from initiating any attack on Spanish settlements in Guiana, and obliged Gondomar even further by secretly supplying exhaustive intelligence on the size, route, and armaments of the whole expedition. Presumably meant as a gesture of good faith, it was a folly that probably sealed Ralegh's fate, since the likelihood of finding El Dorado without some sort of armed conflict with the Spanish was nil.

Even without this knowledge, Ralegh seemed uncharacteristically somber about his chances. His sanguine was at last running thin; his fire and smoke extinguished in the chill dampness of the Tower. His hair was gray; his years were three score, and his body was gaunt and stricken. But sober as he had become, he could have had no inkling that the search for the river-gold would yield a horror worthy of the most dreadful productions of the Jacobean stage.

Already wasted by sickness and death, the expedition led by Ralegh's flagship, *Destiny,* arrived at the mouth of the Orinoco in December 1617. He himself was so sick that for once his sanguine failed him. Unable to travel upstream himself, he appointed his old Oxford friend Laurence Keymis, in his office, with strict instructions to search for the mines, to molest no Spanish unless

molested, to use the Indians well, and to return, if not with all the ore of El Dorado, then enough samples to maintain their credit with the court. Off went the Balliol scholar-poet Keymis, Ralegh's son Wat, his cousin George, and four hundred bravos whom the commander himself characterized, with scant amusement, as "the scum of the world."

It was a month later before Ralegh learned of the sorry debacle that had unfolded at San Tomé, the Spanish fort that Berrio had established at the junction of the Orinoco and the Caroni. Instead of sidestepping the garrison, Keymis had led his men right to it, where the soldiers, led by Wat Ralegh, had launched a chaotic night attack. Wat had been killed urging his men on to the stockade in a classic example of Raleghesque noble futility. Keymis had then occupied the ruined fort with no clue as to how or where to search for the missing Mine Royal. After weeks of ineffectual scrambling around, the English had burned the fort and retreated wretchedly to the mouth of the Orinoco with nothing but a piece or two of gold stolen from the Spanish to show for their pains.

Abject, Keymis related the fiasco in all its misery to his captain, adding the wounding information that documents taken from San Tomé proved beyond any doubt that the Spanish had been supplied in advance with every detail of the expedition. Consumed with grief and rage, Ralegh turned on the miserable Keymis. "I told him he had undone me and that my credit was lost forever," he wrote to his wife. "I know then, Sir, what course to take," Keymis replied, retreating to his cabin. When a shot was heard, Keymis answered through the door that he had shot his pistol into the air. Half an hour later he was discovered lying in a pool of blood, a stab wound to the heart providing the coup de grace, pathetically clumsy to the bitter end.

Ralegh's life was done, too. But where would it finish? To return to England was to make an appointment with the block. He turned his ships due north toward Newfoundland, until his "scum" made their intention to mutiny so plain that he abandoned his wandering. Landed at Plymouth, the old river rat went through unseemly dramatics to stave off the inevitable, feigning madness and finally trying to elude arrest with an abortive flight downstream to the Thames estuary and a ship to France.

It was at Greenwich that he was finally arrested, betrayed again by one of his companions as the king's boat loomed up astern in the darkness. At the reach where the river bends again toward the sea, where he had supped with the queen, laid posies of verse about her person, rejoiced obediently in her banter, he was taken, humiliatingly disguised like a low comedian in a villain's false whiskers.

It was at Westminster, rather than the Tower, that he was interrogated, charged, condemned. Yet at the very moment of death, on the twenty-ninth of October, 1618, his famous sanguine returned, flowing with disconcerting vital-

ity. For when, after a forty-five-minute protestation of innocence, loyalty, and Christian stoicism, and an almost debonair insistence on running his finger on the axe's edge, his head was struck off, witnesses reported that the unnaturally "large Effusion of Blood, which proceeded from his Veins, Amazd the Spectators, who Conjecturd he had stock enough of Nature to have survived many Years."[13] Running over the block, it formed little ponds and streams between the cobbles, before draining finally into the moist, Thames-side earth.

ii The Man in the Brown Paper Boat

The miracle of it, really, was that it lasted so long.

The water to the paper being got
In one half hour began to rot.[14]

Three miles further downstream, and the water had risen to their knees. The two boatmen, Roger Bird the vintner and John Taylor the self-designated "Water-Poet," then tied eight inflated bullock bladders to the sides of the wherry, and while one rowed, the other baled. Alas, "our rotten bottom all to tatters fell/And left our boat as bottomless as hell." Somehow, "drenchd with the swassing waves and stewd in sweat," the two men managed to stagger on in their foundering craft until they could land its remains at Queenborough Castle. Survivors, heroes, they were entertained "as we had been lords," though their plan to present the boat to the lord mayor as a Grand Memento came to nought when they discovered that the sodden pieces had been ripped apart by locals, eager to have their own fragment of History.

Nothing, though, could dampen John Taylor's jubilation that he had Done It Again. The captain of the Ship of Fools, prince of watermen, unstoppable rhymer, doggerel philosopher, had fashioned an event. Even by his standards, it was improbable. His poem on the manifold uses of hempseed had ended with lines devoted to the stout paper made from its fiber. What better way, then, to celebrate its homely virtues than by making a boat out of it, and row it down the Thames, using for oars unflattened stockfish tied with packthread to the end of canes. As usual, Taylor would take subscriptions from gentlemen and commoners alike prepared to make a wager on the venture, which

monies to be collected should the enterprise succeed. Defaulters (of which there were always many) knew that should they be tempted to perfidy, they would be mercilessly dealt with in the next of Taylor's ceaseless run of publications.[15]

Even if he did not quite live up to his own grandiose billing as the boatsman's bard, John Taylor was not simply some twopenny-ha'penny trickster spawned in the taverns of Bankside. He was, in his way, truly unique: a self-invented celebrity, a wicked parodist of literary pretensions, the *vox populi* of the dockyards and alehouses that lined the south bank of the Thames. The very awfulness of his rhymes instantly endeared him to a populace whose tastes were being written off as so much ruffian trash by the high-minded likes of Inigo Jones. A clumsy if passionate royalist pamphleteer who never hesitated to put the Devil's tongue into the mouths of the Puritans and parliamentarians he so cordially detested, Taylor was also taken seriously as a guardian of the rivers, commissioned to present proposals on the cleaning and dredging of the Thames, Severn, and Avon. "For as a monument of our disgraces/The River's too too fowle in many places." But most of all, he was, in the reign of Kings James and Charles, a bona fide genius at every kind of publicity. In our own time, he would be recognized, and exploited (though he was no man's gull), as that most modern phenomenon: the lowbrow Public Talker, irate in his opinions, obstinate in his passions, saucy in their expression, selectively high-minded, deeply politically incorrect, hugely entertaining. John Taylor would be (with a little coaching) a Star.

None of these sterling qualities would have revealed themselves to Sir Walter Ralegh and the earl of Essex when they took Taylor on the expeditions to Cádiz in 1596 and to the Azores the year after. He was just one of the two thousand or so watermen who were mobilized by the navy every summer, supposedly (but not invariably) for the pay of nine shillings and four pence a month. Taylor had been born in 1580, by the Severn in the cathedral city of Gloucester, where his father practiced as a barber-surgeon. But it was as a Thames waterman, ferrying passengers between the banks, that he acquired a trade. It was not, as he himself eloquently pointed out in a petition to the king, a good time to be a boatman. There were too many in the craft (though his own figure of forty thousand seems fantastic). They had suffered from the encroachments of wagoners and coachmen and their fares and fees were still prescribed by a tariff that had been set half a century before, in the reign of Queen Mary. Worst of all, the construction of theaters on the relatively polite north bank of the Thames had robbed them of a major staple of their livelihood: the ferrying of audiences across to the Southwark shows at the Rose, the Globe, and the Hope when the trumpets sounded and the flags waved on the riverbank.

So John Taylor decided that the thing for an underemployed, underpaid wherryman to be was a poet. Just how this improbable course suggested itself

to him we shall never know. Taylor himself waxed allegorical on the subject. Sitting in his boat one night reciting verses from *Hero and Leander* (in which swimming, loving, and drowning feature in the tragedy), he was apparently summoned by the Muse, who called him ashore and had him quaff the transforming Helicon. The self-consciousness with which he depicted himself as the Plain Man drinking deep in Virgil and Ovid would become part of his adopted role. Yet he took care to emphasize that he was the sculler, not the scholar. For these calculated contrasts between the dry pedant and the fluent rhymer became part of his public personality. Calling himself the "Water-Poet," he meant not merely to follow in the wake of the official men of letters who had written Thames poems, men such as William Camden and Michael Drayton; his own lines would somehow be more authentically amphibian. While the lyric poets would sing of the Thames as the silver stream, Taylor, who made his living on it, knew it to be toad-brown, and managed to convey its rich coarseness without robbing it of heroic power. His oar would be his goose quill, Thames water his ink.

> *As they before these Rivers' bounds did show,*
> *Here I come after with my pen and row.*[16]

In all likelihood Taylor imbibed something from the vitality of the riverbank culture he claimed was passing away. He was the Jacobean counterpart of the cabbie Man of Letters: proudly autodidactic, gossipy, opinionated, addicted to bad jokes and long books, and a little relentless. It's not hard to imagine Taylor pulling away from the Whitehall Stairs toward the bear gardens and bawdy houses of Southwark, looking over his passenger in the slouch hat and millstone ruff and determinedly engaging him in conversation, thrusting on the captive his views on Jonson's latest play, the number of carrion horses floating in the water, the temerity of the king's adversaries in Parliament, the relative merits of ale and sack (on which he counted himself an expert), and finishing the passage off with a few ostentatiously well-chosen gobbets from the *Aeneid*. Perhaps someone on a fine night crossing laughed loudly enough at one of his verses to make him believe in his own powers of entertainment.

In any event Taylor must have acquired a reputation as something more than the common run of watermen, however verbose. For in February 1613 he was given the job of organizing part of the festivities on the Thames to celebrate the marriage of James's daughter, Princess Elizabeth, with Frederick, the elector palatine. This was all the more weighty a responsibility since Elizabeth (and much of the country) was still in deep mourning for her brother, Prince Henry, who, despite the administration of Ralegh's Great Cordial, had expired the previous November. But, as the poets (the real poets, that is) recom-

Frontispiece from *All the Workes of John Taylor*, London (?), 1630.

mended, the betrothed couple had betaken themselves to the willow-wept waters for consolation, and perhaps it was on boat trips upstream to Putney and Hampton Court that Taylor might first have found favor.

He also commanded a unique combination of talents, based on his own experience. From Cádiz and the Azores he knew all about battles, the better to stage a thunderously spectacular mock version. From his dockyard comrades he could, if the coin was sound and the ale copious, muster crews. And his friends and neighbors, the players of Southwark, could be put to use devising a brilliant piece of theater. By the late afternoon of February 11, he had already transformed the whole stretch of the river between Westminster and the Tower—*his* stretch of river—into a huge outdoor water-stage. Above London Bridge (from which the usual quota of impaled heads had been removed for the festivities), a great throng of ships and boats, from great pinnaces to little cogs and barges, all decorated and illuminated, rode at anchor. Opposite Whitehall Palace, from which the royal family watched the proceedings, a wood-and-paper version of the port of Algiers had been erected. Once dusk had fallen, a part of Taylor's "fleet" duly set about firing the lair of the Mussulman corsairs before the huge crowds gathered at the banks. The fusillades were satisfyingly deafening, the gunpowder copious, the fireworks dazzling, and pieces of Algiers orange with flame tore into the night sky before floating gently into the Thames.

Three days later, on St. Valentine's Day, Taylor staged another mock version of Lepanto, featuring Turkish galleys and Venetian caravels, with the freely improvised addition of a fleet of fifteen English pinnaces deciding the outcome.[17] And whatever Taylor's directions, the seamen and watermen must have thrown themselves convincingly into the action, since at least one was blinded, another lost his hands, and many more received wounds during the fray. James, the Prince of Peace, seemed only delighted, not least by having the pseudo-Turkish admiral brought to him in chains; the kind of battle the king liked to fight, and win.

It was just as well that Taylor's watermen were on their mettle since other events were unpredictable. The great masque designed by Inigo Jones and written by George Chapman went off well enough. Francis Bacon aimed to outshine his rivals by having the masquers of Gray's Inn and the Inner Temple arrive for their performance of *The Marriage of the Thames and the Rhine,* in a flotilla of illuminated boats. This was accomplished prettily enough, lilting madrigals floating over the candlelit water. But the play then became the victim of its overture, as the crowds thronging toward the Whitehall galleries to see the boats trapped the first rank of spectators attempting to get back to the banqueting hall to see the masque. By the time the traffic was sorted out, the king professed himself too weary to endure yet another entertainment and waved everyone away.[18]

Such fiascoes could only have helped Taylor's reputation as the commodore of river shows. Building on his reputation, he later took charge of the water processions that celebrated the inauguration of the lord mayor of London. Yet he evidently aspired to something grander than a reputation for lining up watermen in the right order; what he truly wanted were the laurels of literature, a nook on Parnassus.

But how to win that renown? From friends like George Wither he knew that nothing was likelier to attract attention than controversy, however spuriously manufactured. For despite its professions of virtue and refinement, the Jacobean world of letters, he knew, was still lubricated by the poisoned oil of malicious envy.

So, a year after the water revels, Taylor transferred his skills at mock battle from pinnaces to poetry. He publicly challenged William Fennor, a rival poet, to a poetry contest on a platform at Bankside, close by the Southwark theaters. A thousand handbills were printed at his expense advertising the contest, whipping up public expectations of a bardic tournament. The publicity worked only too well. Huge crowds materialized at the site, but the opposition, alas, failed to show. As soon as the crowd realized they were to be denied an afternoon's bard-baiting, they got ugly and Taylor became the victim of his own promotion, pelted unmercifully with the usual savory array of pillory projectiles.

Yet he survived the ignominy and the bad eggs and even turned the fiasco to his own purposes by flaying the pusillanimity of Fennor in another broadside. This time, his foe rose to the bait, offering a counter-tirade, and before long Taylor had exactly the public wrangle that he had always wanted. He then turned to parodying other well-known figures in Jacobean letters like Thomas Coryate, the much-published traveller, as well as stock types whom he particularly abhorred (Puritans, coachmen, tax collectors, whores). The waterman had turned gadfly and he clearly enjoyed his sting.

It may have been his skirmish with Coryate that gave Taylor an even better notion. His self-presentation turned on the fancy that somehow he was the authentic yeoman type to which his more literary rivals merely pretended. Thus where Coryate passed off his travel writings as intrinsically notable, Taylor would go one better by reinventing the journey (by water or land) as a kind of adventure in improbability: a Travel-Marvel. Thus he had bills printed up announcing his intention of travelling from London to Edinburgh with no money to sustain him and a vow to abstain from either begging or thieving. He invited any interested parties to subscribe (or wager) a sum (not less than sixpence) for the expedition and to pay up on his return. He was, in effect, taking a leaf from the book of all the grandiose colonial and merchant ventures. And after all, a trip from London to Scotland without funds was no less foolish than the organized pursuit of El Dorado. But with the chastening example of Ralegh's misfortunes still fresh in the country's memory, Taylor decided,

prudently perhaps, that his Orinoco would stretch from the Cotswolds to the Medway and his El Dorado would be mined from the purses of London.

In fact, Taylor's journey from London to Scotland reversed the stereotypes of gold-mad adventuring that lethally wounded Ralegh, even when he was about the king's business. For the ostentatious poverty and simplicity in which Taylor cloaked himself suggested the innocence of the medieval palmers, those who, Thoreau would remind us, saun-tered to the Saint-Terre, rather than the impatient greed of the explorer. Taylor could thus play (and play brilliantly) the three parts of the Holy Fool, Diogenes-on-the-road, in search of an Honest Man, and Everyman, sustained by the three cardinal virtues. And the best part of all was that this selectively assumed role of modern pilgrim was rich in cash. Not only would he collect his dues on return but the publication of *Taylor's Penniless Pilgrimage* recruited more customers for the next trip.

Not that the Water-Poet ever got rich from his travels. But he made a decent livelihood from his cultural invention, and he certainly reaped his small share of renown. Much grander literary figures like Thomas Dekker were pre-pared to endorse him, and by the time of Charles I's accession in 1625, Taylor had become a man to be reckoned with, at least on the London waterfront. It was precisely because he was the absolute opposite of the Caroline courtier, someone who had chosen to produce the definitive guide to London pubs and the first comprehensive directory of carriage services, *The Carrier's Cosmogra-phy,* as well as popular chronicles of the kings of England (beginning of course with the Trojan Brutus, reputed to have founded ancient Britain), rather than watered-down versions of Italian court lyrics, that his standing as a *royalist* polemicist was so strong.

And like the notoriously predictable rains of England, it was always to the rivers that the Gypsy-Sculler returned.

> *Of all the elements, the Earth's the worst*
> *Because for Adam's sinne it was accurst*
> *Therefore no parcel of it will I buy*
> *But on the* waterz *for relief relie.*[19]

Once established as a success, Taylor took the *Penniless Pilgrimage* to the water, travelling (dangerously as it turned out) by open bark from the mouth of the Thames, up the eastern coast, to the river Ouse and the city of York.[20] And in an even more celebrated journey he went first from London to Christchurch in the New Forest and thence up the Avon River toward Salis-bury. On the river-town of Ringwood he had his little apotheosis when a quar-tet of "His Majesty's Trumpeters" regaled him with fanfares as he rowed by. For by this time, in addition to all his other roles, Taylor had become accepted as something of an authority on the economic and social importance of the

rivers of Britain. Though his purpose was still to entertain, he increasingly paid attention to the equation, as he made it, between navigability and prosperity, praising the Dutch whenever he could as the living proof of such an axiom. Where rivers like the Avon and the Wye were clogged and silted, or where riparian rights had been privately engrossed, Taylor's wrath on behalf of the fluvial commonweal rained down on the culprits, the mightier the better.

> *I truly treat, that men may note and see*
> *What blessings navigable rivers are*
> *And how that thousands are debarrd those blessings*
> *By few men's ambitious hard oppressings.*[21]

No wonder that, during the 1630s and 1640s, aldermen, mayors, and local gentry made sure they entertained him with royal hospitality, for Taylor's partiality to the table and indeed to ale and claret was legendary. For all his pious professions against excess, the detailed relish with which he described guzzling and sousing in, for example, *The Great Eater of Kent*, left no doubt about his own appetites. He may well have been the first to coin the phrase "the English dyet," which was, of course, crammed with good yeoman things, above all puddings (Norfolk dumplings, Gloucester bag puddings, Hampshire hasty puddings, Shropshire pan puddings), sweetmeats, custards, flapjacks, pancakes, fools, kickshaws, and gallimaufries and the harvest of the waters, oysters, shrimp, fish, and above all else "the mighty scarlet lobster," without which Taylor's accounts of his feasts always took on a kind of discontented pallor.[22]

Drink was another and more complicated matter. The same streak of disingenuousness ran through his copious writing on the subject. For in the same tract in which he railed against the horrid vice of drunkenness he would offer an entire history and recipe for all known beverages served in the taverns of the kingdom, not just beer, ale, claret, and sack but bragget, mead, pomperkin, and perry. Yet from his own life with the habitually marinaded fellowship of watermen John Taylor drew a solemn conclusion: that the drunkenness of the nation and the salubrity of its waters were in exactly reverse correspondence. The more drink circulated through the veins of the people, the more foul would be the arteries of their commerce. It was almost as if they had no option but to turn them into pismires. In the year of King Charles's crisis, 1645, the ills of the realm could thus be diagnosed by Taylor as "the Causes of the Diseases and Distempers of this Kingdom, found by Feeling of her Pulse, Viewing her Urine and Casting her Water."

For the propagandist of the virtuous kidney, cleansing the waters, making them clear, vigorous, and navigable, was to make a sound royal revolution. So while monarchists and parliamentarians quarrelled over niceties of liturgy, the legitimacy of imposts, and the authority of royal tribunals, Taylor looked

instead at the bloodstream of the nation. In his mind's eye, he saw something unspeakably grand: a great, single watercourse, running from west to east, connecting the three great rivers—his native Severn, the Avon, and the Thames—if necessary by portage canals. Had *he* drawn Leviathan, he would have traced it with Dr. Harvey's vascular system transposed to the geography of England: veins, arteries, little capillaries, busy carrying and exchanging the vital substances of the body politic.

It was not out of the question that a reader as voracious as Taylor would have known the English translation of the political theorist Giovanni Botero's *Treatise Concerning the Causes of the Greatness and Magnificence of Cities,* published in 1606. Reviving the classical tradition of geographers like Strabo and Pliny, Botero tried to classify the topographical features that accounted not just for a state's economy but its polity. Thus Italian turbulence was (in part) accounted for by the violence and unpredictability of rivers that rose in the Apennines or Dolomites and rushed headlong to the sea. Not for nothing, he believed, were the Tiber and the Arno notorious among the commonwealth of waters as watery condottieri, children of Acheloüs that could bring havoc along with abundance. Their principal defect was that the force of their flow broke up what Botero's translator rendered as "sliminesse": the solute density and surface tension that he believed helped rivers carry maximum cargo-traffic.[23]

According to Botero, no rivers were more wondrously slimy than those of Belgica (the Netherlands) and Gallia Celtica (northern France), where the Seine, "a meane river . . . beareth ships of such bulke and carrieth burdens so great that he that sees it will not believe it."[24] For the most part they were

> calme and still and therefore they sail up and downe with incredible facilitie . . . by means whereof their course is not violent and they run not between mountains nor yet a short and little way [as in Italy] but many hundreds of miles through goodly and even plaines.[25]

There was no arguing the benevolent sluggishness of meandering, mud-laden rivers like the Scheldt and the Seine. But along with his fellow river poets Taylor believed no stream was more fruitfully temperate than the Thames. Drayton's *Poly-Olbion* summed up their idyll of the river as the perfect *via media,* watering

> *The sundry varying soyles, the pleasures infinite*
> *(Where heate kills not the cold, nor cold expells the heat . . .*
> *The Summer not too short, the Winter not too long).*[26]

Much of this blessed sweetness of temper could be explained by the river's course from west to east. For at their origins in the Cotswolds, the tributaries

of the Thames, the Isis, and the Tame were "British" waters, which is to say, mysterious, Celtic-Druidical. Like the Tudor dynasty, they were western-born but made their way toward England, not as conqueror but protector, benefactor, fertilizer.

Like as not, John Taylor, whose own life followed the same course from west to east, would have had no trouble in identifying with this trajectory. But by the time he wrote his own allegorical *Thames-Isis,* the genre of a river progress, at once geographical and historical, was well established. From the start, the effort by Tudor chroniclers and apologists to create a new patriotic geography had been water-born. John Leland, Henry VIII's antiquary, inaugurated the genre of the English river poem in 1545 with his *Cygnea Cantio* (Swan Song). With twelve companions, the swan (a bird so powerfully royal that the Crown strictly reserved to itself the right to kill and eat it) sets off from the junction of the Tame and Isis at Oxford on a downstream progress. On its way it passes sites that had already become sacred in the mythology of the English imperium: Runnymede (where the Magna Carta had been signed) for *libertas,* Windsor (sounding much more imposing as Vindseloricum) for *potestas.* Eventually, at the union of the Medway and the Thames, below Deptford, where the swans sail past Albion's future in the shape of the new Royal Navy, the birds, like their august sovereign, will expire. But their song was sung not just in elegy but as a gloria for the birth of a brilliant new epoch through the line of the Great Harry.

Even if Elizabeth had not herself been born at Greenwich, she could hardly have escaped the fluvial line of power that washed past her palaces. From the beginning of her reign she showed every sign of understanding the enormous psychological significance it was coming to have in the definition of Englishness. On St. George's Day, 1559, in the second year of her succession, after supping at Barnard Castle, the queen embarked on a river progress through her capital. She was "rowed up and down the river Thames, hundreds of boats and barges rowing about her, and thousands of people thronging at the waterside to look at Her Majesty . . . for the trumpets blew, drums beat, flutes played, guns were discharged, squibs hurled up and down into the air as the Queen moved from place to place. And this continued till ten of night when the Queen departed home."[27] Using the river as a stage on which to embrace all of her subjects was a brilliantly calculated triumph of public relations at a time when Elizabeth needed to establish her legitimacy. "By these means," the chronicler went on, "shewing herself so freely and condescending unto the people, she made herself dear and acceptable to them."

As time went on, alas, it became apparent that the proverbial fertility of the Thames would not pass on its blessings to the sovereign. Those hopes, withering on the vine of Elizabeth's inscrutable vanity, may account for the developing obsession about marriage unions in the poetry of her long reign.[28] Both

Edmund Spenser (who had entertained Walter Ralegh at his house on the Blackwater River in Ireland) and William Camden, Leland's successor as anti-quary-geographer, produced poems on the wedding of Tame and Isis.[29] Both works followed the birth and growth of the Isis, set by Camden in a mysteri-ous cavern roofed in pumice that was the spring not merely of English waters but of all the great rivers of the world: "Here rise in streams of brother-hood/Nile, Ganges and Amazonian flood." Eden, it turns out, was located in the Cotswolds.

Below Oxford, the wedding of waters takes place, attended in Spenser's *Epithalamion Tamesis* by all the rivers of England, personified as a gathering of water nymphs. Its fruit is young Thames, already growing in rippling, muscu-lar power as he rolls through Berkshire toward his metropolitan and imperial destiny. As Wyman Herendeen points out, English history itself is made to travel with the current.[30] The confluence of waters, moving irresistibly to the sea, seems to embody both the natural harmony of the English landscape and an end to the strife that for centuries had torn the realm. And when Stuart pol-itics proved that disquiet had not been banished for very long, poets like Michael Drayton used the progress of the Thames to proclaim the victory of Concord over the warring contention of "British" and "English" waters.

Poems like *Poly-Olbion* and John Denham's *Cooper's Hill* managed to marry up more than different regions and dynasties along the royal river-road.[31] They also tried to harmonize, as best they could, the pastoral and the mercan-tile landscapes: worlds which in political realities were very often in conflict. Upstream, the union of Tame and Isis (who, in keeping with her Egyptian namesake, is now feminine) takes place in a fleecy arcadian world where zephyrs puff over the smiling water. Once born, the stripling Thames passes below the guardian citadel of Windsor, the mediator (which is to say, halfway point) between pastoral childhood and mercantile maturity. By the time he reaches Westminster, Youngblood Thames has accepted the crown of his fortune and in Drayton's lines is not above a little virile bragging:

> *As doe the bristling reeds, within his banks that grows*
> *There sees his crowded wharves and people-pesterd shores*
> *His Bosome over-spread with shoals of laboring oars*
> *With that most costly Bridge that doth him most renowne*
> *By which he clearly puts all other Rivers downe.*[32]

The climax of the journey is a second union: that of Thames and Medway, from which another, still mightier pregnancy is conceived. For within the womb of the swollen waters, salt and sweet, pastoral and commercial, floats the awesome embryo of the British Empire. Its birth upon the open sea is to usher in a new epoch of historical power. And since it was an axiom of the hydrolog-

ical cycle that the vapors of the sea would return again to the springs of the British Grotto, the future of that empire seemed self-fulfilling.

Only one river poet could see anything in the way of this impending glory. But when John Taylor saw it, he saw it from the tiller. Where Camden and Drayton sailed past Windsor with their eyes raised to the noble mass of the castle, Taylor was too busy frowning at the waterline and fretting at the impedimenta:

> *Below the bridge at Windsor (passing thus)*
> *Some needlesse piles stand very perilous*
> *Near Eaton College is a stop and a weare*
> *Whose absence well the river may forbeare*
> *A stop, a weare, a dangerous sunke tree,*
> *Not far from Datchet Ferry are all three.*[33]

All these mischiefs and iniquities done to the river were committed, so the Water-Poet thought, from brazen cupidity. Only the disinterested prince, godly and upright, he supposed, could mend such ills. Yet his verses ended not with a glimpse of a Whitehall Augustus, but a more fustian commonwealth where devotion to the civic good had checked the lust for private gain.

> *Tis said the* Dutchmen *taught us drinke and swill*
> *I'm sure we goe beyond them in that skill,*
> *I wish (as we exceed them in what's bad)*
> *That we some portion of their goodnesse had.*[34]

On his way to Heidelberg (courtesy of Princess Elizabeth, whose nuptials had been blessed by his mock fusillades), Taylor had seen the Dutch republic firsthand, and again on a later trip to Bohemia. How could its watery virtues not stir his boatsman's passions, for everywhere there were oars and sails, nets and cordage, biscuits and caulk, an amphibious republic. And by 1632, when he wrote *Thames-Isis,* Taylor might have noticed that, not content with their own world of low horizons, the Dutch had begun to hop mud flats to the other side of the North Sea. After the seawall at Dagenham had been breached in 1621, it had been the famous diker and drainer Cornelis Vermuyden who had taken charge of its reconstruction, using Dutch capital and baked marsh-clay.[35] Dutch laborers engaged on the works were then established on Canvey island in tenant farms, keeping sheep and even converting the salt marshes into workable arable fields. Other colonies of Hollanders had settled at the river mouth and in colonies along the Medway at Sheerness and Rochester. In the lee of the stinging wind they huddled together in little hamlets of piety; the *mynheers* cloaked in black broadcloth, their hands (so their vexed English neighbors said) smelling of herring; the *mevrouws* buxom and pallid, with bad teeth set in oval

faces; the children enormous, caps pulled over butter-colored hair as they shouted and skated over the frozen winter marshes. And when they petitioned the king to build a Calvinist chapel, the fears of the English rivermen that they were being colonized began to be voiced. Was there not, after all, something conspiratorial about the Dutch actually wringing out their waters so the English would be left gasping on the dry mud flats?

> *Our smaller rivers are now dry land*
> *The eels are turned to serpents there*
> *And if Old Father Thames play not the man*
> *Then farewell to all good English beer.*[36]

A mercy, then, that Taylor never lived to see the Year of the Dutch, the sum and consummation of all calamities visited on the sinning river. He had died in 1653, an obstinate old royalist railing against "the Dishonrable, Disworshipfull, Disloyall and Detestable he Rebells of what Nation, Sex, Sect, Degree, Quality, Ranke, Age, Function and Condition whatsoever." The "swarm of sectaries" had come into possession of the city; King Charles, whom he had served in his exile court upriver in Oxford, had been beheaded at Whitehall. The Devil, as he wrote, had turned Roundhead, and the whole world topsie-turvie.

Perhaps after these revolutions nothing would shock the "Acqua-Muse," as he liked to dub himself in his old age. Had he lived to witness the plague year of 1665 he would have doubtless unearthed *The Fearfull Summer* with its apocalypic vision of a "*London* filld with mones and grones/ . . . Like a Golgotha of dead men's bones/ . . . The very *Water-Men* give over plying,/Their rowing trade doth faile, they fall to dying." And even the Great Fire of 1666 that consumed the waterfront would not have surprised a survivor of the London Bridge fire of 1632.

But nothing, surely, could possibly have prepared Taylor for the Dutch raid on the Medway in 1667, for the spectacle of the king's navy, caught at anchor, burning in the river, and the pride of the fleet, *The Royal Charles,* taken as prize to Amsterdam. All along the estuary there was smoking havoc. The barrier chain was broken. The city banks were besieged by depositors, frantic lest the Dutch sail unimpeded up the river. When John Evelyn saw the victorious Dutch ships at Chatham lying "within the very mouth of the Thames, all from Northforeland, Mergate even to the Buoy of the Nore," he grieved bitterly at "a Dreadful Spectacle as ever any English men saw and a dishonour never to be wiped off."[37] It was as if a punishing wind had reversed the fluvial tide of English history, building a great flood on its outer bank and ramming it back upstream, with the guns and canvas of Admiral de Ruyter riding high on its gloating crest. It was as if, in mockery of the Water-Poet's whole life, the river itself had gone to the Devil.

iii Power Lines

JUNE 8, 1660

A blare of brass by the edge of the Bidassoa, so loud it shook the water, too loud for the gaunt old king of Spain, whose eyes were rheumy and myopic but whose hearing was still acute. Not loud enough for the strapping young king of France, whose crowing triumph sounded in the fanfares just as it was inscribed in the Treaty of the Pyrenees. But the proprieties, at least, were all observed. Resigned to his sacrifice, El Rey Planeta, Philip IV, he whom Quevedo and Lope de Vega had proclaimed could stop the stars in their tracks, permitted himself to be quietly rowed to the island in the center of the stream. Unfortunately, facing the French bank, he was forced to observe, as usual, the immense and gaudy show of Bourbon gallantry: capes of brocaded silk trimmed with silver and gold, overdressed horses, great plumes on the hats of the cavaliers, scarlet boots, the fleur-de-lys pennants laughing on the pavilions, muskets and drums, sabers and sashes, heathen vulgarity. Just as it was in 1615. Nothing had changed.

But of course everything had changed. Forty-five years before, the boy Philip had stood patiently in a floating pavilion in sight of the Isle of Pheasants, while the dauphin Louis, the child of Henry of Navarre, had waited on *his* tented raft opposite, as their betrothed princesses drifted obediently toward them. They had pretended equality then, but what was poor, bloodied France, with its belly full of heretics, to the stupendous empire of Spain, which stretched from Peru to the Indies? It was Habsburg blood that had then deigned to be mingled with Bourbon in the midstream of their common river. And how altered was his sister Anne, become the shrewd creature of Cardinal Mazarin; the mother of this new Louis, with his precocious Apollonian vanities. He preferred to recall her as she had been that earlier day on the river, a veiled and demure child. Certainly she had not been fortunate. Widowed early, Anne had been tossed about in the gales of French faction and rebellion, chased from Paris, until Mazarin had made her court secure through an exquisitely calculated work of ruthlessness and corruption. Be that as it may, she had become

a harpy, presuming, so the queen told him, to lay down the law to their daughter on what she might or might not wear, commanding her to dress in *costume à la française* for the marriage.

So be it if God wills it thus. In his most stoically grave manner, Don Luis de Haro had come from the tent on the floating island last November and counselled the king that there was no alternative but to sign the peace and marry his daughter to Louis XIV. His treasury was exhausted, the American silver gone, his troops mutinous. The minister had made every effort to salve the wound. Such a family compact, signed, sealed, and sworn on the river separating their realms, would, he opined, finally bind up the terrible wounds of their endless war. Yet even as he said this there was on his face the unmistakable look of a man obliged to drink sour wine down to the lees. What, the king had objected, if this marriage should produce an heir to the *two* realms, as if the Pyrenees themselves had been levelled? But how could that be, the minister had responded, seeing that Infante Felipe Prosper was so robust, so clearly destined for the throne?

Diego Velázquez, *Portrait of Philip IV,* ca. 1655.

But hardly had the paint on Diego Velázquez's painting dried than the little prince, not yet four, had perished, like so many of his family before him. His old father, whose countenance at the best of times was mirthless, now composed itself into a funereal mask as he dragged his bones to the river in the jolting carriage. What did it matter? Very soon he would be gathered to his ancestors and to his Heavenly Father and like all his royal forebears needed to concentrate all the energies that remained to him in prayers of atonement, imploring the Almighty that his countless sins would not be visited on his unhappy people.

From the other bank of the Bidassoa, which the French preferred to call the Dendaye, the prospect seemed a good deal fairer, always excepting his bride, of course. Louis did not need to look at Marie-Thérèse to know the worst. It was enough (begging his mother's pardon) that she was a Habsburg. So that he fully expected just what he got: the long fleshy nose, the threads of fine blond hair, the large weak eyes, the alarming jaw. But along with that would be a becoming piety, a pleasing submissiveness, and, he fervently hoped, fecund blood, so that he would not have to spend undue time and

effort producing an heir when his passions could be excercised in more agreeable company.

So the king put on his most amiable face and affected to enjoy everything that was presented to him: the noisy Te Deum, the long ballet in the Hôtel de Ville featuring a painted galliot pulled across the stage, the interminable eulogies. Surrounded by the *noblesse de sang,* attended by his personal guard, the Cent Suisses, as well as troops of light horse, musketeers, and pikemen, more than a thousand in all, overwhelming the thinner ranks of Spanish grandees and horsemen, the young king stood beneath his fleur-de-lys canopy as the princess was towed across the river in her boat. Nothing had to be done except the most

Anonymous, Exchange of brides on the River Bidassoa, 1615.

formal exchange of greetings and salutes, according to the exact protocol arranged by the respective masters of ceremony.[38] There were brief toasts, a bouquet of poems, a most pleasing and delicate show of tears by the princess and her mother, the usual speech from Philip, regretting the loss of his daughter, consoled by her great destiny as the queen of France, and so on and so on, an incongruously wan smile slowly creeping across his dolorous face like the moon at dawn just before it vanished in the sunlight.

The next day their marriage was solemnized in the chapel at Saint-Jean-de-Luz by the bishop of Bayonne. That it took place firmly on the French side of the border was meant to emphasize Louis's claim, now conceded, to sovereignty over the frontier province of Roussillon. The finesse of these gestures

across the little Bidassoa had a long history.[39] In 1463 Louis XI of France and Henry of Castile had met on the river and in 1530 François I had ransomed two Spanish princes for his own return to France. Between 1564 and 1566 Charles IX, accompanied by his mother, the formidable Catherine de' Medici, had deliberately toured the limits of his kingdom, in an effort to assert their rights to the disputed territory of Roussillon. Though the king went to the edge (but not over) his river border, Catherine exploited her family role as the mother of the queen of Spain to cross into that realm.

So the significance of the marriage itself taking place behind the common blood-and-waterline, on French soil, was not lost on contemporaries. From Saint-Jean-de-Luz the court travelled to Bordeaux, where they passed through *arcs de triomphe* and were required to listen to more loyal addresses of felicitation from the magistrates of the Parlement. In Paris these gestures were repeated yet again (as they had been all along the route). But in addition there was a seventy-foot-long allegorical Ship of State moored beside the Louvre upon which rested a great globe of the world held aloft by two figures representing France and Spain, who managed at the same time to shower blessings on the throngs of people on the riverbank.[40] That same night a fireworks version of the same vessel exploded over the Seine as the great golden ship seemed to sail off into the night sky, trailing behind it a wake of fire.

✦ ✦ ✦

A YEAR LATER, on August 17, 1661, Louis XIV was presented with another spectacle of pyrotechnics, indeed another ship of fire. But this time he drew no satisfaction from the *divertissement*. His host was the superintendent of finances, Nicolas Fouquet, eager (mistakenly, as it turned out) to show off his spectacular château of Vaux-le-Vicomte. Solicitous of the king's vanity, he had taken good care to order fireworks arrangements in which the king's monogram was interlaced with that of the queen and Queen Mother, both in attendance. But pyrotechnical hubris overcame him when he went so far as to display, for general amusement he supposed, a fiery version of one of his whaling boats, complete with cetacean spouting flame. And if Louis had not been so out of temper with the stunning display of elegance he saw at Vaux, perhaps amusement might indeed have offset royal envy.

But the more the king saw, the more he coveted and the more he fumed. And since Jean-Baptiste Colbert had been whispering constantly of Fouquet's malversations, of his financing Vaux by raiding the royal treasury, the more convinced Louis became that the palatial brilliance of Vaux-le-Vicomte was itself proof of a kind of *lèse-majesté*, if not of outright treason. What were those whaling ships moored at Fouquet's private island off the coast of Brittany for, if not to create a floating *imperium in imperio*?

Israël Silvestre, Vaux-le-Vicomte, cascade and reflecting pool.

Perhaps, too, there was another aspect of Vaux which cut to the royal quick: its water. Not content with razing an entire village, levelling the hills in which it was set, and planting a forest where there had been tilled fields, Fouquet had also diverted a local river to feed the spectacular pattern of fountains, cascades, and reflecting pools that extended the design of the house into the park. Surrounded by a graceful, ostentatiously dysfunctional moat, the house and gardens seem, as Vincent Scully has put it, to have been slipped over a taut skin of water.[41]

Superficially, Fouquet's great landscape gardener, André le Nôtre, retained the traditional Italian promenade of waters, found at Bagnaia and the Villa d'Este that led to a grotto where river-gods reclined in rustic niches. And from the garden terrace of the château, below the guardian busts of Roman emperors (another detail unlikely to endear itself to Louis XIV), it did indeed appear that the visitor could proceed along another river-road toward the usual rendezvous with the Source, taking in along the way various allegorical

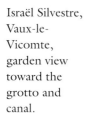

Israël Silvestre, Vaux-le-Vicomte, garden view toward the grotto and canal.

representations of water nymphs and deities. But the waters of Vaux-le-
Vicomte, in contrast to the Italian villa gardens, are still contained within cir-
cular or rectangular stone basins. Instead of behaving with the kind of
elemental vitality liberated by Buontalenti or Bernini, the waters behave them-
selves, as decorously as a Cartesian proposition, an Alexandrine couplet, or a
courtier's epigram. They do not initiate anything; they reflect. And what they
reflected at Vaux was the controlling intelligence of their witty and elegant
seigneur.

Even the jokes are different. In the gardens of the Renaissance Italian vil-
las the unsuspecting visitor, rounding a corner and confronted with another
eccentrically wrought statue or gaping cave, might without warning trigger a
jet that would soak him to the skin. General mirth. Not for the likes of Fou-
quet, for whom water was the material of intelligent wit—*esprit*—not coarse
ebullience. So that approaching the arched grotto at Vaux, the visitor would
suddenly discover that the path was interrupted by a rectangular basin of
water, invisible at eye level, which inevitably framed another reflection of the
château. And on the very threshold of the grotto, the ground suddenly and
unpredictably drops away to a gentle cascade feeding a broad canal. Short of
being rowed across, the only way to reach the destination was to walk round
its entire sycamore-ringed perimeter. And the reward for all this perseverance
was to climb the balustraded stairs over the grotto to a raised terrace. Behind
was a copy of the Farnese *Hercules* proclaiming the power that had been exer-
cised on nature to produce grace. And before the inspecting gaze were the
elegant pavilions of Vaux, extended ninety degrees into the gardens through
the careful, patterned composition of the low-clipped boxwood *broderies,*
the colored gravel walks, and the pools, all harmonizing in discreet self-
congratulation.

Le roi ne s'amuse point. Within three weeks of the *fête* at Vaux-le-Vicomte,
Louis' sour grapes had turned lethal. Fouquet was arrested for treasonable pec-
ulation. Though the charge that he had arrived in office poor and had enriched
himself at the king's expense was precisely the opposite of the truth, the court
was expected to return the required conviction and sentence. Yet the judges
were sufficiently ashamed of themselves to recommend banishment rather than
the death sentence desired by Colbert and the king. Stung by their insubordi-
nation, Louis ordered a living death: incarceration at his own pleasure. Fou-
quet spent the rest of his life immured in the terrible Haute-Savoie fortress of
Pignerol.

But it was not merely the temerity of his perfect taste that had brought
about his downfall. In its calculated manipulations of scale, distance, and opti-
cal angle, Vaux was the triumphant proclamation of mechanics over nature.
And as all the historians of the seventeenth-century garden have noted, the arts
that were put to work in order to create a place like Vaux were essentially mil-

27. J. M. W. Turner, *River Scene with Rainbow*, 1805.

28. J. M. W. Turner, *England: Richmond Hill, on the Prince Regent's Birthday*, 1819.

29. J. M. W. Turner, *The Fighting Temeraire, tugged to her Last Berth*, exh. 1839.

30. J. M. W. Turner, *Rain, Steam and Speed—the Great Western Railway*, exh. 1844.

31. David Roberts, *Hypaethral Temple, Philae.*

32. Francis Frith, *Dahabieh Moored under Pharoah's Bed, Philae.*

33. Mount Rushmore National Monument.

34. Pierre-Henri de Valenciennes, *Mount Athos Carved as a Monument to Alexander the Great*, 1796.

35. John Robert Cozens, Cavern in the Campagna, 1786.

36. John Robert Cozens, *Entrance to the Grande Chartreuse.*

37. J. M. W. Turner, *Snowstorm: Hannibal and His Army Crossing the Alps,* 1812.

38. John Robert Cozens, *Between Chamonix and Martigny*, 1778.

39. John Ruskin, *A Fragment of the Alps*, 1854.

40. Jules Hebert, *Henriette d'Angeville in Mountaineering Costume.*

41. Albert Smith, photograph.

itary. The same mathematics that was needed in the perfection of siege artillery and fortifications was applied to the exact construction of space within a garden.[42] Moreover, Etienne Binet, writing in 1629, explicitly compared the creator of such gardens to a "little god."[43] But it was only absolutist monarchs in the Baroque who were supposed to describe themselves as earthly deities. So it may have been for his usurpation of the roles of both landscape marshal and hydraulic muse that Fouquet paid such a heavy price.

The end of Fouquet was, famously, the beginning of Versailles. Egged on by Colbert, the king stripped Vaux of all its treasures, or at least all of those that could be moved. It was, at least, a backhanded compliment to Fouquet's extraordinary discrimination and generosity as a Maecenas of the arts. For along with the great collection of paintings, the bronzes, the tapestries, and the furniture went the personnel—the architect (Le Vau), painter (Le Brun) and gardener (Le Nôtre), not to mention pastry cooks, ballet masters, musicians, playwrights (Molière), poets, and, not least, the hydraulic engineers, the *frères* Francini, who had created the great water grilles, reflecting basins, and fountains of Vaux. The only servants of the arts not to desert their master were the sculptor Puget (who spent the rest of his life in the naval dockyards of Toulon) and La Fontaine, who not only made no secret of his contempt for the judicial farce but published a *Dream of the Waters of Vaux* in which the fountains, bereft of their water, weep to make good the loss.

The Vaux make-over transformed a nondescript little hunting lodge at Versailles into the nonpareil of all royal residences. But, to their credit, neither the king nor his trio of builders were satisfied with mere transposition. And given the king's absolutist temperament, the element of caprice, so strongly felt at Vaux, was made strictly subject to the prospects of grandeur. Even before the first château was built by Louis Le Vau, the park was made the setting for entertainments that catered to the king's hunger for self-aggrandizement. Whether they were ostensibly performed in honor of military victories, the king's latest mistress, or both, they used bodies of water as theatrical platforms on which spectacles that flattered his omnipotence could be performed. Both in 1664 and 1668, fire and water were incorporated, as they usually were, into the *divertissements* that stretched over several days and in which the king often took part. In the 1664 *fête* of the "Pleasures of the Enchanted Island," for example, he took the leading role of the knight Roger, who destroys a witch guarding a magic isle, the moment of victory being celebrated in an immense detonation of fireworks over a reflecting pool so that Louis could appear as a Lord of Creation, the arbiter of fire and water, a new Osiris or, rather, the Gallic Apollo.

From the outset, the myth of Apollo, as well as the absolutist gaze, determined much of the design of the park and its waters. Where the axis of the *allée* at Vaux connected the stone Caesars with the river-gods reclining in the grotto,

at Versailles the line of inspection was moved east-west, in keeping with the progress of the sun. From the uppermost terrace of the garden side of the palace Louis could look down a flight of stone steps at a fountain group that bore immediate witness to the divinely royal power over the waters. Drawn from the sixth book of Ovid's *Metamorphoses,* it related the myth of Latona, daughter of the Titan Coeus, hounded by Juno for the usual misdemeanors with Jupiter. She is shown with her children, Diana and Apollo, appealing to the hostile peasants of Lycia to be allowed to drink from a local pond. Not only were the peasants unmoved and added curses and threats to their churlishness, but, Ovid tells us, they stirred up mud and dirt from the depths to make the waters foul and unappetizing. And it is at the point where the Titan's daughter has had enough that the fountain offers its metamorphosis, with the peasants suddenly turning into frogs, some still with human torsoes beneath their abruptly bulging eyes and webbed limbs.

What is, in any case, an unparalleled moment in amphibian myth was, for Louis XIV, also history: history political and history familiar. For the fountain alluded to the eviction of Anne of Austria and her two children, Louis and Philippe, at the time of the uprising of the Parisian Fronde. And whether or not the king actually disliked the capital as much as conventional histories claim, there is no doubt that the sovereign position of the fountain of Latona, directly beneath the château and pointing down the *grande allée,* was a royal retort, a proclamation of the realm's metamorphosis from anarchy to order.[44] At the end of the *allée* is the equally extraordinary fountain of Apollo, where the gilded sun-god can be seen rising from the waters at the beginning of the day. Thus the two fountain groups—Latona and Apollo—were in poetic and historical correspondence with each other, adversity and ascendancy; back and forth down the line of light and water.

The visitor alert to all these meanings might then retrace his steps up the paths and steps to the north end of Le Vau's château, where he would find the grotto of Thetis. Inside, Girardon's sculptures showed Louis-Apollo flanked by his steeds, being refreshed by the nymphs of the ocean at the end of another hard day's celestial charioteering. And it is inconceivable that Louis (who was pedantically learned in anything that flattered his divinity) was not aware that Thetis herself was the mother of great Achilles, so that the king could now add that hero's attributes to his *gloire* (always excepting, of course, the fatally undipped heel).

Though the interior walls of the grotto were covered with the usual materials of mother-of-pearl and polished pebbles, from the outside the triple-arched building, with its grilles bearing the emblem of the sun, hardly resembled a rustic grotto at all. And siting it close to the palace reversed the conventions of the rustic Italian caves. Instead of making the pilgrimage away from civility and through the *sacro bosco,* the "holy wood," to the Source and

Versailles, fountain of Latona (Gaspar and Balthasar Marsy), engraving by Pierre le Pautre, 1678.

Spring, the Versailles courtier was obliged to approach the royal presence to share in its wisdom and mystery. And as the château expanded along with the park, so the grotto seems to have become considered a charming anachronism, even before it was finally demolished in 1681 to make way for Mansart's endlessly elongated northern wing.

Everything now seemed to proceed along the imperious direction given from the palace. The figure of Latona was herself turned a hundred and eighty degrees so that instead of looking imploringly up at the sovereign, she now joined him, like a staff officer with the general-in-chief, in staring down the line of command. In fact the sloping lawn of the *tapis vert* controlling the prospect down to the fountain of Apollo seems for all the world like a grassy extension

Versailles, engraving of the interior of the grotto of Thetis, ca. 1668.

of the parade ground in front of the palace, a manicured muster-yard on which the king could inspect the obedient platoons of his court.

And though all these visual commands were signalled by the lines of trees, hedges, and sanded paths that tracked through the park, they were also punctuated by pools of water and (by the 1680s) a set of allegorical bronzes representing the rivers of France. Rather than preserve the drowsy serenity of Vaux, the Francini brothers had created the astonishing spectacle of the *grandes eaux*, fed by an enormous hydraulic-pressure machine at Marly and a sharp diversion of the river Eure. It was surely revealing that while the careless Fouquet had chosen the device of the squirrel along with the tactlessly worded

Jean-Baptiste Tuby, basin and fountain of Apollo.

motto *Quo Non Ascendet* (To what heights may one not climb?) to suggest his own ascent, Louis XIV chose the fountain as an emblem of eminence. In a tapestry designed by Charles Le Brun and representing the element of water, the fountain shooting "as high as its source" is meant to signify the king's equality, through virtue and power, with his most illustrious ancestors, Charlemagne and St. Louis.[45]

Fountains like the Dragon (representing another royal victory over the hideous forces of faction and disorder), and set on north-south transverse paths leading off from the main axis, were but interludes on the march toward Apollo. But by 1682, when Louis officially transferred his residence from Paris

to Versailles, it was possible to see *beyond* Apollo to a further body of water that extended the sight line to the point where it seemed to vanish in the dissolving boundary between earth and sky, mortality and immortality. At right angles lay another of Le Nôtre's great canals, six years in the making, much wider and longer of course than its equivalent at Vaux and actually carrying some traffic. Plying their way up and down the water, as if regulated by some omniscient mercantilist majordomo, were versions of the nautical and fluvial craft of the world: ornately worked Venetian gondolas that had been hauled over the Alps so that they could be launched in the Sun King's play-pond; Dutch flyboats and English frigates scaled down in size; French men-of-war, Colbertian prototypes that shot noisy broadsides off at their make-believe foes.

There was a wealth of commercial, as well as military, associations afloat on the grand canal of Versailles. At the same time that the great pile of the palace was growing, royal engineers were cutting their way through ranges of hills to create a spectacular network of royal canals in the Midi and in Burgundy. Their purpose, of course, was to provide the infrastructure necessary for the kind of commercial revolution that Colbert had envisioned as necessary if absolutist France was to prevail over the greatest canal power of the world: the Dutch republic. But the canal, along with the new generation of aqueducts, like the aqueduct of Maintenton, was the perfect expression of absolutist control over the waters: linear, obedient, and free from the unpredictable ebbs and flows of both history and geography. It was a true highway even if, in the end, it went (like absolutist France) nowhere.

In reality, Louis XIV had difficulty in establishing the unchallenged supremacy that seemed to have been in his stars on the floating island in the river Bidassoa. But consolation for his frustrations was always available in the Hall of Mirrors. On the ceiling Charles Le Brun had provided the king with the most flattering representation of fluvial mastery: the armored Apollo hurling his chariot across the Rhine (represented by the usual bearded deity, though looking more dejected than usual) while the awestruck Dutch bore impotent witness to his triumphant passage. A few strides to the window would then take the king to his absolutist line of power: directly down the *grande allée,* through a perfectly articulated ensemble of water, light, and vegetation, toward the authentic Ludovician destination: infinity.

Oddly enough, though, it was left to the Sun King's great-grandson Charles to accomplish the most complete realization of the river-road as a linear myth of authority. And even odder, it was in the chaotic, impoverished Kingdom of Naples that it would be constructed. At least part of the dynastic future anticipated by Louis and feared by Philip IV on the Bidassoa had indeed come to pass upon the extinction of the Habsburg line in Spain with the tragic and demented Charles II. His successor had been Louis XIV's grandson Philip V, and thirty years of bitter war between the Bourbons and the Habs-

burgs (supported by their British and Dutch allies) had failed to dislodge him. In Italy itself a nervous equilibrium was established between Habsburgs and Bourbons and in 1734, after one of the campaigns that periodically broke the stalemate, Philip V's son Charles was enthroned as the king of Naples.

As George Hersey has argued in a brilliant monograph,[46] the creation of a new palace at Caserta, north of Naples, was meant to stamp the new monarchy with unquestionable legitimacy, not least by appropriating land from the local nobility that was most hostile to Charles's accession. Fresh water was in desperately short supply for the chronically wretched metropolis of three hundred thousand souls. But, as Hersey points out, it was also an obsession of local lore and myth, not least for the royal historiographer and sociologist of myth Giambattista Vico. Naples, of course, had its own version of a fluvial myth of origins: the union between the Siren Parthenope, daughter of the Muse Calliope, and the river Sebeto. And it also had a long tradition that imagined the waters coursing through a labyrinth of subterranean reservoirs and passages, perhaps forced with the infernal fire that from time to time erupted from Vesuvius.

Caserta, cascade and fountain of Venus and Adonis, Gaetano Salomone and Luigi Vanvitelli.

It was an inspired decision, then, to make the approach to the new palace run along a long, canal-like river-road, punctuated with sculpture groups and

fountains that commented on the royal power over the elements. And the benevolence of that power was supposed to be exemplified by continuing the aqueduct that brought water to Caserta past the palace, on into the town, and all the way along the ancient line described by the Via Appia to Naples itself.

That, at any rate, was the original plan of its architect Luigi Vanvitelli and it certainly corresponded with the amiable paternalism of the king, one of the brighter and more conscientious members of a dynasty whose supply of both qualities was becoming dangerously depleted. Originally, the layout of the garden approach to the palace emulated (as did so many others of this period) the dominating château of Versailles. But as his plans developed, Vanvitelli seems to have chafed under the yoke of that obligatory paradigm; he complained in his plans of "Versaglia" and returned instead to the older river-roads of the Italian villas for inspiration. But instead of a water-journey to the Source, he reversed the direction of the flow, moving from a mountain spring to the great controlling block of the palace.

Deploying an army of laborers and engineering techniques worthy of the Romans (whom he evidently admired), Vanvitelli cut a cleft in the hillside facing Caserta from which poured a cascade, as if in literal demonstration of the copious literature on the origin of rivers. From there it flowed along a two-mile stretch of canal toward a series of fountain groups, each of which suggested the relationship between water and the power over life and death. Their order, as Hersey has convincingly shown, was not at all random. The first fountain, heavily rusticated, illustrated the chapter of savagery when the naked Diana has Actaeon turned into a stag and torn to pieces by his own hounds as the price of seeing her bathing naked. The stream then dips below ground to re-emerge as the more harmoniously coupled Venus and Adonis, another hunting scene doomed to end badly at the waterside, but which presented a spectacle of love rather than chastisement. As one moves closer to the palace, the language of myth becomes more orderly and benevolent, with a statue of the goddess of agrarian abundance, Ceres, raised on a pedestal. A vast group, fifty-four figures in all, representing Juno ordering Aeolus to make the winds blow Aeneas toward Magna Graecia, was supposed to have decorated the great waterfall that pours over an arched structure, at once an aquatic palace and aqueduct. The statuary remained incomplete when Charles was called to Madrid to succeed his helplessly melancholic brother, but the palace of Aeolus, with waters literally running through tunnels behind the cascade, was evidently meant as a kind of anticipation of the royal residence itself.

For all the density and calculation of its water allegories, there is one startling fact about Caserta that instantly distinguishes it from Versailles. Its monarch never spent a single night under its roof, never went to sleep to the

sound of its water music, nor was wakened by the distant rumble of the rocky cascade. And for once it is to the king's credit that he was, unlike Louis, an absentee megalomaniac. For even while this phenomenal architectural compliment to his omnipotence as the lord of the waters was under construction, Charles was doing his best to fulfil the hopes invested in him in more quotidian ways: building roads, hospitals, granaries; founding academies (always those!); adding to the city's meager supply of public fountains while repairing those that had become polluted or unusable. He was simply doing what enlightened despots were supposed to do: feed the poor, disabuse the ignorant, palliate injustice, silence the disaffected.

It was not enough, of course, especially in the boiling sewer of Naples. For all the fixation with supplies of fresh water, dysenteric fevers still took the biggest trawl of the dead in the city. Four years after the king's departure to Spain (where he came to enjoy a further reputation as about the best enlightened despotism could offer), a revolt of hellish proportions exploded in the filthy and ravenous alleys of Naples. What the rioters wanted was bread, wine, and blood, in that order. And as the *lazzaroni* were energetically sacking the city, the waters of Caserta continued to roll down from the mountain, past Diana, past Venus, past Ceres, toward the immovable, imperturbable palace.

⚶ ⚶ ⚶

ORNAMENTAL FOUNTAINS, however grandly conceived, would not alone safeguard the royal line of power. Besides measuring his authority by the height of *les grandes eaux,* the monarch also had a duty to slake his subjects' thirst. Even the mother of Apollo knew something about this, for Ovid has Latona make a speech to the peasants declaring water "the pleasure of everyone to drink. . . . Nature has not/Made sun and air and vivacious gifts of water/For a few alone."[47] And in the center of Paris, on the very site that was often known as the "heart" and center of circulation of the whole city, the Pont Neuf, stood a contraption that symbolized the royal obligations of charitable refreshment: the Samaritaine.

Does the department store that has inherited its name, and its site, sell bottled water? (That too was on offer in old regime Paris, the best coming from Bohemia; the worst, Seine water spuriously purified and sold as an elixir by enterprising charlatans.)[48] But even if the products of the *sources* of France are on its shelves, it seems unlikely that the customers who pour through its doors give much thought to the woman who gave Christ water from the Samarian well. But it was she who gave her name to the most famous pumping mill in seventeenth-century Paris and she who featured in a lead relief-sculpture set into the side of a wooden building housing the machine. The Samaritaine was the protégée of a German-born Flemish engineer named Lintlaer who, in 1600, offered to provide Henri IV's palace of the Louvre, and the town houses of the

nobility, with supplies of fresh water. Into the bargain he was also prepared to conduct the water through a system of pipes (most of them hollowed tree trunks) to the badly depleted public fountains of the city. The pumping energy was to be supplied by a five-meter-diameter wheel, inserted inside one of the arches of the Pont Neuf, revolving about three times a minute and producing a lift of around two feet.[49]

The arrival of the Samarian woman was not universally welcomed. The water vendors of Paris who stood to lose from mechanical supply petitioned the king against it, and the head of the Paris corporation, the *prévôt des marchands,* bitterly resented the abridgement of his own power to regulate water supply. But the king was determined, and was prepared to make the provision of water a part of his own royal prerogative. To attack the pump, then, was to question his legitimacy.

The victory assured, the mill was established in a structure sufficiently imposing to cow the critics and deter saboteurs. Surrounded by a kind of Flemish *donjon,* it rose two stories from the end of the bridge: its two pointed turrets surmounted by a slate roof, it looked for all the world like a cross between a pilgrimage chapel (apt, given its sobriquet) and a castle gateway. Apart from the sculptured decorations, the Samaritaine was also supplied with a clock whose hours were struck by a mechanical figure wielding a hammer, and a carillon that supplied a pleasing chime above the familiar creaking sound of the revolving wooden wheel. Together, the clock, the bell, and the wheel made up a kind of watery chorus that, during the two centuries of the pump's existence, sang the virtues of Henri IV (in other respects not an especially Samaritan figure), whose bronze statue stood in the center of the bridge.

Immediately below the king was his governor of the pump. For since Lintlaer was reputed (not least by himself) to be the only man at the time with the expertise to maintain the machine, he was lodged on site. Originally, he and his family were housed in the wooden tower. But when fire repeatedly threatened the structure, he was moved to the interior of the bridge itself, where he excavated for himself and his heirs an extraordinary lodging. As his business (based on the quantity of water delivered) prospered, so the pretensions of the governor of the pump grew with his fortune. Additional chambers carved inside the bridge created an entire apartment, sandwiched comfortably between the bridge and the Seine. By the end of the seventeenth century the lodging was spacious enough to house collections of gems and minerals, paintings, cameos, and bronzes: it was both a *Kunstkammer* and an urban grotto whose mirrored walls reflected the river that had made it all possible.

The Samaritaine was finally demolished in 1813. But long before that, it had been judged inadequate to serve the water supply of the rapidly growing city. Toward the end of the reign of Louis XIV, the pump's lifting capacity was enhanced, and to celebrate another chapter in the royal line of water supply,

the Samaritaine's wooden housing was refaced with a stone structure so that it could face the Louvre on one side and the statue of Henri IV on the other without any picturesque embarrassment. A generation later a second pump was added on the Pont Notre-Dame, though both the equipment and more particularly the stewardship of its superintendent were found wanting when it was discovered that in an effort to emulate the grandeur of the governor of the Samaritaine, M. Mance, the custodian, had burrowed his way through the wall shielding the pump, sawed away some of the piling supports, and had created a miniature indoor Versailles, complete with little cascades and fountain jets.

To Bernard de Belidor this was a cautionary tale: luxury, frivolousness, and envy literally undermining the establishment of responsible royal hydraulics. During the Regency and in the reign of Louis XV, Belidor, professor of mathematics, member of the Royal Academies of Science (in Berlin as well as Paris), was placed in charge of the comprehensive renovation of the city's water supplies. The river-pumps and the piping system he set in place survived, more or less, until the advent of steam hydraulics at the end of the eighteenth century. But more than any actual improvements that he may have made, Belidor left behind in his monumental *l'Architecture hydraulique* an extraordinary vision of how a paternalist government ought to discharge its aquatic responsibilities.

Frontispiece portrait, Bernard de Belidor, *l'Architecture hydraulique*, 1737.

Belidor, fountain designs for villa parks and gardens.

The differences from the miraculous refreshments and spectacles of the Baroque popes are unmistakable. Belidor, contemporary of Watteau, could hardly have been altogether without his epicurean streak. And at the very end of his multivolume book he provides a fascinating lexicon of the manifold types of jet—"champignon"—the *gerbe* (sheaf of waters); the *cierges d'eaux* (candelabras of water)—that were available to ornamental engineers along with the technical problems involved in producing ever more fantastic effects. But this is strictly *dessert*. The substance of his huge work is altogether more serious, the hydraulic equivalent of the proposals for reforming the government of the monarchy that were already coming from the pen of the more public-spirited ministers of Louis XV like the marquis d'Argenson.

There is no doubt that Belidor knew the Renaissance geographers who had already associated French destiny with its rivers, in particular François de Belleforest and writers like the Champier brothers, who in the sixteenth century produced a comprehensive anthology of the myths and legends associated with the entirety of known streams: the crystalline waters of the Auvergne that could wash away cataracts of the eye; those which could naturally polish pebbles so that they sparkled like true brilliants. But Belidor's sources of authority were, inevitably, Roman. Like the popes' superintendents, he had indeed read Fron-

tinus and Pliny and had marvelled at the staggering scope and organization of their hydraulic regime. And the ruins of their greatest aqueducts, beside which the best efforts of the Bourbons seemed but paltry, were there to remind him of the desired scale of a truly imperial system. But what seems to have impressed Belidor were the punitive sanctions that could be invoked by the most hydraulically minded emperors, who would not hesitate to confiscate the entire land and property of any officer of the corps found derelict in his duty (and whose possessions would be distributed to the needy). He also admired the thought-

fulness that required avenues of trees to be planted alongside the aqueducts to provide natural shade and coolness for the water flowing within the stone. And most admirable, most enviable of all in fuming, putrid Paris was the great *cloaca maxima,* whose vaults and cisterns and conduits were of a grandeur unknown to man before or since. It seemed grimly fitting to Belidor that Versailles had managed to create as a feast for the eye the *grandes eaux* of its fountains but still carried its excrement off to the Orangerie.

Everywhere he saw work that had to be done: riverbeds to be dredged and made navigable; bridges to be flung across their span; new canals to be cut through hills; sawmills and gristmills constructed using the new knowledge of fluid mechanics that would put the old structures to shame. There were public fountains to be purified, for in some regions of the country the water was so filthy it caused chronic dysenteric fevers and was even blamed for the goiters that hung from necks and breasts. There were conduits to be relined; harbors to be enlarged; wells to be drilled; an entire regnum of water to be made to flow and run with the energy and efficiency worthy of the heirs of the Sun King.

Yet, in the midst of this relentlessly virtuous, inexhaustibly exacting engineering, Bernard de Belidor suddenly stops. He tells a story. It is a story that might have been written by that dynasty of fabulists and fairy-tale inventors (as well as architects, fountain-builders, and river geologists) the Perraults. It is a story of water, magic, death, and the power of princes. But it was not a Perrault fairy tale. It was not even a fable by Fouquet's companion of the gardens and waters, La Fontaine. This story, so Belidor, the grave professor in the perruque, insists (and surely we, who cannot match his mathematics, must believe him), is true.

It seems that in 1693 (how suspicious the precision of this date is) there came to public attention in the Paris of the Sun King one Jacques Aimar or Aymar. He was no more than yet another peasant from some mud-bath patch of hovels in the Dauphiné to have come to town in search of something better than clawing subsistence from the thin dirt of the mountains. And unlike the great, endless parade of mountebanks who peddled their wicked follies on the Pont Neuf under the gaze of *le bon roi* Henri, Jacques Aimar had something to offer: his hazel wand. It was like other water-diviners' rods, coarsely cut as if by dull druidical blade, but it was, nonetheless, his *baguette divinatoire,* the rod that would twitch and shake and tremble its way to water.

But who gave a fig for such poor follies except the credulous imbeciles of the *quais:* the brawny *flotteurs* of the Morvan and the Yonne who were so desperate and so witless that they found their living by heaving great floats of logs all the way from the mountains to the sawmills of Paris, standing neck-deep in freezing water while they pushed and lugged for a black loaf and a jug of *rouge?*

Aimar, so M. le Prof Belidor tells us, made a living even so.

Then one day his life changed. He was at work, guided by the twitching wand. The usual little crowd was faithfully following, perhaps imagining the sweet clear underground spring that flowed beneath the strata of offal and mud under their feet. He held the rod at shoulder-height, pointing directly before him. Suddenly (it was always suddenly) it forced his arms down as though a great weight had fallen on his shoulders. He pointed, knelt, and dug. The smell rose to him. There was no water. In the slimy ditch he had excavated lay the rotted remains of a female cadaver.

Did he take good care to be surprised? M. Belidor does not tell us. But Jacques Aimar's *baguette divinatoire* was suddenly reputed to do more than locate hidden springs. He knew, so he said, that the woman's killer was her husband, and his hazel wand would take him all the way to Lyon, where it would twitch accusingly at her murderer. The rod, it seemed, responded not just to water but to blood. And what, after all, was the difference? It could smell vitality and mortality indifferently. *Mais alors, ça respire!*

Aimar found the body. Who found Aimar? Who was the engine of his sudden celebrity? For in a Paris where *les Grands* affected to comprehend the workings of the universe by elegantly deduced theorems and propositions, there was, of course, a very low threshold of hysteria.

In no time at all Aimar was said to be able to identify all manner of subterranean things: crystals, veins of gold, deep strata of boiling minerals. But what most took the public fancy was his ability to point to criminals; most damning when his wand shook itself into a state of wrath at the feet of some wretched miscreant.

It would not do, so the *gentilshommes* of the Royal Academy said, this charlatan gulling the public, driving it into a foaming frenzy, usurping the appointed authorities of science and justice. What had been done in the old days when wizards and witches had done their mischief? *Une petite épreuve;* a little test.

It was Louvois, the minister of war, who arranged the proceedings; M. l'Abbé Gallois, who organized it on behalf of the Royal Academy. The mountebank Aimar was brought to the academy, asked again if with his wand he could identify a purse of gold that would be buried in a garden. Doubtless he paled, stuttered and stammered. But what could he do? The comedy was staged in the courtyard of the Bibliothèque du Roi, the palace of Mazarin. After walking self-consciously hither and thither (courtiers tittering behind their *jabots*), Aimar came directly to the abbé, complaining that the purse had been set at the foot of a wall where it was physically inaccessible. How unjust of his judges! Well, perhaps, responded the abbé, with a dryly cracked smile, suddenly pulling something from the folds of his coat, but, you see, monsieur, we did not hide it all! A draught of cackling, rising to a gale. End of the diviner?

Not exactly. For the great Belidor tells the story, of course, as a cautionary tale, as only a scientist could. Yet what then follows, with all the fastidious detail that he brought to fluid mechanics and the engineering of bridges, is an exhaustive guide to water-divining.[50] Use only switches of hazel; cut them around June 22, when the sun enters the sign of Cancer and there is a full moon; make them no more than eighteen to twenty inches long; read what the great Cicero and Agricola have to say about it; lie flat on the ground to search for telltale vapors or the presence of clouds of gnats to indicate subterranean moisture; then walk *slowly* with it, properly held at shoulder level, arms fully extended, and it will, verily it will, force its way to the soil, as surely as a willow tree bends its branches to the flowing water.

For there is, so Belidor, master of the king's hydraulics, virtuoso of the absolutist waterline, maker of pumps and canals, conceded, a certain *divinity* about the moisture of the world. For though we may measure it with our mathematics, it is the vital sap of green trees and the pulse of our blood that will, in the end, reveal its circulation.

iv The Political Theory of Whitebait

It was one of my father's firmest beliefs that no one could know real happiness who had not, at some time, gorged on a plate of crisply fried whitebait. The fact that this excluded much of the world's population was unfortunate, but merely another sign of the elect position of those wise enough, or blessed enough, to live by the Thames. For the poor fools who deluded themselves into imagining the flabby sprat or the bony smelt an approximation of whitebait, he had only mirthful pity. As for the oleaginous jaw-working scrapings passed off in the primitive London trattorie of the 1950s as "fritto misto," these were barely worthy of contempt. Only the herring fry that appeared in huge silver shoals in the springtime estuary between Woolwich and Gravesend could be accorded the proper veneration due to whitebait. And as the auspicious day when it would be featured on the menus of the riverside restaurants and pubs approached, he would become noticeably restive, telephoning their kitchens or interrogating knowledgeable porters at the Billingsgate Fish Market for communiqués on the progress toward the deep fryer.

On some brilliant day in May his prayers (and his telephone calls) would be answered. Trains and black sedans would speed us to the Trocadero or (business permitting) the Savoy for our appointment with fishy bliss. While my sister and I nibbled on peanuts, my father would order the proper hock and the proper brown bread and settle back in beaming anticipation.

The aroma came first: a mighty wave of salt-toasted, pungent splendor advancing toward the expectant table. Then followed, in short order, the spectacle of a mountain of tiny fish, rising conically from a glittering charger, hundreds upon hundreds of them, a vast baroque tower of coiled, curled fry, an entire *corps de ballet* of fish suspended in batter; agonized in oil. The first time I saw them, when I was five or six, I couldn't help flinching at the myriad tiny black eyes in the elegant silver heads that still seemed to be darting desperately about for directions. But even then, I impaled a trio on my fork with greedy brutality. We would gobble every last one up in a kind of silent trance of pleasure, slowing down as our plates began to show through the layers of fish and reaching for slices of heavily buttered bread to postpone the inevitable. We never ordered more. We never came back until the next spring. "Dayenu [It suffices]," my father would decree, sacrilegiously borrowing a phrase from the Passover Haggadah. Had the Pharaohs only leavened our servitude with whitebait, some of us might still be living by the Nile.

But my father knew there was a long historical alliance between the British constitution and the humble whitebait. Sitting on the Fenchurch Street train he would jab an angry finger at the Dagenham gasworks and splutter, "There, right there, not so long ago there were *whitebait*." "Not so long ago" meant, in fact, the reign of the Hanoverian Georges, but Arthur Schama had this happy habit of tacking anecdotally up and down the Thames as if it were indeed a breezy stream of time. So he told me about the great flood defenses of Dagenham, built in the first decade of the eighteenth century to protect the Essex coastal lowlands; the first native hydraulic engineering which replaced the mud-and-reed dikes of the Dutch. To celebrate the achievement, the king's commissioners of works had, it seems, held a great whitebait dinner every spring as if somehow the appearance of the fish were a sign that God would indeed Save the Hanoverian King and his fishermen from the tides of flood and war.

During one of the many wars with France, the feast was dignified by a visit from the prime minister, William Pitt. Thereafter, it became an obligatory ritual of government for the entire cabinet to descend on Dagenham to celebrate the impregnable security of the Thames. Predictably, ministers eventually tired of the tedious journey by coach along the north bank, and moved the feast to Greenwich. Uprooted from its original parochial home and transferred to the Ship Tavern, the whitebait dinner now became a ritual attached to the parliamentary calendar, rather than a rite of hydraulic thanksgiving. At the end of the parliamentary term the grandees of the currently ascendant political party

would assemble and celebrate their fortune in mountains of little fish. Inevitably, the whitebait dinners evolved into more grandiose occasions, involving eels and crab and cutlets, duck and beans. Home-brewed Essex ale gave way to champagne and Moselle, and the great fry-baskets indiscriminately harvested all kinds of pseudo-whitebait—pricklebacks, gobies, weevers, pipefish, and stone-loach—along with the herring. Yet, by definition, it was impossible for a whitebait dinner to be an act of aristocratic self-congratulation; nor was it ever so intended. By gorging on the common food of the river, the politicians were demonstrating their virtual community with the People, even while they were obstinately resisting giving them the vote!

As the constituency of representation expanded with succeeding reform acts, so did the availability of the Greenwich Dinner, famous by mid-century for its gargantuan gluttony. *The Dictionary of the Thames,* written by Dickens's son (also named Charles), comments that "the effect at the moment [of consumption] was eminently delightful. The sensation experienced when the bill was produced was not so pleasurable and it has been said that there was no 'next morning headache' like that which followed a Greenwich dinner."[51]

You can still get a Greenwich dinner, albeit on a suitably post-imperial shrunken scale, at the Trafalgar Tavern. But the parliamentary ritual died finally in 1894, along with Gladstone's last Liberal administration. And long before that, the feast had lost much of its original associations as a rite of propitiation and consecration for the safety of the Thames; the British equivalent of the Venetian Marriage to the Sea, or the Cairene festival of inundation. Yet in its gluttonous heyday, from the late eighteenth to the middle of the nineteenth century, the annual whitebait feast in the week of recess remained a celebration of the immemorial virtues of the British constitution. It was a parliamentary rite of spring, a Pentecostal affirmation of political continuity. As a member of the Whig government that had passed the great parliamentary reform bill of 1832, Thomas Babington Macaulay shovelled down trenchers-full of the little fish. And when he came to write the history of what was claimed to be the uniquely successful evolutionism of British politics, Macaulay saw in the river Thames itself a blessed alliance between abundance, liberty, and moderation.[52]

Macaulay had not always assumed that the tide of progress flowed so sweetly on the waters of the Thames. In an essay written for *Knights Quarterly* in 1824 he had imagined two poets, the royalist Cowley and the regicide Milton, sailing on the river on a summer's evening in the reign of Charles II and debating the rights and wrongs of the execution of Charles I. To Cowley's indignation at the "river of blood" that issued from the work of the Whitehall axe, Macaulay has Milton respond that it was "a blessed flood like the . . . overflowing of the Nile which leaves fertility in its wake."[53] But while the young radical Whig was eager to defend not only Milton but the Puritans of Parlia-

ment as revolutionaries forced to act violently in a just cause, the older Macaulay—member of Parliament, imperial legislator in India, and eventually historian of constitutional evolution—is naturally more circumspect when it came to fluvial metaphors.

In October 1838, on his thirty-eighth birthday, while travelling to Italy, Macaulay stopped to admire the river Rhône, "blue, rushing, healthful-looking," and was moved to ponder "the singular love and veneration which rivers excite in those who live on their banks." The reason, he thought, was that

> rivers have, in greater degree than almost any other inanimate object, the appearance of animation, something resembling character. They are sometimes slow and dark-looking, sometimes fierce and impetuous, sometimes bright and dancing and almost flippant. The attachment of the French for the Rhône may be explained into a very natural sympathy. It is a vehement and rapid stream. It seems cheerful and full of animal spirits, even to petulance.[54]

The Rhône, in other words, for Macaulay was a revolutionary stream, by turns capricious and exhilarating, about as far from the sluggish, fatalistic Hooghly he had seen in Calcutta as rivers could be. And though investing the river with the simple-minded generalizations of national character was of a piece with Victorian prejudices about Foreigners, Macaulay did actually echo some of the impressions the French themselves had of their most notoriously wilful river. Not only had its great towns—Lyon, Saint-Etienne, Arles, Beaucaire, Tarascon, and Marseilles—seen some of the most bloody and unsparing slaughters during the Revolution, but the river itself had a justly earned reputation for frequent and severe floods. Its major tributaries like the Ardèche, the Garance, and the Drôme that rose in the Alps might carry an unpredictable volume of snowmelt toward the Rhône and with it a tremendous weight of vegetable debris and rocky gravel that smashed past anything in its way. At the time of Macaulay's journey in 1838, the boatmen and villagers along the banks still spoke mournfully of the terrible flood of 1825; but two years later, in 1840, the loss of lives and property would be even worse.[55]

Even within French topographic lore, there were supposed to be affinities between rivers and peoples, so that the Garonne, the river of the impetuous Gascons, was almost as savage in behavior as the Rhône, while the relatively well-behaved Seine, flowing decorously through Rouen and issuing to the sea at Le Havre, was equally supposed to reflect the stalwart virtues of the Normans. It was all, as Macaulay himself admitted of his own reverie, a little "fanciful." But from the prospect of the Ship Tavern on whitebait day, the contrasts between the temperate Thames and the rushing streams of the Gauls could hardly seem more apposite.

Ever since the days of the Tudor poets, the Thames was supposed to have been unique among rivers for being suited to commerce as well as courts, for combining along its course pastoral innocence and imperial power. James Thomson, who was born exactly a century before Macaulay, in 1700, in his long poem *The Seasons* looked down at the "silver Thames . . . calmly magnificent," and saw vistas of a "vale of bliss" a

> *. . . goodly prospect spreads around*
> *Of hills and dales and woods and lawns and spires*
> *And glittering towns and gilded streams, till all*
> *The stretching landscape into smoke decays!*
> *Happy Britannia! where the Queen of Arts,*
> *Inspiring vigour, Liberty abroad*
> *Walks, unconfined even to thy farthest cots*
> *And scatters plenty with unsparing hand.*[56]

A hundred years of war and revolution did nothing to dissuade the British panegyrists of the Thames from this convention of extolling the temperate harmonies of the river. In the midst of the war with Napoleon, Thomas Love Peacock's *Genius of the Thames* took pains to contrast the "polluted stream" of the Seine, stained with "the blood-red hours of frantic freedom's transient dream," with the Thames,

> *Where peace, with freedom hand-in-hand,*
> *Walks forth along the sparkling strand,*
> *And cheerful toil and glowing health*
> *Proclaim a patriot nation's wealth.*

In the hands of the most shameless celebrants of Hanoverian imperialism, the Thames was not only a balm for political friction; it was also a winding ribbon that bound together all ranks and conditions, mean and mighty, plebeian and patrician, in a single, indivisible community. A poetic cruise along its course supplied scene after scene of perfect social concordance:

> *The tranquil cot, the restless mill,*
> *The lonely hamlet, calm and still,*
> *The village spire, the busy town,*
> *The shelving bank, the rising down,*
> *The fisher's boat, the peasant's home,*
> *The woodland seat, the regal dome*
> *In quick succession rise to charm*
> *The mind with virtuous feelings warm*

Till, where thy widening current glides
To mingle with the turbid tides,
Thy spacious breast displays unfurled
The ensigns of the assembled world
Throned in Augusta's port
Imperial commerce holds her court.[57]

Needless to say, there was no place "in Augusta's port" for any view of the gin rookeries and verminous hovels of Shadwell and Wapping that lay just behind the "unnumberd vessels" crowding its quays. The Thames seemed to have absorbed the challenges of commercial modernity with perfect ease, swelling with power as it pushed its fleets downstream and out into the world, their sails filled with breezy imperial confidence.

It was this kind of drum-beating patriotism that led the artist James Barry to try to supply a visual equivalent of the triumphal poetry of the Thames. During exactly the period when Britain was losing its American colonies, Barry determined to produce, for the Great Room of the Society of Arts, Manufacturing and Commerce at the Adelphi, a grandiose series of history paintings that would, as he put it, "overcome the humiliation of being a scoff and a bye-word amongst nations."[58] British artists were altogether too preoccupied, he thought, with "inconsequential trash": landscapes, portraits, and the like. Having read the German scholar Winckelmann's treatise on the "imitation of the Greeks," Barry aimed to give new life to the intermittent tradition of British history painting that had begun, rather feebly, with the murals done by James Thornhill for the Greenwich naval academy, and had been continued in fits and starts by efforts like Francis Hayman's *Triumph of Britannia* at Vauxhall Gardens.

Barry has to be credited for aiming high. It was the effect of Michelangelo (whose modelling is obviously responsible for the muscled reclining personification of the Thames) and Hayman's beefy Britannia that he was after. But alas, his ambitions exceeded his painterly skills. While he echoed Joshua Reynolds (and Winckelmann) in asserting the classical maxim that "the principal merit of painting as of poetry is its address to the mind," it was precisely in the conceptual department that he fell so woefully short. His *Commerce; or, The Triumph of the Thames,* one of six large paintings produced unsolicited for the society and exhibited in 1777, is a lamentable mishmash of allegory, history, and fluvial landscape that topples over into unintended comedy.

But if we titter (and it's hard to resist), we should recognize that our chuckles are those of the snob as much as the connoisseur. We patronize poor Barry precisely for his temerity in making his Nereids carry "several articles of the commerce of Manchester and Birmingham," because to modern tastes the classicizing of industry seems a grotesque oxymoron. Yet it was the superimposi-

James Barry, *Commerce; or, The Triumph of the Thames,* 1777–84.

tion of classical taste on industrial technology that made, for example, Josiah Wedgwood's jasper pottery such a phenomenal success. And if there is a kind of unpalatable clumsiness in Barry's version of the Thames (Osiris made over as commercial salesman), it does at least exude the earnest encyclopedism typical of Britain's commercial and industrial revolutions. Of course success in compressing the traditional definition of Art into the modern usage of "Arts" (to denote technology) called for the talents of artists as original as Joseph Wright of Derby. What the Society of Arts got, alas, was James Barry.

So the painting offers us the Michelangelesque Thames carrying a mariner's compass, pushed through the waters (at what seems a fairly laboring pace) by an assortment of imperial worthies: Drake, Cook, Cabot, and Ralegh, each dressed in the costume of their period except for Ralegh, who in one of Barry's more inspired inventions is shown naked. Above the scene flies Mercury, the god of commerce, and in the background an immense beacon, emulating the classical lighthouse of Alexandria, rises from the busy estuary, across which seems to have been slung the modern London Bridge. Which leaves the wigged figure at the front of the water-car, seated at a submerged keyboard, whom Barry reveals as Dr. Burney, the composer, founder of a "national school of music" at the London Foundling Hospital and critic of "expense and atten-

tion" bestowed on Italian operas "and other foreign musical entertainments in a language unintelligible to the many."[59]

History does not record the response to Barry's unfortunate concoction, though the series certainly failed to make his reputation as a history painter of modern Britain. Possibly the general reaction of the public was exemplified by one lady at the Adelphi who commented that "she was by no means pleased with Mr. Barry for representing the Doctor [Burney] with a party of girls dabbling in a horse pond."[60]

Barry's failure was as much of the imagination as of technique. It was his uncritical subscription to the "Happy Britannia" platitudes of the river poets, from Leland to Thomson, that made it impossible for him to grasp that there might actually be some drama to observe in the incursions of the industrial revolution on the banks and wharves of the modern Thames.

The realization of that drama would have to await the real genius of Turner. But even that painter, to whom, more than any other, the Thames was truly home, took pains to preserve and embellish its ancient myths rather than directly confront their modern corruption.[61] Even his earliest views, which appear to be frankly, almost naively naturalistic, actually manipulate the riverscape to accommodate some prior Romantic impression or the canon of the European "schools" he so much admired. Thus the watercolor of the river rushing through the arches of Old London Bridge not only reversed the actual flow; it also monumentalized a structure that was already mostly a ruin and which would be entirely demolished in 1832. Needless to say, Turner was not drawn to paint the *new* London Bridge. Similarly, his *Moonlight, a*

J. M. W. Turner, *London Bridge, with the Monument and the Church of St. Magnus, King and Martyr,* ca. 1794–95.

Study at Millbank, exhibited in the Royal Academy in 1797, has a striking and realistically rendered nocturnal skyline glimmering beneath a buttery moon. But the scene of fishing smacks and boats gliding along in the dark is straight out of Aert van de Neer and the Dutch nocturnal tradition, so that the whole riverscape is bathed in the Romantic moonglow of unhistorical time and place.

J. M. W. Turner, *Moonlight, a Study at Millbank*, 1797.

 This is not to say that Turner was incapable of seeing the nineteenth-century river for what it was, and finding a painterly and poetic language to embody it. He was, after all, a true river rat—fisherman, rower, sailor—who understood the movement of light and water and wind, not to mention the practical business of navigation, better than any other riverscape artist before or since. And in a superb book David Hill has convincingly shown how Turner's stay at Sion Ferry House in Isleworth during 1805 produced a series of exquisite and compositionally daring watercolor sketches that are among the very greatest wonders of his whole stupefying career.[62] Yet Turner knew what he was doing by calling the whole series *Hesperides* (meaning the world of the Happy Isles) since he frames one of its most beautiful scenes beneath a radiant rainbow and manages to make Kew Bridge and Palace appear like Italian villas and a campanile in an arcadian *campagna* (color illus. 27).

For all the poetic license, there is in the watercolors a sublime fit between the medium and the objects, almost as if Turner had actually let Thames water itself (suitably purified) wash over his paper and spontaneously form the reflections of light, air, and water that fill its space. But when he worked these observations into oil paintings, often for aristocratic patrons like the lord Egremont, they lost the freshness and spontaneity of the sketches and were cozened instead into Anglicized versions of a Claude Lorrain pastoral, or else a rather laborious visualization of the standard mythology of the Thames.

His *England: Richmond Hill, on the Prince Regent's Birthday,* for example, exhibited in 1819, offers a vast panorama of the river as it makes the classic bend to the south (color illus. 28). And there is even some plausibly rendered barge traffic making its way along the water. But the enormous painting is, as the title implies, some sort of summation on Turner's part of the essential Albion, delivered by its heroes from the jaws of Bonaparte, and reposing in the well-earned fruits of peace and prosperity. As such, it never really escapes the oppressive stylization of its patriotic piety. The visual mnemonics of tub-thumping Anglomania are there—the resting drum, the little cannon, the uniforms mingling with frock coats and Regency millinery. But they are all assembled, additively, by Turner, as though he were auditioning the cast of a formal masque or ballet, also called "England." Indeed the three maidens facing the beholder, for all their fashionable dress, resemble nothing so much as the Graces, which, given Turner's passion for myth, seems not implausible. And beyond Richmond, the river curves upstream toward an immense horizon, with the gentle range of the Cheviots barely suggested at its edge. Beneath the late afternoon light, drenched in gold, a game of cricket proceeds at its hallowed, leisurely pace. It is immortal England laid out on the stream. No wonder the duke of Wellington liked it enough to lend Turner and his friends his own shallop for a summer excursion on the Thames.[63]

Twenty years separate the scene on Richmond Hill from the two masterpieces *The Fighting Temeraire, tugg'd to her Last Berth to be broken up, 1838* (1839) and *Rain, Steam and Speed—the Great Western Railway* (1844) (color illus. 29). In both cases, the power of the paintings comes directly from the degree to which Turner has internalized the great myth of the Thames as the nation's bloodstream, indeed has made it flow along with his own bodily pulse. But in the *Temeraire* the river is also the river of history bearing the redundant hulk of the man-of-war to its demolition at the hands of ironclad modernity. It should not surprise us to learn that in reality the vessel was nothing like the magnificent, tragically timbered ghost-ship that sits stoically beneath the setting sun. (For that matter, as no art historian fails to point out, Turner makes his sun set in the *east* as the ship is being towed upstream to the Rotherhithe breakers.) The old ship, and the four-master in the distance, are witnesses to the whole backstream of British history; the aggressive iron tug, powering its

way through the impossibly limpid water, is without question the force of the new age, the past mastered by the future.

At least, however, the ships are travelling along the same line of time and space. *Rain, Steam and Speed—the Great Western Railway,* painted seven years before Turner's death in the year of the Great Exhibition (color illus. 30), offers a final glimpse of the river-road decisively severed by a different line altogether. Commentaries on the extraordinary painting have differed sharply on the degree to which Turner intended another elegy on the passing of the ancestral Thames or a vision of the irresistible, heroic energy of the railway age.[64] The truth, as with all very great artists, is more ambiguous and unstable. And Turner has set himself in the scene in two places rather than one: in the little rowboat on the river, the kind of craft in which he spent so much time, *and* in the train itself, where he famously leaned out of the window the better to seize the sensations of the weather and the (not very tumultuous) burst of speed.

Of one thing we can be sure. Even though the ostensible setting for the painting is Maidenhead, a gentle little river-town newly crossed by Isambard Kingdom Brunel's new railway bridge, Turner has taken the scene to some altogether different and elemental place. The river itself has become an immense and ancient highway, a vast and unbounded space fed by the waters of all the rivers he has ever painted—Loire and Rhine, Seine and Ex, Medway and Thames—flowing very slowly through a great shroud of shimmering crepuscular light. But the very indeterminacy of the water, its lake-like *indirection,* reinforces the unsparing decisiveness of the railway, its usurpation of the line of power. Indeed Turner has artfully distorted the angle of the old road bridge to the left, so that on its far side it actually seems to follow, rather than span, the river. But this is certainly a crossing: the broad avenues of water and stone bisected by the line of iron and smoke. Surely Turner didn't need a whole new generation of writers to tell him that while once the river had been the favored metaphor for the flow of time, modern history was already being compared to the runaway force of the locomotive.

v Bodies of Water

Ironically, the arrival of steamboats on the great rivers of Europe and America made possible a whole new generation of makers and consumers of fluvial

myth. From the railings of a paddle steamer, the diligent tourist could bone up on the Lorelei, or read Heine's version (if necessary in a translation by Mark Twain), while Rhineland castles, half-timbered villages, and vineyards drifted by. Cruising on the Loire by *promenade à vapeur* was set back by the notorious combustibility of the boats, culminating in a dreadful explosion aboard the *Vulcain* in 1837 that took the lives of two families, including four small children.[65] Once, however, a new generation of *inexplosibles* had been put into service, passengers could sail from Angers to Nantes, past the châteaux that told their own stories of French history. A two-day excursion from Oxford to Greenwich via Windsor, Hampton Court, and the Tower could provide an entire course of gratifying instruction in the history of the British constitution: potted Macaulay along with the potted shrimp teas.

And since the ancient metaphor that rivers were the arterial bloodstream of a people remained very much alive, it was natural for nationalist propaganda to project its obsessions onto their waters. The sheer length of the Danube, for example, rising in Germany and flowing through Slav and Magyar lands, was a gift to the apologists of the polyglot Habsburg Empire since they could pretend that it bound the several nations together like an imperial ribbon.[66] Conversely, the inventor of a national music for a nation that as yet had no political existence, Bedřich Smetana, used the life cycle of the river Vltava, flowing from the Tatras through "Bohemia's woods and fields," as an emblem of the autonomy of Czech history.[67]

Fluvial geography did not, alas, always distribute national myths this neatly. Though the Rhine became the favorite river for Romantic tourism in the second and third decades of the nineteenth century, French and German passengers had quite different notions of how it figured in their own popular histories. For the French it had been a "natural frontier" since the time of Louis XIV, with Strasbourg as the great citadel of the east. But to German nationalists it was essential to imagine the Rhine as flowing *through* the body of the Fatherland, a metaphor that presupposed both banks belonged entirely within the *Heimat*. Alexandre Dumas, who loved the river (while detesting its steamboats), warned his compatriots that they would never comprehend "the profound veneration" that Germans had for its "protecting divinity." For them, he wrote, "the Rhine is might; it is independence, it is liberty; it has passions like a man or rather like a God. . . . It is an object of fear or hope, a symbol of love or hate, the principle of life and death."[68]

Modernity, it turned out, did not at all make the river myths redundant. On the contrary, it gave them a whole new appeal. Even Turner, with all his misgivings about the industrial future, had a shrewd understanding of this. In the 1820s he went into partnership with the publisher Charles Heath to produce on commission a number of views of the rivers of France that were anthologized and sold in lithographic reproduction as *Turner's Annual Tour*.[69] But

he also knew that what his middle-class customers wanted were not faithful representations of industrial-barge traffic and dockyards. So he carefully selected sites on the Loire (the least commercially navigable of the great French rivers) like Blois and Tours that had the most obvious picturesque appeal. Even the views of the prosaically busy Seine were judiciously edited to display elements with the most dramatically romantic allure: crumbling towers looming over huddled villages; old stone bridges athwart a river travelled only by the occasional fisher-boat. At the mouth of the Seine, at Quilleboeuf, the river is dominated by the huge, encrusted mass of the Château Gaillard. Precious little steam, no rain, and certainly no speed. The French, it could be safely implied, were now part of the picturesque past.

What, though, were river artists to do in a country where none of these conventional markers of history were available? For the first generation of American landscapists the issue was acute since, following the Lewis and Clark expedition up the headwaters of the Missouri, it was evident that national destiny was charted along the course of the transcontinental rivers. The realization that there seemed, after all, to be no "great western river" that would connect the Missouri with the Pacific was one of Jefferson's bitterest disappointments. But the Hudson, the Ohio, and the Mississippi, in their different ways, still provided the extended lines of circulation along which the busy commercial traffic of the new Republic streamed.

The patrons of the Hudson Valley painters—men like Luman Reed and Daniel Wadsworth—had made their fortunes largely from commerce and banking. But they also fancied themselves as *patroons*—connected with, or the natural heirs of, the Dutch knickerbocker class that had dominated the agricultural estates on either side of the river.[70] So they were not especially eager to have views of the Hudson that celebrated its prosaic business: steamboats and coal barges chugging along the Hudson; wharves loaded with dry goods and backed with rickety taverns and warehouses. Paradoxically, the only commission that *did* expressly request these views from Thomas Cole was from the English publisher of Turner's *Picturesque Views of England and Wales*. But his bankruptcy precluded discovering whether the sketches of docks and steamboats that Cole conscientiously made in 1835 did actually correspond to the expectations of "views of the noble Hudson."

More typically, the Hudson Valley painters had to navigate carefully between the savagery of "wild" scenery and the mechanical clutter of the industrial river. But while European painters could superimpose the garment of history over the smokestack rivers, using "picturesque" sites that were old in associations but new in their construction (like the new London Bridge and the Gothic Revival houses of Parliament), their American counterparts had nothing to work with but a prospect of the happy future. This, however, they did with gusto. Thomas Cole's *Essay on American Scenery*, published in 1836,

specifically contrasted the "castled crags . . . vine-clad hills and ancient villages" of the Rhine with the "*natural* majesty" of the Hudson. "Its shores are not besprinkled with venerated ruins or the palaces of princes; but there are flourishing towns and neat villas, and the hand of taste has been at work."

But it was (significantly) a different river, the Connecticut, that supplied Cole with a detailed vision of how a cultivated state of grace would rise, almost spontaneously, from the "trackless wilderness." For in *View from Mount Holyoke, Northampton, Massachusetts, after a Thunderstorm (The Oxbow)* he

Thomas Cole, *View from Mount Holyoke, Northampton, Massachusetts, after a Thunderstorm (The Oxbow),* 1836.

represents himself painting and, as the *Essay* describes, looking "down into the bosom of that secluded valley, begirt with wooded hills through enamelled meadows and wide-waving fields of grain, [as] a silver stream winds lingeringly along."[71] As an inventory of details this seems to be little different from the stock imagery of the Thames-side arcadias. But Cole has, in fact, impressed a particularly American stamp on the scene. Diagonally separated, the primitive, storm-ravaged wilderness (the past) is transformed across the river into neatly cleared fields, overhung with skies of celestial-blue clarity (the future). Sheep gently graze; wisps of the most delicate smoke rise from unassuming cottages; and the hills (which Cole has made more prominent than the topography allowed) tower unthreateningly on the horizon.

Sanford Gifford,
*Hook Mountain,
near Nyack, on
the Hudson,*
1866.

George Caleb
Bingham,
*Fur Traders
Descending the
Missouri,*
ca. 1846.

As for the river itself, though, it lies peculiarly confined within the oxbow, not so much a dramatic meander as a wholly self-contained loop. And that, surely, is the problem. Though Cole has included details of a rowboat and a sailboat, this river is not really going anywhere. And likewise the balance between settlement and pastoral innocence, between cultivation and wilderness, has been magically frozen at a moment of perfect equilibrium. For Cole, it was, in every sense, a moment of enforced rest. His patron Luman Reed, for whom he was producing the vast history cycle *The Course of Empire,* had himself suggested that Cole take time off for a different kind of painting.[72] So that Cole deliberately stepped back from the inexorable march of time that took all civilizations from Edenic innocence to imperial self-immolation to pause at an impossibly perfect place and moment.

And following Cole's cue, American artists became ingenious at finding ways to make the industry and enterprise an undisturbing presence in the American arcadia. George Inness managed to aestheticize the Lackawanna railroad so that it drove cheerfully at middle distance, through the verdant hills and dales, a far cry from the ominous oncoming machine on Turner's bridge. And when Sanford Gifford painted Hook Mountain on the Tappan Zee stretch of the Hudson, he took good care to choose a point of view on the west bank that would look directly south, thus concealing the clutter of sheds, brick warehouses, and jetties that stuck out from the port of Nyack into the river. And George Caleb Bingham's version of the Missouri and Mississippi featured groups of *voyageurs,* the flatboatmen and fur traders notorious for their hellion ways, doing virtually anything but labor. At exactly the period when the cotton boom was at its height, Bingham's protagonists were heroic anachronisms whose devotion to pleasure and mischief put them at serious odds with the great Yankee work ethic. Like the river on which they were easily floated, they were drifters.[73]

Back east, though, there was another way to make the river more welcoming to the kiss of modernity: change its sex.

IN 1809 the sculptor William Rush, who until very recently had specialized in ships' figureheads, carved an *Allegory of the Schuylkill River* in the form of a standing maiden holding a wading bird, specifically a bittern, on her shoulder. The statue was meant as a fountain, mounted on rocks, with water gushing from the bird's beak eight feet into the sky of Center Square. And to both Rush and the city that paid for the sculpture, the commission had more than ornamental significance. In this most practical of all American cities, Rush was a member of the Watering Committee which, since the outbreak of yellow fever in 1793, had been attempting to control its virulence by cleaning Philadelphia's notoriously filthy water supplies.[74] In 1799 the English

engineer and architect Benjamin Henry Latrobe proposed a solution that would use the new steam hydraulics to pump fresh water from the Schuylkill, which he believed to be of exemplary purity. In 1801 he had installed two machines in Center Square and had housed them within an elegant Greek temple, very much to the neoclassical taste of the time. What better way to celebrate the success of the enterprise than for Rush to create a fountain that not only would be in keeping with the marriage of the modern and the antique but would also have the effect, much vaunted by Latrobe, of refreshing the air around the display?

Attributed to Rembrandt Peale, *William Rush,* before 1813.

By all accounts the fountain was a famous success, and when the water-works had to be enlarged and moved to Fairmount Park, the Schuylkill and her bittern went with it. The statue stayed there until 1872, when a bronze cast was taken to replace the rotted wood of Rush's original figures. But five years later a much more spectacular homage to the work was provided by Philadelphia's most gifted artist, Thomas Eakins, in his painting *William Rush Carving His Allegorical Figure of the Schuylkill River.*

Devoted as he evidently was to the vindication of the largely forgotten William Rush as an authentically American artist, Eakins took one enormous liberty with the original history. He posed the model nude, when, as was plain, even from the carving in his own painting, the statue was represented as draped.[75]

But how much of a liberty was this? The story that Philadelphia society was scandalized by seeing Louisa Van Uxem, the daughter of the chairman of the Watering Committee, posing for the Schuylkill was, it is true, a pure invention of Eakins.

John Lewis Krimmel, *Fourth of July in Center Square,* 1810–12.

William Rush, *Allegory of the Schuylkill River, or Water Nymph and Bittern,* bronze cast of wooden original, 1809.

And it is also undeniable that he exploited the myth as an honorable precedent for his own difficulties when using live models in mixed classes at the Pennsylvania Academy. Eakins has been taken to task for his disingenuousness in this. Yet a glance at the bronze version of Rush's sculpture actually makes the transgression wholly understandable, if not altogether pardonable.

For though we can be sure that William Rush, the ship's carver, was unlikely to be at all daring in his representation of the river as a water nymph,

it is also the case that he fully exploited the ambiguities of neoclassical dress to suggest, as strongly as possible, the naked body, indeed the *wet* naked body, beneath the clinging drapery. Doubtless in the city that prided itself on its Greek name, Rush would have been aware that there was an alternative type of antique river sculpture to the reclining bearded male gods that had been adopted by the Romans and made the centerpiece of the great Renaissance and Baroque fountains. That alternative was a standing (or occasionally seated) nymph or goddess often holding a vase from which the fresh waters of a river issued. When the personification of flowing water was the river goddess Isis,

her garment seemed made of a film of moisture issuing from her body. In other words, if the great leaning river-gods represented, symbolically, the force and horizontal flow of the river, the open vase of the water nymph and the robe of Isis represented the fertile copiousness of the Source.

So although there was not a whiff of scandal surrounding Louisa Van Uxem's pose, and although Rush himself could hardly have been happy at the popular misidentification of the fountain group as "Leda and the Swan" (the

Thomas Eakins, *William Rush Carving His Allegorical Figure of the Schuylkill River*, 1877.

bittern, after all, was a wading bird that lived in rushes), Eakins's deliberate transgression sustained the conceit of an affinity between the source of pure water and the female body. Indeed how could Eakins, who more than any other Western artist registered the force of *male* bodies upon, and in, American waters, *not* give expression to its sexual complement?

What, after all, is the illuminated focal point of the composition? Not Rush himself, dressed as a yeoman artisan and, like the carving, shrouded in darkness;

Gustave Courbet, *The Painter's Studio*, 1855 (detail of central group).

not the chaperone, though the fall of her dress and bonnet are clearly meant as a wistful echo of the nude. Where, in fact, is the light source? Notionally, there must be a window opening or lantern of some sort beyond the picture space at left. But it lights selectively, first the throw of clothes on the chair, and *then* the left outline of the nude body. And by visually rhyming the two lines—of underclothes and glowing skin—Eakins has in fact created not a nude scene at all, but one of undress.

So Rush's liquid drapery is present in Eakins's interpretation after all. And we see immediately that there cannot possibly be any accident in the colors and

textures that the painter has brought together in the drop of dress: blue hose, white fabric edged with lace. What he has created, in a sweetly poetic compliment not just to Rush the artist but to the Fairmount waterworks and the Schuylkill itself, is a cascade.

✤ ✤ ✤

EAKINS'S PAINTING is not the only instance of a meaningful discrepancy between a model and its ostensible object. Twenty years before, Gustave

Courbet's *Painter's Studio* had marked a much more startling difference between the standing nude and the work of art in progress. In a brilliant reading, to which this whole line of discussion is indebted, Michael Fried responds to the assumption that the nude is not, after all, *in* the painting by insisting that, in fact, she is.[76] Once seen, it is impossible to miss the relationship between the river water, issuing from the grotto in Courbet's painting, and the cloth falling down the model's body and, as we must say, cascading into the pool of her dress. As Fried notes, the flow is not necessarily in one direction. It works as well moving from painting to model to drapery, and perhaps spilling out from the whole picture space into the lap of the beholder. But equally it is possible to paddle one's gaze upstream, fighting the current, into the heart of the painting's painting, toward the dark, rocky crevice at its center.

Gustave Courbet, *The Source of the Loue*, 1863.

Gustave Courbet, *The Origin of the World*, 1866.

All this becomes more compelling when set against Courbet's passion for anthropomorphic landscape. In the 1860s he painted a series of views of water-caves, all sited in his native region of the Franche-Comté. At the center of each is a dark opening from which the waters of the river Loue or the Puits Noir flow back and forth. And it doesn't take a feverishly Freudian imagination to see them as vaginal orifices in the face of the rock, especially when, at about the same time, Courbet also produced at least one explicit painting of female pudenda, for the Turkish collector of erotica Khalil Bey.[77] The artist gave it the title of *The Origin of the World*. And if we are indeed meant to think of the water-caves of the Franche-Comté as a site of native origins—geological and prehistoric—it may be said that Courbet was indeed returning very far upstream.

Is this where we have arrived, then, in the middle of the industrial-impe-
rial century, back in the Renaissance river grottoes, the dimly glowing *fons et
origo,* where the secret of creation was promised in a fusion of wisdom and love?
Only instead of the woman in the cave, Courbet has offered us the cave within
the woman.

vi The Waters of Isis: The Thames and the Nile

When they pictured the Source of the Nile, travellers imagined a cascade forc-
ing its way through a cleft in a solid wall of rock. That is what George Sandys
supposed he might find somewhere above Nubia in 1610; what "Abyssinian"
Bruce hoped to have revealed in the Ethiopian Mountains of the Moon in
1770. Those waters of Isis, at the very core of the mystery of the earth's mois-
ture, were imagined as the issue of hidden places; the "coy fountains," a secre-
tion of dark bodies; an invitation to deep and deathly penetration.

One of the two Victorians who set off in 1863 in search of the Source might
have appreciated these compulsions. For Richard Burton had spent much of his
life investigating and codifying the sexual mores of the Islamic and Indian
worlds, staining his own already saturnine features so that he could pass unno-
ticed in the brothels of Calcutta. His colleague in the overland expedition north
to the Nile was, however, the blond-bearded, white-skinned bachelor John
Hanning Speke. And of the two geographers it was Speke who had the propen-
sity for losing his bearings, having his grip go distracted in the immensity of
Africa.

That immensity appeared to him one day in the camp of King Rumanyika
in the form of a woman, the king's sister-in-law, vast, oiled, and black. Even in
the carefully repressed pages of his memoir of the expedition Speke cannot help
but recall his horrified, enthralled fascination with her. She arouses the explorer
in him. "I was desirous to obtain a good view of her and actually to measure
her and induced her to give me facilities for doing so by offering to show her
a bit of my naked legs and arms."[78] An exchange typical of imperial negotiation
followed. For a glimpse of freckled British limb, the Explorer was able to make
a precise survey of the subject body, all set down with precision worthy of the
Royal Geographical Society: two feet seven inches about the thigh, one foot
eleven inches about the arm, and so on. And all the time this mapping was

Richard Burton, ca. 1863.

under way, Speke felt himself observed by the king's daughter, "a lass of sixteen, stark naked, sucking on a milk pot." Emboldened, he "[gets] up a flirtation with Missy and induced her to rise and shake hands with me. Her features were lovely but her body was as round as a ball."

Deeper in the heart of Africa, indeed almost at its very geographical center, Speke reaches the city of the notoriously murderous King Mutesa of the Baganda. He watches (and is conscious that he is being watched by the amused tyrant) as thirty naked virgins, the daughters of a defeated enemy, "all smeared and streaming with grease," are marched before him, ready for execution or concubinage. Speke is invited to inspect them at close quarters. He does so. The king then asks him "if I would like to have some of these women and if so how many." Struggling to reconcile clemency with chastity, the Victorian bachelor graciously accepts but one and then immediately delivers her to his servant. Everybody is offended except the Explorer, who has surely done the Christian thing.

A slippery thing is this colonial geography! The fountains remain coy. The two mismatched explorers fight constantly and bitterly. Burton becomes lame, Speke almost blind. His legs monstrously swollen with infection, Burton is left behind while the weak-eyed Speke stumbles on north, trembling like a divining rod, toward the waters. Only when his sight is virtually gone does he arrive at the Source itself, at the northern end of Lake Victoria.

John Hanning Speke.

Driven by the need to possess the Source for the empire, the geographers are themselves dispossessed. Back in Britain their feud turns lethal. Speke takes the sole credit for the discovery; Burton declares him deluded. A debate is called for a special meeting of the Royal Geographical Society. But before it can convene Speke shoots himself, falling bloodily on a country stile. The wound, called accidental, is fatal. He is commemorated with an obelisk in Kensington Gardens. On bright days, the black shadow cast by the rays of Amun-Ra, S.W.7, falls in the waters of the Round Pond.

It is not the most famous obelisk in London. That arrived in 1878, while the opera of the Ethiopian captive Aida was playing at Covent Garden. Like most other trophies and sculptures of imperial rivers, the obelisk had also undergone a sex change. It was one of a pair that had been quarried from Aswân rose-granite, around 1450 B.C., by the formidable conqueror Pharaoh Thutmose III. For fifteen centuries the two obelisks had stood before the temples of the sun at Heliopolis, on the east bank of the Nile. But the last of the Ptolemies, Cleopatra, also the last Egyptian ruler to protect the traditional veneration of Isis and Osiris, had given orders for the columns to be moved to the Caesareum at Alexandria. This was the palace that the Egyptian queen had built to the memory of her lover, who had himself been obsessed with the secret of the Nile's source. Around 18 A.D., in the reign of Augustus, the two columns were re-erected before the gates of the Caesareum. Malicious tradition believed them to stand, priapically, in the tradition of the licentious rites of Isis and Osiris for the queen's two Roman lovers, Julius and Antony.[79]

So it was as "Cleopatra's Needles" that they came to be coveted by the two warring empires of Britain and France. And by this time, eighteen centuries later, one of the obelisks had fallen into the sand outside Alexandria. It was the eagerness of the French to carry them off as trophies that first spurred British jealousy and emulation. And since the British victory at Alexandria in 1801 had resulted in the final expulsion of Bonaparte's troops from Egypt, the opportunity was taken to "suggest" to the Turkish viceroy, Mehemet Ali, that his offer of a gift of gratitude for the liberation might take the form of one of the obelisks. The hope was that it might be re-erected somewhere in London as a memorial to the British troops, especially General Abercromby, who had died during the campaign.

Then a terrible thing happened. Mehemet Ali (after a properly Levantine delay) made the offer, only to find the British hemming and hawing over the fifteen thousand pounds needed to transport the obelisk. Each time the offer was renewed, at the coronation of George IV (1820) and William IV (1830), the same stingy objections were raised at Westminster. By this time, Mehemet Ali, nobody's pawn, had turned into a formidable ruler in his own right and was brilliantly exploiting Anglo-French tension in the Middle East to assert his own power. An obelisk was offered to the government of King Louis-Philippe;

it was gratefully accepted. Even worse, when the French asked if they might instead have one of the spectacular obelisks of Luxor, no objection was made. In 1836 it duly went up on the Place de la Concorde, on the very site where the statue of Louis XV had once stood and where his grandson Louis XVI had been beheaded.

For London's Egyptomanes this was a bitter blow. But in the parsimonious world of Victorian liberalism, nothing was going to set it to right without private philanthropy. It took the classic combination of Scottish money (provided by the dermatologist Erasmus Wilson), the military patronage of General James Alexander, and the engineering skills of the brothers Waynman and John Dixon before the campaign to bring the needle to London could be properly launched.

The enterprise was heroic engineering at its most dashing. The half-buried column was to be encased in an iron cylinder that would be prefabricated and assembled around the horizontal needle. It would then be rolled toward the shore, attached with hawsers to a steam-tug, and towed, very carefully, all the way to London. At the end of August 1877 the cigar-tube barge, containing the obelisk lying within, was launched into the Mediterranean. It was named the *Cleopatra*. But to the learned might it not have suggested an uncanny resemblance to that earlier, fatal coffin, with the body of the dead lord Osiris nailed within that also bobbed and pitched about in the cobalt waters of the Eastern sea?

It was unlikely, of course, that either the habitually drunken Maltese crew aboard the *Cleopatra* or its master, Captain Henry Carter, was especially familiar with Plutarch or Diodorus Siculus. But when Carter dropped through the trap in his little turret and crawled on his belly, holding a lit candle between his teeth, when he burned his nose so badly in this position that he dropped the light and was obliged to palm his way along the hieroglyphs, his belly flat against the granite, did he then feel the slightest tweak from the God of the Underworld, He who Died and Sank and Rose and Died Again?

Was it the breath of Typhon that whipped the waves in the Bay of Biscay into mountains? The *Cleopatra,* which even in moderate swells pitched at a peculiar angle, now bucketed insanely up and down, driving the crew into terror. Desperate signals of distress were sent to the towing ship, the *Olga,* which launched a boat to try to take off the frantic sailors from the *Cleopatra.* Before they could get alongside, a wave of monstrous height fell upon the rescuers, engulfing them so completely that neither boat nor sailors were to be seen. They had all been swallowed entire by the deep.

Eventually the crew was brought aboard the *Olga* and a decision taken to cut the *Cleopatra* loose and abandon it to the waters. Three days later, grieving for their dead comrades and demoralized at the loss of the obelisk, the *Olga* put in at Falmouth harbor. For a day, the abandoned iron coffin floated on the

gale-whipped sea; the lookout cabin lying parallel to the waves. When the steamship *Fitzmaurice* spotted her, the *Cleopatra* was describing violent and crazy circles, like a harpooned whale in its death throes. But as the storm abated, lines could be attached and the famous tube with its recumbent monument was towed into a Spanish harbor.

Refitted, it finally arrived at the mouth of the Thames the following January, 1878. And while it lay moored at the East India docks, a captious debate ensued over where the needle should be erected. Its sponsors naturally wanted the maximum prominence. The general thought St. James's Park would be best; the eminent dermatologist insisted Parliament Square was the most fitting. But the commissioners of the new Metropolitan Underground Railway were anxious lest the obelisk drop into the tunnel below, seriously inconveniencing passengers. So it was as a compromise that the embankment of the Thames, at the Adelphi steps between the Savoy and Whitehall, was finally agreed upon. But once selected, the riverbank site seemed somehow the most fitting of all, with the granite stone raised on a pedestal above the turbid sludge of the great imperial river.

While the elaborate preparations for the re-erection were being made, thousands came to inspect the column, docked by St. Thomas's Hospital, panels removed from the *Cleopatra* for better viewing. The Prince of Wales did his duty and peered at it; Disraeli, Romantic novelist of the Orient as well as prime minister, peered at its hieroglyphs and stroked his goatee; the queen, whom he had just exalted into an oriental empress, sent her earnest good wishes and made the dermatologist a *Sir* Erasmus. And on September 13, through the miracle of hydraulic power, the science that had been born on the banks of the Nile Delta at Alexandria, the needle was lowered into place.

Before the needle was set, a number of memorabilia had been deposited within the supporting pedestal, in the manner of votive offerings placed by the body of dead kings in the Pyramids of Egypt. They were, of course, in the Victorian rather than the Pharaonic manner, to wit, a standard "foot and pound" presented by the Board of Trade; a bronze scale model of the obelisk; copies of *Engineering* printed on vellum with plans of the transport and re-erection; a complete set of British coins including an empress of India rupee; Bibles in various languages; *Bradshaw's Railway Guide;* a case of cigars, pipes; a box of hairpins "and sundry articles of female adornment"; and, courtesy of Captain Henry Carter, "photographs of a dozen pretty Englishwomen."[80]

Would Osiris have found *Bradshaw's Railway Guide* or the dozen pretty Englishwomen an acceptable votive offering on the banks of the Thames? In any event Englishwomen of all complexions, their imaginations stirred by obelisks, tablets, and the colossal head of Ramses II that stared at them in the galleries of the British Museum, were sailing to Egypt to encounter the gods and the Pharaohs at first hand. They were duly stupefied by the Pyramids of

The *Cleopatra*
cut adrift,
cover,
*The Illustrated
London News*,
October 27,
1877.

Gizeh, the "palace of giants" at Karnak, and the heads of Hathor at Dendera, where, reported Amelia Edwards in 1877, "a heavy, death-like smell as of long imprisoned gases met us on the threshold."[81] But of the places of marvel and pilgrimage on the Nile, one above all others sent the women into a transport of ecstasy: the temple island of Philae, believed by an ancient if corrupt tradition to be the final resting place of the remains of Osiris.

The homage to Philae was all the more improbable since its architecture, by Egyptian standards, was not at all ancient. Its oldest building was the temple of Isis but this only dated from the late Ptolemies, and the colonnade along one bank of the island was an even later, unfinished structure built during the reign of Augustus. And as Florence Nightingale, who spent what she called her "Holy Week" on the island in January 1850, bluntly observed, "everything in Philöe is *ugly*. The hypaethral temple is hideous; the sculptures (after what we have been accustomed to in Nubia, of the times of the great Rameses) would disgrace a child—ill-drawn, ill-cut, ill-painted."[82]

What accounted, then, for the peculiar spell that Philae seemed to put on all who set foot on the "sacred isle," as Florence Nightingale baptized it? Its situation, to be sure, was pure magic: set high on an island at the "gates of Nubia." Because it was sited just above the First Cataract, travellers were obliged to reach its stretch of the Nile by mule or camel, and then embark on a boat south of the rapids. This had the effect of detaching them from their conventional responses to Egypt: learned wonder, mixed with European vexation at the flies, the baksheesh, the flat monotony of the riverbanks. Abruptly, as if by some enchantment, everything changed above the cataract. The river itself had altered color to a slightly less turbid hue. It flowed faster and beneath granite cliffs that towered hundreds of feet high; then, before Philae itself, it suddenly pooled into a strange and beautiful calm, as though the Nile were trying to become a lake. The palms were wilder, set against the great Golden Mountains, the Nubians darker and so, the Europeans always thought, somehow more dignified and silent than the Arabs who had all but disappeared from the riverscape. The women, too, were tall, erect, their long black hair brilliant with castor oil, their bodies often exposed to view. If the Egyptomanes fantasized about the "true" descendants of the people of the Pharaohs, surely these were they.

But there was something else about Philae for which most of its visitors were unprepared, however many times they had looked at the Romantic watercolors and engravings of David Roberts (color illus. 31). For, however crude, the brilliant hieroglyphs of Ptolemy XI (the father of Cleopatra) were ennobled by their devoted preservation of the old religion; of the sun cult of Ra; and above all the cult of Isis and her son by Osiris, the great god Horus. And despite all the depredations of the Copts and the Mamluks, the spirit of the Egyptian gods of the Nile breathed through the sandstone and granite. "This last failing

effort of the failing nation to embody their spirit," Nightingale wrote, "makes it all the more affecting."

> It is like the last leaping up of the light in the socket which shows the dying face you loved, of which the spirit is beautiful, though the body is disfigured and agonising—it is like the last dying words, the farewell. I am not sure that I did not love Philöe better for her struggle to say one thing more to our watching ears, to teach us the great truths *she* felt so deeply.[83]

In her rapture, the exemplary Christian Florence even imagined that He Who Sleeps in Philae, the lord Osiris, whose bed was said to be beneath the temple parapet, was actually identical with "our Savior." They had the same torn body, the same commingling of blood and wine and water. "When I saw a shadow in the moonlight in the temple court, I thought perhaps I shall see him, now he is there."

Many others, less given to piety, had the identical experience of transfiguration beneath the moon of Philae, a trembling disturbance beneath the skin that shook their composure. Lucie Duff-Gordon, who had been sent to Egypt to have her consumption cured, on a May night in 1864 slept beneath the stars, as she wrote, "on the very couch of Osiris himself." The next day she woke at dawn and bathed in the Nile, tinted blood-red by the sunrise, and then

> went up and sat at the end of the colonnade, looking up into Ethiopia, dreaming dreams of "Him Who Sleeps at Philae" until the great Amun-Ra kissed my northern face too hotly and drove me into the temple to breakfast on coffee, pipes and kieff.[84]

Five years later Lucie was dead, for, contrary to Victorian dogma, the climate of Egypt did little for tuberculosis but scour the lungs with sand. But forty years almost to the day after her Isis-like communion with great Osiris, her daughter Janet Ross arrived to see Philae. She too decided to escape the heat of the temple by sleeping on the parapet. When she awoke, however, and walked about the isle, her spirits sank amidst the hordes of chattering tourists who had come from Thomas Cook's tennis-court hotel at Elephantine, and the hordes of beggars who came with them like the scavenging birds that followed the boats. Osiris, who was supposed to see to these things, had been unable to prevent the Western engineers of Lord Cromer's Egypt from beginning the project of the Aswân Dam and submerging the temple for several months each year.

"Philae, beautiful Philae was no more," she wrote. "For a few minutes hatred of the utilitarian science which had destroyed such loveliness possessed us."[85]

It was just the beginning of the end. What the British Empire commenced, the Soviet Empire (which believed in great dams as if they were ordained by the dialectic) completed. Gamal Nasser's Aswân High Dam supplied him with the political voltage in 1956 to defy the enfeebled powers of Europe. But the rising waters would doom Philae, the temple of Isis, and the couch of Osiris to a drowning more final than anything imagined by Plutarch. The alternative was, of course, dismemberment. In 1972 a barrier shield made of steel corseted the island and millions of cubics of sand were dumped to prevent leakage. The temples were cleaned, photographed, and numbered. And then they were taken apart, stone by stone.

Did Isis preside over the reconstitution? Was anything left behind in the Nile?

Is *that* the problem? That *nothing* was indeed left behind? Is this why, with Isis and Osiris reunited on the scrubby, muddy little island of Agilkia, something is wrong with the Nile? Polluted, evaporated, exhausted, it is dying. And it is hard to have faith, this time, in the resurrection.

ROCK

Mountains are the beginning and the end of all natural scenery.
 JOHN RUSKIN,
 Modern Painters

I should like the Alps very much if it were not for the hills.
 JOHN SPENCE, 1730

Dinocrates and the Shaman:
Altitude, Beatitude, Magnitude

i The Woman on Mount Rushmore

And why not, pray? To Rose Arnold Powell, who had campaigned for ten years to have Susan B. Anthony, the heroine of the long crusade for women's suffrage, up there on the granite with the four presidents, it was surely right and fitting, so long as America had any claim on the world's attention to be a place where justice and equality were truly served. And hadn't she explained all this to Mrs. Roosevelt, who had had the goodness to read her letters properly and to answer, not like some others in Washington who pretended to be fighters for the Women's Cause, but who returned her nothing but patronizing smirks and knowing shakes of the head back and forth as if she were simpleminded. She had paid them no heed. She had fought on and on and never minced her words any more than Miss Anthony herself would have done. "I protest with all my being against the exclusion of a woman from the Mount Rushmore group of great Americans," she had written the First Lady in 1934. "Future generations will ask why she was left out of the memorial . . . if this big blunder is not rectified. The Mount Rushmore Memorial Commission can amend its present plan and include her if the gratitude of women will rise

Gutzon Borglum, in harness on the cliff of Mount Rushmore.

Mount Rushmore, near completion.

as a flood and sweep away all objections."[1]

It had come to her in St. Paul, while she was laboring away for the Internal Revenue Service, that she had more important dues to collect than income tax. The constitutional amendment that had finally *recognized* women's right to vote (she would never say *granted*) was but a decade old. How could Americans—men as much as women—*not* think a great national monument should commemorate the woman who had saved American democracy from its sin of omission? Was Miss Anthony not as worthy as Jefferson, who had given democracy its institutional design, or Lincoln, who had brought the freed Negroes within its walls? Was her nose not as aquiline, her jaw as craggy, her brow as determined, and her spirit no less magnificent? Why, nature might have designed her for a stone memorial. There was talk of postage stamps. Postage stamps indeed. She would not be fobbed off with postage stamps; little pieces of gummed paper, licked and forgotten. It was not such a paltry little thing she had in mind, but something mountainous in its scale of honor.

She would explain all this to the sculptor, Mr. Borglum. He seemed a man of big vision who would surely understand the rightness of it. In 1927 she had seen pictures of him swinging away in his harness contraption against the granite face of the mountain, while President Coolidge, vacationing in the Black Hills, looking foolish in cowboy boots and Sioux headdress, had let fly a surprisingly mighty gust of speech on "the National Shrine to Democracy." Now, how could such a thing be truly *national* and ignore half of all Americans? She wrote to the president in this vein, but Silent Cal, alas, seemed to have reverted to type.

In 1930 the head of George Washington, sixty feet high, was ceremonially

Rose Arnold Powell.

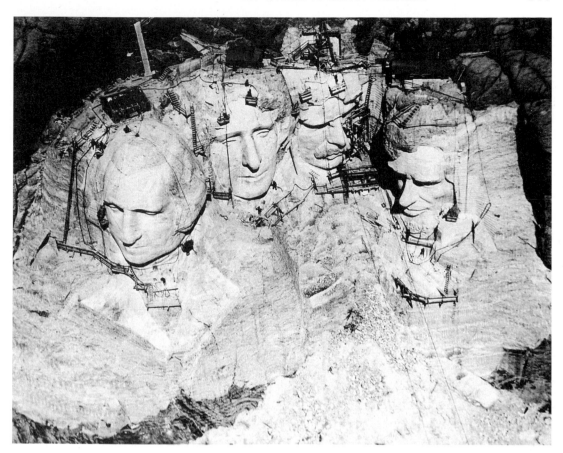

unveiled. On the movie-house news in St. Paul, five hundred miles east of the mountain, Rose Powell saw a vast Stars and Stripes furl itself *upward,* as if moved by the hand of Providence, revealing the noble Washingtonian nose (a foot longer than originally calculated), the majestic overhanging brow lit by the morning sun. Through the crackle of microphones she heard Borglum prophesy that this was a face that would outlast all the civilization it represented. There was cheering, flights of airplanes, salutations in rifle shots, and festive blasts of dynamite spraying rubble high in the air like confetti.

Rose made her mind up. What was to keep her in Minnesota? She had no family other than her mother, who would fuss but keep her peace. She knew Washington from her time there as secretary and treasurer of the Susan B. Anthony League in the 1920s.[2] And if the cause was to prevail, she had to be in the capital, writing to any and everyone who might show interest, knocking on doors, being a righteous pest. She knew well enough that it would be a lonely fight. "Like Moses I felt utterly inadequate for the undertaking."[3] But hadn't Miss Anthony herself shown what sheer dogged tenacity, and belief in the rightness of the cause, might accomplish?

In November 1933 Rose Powell put on her best hat and stepped into the lobby of the Willard Hotel, in Washington, D.C. A block away, men and women in worn coats stood vacantly in front of the White House as if hoping for prophecy from the new president. In the Willard's "Peacock Alley" gold watches and silk scarves lay on satin cushions, catching highlights from the brilliant display lighting. The place smelled of cigars and French perfume. It rustled with riches. Not for her, though, and, she told herself by way of encouragement, not for Gutzon Borglum either. For all his fame and his grand friends like Teddy Roosevelt and William Randolph Hearst, he had the reputation of being constantly hard up, always getting into scrapes and squabbles over money. Years ago he had mortgaged his big Connecticut estate, Borgland, to help finance the Confederate monument on Stone Mountain when the Georgians got stingy. Before his term was up Coolidge had managed to establish the Mount Rushmore Commission and had got a quarter of a million dollars from Congress for the work, conditional on its being matched from private funds. But with the Depression hitting Dust Bowl states like South Dakota so hard, and what with the banks full of failed farms and businesses, most of the philanthropic promises had come to nothing.

Lately things seemed to have been going a little better. For all his renown as the Great Engineer, Herbert Hoover had shown no interest at all, maybe even something worse, toward the monument. The new president, though, was a different story; another Roosevelt, good for America, good for Borglum. Prompted by the senator for South Dakota, Peter Norbeck, he had squeezed fifty thousand from the grudging New Deal Congress. It was made acceptable as a works project to sponge up the local unemployed, though Borglum had his doubts they would be up to much except for maybe clearing dirt and scrub and boulders from the site. Perhaps somehow he could use the money to make good the disaster with Jefferson's head, when one of his cutters had bit too deep into the forehead with his drill, making old Tom look like he had a permanent migraine. Though the commission was now free to use federal money without waiting for matching grants, he had the National Park Service on his back, with some pinstripe giving him lectures about "mutilating" mountains and as how National Memorials ought rightly to be the work of Nature and God, and so forth.

All this was evidently on Borglum's mind when he stood up to shake Miss Powell's hand. His sunburned brow was deeply creased; his blue eyes watery behind the pince-nez which went oddly with his fedora and silk scarf, half bohemian, half bank manager.[4] Removal of the hat exposed a dome of brilliant baldness, and below it Borglum wore an expression that was somehow both impatient and importunate. He still needed funds. That, she assumed (rightly), was why he had agreed to see her at all. As she made the case for Miss Anthony as forthrightly and eloquently as she could, she felt his attention wander to any

money that might drift across the lobby and be snared for the mountain. She was acutely conscious of lacking Miss Anthony's own famous eloquence, which could sweep aside cavils with an unanswerable epigram, with the adamant force of its truth. She pulled out an old photograph, taken when the great suffragist had been president of the National American Woman Suffrage Association. Perhaps the powerful nose and jawline would move the sculptor more than her awkward words? Borglum took a look, shrugged and grunted, with unnecessary discourtesy so she thought, and made his sense of being put upon only too plain. Still, he did not reject her outright. And even when he took his leave of her, rather abruptly, mumbling something about "thinking it over," she accepted the dismissal as though it were an invitation to persevere.

And persevere she did, even when Borglum failed to respond to her many letters. There were no women's organizations in Washington, in the *country*,

Adelaide Johnson, *Portrait Busts of Susan B. Anthony* (center) *with Lucretia Mott and Elizabeth Cady Stanton.*

that did not hear from Rose Arnold Powell about Mount Rushmore and Susan B. Anthony. And when even the Susan B. Anthony League found her relentless hammering a bit much to take, she upbraided the organization for its spinelessness and want of large imagination, and resigned to found the Susan B. Anthony *Forum*. Never mind that the forum was mostly her, a handful of like-minded devotees, and an old typewriter. It elbowed its way into the attention of those who wielded some real political clout. And when the grandly titled National Federation of Business and Professional Women's Clubs signed on for the campaign, that "Mount Rushmore woman" stopped being a joke at Washington cocktail parties.

Nineteen thirty-six was an election year. The women's vote *might* count in tight races; no one knew for how much. Senators and congressmen who had

chuckled at the very idea now put their names to a bill supporting the inclusion of Susan B. Anthony on the Mount Rushmore monument, much to the horror of Pete Norbeck. Eleanor wrote to Borglum; harassed Franklin. Franklin procrastinated and then offered the postage stamp as a sop. This only spurred the women's organizations (orchestrated by Miss Powell) to swamp the White House with more mail. In the summer, doubtless moved by the distinct possibility of South Dakota going Republican, Roosevelt went to Mount Rushmore for the dedication of the Jefferson head, using the occasion to identify himself and his party with the founding father of American democracy. But any possibility of pressing the women's cause was drowned out in the din of Borglumania that attended the dedication—dynamited rocks tumbling down the mountain slope as yet another oversize Old Glory rose to reveal Jefferson's properly corrected profile.

In October of 1936, with her campaign evidently in the balance, Rose Powell stepped off the curb on Sixteenth Street and into the fender of a speeding taxicab. Coming when it did, the accident was especially catastrophic. She had been planning a grand statement to send to the chairman of the Mount Rushmore Commission before it made its report to Congress. Enduring savage pain from a battered spine, Rose dictated the long document to a halting stenographer. It was an appeal to take democracy seriously, to insist on giving "feminine heroism" its rightful due, to make future generations of young Americans understand that the country had not been built by men alone.

The time that followed was bleak. The accident seemed to have mobilized a whole army of discomforts that would no sooner pass from one region of her body than it would show up in another. Demoralized, Rose Powell went back to Minnesota, knowing that from that distance she would be hard pressed to capitalize on all the work she had put in before 1936. The Anthony Bill was reintroduced, but with the election past it was little more than a gesture and died on the floor of the House. Funds for her forum dwindled and dried up altogether, forcing its liquidation. A last meeting was held at the house of the sculptor Adelaide Johnson, who had made a marble bust of Susan Anthony, as well as two other founders of American feminism, Elizabeth Cady Stanton and Lucretia Mott. To Rose Powell, it seemed like a wake. "I felt utterly crushed," she wrote later, "by the thought of failure of my great mission with no-one interested to carry on the work as I had done."[5]

Even in her lowest moments, though, Miss Powell could not cut loose from her obsession. She soldiered on, as best she could, from Minneapolis, converting the president of the National Organization for Women and arguing over and over again with Borglum himself. He protested there was no room. She gave him the measurements of the rock to show there was. He objected that Miss Anthony, however noble, was no president. The more the pity, said she, but women's disgraceful exclusion from democratic representation was all

the more reason to make proper atonement and recognition. No one, he shouted in his letters, *no one* had a greater regard for the women of America. Had he not risked scandal and outrage when he had made his Atlas supporting the very globe a *woman?* To Eleanor Roosevelt he insisted that "I have resented all my life any and all forms of dependence or second place forced on our mothers, our wives or our daughters, as has been the history of men's civilization, but I feel in this proposal that it is a very definite intrusion that will injure the specific purpose of this memorial."[6]

And then, quite suddenly in the darkening months of autumn 1939, with Europe at war, there arrived what Rose Powell took to be a capitulation. A letter from Borglum enclosed another he had written to the president of NOW, proposing the western wall of Mount Rushmore as a suitable site for a portrait of Susan B. Anthony! He wrote as if he had been intending this all along. Could Miss Powell, Mrs. Roosevelt, and other interested parties come out to the mountain to take a look? Surprisingly, no one could. But two further letters, in January and April 1940, seemed to assume this commitment would be honored. Her likeness would stand next to the "great inscription" (as yet unwritten) that was to be carved below the heads.

A year later Borglum was dead, and the Susan B. Anthony project was buried along with him. His son, Lincoln, who had worked at the monument, inherited the responsibility for its completion. But in wartime there were no dollars for Congress to spend on monumental mountains out in the middle of nowhere, especially since Theodore Roosevelt's head, the last of the four to be completed (and, technically, perhaps the most accomplished), had been dedicated in the summer of 1939. Needless to say, Miss Powell wrote as earnestly and as frequently (two letters a week, average five pages, single-spaced) to the son as she had to the father, shamelessly using filial memory as a call to fulfil what she unhesitatingly called Gutzon's "promise." But though she herself lived on to 1960 and never failed to remind each succeeding president and even Vice President Richard Nixon of their "duty," her moment had passed and she was tolerated merely as another harmless old crank, a relic from the ancient days of the suffragettes.

There would be (at least in Minnesota) a Susan B. Anthony Day. There was indeed a fifteen-cent Susan B. Anthony stamp, and a fifty-cent Susan B. Anthony coin (in 1947); and automatic ticket machines at Grand Central now dispense Susan B. Anthony dollars as change. Adelaide Johnson's fine bust stands in the Capitol rotunda. But that heroic jaw and set expression do not look down from the Black Hills, inserted between the intelligent, concupiscent Jefferson and the roughriding, bespectacled Teddy Roosevelt.

And the sad fact of the matter is that the head, as Rose Powell imagined it, was *never* seriously countenanced by Gutzon Borglum, much less by Franklin Roosevelt. In her elation at his apparent change of heart Miss Powell glossed

all too lightly over what in fact was the most crucial element in his letter: its specific identification of the *west* wall as the site of the "portrait." What he meant was the *back* of the monument, somewhere in the vicinity of a planned (but never executed) "Hall of Records" that was intended as a more inclusive pantheon of American worthies. So Miss Anthony would have been in the company not of Washington et al. but Thomas Edison and Alexander Graham Bell, as if she had been the inventor of something as unlikely as women's suffrage. Nor did Borglum ever make it clear what the dimensions of the "portrait" were going to be. Miss Powell chose to imagine something on the same scale as the heads of the presidents. But what he evidently had in mind was something more akin to the relief figures of Stone Mountain, but on a significantly smaller scale.

What Gutzon Borglum really wanted more than anything, for all his protestations of championing the women's cause, was to get the remorseless Rose Arnold Powell once and for all out of his hair. Perhaps he supposed that by humoring her he might even be able to tap women's organizations for the money desperately needed to complete the whole memorial, Hall of Records, "great inscription," and all. When a congressman asked him (incredulously) whether he took the Woman on Mount Rushmore Project seriously, his response was crisp. "Pay no attention," he wrote; should the foolishness ever come to anything, "I would brush it aside as I would an annoying fly on a wet day."[7]

"Nothing is hopeless that is right," wrote Rose Powell, nearing the end of her life in 1960, in what might have been her epitaph. But had she known more of Gutzon Borglum's real character and purpose, even her formidable faith might well have wobbled, if not crumpled altogether. After all, someone who saw mountain carving as a supremely masculine act of possession was unlikely to welcome the addition of America's most famous suffragette to his rock-gallery of heroes.

Borglum had his own, peculiar women's history. He was the son of a Danish Mormon immigrant who had taken two sisters as his wives. When he was still an infant, his biological mother, Christina, was cast out, Hagar-like, from the Borglum household, and little Gutzon was reared by his aunt/stepmother. With this ghost of the lost mother preying on him through adolescence and into adulthood, it comes as no surprise to learn that he married his art teacher, Lisa Putnam, eighteen years older than himself, nor that he found it impossible to say anything about her to his dreadful old father until after the marriage. Needless to say, once Borglum deserted his wife and married again, he obliterated the memory of Lisa from the family history. As Albert Boime has aptly put it, "as a creator of monuments he was a destroyer of his own personal history."[8]

At the same time, Borglum felt himself moved by assertive, almost androgynous women. In London and Paris, where he did his art studies, he became acquainted (so he claims) with Isadora Duncan and Sarah Bernhardt. And when he later professed the intensity of his admiration for women to Rose Powell, it was these kinds of women he had in mind—the sort that became his female Atlas,

and the women-angels of the Savior Chapel in the Cathedral of St. John the Divine in Manhattan, rather than Susan B. Anthony. But the influence that imprinted itself most deeply on his early career as a sculptor was that of Auguste Rodin, whom he had known well during his years in Paris and who was himself a long way from being a feminist sympathizer. For years Borglum surely fancied himself the American Rodin, a creator of muscular heroics in bronze. And though Borglum never committed himself to anything approaching Rodin's expressive erotics, he certainly identified with the masculine egotism of the sculptor-as-god, kneading flesh to his own will. The trouble with modern art was that it had gone degenerate. The trouble with America was that it had gone limp.

All these impulses were allowed exposure only once they had been given a bracing cold shower of American patriotism. Rodin's clinging calves and tensed thighs turned into the cavalryman's boots and spurs holding fast to the fetlocks of some military mare. Born a year after the Civil War ended, Borglum was still addicted to its Homeric epic and was naively impartial in his allegiance. His crudely romantic view of heroic sacrifice made room for both Lincoln *and* for Jefferson Davis, whose likeness he was going to carve on Stone Mountain along with Lee and Stonewall Jackson. Likewise, he could make sentimental figures of Sioux warriors as well as their ruthless tormentor, General Phil Sheridan. It was not the historical meaning of the cause that mattered for Borglum so much as the masculine vigor with which it was prosecuted.

America's real enemies were small-minded commerce and big-bellied corporations. "Because the acquisition of money amounts to madness," he declared, "civilization has failed."[9] And the more Borglum saw of the century of the common man, the less he liked it. Instead he clung to a vision of redeeming heroes and roughriders: Nietzsches in Stetsons. He campaigned for Teddy Roosevelt, befriended the Wright Brothers, admired William Randolph Hearst, and extolled Benito Mussolini as the sort of man who could really shake up the presidency.[10]

But there was another all-American bona fide genius who surely gave Borglum his lifelong exhilaration for masculine magnitude: D. W. Griffith. That Borglum was besotted with the movies there is no doubt. He would later explain that the design of the hundred-foot-long Hall of Records, with its vast ceilings, polished granite floors, and twenty-foot-high doorway inset with lapis lazuli and gold mosaic, was drawn from the Griffith-like Hollywood epic of Henry Rider Haggard's *She*. But the portentous scale of the hall also surely owed much to the colossal Babylonian fantasy-palaces of Griffith's epic *Intolerance*. And there was an earlier, more sinister connection between the horseplay of the sculptor and the director. Griffith's *annus mirabilis,* 1915, when *The Birth of a Nation,* his racist romance of the Ku Klux Klan, appeared, saw Borglum working at Stone Mountain. And there was an attempt to persuade the distributors of the movie to donate funds from matinee performances to the monument. But the mountain outside Atlanta was also the site of the ceremonial reinauguration of the

modern Klan where on Thanksgiving night that same year, "bathed in the sacred glow of the fiery cross," the Invisible Empire was reborn. Borglum's patron, Helen C. Plane, a formidable octogenarian Confederate widow and the president of the United Daughters of the Confederacy, actually asked him to include mounted Klansmen in the relief sculpture since, as she put it, "they had saved us from Negro domination and carpetbagger rule" (the great themes of Griffith's film).[11] And though he balked at this suggestion, he was prepared to incorporate an "altar" to the Klan into his plan for the monument.

By the time he began active work on Mount Rushmore, Borglum had himself become a member of the Klan and was friendly with members of its inner "Kloncilium," including the Grand Dragon of the Northern Realm, D. C. Stephenson, to whom he wrote bilious letters complaining both of the mongrelization of America and the political feebleness of the Klan's leadership. His ardent hope was that, sooner or later, there would be a Knight of the Klan in the White House. Enfolded in the cult of racially pure horsemen-heroes, Borglum railed against all the enemies of True America, the little ant-people, beetles, and parasites who were feeding off the marrow of America: Jews, banks, stockbrokers; miscegenation; and Jews again. Though he wrote a whole paper on "the Jewish Question," his most poisonous tirades were kept carefully away from the official and private sponsors of "the National Shrine to Democracy." But if Rose Powell was engaged in a lost cause, the Jewish community leaders who asked Borglum to carve scenes from Jewish history on the Hudson River Palisades could hardly have dreamed how incongruous their suit was. And although, in the end, Borglum's patriotism got the better of his racial obsessions—enough, at any rate, for him to attack Hitler—his own architectural gigantism was close to that of Albert Speer.

The peculiar thing was that although Borglum had the temper and prejudices of a naive fascist, he sincerely supposed himself to be a democrat. So that when he ranted in language that could have been taken directly from the favorite speeches of Mussolini or Hitler that "we are at the spearhead of a mighty world movement—an awakened force in rebellion against the worn and useless thought of yesterday," he then went on to add that "we are reaching deep into the soul of mankind and through *democracy* building better than has ever been built before."

Perhaps the democracy in Borglum's nationalist democracy was no more coherent than the socialism in National Socialism. It never seems to have occurred to him that democracy was more valuably represented in the drab, often picayune wranglings of Congress than in four granite colossi carved from the side of a mountain. Indeed one of his favorite indicators of the heroic *magnitude* of his work (and the incapacity of humdrum politicians to appreciate it) was that his head of George Washington *alone* could fit over the entire dome of the Capitol. For Borglum, bigness was bigger than just big: it was endurance,

magnificence, the spiritual awesomeness without which Angkor Wat and the heads of Easter Island would have barely merited notice. The ideological grandeur of America demanded something on the same scale as "the thick volumes of American writers," the "vast ranches of the West."[12]

His passion for magnitude was necessarily mountainous, continental in scale. Urban culture, he felt in his bones, was (skyscrapers honorably exempted) puny, pallid, enervated. No wonder its art was raving, a degenerate celebration of deformity. America had been created to escape the metropolitan sickliness that had infected the Old World. So its greatest and truest monument had to be sited in the western heartland of the great continent, high in the cleansing skies, hewn from its heroic geology. To date, all the memorials to great Americans had betrayed America's singularity by being obsequiously derivative. What was the Washington Monument except "another Egyptian obelisk"; the Lincoln and Jefferson memorials, Greco-Roman pseudo-temples? Only in the Black Hills, on the very spine of the continent, could something be built that would celebrate America's true essence: its territorial expansiveness.

A letter to Eleanor Roosevelt in 1936, when Borglum was being pressed by the congressional sponsors of the Anthony Bill, revealed that his reasons for choosing the four presidents were not as self-evident as might be supposed. Jefferson, for example, was included less for his authorship of the Declaration of Independence, or his reaffirmation of a decentralized democratic republicanism, than for "his taking the first step towards continental expansion" with the Louisiana Purchase. South Dakota was a perfect site for such a statement, Borglum explained, because it was at the center of the territories acquired in the Purchase and because the original French "tablet" claiming the western lands, had been "discovered" near the old fort Pierre.[13] And Jefferson's head had been turned to face due west, in the direction he sent Lewis and Clark, for the same reason. Lincoln was there for the more obvious reason of the "preservation of the Union." But Teddy Roosevelt's price of admission was his success in "breaking the political lobby that had blocked for half a century every effort to cut the Isthmus." The Panama Canal, he declared, "accomplished the purpose of Columbus's entrance into the western hemisphere."[14]

Of the nine dates Borglum wanted inscribed on a giant "entablature," no fewer than *seven* concerned the acquisition of territory. Preferring 1867, the date of the purchase of Alaska, to any reference to the Civil War might have struck a modern visitor as quixotic, had the entablature actually been realized. But to Borglum, as the inscription would make clear, these dates constituted "The History of the United States of America." Only from the heights, he believed, could this essential, imperial truth be properly appreciated. To grasp magnitude required altitude.

The reference to Columbus, the man "who did more for mankind than any man since Christ," was less bizarre than it seems. One of Borglum's earliest and

most enthusiastic patrons was Jessie Benton Frémont, the widow of the moun-
taineer-explorer John Charles Frémont, who had set the Stars and Stripes on
the summit of the Continental Divide. For Borglum, Frémont was the ideal
type of American hero, and, as Albert Boime points out, it is inconceivable that
he did not know of the proposal for a colossal statue of Columbus made by
Jessie's father, Senator Thomas Hart Benton, in 1849. The figure was to over-
look the great transcontinental highway that would unite America and would
be "hewn from a granite mass or a peak of the Rocky Mountains . . . pointing
with outstretched arm to the western horizon and saying to the flying passen-
gers—'There is the East; there is India.' "[15] The face in the rock was thus fur-
ther exalted from a continental to a global significance: the world, east and
west, tied together at the knot of the great cordillera. (As of this writing, a

colossal three-hundred-foot
statue of Columbus, frater-
nally sculpted by a Russian,
from the *other* landmass
empire, Zurab K. Tsereteli,
languishes in a Fort Lauder-
dale warehouse while the citi-
zens of Columbus, Ohio,
decide whether they can
afford something so titanically
incorrect.)[16]

To make over a mountain
into the form of a human head
is, perhaps, the ultimate colo-
nization of nature by culture,
the alteration of landscape to
manscape. Raw topographical
scale, after all, seems to
declare the littleness of man in
nature. But this is to reckon

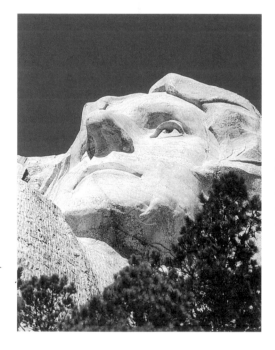

Gutzon
Borglum,
head of
Thomas
Jefferson,
Mount
Rushmore.

without what was inside those heads: the force of ingenuity and will. The exer-
cise of those human qualities, so the mountain-masters believed, might cor-
rect for scale, and the temerity of the peaks be transformed into a compliment
to the mountainous supremacy of man. Of all landscapes, then, mountain alti-
tudes were fated to provide a rule against which *men* (for this was a distinc-
tively masculine obsession) would measure the stature of humanity, the reach
of empire. Sir Francis Younghusband, the British imperial conqueror of Tibet
and the chairman of the Everest Committee that sponsored the great expedi-
tions of the 1920s, put the matter in terms Borglum would undoubtedly have
endorsed:

Both man and mountain have emerged from the same original Earth and therefore have something in common between them. But the mountain is the lower in the scale of being, however massive and impressive in outward appearance. And man, the punier in appearance but the greater in reality, has that within him which will not let him rest until he has planted his foot on the topmost summit of the highest embodiment of the lower. He will not be daunted by bulk.[17]

Mountain carving, of course, went one better than mountain climbing, for it proclaimed, in the most emphatic rhetoric imaginable, the supremacy of humanity, its uncontested possession of nature. But it was not given to all cultures to accomplish such feats. For Gutzon Borglum, only in the New World empire of America—the most heroic, the most *masculine* since the Greeks'—could such a thing be imagined, let alone executed. And that it had been left to white American manhood to realize this ancient Columbian vision of girdling the earth was of a piece with Borglum's theory of imperial succession. This, too, he borrowed from one of the craziest and most influential of all the scriptures of American Manifest Destiny: Colonel William Gilpin's *Mission of the North American People,* first published in 1860 and reprinted many times thereafter.[18] Gilpin, a peculiar hybrid of the wild-eyed prophet and the hard-boiled engineer, had a favorite crackpot theory that located all serious civilizations along a single global belt aligned about the fortieth degree of latitude, north of the Equator. But earlier forty-degree powers like Britain and France had now atrophied beyond hope of revival and had been succeeded by a New World empire, secured through the "immortal railroad." This was even better than Benton's transcontinental highway, for as it rushed invincibly along the fortieth, binding vast territories to its iron tracks, the moribund "pigmy" empires of the Old World would be forced to acknowledge their geographical (which was to say, historical) insignificance. They would be replaced by the vast new American Empire, watered by the great rivers that rose in the sheltering mountain chains, east and west, Appalachians and Rockies. And since this impregnable America was now realigned along the Rockies, Gilpin, who had been governor of the Colorado Territory, could make the confident prediction that a great metropolis would arise, to dwarf New York or Philadelphia, at the precise geopolitical center of the continent. The future, without question, belonged to Denver.

Half a century later, beleaguered by money fights over Stone Mountain, Borglum was brooding about an escape to some primordially free place:

somewhere in America, in or near the Rockies, backbone of the continent, removed from succeeding, selfish, coveting civilizations and out of the path of greed, an acre or two of stone should bear witness,

carrying likenesses, a few precious words pressed together, an appraisal of our civilization, telling of the things we tried to do, cut so high, near the stars, it wouldn't pay to pull them down for lesser purposes.[19]

Such a place suddenly came to mind when Doane Robinson, the state historian of South Dakota, wrote to Borglum suggesting some sort of carving, perhaps of Lewis and Clark, on the needles of the Black Hills. Both men had an emotional investment in the vision—Borglum because he had first seen the Hills on his second honeymoon; Robinson because his notion had been voted, then repudiated a week later, by a South Dakota women's club.[20] When, in the company of Robinson and his own twelve-year-old son, Lincoln, Borglum saw the cliff of Mount Rushmore, he experienced an immediate rush of exhilaration, as though he had identified a celestial platform from which America's Manifest Destiny could be surveyed.

And since it had fallen to America to realize the god-like potential of humanity, it was entirely fitting to perpetuate the likenesses of its greatest men on an Olympian scale. Of course Borglum knew full well that the mountains he had chosen for this triumphalist act were also the site of the bloody dispossession of the Sioux to whom they had been granted in perpetuity by formal treaty in 1868. While Borglum was growing up in his unhappy Mormon household in St. Louis, George Custer had set off the gold rush that violated the integrity of the Black Hills Reservation. Defeat at the Little Big Horn had only postponed the inevitable eviction to which the genocidal slaughter at Wounded Knee in 1890 was but a tragic coda. Not that Borglum's hearty racism encompassed the Indians. On the contrary, he allowed them the kind of native dignity he denied the incorrigibly inferior races—Jews, Asians, Negroes. And when he discovered that the Lakota at the Pine Ridge Reservation were in terrible distress during the worst years of the Depression, he went out of his way to have federal and state agencies provide them with blankets and adequate provisions to see them through the bitter winter.

Playing the Great White Father, and dressing up in a feathered war bonnet as honorary chief Stone Eagle, did not, however, mean that Borglum paid much attention to Indian protests at the desecration of what, for them, was a sacred place. Talk of Great Spirits was so much childish superstition, exactly the kind of foolishness that was being properly swept aside by the onward rush of American technology. If the Great Spirit was bothered by his pneumatic jackhammers, let him do something about it. It was all very simple, really. If you couldn't see it, feel it, touch it, it wasn't there.

But to a Lakota shaman, of course, invisibility was the sign of presence, not absence. And for that matter there *was* something to be seen: the mountain itself, in which the Great Spirit, Wakonda, was indistinguishably embedded with the rock and the scree. To feel its presence and that of all the ancestors

buried in such a place required only a kind of respectful annihilation of the human self. Which is why Indian campaigns, from the 1930s onward, to have the face of Crazy Horse or Sitting Bull inscribed on Rushmore or another mountain in the Black Hills (even had they not been brushed aside) have been tragically self-defeating. Emulating the white obsession with visible possession, with self-inscription, with cutting the mountain heights to the scale of the human head, would, in the most poignant way imaginable, be to accept the terms of the conqueror. It would be as if Sioux religion were merely a dumb echo of the anthropocentric fixation suggested by Frank Lloyd Wright's reported remark that the heads on Rushmore made it look as though the mountain had responded to human prayer.[21]

ii Dinocrates and the Shaman

One of the best of Gutzon Borglum's sculptures was his early *Mares of Diomedes,* representing the horses, fed on human flesh, whom Hercules tamed after slaying their owner. And for Borglum, it went without saying, America was either heroic or it was nothing. He had begun as a painter, but one of the irresistible attractions of sculpture had always been its muscular physicality. "A man should do everything," he declared, "boxing, fencing, horseback-riding . . . turn handsprings."[22] And what could be more truly Herculean, after all, than mountain-carving? No dedication ceremony was complete without a carefully staged and lit performance of the Sculptor-as-Stunt-Man, dangling from the rock-wall in his harness, as alarming to behold as any circus trapeze act, but, because of the strength and technical ingenuity of the device, perfectly safe. Whenever a grandee appeared at the monument—Calvin Coolidge, Franklin Roosevelt, or, in 1939, the cowboy movie star William S. Hart—Borglum made sure that he would be photographed by his side. (Though when Hart was so presumptuous as to use the occasion to make a public appeal for justice to the Lakota Sioux, he found that his microphone had suddenly died.)[23]

So tireless was Borglum's self-promotion that it is not too much to suggest that, somewhere in his mind, there was always meant to be a fifth head up there on the mountain. And it was not Susan B. Anthony's but his own. He probably would not have been embarrassed by the hierarchy of importance suggested

in the funeral eulogy spoken by the poet laureate of South Dakota, one Badger Clark:

> He did not die, this artist, engineer and dreamer. He will live longer than the monument he created. Coming generations, five thousand years hence, will not ask who the characters on the mountain are, but who carved them?[24]

Gutzon Borglum, *Mares of Diomedes*, bronze, ca. 1906.

In his heroic solitude, Borglum sometimes compared himself not just to his heads, but to the granite wall of Rushmore, isolated from the range, indomitably separate. For he too had towered over the tribes of the small-minded: the pettifogging bureaucrats; fastidious Park Service men; intriguing politicians; the arbiters of modern taste in their carpeted galleries who sneered at his honest classicism; the government cutpurses; the milquetoast patrons, scared off by a poor quarter's profits. He had stared them all down and exploded their doubts off the cliff face. And when he considered it *historically* (as he often did), it had not been the pneumatic "bumpers" shaving off granite to his design that had powered the creation of the heads. It had been the sheer scale of his Great Idea.

In 1934 an astute cartoonist for the *Washington Herald* shrewdly exposed Borglum's secret obsession that he was himself a kind of man-mountain, by creating a portrait that was all slopes and overhangs, crowned by an unmistakably geological dome. That this seemed barely a caricature at all was borne out by

the caption, evidently a report on Borglum's own promotional pitch, comparing himself to Michelangelo and to Alexander the Great, who "wanted to convert the Olympian mountains into sculpture."[25]

It was typical of Borglum that he both knew of his most important ancestor in mountain carving, and that he carelessly garbled the source. For it was not Alexander who set the precedent, but Dinocrates.

THE SCULPTOR OF MOUNT RUSHMORE

GUTZON BORGLUM, WHO HAS BEEN IN WASHINGTON PERFECTING PLANS FOR THE MOUNT RUSHMORE COMMITTEE, SAYS OF THE MEMORIAL :——

"ALEXANDER THE GREAT WANTED TO CONVERT THE OLYMPIAN MOUNTAINS INTO SCULPTURE —— MICHAEL ANGELO WISHED TO CARVE COLOSSAL FIGURES ON CARRARA MOUNTAINS — AMERICA ALONE IS ACHIEVING IN A NATIONAL MEMORIAL THE DREAMS OF THESE GREAT MEN."

Malone—Washington '34

Caricature of Borglum, *Washington Herald*, March 19, 1934.

Had he got the story right, Borglum would surely have acknowledged his Macedonian predecessor. For the legend of Dinocrates is also a story of a Big Thinker, fighting his way past officious underlings to fire the imagination of his patron. In the preface to book 2 of his *De architectura* the Roman Vitruvius, writing in the reign of Augustus, offers the story as part inspiration, part caution. But from his first words, "Dinocrates architectus cogitationibus et sollertia fretus," we can recognize already the portrait of the archetypal young architect, "confident in his ideas and his skill," setting out to imprint his daring on the imagination of the powerful, in this case Alexander the Great, "master of the world."[26] Armed with commendations from his native Macedonia, he arrives at Alexander's camp meaning to make an impression: native son with grand ideas. And perhaps his sunny optimism melts the reserve of the courtiers and counsellors, for they receive him with politeness, even with cordiality, reading the letters from the uncles, inquiring about his home, his work, his family. The king would surely see him just as soon as the right moment offered itself for an introduction. It would not do, of course, to press himself on the lord Alexander, not with his temper. No, as soon as the occasion was right, he would most assuredly be brought forward.

But the time never seemed to be perfectly ripe, and architects, especially young architects, seldom count patience among their many virtues. All those cups of wine and smiles, Dinocrates realized, were designed to unman his will. Very well, then, he would display it.

First he took off his clothes, all of them, revealing his "ample stature, pleasing countenance and the highest grace and dignity." Then he oiled his body, top to toe, rubbing the grease well in so that his muscles shone in the sunlight. He set a wreath of poplar on the crown of his head and slung a lion's skin over his left shoulder. A great club completed the transformation from hometown boy into, of course, Hercules.

Even Borglum would have envied the brazenness of the self-promotion. And, needless to say, it worked. In his Herculean fancy dress Dinocrates simply made himself visible "opposite the tribunal where the king was giving judgement," and was called over to account for himself. He wasted no time in proposing a project of Herculean presumption, an idea "worthy of you, illustrious prince." The plan was to carve Mount Athos, all of it, "into the figure of a statue of a man," the implication, moreover, being not any man but the king himself. Nor would this be merely the Hellenic Rushmore but an entire habitat. In the left hand Dinocrates sketched the ramparts of "a very extensive city"; in the right, "a bowl to receive the water of all the rivers which are in that mountain."

Though he was much taken with the sheer audacity of the project, Alexander was not so disarmed as to overlook its weaknesses. Was there, for example, an adequate supply of corn to feed such a city? Not as such, the terrain being, well, mountainous, responded Dinocrates, on the defensive for the first time. But food could of course be shipped in. The king, charmingly confirmed in his wisdom, then allows himself a little homily. The young man is congratulated for his originality and chastened for his woolly logistics, "for if anyone leads a colony to that place his judgement will be blamed. For just as when a child is born, if it lacks the nurse's milk it cannot be fed, nor led up the staircase of growing life, so a city without cornfields and their produce abounding within its ramparts, cannot grow or become populous."[27]

Given an alpha for imagination and a gamma for experience, Dinocrates is nonetheless hired. The mountain-man-city remains a brilliant fantasy, and Dinocrates goes off on his next assignment: the survey and design of Alexandria.[28]

As a parable of the temptations of hubris in architectural psychology, it would be hard to improve on the myth of Dinocrates. Resisting censoriousness, Vitruvius acknowledges the egotism in the vocation, the role that "dignity of body" may play in advancing a career. As for himself, he concedes wistfully that "nature has not given me stature, my countenance is deformed by age, and ill health has sapped my virility."[29] All that he could offer, he adds with disingenuous humility, is science and his writings. See the next eight books.

And running through the next eight books is Vitruvius's great theme of proportionality, not least in the underlying harmonies that informed the structure of both architecture and the human body. It was Dinocrates's manifest offense against that fundamental principle, as much as his jejune indifference to economy, that marked him as the first of architecture's callow Prometheans. To demon-

Pietro da Cortona, *Pope Alexander VII Shown Mt. Athos by Dinocrates,* ca. 1655.

strate his heroic contempt for difficulty, Dinocrates had taken the most inaccessible of all landscapes, the mountainous abode of gods, and had subjected it, simultaneously, to the use and the likeness of Sovereign Man. It is hard to conceive, until Mount Rushmore, of a more drastic correction of natural scale, nor a more categorical statement of nature made admirable by being made human.

Though the story of Dinocrates was believed by some later commentators, not least Goethe, to be historically plausible, it functioned principally as a mythical touchstone for architectural theorists like Alberti, exercised about the relationships between balance and hubris, between conceptual daring and structural practicality.[30] A commentator such as Buonaccorso Ghiberti was so embarrassed by the legend that he had Dinocrates (altogether against the grain of Vitruvius's Hercules) withdraw the whole idea after second thoughts, offering elaborate explanations of its impracticability. But as much as these generations of writers invoked Dinocrates as a negative model, the fantasy of a mountain colossus haunted the dreams of the superegotistical. Ascanio Condivi's life of Michelangelo, for example, relates that the most prodigious of all sculptor-architects wanted to carve a colossus into the towering marble cliffs of Carrara. But Michelangelo was no Borglum of the Renaissance, and marginalia that seem to be in his hand ruefully confess the ambition to be "a crazy idea that came to me because I was young." Yet, says the artist, reverting to the realm of the impossible desire, "had I been sure of living four times as long I would [still] have embarked on it."[31]

The vulgarity of the vision did not prevent artists shamelessly invoking Mount Athos to flatter the egotism of their patrons. Pietro da Cortona, for example, depicted himself genuflecting before Pope Alexander VII in the company of Dinocrates (represented here as a mature professional rather than as a brash youth). The new pope's vanity was meant to be tickled by the implication that his choice of name was a worthy echo of the Alexander of antiquity, especially since he had ambitions to be the very greatest of Baroque Rome's builders and renovators.

The Dinocratic vision seemed to surface whenever a new generation of architects or sculptors imagined their buildings as a metaphorical vision of the reordering of states and societies. Thus the most prolific and learned of all Baroque architects of the second generation, Johann Bernard Fischer von Erlach, included in his *Sketch of Historical Architecture* (1721) a spectacular engraving of the Mount Athos city-colossus, as it might have been actually constructed.[32] And in 1796 Pierre-Henri de Valenciennes painted a tranquil arcadia overlooked by the Alexandrian mountain (color illus. 34). A group of figures in the foreground observe the mountain-king who stares calmly back from the summit. The painting is a benevolent reworking of Poussin's *Polyphemus,* whose Cyclopean eye is hidden by the rear view of the geological giant, and had first been tried out by Valenciennes in a chalk drawing done during his obligatory trip to Italy almost twenty years before.[33] The painting was shown at the salon of the Republican Year VIII, when enthusiasms were running high

J. B. Fischer von Erlach, engraving, "The Mount Athos Colossus," from *Sketch of Historical Architecture,* 1721.

for both Hellenic "purity" and the cult of nature. Shrewdly marrying the two together, Valenciennes produced the perfect icon of benevolent republican sovereignty, where the impossibly exquisite landscape, verdant and gently watered, is shown directly dependent on the mountainous authority of the paternal state.

For all the richness of the Dinocratic tradition, no mountain colossi had actually been carved in the West (giving Borglum an eagerly seized opportunity to claim he had surpassed the ancients). Fischer von Erlach reported, as though it were common knowledge, that Semiramis, the empress of the Medes, had carved Mount "Bagistane" in her likeness. And though there were vague

Athanasius Kircher, "The Mountain-God of Tuenchuen," from *Sina Illustrata.*

reports of Egyptian colossi, carved
from sandstone, somewhere in
Upper Egypt, the great colossi of
Abu Simbel were not discovered
until 1813. Predictably, though, it
was the ubiquitous Athanasius
Kircher who, in his *Sina Illustrata*,
reported his Jesuit colleague
Father Martini as having seen the
"mountain-god" of "Tuenchuen."
Whether this was a naturally
anthropomorphic mountain or a
figure actually carved in the rock
the Jesuits were not sure.

Rock face
Buddha,
Ling Ying Su,
Fukien Province.

What Father Martini probably
saw was one of the many Buddhas
carved into the hillsides of the
southern province of Fukien by
Sung dynasty monks sometime
during the ninth century A.D. If
they resembled the few survivors at Ling Ying Su, they represented the Buddha
in the pose of sublime meditation during which he sought illumination through
resisting the temptations of the world. In which case the image on the rock face
was meant to evoke a sense of natural *dis*embodiment rather than the reverse.[34]

*Dreaming of
Immortality in
the Mountains*,
tenth century.

The older Taoist tradition was even more hostile to the idea of mountains as a site of human triumph and possession. The five sacred mountains of ancient China were features of a vision of the world that was, in its essence, spiritual rather than physical. Taoist teaching emphasized the pure vacuum from which the material world had been created and toward which its adepts always had to concentrate their meditations. "A thing confusedly formed, born before heaven and earth, silent and void," as the *Tao-te Ching* has it.[35] The high sacred mountains, then, were places from which to survey not the panorama of the earth, but the mysterious immaterial essence of its spirit. Four were located at each corner of the universe, with a fifth at its center, and together they were axial pillars connecting the celestial with the terrestrial and infernal realms. Each newly established dynast was required to make a pilgrimage to all five (or at the very least the eastern Mount Tai) to receive the heavenly mandate. As the "Lower Capital" of the Heavenly Sovereign, the August Personage of Jade, ruled by his deputy, the Queen Mother, the western mountain "K'un Lun," perhaps because it was the most remote from the capitals of classical China, was thought to be the most celestially connected of all.

The peaks were also the abode of the Immortals, persons who, while not fully divine, had added some centuries to their existence through diligent pursuit of the way of Tao. Such was their success at transcendence, in dissolving themselves into the vital breath of *ch'i*, that they could materialize on the backs of storks or, as in one spectacular Taoist mountain painting, travel through the thin, vaporous air.

Needless to say, such a realm was patrolled by fierce monsters assuming the form of dragons or tigers, against the trespass of presumptuous, earthly mortals. Only the true adepts of Tao, solitary shamans, could climb or descend the

Han dynasty mountain-form censer.

Single standing rock, Yua Hua Yuan.

peaks, and then only in the mystical trance that came from exercises of ascetic self-abnegation. On the mountains themselves, they perched on rock-ledge hermitages where they gathered the mushrooms and secret herbs that constituted the potent elixirs of immortality.

It was possible, of course, for the earthbound to represent such places and, by so doing, receive some of their spiritual benefits, even if they were unable to ascend to them. In solid form, during the Han dynasty from the third century B.C. to the third century A.D., the sacred mountains took the form of incense burners, their peaks stylized into the writhing, heaped, and layered forms that suggested the dynamic, erupting spirit within them, rather than so many slabs of inert stone. Or they might be introduced in gardens in miniature form as fantastic, columnar rocks. In both cases what was sought was the compressed essence of mountain sacredness, comparable to the herb-and-fungus reductions from which elixirs of immortality were concocted by the shaman.[36]

When the sacred mountains were drawn or painted, the cosmic relationship between the massively piled celestial pillars and the minute humans, perched on a ledge, was made unequivocally clear. Even the act of painting itself was thought of as a Taoist exercise, imitating an arduous ascent. The late Han artist Gu Kaizhi, for example, left an instruction on "how to paint Mount Yun-tai" in Szechuan, the place where the master Zhang Ling took his pupils to test their faith. To convey the impression of "a great vital energy concentrated into a mass and perpetually ascending," the peak, wrote Gu, had to be painted, bottom to top, the master and novices seated on the westward, "watered" (and thus living) face of the mountain, with the cliffs writhing upward like the coils of a tremendous dragon.

Even allowing for the millennium and a half that separated them in time, there seems to be an unbridgeable distance between the mountain sensibilities of a Tao master like Zhang Ling and a Dinocratic egotist like Gutzon Borglum.

Fan K'uan,
*Scholar Pavilion
in the Cloudy
Mountains,*
early eleventh
century.

While the shaman concentrated on dematerializing his bodily substance into the receiving rock, the Herculean sculptor banged at it with his jackhammer to effect the likeness of Teddy Roosevelt's whiskers. So it's tempting to construct a simple dialectic in the cultural history of the mountain: occidental and oriental, imperial and mystical, Dinocratic and shamanic. Even with the obvious acknowledgement that the Judaic, Christian, and Muslim traditions are full of mountain epiphanies and transfigurations—on Horeb, Ararat, Moriah, Sinai,

The Adoration of the Shepherds, illuminated manuscript, School of Reichenau, eleventh century.

Pisgah, Gilboa, Gibeon, Tabor, Carmel, Calvary, Golgotha, Zion—the earliest medieval representations of such events are in the starkest possible contrast to their Taoist or Buddhist equivalents. Where the Chinese paintings minimize the human presence, investing the mountains themselves with vast, omnipotent vitality, the Ravenna mosaics or manuscript illuminations show hulking great

patriarchs and saviors bestriding absurdly shrunken peaks, little more, as Ulrich Christoffel has suggested, than gathered heaps of pinecones.[37]

But, of course, nothing is quite this tidy. While the Chinese spiritual tradition represented mountains as staircases to the celestial, or crumbly aerial platforms on which to concentrate on the dissolution of the bodily self, some emperors were not beyond turning entire cliff faces into calligraphic sheets on which their greatness might be inscribed for posterity. And conversely, there was a strong strain of ascetic world denial in the Christian retreat to the mountaintops. Instead of being a place that would testify to the loftiness of human ambition, to the devout a holy mount might still be a place of terror and awe, the trial chamber of the spirit.

iii Elevations

Nothing illustrated the difference between Eastern and Western attitudes to the high mountains more clearly than their respective feeling toward dragons. For, to be sure, there *were* dragons up there in the European cliff-caves. But while Chinese tradition venerated the creatures as lords of the sky, guardians of esoteric, celestial wisdom, Christianity deemed them winged serpents, and as such, the embodiment of satanic evil. On the rock-ledge they were the demonic opposition for holy cave-dwellers, anchorites, and hermits. To slay such an abomination was to exorcise the mountain for the Lord. According to the friar Salimbene, King Pedro III of Aragon, "a valiant knight of stout heart," in the year 1280 was moved to try to climb the Pic Canigou, nine thousand feet high, on the frontier of his realm with Provence. "No man ever lived, nor did any son of man dare to scale it, on account of its excessive height and the toil and difficulty of the journey."[38] Some way up the ascent, "horrible thunder-claps" were heard, together with hail and lightning, the effect together being so unnerving that Pedro and his knights "threw themselves on the ground and lay there, as it were, lifeless in their fear and apprehension of the calamities that had overtaken them." Rallied by the king, the knights were eventually so fatigued and discouraged that they turned back.

> So Pedro with great labor made the ascent alone and when he was on
> top of the mountain he found a lake there; and when he threw a stone

into the lake a horrible dragon of enormous size came out of it and began to fly about in the air and to darken the air with its breath.[39]

The king's achievement in braving (though not slaying) the monster and getting back safely to the foot of the mountain was so extraordinary, thought the friar, that it could only be compared to the feats of Alexander.

A winningly naive tale of Christian knightly zeal, straight from the repertoire of the Spanish *reconquista,* where chivalry had a long afterlife, Pedro's fleeting but memorable encounter with the dragon of Pic Canigou has an inadvertent eloquence. The truth was that, even by thirteenth-century standards, the mountain was not an especially daunting climb. But as a satanic serpent, the dragon obligingly supplied the ambitious king with certification as an authentic Christian warrior. On Chinese sacred mountains the battles are mostly fought between the internal contentions of flesh and spirit. On the needles of Europe, the forces of good and evil are externalized into holy men and monsters and the battles are in deadly earnest. This had been the way of it, ever since the first diabolical temptation, recorded in St. Matthew 4.8, where Jesus is taken by Satan "to an exceeding high mountain" and is shown "all the kingdoms of the world, and the glory of them."

As a sign of their diabolical contamination, mountain ranges like the Alps were thought to be densely infested with dragons. As late as 1702 Johann Jacob Scheuchzer, a professor of physics and mathematics at Zurich University and a correspondent of Isaac Newton, collected evidence of dragon sightings, canton by canton, into a comprehensive dracology. There were cat-faced dragons, and serpentine dragons, inflammable dragons and noncombustible dragons. There were fliers and slitherers; malodorous dragons and cacophonic dragons; scaled and feathered; bat-like and bird-like; crested and bald; fork-tailed and fork-tongued. There were even relatively friendly dragons like the dragon of the Val Ferret who sported a diamond-encrusted tail and the *ouibra* of the Valais who lived in a crevass guarding the liquid gold in its depths. A peasant whose cupidity had got the better of him and who had fallen into the lair swore that he had lived there perfectly well for seven years, though he had never managed to retrieve the gold!

As for Mons Pilatus, near Lucerne, with a name like that a resident dragon was only to be expected. (Though in fact the mountain was originally called, simply, Mons *Pileatus,* referring to the capped peak for the clouds that continually draped its summit. Only later did it somehow turn into the burial site of Pontius Pilate.) But once the execrated Roman was thought to be entombed under its rock, he generated a dragon of distinctive repulsiveness, whose presence was formally attested to, in 1649, by no less an authority than the sheriff of Lucerne. Its head "terminated in the serrated jaw of a serpent," and "when flying it threw out sparks like a red-hot horseshoe, hammered by the black-

"Cat-Faced Dragon," from J. J. Scheuchzer, *Itinera per Helvetiae Alpines,* 1702-11.

smith."[40] Scheuchzer had no hesitation in giving the story credence, seeing as how the local cabinet of curiosities at Lucerne contained a "dragon-stone" said to cure all manner of maladies from headaches to dysentery. The specimen had been conveniently dropped by the local dragon en route from Rigi to Mons Pilatus, which was just as well since Scheuchzer counselled that the most reliable way to secure these panacea was to cut them from the living head of a sleeping dragon, taking the precaution, of course, to strew soporific herbs about his nest. What better abode for a dragon than the mountain lake where Pilate himself lay many fathoms deep, surfacing only on Good Friday, clad in the blood-red robes of his judgement?[41]

So while an ascent, in the Taoist tradition, pointed the way toward celestial transcendence, in the Christian West, it was as likely to bring the doughty climber into the presence of evil as of good. This did not mean, however, that the pious shunned the high places of the world. Many local images of St. Bernard on Mont Joux showed the saint standing on the body of a dragon: the symbol of a successful exorcism. And even without this Manichean element of

"Dragon of Mons Pilatus," from J. J. Scheuchzer, *Itinera per Helvetiae Alpines,* 1702-11.

a high-altitude combat, the mountain traditions of epiphany were so strong that from the very beginnings of Christianity anchorites and holy men sought out remote desert hilltops and mountains as their favored site of self-purification. When the most austere of the Benedictines sought remoteness to seal themselves off from the fleshpots of the world, they established monasteries like Montserrat in the Pyrenees or the Grande Chartreuse on Mont Cenis, behind bastions of inaccessible mountain rocks. And as the tempo of pilgrimage and trade picked up in the High Middle Ages, those same places became famous as hostelries that would shelter the anxious traveller from dragons and brigands and the countless other terrors that lurked in the crags.

Following the First Crusade, it became possible to construct an entire pilgrimage of peaks, hopping from holy mount to holy mount. The adventurous Fulcher of Chartres, in the army of Baldwin of Flanders, went all the way south to the Wadi Musa to see Mount Horeb, where Moses struck the rock for water, and at Petra visited another "Moses monastery" on Mount Hor.[42] The Russian abbot Daniel, inexhaustible in the desert, witnessed the miraculous preservation of Saints Euthymius, Aphroditian, Theodore of Edessa, and John Damascene, all embalmed in mountain tombs and giving off the delectable perfume of perpetual sanctity.[43] Deeper into the wilderness were the cave-cells of St. Sabas, chiselled into the vertical cliff and, as Daniel wrote, "attached to the rocks by God like stars in the sky," and the mountain that miraculously opened to shelter St. Elizabeth and the child John from the wrath of Herod.

While most pilgrims sensibly stayed within the confines of Crusader Palestine, the twelfth-century writer of a geographical *Descriptio* provided elaborate information for the seriously intrepid zealot who was prepared to slog the eighteen-day journey through the middle of the Sinai peninsula to the monastery of St. Catherine. The short of breath and halt of limb were severely cautioned by the writer of the *Descriptio*.[44] The only way up was via three thousand five hundred steps. And be prepared, he warned, for the presence of angels, habitués of Sinai since the time of Moses, and generally announced by "smoke and flashing of lightning."

> Of Sinai it is stated (and it is true) that each Sabbath a heavenly fire surrounds it but does not burn it, and whoever touches it is not harmed. It appears many times, like white blankets going round the mountain with an easy motion, and sometimes it descends with a terrible sound which can hardly be tolerated and the most holy servants of Christ hide themselves in caves and cells of the monastery [of St. Catherine].[45]

Yet the monks of St. Catherine's seem to have been able to transcend their terror, since the author of the *Descriptio* also suggests a shaman-like ascetic

quality on Mount Sinai. They were, he wrote, "free from the passions of the body ... and only fight for God ... so famous that from the borders of Ethiopia to the furthest bounds of Persia, they are spoken of with respect."[46]

The most famous of all Christian shamans was, of course, the fourth-century saint Jerome, who for a time lived as an anchorite hermit. It was a *liber locorum,* a book of distances between places, attributed to Jerome, that seems to have provided the writer of the *Descriptio* with many of his anecdotes of holy mounts. The most compelling of all concerned the (essentially mythical) "Mount Eden" in the district of Hor, sometimes called the "Mount of Sands."

> It is hard to climb and amazingly high and in natural form like a high tower with the steep part as if it had been cut by hand. The way round it takes more than one day. On the sides of the mountain trees are scarce. Many birds of various kinds fly round the mountain in flocks, but the mountain itself would seem to be without plants or moisture, and is far from any living growth in the desert.[47]

One day two pilgrims decided to climb this wilderness mount. "One of them was nimble and energetic and easily climbed the hidden parts of the mountain but the other hardly managed to come up half way, and there, tired and breathless, sat down." This was his misfortune since, on the peak itself, the first climber beheld an astonishing miracle in the midst of the desert: a place alive with fragrant flowers, gushing fountains, heavily laden fruit trees, and brilliant pebbles spied on the bed of crystalline brooks. "There he decided and promised for himself, should God see fit, the joy of living and dying." Suddenly aware of being alone, he came to the brink of the peak, clapped his hands, and called to his friend, relating the beauty of the place, that it was like eternal spring, a veritable paradise. But the man below, "whether frightened by the difficulty of the mountain or deterred by God's prohibition, refused to ascend and enter." He minded what had been said to him, though, and, when he went down, told everyone what he had seen and heard.

It is the archetypal parable of the Christian holy mount, repeated in images and narratives of ascent all the way through to the High Renaissance, and well beyond that, indeed to the Western infatuation with Shangri-La.[48] The associations with Jerome can hardly be fortuitous, since many of the representations of the desert saint, especially in the fifteenth-century Netherlandish mountain art of Joachim Patinir and Herri met de Bles, feature precisely the kind of bizarre, stalagmite-like rock-towers mentioned in the *Descriptio* as the topography of Mount Eden.[49]

How could the art of the Low Countries produce such high places, and more particularly these grotesquely petrified termite-towers rising straight up from the earth? The printed homilies of Jerome were immensely popular in

the Netherlands in the fifteenth century, appealing especially to those sects of the so-called Devotio Moderna like the Brethren of the Common Life, who sought to revive the spirit of ascetic unworldliness without traditional monastic confinement. So although Jerome's own life had no particular associations with the hermitages of the Holy Land, siting his cell or chapel in the eroded cavities of rock forms, or at the foot of some unearthly standing arch, was a way of identifying him as a sacred exotic, the archetypal wilderness Father, the true inheritor of the righteous solitude of the desert saint John the Baptist.[50]

And then there were the rocks of Dinant. Tucked into a narrow, cliff-girt gorge of the Meuse, the medieval cloth town was the birthplace of Patinir.[51] Dinant is seldom visited by tourists (being too far south for the Flemish paintings tour and too far north for the Ardennes's hikers and bikers), and those who do stumble upon it are treated to a startlingly un-Netherlandish landscape. A little way upstream from the town is a group of strange, freestanding gray limestone outcrops, rising erect from the riverbed as if they had somehow been deposited there from an overflying asteroid. Their marvellous deformities and protuberances were surely the model for Patinir's holy rocks. Yet their significance is less in the care with which they were drawn than in their transformation in the finished paintings from a domestic to an exotic spirituality. For that matter the Chinese painters of the Han and Sung also had available to them extraordinary geological forms on which to model their sacred mountains. But conveying the sense of a cosmic axis, extending from regions deep below the bowels of the earth's crust, through its vegetable surface, and up toward

Joachim Patinir, *Landscape with St. Jerome,* ca. 1515.

the celestial regions of immortals and gods, required much more than literal transcription.

In the same way, the discontinuousness of the Dinant rocks with the conventional scenery of the Netherlands made its blessed unearthliness more powerful. Once the Netherlandish Jeromes made their way to Italy in the late fifteenth century, they were evidently successful enough to have produced local variants, none more fantastic than the painting by Jacopo da Valenza, now in the Museum of Fine Arts in Boston.[52] Technically, the panel is a crudely additive composition, archaic in the stylization of its details of flora, fauna, and figures. But that is precisely its point. Without being at all self-consciously "Gothic," its primitivism recalls exactly the Byzantine icons and early Christian illuminations that equated altitude with beatitude. Yet instead of oversize patriarchs in danger of impaling themselves on pinnacles, Jacopo's column is really a cosmic staircase that, in defiance of topographical reality, becomes more lush and paradisiacal the higher it extends. It is, in fact, very like the "Mount Eden" of the twelfth century *Descriptio,* the fleecy sheep grazing among the fleecy clouds.

And it is also very much like Dante's *Purgatorio.* Having emerged from what the mountaineer-poet Wilfred Noyce winningly described as the "gigantic pot-hole which forms Hell,"[53] Dante has Virgil take him to a mountainous island where daunting cliffs rise sheer from the seashore. The labor of atonement is then characterized as an arduous climb, the angle of ascent often steep enough to require scrambling up the stone face on hands and knees. And in keeping with the tradition of spiritual mountaineering, the going gets easier as it gets higher, until, at the very summit of purgatory, when "I felt the force within my wings growing for the flight," the terrestrial paradise is discovered. Though it is washed by cool brooks and is brilliant with pasture and flowers, this is not, of course, the true *Paradiso,* but merely the place of self-purification that completes the work of heavenly eligibility.[54] There is even a dragon lurking amidst the fountains and trees. But the radiant Beatrice, who has replaced Virgil as the guardian of the poet's soul, leads Dante safely through these final perils, interrogating him constantly on his past transgressions. The top of the hill is revealed as the place where innocence is restored. And it is, at least, a more agreeable waiting room than the "purgatories" of American geology, which are almost always identified as arid ravines, with little maneuverability for the doubtfully penitent.

In the late medieval imagination, then, the high mountain slopes were imagined as a cloud-wreathed borderland between the physical and the spiritual universe. Arbitration was necessarily made in favor of the latter (with the scenery becoming more ravishing the closer one approached lofty disembodiment), partly, at least, because no one did any actual climbing. Once real ascents (rather than anxious journeys through the mountain passes) were attempted, and the "kingdoms of the world" were displayed from the heights,

the conflict between the exhilaration of the body and the repose of the soul became more urgent.

The tension between physical and metaphysical exertion is, for example, at the heart of the most famous of all early climbing narratives: the poet Petrarch's ascent of Mont Ventoux in April 1336.[55] Some scholars continue to speculate whether Petrarch's letter to the Augustinian friar Dionigi di San Sepolcro might not be an elaborate parable of the transcendence of the soul over the body (in the Dantean manner), rather than a report of a real event.[56] The consensus now seems to be that Petrarch did actually clamber up the six thousand feet of the mountain near Carpentras in the Vaucluse. But it is impossible to read his letter without noticing how carefully he has crafted the excursion as a cultural history, for all his artless profession that his "only motive was to see what so great an elevation had to offer."

To begin with, the event was framed between two texts: the Roman historian Livy's *History of Rome* and the *Confessions* of St. Augustine, uphill and downhill, ambition and contrition. Living at Avignon, "cast here by that fate which determines the affairs of men," Petrarch tells us that the mountain was "ever before my eyes." But the spur came with Livy's account of the ascent of Mount Haemus by Philip of Macedon, none other than Alexander the Great's father. King Philip's object was to discover whether from the summit in the Balkans he could see both the Aegean and the Adriatic, and thus be possessed of a royally farsighted vision: omniscience. Drawn to a good squabble, Petrarch is struck by the fact that Livy and the cosmographer Pomponius Mela disagreed as to whether Philip was actually granted this strategic omniscience. The implication is that the issue was unresolvable since the two disputants were unable to see the view for themselves. Though he had no plan to climb Philip's mountain, Petrarch in turn wonders whether from the top of Mont Ventoux he might himself be able to see both the western Mediterranean at the Pyrenean border, and east to the Tyrrhenian Sea and his native Italy.

Even before his climb gets under way, though, the narrative becomes densely allegorical. Like Dante, Petrarch uses the humanist device, also drawn from antiquity, of a set of choices confronting the hero, as a way of commenting on the moral significance of his action. The first decision concerns his choice of companions for the ascent. None of his friends seemed to have "just the right combination of personal qualities: this one was too apathetic, that one over-anxious, this one too slow, that one too hasty; one was too sad, another over-cheerful." In the end, "Would you believe it? I finally turned homeward and proposed the ascent to my only brother."

Leaving the village of Malaucène, the two brothers are intercepted by the obligatory bearer of cautionary tidings, a grizzled shepherd who warns them that fifty years before, he too had attempted the climb and had got only "fatigue, regret, and clothes and body torn by the briars" for his pains. Seeing

Jacopo
da Valenza,
*St. Jerome in
the Wilderness*,
ca. 1509.

they are undeterred, he offers them advice on the route and receives all the objects and clothes which the brothers consider would slow them down. They are, in other words, already casting off their worldly impedimenta.

As they begin their climb, another decision looms directly. Should they take the difficult route straight up the rock face, or the apparently less toilsome way that snakes about the mountain? The younger brother, Gherardo, as befits his energetic and resolute disposition, opts for the harder, swifter path. Petrarch, of course, takes the procrastinators' trail, winding deviously about the mountain, and is duly punished for his evasiveness by having to work twice as hard to catch up with his brother.

> After being frequently misled in this way, I finally sat down in a valley and transferred my winged thoughts from things corporeal to things immaterial, addressing myself as follows: "What thou hast repeatedly experienced today in the ascent of this mountain happens to thee, as to many, in the journey toward the blessed life. But this is not so read-ily perceived by men, since the motions of the body are obvious and external while those of the soul are invisible and hidden. Yes, the life which we call blessed is to be sought for on a high eminence, and strait is the way that leads to it. Many also are the hills that lie between and we must ascend by a glorious stairway from strength to strength."

His burden, he explained to Father Dionigi, was that he had not yet attained the necessary (shaman-like) lightness of being. While those who were pure of soul could leap like a goat to the summit "in a twinkling of the eye," he was weighed down by his clumsy limbs and failing trunk.

Arrived, finally, on top of Mont Ventoux, all thoughts of Philip, Livy, and the rest disappear in the mountain mist. Instead Petrarch is flooded with elated dizzi-ness, the clouds curling beneath his feet. For a moment he thinks of celestial places, of Olympus and great Athos, before turning toward Italy and feeling a double pang of homesickness and lovesickness, the one stirred by the other. To his Augus-tinian friend he now invokes the saint and his *Confessions* for the first time as an exemplar of the high-altitude combat to be fought out between the pure and the impure, body and soul, holy men and dragons. It is ten years, he recalls, since he had left Bologna, but only three since he had managed to renounce his carnal pas-sion. He is, in other words, at the purgatory summit, residually impure, but at some measurable distance from the base of his original transgression.

Petrarch's attention now wanders distractedly between terrestrial and celes-tial things. He picks out the Rhône, flowing south from Lyon toward Marseilles. Then he turns to the Mediterranean coast, toward Catalonia, his body revolv-ing on the windy hilltop, finally facing west into the slowly setting sun. This was not a neutral time of day for a conscience-stricken Christian humanist.

And it is at this precise moment that the real climax of the ascent occurs. Petrarch takes the copy of Augustine's *Confessions* that Father Dionigi had given him and opens it at random, as if he were consulting an oracle. And—*mirabile dictu*—the book falls open at:

> And men go about to wonder at the heights of the mountains and the mighty waves of the sea and the wide sweep of rivers and the circuit of the ocean and the revolution of the stars but themselves they consider not.

Suspiciously apt, the passage nonetheless touches the most acute dilemma for humanists of Petrarch and Dante's generation: the problematic relationship between empirical knowledge and devout introspection. Could the survey of the outer world (and what better place to seize its form than from the prospect of a mountaintop?) ever disclose essential inner truth? Was such a lofty view a faithful picture of the world or was it merely a moral mirage, a shadow of the eternal verities that were, in their nature, unavailable to the scrutiny of the senses?

Whether the visible, outer garment of the world was its true substance or a deceiving illusion was an ancient question, inherited from Plato's *Republic,* and it would be passed on to the mountaineers of the Renaissance, the Enlightenment, and beyond. But as the two brothers made their way down the mountain slope, Petrarch surrendered to a stream of holy associations, triggered by the passage from the *Confessions;* Augustine in his time opening the Bible and reading a passage from St. Matthew which told him to put aside whoring and drunkenness; St. Anthony being instructed by the Gospel to divest himself of his worldly goods. As the inky dusk came on over the Monts de Vaucluse, the contest was decided. And suddenly the peak over Petrarch's shoulder shrank to a moral molehill.

> How many times, think you, did I turn back that day to glance at the summit of the mountain which seemed scarcely a cubit high compared with the range of human contemplation—when it is not immersed in the foul mire of the earth? With every downward step I asked myself this: If we are ready to endure so much sweat and labor in order that we may bring our bodies a little nearer heaven, how can a soul struggling toward God up the steeps of human pride and human destiny fear any cross or prison or sting of fortune?

Five years after their climb Gherardo would enter the monastic order of the Augustinians, and Petrarch himself, in the margins of a text of the natural historian Pliny, would make a drawing of a mountain of the Vaucluse, surmounted by a church.[57] Such expressive projections of the mind's eye would recur over and over again to future generations of mountaineers, even when they lacked

the fortitude of Christian faith. An ascent toward a perfectly unobstructed view could be confounded by what was actually seen—or sensed—from the summit. Instead of a clear prospect, there might be obscured vision, a loss of balance, an abruptly altered grasp of scale. On Mont Blanc, this high-altitude disorientation would make the poet Shelley feel close to madness. And the confident nineteenth-century Alpinist Edward Whymper would be startled by a prophetic vision of ominous phantom crosses standing in the Matterhorn "fogbow." To the soldier and Himalayan mountaineer Francis Younghusband, who had mowed down the Dalai Lama's troops for the greater good of the Raj, it dawned that he must hence atone for the blood in the Himalayan snow, by seeking the Inner Way via anthroposophy and mystical self-interrogation. For all of them, the panorama showed nothing so clearly as the scenery of their inner selves.

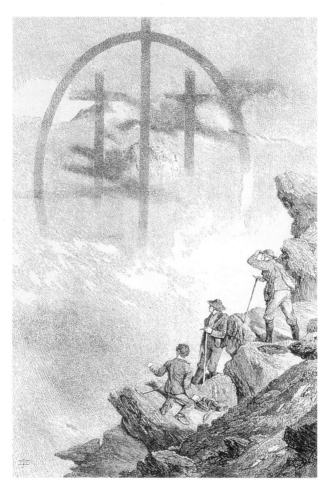

Edward Whymper, "The Fog-Bow on the Matterhorn," from *Scrambles in the Alps,* 1871.

Even the first explicit political annexation of a mountain ended in a revelation of piety. In late June 1492 Antoine de Ville, chamberlain to King Charles VIII of France, lord of Dompjulien and Beaupré, and captain of Montélimar, en route to campaign in Italy, was ordered to scale the well-named Mont Inaccessible, about twenty-five miles south of Grenoble. As late as the nineteenth century the French Alpine Club estimated the daunting seven-thousand-foot peak as an eleven-hour climb, up and down. But the summit was reputed to have untold natural wonders, and in a decade when Spanish and Portuguese monarchs were laying claim to far-flung tracts of the earth through

their licensed surrogates, doubtless Charles thought of the ascent as an exercise in vertical colonialism. He already knew what would become a commonplace in the eighteenth and nineteenth centuries: that the possession of a mountaintop was a title to lordship. To a truly absolute prince, nothing, certainly not a pile of rock, should be "inaccessible," beyond the reach of his sovereignty. Antoine de Ville, then, was the king's rock-face Columbus.

Along with Antoine de Ville went a party of six, including three clerics, the King's Preacher, a carpenter, and, very sensibly, "a ladder-man to the King." All that they could have had, to get a purchase on the sheer rock, were the instruments of siege warfare: ladders, ropes, perhaps hammers. And given the obvious perils of the ascent, it is hardly surprising that the party decided to stay put for six days before attempting the descent.

In the meantime news of the expedition had reached the royal court of the Parlement at Grenoble. And it was thought so extraordinary that a group of its officers was sent to verify the claim. Discovering the ladders propped against the cliff, the usher made an attempt to scale the rock but gave up in a state of exhausted fright while his companions, including the cream of local chivalry, refused even to approach the mountain, much less climb it. From his ledge, halfway up the usher had seen Antoine de Ville and his men perched on the little plateau, and that was good enough to provide them with the required attestation.

The official relation of the event, provided for the Parlement of Dauphiné, is an odd mixture of legal and sacred language.[58] Antoine de Ville's almoner, François de Bosco, duly confirmed that Antoine de Ville had baptized the peak (equally appropriately) Mont Aiguille (Needle Mountain) in the name of the Father, Son, Holy Ghost, *and* (bearing in mind his royal authorization) "Saint Charlemagne." A Te Deum and a Salve Regina had been sung and three crosses had been set up (as if on Calvary) which would be visible for miles around. A primitive chapel had been built and masses said each day. But most striking is the description of the fauna and flora atop the flattened peak which, from the predictable meadows to the wild sparrows (in three hues), the bounding chamoix, and the intensely fragrant flowers (described as lilies, *fleur-de-lys,* of course, by the royal chaplain of France), all conform to the standard expectations of the Alpine purgatory, a.k.a. the terrestrial paradise. The lord of Dompjulien and Beaupré, after all, was no original, not even a poet. Doubtless he had seen such landscapes before, woven into tapestries in the Burgundian-Netherlandish style or on painted panels. Perhaps he had read Dante's purgatorial climb. No wonder he too believed himself to be atop the pillar that connected the celestial to the earthly realms. In any event, when a curious party of climbers made it to the top (with great difficulty) more than three centuries later, in 1834, they found absolutely no sign of any animal life whatsoever except for flocks of shrieking, scrawny crows perched on the bald rock.[59]

iv Exorcising Pilate

While Antoine de Ville, in the company of the royal ladder-man, his carpenter, and almoner, was ascending into Lilyland, Renaissance artists like Leonardo da Vinci were making unprecedentedly scrupulous studies of rocks, cliffs, and mountains. One of the most remarkable of all da Vinci's drawings records the Alpine horizon, seen from Lake Maggiore, with virtually the entire foreground eliminated, as if the artist's eye had risen aloft in his imagined aerial machine. In their painted versions, though, technically exacting drawings of rocks were converted into backgrounds for familiar sacred histories. In a justly famous essay Sir Ernst Gombrich pointed out Leonardo's disarming celebration of the landscape artist's conceptual imagination as a self-conscious act of creation scarcely less potent than its original model.[60] More recently A. Richard Turner has noticed that some of Leonardo's ostensibly meticulous descriptions of the physiognomy of mountains were actually the product of his fertile imagination.[61] His account of Mount Taurus, for example, describes first a lush countryside, then fir and beech forests, and finally "scorching air with never a breath of wind." The bare topography of the peak is at least a welcome and realistic

Leonardo da Vinci, studies of Mountains, ca. 1511.

Leonardo da Vinci, *Great Alpine Landscape with Storm,* ca. 1500.

departure from the clichés of the Alpine paradises. But it is nonetheless a kind of fiction, for Leonardo, it turns out, had never been anywhere near Mount Taurus.

In another ostensibly "Alpine" drawing in Windsor Castle, Leonardo further muddies the boundary between fantasy and nature by delivering a rainstorm from incongruous puffballs that, with wind-swollen cheeks, would better belong on a Renaissance *portolano* navigation chart. Beyond the foreground hills, as if layered in his imagination, lie successively improbable landscapes: a turreted town; sharply rearing cliffs; and finally, at the very top, a piled range of cloud forms which, by rhyming with the mountains, serve to lift the whole composition entirely out of the realm of the terrestrial world.

Conversely, when a Renaissance artist made a conscientious effort to insert a prosaic topographical record of a mountainscape into an otherwise conventional history, the effect could be disjointed. In Konrad Witz's *Miraculous Draught of Fishes,* painted as early as 1444, where Lac Léman, seen from Geneva, stands in for the Sea of Galilee, the Alpine horizon (including the first representation of Mont Blanc) seems perpendicularly attached to the middle and foreground, as if it were a cutout cartographical addendum rather than a natural extension of the narrative space.

So when sixteenth-century artists who were *both* genuine landscapists and history painters (like Albrecht Altdorfer or, a generation later, Pieter Bruegel the Elder) used mountains as rhetorical elements in their narratives, the temptation to stylize was irresistible. As many commentators on Altdorfer's *Battle of Alexander and Darius on the Issus* have pointed out, the apocalyptic defeat of the Persian king Darius by Alexander is not only registered in the magnitude of the brutal mountain that looms over the fray, but extended into the heavens, where the contours of the rocks are echoed in the swirling cloud forms.[62]

As well as performing as actors in these dramas, mountains could be constructed as platforms of hubris. Even though Pieter Bruegel the Elder had travelled over the St. Gotthard to Italy in the 1550s, and had had his drawings of the Alpine peaks and passes etched at the Antwerp print shop of Hieronymus Cock, the kind of mountainscapes he used for *The Suicide of Saul* or *The Conversion of St. Paul* owed more to his poetic imagination than to faithful topographical recall. In both cases the fearful precipices and abysmal chasms are stage prompts for holy drama—descents into perdition or sublime elevations.

And yet, for all these acts of creative license, something *had* evidently changed in the Western vision of mountains. Apprehension had been overtaken by perception. Even though mountains, unlike the arboreal garden and the sacred stream, had gone unmentioned in the account of Creation given in Genesis, they were at last admitted to the universe of blessed nature. Which is only to say that by the lights of the Renaissance fathers, nothing

Konrad Witz,
*Miraculous
Draught of
Fishes*, 1444.

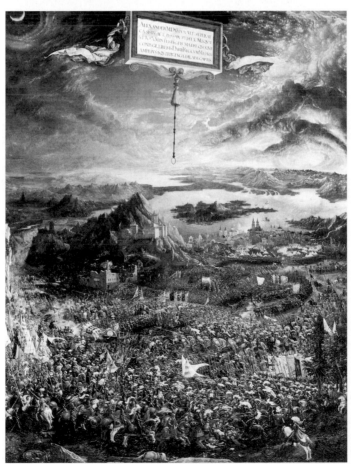

Albrecht
Altdorfer,
*Battle of
Alexander and
Darius on the
Issus*, 1529.

was to be excluded. By the middle of the fifteenth century there had occurred, in the literature of Christian humanism, one of those periodic convergences between the visible and the ineffable. So the informed contemplation of nature became not merely *compatible* with awe of the Creator but a way to affirm his omniscience. Respected, *inspected,* regarded with pious attentiveness, the sheer diversity of the outward slopes of the world attested to the inexhaustible creativity of God. The more fantastic the terrestrial forms, the more prodigious must be his power. The systematic inves-

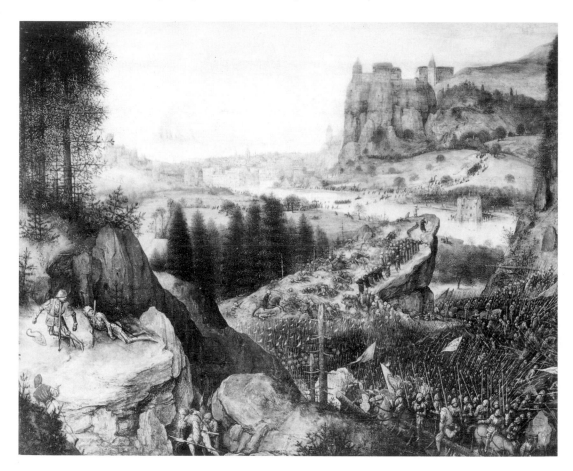

tigation of the earth's structure no longer seemed to infringe on the sacrosanct mysteries of the Creator, but rather to offer a glimpse of his ingenuity. No feature of this marvel, even the blistered mountains, could possibly have been an unsightly oversight. And theological works like *De Venustate Mundi et de Pulchritudine Dei* (Of the Magic of the World and the Beauty of God), by the Dutch Carthusian monk Dionysus van Rijkel, expressly included mountains among naturally beautiful forms that were the product of divine benevolence.[63]

The possibility that mountain peaks and valleys might not be the accursed places of the world coincided with the recovery of classical texts of natural history, especially the many congested volumes of Pliny the Elder. To the first generation of Renaissance fossil-hunters and mineralogists, mountains began to seem as if they had their own histories to tell. At the same time, topographical illustrators, like the prodigious Frans Hogenberg, offered views of *populated* mountain valleys: villages and little towns set amidst neat pasture, rather than cowering below demon-haunted rock piles.[64] By the end of the sixteenth century printed

Pieter Bruegel the Elder, *The Suicide of Saul*, 1562.

Frans Hogenberg, "Svicia," from *Civitatus Orbis Terrarum.*

guides indicated the location of hospices, inns, chapels, and mountain paths. This was no longer wilderness, but a recognizable human society. In 1578 the first detailed map of the High Alps, prepared by the Berne physician and geographer Johannes Stumpf, was published. For the first time, the literate world was given the names of peaks hitherto known only in the oral culture of the villages: Eiger and Bietschhorn, Jungfrau and the alarming-sounding Schreckhorn.[65]

Swiss humanists in particular, living in Lucerne, Basel, and Zurich, felt the need to exorcise their mountains of their demonic fables before they could

properly claim them as patriotic topography. In 1555 the great naturalist Conrad Gesner walked straight up the notorious Mons Pilatus overlooking Lucerne, expressly to lay to rest the absurd legend of its malevolent ghost, said to be responsible (among other things) for violent disturbances of the weather. A fourteenth-century local edict prescribing the death penalty for anyone visiting the haunted lake and raising old Pilate by recklessly flinging rocks into his marshy grave Gesner found preposterous. And he was aghast that a party of ostensibly sage and scholarly men, led by Vadianus—the professor of medicine and burgomaster of St. Gall, Joachim von Watt—should have taken the nonsense seriously enough to visit the lake in 1518 and declare the whole matter an open question! Gesner, by contrast, was boldly categorical in his dismissal of the myth. "This belief, having no raison d'être in the laws of nature, commands no credence from me. . . . For my own part I am inclined to believe that Pilate has never been here at all, and that even had he been here he would not have been accorded the power of either benefiting or injuring human kind."[66]

Gesner was not so bold as to deny the presence of evil spirits in the world altogether, nor even that they might haunt remote and disagreeable places. But the Alpine peaks and valleys, he believed, could not possibly qualify as their abode, for they were unquestionably a blessing, not a curse. In an earlier letter written to a friend in 1543, and published as a dedicatory epistle to his treatise *Concerning Milk,* Gesner had already extolled mountain climbing as essential not only for the pursuit of botany but "for the delight of the mind and the exercise of the body."[67] And in his account of the climb on Mons Pilatus he goes into ecstasies over the clarity of the mountain water, the fragrance of the wild flowers, the restful sweetness of the hay on which he slept, the verdant brilliance of the mountain pastures, the purity of the air, the richness of the milk, the ingenious stoutness of the alpenstock, and even the Alpine horn which the learned doctor sent bellowing and booming over the slopes.

What is so striking about much of Gesner's eulogy is its concreteness. Instead of the kind of rapture that assumed a sort of mystical disembodiment on the peaks, Gesner's senses tingle with the altitude. Unlike Petrarch's divided sensibility, Gesner's body and soul seem perfectly companionable in the light, thin air.

By the last quarter of the sixteenth century the well-prepared Alpine traveller had a rich variety of maps and guides to help his body over the more than a hundred passes between northern Europe and Italy. From Aegidius Tschudi he could learn something of the local history and politics of the Swiss cantons. If his route took him through the Bernese Oberland he could follow Johannes Stumpf's route, taken in 1544, inn by inn, flagon by flagon, cheese by cheese, and, if he felt so inclined, chapel by chapel. From the solicitous counsel offered by Josias Simler, professor of theology at Zurich, he might think to equip himself with simple

snowshoes and ropes to guard against crevasses; to have his horse and himself shod with protruding spikes for the icy trails; to guard against frostbite by enfolding himself with garments of hide and parchment, and against snow blindness by wearing the strangely darkened spectacles recommended by Simler.[68]

This was all well and good for the Swiss. But for many foreign Alpine travellers, the mountain passes remained more of an ordeal than an opportunity to sample the "work of the Sovereign Architect," as Gesner called him. Cellini was terrified, Montaigne depressed, Fynes Morison repelled, by negotiating a precarious track between threatening overhangs and vertiginous Alpine ravines. And while some of Gesner's readers may have responded to his exhilaration at the *variety* of scenery ("ridges, rocks, woods, valleys, streams, springs and meadows"), the suddenly changing microclimates and flickering alterations of light and shade that could be experienced from a single summit point of view, many more might have preferred to digest this comprehensive view of the universe in the comfortable, proxy form of a print or a painting.

The aesthetic regurgitation of geological awfulness was exactly what Karel van Mander meant when he described Pieter Bruegel the Elder as swallowing whole mountains and rocks and vomiting them up again on canvases and panels. Leonardo's god-like shaping hand set on the awesome mountainside now became the Fleming's gift of making mountains palatable. For while many of those who bought the etchings made from Bruegel's Alpine drawings were (like the patron of his famous landscapes of *The Months*) merchants, we can be sure that they were not drawn to the images as souvenirs of the road. In fact they were something like the very opposite: an idealized composite of the world taken in at a single Olympian glance. For the point of view of Bruegel's *Dark Day* (February), for example, is not so much mountainous as avian. The prospect hangs from an elevation so impossibly high that it can travel, pushed by Bruegel's fiercely strong lines of composition, through a whole succession of arbitrarily stitched together, discrete landscapes: Flemish cottages, Mediterranean river mouth, and Alpine needle-peaks. As Walter Gibson, who has written perceptively about these so-called "world paintings" has observed, they came to be a painterly equivalent of the extensive maps that were produced as a speciality in Antwerp and later in Amsterdam.[69] And the scenes, painted a decade after Gesner's descriptions, certainly correspond to his exhilaration that from high altitudes an entire cosmography might be surveyed and vicariously possessed. Even Bruegel, though, refrained from attempting to convey Gesner's claim that from a mountaintop one might "observe . . . on a single day . . . the four seasons of the year, Spring, Summer, Autumn and Winter [as well as] the whole firmament of heaven open to your gaze."[70]

According to this Olympian vision, it was possible, from the heights, to grasp the underlying unities of nature in a way denied by the closeup inspec-

tion of incompatible details. Such a normatively charged view from above antic-
ipated our own intuitive compassion for the whole earth, seen in satellite pho-
tographs not as an arrangement of continents divided by oceans, but as a whole
and indivisible planet. In one respect, at least, though, the painter's eye sur-
passed the orbiting lens. For by combining close figures with far-off prospects,
Bruegel managed to suggest a sense of the working fit between raw nature and
human habitat, even when the February wind was biting and ships were

Pieter Bruegel
the Elder,
The Dark Day,
1565.

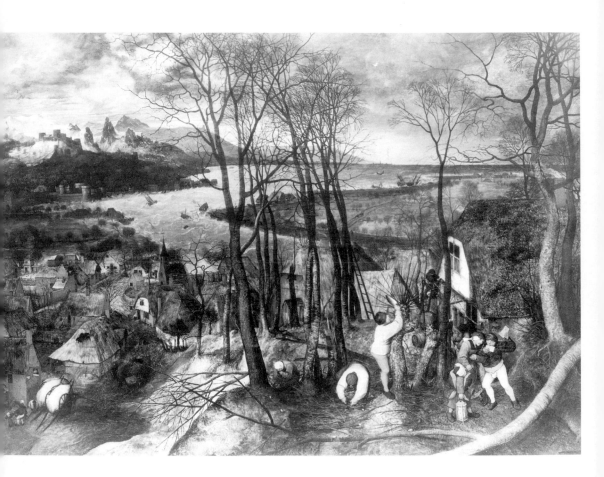

foundering in the bay. If these landscapes belonged to the diligent labor of Vir-
gil's *Georgics* rather than the dreamy arcadia of the *Eclogues,* they were at least
a populated place.

 This is not to say that mountain scenery had yet been exorcised of all its
demons and dragons, nor that painted mountainscapes were now disenchanted
heaps of stone. Bruegel's views were, in their way, every bit as informed by reli-
gious conviction as the late medieval hermitscapes. And Gibson has even sug-

gested that the iconographic origin of Bruegel's cycle of *The Months* is to be found in the prayer-book miniatures of Simon and Alexander Bening.[71] So it is hardly surprising that the first artist to have been described (in an engraved portrait by van Dyck) as the *pictor montium* (painter of mountains), Josse de Momper the Younger, should have sustained into the seventeenth century all the archetypal Bruegelesque themes. This becomes even less surprising considering that de Momper was born in Antwerp and that his father and grandfather were friends of Bruegel's son Jan.[72]

In many of his works de Momper actually returned to the older Netherlandish tradition of mountain scenes featuring pilgrims, palmers, rock-grottoes, and hermitages. He had worked in the Catholic world of Counter-Reformation Antwerp, where the church had resolved to glory in precisely the extravagantly theatrical images that the Reformation had proscribed as idolatrous. For this sacred propaganda of awe, mountain scenery was perfect. So de Momper brought anchorite saints like Jerome and Fulgentius back to his bare, wild rockscapes.

In one other respect, too, de Momper from the Catholic south and Hercules Seghers from the Protestant north returned to a sharply vertical angle of vision. In their canvases and panels (in Seghers's case, imagined entirely without direct experience), sheer cliff walls once again rear up over the heads of puny travellers winding along a perilous path, quite without the benefit of Josias Simler's crampons and crevass ropes. In the spectacular painting in Vienna the figure of a beggar (left foreground) is picked out in scarlet while another pair of vulnerable travellers is seen from the rear, making their way toward hostile crags. In the bottom right corner, de Momper squeezes a diminutive hermit seated beneath a crag, almost as if barring the way to the presumptuous and foolhardy wayfarers. But as in many paintings of this genre, the figures are dwarfed by the colossal drama being played out by the geology itself. For the rocks themselves have become combatants in some enormous cosmic confrontation: the vast talon-like boulders at right lean intimidatingly into the bowl of the lit valley. All that stands between them and the road is the darkened mass of the forested hill at center, itself sheltering the church on which the travellers converge. The sixteenth-century humanist vision, from the heights, of an intelligible, harmonized universe has been superseded, yet again, by the more histrionic view up from the dale where expendable man is trapped between the horrid crag and the rock of faith.

Josse de Momper the Younger, *Great Mountain Landscape.*

v Calvaries of Convenience

It was not only through paintings that the Catholic church exploited moun-
tains as sacred spectacle. In a stroke of great audacity, the Franciscans actually
managed to convert the mountains *themselves* into inspirational theater.

They took their cue from the founder of the order. In 1224, two years
before his death, Monte Verna, just outside Varallo, in Piedmont, had been
selected by St. Francis for a forty-day retreat of fasting and prayer. The hagio-
graphical anthology of stories called the *Fioretti* (The Little Flowers of St. Fran-
cis), compiled a century later, recorded that while he was standing by his rocky
cell,

> considering the form of the mountain and marvelling at the exceeding
> great clefts and caverns in the mighty rocks, he betook himself to
> prayer and it was revealed to him that those clefts . . . had been mirac-
> ulously made at the hour of the Passion of Christ when, according to
> the gospel, the rocks were rent asunder. And this, God willed, should
> manifestly appear on Mount Verna because there the Passion of our
> Lord Jesus Christ was to be renewed through love and pity in the soul
> of St. Francis.[73]

Since the saint also received the stigmata on the same mountain from a ser-
aph carrying the crucified Christ, Monte Verna became, for his devotees, an
alternative Calvary: not simply a place that would remind the faithful of the Pas-
sion but the place where it had been mysteriously re-enacted in the Franciscan
miracle. The very fissures of its rocks, as the *Fioretti* made clear, bore the mark
of that mystery, just as surely as Francis himself bore the mark on his palms. To
the most fervent it became known from its angelic presence as the Monte Se-
rafico, or the "Seraphic Theater of the Stigmata of Christ."

In 1486 the Franciscan friar Bernardino Caimi, who had seen the real
Mount Zion while acting as patriarch of the Holy Land, determined to create
a more available version on Monte Verna.[74] His "New Jerusalem," five hun-
dred feet above the river Mastallone, would reproduce the Stations of the
Cross, but in a more theatrical, Franciscan vernacular, using life-size tableaux

from the lives of Christ and St. Francis, housed in their own individual chapels dotted over the hillside. As the pilgrim ascended the steep but terraced slopes, he would pause at the chapel of "Nazareth" of "Bethlehem" for moments of contemplation, prayer, and engagement with the groups of figures. By the time he had reached "Calvary" and the "Holy Sepulchre" he would feel himself close to the site of the Passion and, through his journey up the slopes, to the agony and exaltation of the Savior.

Raffaele Schiaminossi after Jacopo Ligozzi, *The Bed of St. Francis,* 1612.

A century later, in 1586, the sainted zealot of the Milanese Counter-Reformation, Carlo Borromeo, re-treated to the sacred mountain at Varallo. Thereafter its popularity as a place of pilgrimage was guaranteed. Even in the second half of the seventeenth century tens of thousands of pilgrims were said to climb the mountain, congregating in large numbers during Holy Week. And for those who were unable to make the journey, an extraordinary group of twenty-six prints, engraved after drawings by the Florentine artist Jacopo Ligozzi, who had visited Monte Verna in 1607, were published to approximate the experience. First published in Florence in 1612, they were reissued in 1620, and again fifty years later, in Milan, from which publishing history one deduces the volume was not a spectacular success.[75]

Perhaps the prints were simply too grandly Baroque for the pilgrims of St. Francis, or too expensive, or simply too startling. Because while some of the Ligozzi designs were content merely to reproduce the interior of the chapels of Mount Verna, others, especially those engraved by Raffaele Schiaminossi, used astonishing effects (including movable paper flaps and hinges) to suggest

Raffaele
Schiaminossi
after Jacopo
Ligozzi,
*The Temptation
of St. Francis,*
1612.

the precipitous experience of the saint on the mountain. No two-dimensional photographic reproduction can do justice to the vividness and power of the originals, with vast slabs of rock mysteriously opening to reveal the stone bed of the saint; Francis moving dangerously forward on his paper parapet, tempted by a Satan-like Christ on the High Place. Pop-up pieties, the prints offered Calvary at fourth hand since they were an approximation of an approximation of a repetition of the Passion. But in terms of the vastness of the scale, the production of a shocking sense of the vertiginous, of the mysterious disorientation

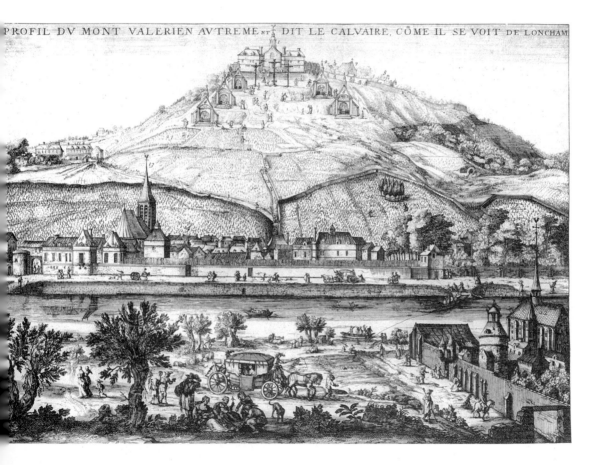

PROFIL DV MONT VALERIEN AVTREMENT DIT LE CALVAIRE, CÔME IL SE VOIT DE LONCHAM

Anonymous,
engraving,
*Profil du Mont
Valérien,* mid-
seventeenth
century.

of the senses, alternating between elevations and abysses, the Schiaminossi/ Ligozzi prints represent one of the most stupendous achievements in the tradition of the holy mountain.

Before long, *sacri monti* sprouted throughout mountainous northern Italy, at Locarno, Varese, Arona, and Domodossola, each with its own saintly or miraculous theme chapels, all with some sort of culminating Calvary at the peak. In Spain a holy mount was superimposed on the site of the old Muslim citadel of Granada, paradoxically by Moriscos, Christianized Arabs who pro-

duced specious evidence to suggest that St. Cecilio, the first bishop of Granada, had actually himself been an Islamic convert.[76] Others were built at Braga in Portugal, where impious figures of Diana and the allegorical representations of the five senses were inserted among the saints and martyrs, and on Mont Valérien, just west of Paris in the faubourg of Suresnes.[77]

In many respects Mont Valérien followed the original design of the Italian Franciscans. It used an impressive (but not too daunting) hill for the usual arrangement of inspirational chapels and tableaux. And hillside Calvaries had already been established in the more fervent regions of France, Brittany in particular. What made Mont Valérien different, though, was that from the beginning it was a Paris fashion, with a serious following among the noble elite of the city. Its founder was another frontier evangelist, Hubert Charpentier, grand vicaire of the diocese of Auch in the Pyrenees, where he had also established an order of "the priests of Calvary." Just how the idea came to him to preach a mission to the sinners of the metropolis is uncertain, but in 1633 he had acquired from Cardinal Richelieu the rights to construct his *chemin de croix* on the hill at Suresnes. There were to be fifteen chapels (though only five seem to have been built by the end of the century), and nine "Stations": the betrayal by Judas in Gethsemane, Christ before Caiaphas, the flagellation, and so on, leading to the climactic peak where three crosses arose from a roughly

Moncornet, "Pourtrait du Mont Valérien, dit à Present le Calvaire...."

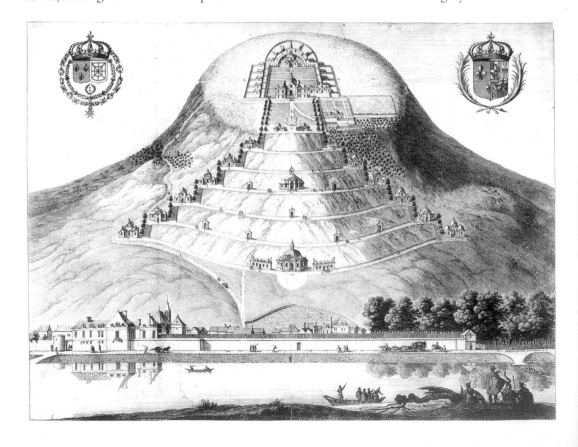

shaped rock. The print by Moncornet representing the plan, rather than its execution, shows a strangely humped tumulus swelling into the sky, with the "Calvary" site of the three crosses themselves surmounted by a further two sanctuaries, the uppermost Church of the Ascension, haloed by little cells where those moved by the spectacle could retire for additional contemplation and prayer.

After Louis XIII and Anne of Austria had made the pilgrimage, Mont Valérien became enormously popular with grandees, especially the women of the court, who by patronizing the chapels could advertise their piety. Such was the competition to have a chapel named for its benefactors that the upper terraces began to resemble a kind of spiritual *salon* led by Mme de Guise, who was also abbess of Montmartre. On one flank of the hill was a Liancourt chapel; on the other, a Mme la Princesse de Guiemenée chapel (donation: fifteen hundred livres). But the aristocratic tone did not at all constrain the excitements of ostentatious self-mortification. Self-flagellation with ropes became commonplace, whacking the shoulders and back with wooden crosses a positive obligation. The higher the breeding, the fiercer the whacks. As a site of penitential demonstrations, Mont Valérien became such a fervent place (in spite of the fact that only five of the planned fifteen chapels were actually built) that rival orders to the Calvarians, in particular the Jacobins, attempted to seize it with a show of frocked force in Holy Week, 1664. Inevitably, the slightly savage atmosphere of primitive faith that hung over the holy hill attracted throngs of the usual charlatans: faith healers, miracle workers, hot-tongued prophets, and swarms of rogues and beggars, all eager to profit from the gullibility of the mighty and the humble alike. To help stoke the fires of the faith, taverns and *guinguettes* crowded about the foot of Mont Valérien, and, according to the critics of the Parisian Calvary, there was enough bawdiness to ensure that the penances along the Way of the Cross would not be in vain. By the end of the seventeenth century the holy hill had such a reputation for disorderliness, especially in Holy Week, that the archbishop of Paris, Cardinal de Noailles, ordered the chapels shut on Good Friday.

During the long, skeptical eighteenth century, the chapels of Mont Valérien gradually succumbed to neglect. Yet as the gilt-painted apostles became veiled with a film of grime, the very decay of the place lent it a picturesque allure for a generation much drawn to the melancholy of ruins. In 1766 the autodidact painter Simon Mathurin Lantara found his way to Suresnes to sketch what he called, with picturesque exaggeration, "the Church of the Hermits," surrounded by bucolic, rather Franciscan scenes of goatherds and rustic cottages. The combination of mournful innocence and fading fervor was, of course, irresistible to Jean-Jacques Rousseau, who climbed the hill with his botanizing friend Bernardin de Saint-Pierre.[78] Brought to the "hermitage," they trembled with emotion at the liturgy and listened raptly to a sermon deliv-

ered on "the unjust complaints of Men; God who has raised them from Noth-ing owes them Nothing." "Oh," sighed Rousseau, dropping one of his suspi-ciously lapidary epigrams, "how happy it must be to believe!" Walking in the cloister gardens and taking in the view of far-off Paris, the French Jerusalem wreathed in dark clouds, Rousseau made his own vow that he would return to the holy mountain to immerse himself in silent meditation.

De Monchy after Simon Mathurin Lantara, engraving, "Vue du Mont Valérien," 1766.

vi The Last *Sacro Monte*?[79]

Notoriously inconsistent, Jean-Jacques seems not to have returned to the Holy Mount of Suresnes. But his apostles, dressed in the garb of French revolution-ary zealots, certainly did. There had always been a sharp genre of anti-monas-tic satire directed at the misty pieties of Mont Valérien, and in the Revolution

it turned into ferocious iconoclasm. The chapels were ransacked, the statuary and paintings mutilated and burned. Only the vegetable gardens by the cloister were spared for their republican usefulness and their conformity to the sole acceptable cult: that of nature. Bernardin de Saint-Pierre would have been pleased.

Busily substituting bureaucratic paternalism for monastic superstition, the authorities of the Napoleonic Empire in 1811 replaced the Order of Trappists, then acting as custodians of the sole surviving church at the top of the hill, with the Order of the Legion of Honor. That order had the responsibility of turning the building and site into a state orphanage that would reflect modern social morality, decently rational and demonstrably utilitarian.

But the ecstasies of Mont Valérien were not quite obliterated, merely entombed. Come the Bourbon Restoration, a fervent cult of the cross swept the traditionally Catholic regions of France, and Paris's own holy mount became, for the last time, a place of public expiation, not least for the manifold sins of the regicidal Revolution and the usurping emperor. It may have been precisely because of the notoriety of Parisian republicanism that the "missionaries" shown in a print of 1819, at the height of the Ultra-Catholic reaction, were committed to preaching their own Sermons on the Mount against the iniquities of the World's Fleshpot. Among the incompletely convinced, though, may have been the anonymous artist who managed to smuggle into the scene all kinds of subversive details, not least the formidably sanctimonious

"Les Missionaires au Mont Valérien près Paris."

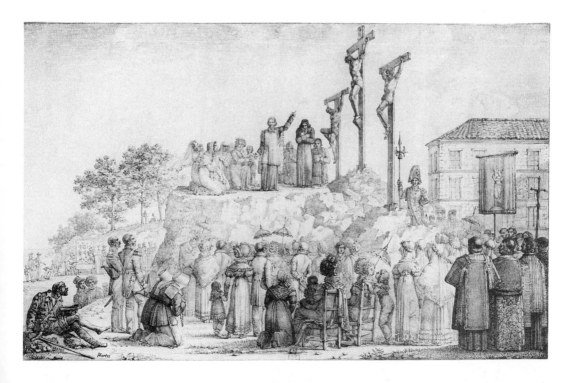

expression of the preacher and the ferociously unreconciled *invalide,* bottom left, reduced from the splendor of the imperial armies to pitiful begging and impotent rage.

Doubtless the old veteran (along with most of his colleagues) cheered on the July Revolution of 1830 that disposed of the Bourbon monarchy for good, and with it whatever remained of the odor of sanctity on Mont Valérien. The church and chapel were razed yet again, and in 1840 an edifice more typical of the secular century was erected: a barracks. This "Fort du Mont Valérien" still dominates the hill at Suresnes, perched above the Seine and the Bois de Boulogne, gloomily facing down the miserable collection of tower-blocks planted on the slopes of the hill. Below the barracks there are still crosses, grimy and untended. But they belong to the American war cemetery on the boulevard Washington.

✦ ✦ ✦

AFTER 1945 martyred Europe could have no further use for artificial Calvaries. But in America, Italian Catholics, not at all unlike the first pilgrims to Monte Verna, conceived of a new "New Jerusalem" that would fend off the inexorable march of humanism, secularism, and, of course, Communism. The latter-day Father Caimi was John Greco, a small-town attorney in Waterbury, Connecticut, who gazed at the scrubby Pine Hill overlooking his hometown and saw "Holy Land, USA" rising on its summit.

It began, of course, with a cross, thirty-two feet high, made of stainless steel and lit with neon, the illumination of choice in the 1950s. But as Cristina Mathews has pointed out in her perceptive essay on the Waterbury *sacro monte,* this "Cross of Peace," while imposing, was too stripped-down and austere to serve the evangelical purposes of the men who built Holy Land, USA.[80] It had, in fact, been constructed by a group known as the Retreat League, who seem to have been, culturally and socially, a cut above the blue-collar parishioners who made up John Greco's circle of enthusiasts. They were nearly all first-generation Italian immigrants, many of them from the south, where a popular tradition of life-size, vividly painted, and heavily decorated sacred sculpture still flourished. Greco's own church, for example, located just below Pine Hill, was Our Lady of Lourdes, and some of the statues he brought to Holy Land were shipped in directly from Italy. If they worked miracles like the Madonna of Scafati, whose painting, it was said, had parted the lava stream from a local volcano, so much the better.

What the makers of Holy Land added to this native appetite for religious spectacle, was pure 1950s candy-colored theme-park theology. But this was, both of necessity and choice, a low-tech sacred mountain. Unlike the corporately funded, industrially constructed, electronically switched-on theme parks of the 1980s, Holy Land USA, was actually built by Greco and his friends, from

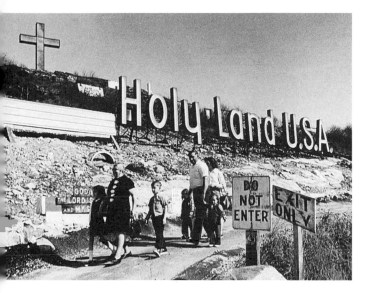

Holy Land,
USA
(photographs
Virginia Blaisdell).

the primitive carpentry to the concrete scalehouses, to the repainting of discarded church sculptures and architectural details, rescued from the ecclesiastical junkyard. It was chicken-wire evangelism in earnest.

In 1958 HOLY LAND USA, announced by giant capital letters—the beatific rebuttal of the HOLLYWOOD sign—opened for business. It combined the Franciscan fervor and innocent literalism of Monte Verna with the inspired hucksterism of Mont Valérien. For a hill in industrial Connecticut it did turnstile trade. At its peak, in the late fifties and early sixties, about two thousand visitors a day wandered round the hundred-odd quarter-size buildings representing Bethlehem, Jerusalem, and Nazareth. And in 1969 they could extend their visit to "The Garden of Eden" and "The Tower of God" (not Babel) as well. For that extra touch of immediacy Greco added "small stones and dust" which he said he had collected on a "research trip" to Italy (Varallo was not specified) and the Other Holy Land.[81]

History moves fast in twentieth-century America. It took nearly a century for Mont Valérien to crumble into the shabby ruin that brought a catch to Rousseau's throat. Fifteen years after its opening, Holy Land USA had already passed its peak. John Greco had died; his friends of the Campaign were late-middle-aged or older. The ardor of Catholic Action that had promoted an active mission to the laity retreated before the all-conquering pleasure principles of the 1960s. And though the archbishop of Hartford had originally blessed the project, much of the official Catholic hierarchy outside Waterbury were embarrassed by the fairground tone of the place, a low-rent biblical Disneyland.

Before very long the concrete manger and the NO VACANCY Bethlehem nativity motel were peeling. Rust invaded the lean-to Garden of Eden. And it was the American equivalent of the French Revolution, an interstate freeway, that delivered the coup de grace to the expiring mid-Connecticut Jerusalem. I-84 freeway devoured chunks of Pine Hill for its lanes, the backhoes entirely consuming Greco's replica of the Roman catacombs (authentic dust included). Concrete to concrete; dust to dust.

As if in memorial, a second Cross of Peace was erected on site in 1968, the industrial studs masked by the neon-emitting panels. On a murky afternoon it still casts a holy pallor over the few remaining statues, now cared for by the Sisters of the Holy Land Convent, and down the hill to the town, brutally bisected by the freeway. A little further west, a second, more modest cross has been applied to the wall of an institution, perhaps a hospital, that has turned its back to the trucks. Together they have scarcely turned I-84 into a *Via Crucis*. But they are, at the very least, a beacon in the wasteland. And, as it approaches the millennium, Waterbury, the "Brass Capital" of America, could probably use, like the rest of us, all the blessings it can get.

Vertical Empires, Cerebral Chasms

i Delightful Horror

It was when his lapdog, Tory, got eaten by a wolf that Horace Walpole began to have serious reservations about Mont Cenis. Swathed in beaver furs, he had been lumbering up the mountain path on a *chaise* carried by four sweating porters.

> I had brought with me a little black spaniel of King Charles's breed, but the prettiest, fattest, dearest creature! I had let it out of the chaise for the air, and it was waddling along, close to the head of the horses, on top of one of the highest Alps, by the side of a wood of firs. There darted out a young wolf, seized poor dear Tory by the throat, and before we could possibly prevent it, sprung up the side of the rock and carried him off. The postillion jumped off and struck at him with his whip, but in vain; for the road was so narrow that the servants that were behind could not get by the chaise to shoot him. What is the extraordinary part is, that it was but two o'clock and broad sun-shine. It was shocking to see anything one loved run away with so horrid a death.[1]

His shock was understandable. Whoever would have imagined that when the poet James Thomson populated the Alps with "assembling wolves in ranging troops descend," he knew what he was talking about?[2] Shaken, Walpole's travelling companion, Thomas Gray, commented that perhaps Mont Cenis "carries the permission mountains have of being frightful rather too far."[3] And Walpole decided that the cursed mountain was indeed a devilish place. On its narrow path, "scarcely room for a cloven foot," their porters had begun a brawl that nearly tipped the travellers from their chairs over the cliff. And even before the lupine ambush the scenery had stopped being agreeable: "What uncouth rocks and such uncomely inhabitants!"[4]

Rosalba Carriera, *Portrait of Horace Walpole.*

How different from the mountains of French Savoy, where, the friends agreed, the frightfulness had been a heady tonic for the senses. "Not a precipice, not a torrent, not a cliff but is pregnant with religion and poetry," wrote Gray of the scenery east of Grenoble.[5] It was just the sort of thing they had hoped for when planning their Grand Tour to Italy. Walpole was the son of the formidable Whig prime minister Sir Robert Walpole, and until the lamentable encounter with the wolf had obviously enjoyed having a silk-eared, sycophantic "Tory" in his lap. At Eton he had made friends with the witty and articulate Gray and along with two other equally precocious and literary comrades, Richard West and Thomas Ashton, had formed what they were pleased to call, in gentle parody of Sir Robert's diplomacy, "The Quadruple Alliance."

In 1739 Horace was an undergraduate at King's College, Cambridge, enjoying an income from an exchequer sinecure thoughtfully provided by his father, and making occasional visits to the library when not being told by his blind professor of mathematics that he was unteachably obtuse. Mournfully contemplating the murky damp of an East Anglian March, Walpole issued an invitation to Gray to join him on the trip over the Alps and into the vales of sunlit antiquity.

J. G. Eckhardt, *Portrait of Thomas Gray,* 1747–48.

Destined to be the most famous and widely read English poet of the eighteenth century,

Thomas Gray was then himself restively shackled to the law in the chambers of the Inner Temple. He had gone down from Peterhouse, Cambridge, the previous year without taking a degree, complaining that "the Masters of the Colleges are twelve gray-haired gentlefolk who are all mad with Pride and the Fellows . . . sleepy, drunken, dull illiterate things." (The harshness of this judgement did not, however, preclude the poet from becoming Professor of Modern History in 1767, nor from adding to the inglorious reputation of the despised faculty by failing to deliver a single lecture during his three-year tenure.) Summoned by Horace Walpole, he seized the chance to escape from the drudgery of the law chambers. So the "little waddling Fresh-Man of Peterhouse," as Gray described himself, and the "long ungainly mortal of King's" set off together on the journey that would provide the first unequivocally Romantic account of mountain sublimity, nearly two decades before Edmund Burke's *Philosophical Inquiry into the Origin of Our Ideas of the Sublime and Beautiful.*

The most histrionic versions of seventeenth-century sacred mountains had presented them as spectacles of holy terror. The expected response to a toiling ascent up an artificial Calvary, or toward a de Momper painting of a rock-cell saint, was devout and uncritical prostration: the crushing of the human ego beneath the rock of faith. For Gray and Walpole, though, the mountain experience was different. Intellectually skeptical, they could *make* themselves reverent as a form of aesthetic play. What they were interested in, along the high mountain passes, was not a true epiphany with the omnipotent Almighty, but an experiment in sensation. Their journey was designed to take them close to the edge, to toy with disaster. Where earlier mountain travellers had recoiled from mountain terror, Walpole and Gray revelled in it. They might have taken as their text the revealing remark by one John Dennis, who, on crossing the Alps in 1688, thought he had "walkd upon the very brink in a literal sense, of Destruction. . . . The sense of all this producd in me . . . a delightful Horrour, a terrible Joy and at the same time that I was infinitely pleasd, I trembled."[6]

With the prospect of so much delectable horror before them, their pace was deliberately unhurried. They enjoyed spring in Paris, where, wrote Gray to his mother, "you have nothing to drink but the best champagne in the world." Following the effervescence they spent the summer in Rheims purporting to improve their French. And in September, with Geneva as an eventual destination, the two friends took a long, looping excursion southeast from Lyon, precisely so that they could visit St. Bruno's famously isolated monastery of the Grande Chartreuse, up on its mountain eyrie between Chambéry and Grenoble. From the village of Echelles, just to the north, the road ascended for six miles of "magnificent rudeness . . . on one side the rock hanging over you, & on the other a monstrous precipice. in the bottom runs a torrent, called Les Guiers morts, that works its way among the rocks with a mighty noise, & fre-

quent Falls. You here meet all the beauties so savage & horrid a place can present you with."[7]

When they finally arrived at the Grande Chartreuse they found a Carthusian idyll, a place of "wonderful decency": a hundred monks, cowled in silence, and three hundred servants to minister to them! Two brothers, absolved from silence to care for travellers, supplied them with the sort of simple, wholesome fare that Romantic preconceptions about mountain hostelries assumed: pickled salmon, dried fish, conserves, cheese, butter, grapes, eggs, and figs. And the views around the monastery were so breathtaking that, Gray wrote, "I do not remember to have gone ten paces without an exclamation, that there was no restraining." Worldly as they were, the experience they surrendered to at the Grande Chartreuse was at least pseudo-religious. "There are certain scenes," Gray conceded, "that would awe an atheist into belief, without the help of other argument. . . . I am well persuaded St. Bruno was a man of no common genius, to choose such a situation for his retirement; and perhaps should have been a disciple of his, had I been born in his time."[8]

But even though he would become famous for lines written in a country churchyard, Thomas Gray was no more cut out for the ascetic life than Horace Walpole. They affected monkishness rather than submitted to the Rule. And they declined the insistent offer of the brothers that they stay the night in a cell. What the religiosity of their mountain narratives suggested, though, was a thirst for the awe-ful, the shivering pleasure of being half scared to death, a roller coaster by mountain-chair.

Born from the oxymoron of agreeable horror, Romanticism was nursed on calamity. While the eighteenth century is conventionally thought of as the epoch of light—the Enlightenment, led by what the French called their *lumières*—Edmund Burke set himself up as the priest of obscurity, of darkness. To be *profound* was to plumb the depths. So it would be in shadow and darkness and dread and trembling, in caves and chasms, at the edge of the precipice, in the shroud of the cloud, in the fissures of the earth, that, he insisted in his *Inquiry,* the sublime would be discovered. And how much *more* important, he argued, to face such dreadful sublimity than bathe in the glow of complacent illumination. And if the quest for the sublime took one right over the top (as Burke was quite consciously essaying in the manner of his own rhetoric), so be it.

Decades before the publication of Burke's *Inquiry* in 1757, though, as Marjorie Hope Nicolson's brilliant book *Mountain Gloom, Mountain Glory* suggested over thirty years ago,[9] mountain scenery had already become associated with the ruin, chaos, and catastrophe on which Romanticism thrived. And if mountains were now perceived as the landscape of violence, eighteenth-century connoisseurs credited two figures, above all others, with being responsible for that disturbing and exciting vision: the theologian Thomas Burnet and the painter Salvator Rosa.

In truth, neither was exactly what his enthusiasts took him to be. Salvator was not the artistic bandit that William Gilpin, one of his most passionate devotees, supposed. And Burnet was only involuntarily the apostle of mountain convulsions. That Burnet's book *Telluris Theoria Sacra* (The Sacred Theory of the Earth), first published in 1681, had the effect of making mountains more fascinating, rather than more repulsive, was itself a paradox. For he had been arguing *against* the complacent view of Platonists at Cambridge, that even if mountains appeared to be erupted carbuncles on the face of the earth, the mere fact of their inclusion in the Creation necessarily meant they must have been intended by the Almighty for some benign purpose. Optimistic and pragmatic natural historians like John Ray managed to produce a list of twenty reasons why mountains were truly useful for mankind, and a sign of "the wisdom of God" (as his book was titled). Not least was their role in the hydrological cycle, transforming evaporated salt water from the sea into condensed fresh water of rain, evidence of this benevolence.[10] But, unlike many of those who pontificated on the subject, Thomas Burnet had actually seen the Alps, when he had accompanied the young earl of Wiltshire on his Grand Tour in 1671. And he was not so much impressed as appalled by what he saw. The sight of those "vast undigested heaps of stone" struck him so powerfully that "I was not easy until I could give myself some tolerable account of how that confusion came in nature."

Instead of averting his gaze and accepting the inscrutable ways of the Almighty, Burnet stared directly at the brutality of the earth's mountain ranges. In fact he actually complained about the distortions of conventional globes and atlases, urging instead what he called "rough globes" with raised, contoured surfaces "so we should see what a rude Lump our world is which we are so apt to dote on." Like Ruskin, a century and a half later, Burnet wanted to shake up lazy conventions, to revel in the profound eloquence of the earth's *irregularity*. "So much is the world drownd in stupidity and sensual pleasures and so little inquisitive to the works of God," he complained irritably, "that you may tell them that mountains grow out of the earth like Fuzzballs or that there are Monsters that throw up Mountains like Moles do Mole-Hills, they will scarce raise one objection against your doctrine."

What Burnet offered in place of a neatly well-ordered cosmology was a stupendous primordial drama. Instead of the providential clockmaker, the Jehovah who had made mountains was a sublime, if infuriated, dramaturge. Mountains, Burnet explained, had not been mentioned in Genesis for a very good reason. They were not, in fact, contemporary with the Creation at all. The original, paradisiacal earth had been a "Mundane Egg," smooth and unwrinkled, "not a scar or fracture in all its body, no rock, Mountain nor hollow cavern." Its rivers had all run from the poles toward the torrid zones, where they ran dry. And as Stephen Jay Gould reminds us, Burnet imagined this per-

fectly spherical globe to revolve "bolt upright" with Eden, at mid-latitude, thus enjoying a "perpetual spring."[11] But when the Great Deluge had come to wash away iniquity, it had permanently shattered this unblemished sphere. To cover the face of the earth, he argued, required a volume of water the equivalent of eight oceans, a liquid mass that could not have been supplied alone from forty days of rain, however torrential. Suppose, though, that beneath the shell of this egg-world lay a wet yolk of subterranean water. And suppose, too, that the constant heat of the sun dried out the shell and generated pressure below. Why, then, it would take no more than a scowl of the Almighty to crack the thing open, releasing a vast flood from the watery abyss. The drainage of those waters into the rifts and fissures produced the great river gorges, lakes, and oceans on what had been a featureless globe. And the most violent scars of the calamity were "wild, vast and indigested heaps of stone—the ruins of a broken world."

As preposterous as all this might seem to a modern sensibility, Burnet's thesis, accompanied by startling and haunting images of his geological apocalypse, had a phenomenal impact, not just on scholars debating the ancient history of the earth but on makers of taste. All seventeenth-century cosmology, after all, was to some degree deductive, and what Burnet's vision missed by way of empirical substance it more than made up for in sheer poetic coherence. The great essayist Joseph Addison, who had read *Telluris Theoria Sacra* as a youth, wrote a Latin ode to

"The Mundane Egg," from Thomas Burnet, *Telluris Theoria Sacra*.

Burnet. His friend and colleague at *The Spectator*, Richard Steele, compared Burnet to Plato, Cicero, and Milton as a transcendent genius. That, he assuredly was not. His argument was certainly original enough to make opponents, as well as disciples, look with new and goggling eyes at a landscape that had been hitherto regarded as fit only for scrawny hermits. Burnet did well enough by the controversy to become King William III's chaplain after the Glorious Revolution of 1688. And his much more powerful namesake, Gilbert Burnet, bishop of Salisbury, who travelled through the Alps a year after the translation from Latin to English of *Telluris Theoria Sacra*, paid its author the compliment of describing it as "ingenious conjecture." "When one considers the Height of these Hills, the Chain of so many of them together, and their Extent both in Length and Breadth . . . these cannot be the Primary Productions of the Author of Nature but are the vast Ruines of the First World."[12]

Neither Gray nor Walpole may have subscribed to the letter of Burnet's theory. But they had been brought up, in a generation educated by Addison,

Steele, and the third earl of Shaftesbury, to invest mountains with archaic magnificence, glorious precisely because of their primordial dreadfulness and savage irregularity. In *The Moralists,* published in 1711, Shaftesbury thought the true magnificence of "Nature was better served by the rude rocks; the mossy caverns, the irregular unwrought grottoes and broken falls of water, the horrid graces of wilderness itself" than "the formal mocking of princely gardens."[13] A year later Joseph Addison commented that "the Alps are broken into so many steps and precipices that they fill the mind with an agreeable kind of horror and form one of the most irregular and mis-shapen scenes in the world."[14] And if

"The Opening of the Abyss and Creation of the Mountains," from Thomas Burnet, *Telluris Theoria Sacra.*

this still seems unintelligible, think of petrified dinosaurs: vast, frightening, prehistoric, but somehow also ancestrally connected to our own world.

An obscure theologian at Christ's College, Cambridge, however notorious, could not by himself generate the psychology of Gothic geology, the peculiar taste for brutally jagged rock pinnacles and unfathomably deep ravines. Horace Walpole's shorthand, to his friend West, for the scenery of pleasing terror was: "precipices, mountains, torrents, wolves [this was before the misfortune with the spaniel], rumblings, Salvator Rosa."[15] And when he went on to describe himself and Gray as "lonely lords of glorious desolate prospects," what he had in mind were the paintings of the seventeenth-century Neapolitan artist who had become the object of a cult among the collecting aristocracy of Whig England. Shaftesbury, who died in Salvator's native town of Naples, owned a Salvator, and Horace's own father, Sir Robert, acquired no less than four for his collection at Houghton. No wonder that in his catalogue of Walpole Senior's collection Horace went out of his way to sing the praises of "the greatest genius Naples ever produced . . . the great Salvator Rosa. His Thought, his Expression, his Landscapes, his knowledge of the Force of Shade, his masterly management of Horror and Distress have placed him in the very first class of Painters."[16]

What his greatest admirers had actually invented for themselves was a "Salvator effect" rather than anything resembling the truth about the artist. To read Horace Walpole or William Gilpin one would imagine that his repertoire con-

sisted almost entirely of desolate mountainscapes where brigands set upon unfortunate travellers. But such scenes were actually only a small part of Salvator's output, which was dominated, like any Baroque artist who sought to be taken seriously, by histories, sacred and classical, and by portraits. At some point toward the end of the seventeenth century, the dramatically grimacing etchings Salvator called his "Figurines" came to be known as *banditti*, which Salvator himself invested with the qualities of a wild man. Turned into a Romantic outcast, he was said to have roamed the hills and mountains of his native Abruzzi

Salvator Rosa, *Bandits on a Rocky Coast*, ca. 1656.

as a child and to have kept company with the very *banditti* he later painted. This, Gilpin insisted, meaning the remark as a compliment, was why he succeeded so well in "views entirely of the horrid kind."[17]

At the bottom of this fantasy was, however, an undeniable truth about Salvator: his obsessive self-presentation as a genius governed by his own muse and freed from subservience either to classical conventions or the tastes of patrons. Perhaps it was his Neapolitan background, with its pleasure in the flamboyant

Salvator Rosa, *Empedocles Throwing Himself into Mount Etna*, drawing, late 1660s.

and the macabre, and his Spanish training amidst the circle of Jusepe de Ribera, who had settled in Naples, that pointed Salvator toward darkness and craggy solitude. There is no doubt, at any rate, that his portraits of the figures from antiquity who disdained the conventions of polite society—like the misanthrope Diogenes, who spurned the attention of Alexander—were meant as personal utterances. And he appears in his extraordinary self-portraits either with half his face shadowed by melancholy or else writing Stoic inscriptions on a death's head. Nor is there much question that Salvator did indeed celebrate the brutal, rocky wildernesses that French classicists like Claude Lorrain preferred to keep on a misty horizon. He seemed, almost perversely, to delight in exactly the scenery that convention rejected as savage: the steep, bare granite hills near Volterra, or the high Apennines. In a justly famous letter of May 1662 to his fellow poet and friend G. B. Ricciardi, describing his journey form Ancona to Rome through Umbria, Salvator goes out of his way to celebrate the "wild beauty" (*orrida bellezza*) of the scenery, "a river falling down a half-mile precipice and throwing its foam up again almost as high."[18] In keeping with his cultivation of a personality of hermit-like loneliness (totally at odds with his earlier, sociable life as street actor and public poet in Florence and Rome), Salvator cherished this landscape of turbulence as the right kind of setting for his adamant genius.

There was, moreover, at least one painting by Salvator, executed toward the end of his life, that was *both* brilliant and influential in promoting the cult of agreeable terror. It depicted the rash Empedocles hurling himself into the mouth of Etna to test his presumption of divinity. The daring of the composition is seen to better effect in the chalk drawing in the Pitti Palace, where the disruption of conventional expectations of space and depth is genuinely disorienting. (It is rather as though the suspension of gravity common in Baroque and rococo decoration of church ceilings had been turned upside down to suggest infinite depth.) Spread-eagled (in exactly the way later generations of Alpine illustrators would represent the unfortunate victims of falls), the over-confident Empedocles is, just momentarily and optimistically, airborne, suspended over the terrible chasm that will give him his answer. All that would remain of his arrogance would be a bronze sandal, hiccoughed up from the belly of the crater. And it is through conveying the hang-gliding trice before freefall that Salvator proved his mettle as a virtuoso of suspense.

The *Empedocles* was bought in Rome by one of the very grandest of the Whig grandees, Lord Chancellor Somers. Engraved, it became the English icon of the vogue for *terribilita*. By the early eighteenth century there were at least a hundred Salvators in England (even more than the number of Claude Lorrains). A thriving industry of Salvator engravers like Hamlet Winstanley, John Hamilton Mortimer (who became known as the "Salvator of Sussex"), and Joseph Goupy had brought what were invariably complimented as "savage" scenes to a public rapidly developing a taste for measured doses of fearsome-

ness. Goupy's *Robbers,* an engraving after a genuine Salvator mountainscape, complete with blasted tree and soaring peaks, was produced around 1740— precisely the moment when Walpole and Gray set off on their journey.[19] No wonder, then, that when Walpole wrote to his friend West "from a hamlet among the Mountains of Savoy," he described a scene that was directly drawn from the efforts of Salvator's imitators and engravers.

> But the road, West, the road! winding round a prodigious mountain . . . all shagged with hanging woods, obscured with pines, or lost in clouds! Below, a torrent breaking the rough cliffs, and tumbling through frag- ments of rocks! Sheets of cascades forcing their silver speed down chan- nelled precipices, and hasting into the roughened river at the bottom! Now and then an old foot-bridge, with a broken rail, a leaning cross, a cottage, or the ruin of an hermitage! This sounds too bombast [*sic*] and too romantic to one that has not seen it, too cold for one that has. If I could send you my letter post between two lovely tempests that echoed each other's wrath, you might have some idea of this noble roaring scene, as you were reading it. . . . We staid there two hours, rode back through this charming picture, wished for a painter, wished to be poets![20]

Twenty years on, Gray would in fact write some of his best lines on the scenery of the English Lake District, less uncompromisingly rugged than Savoy but more accessibly picturesque. But Walpole's letter to West, with its forced onomatopoeia and repeated exclamations, is the writing of someone working hard at hyperbole. Good-naturedly, Richard West teased Horace a little by see- ing through the affected spontaneity of his descriptions and repeating them as though they were verse:

> *Others all shagg'd with hanging woods,*
> *Obscured in pines or lost in clouds.*[21]

Walpole's groping toward a poetic diction of the sublime is not altogether sur- prising. The same year that the two young men of letters went on their tour saw the translation by William Smith of the Greek writer Longinus's treatise on rhetoric, chapter 35 of which was devoted entirely to the sublime.[22] The work had been parodied by Augustan classicists like Pope as the epitome of bathos. So, by embracing the very literary effects rejected by polite opinion as unseemly, Walpole was ostentatiously throwing his allegiance in the direction of the wild men, of whom he imagined Salvator to be the wildest and most uncompromising of all.

If mountains were now seen not as inert heaps of rocks but as *active* forces of nature, protagonists of calamity, their prehistoric role in the upheaval of the earth was complemented by the most famous disasters of antiquity: Hannibal's passage

over the Alps. To relive that history as he journeyed through its landscape, Gray had brought along in his baggage another epic of overwriting: the verse history of the Second Punic War by Silius Italicus.[23] As he was jolted along on the chair-litter, Gray managed to read the better-known (and better-written) account by Livy. But there was precisely something in Silius's crude fury, especially when it came to the famous crossing of the Alps by Hannibal and his elephants, that appealed to the young men's taste for the extreme. And although Gray may not

have known this at the time, in choosing Silius as his literary companion he was connecting himself to one of the most compulsive memory-merchants in the Latin tradition. For besides writing the longest Latin poem of all, Silius Italicus, who had been consul in the Roman province of "Asia" during the reign of Nero, and a famous legal orator, had spent a fortune buying up any available properties that had historical or literary significance and restoring them. The most famous but by no means the only such estates were Cicero's Tusculan villa and Virgil's tomb at the grotto of Posilipo outside Naples.

Frontispiece of Gray's copy of Silius Italicus, *De Secundo Bello Punico* (Amsterdam, 1631).

Silius clearly meant his poem on the war to be a Virgilian epic, and apparently would read it aloud, relentlessly, to captive guests at his dinner parties. But if he fell short of Virgilian elegance, the poem, as Gray discovered, was something more than mere "catalogues and carnage."[24] Though indebted to Livy for the historical outline, Silius creates a memorable picture of Hannibal, the dauntless hero, confronting a monstrous realm of ice that never melts, the "earth rising to heaven, shutting out the sky with its shadow," a place without seasons; the multiply heaped peaks, "Athos added to Mount Taurus, Rhodope united to Mimas, Pelion piled on Ossa."[25]

Aware that only Hercules himself had ever conquered these mountains, "he forced a passage where no man had passed. . . . And from the crag's top called his men to follow." Innumerable horrors follow this fatal act of hubris. Avalanches "swallow men in their jaws"; a violent northwester "strips the men of their shields and rolls them round and round, whirls them aloft in the clouds." "Half-savage men, peeping from the rocks," attack the Carthaginian soldiers, "their faces hideous with filth and with the matted dirt of bristling locks." Frostbite is so merciless that arms and legs are left behind in the snow. Only the warm blood of dying warriors can melt the unforgiving ice.

Though he is unlikely ever to be rescued from his reputation as a second-rate Livy, Silius's rousing verse with its chariot-full of low effects certainly appealed to the first generation of Romantic Alpinists for exactly its clumsy ruggedness. And its core themes: the Herculean lure of the mountains, the fate of the peaks under martial assault, the disasters that befell the overconfident, the fate of great empires on the wintry slopes—all were to become the obsession of mountaineers, generation to generation. From the top of Mont Cenis, terrible and tremendous, minus his fat little black dog, Walpole wrote to his mother about Hannibal confronting "the dreadful vision" of the peaks, "all nature animate and inanimate, stiff with frost."

It was natural, then, for Gray to regret that the great Salvator had not himself painted a Hannibal "passing the Alps, the mountaineers rolling rocks on his army, elephants tumbling down the precipices." Gray took pleasure in seeing the mountains as a chastiser of human vanity, the natural saboteur of those who, literally, got above themselves. This fondness for mountains as instigators of political hubris seemed to find its *locus classicus* in the Hannibal history, so that, throughout the eighteenth century, the tale was rehearsed over and again by poets and painters, the formidable Alps always featuring as the downfall of the high and mighty. The shudder of *personal* danger that Gray and Walpole enjoyed feeling, close to the brink, could be expanded into a mischievous schadenfreude, a sort of gloating at empires coming to grief on Monte Rosa. Gray's letter to his mother connecting Livy's scene-painting with Salvator had been published in William Mason's edition in 1775, so it was possible for another young artist to have taken the Neapolitan artist's omission as a challenge.[26] In 1776 the twenty-four-year-old John Robert Cozens submitted to the Royal Academy *A Landscape with Hannibal in his March over the Alps, Showing to his Army the Fertile Plains of Italy*. Since it was, in effect, his debut piece, Cozens must have assumed that the grandeur and moral implications of the subject would appeal to the elders of the Academy. As befitted these ambitions, he executed the work in oils for the first and last time in his career. The painting is, alas, lost, but it is evident from the title alone that it depicted the moment when, to raise the morale of his men, beset by the bestial montagnards, Hannibal shows them, from the high mountaintop, the fruits of their perseverance.

Alexander
Cozens,
*New Method.
Composition
of Landscape
No. 2*, aquatint,
1785–86.

Alexander and
John Robert
Cozens, *Blot
for Hannibal
Passing the Alps*,
drawing and
tracing over
wash sketch.

What survives of the painting are three very discrepant pieces of evidence as to its appearance. The first is a roundel drawing by Cozens in which the horrid Alps are barely suggested by a projecting crag from which the general points toward the Italian valley. But the painting was seen later by Turner, who made a pencil sketch suggesting a much more dramatic and much more mountainous scene, with soldiers toiling up massed and jagged peaks. And a third drawing is the most ambitious, and surely the work of both John Robert and his father, Alexander, who had invented a whole new pictorial language of "blots": the visual expression of the sensationalism of the sublime.[27] These "blots" were deliberately random impressions meant to express, rather than to slavishly outline, the natural heaping of rock forms. The impulsiveness and spontaneity of their production served to reinforce the new idea—so appealing to the early Romantics of Gray's generation—that mountains were dynamic, even turbulent things. But the way they built into great block-like structures also seemed a practical application of Edmund Burke's doctrine in the *Inquiry* (published two years before Alexander's *Essay to Facilitate the Inventing of Landskip Composition*) that irregular sublimity was to be shown in dark and massive forms.

The colossal Alpine cliff of the Cozenses' *Hannibal* sketch is pure Burkean sublime; frighteningly jagged and vertiginous, it was almost certainly executed by the blot-making Alexander. The delicately misshaped fir trees that act as a repoussoir in the foreground and the lightly inked-in figures of soldiers are surely the work of his son, John Robert. In compliance with Gray's posthumous instructions, there is even the obligatory elephant falling down a crevass.

Though it failed to earn the young Cozens a place in the academy, the painting, according to a contemporary, "astounded everyone" and was evidently a huge success.[28] And if the Victoria and Albert Museum drawing is indeed a reliable guide, then it certainly obeyed father Cozens's doctrine (much influenced by Burke) that "landskips" were essentially expressive projections of specific sensory and nervous states. According to this scheme, "the tops of high mountains" were supposed to represent "surprize, terror, superstition, silence, melancholy, power, strength." And the *edge* of a "mountain that's near" would convey (among other feelings) "admiration from contemplating a great expanse of Sky, fear, terror."[29]

Put all these sensations together and they clearly correspond to the kind of rhetoric used by the Latin historians in describing the mountains as accomplices in luring Hannibal toward his fatal act of overconfidence. And there was another subtext to the *Hannibal* that may have lent the painting immediacy, indeed may have made it controversial as well as spectacular. The Cozenses moved in the circle of some of the most outspoken critics of the American war, including Edmund Burke, John Wilkes, and the notorious republican Thomas Hollis. So it is not inconceivable, as Kim Sloan has suggested, that John Robert's painting was meant as a critical comment on the fate of the British Atlantic Empire.

Cautionary sermons on imperial overreach were not lost, at any rate, on Turner, who accompanied his own extraordinary version of the Livy/Silius history with his poem "The Fallacies of Hope," as if in combined homage to Gray and Cozens[30] (color illus. 37). According to one nineteenth-century source, Turner learned more from John Robert's painting "than anything he had seen."[31] While certainly more tumultuous than anything ever attempted by either father or son, Turner's debt to the Cozenses was twofold. The drama of the precipices and the subject itself may have been prompted by their famous *Hannibal,* but the violent atmospherics of Turner's livid sky seems directly drawn from one of John Robert's most Salvator-esque works (sketched, moreover, in a place where Salvator himself spent a great deal of time): the *Coastal Scene between Vietri and Salerno.*

The year, moreover, was 1812. The fate of Napoleon's Grande Armée in Russia was not yet known, and Turner's narrative emphasis on the fateful sun seducing the Carthaginians to their trans-Alpine doom has been associated with a caution against *British* imperial hubris. But how much more likely (and how much more satisfying) to imagine the patriot Turner lunging at the canvas and building the immense, howling storm, the black squall that hovers over Hannibal's army like a monstrous bird of prey, waiting to enfold and devour. At the very compositional center of this gathering calamity, seen in minute silhouette against the horizon, is a tiny figure. Suppose (as is likely, considering the many engraved versions of it) that Turner knew of David's *Napoleon Crossing the St. Bernard* (1804). Suppose, too, that he knew (and who did not?) of Bonaparte's famous address to the army of Italy in 1796, urging them on over the Alps with happy prospects of plunder from the dreaming cities of the Italian plain. Suppose, then, that some such ghastly tempest as this awaits the new Hannibal, lured by the "Fallacies of Hope" to a richly merited doom. If we can suppose all this, the Lilliputian generalissimo, astride his micropachyderm, may be the most devastating image of Napoleon ever executed.

Turner's *Hannibal,* then, is the culmination of a tradition that made mountains the dreadful judges of human delusions about omnipotence and invincibility. The reinvented Salvator who cast himself as rejecting Alexander; the Burnet-enthusiasts who imagined mountains as the result of the punishing Deluge; the Romantic travellers through the landscape of the outcast, the hermit, and the brigand; and the Hannibalists who rejoiced at the overthrow of arrogance—all contributed to the cult of moralized mountaineering. And at the end of it was Turner's doomed commander, hanging on to his elephant amidst the roaring horror of the storm. The drastic reduction of his pretensions is at the opposite extreme from Dinocrates: the hero made minuscule by the mountain.

ii Vertical Empires, Cerebral Chasms

Hubris, fatalism, and somber melancholy were not obligatory travelling companions over the Alps in the middle of the eighteenth century. Two years after Gray and Walpole went in search of horror, another pair of Englishmen, William Windham and Richard Pococke, undertook a journey to the glacier of Mont Blanc in a quite different frame of mind. Where the Romantic friends had relished the demolition of empires, Windham and Pococke sought to affirm their vigor, as if the fatal mistake that Hannibal had made was in not, alas, being British. When a French writer looked back on their climb up Mont Blanc in the summer of 1741, he conceded that "only an Englishman or a Knight Errant could have done it," a verdict with which the objects of his admiration, Windham and Pococke, would have heartily concurred.

Jean-Etienne Liotard, *Portrait of Richard Pococke in Oriental Dress*, ca, 1739.

They were a wonderful combination of brawn and brains. Windham came from a powerful family of Norfolk aristocrats and, as his nickname of "Boxing Windham" suggests, had an early reputation for rowdy athleticism. In Geneva, where his tutor Benjamin Stillingfleet was supposed to be fortifying the soundness of his Protestant education prior to the Grand Tour of Italy, he boxed his way into trouble, charged by the magistrates with repeated acts of assault, battery, wanton shooting, and general hellraising on the property of sober citizens of the republic.[32] Pococke, for his part, had managed to channel his own restlessness into less notorious pursuits. The son of a grammar school headmaster, he had only reconciled himself to the career in the church his father had organized for him by embarking, in his late twenties, on a series of ambitious and scholarly voyages purporting to test the geographers of antiquity. Together Windham and Pococke represented exactly the union of patriotic muscle and curiosity that sent the British about the globe in the Hanoverian eighteenth century.

Standing on the gelid green spikes of one of Mont Blanc's glaciers, the two men uncorked a bottle of wine and drank "to the success of British arms," and in particular to the health of Admiral Vernon, the hero of Portobello in Walpole Senior's naval war against Spain.[33] It was a war that Walpole had been pressed into waging by London merchants intent on wrecking Spain's claim to control the Atlantic trade with its own colonies in South America. By toasting Vernon, the two young empire-builders were celebrating the admiral who had made the prime minister look weak and foolish. For the year before Windham and Pococke made their ascent, Admiral Vernon had fought the Westminster election of 1740 as a red-blooded patriot and had managed to provoke riotous enthusiasm among the London mobs that cheered him while they burned Walpole's effigy.

It was a knowing toast, then, that brought together patriotism, pugilism, liberty, and the Alps. But over the next century there would be many more paths of glory leading up the high mountains, and not all, contrary to Gray's greatest poem, would lead to the grave. For the Romantics who saw in the mountains the refutation of imperial ambition coexisted with hearty patriots for whom the peaks represented an occasion to demonstrate imperial strength.

In Windham's claim, published in his account of the climb, that he had "long" desired to scale the alarming peak near Chamonix known for centuries as Mont Maudit (The Cursed Mount) we can already hear the authentic voice of throwaway British dauntlessness. There was, too (as there would be for future generations), some genteel scientific ambition. But the mathematician selected by Windham from his Geneva circle to make the climb declined the honor. In fact none of the group of milords that included his tutor, the naturalist and musician Benjamin Stillingfleet, Thomas Hamilton, the seventh earl Haddington, and Robert Price of Foxley appeared especially eager to follow Windham to the remote and probably dreary little hamlet of Chamonix. Perhaps they wrote off the whole idea as a folly typical of a blood like Windham, who had become notorious for shocking the Calvinist fathers of Geneva with his theatricals, and for wallowing in the kind of drunken routs that were second nature to young English gentlemen abroad.

In any event, the prospects for the expedition were looking dim when suddenly there appeared a perfect comrade for Boxing Windham. Exhibiting "a solemn air, wild manners and primitive simplicity," Richard Pococke was one of those irrepressible adventurers, half scholar, half lunatic, on whose existence whole empires are predicated. Windham's laconic comment says it all. "Dr. Pococke arrived at *Geneva* from his voyages into the *Levant* and *Egypt* which countries he had visited with great exactness."[34] "Exactness" may not be quite right since Pococke had been sailing up the Nile with only the craving to find the ruins of ancient Thebes and Memphis to guide him. But he had certainly covered distances, having explored Baalbek and bathed in the Dead Sea to test Pliny's propositions on its salinity.

To a man who still wore the sunburn acquired from climbing the Pyramid of Gizeh, not to mention Vesuvius and the holy mounts of Athos and Ida, what was a mere Alp? Nor was Pococke especially shy about displaying his exotic streak. At Sallanches, a few days into the expedition, the party decided to bivouac, military style, on the meadows, rather than spend the night in some grubby little hostelry. While the servants were preparing dinner, Pococke dressed himself in full oriental finery, turban, flowing kaftan, and sandals, and appointed two of the men to mount guard before his tent with drawn swords. Word spread, of course, that a caliph or sultan had pitched tent at Sallanches, and the shepherds crept toward this Arabian vision with wonder and dread. Within the tent Boxing Windham and Pasha Pococke chuckled at the credulous Switzers.

The remainder of the journey to Mont Blanc is, in fact, narrated as a victory of imperial confidence over timorous native superstition. Toward Chamonix a well-meaning prior tries to dissuade the mad Englishmen from their goal. Like Petrarch's shepherd, like all the fussing wise men since Tiresias, he is a fretful ancient. The peasants who were persuaded to act as guides only by lavish payments were themselves so skeptical that they carried stores of candles and tinder to strike a fire when the party would be so exhausted that they would have to spend the night on the mountain.

Over scenes of old havoc, where avalanches had destroyed everything in their path, the party clambered upward, conceding that, at least at one point, the view was "terrible enough to make most people's heads turn."[35] All the effects of mountain Gothic were anticipated in Windham's description: the bare peaks compared to ruined architecture, "the Tops of which being naked and craggy Rock, shoot up immensely high; something resembling old *Gothic* Buildings or Ruines, nothing grows on them, they are all the Year round covered with Snow." Marvels and horrors continued. The surface of the glacier on which they trod so rent with gaping fissures that it could swallow the local crystal-miners, "their bodies generally found again after some days perfectly well preserved."[36] The nervous peasant guides told stories of witches who emerged at night to dance on the thirty-foot pinnacles of the glacier. But what Windham and Pococke could see with their own eyes was fantastic enough: a turquoise-cream lake whipped into fifty-foot conical waves and then frozen, *tout à coup*. "Greenland" was how the English spoke of it. But in the elegant French account of the expedition which Windham published the following year in the *Mercure de Suisse*, the place was permanently baptized the Mer de Glace.

In the middle of the previous century the great engraver Matthäus Merian had published the first image of a glacier: that of Grindelwald. But none before Windham had dwelled so intensely on its profoundly paradoxical nature: a solid body of ice, to casual appearances inert but which was nonetheless in slow and

inexorable motion, advancing like some remorseless, omnivorous animal (to which it was often compared) eating up woods and meadows.

When the two heroes finally descended from their conquest of "Greenland," the locals were, of course, gratifyingly astonished and "owned to us that they thought we should not have gone through with our undertaking."[37] Another celebration was laid on, perhaps the first in what would become a ritual of Alpinism: the victory supper.

⊹ ⊹ ⊹

THE REACH OF EMPIRE was not yet truly Alpine. But for the restless English there were mountain ranges closer to hand which invited subjugation, survey, and appreciation, very much in that order. In some circumstances altitude was not merely a challenge to imperial energy; it could also be a strategic requirement. Following the final defeat of the Stuart pretender at the battle of Culloden in 1746, the Scottish Highlands were not only scourged of Jacobites; they were also colonized by political arithmeticians from Westminster and Edinburgh. So that in post-Culloden Scotland the conquest of the mountains was not so much a figure of speech as a military fact. The brothers Sandby exemplified this peculiar alliance between drawing and subjugation. Thomas, the elder brother, was attached to the camp of the "Butcher" of the Jacobites, the duke of Cumberland, throughout his bloody campaign in the Highlands, and through the duke's influence won an appointment in the Ordnance Office in London, drafting maps and surveys of the conquered territory. He in turn found a place for his younger brother, Paul, who, following a spell in the London office, was sent to Scotland in 1747. He was just sixteen years old, skilled enough to act as draughtsman to the official survey of the country organized by Lieutenant Colonel David Watson, the deputy quartermaster-general of North Britain. The survey was supposed to provide information to support an extension of the system of strategic forts, roads, and bridges that had originally been built by General Wade after the first Jacobite uprising of the "Old Pretender" in 1715.[38]

Whether from prudence or audacity, Watson, a Lowland Scot, had resolved that the survey (which continued for nine years) would begin in the Highlands and work its way south. From the beginning of his tour of duty, then, Sandby penetrated the remoter fastnesses of Argyll, Moray, and Inverness, sketching for his own pleasure while wielding his theodolite for the king. And though his vision necessarily reflects the obedient topography of pacification, its delicate and decidedly unfearsome aspect may have advanced a more sympathetic view of the Highlands. How was it possible to regard the country around Drumlanrig Castle or the valley of Strathtay as so much barbarian waste when it looked, from Sandby's drawings, to be so many undulations, so very *English*?

Once the sense of threat was removed, a more positive appreciation became possible. Linda Colley has described the several processes by which the Scottish elite was actively co-opted into a reminted Hanoverian union.[39] Confiscations and cross-border marriages resulted in the transfer of substantial Scottish real estate, not just to English dynasties but to aggressively acquisitive Lowland magnates. No wonder, then, that by the third quarter of the eighteenth century there began to be a market for more picturesque depictions of Highland scenery by Scottish artists like Jacob More, Alexander Runciman,

Paul Sandby, *Survey Party at Kinnloch Rannoch, Perthshire,* watercolor, 1749.

and John Clerk, whom Sandby had met in Edinburgh. Sandby himself responded to this tentative exploration of Scottish sublimity by drastically altering his survey drawings for the engraver. The identical view of Strathtay which had looked so innocuous in 1747 was made more dramatic, with loftier peaks and crags; the upland meadows replaced by the suggestion of gorse and heather; and, most significant of all, the inclusion of a kilted Highlander, unthinkable in the earlier period, when wearing the tartan was itself a criminal offense.[40]

It may have been his experience in another region of British mountains that gave Sandby the confidence to adjust his image of them from tame hills to

View of Strath-Spey County Perth 1747.

picturesque heights. In 1771 he went on a sketching tour of northern Wales with Sir Watkins Williams-Wynn (accompanied by four other gentlemen artists, nine servants, and thirteen horses). The result was an album of views of rocky cascades and ruined castles like Dolbadern, where the masonry seems a pure outcrop of the mountains. Together with views from a second sketching tour, Sandby published them in 1778, where they supplied a new route-map of the Celtic picturesque. Williams-Wynn's own house at Wynnstay, set in an arcadian vale, became a favorite subject of Welsh Romantic painters like Richard Wilson, who drenched it in improbably Italian sunlight.

The makeover of Wynnstay into a Celtic idyll was eloquent of an important change in the way the metropolitan center of Britain was beginning to see its mountain periphery. The starkness of Welsh scenery had long been imagined in London as the epitome of barbaric rudeness, and the language spoken by the natives the phonetic equivalent of the landscape. But the massive pull of centralization that came with revolutionized communications in print and transport in Hanoverian England made possible a kind of hybridization of English and Celtic cultures. Earlier Williams-Wynns had been notorious for their defiant provincialism, the third baronet actually declining a peerage with the ostentatious gesture of burning George II's portrait in public. But Sandby's patron, the fifth baronet, actively cultivated the persona of a squire of sublimity, so that before long Wynnstay became an obligatory stop for tourists of the picturesque.[41]

The process of making Welsh scenery desirably Romantic had been developing for some time before Sandby took his own turn to exploit it. In the same year, 1757, that Burke's *Philosophical Inquiry into the Origin of Our Ideas of the Sublime and Beautiful* appeared, Thomas Gray went to a recital in Cambridge given by the blind Welsh harpist John Parry, whose patron, predictably, was Sir

Paul Sandby, *View in Strathtay,* pen drawing, 1747.

Paul Sandby, "View in Strathtay," engraving from Sandby, *150 Select Views in England, Wales, Scotland and Ireland,* 1780.

Paul Sandby, *Sir Watkins Williams-Wynn Sketching,* 1777.

Watkins Williams-Wynn. The performance, which "scratched out such ravishing blind harmony," sent him back to his own ode "The Bard," on which he had been laboring, fitfully, for two years. Now, with the "tunes of a thousand years old" ringing in his increasingly melancholy brain, he finished the poem. Set in the craggy ruin of Conway Castle, "On a rock, whose haughty brow / Frowns o'er old Conway's foaming flood," a bard confronts the invading English king Edward I:

Robed in the sable garb of woe,
With haggard eyes the Poet stood;
(Loose his beard, and hoary hair
Stream'd, like a meteor, to the troubled air)
And with a Master's hand, and Prophet's fire,
Struck the deep sorrows of his lyre.

Defiantly summoning revenge, prophesying doom to the Plantagenet line, the bard announces his own fate of triumph and death, "and headlong from the mountain's height / Deep in the roaring tide he plung'd to endless night."

With Welsh and Scottish troops serving in the British army, the Union could survive Gray's ancient and suicidal guerrilla. Thanks to the ode there was a sudden rage in fashionably sublime circles for druidical harpists, preferably blind. On the eve of his ascent of Snowdon in 1770, for example, Joseph Cradock hired a druidical harpist (as well as a number of "blooming country girls") to sing and dance for himself and his clergyman climbing friend. "It gave me infinitely more pleasure," he wrote of the evening, "to hear this rustic concert than the finest airs of the Italian opera."[42]

Attentive as always to public enthusiasm, in this case for the living relics of druidical antiquity, Sandby produced what, by all accounts, was his best and certainly most acclaimed painting: *The Bard* (also, alas, lost). But Gray's poem became one of the most illustrated narratives of the late eighteenth century, with Thomas Jones, Henri Fuseli, and Philippe de Loutherbourg all weighing in with their increasingly Romantic versions. If literary relics were unavailable they could always be manufactured by the shrewder entrepreneurs of the sublime. The most successful was James Macpherson, the Glaswegian schoolteacher and the manufacturer of *Fingal* and the predictably blind Ossian. In 1760 he published his *Fragments* (they always had to be *fragments,* to suggest ruined authenticity) *of Ancient Poetry Collected in the Highlands of Scotland and Translated from the Gaelic or Erse Language* to instant and phenomenal popular adulation.[13]

Touring books of mountainous Britain were beginning to be popular. If Dr. Johnson's tour of the Highlands and islands is full of dyspeptic com-

Thomas Jones, *The Bard,* 1774.

Joseph Wright of Derby, *Matlock Tor,* 1772.

plaints about the barbaric filth, destitution, and ugliness of the region, Boswell defends the Hebrides as best he can against the torrent of irascibility.[44] And the Welsh naturalist Thomas Pennant's *Tour in Scotland and Voyage to the Hebrides,* traversing much the same route, but which offered a benign view of the scenery precisely opposite from Johnson's, was its equal as a best seller.[45] In 1765 the ailing Gray actually went on a Highland tour to recover his health, something inconceivable a generation before, and stayed at Lord Strathmore's Glamis Castle, where his insomnia could keep company with Lady Macbeth.

It was possible, of course, to encounter the sublime in the very heart of England. Gray's *Journal of the Lakes* was published in 1769, two years before his death, and transposed much of the vocabulary of "horrid beauty" that he had coined on his Alpine journey thirty years before. Its prose-pictures of "turbulent chaos of mountain behind mountain" coupled with the "shining purity" of the lakes immediately and permanently established the Lake District as the definitively sublime English landscape. But it was in the Derbyshire Peak Dis-

trict, for example, that some of the earliest and boldest attempts to produce a new *pictorial* language to represent the rocky heights were attempted. In 1772 Joseph Wright of Derby, for whom landscape had hitherto featured principally as a pastoral setting for aristocratic portraits (but who had long been a Salvator enthusiast), suddenly produced a shockingly direct image of Matlock Tor, with the point of view pushed right against the cliff face, the rock itself painted in thick, scumbled, Rembrandtesque pigment. (Seven years later, on the Grand Tour, he would paint Silius Italicus at the tomb of Virgil.) And it was in the Derbyshire Peak District, praised in the 1770s as the "English Vale of Tempe," that John Robert Cozens first began to experiment with his father's "system" of landscape sensations. While some of his views of the country around Matlock are tamely pretty, two drawings of bald masses of rocks climbing brutally up the page suggest some sort of revelation impending.

In the valley of the river Arve, whose turbulent waters had intimidated even Boxing Windham, Cozens's vision suddenly cleared. A few months after his *Hannibal* was exhibited in the Royal Academy to general (but not universal) acclaim, Cozens had an opportunity to see the Alps for himself. He was invited to go on the Grand Tour with the young antiquarian Richard Payne Knight, future author of *A Discourse on the Worship of Priapus* and pontificator on the picturesque. As befitted a connoisseur of antiquity, Payne Knight insisted that true sublimity came wrapped in a garment of memories and associations. The sublime was not, he thought, simply an apparition that imprinted itself on the untutored senses. On the contrary, the force of its emotional effect depended on the beholder responding through a veil of remembered phenomena: stories, myths, histories, views natural, views pictorial, poetry, and music. The artist who would do most justice to the power of mountain glories, then, would make sure he evoked these memories in his landscapes.

Though they seem to have got on reasonably well, it was his father Alexander's voice, rather than Payne Knight's, that John Robert was hearing when he produced his astonishing watercolors of the Alps. Nothing that had been previously seen, and especially not William Pars's laboriously conscientious views of the Rhône glacier, could possibly have prepared the way for Cozens's version of the same scenery. It seems likely that he had read Marc Théodore Bourrit's books on the Mont Blanc peaks and glaciers. Bourrit was precentor, leading tenor, and choirmaster of the Cathedral of St. Pierre in Geneva. But he had trained as an enamellist and painter and nursed ambitions to become the first great publicist and illustrator of Mont Blanc. His efforts in this line, alas, were woefully anecdotal and amateurish. But the introduction to the English translation by the Reverend Charles Davy and his brother Frederick, published in 1776, was virtually a commentary on Alexander Cozens's intuitive sensationalism. And one observation of Bourrit's spoke a powerful truth, namely, that the spectacle of Mont Blanc was so astonishing that "the mind is almost lost in

the sublimity of its own idea."[46] Payne Knight, speaking (inappropriately) of Salvator, had written something similar in a letter to George Romney when he spoke of mountain scenery as leading "the mind beyond what the eye sees."[47]

It was this super-optical, transcendental self-absorption that John Robert Cozens somehow managed to convey in his monochromatic drawings and watercolors. Impossible to reproduce adequately on the printed page, they are eerie achievements of the highest order, instantly recognized as masterpieces by Constable, who celebrated John Robert as "the greatest artist who had ever touched landscape." Cozens avoided anything like a slavish transcription of his father's blot-rocks, but adhered to the principle that the vision of mountain

Alexander
Cozens,
*A Rocky
Landscape.*

scenery was something conceived cerebrally, as if the artist's imagination interceded between retinal observation and the impression dispatched to the brain. So instead of the sharply delineated views of more conventional watercolorists like William Pars, or the more predictably "sublime" rockscapes of Francis Towne, Cozens's Alpine world is frozen in time-warp Romanticism, mantled with a surreal, hallucinated stillness. Mont Blanc's jagged *aiguilles* have been transformed into pinnacle spires piercing thin-stretched, numinous clouds (color illus. 38). Horizons are interrupted or completely masked by walls of rock that rise sheer and parallel to the picture plane. Everything seems strangely flattened and stretched as if in a dream where the processes of nature have been unaccountably decelerated. In the most disconcerting pictures the traditional rules of perspectival depth have been thrown away altogether, with the delib-

erate sacrifice of middle distance. In place of the classical markers of depth and space, Cozens disrupts the expected relationships between sky, water, and rock, inserting the beholder into crevice-like spaces between suffocating rock-walls, or lifting him aloft in a kind of optical hot-air balloon to drift without benefit of sandbags amidst the capricious Alpine winds. Vegetation is stripped down to the most minimal indication of wispy, wind-beaten pines protruding from the rock like a thin beard. As for human figures, the bandits and travellers of Salvator's landscapes, or for that matter the shamans of the Han and northern Sung masters, are lumbering colossi compared to the insects that creep through the valley of Chamonix. Bourrit's description of his own attempt to climb the fearsome *aiguilles* comes to mind: "a small worm stuck on a prickly plant."[48]

John Robert Cozens, *Mont Blanc and the Arve near Sallenches.*

In Italy, where painters conventionally basked in sunlight, Cozens of course went underground. Even when he did sketch the northern lakes, they were made to resemble watery craters surrounded by rearing cliffs, and the Colosseum was painted, fantastically backlit, swimming in unearthly, shimmering light. The most astounding images, though, penetrate the earth itself, as if sucked through some Virgilian vortex at the mouth of hell (color illus. 35). Mere slits and scoops of light, the more agonizing for being painted brilliant cerulean blue, are all that penetrate the Stygian gloom. These are the Alps inverted: the same loss of balance, the disorientation of depth and space, the same scrambling of perception. It is not just that we are much closer to Turner than to Salvator in these paintings. That is not it at all. We have, in fact, been

pulled into a universe of representation where *something* has got in the way between art and its ostensible object. Superficially, it may seem that the older rather than the younger Cozens's works are the bolder. For once we have got over our shock, we have no difficulty in recognizing in Alexander Cozens's blots the startling ancestry of abstract expressionism. But it is in fact John Robert's vision that is the more bewilderingly powerful. For it is precisely because his Alpine watercolors assume the mask of naturalism that their creative disordering is so potent. It is less the art of abstraction than of distraction.

What Cozens was trying to convey in these "distract" paintings was exactly what Percy Bysshe Shelley described to Thomas Love Peacock when he first saw Mont Blanc, precisely forty years later, as "a sentiment of ecstatic wonder, not unallied to madness."[49] Oddly enough, when Cozens returned to the Alps

John Robert Cozens, *The Colosseum from the North,* 1780.

and Italy six years later in the company of a bona fide ecstatic, his father's old pupil and friend William Beckford, Cozens's watercolors, while still dramatic, lost the weirdly narcotic quality that had made them so distinctive. They are still very beautiful but they are more conventionally Romantic. Perhaps it was the overbearing influence of the excessively sublime Beckford, who declared in a letter to Alexander that as he stared at the mountains he was "filled with Futurity." A few years back, Beckford had written a manuscript romance full of mountain Brahmins and visions of caves turned inside out. John Robert's cliffs that wall the Italian lakes, smothered in brooding Romantic weather, are obligingly Beckfordian (though their more liberated passages anticipate Turner). And the little house where Petrarch lived atop the Monte della Madonna is lit by a gloriously washed sunbeam filtered through the clouds. But the psycho-

logical obliqueness, the brave and perverse distortions of scale and depth, the sheer pictorial madness of the earlier work seem to have vanished.

John Robert
Cozens,
A Ravine.

John Robert
Cozens,
*Castle of St.
Elmo, Naples.*

There are, however, two exceptions. The first purports to be a painting of the Castle of St. Elmo, Naples, but it seems more like some monstrous man-made Alp. A colossal concave wall, pierced only by random, half-blocked apertures, rises up through virtually the whole picture space, dwarfing the minuscule shepherd and his flock. Cutting the shallow box of space from the right is the black line of a natural cliff whose relationship to the tyrannical castle wall is impossible to read. Despite the opening to the sky the overall effect is crushingly claustrophobic.

The St. Elmo painting was probably based on a drawing made for Beckford while they were staying with the volcano-loving Sir William Hamilton at Naples. But it was worked up some years later, and, not surprisingly, Beckford did not care for it. There may have been more community of feeling, though, about Cozens's *Entrance to the Grande Chartreuse,* a place Beckford had visited in 1778 and which he venerated as the sacred site of mountain mystery (color illus. 36). But Beckford's Gothic hyperbole is utterly eclipsed by Cozens's stupendous profile. No abbey, no monks, no summit, no pastoral paradise; only a layering of sharply sheared rocks, saturated in the purple radiance of a sinking sun, seen sideways with the eye of a hovering hawk. Because the base and summit of the

cliff are unseen, the depth and height of the rock-wall appear extended to infinity. And beyond the scrubby fringe of firs clinging to the mountain, there is yet another beak of stone, wreathed in clouds, with the implication of endlessly repeated precipices separated by measureless purple chasms.

John Robert Cozens had arrived at his uniquely unsettling vision of the mountains through an arduous eighteenth-century ascent. The pioneers of Alpine sublimity, Gray and Walpole, had played with sensory brinkmanship, urging those who came after them to move close to the edge. While he had been his father's good student, John Robert had got no closer to that edge than to blot his way up the passes, piling up the masses that would serve the moral of their *Hannibal* well. But all this had been from afar. When John Robert actually faced the mountain summit from the ledges, the imperial prospect that ought to have been yielded up to any confident eighteenth-century enlightened mind rushed past him. His head swam. His brush floated vaporously over the page. His art soared. And when his masterpieces had been accomplished, he went mad.

iii The Seat of Virtue

The Swiss Alps were not just the temple of sublimity. To their growing band of admirers and mythmakers in the eighteenth century, they were also the seat of virtue. As early as 1710 Joseph Addison had published an essay in *The Tatler* together with an allegorical emblem of liberty enthroned amidst the mountains. As much as he had mixed feelings about the Alps, Addison believed they should at least be praised for protecting a well-nigh perfect society. Like the traveller come upon a political Shangri-La, Addison professed to be

> wonderfully astonished at the Discovery of such a Paradise amidst the Wildness of those cold hoary landskips which lay about it, but found at length that the happy Region was inhabited by the Goddess of Liberty; whose Presence softened the Barrenness of the Soil and more than supplied the Absence of the Sun.[50]

The myth of a mountain utopia was not invented, so much as reinvented, in the eighteenth century. In the homegrown sixteenth-century eulogies of city Swiss like Conrad Gesner, extolling the frugal robustness and artless virtue of the montagnards, there was already the making of an Alpine idyll. Simler's *De Alpibus Commentarius,* which related the stirring history of the fourteenth-century rebellion of the three cantons against the Habsburgs, and which described the direct democracy practiced in the annual open-air meetings at Glarus and Appenzell, was in all self-respecting humanist libraries the length and breadth of Europe.

It was the eighteenth-century obsession with primitive virtue, though, that made over the Alpine Swiss in its image. The earlier texts had given the Swiss themselves the necessary myths for a patriotic topography and history. The sixteenth-century writers had done their best to make montagnards and lowland Swiss as similar as possible: part of a community of cantons. But now it was the Alpine *difference* that was celebrated as Swiss virtue. And those natural qualities, grown in the high meadows (for an *Alp* literally was a field), became an international cult in the eighteenth century. In an age of increasingly *imperial* dynastic states, it was the obstinately modest, self-sufficient republican cantons that appealed to self-styled Friends of Liberty.

The founding text of the Helvetic myth of liberty was Albrecht von Haller's long poem *Die Alpen,* first published in 1732 and rapidly translated into all the major European languages, and which went through countless editions before the end of the century. By any definition Haller *was* Enlightenment man: a native Bernese, he was both scientist and poet, mathematics professor at Göttingen, physician to King George II, botanist, geologist, engineer, and director of the great saltworks at Bex, at the western end of the Bernese Oberland. His poem achieved the kind of international fame reserved in the eighteenth century only for the likes of James Thomson and Thomas Gray and generated stories like the one about the pirates who, discovering a chest of books addressed to him, delivered them without more ado to the next port with instructions to deliver them promptly to Dr. Haller![51]

Die Alpen was the fruit of a long journey taken with Johannes Gesner, a mathematician colleague at Zurich. It was in Haller's plodding meter that what turned out to be the indelible portrait of the redoutable Alpine peasant was sketched. Protected from lowland greed, fashion, and luxury by the blessed barrier of his mountains, he drank the cold, clear water that gushed from mountain brooks, inhaled the pure Alpine air untainted by the stinking miasma of metropolitan life. His food was given to him by his habitat: the milk of goats and cows, the fruits and herbs of the upland orchards. His dwelling was a rustic timber chalet, his clothes made from the skins of mountain animals. His wants were simple, his speech candid and economical, his morals mercifully free

from urban debauchery. He was governed by the laws of nature, not the lega-
cies of Rome. Blessed was he!

The Hallerian fantasy immediately took hold in the imagination of Euro-
pean culture and never really lost its grip. Just as the natives of Tahiti became
nature's lovers and the clans of Corsica became nature's warriors, bound to a
code of honor, so the herdsmen of the Alps were transfigured into nature's
primitive democrats. They were, in fact, everything Enlightenment Europe was
not: pious rather than witty; fanatically attached to democratic localism rather
than ruled by a centralized bureaucratic monarchy; obstinately traditional
rather than crazed with novelty. No matter that the leading lights in the acad-
emies and universities in Geneva and Zurich yearned to be accepted by their
peers in Paris and Berlin and chafed at the stuffy parochialism imposed on them
by the remnants of Calvinist authoritarianism. Never mind that the Genevans,
if left alone, might well have welcomed the theatricals that William Windham
had brought to the city and which Voltaire would defend against Rousseau's
censorious passion. Never mind, even, that if they looked carefully at the inhab-
itants of the Alpine villages, what observant European travellers saw (and often
remarked on in their manuscript journals and letters) were miserably impover-
ished peasants, reduced, in the case of the villagers of the valley of the Arve, for
example, to hunting chamois or scraping at the sides of caverns for the quartz
crystals they sold to dealers for decorating shoe buckles and snuffboxes. And
as for the vaunted salubrity of the Alps, those who looked with a clear eye saw
the strange phenomena of the throat goiters and excrescences that seemed
inexplicably common in mountain hamlets, as did the conspicuous concentra-
tion of imbeciles. But though it was mentioned all the time, somehow the goi-
tered idiot was not the portrait of the Alpine Swiss that immediately came to
mind when talk of gentians and William Tell drifted over the porcelain cups of
chocolate in Paris salons.

This was Rousseau's doing, of course. His own fantasies about the austere
virtue of his native Geneva had been nourished largely in exile, and in the over-
wrought fabrications of his memory. Geneva was the severe, virtuous watch-
maker father he never actually had, but whose memory he worshipped. Barely
understanding the complicated evolution of Geneva's domestic politics and the
profound social changes that had taken place, Rousseau only wanted his
assumption about its exceptionalism to remain unsullied by vile modernity:
fashion, theater, cosmopolitanism. In other words he wanted Geneva to be
more Genevan than it was, than in fact it had ever been. And he wanted it badly
enough for the bitter dispute over the theater to wreck what was left of his old
friendship and alliances with the *philosophes*, d'Alembert and Voltaire. They
were, he thought, not merely misguided but recklessly wicked in imposing their
alien notions of civility on the one place in the world where liberty and moral-
ity were institutionally, as well as socially, reconciled.

The classic expression of the stubborn virtue of those who dwelled on the slopes by Lac Léman was the twenty-third letter of the lovelorn tutor Saint-Preux to his forbidden love, Julie, in Rousseau's *Nouvelle Héloïse,* perhaps the most influential bad book ever written. The Alps are extolled by Saint-Preux in standard Hallerian clichés. They are the "dike" separating the honest Swiss from the rapacious vices of other nations. The "honest hunger" of their hills and vales "seasons the wild fruit," and though the mountains have nothing to offer their inhabitants but the crudest iron ore, "yet Peru envies you this indigence, for all hardships vanish where liberty reigns and the very rocks are carpeted with flowers."[52]

By the time the complete *oeuvre,* including the *Confessions,* had been published in 1783, the countryside around Geneva had become a site of pilgrimage at least as sacred as visits to Rousseau's tomb on the Isle of Poplars at Ermenonville.[53] In June 1816 Shelley and Byron sailed together on Lac Léman to Vevey, where *La Nouvelle Héloïse* had been conceived. The idea was to approximate, as best they could, what Shelley called "the divine beauty" of Rousseau's imagination. His "Hymn to Intellectual Beauty," composed on the trip, was plainly an act of homage to the shade of Jean-Jacques.[54] Throughout the eight-day boat trip Shelley sat immersed in the book and, like the most dogged literary tourist, read passages aloud when the scenery had specific associations. At Meillerie, the site of Saint-Preux's "exile" from Julie, the two poets ate honey that Shelley declared "the best I have ever tasted, the very essence of the mountain flowers and as fragrant." Learning that Marie-Louise, Napoleon's second empress, had slept in their inn moved Shelley to consider that even though she owed her power to Rousseau's "democracy which her husband had outraged," it somehow reflected well on her that she had come to a place sanctified by the philosopher's memory.

The pilgrimage proceeded with dogged literalism. A violent storm on the lake near Saint-Gingolph that almost capsized the boat reminded the gleeful Byron (who had to take charge to stabilize the bark) not only that had Rousseau's lovers also barely escaped a watery death from a Léman tempest but that the crisis had happened at *exactly the same place on the lake as their own!* At Clarens, Julie's home, Shelley reflected that "a thousand times . . . have Julie and St. Preux walked on this terrassed road, looking towards these mountains which I now behold; nay treading on the ground where I tread." They stroll in "Julie's wood," only to find that the particular spot in which the heroine was transported by rapture had been cut down by the monks of St. Bernard, thereby confirming Shelley in his militant, atheistical anti-clericalism.

Rousseau country was also freedom country. At the grim château de Chillon, mentioned, of course, in *La Nouvelle Héloïse,* the two apostles of republican liberty cursed the horrors of despotism they found in the dungeons,

including an evil sluice gate that could be opened to drown the manacled prisoners. And when they briefly crossed the border into Evian, Shelley saw a population which, notwithstanding the mineral water they drank, was "more wretched, diseased and poor than I ever recollect to have seen." The reason was obvious. They were the subjects of the king of Sardinia, while their happy neighbors gathering roses in Julie's garden were citizens of "the independent republics."[55] And in the same spirit, Shelley could not quite bear to follow Byron in plucking acacia leaves from the desolate garden of Gibbon's old summer house at Lausanne lest he desecrate the memory of the much greater genius of J.-J. After all, how could the "cold and unimpassioned spirit" of a mourner for the Roman Empire possibly compare with the immortal prophet of liberty and equality?

A generation before this summer of Romantic exile on the Alpine lake, there was already a lively competition between English and French eulogists of Helvetic liberty. Sometimes, in fact, the lines of transmission were interestingly crossed. After Rousseau, the most powerful contribution to the myth of Alpine virtue was the French translation of an English travel book. The text was *Sketches of the Natural, Civil and Political History of Switzerland,* originally published by the tireless traveller William Coxe, later archdeacon of Salisbury, who had already produced comparable works on Germany, Russia, and Poland. In the summer of 1776, while John Robert Cozens was revolutionizing the imagery of the western Alps, Coxe took the son of the earl of Pembroke into the high mountains of the northeast ranges. The itinerary was itself significant in that it was not, for once, a mere stage en route to Italy, but rather was deliberately organized as a Swiss mountain circuit, a more spectacular version of the Welsh, Scottish, and Lake District tours that were already crowded with excited devotees of the sublime.

As the title of Coxe's book suggests, he constructed the tour for his pupil as an education in the politics of liberty as much as the aesthetics of the picturesque or the rudiments of geology. "Nature designed Switzerland for the seat of freedom," he announces, echoing Addison, and to observe its practices Coxe took his protégé to northern cantons like Glarus and Appenzell that were reputed to have best preserved direct democracy. He was, himself, no radical, but rather a perfectly conventional Whig, the biographer of Sir Robert Walpole and generally confident that there could be no better system devised for the governance of mankind than the British constitution. But, like many of his generation, Coxe was also painfully aware of its corruptions, and in lofty Helvetia he hoped to show the young aristocrat a portrait of social virtue. What they would see would not be a model for the future so much as a noble anachronism: Greek democracy in chamois leggings.

So far as I know, history does not record what the pupil thought of all this. But the instruction of the teacher, on the printed page, does not make for an

exhilarating read. Whether he is writing about the rural *Landsgemeinde,* assembled in Alpine meadows, or the towns of Lucerne and Zurich, or about the mountains themselves, Coxe seldom raises his evenly pleasant voice above the platitudes of Hallerian idealism or the stock vocabulary of the picturesque. "The country is singularly wild and romantic," he says of the throat-catching region between St. Gall and Appenzell, "consisting of a series of hills and dales, vallies and mountains, the tops of which are crowned with luxuriant pasture." Yes. When he crosses the frontier at the Falls of Schaffhausen (already established as one of the Wonders of the Romantic Universe) and "breathes the air of liberty," the most extravagant compliment he can pay Alpine Switzerland is that "I could almost think for a moment that I am in England."

J. M. Moreau le Jeune, "Julie and Saint-Preux in the Storm," from J.-J. Rousseau, *Collection complet des Oeuvres,* 1774–83.

His French translator, Louis Ramond de Carbonnières, who went to Switzerland a year later, fleeing, like so many other Helvetophiles, a miserable love affair, and in the company (it goes without saying) of the blind poet Pfeffel, believed he understood the reason for this exasperating evenness of temper. The author, he forthrightly declares in his preface, knew not a word of Schweizerdeutsch (or for that matter any other kind of Deutsch), much less Romansch and the many sub-patois of the Alpine valleys which he assiduously catalogues. All that Coxe had to inform himself about such crucial matters as glaciation were dated works in French and English. Ramond himself could afford this churlishly dismissive remark since he himself had grown up bilingual in Alsace, and had added fluent Russian and English (as well as the fashionably pseudo-aristocratic "de Carbonnières") during his education at Strasbourg and Colmar. The son of an official in the army

paymaster-general's office, like countless other hacks in the French Grub Street chronicled by Robert Darnton, Ramond had tried, with little success, to make a living from essays submitted to precarious journals, the most promising of which was the *Journal des dames*. In 1780 he had all but resigned himself to following his father as a minor functionary when he discovered the English edition of Coxe's *Switzerland*.

Lesser men might have been instantly deterred by Coxe's blandness. But Ramond, a genius after his own fashion, saw it as the opportunity of a lifetime. His route in 1777 had been much the same as Coxe's, though he had sought out (or thrust himself on) the luminaries of Swiss intellectual life from Lavater to Voltaire, whose wit, he observed, "was still intact within the ruins of his body." "You see before you," Voltaire had told him, "an old man of eighty-three years and eighty-three maladies."[56] Ramond had always meant to publish these observations on the people and geography of the Alps, especially because he too thought them a living museum of a "natural" society.

In the guise of a conventional translation, then, Ramond decided to piggyback his own book on the shoulders of the unfortunate archdeacon. This augmented book would not only be drastically different in tone but incomparably better informed than its ostensible text. Like an adhesive literary parasite, it would invade, usurp, and ultimately overwhelm its unwitting host. Distancing himself from the outset from the hapless Coxe, Ramond shamelessly exploited the already established French fiction of the haughty and dunderheaded "gentleman" occasionally dismounting from his carriage or horse to condescend to the natives, and planning his route along a chain of agreeable hostelries. He, Ramond, on the other hand, presented himself as a rambler, in the most solitary tradition of Rousseau and Bernardin de Saint-Pierre, travelling everywhere on foot, botanizing meadow by meadow, Alp by Alp, staying in the most squalid hovels, and sharing the curds, whey, and goat cheese of the shepherds.

Thus it was that the mischievous Ramond de Carbonnières came to invent a fresh kind of mountain writing. In its attempt to marry poetic and scientific observation it owed something to the Genevan Horace Bénédict de Saussure's famous *Voyages dans les Alpes* and the genuinely remarkable work of Jean André Deluc on the ascent of Mont Buet. But Ramond's writing aimed to be something more oblique. In virtually the literary equivalent of Cozens's painting, he tried to go beyond mundane observation to record sensory distraction, but to do so with the full force of Romantic expressiveness.

But besides providing the opportunity to exercise this craft for the first time, the Swiss book represents another sort of new genre, one frighteningly close to the most self-conscious experiments of twentieth-century structuralists. In the guise of footnotes, Ramond actually provides a counter-text antiphonally addressed to Coxe's text. The effect is like two badly matched

touring companions endlessly arguing with each other at the back of the bus, the poor Englishman always hobbled by a prior agreement to conduct the debate in high-tone French. Ramond's italicized comments modify, edit, criticize, and even denounce the "father-text." Sometimes, indeed, the interventions escape their grudging confinement as footnotes and climb mountainously up the paper, driving Coxe's wan generalizations right off the page. When he discovered the travesty, the archdeacon was understandably livid. But in a literary culture where piracy was virtually unstoppable, there was little he could do about it. In fact it got worse. In 1803 Coxe suffered the ultimate indignity of having "Coxe-Ramond" (or, we should more accurately say, "Ramond-Coxe") *retranslated* back into English, immediately supplanting his own original version.

The effect of the hybrid is richly impertinent, Coxe indulged as the straight man to Ramond's wicked interlocutor. Coxe utters some generalization about the hospitality of the Swiss peasants. Ramond observes that the locals of Uri and Zug are among the rudest, most grasping, and least hospitable people he has ever had the misfortune to meet. It is Ramond's ground-level discrimination, in ethnography as in topography, that lets him get away with the murder of Coxe and come out crowing at the bier. Where Coxe is content to skim the surface, Ramond plunges into such arcane folklore as the granite boulder lying in a meadow near Gastinen, said by the villagers to have been flung there by that old Helvetic, the Devil, in an attempt to destroy the famous bridge he had built on conditions the locals had flouted. Where at the mountain abbey of Einsiedeln the latitudinarian Coxe sees "a pavement continually covered with prostrate sinners wrapt in meditation and happy to have attained the end of their pilgrimage," Ramond sees a sacred place where the image of the Church as Rock is actually embedded in its site and architecture.

Coxe mentions pastoral ballads, but Ramond knows virtually all the variations of the cowherd's song, the *ranz des vaches*, that had no standard melody or measure but which was altered, village to village, depending on parochial traditions. Made more conventionally melodic, the *ranz des vaches* became, for Helvetophiles, the anthem of Swiss liberty and found its way to the Paris Opera House in the overtures of Grétry's, and then Rossini's, *William Tell* (as well as Schubert's "Shepherd on the Rock"). Ramond is equally knowledgeable about cowbells and costumes, flora and fauna. But there is nothing he knows more about than the paramount matter of cheese. Coxe eats Swiss cheese. Ramond eats sweet, fat Unterwalden cheese; dry, aromatic Bernese Oberland cheese; a great sixty-year-old cheese at Lauterbrunnen "much like a cake of yellow wax"; even the ghastly pickled, putrid cheese of Lucerne. He understood that cheeses were, in fact, important historical sources, since it was customary in many communities to inscribe on the great fifty-pound wheels the names and dates of significant family events: births, deaths, marriages, avalanches, floods, miracles.

To be fair to Coxe (and one could scarcely be less fair than his perfidious translator), there are many passages where the worst that Ramond can do is to complement rather than contradict the author. The most important of these joint efforts describes the famous annual open-air assembly of the inhabitants of Glarus on their mountain meadow. About forty miles southeast of Zurich, flanked by the peaks of Glärnisch and Magereu, Glarus had been adopted by Helvetophiles as the cynosure of Swiss democracy, not just because of the *Lands-gemeinde* but because its village church was actually shared between Catholics and Calvinists. Coxe, of course, thought this mutual tolerance charmingly typical of Switzerland as a whole; Ramond knew that it was unique. Ramond describes the solemnities in the field: the city sheriff, the *Landammann,* leaning on the archaic sword which, it was said, had laid about the Austrian soldiers in the fourteenth century revolt. But Ramond understood that Glarus was not just a glorious survival of primitive democracy. It was also a tight little town with all the backbiting and atavistic nastiness to be expected of such places, especially when fenced in between the Glärnisch and the Magereu. So, as he reports it, the grandiose assembly rapidly degenerates into abusive bickering between clans and neighbors, culminating in a heated discussion as to whether two sixty-year-olds should be allowed to marry near relatives, notwithstanding the infraction of permitted degrees of consanguinity (not to mention the near certainty that the idiot ratio at Glarus would take a turn for the worse). The issue was settled, Ramond tells us, when an exasperated speaker declared that if the old men were in *that* much of a hurry to marry, it was better they did the damage to their own families rather than inflict it on anyone else.[57]

When he comes to sum up the Glarus proceedings, Ramond abandons his skepticism for a disarmingly passionate voice. For all its human failings, this was indeed still a true republic in miniature:

> a meeting of free men, assembled to debate on their common interests, sitting on the soil that gave them birth, which feeds them and which they have already defended against despotical usurpation; having before them their children, animated with a love of liberty which they are taught to cherish. . . . It is a grand and awful spectacle.[58]

After this testimony to political sublimity it comes as a disappointment to learn that in the short term Ramond not only failed to devote himself to the cause of liberty and virtue but actually went about as far from it as anyone could go: namely, to a post with the lecherous, indiscreet, and credulous cardinal de Rohan. It was on the strength of the smashing popularity of the Swiss book (and partly through his Strasbourg connections) that the erstwhile literary struggler was appointed secretary to the cardinal. Being who the cardinal was, this could mean anything. Ramond went along with him to Geneva,

where he became entangled in one of Rohan's affairs that managed to include both adultery and accusations of incest. And before Ramond knew it, he was caught up in the infamous Diamond Necklace Affair, in which the cardinal was fooled into buying and presenting the jewelry to someone he supposed was the queen.

The whole farcical business was made to symbolize the irretrievable rottenness of the Old Regime. So instead of communing with mountain virtues, Ramond got himself mired in metropolitan vices. Instead of watching the meadow democrats, he was obliged to indulge the antics of the great charlatan Cagliostro, who was in Rohan's retinue. Instead of searching for the spirit of liberty, he had to waste time with the Spitalfields fences looking for shady goods.

Unlike France, he got over it. But he needed the help of the mountains to recuperate from the notoriety. By now, sublimity tourism on the roads to the Alps was so popular that Ramond decided to explore a different and much lessknown wilderness: the Pyrenees. There he discovered ranges that, while possessing all the heart-stopping majesty of the High Alps, were refreshingly free of jaded associations. He climbed the terrifying Pic du Midi and lost himself in the rain, fog, and silence. When the mists cleared he wandered over the rocks feeling, as he later wrote, that he had stumbled on some immense primordial convulsion, like a rambler who loses his way and strays onto some battlefield where the bones of fallen soldiers are still strewn about.

The truth was, though, that for many years there were two Ramonds: the solitary prose-painter of the mountains and the gregarious man of society. The Revolution gave him the opportunity of pretending to reconcile the two personalities since it seemed to call for New Men whose very zeal was the product of their estrangement from urbanity. And it may have been the fervor with which his old Strasbourg friends threw themselves into the fray that encouraged him to do likewise. It was not, however, as a Rousseauite republican but as a moderate constitutional monarchist that he was elected to the Legislative Assembly in 1791. Imprudently implicated in the failed coup attempt by General Lafayette in the spring of 1792, he saw his public position become even more dangerous with the overthrow of the monarchy in August of that same year. As quietly as he could, Ramond went back to the little Pyrenean town of Tarbes, from where he went climbing with a peasant botanist he had befriended, his "ben Jacou." But he was too unusual in such a place to escape attention, especially since he publicly adopted incorrect positions, opposing, for example, the prosecution of priests who refused to swear oaths of allegiance to the Republic. In 1794 he was duly detained by the local revolutionary tribunal, first under house arrest and then in ominous solitary confinement.

Liberated at the fall of Robespierre, Ramond became another provincial notable, living with his sister, helping to found, and then teaching at, the local Central School, climbing whenever he could (in particular the deservedly

named Mont Perdu), collecting geological and botanical specimens. But among the luminaries and scientists who made up the ranks of the Institut in Paris and who had been his colleagues in the Legislative Assembly, Ramond had not been forgotten. His austerely scientific measurements in the Pyrenees generated the kind of papers (read in 1802) which guaranteed an invitation to join them. He accepted his rehabilitation with grace; though flattered by Napoleon, he refused, admirably, to keep his mouth shut about the deficiencies of the regime. Happily for him, Bonaparte took this as a sign of integrity rather than sedition and made him a prefect of the Puy. This enabled him to return often to the Pyrenees, where he continued to climb and record, in elaborate detail, the effect of height on the sense faculties.

To those who knew him at Tarbes, Ramond must have seemed a rather remote and saturnine character, not unlike the arid peaks for which he sustained an inexplicable passion. But to read the pages of the *Voyages au Mont-Perdu* is to encounter the most interestingly peculiar mountain writing of its generation. Ramond's aim (like Ruskin's a half century later) is not just to characterize the sensory disorientation of very high altitudes but to describe them with as much scientific precision as he can command. Yet he also wants to give his account the visionary power of poetry. The result is an extraordinary mélange of optical effects and sensuous responses: vertiginous empiricism. He is as fascinated by the subtle alterations of color produced by mica in the granite as by the illusions of color changes in the dark blue skies overhead; by the fogs that seem to be "vomited from the mountains," the impression that the valleys are multiplying themselves beneath the cloud layers.[59] He sees an eagle flying against the wind at what seems to be full velocity and, virtually at the same time, attempts a calculation about the bird's flight mechanics relative to the wind speed, *and* meditates on the violent battles he has seen between ravens and eagles, tearing at the same carcass.

At the heart of it all is his perverse insistence that mountains not only *seem* to be moving when one loses middle distance; in the very long-term view, they are. Spend any time in their company, Ramond warned, and you will be robbed of your conventional grip on time. Human history, human *revolutions* will suddenly seem a momentary blink against the immense scroll of eternity embedded in the rock. At a particular geological fault line, "one world ends; another begins, governed by laws of a wholly other existence."[60] In another passage in the *Voyages au Mont-Perdu* he is more dramatic still: "Traversing the mountain, one travels from life to death."[61] As one ascends or descends different strata, whole epochs, millennia, with their shells and fossils enclosed within the rock, pass by. So that mountaineering for him becomes akin to time travel: a way to access the perspectives of the planet, if not the universe.

In another respect, too, the essential faculty of Enlightenment man, reason, seemed to fail the mountaineer on Mont Perdu. For when the climber is

surrounded both above and below by cloud, mist, and granular snow, his power of *measurement,* of relative scale, is alarmingly disrupted. And "suddenly" the "earth disappeared." Not only the earth, actually, but Ramond's spectacles, when, on the horrendous face of Mont Perdu, they fall into a crevass. Short-sighted as he is, and only able to crawl along *very* carefully, Ramond sees a horsefly and a mountain earwig maneuvering with careless ease over the rock. So much for our god-like omniscience, he thinks. "A feeble insect plays about here where I have to hang on for dear life."

When all the soundings had been taken, the barometric pressures recorded, altimeter readings made, flags planted on peaks, sketches taken to immortalize the moment, something still seemed to have gone wrong with the picture. In the passages that deal with this out-of-kilter dislocation Ramond seems almost like the astronaut diligently performing his assigned duties, only to discover that he is in some sense more than merely a matter of physics, weightless. Lost in exterior space, he is disconcerted to see a whole new prospect open up: the endless space of our interior self. Petrarch had thought this the landscape of his soul. Ramond envisaged it as the frighteningly roomy contours of the mind. The designer of "Space Mountain" for Disney World must have understood this perfectly, even without benefit of reading the forgotten Pyrenean. For inside the concrete Matterhorn there is total darkness save for the shrieks of victims thrown up and down the pitch-black precipices of its indeterminate space.

Would Shelley have taken the ride? His last letter to Thomas Love Peacock from Chamonix, which spoke of "extatic wonder not unallied to madness" at the sight of Mont Blanc, is not a song of rapture. The approach through the valley he found daunting, the mountain walls seeming to bear down on the path, an avalanche exploding in muffled thunder, the snow pouring down the slope like smoke. The brilliant glacier raised in fifty-foot spikes from the bed, crushing the trees in its path, had Shelley imagining some future ice-apocalypse when the whole world would again be covered by glaciation. And the White Mountain itself called from him one of his very darkest and most disturbing poems.[62]

"Mont Blanc" begins and ends in the caverns of Shelley's own mind, where "The everlasting universe of things/Flows . . . and rolls its rapid waves." And unlike all other conventional mountain poems, it is the gaunt inevitability of natural process that grinds its way through the bleak and beautiful poem: "The chainless winds still come and ever came." It is the impersonal imperturbability of the mountain, the pitiless continuity of geological time, against which the "works and ways of man" are impotent, insignificant. "The glaciers creep / Like snakes that watch their prey, from their far fountains, / Slow rolling on." And though, in a brief burst of optimism, Shelley hails the "great Mountain" as having "a voice . . . to repeal / Large codes of fraud and woe," the real lesson of Mont Blanc is its adamant inaccessibility, guarding the "secret strength

of things . . . the infinite dome." And the "Dizzy Ravine" produces in the poet
(as it seems to have done to Cozens the painter and Ramond the writer)

> *a trance sublime and strange*
> *To muse on my own separate phantasy,*
>
> *My own, my human mind, which passively*
> *Now renders and receives fast influencings,*
> *Holding an unremitting interchange*
> *With the clear universe of things around.*

iv Conquests

It was not his mind that was bothering Saussure; it was his forty-seven-year-old
body. For two-thirds of that life he had devoted body *and* mind, heart and soul
to the ascent of Mont Blanc. And now that he had done it he did not feel at all
well. In fact he was overcome by a tide of nausea that made it impossible to
glide into the state of exalted contemplation that the prospect required. For a
man of science, it was bad enough to lose control of one's faculties without
quite understanding why. For a man of sensibility, the theft of the Life-Moment
was almost too much to bear. "I was like a gourmet invited to a superb ban-
quet," he wrote later (when his stomach had calmed down), "whose utter
revulsion prevented him from enjoying it."[63]

Saussure stayed on top of the mountain for three and a half hours before
beginning the weary and painstaking descent. The dread of going down might
have been less acute had he felt at least some of the sense of elation incumbent
on a conqueror of what he had now calculated, beyond any dispute, to be the
highest mountain in all Europe. But (as many other climbers of Mont Blanc
would confirm) the prospect from the peak, even when not cloud-shrouded,
somehow never quite lived up to expectations. Despite the vast expanse of view,
stretching from the Lombard plain to the French Jura, the elevation was, as one
might have supposed, *too high* to see very much. Even on bright days, all sense
of detail below was blurred by the film of mist that hung over the minor peaks.
Later Saussure even confessed to a sense of petulant anger with the mountain,
stamping his blistered feet on the snow as if he could punish it for some of the
discomfort it had cost him to get to the top.[64]

Of course there had been nothing in his science to tell Saussure, when he had gazed up at the mountain for the first time from the valley in 1760, what standing atop it would feel like. He had only the lines of his friend and mentor Haller, his own certainty that it would feel like the perfect melting together of art and science, poetry and data. It would be the ultimate conquest of the Enlightenment because it would enact, simultaneously, both senses of *Aufklärung:* spiritual illumination *and* profound comprehension. He was a decent, rational Genevan Christian, of course, but he had always secretly supposed that the feeling would be god-like.

But Saussure had never felt so mortal. He went about the planned scientific tasks, studying barometric pressure, taking careful altitude surveys, using the hygrometer to measure the dryness of the air (though his cracked and burning skin told him all he needed to know about that). He could feel his heart feathering through his breast; his head throbbed from the cruel alternation of insomnia and narcolepsy that had overtaken him above seven thousand feet; his legs were leaden, his respiration so labored and so painful that it felt as though splinters of ice had pierced the raw cavities of his lungs.

And it is, of course, this candid record of human frailty that makes Saussure's account of his climb so compelling, and its author so endearing. It was the *Voyages dans les Alpes,* put into the hands of the fifteen-year-old Ruskin, that converted him to the cult of mountains for the rest of his life, precisely because, unlike the modern mountaineering epics that he despised, it did not presume to be a chronicle of a superman engaged in a military campaign over the enemy—height. And there is even something engaging (at least to me, in my fiftieth year) about the fact that what is still the very best book about Mont Blanc was written by a middle-aged intellectual whose climb was the *second* to reach the summit.

Saussure was too decent to have been particularly jealous on this score. Indeed it was he, in 1783, who had actually offered a premium to the first man to scale the mountain. He might even have given it to the relentlessly self-promoting Bourrit had he actually been able to accomplish the feat himself. And Bourrit had tried a number of times, between 1775 and 1783, but had never made it much beyond the pinnacles of the Grands Mulets, even though he had consciously organized his expeditions, as the Englishman Hervey had told him to, according to "the rules of a soldier." In 1786 it had been Dr. Michel Paccard and the guide Jacques Balmat who had finally reached the top. And no sooner had they done so than their climb was poisoned by controversy, notwithstanding (or possibly because of) the fact that Paccard was married to Balmat's sister. As Claire Eliane Engel shrewdly points out, it was all very well, so far as Bourrit was concerned, that an unlettered crystal-digger like Balmat would take the laurels for the "conquest." But that a doctor, a bourgeois like himself, should share the glory was galling.

So, as all historians of the climb have noted, Bourrit invented a version of the event which, by featuring Balmat as the hero, would appeal to the fashionable cult of the common man and leave Paccard as the fumbling academic, crawling terrified on his belly and lugged to the top by his put-upon partner. This was the version that posterity accepted, including very important messengers to posterity like Victor Hugo and Alexandre Dumas, who interviewed the old Balmat in his seventieth year.

But the irascible Bourrit's malice failed him when it came to Saussure, whom everyone loved. A mine of information about new approaches to the summit, Bourrit had even encouraged Saussure when they met in 1785. But it wasn't until the summer of 1787, with the Paccard-Balmat controversy still raging, that Saussure arrived with his wife, sister, and two sons at Mme Couteret's inn at Chamonix to prepare for an ascent. It was his fifteenth journey to the valley and he was well aware of the dangers. Another of their Genevan circle, the young banker and son of Saussure's colleague at the university Ami Lecointe, had died three years earlier in a horrible fall right into the moraine off one of the *aiguilles* of Charmoz. Chez Mme Couteret there was, despite the usual torrential rain of the Genevan summer, keen expectation among her guests. One of them was the English painter Hodges, who had accompanied Captain James Cook to the other ends of the world in the *Endeavour,* and his conversation filled Saussure with the sense that he too was about to occupy, command, analyze, and describe one of the great vacant spaces of the earth. His generation demanded as much and he would oblige them, not for his own glory, of course, but for the greater good of human understanding.

Ambroise Tardieu, after St. Ours, *Horace Bénédict de Saussure.*

And it was almost a shipload that Saussure took with him when he started up the mountain on August 1: cases of scientific instruments including three barometers; suitable reading for the epic (Homer above all); the substantial provisions, wine, and spirits that were the norm for the time; and a team of eighteen guides, porters, servants, and various hangers-on. It was about as different as could be from Ramond's silent, knuckle-shredding climbs alone or with Jacou, "no library but my memory and no scientific instruments but my senses." Saussure was in no danger of perishing from solitude, and he rapidly discovered that it was possible to overdo military preparation. The next day, on the glacier of des Bossons, the crevasses were so wide that there was nothing for it but to climb down one side of the pinnacles and up the other, with rudi-

mentary steps hacked in the ice. The enormous load carried by the expedition made this a numbingly slow business. Camped in the snow the next night, he woke after midnight, panicked that he would die of suffocation from the sheer numbers sleeping together in the tent. He got up, his body drenched with perspiration, throat like sand, temples pounding, and walked out into the Alpine night. Under a milky, lunar glow an avalanche was beginning to roar down the facing slope.

In fact Saussure was extraordinarily fortunate not to have encountered a similar peril on his chosen route. Some of those who followed were not so lucky, in particular the Hamel expedition of 1820, which failed to judge the freshness of snow newly deposited by an avalanche and lost five members of the

Saussure ascending Mont Blanc, August 3, 1787.

party in a crevass. But for Saussure himself, his pains brought him enormous celebrity. His "Relation" of the climb was translated into English and Italian; his *Voyages dans les Alpes,* while less of a literary tour de force than Ramond's best writing, was *the* Alpine book for two generations. And the climbers who followed—Poles, Russians, Dutch, Danes, even an American, Mr. van Rensselaar, who collected mountains and saw no reason not to add Mont Blanc to Etna and Vesuvius—all sang Saussure's praises as someone who had miraculously combined the roles of Man of Knowledge and Man of Action.[65]

⚜ ⚜ ⚜

SAUSSURE had barely finished enjoying his triumph when a young Englishman, Mark Beaufoy (later the colonel of a London company of militia), showed up at

Chamonix. With an almost vexing insouciance he was up to the top and back again with a speed and agility that stunned even the guides. Later Beaufoy explained that he had been moved by nothing more subtle than "the desire everyone has to reach the highest places on earth." That sort of axiomatic voice would be heard again, speaking clipped English on the peaks. Increasingly, the complicated and cumbersome apparatus of measurement was being left behind and with it the pretension that high ascents were contributing to the sum of human knowledge. The real scientists of the period now wielded the geologist's mallet and they could do their work as walkers rather than climbers. Sketch pads and flags, on the other hand, became commonplace. By 1827, when the Scotsman John Auldjo made his ascent, a muscular, quasi-military determination had replaced the reveries and fatalistic spells of self-annihilation that had assailed the Romantic generation. Though when, at the summit, Auldjo rather decently decided to drink "to the prosperity of the inhabitants of the world," he discovered that high altitude, super-effervescent champagne was not such a wonderful idea. "The rapid escape of the air it still contained produced a choking and stifling sensation which was very unpleasant and painful while it lasted."[66]

Despite the surprises that the mountains could spring on even experienced climbers, Alpine tourism had become big business. By 1830 a *diligence* or a *berline* left Geneva three times a week (in 1840 it would be daily) for the trip to Chamonix, which took about eighteen hours, including stages by horses, mules, and portered chairs.[67] Napoleon's stupendous Simplon Pass ought to have made the initial passage over the Alps a great deal less arduous had not the nervous and despotic Sardinian monarchy blocked up the tunnels again for exactly that reason. But tourists came in droves anyway. Mme Couteret's inn, with lodgings for perhaps three travellers, was transformed into the Hôtel d'Angleterre by the end of the eighteenth century, and before long, guides like the Tairraz family cashed in on the growing tourist boom by building their own hotels. By the time the Shelleys were at Chamonix, two thousand travellers would find their way during the "season" between the end of the spring avalanches and the beginning of serious fall snow. Coxe-Ramond had made the cantonal *Landsgemeinden* so popular that Ebel's *Traveller's Guide through Switzerland* was suggesting all-democratic tours that would begin with Appenzell in April and end up with Glarus in mid-May. There were enough mineralogists and botanists arriving to warrant their own section of the guide, and the country was so packed with watercolorists that Ebel had to warn that in some parts of the Alps sketching was thought of as a kind of larceny, *das Land abreissen,* the seizure of the mountains through their representation. Leonardo would surely have loved this, but, Ebel solemnly counselled, "as soon as you perceive these suspicions to rise in their mind, you had better leave off immediately."[68]

Offering comprehensive and up-to-date explanations of avalanches and glaciers, Ebel was full of precautions for mountain walkers and climbers. Do

not, he insisted, "eat a great deal of fat cheese, especially of that which has been toasted, for it occasions . . . violent colics." *Do* remember to take some Kirschwasser along, "for although you had eaten a copious breakfast before you started, a few hours of painful walking in the subtil air of the mountains will create an appetite and you will be tormented by hunger." Make sure you have a piece of green or black crepe to tie over the eyes against snow blindness, and never cut your blisters with a scissor but run a thread through them as close as possible to the flesh without touching it. The very best thing for feet tortured by a hard day's slog up the glacier was, of course, a good soak in a tub of neat brandy, "nothing more refreshing or strengthening."

By 1836 Mariana Starke's guide was *assuming* that a considerable number of those who came to Chamonix to explore the mountains would be ladies.[69] She gave them prudent advice about the seven-hour trip up to Montanvert to see the Mer de Glace and they were told that "persons who venture to walk on its surface should be especially careful to avoid the cracks and chasms upon which it abounds." On precipices, the guidebook writers evidently believed in the cure of familiarity, telling the ladies that it would be a good idea to stare as much as possible over the edge so that the imagination would be so glutted with terror "that you become capable of beholding it with sang-froid." For those whose terror quotient was unlimited, however, whose "eyes cannot get accustomed to contemplate the precipice without fear, you had better give up the pursuit!"[70]

It was precisely to repudiate any lingering notion that women were, in fact, any more prey to terror than men that Henriette d'Angeville climbed to the top of Mont Blanc in 1838, where she cut her motto, *Vouloir, c'est pouvoir* ('To will it, is to be able to do it), into the ice. There was, in any case, not much that could scare Henriette.[71] She had been born at the height of the French revolutionary Terror, which had imprisoned her father and guillotined her grandfather. It was only after Bonaparte came to power that the family was freed from all further liabilities, though they never recovered the bulk of their fortune. She had visited Geneva many times and by her own account had followed the almost annual news of climbs in the mountains of Savoy. So it was natural, after her father died in 1827 and there was the usual bitter fight over inheritance with her brothers, that she moved to Geneva.

Alpine climbs by marginalized aristocrats were common enough to suggest that it was indeed becoming a form of surrogate campaigning, akin to fencing or hunting. And it may have been the first ascent of Mont Blanc by a Frenchman, the comte de Tilly, in 1834, that spurred on Henriette's own determination to follow. In 1838 she was forty-four years old and unmarried. At the time, and since, it has been implied that Henriette was a typically repressed, tough old maid for whom the adventure was some sort of way of acting out her quasi-masculinity.

A mere glance at her portrait ought to be enough to dispose of that claim: vivacious, dancing eyes, dark hair, a strong nose and jaw. Not a great beauty perhaps, but without question attractive. And Henriette made it particularly difficult for herself by refusing to compromise her femininity and *still* be adamant about the climb. In fact, with amazing courage for 1838, she made her sex an issue. In her "green notebook," which was published a year later (with, however, significant omissions), she reports the shock and disgust that greeted her announced intention. "In a city of twenty-five thousand [Geneva]," she wrote, "I was supported by exactly three," which together with her brother Adolphe and another female friend made five allies. Everyone else, from her horrified physician to virtually all her friends and acquaintances, and the guides at Chamonix whom she contacted, assumed it was some sort of "female vanity" that put the idea into her head.

She was, however, in absolute earnest, going ahead with detailed preparations, walking at least a dozen miles a day, toughening her body for the trials ahead. She also designed and made her famous and extraordinary costume, which, although she described it as "peu coquette," was in fact a stunning cross between elegance and practicality (color illus. 40). She knew that layering materials, with silk next to the skin and wool on top of that, would make for the best combination of comfort and warmth, especially on her legs and feet. Her trousers were made of stout Scottish wool, lined with fleece and in a fashionable tartan plaid. On top of these she wore a nearly full-length dress, with the same material belted at the waist. And she already knew enough about the vagaries of the weather to be prepared for both cold and heat, taking, for example, a straw Chamonix sun hat and a full-fur bonnet. But Henriette was also unapologetic about the items which simply pleased her as a woman: the black feather boa, the snow-blind mask not in crepe but in black velvet, the silk foulard, and the one item which she insisted on precisely because it was not *strictly* necessary, the bone shoehorn. In the same spirit, as well as the phial of vinegar, the folding pocketknife, the thermometer and telescope, Henriette made sure she brought along cucumber cream for her face and hands; a decent *cafetière;* a bottle of eau de cologne; and a looking glass, as she wrote,

> a truly *feminine* article, which I would none the less recommend most strongly to anyone contemplating an expedition at altitude (even a captain of dragoons!). For one may use it to examine the skin to see what ravages the mountain air has wrought and remedy them by rubbing gently with cucumber pomade.[72]

It was not, then, that Henriette pretended to be indifferent about what would happen to her woman's body on the mountain. On the contrary, she

actually rehearsed its responses and sensations. What did take her by surprise, though, was the physical strength of the *passion* she felt in the frustrating weeks of bad weather that kept her from what she called her "wedding" to her "frozen lover." When the sun came out she suddenly felt "des élans du coeur" (catches of the heart) when she thought of Mont Blanc, and was so overcome by the emotion that coursed through her body that it sent her to the erotic Song of Solomon to describe her confused and trembling state:

> It seemed to me that I was in exile in Geneva and that my real country was on that snowy, golden peak that crowned the mountains. . . . I was late for my wedding, for my marriage with the face of Israel . . . for the delicious hour when I could lie on his summit. Oh! when will it come?[73]

It was, she confessed (in a passage from the green notebook that is usually omitted from published versions), a *monomanie du coeur,* a true passion, even if it was only a passion that whirled in her head for an icy lover. "La curieuse chose que nous. [What strange things we are.]"

In the Romantic manner, her lover both teased her and dealt roughly with her before succumbing to her determination. Moving smartly along, Henriette quickly won the admiration of the guides who had been deeply skeptical of the whole expedition, especially when she refused to be carried over difficult terrain, and crossed glacier crevasses with ladders, ropes, and sticks like an old Alpine hand. But she was no more exempt from the hardships of Mont Blanc than anyone else. Ferocious winds cut at the small area of her face that was exposed; she experienced the same burning, unslakable thirst, the same palpitations, nausea, and sleeplessness that had affected Saussure. At one point she was so ill that she made her guides promise that if she died they would carry her body to the summit. But that, she insisted, was the only circumstance in which they could think of carrying her. On the summit, though, she was suddenly taken by surprise when Couttet and another guide crossed their hands and lifted her up into the royal blue sky, proclaiming that "you are now higher than Mont Blanc!" It was all right. It was sheer *joie de vivre,* and she, too, did not have much stomach for the champagne, not to mention the leftover gigot.

In Chamonix, Henriette was instantly crowned the "Queen of the Alps." But she was more interested in publicly declaring that she was actually a "sister in Alps" with Marie Paradis, who had been the first woman to get to the top exactly thirty years before, in 1808. Henriette was evidently no feminist in the modern sense, but her climb was not simply undertaken to demonstrate her fitness for admission to the world of men climbers. Though, like Susan B. Anthony's rejection of conventional female attire, Henriette's replacement of voluminous skirts with trousers scandalized polite opinion, it was not at all

meant as an effort to seem manly, and therefore fit to climb. It was emphatically as a woman, and on a woman's terms, that she embarked on the adventure, and her trousers did what similar gear would do for the many other women climbers who came after her: they gave her liberty. Equally, for Henriette the ascent was not the "conquest" that men climbers habitually described; it was a consummation. It gave her what many modern mountaineers, male and female, have sought from the experience of a climb, a dizzyingly heightened sense of self-awareness, a sudden and acute vision of the *scale* of one's faculties— a peculiar mixture of self-affirmation and self-effacement.

Had Marie Paradis had a glimpse of the same self-knowledge? Henriette made a point of seeing the old lady, entertaining her and insisting she be invited to the dinner held in her honor. The fact that Marie Paradis, an illiterate peasant woman, explained that it had all been a mistake, a joke, a bet, that her friends had told her she would make money from the tourists if she did it, and that she had suffered so much they had had to drag her to the top, made absolutely no difference to Henriette. In fact one has the strong impression that it intensified the bond the aristocrat felt for the peasant. This, too, was a woman's lot: that something so extraordinary should have been a source of private shame and embarrassment rather than pride and pleasure. Before Henriette returned to Geneva, in the full flush of triumph she went to visit Marie Paradis in her dark and smoky chalet at le Bourgeat and discovered that a little collation had been laid out, as best as Marie could, on a red tablecloth, everything just as neat and hospitable as it could be. There was nothing much the two could say to each other, but in their parting embrace, with tears pricking and brimming, Henriette made sure to say again, "Au revoir, dear sister," to reaffirm how the mountain had truly made them kin in flesh and blood.

v Albert the Great

There was not much wrong with Albert Smith's appetite when *he* got to the top of Mont Blanc. Which is just as well, since he had brought along four legs of lamb, four shoulders of mutton, six "pieces" of veal, one side of beef, eleven fowl, and thirty-five chickens, to say nothing of the twenty loaves of bread, six-pound bars of chocolate, ten cheeses, and (for this was, after all, an English-

man of Queen Victoria's reign) the vital four packets of prunes. All of which Albert carefully lists for the pleasure of the readers of *The Story of Mont Blanc.*[74] He is not alone in publishing these elaborate lists of victuals. It is as if, in contrast to the feeble guts and nervy imaginations of the Romantics, the Victorians wanted to advertise the imperial splendor of their bowels. They had a constitution, political and alimentary, for this kind of thing: the stomach to take on the world.

No one more than Albert, even though he could not have been less typical of the kind of Oxbridge-educated lawyers, parsons, and medics who made up the gentlemen of the Alpine Club. It is in fact in the ways in which Albert Smith was self-invented that his glory resides.

Not that Albert was, in the universal scheme of things, such an original fellow. Not a bit of it. He was, as he unblushingly tells us right off, a *showman* who liked having a "hit" (his word, apostrophized in all its lovely, vulgar novelty). But for his day Albert was something, all right. And from the very start he knew he would come to something, and that the rest of the world would pay attention.

It was reading *The Peasants of Chamouni,* with its history of the awful fate of Dr. Hamel's climb on Mont Blanc, that got him going. He would go to the little hummock at Chertsey called St. Anne's Hill and pretend that he too was a climber. As his French primer he used Saussure's *Voyages dans les Alpes.* And his first trip to Chamonix was in 1838, just before Henriette's ascent. Smith was then in his early twenties, a medical student in Paris, and was en route to Italy, like Napoleon, via the Great St. Bernard Pass. "Reports of continental disturbances should never keep anyone at home," he insists with wonderful Victorian indifference to the mayhem of foreigners. "On the mountains the glacier will be equally wonderful and the valley equally picturesque whether a republic or a monarchy." And the dinginess of the hotel, all a medical student could afford, was incapable of spoiling the view, "which we must all rave about when we have seen it for the first time. Every step I took that day on the road was as on a journey to fairy-land."[75]

It seemed only right that others should be nudged toward fairyland, even if they were ever so far away. So, back in England, where his medical vocation petered out, Smith divided his time between writing for *Punch* and giving lectures, with illustrations pirated from John Auldjo's wonderful ripping-yarn narrative, painted three feet high and lit with the livid, purple alpenglow everyone expected. Thus equipped with what he called his "Alps in a box," Smith trudged the home countries circuit from Guildford to Richmond, Staines to Southwark. From the heights of his fame and fortune in 1853, he looks back (like the star who was once a spear-bearer) on the days when he and his brother drove their four-wheeled chaise "with Mont Blanc on the back seat," and tells "how we were received, usually with the mistrust attached to wandering pro-

fessors, generally by the man who swept out the Town Hall or the Athenaeum."[76] Those places were generally at the back of the pub, "up dirty lanes," or, worst of all (as he dolefully recollects), in a " 'committee room'—a sort of condemned cell in which the final ten minutes before appearing on the platform were spent with its melancholy decanter of water and tumbler before the lecture and a plate of mixed biscuits and bottle of Marsala afterwards."[77] Only the fact that the audiences were so grateful not to have to hear about the physiology of the eye or watch incandescent charcoal burn in bottles of oxygen *again* saved him. And there was always a good response when, by mistake, the heat of his oil lamps would melt his images and produce spontaneous avalanches at quite the wrong time.

It was, of course, the Americans who showed him how *really* to do it. One of them, Robert Burford, used long dioramas unrolled across a wide stage in Leicester Square and parked his plaster and papier-mâché Mont Blanc on a wagon in Oxford Street to advertise the show. *The* place to do this sort of thing, Smith reckoned, was the faded Egyptian Hall at Piccadilly. After a rapid trip to the Middle East he produced drawings of river journeys from the Nile to the Mississippi, which, together with alarming images of crocodile and buffalo and snatches of exotic music, made up the evening's entertainment called "The Overland Mail." The public loved it.

With the show doing brisk trade, fairyland was looking increasingly like Piccadilly rather than the valley of Chamonix. But 1851, with the Great Exhibition at hand, was a good year to get it over with, exploiting the maximum possible publicity. With the profits from "The Overland Mail" he hired himself an artist, William Beverley, made sure his contacts with the Genevan and English press were in place, and set off for the Mer de Glace on the morning of August 12 with all that meat, a platoon of guides, three other Englishmen including the Honorable William Edward Sackville-West, who seemed not at all abashed by the publicity, sixty bottles of *vin ordinaire,* ten Nuits-Saint-Georges and three great flasks of cognac, none of which were going to serve as a footbath.

Up he went and down he came, on his rear, in fact, clinging to the back of a partner in the quasi-toboggan, quasi-luge position practiced by the guides on slopes that were slippery but safe. (What Albert would have done with the industrial organization of winter sports is beyond imagining.) By a stroke of the kind of luck he kept on having, who was back at the hotel to greet him but the ex-prime minister and hero of the repeal of the corn laws, Sir Robert Peel. This was not bad for publicity, nor was the grand festive supper held to celebrate the "conquest." Within days Albert had completed his story of the climb. In fact the account was finished so quickly that it seems highly probable most of it was written *before* the climb. Dispatched to Geneva, it appeared in *The Times* on August 20, eight days after he had come off the slope.

This was just the beginning of the real adventure. Seven months later, in March 1852, Albert opened "The Ascent of Mont Blanc" at the Egyptian Hall in London, where a pasteboard Swiss chalet at the entrance announced the show. Girls in Swiss costumes showed the public to their seats. This was no Literary Institute lecture at Twickenham. Under dramatic gaslights Albert, in resplendent evening dress, and his outsize muttonchop whiskers, narrated in his high tenor voice as Beverley's dioramas rolled by. Naturally there were some adjustments to the scale and the steepness of the scenery, all by way of adding interest to the story, which itself, of course, was occasionally embroidered. For the same reason, the Mur de la Côte, for example, was said to be

> an all but perpendicular iceberg. You begin to ascend it obliquely—there is nothing below but a chasm in the ice. Should the foot slip or the baton [alpenstock] give way, there is no chance for life. You would glide like lightning from one frozen crag to another and finally be dashed to pieces hundreds of feet below in the horrible depths of the glacier.[78]

In fact, one of the gentlemen, C. E. Matthews, was obliged to point out, "the Mur de la Côte, though one of the steepest bits of the journey, is perfectly safe and the traveller, if he fell upon it, would be landed on soft snow at the bottom."

Albert was not one to let the dullness of the truth get in the way of pleasure and profit. He was, after all, the Hannibal of the Alpine business, the maestro of mixed-media sublimity. Special music was composed for the show, including the Chamonix Polka and the Mont Blanc Quadrille. Both became instant hits. In 1855 his old friend the guide and hotelier Tairraz sent him a pair of chamois which went straight onstage to lend an even greater odor of authenticity. And when one of the St. Bernards (hitherto unknown in England) that lay before the stage during performances obliged Albert with puppies, he was able to present the litter to the queen.

Needless to say, Victoria was delighted. Three months after opening, a command performance was laid on for the Prince of Wales, his brother Alfred, and the other Albert, the prince consort. Two years later Smith was brought to Osborne for the queen, who was sufficiently amused to present him with a diamond scarfpin, exactly the kind of loud bauble he loved. Predictably, the Prince of Wales went back to Piccadilly more than once and it was Albert who introduced him to the pleasures of Chamonix, and the glaciers in 1857, thereby winning even more friends among the hotelier community. Dickens, who had been in Chamonix in 1846, immediately recognized in Albert a virtuoso, charlatan, and genius: his sort of man.

"The Ascent of Mont Blanc" ran for six years, taking thirty thousand pounds and making Albert Smith, before he died in 1860, a seriously rich Vic-

torian. By the next decade Thomas Cook was regularly taking tours to Cha-
monix and the Bernese Oberland; train and ferry and train to Geneva; char-à-
banc to the mountains.[79] At Chamonix they could pay a franc to fire a cannon
and make the Alps echo, and then go, in parties of fifty, up to the Mer de Glace,
where, scarcely more than a century before, Boxing Windham and Richard
Pococke had sat and sipped their wine in the absolute silence of the glacial rift.

<div align="center">vi Prospects of Salvation</div>

Thus began what the members of the Alpine Club, and Leslie Stephen in par-
ticular, mourned as the "cocknification" of the sacred peaks. It was not so much
that they were snobs in the technical sense of pure social contempt. Only nine-
teen of the original two hundred and eighty-one members who made up the
first cohort of the club, from 1857 to 1863, came from the landed classes. Far
more were from the genteel upper-middle-class professions, especially the law,
with clergymen and Oxbridge dons like Leslie Stephen well represented, and
some were even in banking and "trade."[80] Edward Whymper, famous for "con-
quering" the Matterhorn in 1865 (and for having four members of the party
killed in a spectacular accident on its descent), was the son and apprentice of a
Lambeth engraver. It was only as an artist hired to execute illustrations for the
club's regular anthology, *Peaks, Passes, and Glaciers,* that he initially found him-
self in the Alps at all. The club was even prepared to admit the garish Smith,
for all the damage they felt his vulgar entertainment had done to their ideals.
He had, after all, made the thirty-seventh climb of Mont Blanc.

Socially mixed, the clubmen nonetheless did think of themselves as a caste
apart, a Spartan phalanx, tough with muscular virtue, spare with speech, seek-
ing the chill clarity of the mountains just because, as Leslie Stephen, who
became the club's president in 1865, put it, "there we can breathe air that has
not passed through a million pairs of lungs."[81] The lawyers and parsons and
dons who made up the membership were always much more than a dining club,
convening to reminisce endlessly about hanging from a crag on the Schreck-
horn or narrowly avoiding a crevass on the Jungfraujoch. They constituted a
natural aristocracy (the only one worth preserving, they would have said) that
turned its back on the industrial world of gutta-percha shoddiness. They under-

stood the ennobling compulsion of struggle; as George Leigh-Mallory, who lost his life on Everest, would put it, "One must conquer, achieve, get to the top; one must know the end to be convinced that one can win the end."[82] In their moral histories of climbing, the mountain turns headmaster, teaching its students the virtues that were supposed to make them truly *men:* brotherhood, discipline, selflessness, fortitude, sangfroid. And like the far-flung regiments of empire, like the missionaries under palm and pine, like the explorer toiling up the tropical river, they were the true guardians of the patriotic flame. "While all good and wise men necessarily love the mountains," Stephen wrote, "those love them best who have wandered longest in their recesses and have most endangered their own lives and those of their guides in the attempt to open out routes amongst them." It never much occurred to the climbers to ask *why* any-

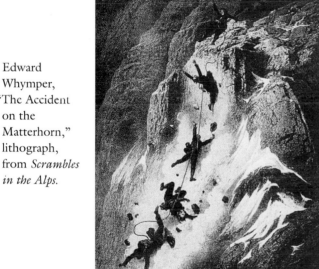

Edward Whymper, "The Accident on the Matterhorn," lithograph, from *Scrambles in the Alps.*

one should need a route over the Rothorn or the Eiger if, at the same time, they wished to hold encroaching modernity at bay.

Writing off Chamonix and the Valais as a tourist swarm, they adopted Zermatt instead, where an appropriately squat little English church immediately arose to take their supplications and commiserate with their disasters. The Matterhorn replaced Mont Blanc as the emblem of their uncompromising ambition; their willingness to take risks, prepare for sacrifices. The quartet who fell from the Matterhorn and are memorialized in the churchyard perfectly exemplified the elements of their community: a clergyman, a younger son of the nobility, an undergraduate, and a veteran guide. The Alpine Club bard, A. G. Butler, invested their deaths with mythic qualities.

> *They warred with Nature, as of old with gods,*
> *The Titans; like the Titans too they fell,*
> *Hurled from the summit of their hopes, and dashed*
> *Sheer down precipitous tremendous crags. . . .*
>
> *Such sons still hast thou England; be thou proud*
> *To have them.*[83]

The more impossible the peak appeared, the more important it was to master it (to use one of Whymper's favorite verbs). The great monsters of the Oberland—Wetterhorn, Jungfrau, Eiger—were all in their sights, and "by 1865," as a modern writer in sympathy with the clubmen puts it, "more than a score of the major Alpine summits which had defied the native Swiss were beaten into submission by the carefully swung axes of British climbers and their guides."[84] And when those had surrendered, the most ardent climbers gave themselves gratuitous difficulties, the better to test their mettle: guideless climbs (much disapproved of by Queen Victoria) or midwinter ascents.[85]

Apart from the mountains themselves, the clubmen had two sets of adversaries to contend with: the vulgarians and the sentimentalists. For the vulgarians, Smith and his type had already done the damage. The best that could be expected was that the hordes—"kings, cockneys, persons travelling with couriers, Americans doing Europe against time . . . commercial travellers and especially that variety of English clergyman which travels in dazzling white ties and forces services upon you by violence in remote country inns"—might be confined to places like St. Moritz "to amuse or annoy each other."[86] It was near St. Moritz, in 1869, that fastidious Leslie Stephen beheld "the genuine British cockney in all his terrors," unmoved by "the soft beauty of an Alpine valley in a summer evening," haranguing the guests and the waiters about the "devilish bad" quality of the Cognac and offering "a few remarks upon the scenery of the country extracted with more or less fidelity from Murray or Baedeker."[87] And the sight of "ladies in costumes, heavy German professors, Americans doing the Alps at a gallop, Cook's tourists" traipsing over the Grindelwald glacier made him feel sorry for the frozen river, as if it were "the latter end of a wretched whale, stranded on a beach, dissolving into masses of blubber and hacked by remorseless fishermen."[88]

The sentimentalists (closely allied to the mystics and metaphysicians) were an altogether more serious problem because they included among them overarticulate, self-appointed enthusiasts for the mountains like Ruskin who supposed that they could actually register the authentic mountain experience just by looking. The presumptuousness of this (even though Ruskin was too important to be excluded from membership in the Alpine Club) struck them as absurd, if not actually offensive. To Stephen, *only* firsthand experience of climbs, the more dangerous the better, actually conferred the right to describe "mountain truth," as Ruskin arrogantly called it. The premise of the Alpine Club aesthetic was that only traversing the rock face, inching his way up ice steps, enabled the climber, at rest, to see the mountain as it truly was. And once he had experienced all this, it became imprinted on his senses in ways totally inaccessible to the dilettante, low-altitude walker.

Leslie Stephen, who, in *The Playground of Europe,* wrote one of the most enduringly profound and remarkable of all mountaineering books, returned to

the perennial obsession with mensuration—measurement—when he attempted to sum up the deepest value of climbing. To gauge the magnitude of a mountain by "the vague abstract term of so many thousand feet," as "the ordinary traveller" or the armchair climber might from his wicker chair on a hotel terrace, was to perpetrate a folly and a delusion. Worse, it was to make such measurement banal. Only the climber who measures its size "by the hours of labour, divided into minutes—each separately felt—of strenuous muscular exertion," could actually provide a *true* account of its magnitude.

> The steepness is not expressed in degrees, but by the memory of the sensation produced when a snow-slope seems to be rising up and smiting you in the face; when, far away from all human help, you are clinging like a fly to the slippery side of a mighty pinnacle in mid-air. And as for the inaccessibility, no-one can measure the difficulty of climbing a hill who has not wearied his muscles and brain in struggling against the opposing obstacles.[89]

It was this confident belief that physical experience yielded the *truth* about the relative scale of mountains and men that most separated Stephen's generation of climbers from the Romantics. Though they anticipated Stephen's awareness of the peculiar intensification of the senses experienced at high altitude, for Ramond, Cozens, Saussure, and Shelley access to the summit was a kind of pyrrhic victory, a *denial* of omniscience. Instead there was an infection of the semicircular canals, a disruption of balance, the unhinging of all the usual markers that fixed bodies in space.

That mental grip might be lost just as physical grip held tight to the rock face was something that the clubmen would never concede. On the contrary, they insisted, it was only on the peaks that their faculties could actually be fully in play and where the true elements of the mountain scenery could be coherently resolved. It was only from some "torn parapet," Stephen believed, that one could make sense of the geographical function of mountains and glaciers, "the vast stores from which the great rivers of Europe are replenished," and properly register the "incredible convulsions" from which the earth was made.[90]

Against what they took to be Ruskin's pretentious obscurantism, his muddleheaded mysticism, and especially his claim that a non-climber could apprehend the "truth" of the mountains, the club mounted an impassioned attack. They held their own art shows, published their own illustrators like Whymper, and congratulated each other on showing mountains *as they really were,* by which they meant an additively constructed assembly of details, each one discretely verifiable.[91] They could never quite grasp the implication of what Ruskin was saying about Turner: that while accuracy of detail is important to absorb

by way of preparation, what he called the "truth" of mountain art could never lie in their literal transcription. Rather, it was in finding a visual idiom to convey the essence of the thing: the beautiful whateveritwas that drew men to mountains in the first place.

✦ ✦ ✦

IT IS HARD to decide which is more amazing: that the Alpine Club ever asked John Ruskin to be a member, or that he consented to join. In the year that Whymper and Charles Hudson climbed the treacherous Aiguille Verte of Mont Blanc, *Sesame and Lilies* erupted with wrath against all those who had desecrated Ruskin's sanctum sanctorum. Lumping together the climbers with the tourists (and certainly knowing how much *that* wounded), he indicted the lot of them.

> You have despised nature; that is to say, all the deep and sacred sensations of natural scenery. The French revolutionists made stables of the cathedrals of France; you have made racecourses of the cathedrals of the earth. Your *one* conception of pleasure is to drive in railroad carriages round their aisles, and eat off their altars. You have put a railroad bridge over the falls of Schaffhausen. You have tunnelled the cliffs of Lucerne by Tell's chapel; you have destroyed the Clarens shore of the Lake of Geneva. . . . The Alps themselves, which your own poets used to love so reverently, you look upon as soaped poles in a bear-garden, which you set yourselves to climb, and slide down again, with "shrieks of delight." When you are past shrieking, having no human articulate voice to say you are glad with, you fill the quietude of their valleys with gunpowder blasts, and rush home, red with cutaneous eruption of conceit, and voluble with convulsive hiccoughs of self-satisfaction.[92]

It was extreme. But then, for Ruskin, everything was at stake. He had first seen the Alps from the Falls of Schaffhausen in 1833, on a trip with his parents. In his wonderful autobiography, *Praeterita,* rightly characterized by Kenneth Clark as the only book Ruskin ever wrote for pleasure, he described that moment as his "blessed entrance into life." Ruskin had roamed over Herne Hill as a child, and had been taken by his parents to the Peak District and to the Lakes. But this was different—different from his anticipation, different from the laborious representations he had seen of the Alps in paintings other than Turner's, different from the poetic clichés that ran together summits and clouds.

> There was no thought in any of us for a moment of their being clouds. They were clear as crystal, sharp on the pure horizon sky, and already

John Ruskin, *Self-portrait with Blue Neck-cloth*, 1873.

tinged with rose by the sinking sun. Infinitely beyond all that we had ever thought or dreamed,—the seen walls of lost Eden could not have been more beautiful to us; not more awful, round heaven, the walls of sacred Death.[93]

One of the few accounts of the Alps that Ruskin had admired was Saussure's (surely the only thing he had in common with Albert Smith). He especially endorsed Saussure's reproaches against those who only gather the details of the Alps, flora and geology; who were only concerned with measurement and the relative scales of men and mountains, without pausing to contemplate the irreducible whole. And in that summer of his Alpine ordination, 1833, Ruskin did his best to capture, in a pen drawing, the "whole" of Mont Blanc, producing, alas, only a fantastically exaggerated pile of pinnacles like beaten egg whites.[94] Starting with the 1842 vacation from Oxford, Ruskin went back to the Alps almost every other year, his technique becoming more Turnerian with each trip. But unlike Turner's, his watercolors and pen drawings seldom succeeded in marrying the profound and elaborate knowledge of natural processes and forms (on which Ruskin spent the most painstaking study) with the explosively poetic impressions of his hero.

"Mountains are the beginning and the end of all natural scenery," he would categorically declare in volume 4 of *Modern Painters*, published in 1856, a year before the establishment of the Alpine Club. "I find the increase in the calculable sum of elements of beauty to be steadily in proportion to the increase of mountainous character" (which is why he called Dutch art the "school of the dead flats"). "The best image which the world can give of Paradise is in the slope of the meadows, orchards, and corn-fields on the sides of a great Alp, with its purple rocks and eternal snows above."[95] *Purple* rocks? Unquestionably, Ruskin would reply, for he set himself to confound conventional assumptions about the look of mountains through the most exacting and fastidious drawing. Two years before publishing part 5 of *Modern Painters*, which he called "Of Mountain Beauty," he produced a watercolor of a single large boulder, and called the fantastic, polychrome composition *A Fragment of the Alps* (color illus. 39). At the time, he was wretched. His marriage to Effie Gray had been unconsummated, it was said, because of his irrecoverable shock on discovering her pubic hair, an odd surprise for someone who claimed to celebrate the decorative glories of irregularity. In 1849 Ruskin deserted her (not for the first time) to travel to Switzerland, where he made loving studies of whole mountains and single rocks. In 1853 Effie and the artist John Everett Millais, who had joined them on a sketching tour of Scotland, fell in love, and the following year she demanded an annulment. Ruskin, of course, went directly to Chamonix with his parents, sketched every day, and worked on the ideas that would culminate in the stupendous prose of "Of Mountain Beauty."

The *Fragment of the Alps* is a Ruskinian manifesto on mountains. It reflected Ruskin's passion for the rich parti-colored, broken decoration that he treasured in stained glass, tapestry, and medieval church sculpture, and which he also saw in natural form in mountains "broider'd with flowers." And it was meant as an attack on lazy images of geological formation, not only in respect of their brilliant color but, even more critically, in respect of their essential shape. Perhaps the greatest of all the revelations that had come to Ruskin, the one that seemed to him to signify how paramount the place of rocks was in creation, was their waviness of deep form. Though their edges might be arbitrarily sharp, their surface was figured with the whorls, loops, braids, and ropes of mineral matter that revealed the dynamic heaves and pressures of geological change. So when the tastemakers of the sublime had eulogized the brutal *jaggedness* of mountain scenery and the impaling spikes of its summits, he argued, they had merely been indulging in callow sensationalism. They had not been looking at all.

Contrary to the climbers' assertions that scaling great heights, in conditions of danger, afforded a knowledge of both the reality and beauty of mountains, Ruskin retorted that climbing was the *least* likely activity to yield the truth of the matter. It was Turner's vision of great waves and humps that were the true revelation, not Whymper's painfully literal sketches of ice staircases. A true report was available to a child or an old man in the revelatory forms of a single rock. Since man's own equipment for measurement was so manifestly inadequate to the scale of whole ranges, why should the understanding of geological processes not be as well expressed in a boulder as an entire mountain?

Those processes had always been at the core of what he called naturalist religion. His guiding light had been William Buckland, the reader of geology at Oxford, whose traditional account of the earth's development in a succession of cataclysms might be more easily squared with the Bible than those who thought of its evolution proceeding in a much longer and steadier process. By the time Ruskin wrote *Modern Painters* he had accepted more of the truth of the second view and had incorporated it into his own account of the structure and forms of mountains. The essential thing to understand, he declared, was that all mountains, even the most apparently spiky of them, were, in their essential structure, curved. The Alpine Club might well have called their self-congratulatory anthologies *Peaks, Passes, and Glaciers,* but the fact of the matter was that there were hardly any mountains in the Alps that could accurately be described as "peaks." What appeared to be pyramidal "spires" from one angle of approach were actually distorted by perspective. Proper inspection actually revealed the mountaintops to be what Ruskin preferred to call "crests," and because of the continual action of moisture were necessarily far more rounded than the received wisdom assumed. This

was even true, as he tried to show in an entire chapter of *Modern Painters,* of the Matterhorn. Though the view from Zermatt, reproduced on all the penny prints and postcards, made the summit appear brutally angular and hooked, if observed correctly, at its highest elevation, its slopes could be seen to be gracefully curved.

John Ruskin, *Junction of the Aiguille Pourri with the Aiguille Rouge.*

These relatively soft and gentle lines documented the continual shifts and folds to which the earth had been subjected, and which were merely overlaid with the splinters and shreds of sharp-ended rocks. The dynamics of glaciation,

explained in the work of J. D. Forbes (whom he had met in the Hôtel de la Poste on the Simplon in 1844), seemed to reinforce this perception, and Ruskin's drawings of the glaciers almost always distort the angle of their curvature into a great flowing convexity. Even the formidable *aiguilles* that posed the greatest test to mountain climbers, when seen edge on, revealed the "writhing folds of sinewy granite." And it was this perpetual abrasion down to curved and sloped forms that demonstrated to Ruskin's satisfaction Nature's abhorrence of brutally straight lines.

She is here driven to make fracture the law of being. She cannot tuft the rick-edges with moss or round them by water or hide them with leaves and roots. She is bound to produce a form admirable to human beings, by continual breaking away of substance. And behold—as soon as she is compelled to do this—she changes the law of fracture itself. "Growth," she seems to say, "is not essential to my work, nor concealment nor softness; but curvature is and if I must produce my forms by breaking them, the fracture itself shall be in curves."[96]

Ruskin did not mean to go out of his way to offend the Matterhorn climbers by characterizing its peak as curved rather than jagged, for he had come to this conclusion long before Whymper and Hudson launched their "assault" on the mountain. But his insistence on the delicate grace and roundness of mountains certainly undercut the military and athletic rhetoric of climbing, which understandably liked to stress the perils of the ascent. If they had to, Ruskin implied, they could play about on the crags to their hearts' content. But let them not suppose for a moment that their *vision* of the mountains was thereby enhanced. "Believe me, gentlemen," he told an audience of Oxford undergraduates, "your power of seeing mountains cannot be developed either by your vanity, your curiosity or your love of muscular exercise. It depends on the cultivation of the instrument of sight itself."[97]

Such shortsightedness, moreover, was not limited to the rock-huggers. Ruskin was equally dismayed by the principle, set forth by the French restoration architect Viollet-le-Duc, that all mountain granite could be reduced to rhomboid or trapezoidal forms.[98] Once these primary forms were grasped, Viollet-le-Duc argued, it would be possible to lay out the basic engineering structure of the mountain, much as one would with a massive building. Viollet-le-Duc was living in a chalet at the foot of Mont Blanc in the 1870s while he worked on the restoration of Lausanne Cathedral, and had decorated its walls with a trompe l'oeil fresco of the mountain. A tireless walker, and an admirer of Ruskin, he assumed that their mutual passion for the Gothic would create a sympathetic bond. He was profoundly in error. But he should have known that Ruskin would have been repelled by his structural determinism. Nor was the author of "The Mountain Gloom" any more likely to warm to Viollet-le-Duc's extraordinary paintings of the Mont Blanc glaciers which attempted an imaginative "reconstruction" of the advance and retreat of the ice streams. As it turns out, Viollet-le-Duc, extrapolating from scars down the face of the Chamonix valley walls (much as he would have extrapolated from ruined vaults and buttresses to the original building), was remarkably close to the truth in his estimate of glacial history. But for Ruskin this was a sacrilegious trespass on the rights of the Creator to present us with geological surprises.

For while Ruskin was indeed fond of making analogies between architecture and the mountain, it was the *ruined* form of the architecture, its pleasing tendency to crumble, that for him proclaimed the mark of divinity. One would no more spend time in painting a "before and after" version of the glaciers than glue back the great chunk of the Matterhorn which seemed to have been sheared away to make the "sublime fragment" of the present mountain. The profound egregiousness of Viollet-le-Duc's fantasy, Ruskin thought, lay in his supposition that there *was* some sort of irreducible geological structure to which the mountain might, even notionally, be returned. There was none such. For the secret of mountains, the quality that made them truly the most blessed of all forms of nature, was their perpetual motion, their inner, ancient pulse working away over the eons. Understand that, and the grim aspect of mountains as the most inert, brutally unyielding extrusion of the earth would fade. This conviction—among the most passionate he held—drew from Ruskin's pen what is, even by his standards, one of his most breathtaking pieces of writing—the passage on "slaty crystalline":

> As we look farther into it [the rock], it is all touched and troubled like waves by a summer breeze; rippled far more delicately than seas or lakes are rippled; *they* only undulate along their surfaces—this rock trembles through its very fibre like the chords of an Aeolian harp—like the stillest air of spring with the echoes of a child's voice. Into the heart of all those great mountains, through every tossing of their boundless crests and deep beneath all their unfathomable defiles, flows that strange quivering of their substance. Other and weaker things seem to express their subjection to an Infinite power only by momentary terrors; as the weeds bow down before the feverish wind. Not so to the mountains. They which at first seem strengthened beyond the dread of any violence or change are yet also ordained to bear upon them the symbol of a perpetual Fear: the tremor which fades from the soft lake and gliding river is sealed, to all eternity, upon the rock; and while things that pass visibly from birth to death may sometimes forget their feebleness, the mountains are made to possess a perpetual memorial of their infancy.[99]

As poetically extravagant as all this is, it is also profoundly subversive. For if mountains were *not* indomitable peaks, then millennia of obsession with their subjugation seemed little other than an exercise in imperial vanity. If their slopes were delicate and graceful, then the hyperbole of the Romantics about "horrid crags" was so much self-indulgent sensationalism. If mountains were soft and giving things, why *not* as well carve an image of woman as much of man into their side? At times Ruskin imagined his mountains as the Almighty's guffaw at the comically masculine presumption to god-like powers. For the truth was that the hills were, like nature, unexpectedly feminine in their creativity, their curved

abundance, their benevolence. Like Henriette d'Angeville, Ruskin addressed Mont Blanc as "Mount Beloved," and he reserved for the mountains a tenderness and intensity of feeling he only managed for women late in his life. And as if the hills *were* indeed his best beloved, he would boil with rage were they to be churlishy dismissed as so much inert mineral deposit. When he looked at the veins of glistening matter encased in a boulder, Ruskin saw a living thing. How could it be otherwise when all the natural energies that made the earth live depended on the generative work of mountain ranges? Mountains regulated the cycle of rain and river without which the land would be desert; mountains moved the "change in the currents of and nature of *air*"; and mountains created the "perpetual change in the soils of the *earth*." Only a dullard could not see, then, that mountains, not man, were at the heart of the life of the world. "Their operations," he wrote, were

> to be regarded with as full a depth of gratitude as the laws which bid the tree bear fruit or the seed multiply itself in the earth. And thus those desolate and threatening ranges of dark mountain which, in nearly all ages of the world, men have looked upon with aversion or terror and shrunk back from as if they were haunted by perpetual images of death are, in reality, sources of life and happiness far fuller and more beneficent than all the bright fruitfulness of the plain. The valleys only feed; the mountains feed and guard and strengthen us. We take our idea of fearfulness and sublimity alternately from the mountains and the sea; but we associate them unjustly. The sea wave with all its beneficence is yet devouring and terrible; but the silent wave of the blue mountain is lifted toward heaven in a stillness of perpetual mercy; and the one surge, unfathomable in its darkness, the other unshaken in its faithfulness, forever bear the seal of their appointed symbol:
>
> > "*Thy* righteousness *is like the great mountains.*
> > *Thy* judgements *are a great deep.*"[100]

WOOD, WATER, ROCK

Thus I sang of the care of fields, of cattle, and of trees, while great Caesar thundered in war by deep Euphrates.

<div align="right">

VIRGIL,
Georgics

</div>

Arcadia Redesigned

i *Et in Arcadia Ego*

There have always been two kinds of arcadia: shaggy and smooth; dark and light; a place of bucolic leisure and a place of primitive panic. I was about ten when I discovered both of them, not two miles from my doorstep. We had moved, unhappily, from the big house by the sea to a small house in London. "Just a bit of bother" was my father's explanation, but it didn't seem to explain very much, especially not the accusations and counter-accusations that flew across the dinner table.

I took to roaming the ten-year-olds' circuit. In my own resort of delight, the local suburban park, two strange-looking grassy mounds, about twenty feet long and ten high, invited occupation, fortification, and defense against all comers. They had to be, we reckoned, funeral barrows left by the Anglo-Saxons, Egberts and Athelstans whose dates we were being ordered to memorize at school. It stood to reason, since there was a similar hummock on Parliament Hill which everyone called "Boadicea's Grave." Sir Hercules Read had excavated it in 1894, hoping to discover ancient British remains, but had failed to find a single solitary spearhead. We all agreed he hadn't looked hard enough.

One day I scraped my ankle on something sharp beneath the tufts of dandelions and thistles covering the grass ridge. The offending object turned out to be a protruding, rusty iron plate, the size of a manhole cover, but squared off and secured with an equally rusty chain. It took a week for someone in the gang to liberate a file from a paternal toolbox, and another week of furtive after-school filing, before we got the chain off. Taking turns to saw away at the flaking chain made us feel happily wicked, though we couldn't exactly put our finger on what we were doing wrong: tomb-robbery, perhaps; at the very least, a grave infraction of the borough bylaws?

When we finally heaved up the iron door, a fearsome smell at once rose from the darkness and punched us in the face. It seemed to have been brewed from rancid mud and ordure, and was of a vileness that not even the most barbaric funeral customs of the ancient Britons could possibly have produced. With grimy handkerchiefs pressed to our faces, we shone bicycle lamps down a set of iron steps and onto an empty dirt floor. It took weeks for us to get up enough courage to penetrate the space, where we were sure we would find something unspeakable, something (we shuddered to imagine) not quite dead. Alas, we had no better luck than Sir Hercules, at least as far as Celtic or Saxon remains went. But the abandoned air-raid shelter did contain a cornucopia of refuse which we instantly invested with the aura of hallowed antiquity. There were empty cigarette packs of glamorously extinct brands; a single lonely sock of uncertain age; a dirty bottle that had once held Tizer, the amber-colored soda pop that still did incredible things to one's innards; a half-buried nine of diamonds that must, we thought, have been concealed up some villain's sleeve when he falsely claimed victory in an air-raid game of gin rummy.

Nicolas Poussin, *Et in Arcadia Ego,* ca. 1639.

Guercino (Francesco Giovanni Barbieri), *Et in Arcadia Ego,* ca. 1618.

We gathered up all this fabulous rubbish and like good archaeologists scrupulously labelled every item, using no more than the usual quota of archaeological deduction, as in: "BUTTON RIPPED FROM SHIRT AT HEIGHT OF HITLER'S HELLISH BLITZ." Word got out and the secret hoard turned into a travelling exhibition, moving surreptitiously from house to house to avoid detection by the borough authorities. One day a pile of bones was mysteriously added to the show. To my suspicious eye they looked distinctly like something rescued from the back of the butcher's shop. But Gerry, that week's temporary curator, swore he had found them in a second shelter and that someone must have forgotten their dog on the day the war ended. We gave him the benefit of the doubt and labelled it accordingly. It seemed right that there should have been *some* sort of sacrifice in our Allied bunker; the bones beneath the playground.

<p style="text-align:center">✦ ✦ ✦</p>

ET IN ARCADIA EGO. The first time I encountered the phrase was not in a pastoral painting or poem, but as an object in Evelyn Waugh's *Brideshead Revisited*. It was inscribed across the pate of the skull that sat in ostentatious splendor in Charles Ryder's Oxford rooms. When the great art historian Erwin Panofsky came to write his article on the two meanings of the classical motto, he congratulated Waugh for both grasping and exploiting its ambiguity.[1] For who, exactly, was the "I" in "And I too was in Arcady"? Read innocently, the tomb inscription discovered by Poussin's shepherds seems to be a wistful epitaph for a pastoral idyll enjoyed and then lost. The monstrous skull in Guercino's earlier version, though, was unequivocal in its declaration that "*even* in Arcady, I, Death, am present." The cunning of Waugh's con-

ceit is to lure the reader into assuming that Ryder's revisitation of Brideshead speaks an elegy for a golden age when in fact it turns into a long graveside oration for the death of faith, love, dynasty, England itself.

Five years on from my descent into the air-raid shelter, my little patch of the English arcadia seemed more golden than gloomy. From Highgate Hill looking south toward the gray city, it coincided precisely with the view that Henry Peacham chose in his *Graphice* (1612) as one of the three fairest in all England.[2] (The

other two were the view from Windsor and the gently hilly countryside around Royston.) Arcadian Hampstead, though, was also a divided territory. On one side lay the great Palladian villa of Kenwood, home, during the late eighteenth century, to William Murray, Lord Chief Justice Mansfield, a colossus of judicial rectitude whose least rustle of periwig made malefactors tremble. The house, though, was sweetness itself. Robert Adam had supplied it with graceful Ionic columns (on the north side) and pilasters on the garden facade beneath an elegant pediment. At the end of the century Humphrey Repton had pushed back the straggling copses of trees and had created a park

that swept down to an ornamental lake. In 1789 Mansfield snapped up "the Singularly Valuable and truly desirable Freehold and Tithe Free Estate," Millfield Farm. The advertiser in *The Morning Herald* shamelessly played to the arcadian market:

> The beautifully elevated situation of this estate, happily ranks it above all others round London, as the most charming spot where the Gentleman and the Builder may exercise their taste in the erection of Villas, many of which can be so delightfully placed as to command the richest home views of wood and water and the distant views of the Metropolis, with the surrounding counties of Essex, Surrey and Berkshire.[3]

In no time at all, Mansfield had the estate stocked with fashionable breeds of cattle. Sheep safely grazed not ten miles from where the objects of the lord chief justice's attention danced on the Tyburn gallows.

The sheep were still there in 1960, tucked away to the southeast of the park, separated from the rhododendron-fanciers and concertgoers by rustic stiles and fences as if they were grazing the pasture of the Cotswolds or the Dales. The house, extended by Mansfield's son, the second earl, was full of paintings of itself, or of similar estates that testified to the elegant pastoral taste of the ruling class. In the graceful Orangery a Gainsborough couple posed before their park, beaming with self-satisfaction. Facing them, through the windows and down the grassy slope, crowds gathered on drowsy summer evenings to hear

George Robertson, *A View of Kenwood*, 1781.

J. C. Ibbetson, *Long-horned Cattle at Kenwood*, 1797.

music played from a pavilion on the far side of the lake, spanned by one of the Chinese bridges Gilpin thought "above all, disgusting." Summer music was, of course, standard arcadian practice, though the typical offering on Saturday night in Hampstead ran to Mendelssohn on massed strings rather than Monteverdi on a plaintive lute. And even Berlioz and Bizet sometimes failed to hold their own against the lusty mallards and the incoming jets.

Only one important ingredient of the idyll was missing. And by the time I was fifteen I had a better chance of completing the picture. Hampstead was, after all, one of Romanticism's holy places. You could walk to Kenwood along the path where nightingales perched in the beeches and where Keats listened as Coleridge's huge, unstoppable *vox humana* drowned them out. Reclining on a blanket on a musical evening beside a crisply shirtwaisted girlfriend, I affected the regulation arcadian manner (as indicated by Titian), leaning nonchalantly on one elbow, a pose that guaranteed paralysis after fifteen minutes.

But what was a little peripheral numbness when the air was thick with the scent of cow parsley and Hampstead lay before us like the golden *campagna* itself?

On the walk home it was an easy thing to stray into the other arcadia: a dark grove of desire, but also a labyrinth of madness and death. By the North End there was a wild garden, conscientiously allowed to choke itself with bindweed, above which wild foxgloves poked their freckled faces. On the garden wall the conventional blue plaque tells the passerby that the Elder Pitt, elevated to be earl of Chatham, once lived in a mansion next to the overgrown yard. It does not, however, say that, in 1767, the deposed prime minister had shut himself away in this Wildwood House, and dropped into a raving melancholy. His paranoia would admit no one across the threshold, so the earl of Chatham had his meals delivered through a hatch at the other end of which his gouty hands snatched at the food. The asylum had been given him by an ambitious parvenu, Charles Dingley, who had made money from Russian sugar beets and Limehouse sawmills and who now meant to ingratiate himself into place and profit. But the madness pursued Dingley all the way to the Brentford hustings, where he made the terrible mistake of allowing himself to be put up as the government's election candidate against the idol of the mob, John Wilkes. When the inevitable brawl broke out, Dingley was so badly roughed up that he died of his injuries some months later.[4]

I doubt that the squire of Wildwood House would have had many mourners among the squatters and sand-diggers of Hampstead Heath. At night, especially, it took little imagination to repopulate the hollows with the carters and footpads who lived there through much of the seventeenth and eighteenth centuries. The wild heath that I knew in the 1950s had already been extensively reforested, so that, on its northwest side, I could make my way through a dense wood, remembering the route from natural signposts: a big hollow oak, a brackish ditch, an embankment carpeted in lily of the valley. But for most of its history it was a wild, open space where only the most tenacious shrubs and bushes would root in its windblown, sandy soil. John Gerard, the Elizabethan botanist, on one of his rustic excursions, found not only brooms and gorses but bilberry and juniper and "wild cow-wheat" growing between the covers.

The primitives of wild arcadia gobbled acorns and kept goats, at least according to Herodotus and Pausanias. All that Hampstead Heath had were bilberries and rabbits and not enough of either to support a settled population. But from the seventeenth century, when its wells and spring were tapped for London's new water supply, the scruffy hills and hollows attracted a shifting, transient population. Sheltered in windowless huts with dirt floors, they lived with an animal or two kept in pens on a scrap of adjacent land. It was then that the heath developed a reputation for lawlessness and drunken riot. Many of the stories were apocryphal. The famous pub on the crest of the North End is supposed to have been named for one of the leaders of the Peasants' Revolt against

Richard II, Jack Straw, but the story remains as much of a fable as Hampstead's other notorious tavern, the Spaniards Inn, sheltering infamous outlaws like Dick Turpin and Jonathan Wild. It certainly was true, though, that Francis Jackson's gang of outlaws fought a pitched battle on the heath in 1674 against the King's Men and that the survivors were hanged on a gibbet between the two great elms that marked the brow of the North End.

And if Hampstead waters were supposed to run with salubrity (like the brooks of old Arcady), many of the local population depended on stronger stuff. They subsisted, after all, by digging for sand meant to be thrown on the floors of London's taverns, so many that even John Taylor could not count them all. And their own parish was rich in drinking haunts and pleasure gardens. During the Gordon Riots in 1780, demagogically incited against attempts in Parliament to relieve Catholics of their legal disabilities, a mob sacked Mansfield's house in Bloomsbury Square. It was moving on Kenwood when the shrewd landlord of the Spaniards Inn slowed the rioters down with such quantities of ale and porter that they were no match for the troopers who eventually arrived on the scene. Further up the road, another platoon of rioters was enjoying ale from Kenwood's own cellars, ladled directly from barrels set by the roadside.

Here, then, was a confrontation between the two tribes of suburban arcadians. In the same year as the riot, George Robertson painted a scene of bucolic contentment that precisely illustrated the rustic paternalism of a Mansfield or his neighbor Fitzroy, who also owned a Palladian villa and attached farm estate. With the dome of St. Paul's in the distance, a harvest is in progress, the threshers and reapers laboring diligently while a couple takes time off from their work to dally in the afternoon shade. This was the sort of arcadia being anxiously defended with the ladles of ale and (if need be) musket shot. Up from the sandpits and rookeries of quite another arcadia rose the brutish hordes of cottars and squatters, brawling, drinking, and fornicating their way over the heath, without benefit of lute or lyre.

From time to time the poor of the heath would take to arms—usually nothing more than a pitchfork or a hunting gun—and march on whichever great gentleman was threatening to abridge their customary rights. But although the colonization of the heath by the polite and the fashionable was irreversible, it remained a favorite pleasure site for the common people of north London. With their horse races banned by the residential judges, they turned to donkeys. And the annual fair brought together gypsy wagons from the county with the tinkers and peddlers of the city. Neither arcadia nor bohemia, exactly, it was this wilder place that was the object of one of the first great preservation campaigns in urban history.

For when, in 1829, the proprietary "Lord of the Manor," Thomas Maryon Wilson, proposed to enclose part of the heath and turn it into a picturesque park, complete with "ornamental walkways," an immediate hue and cry went

up against the despoiler. It was a classic confrontation between developer and conservationists. Thwarted in the plans for his own property, Wilson began to carry out his threat to build extensively over the heath, with his real estate office erected at its most conspicuous point, beside the flagpole on Whitestone Pond. Dickensian in his brazenness, Wilson boasted of his brickworks and precut fencing that would annex the developed land. The response was a legal campaign that ended in two hundred acres of the heath being taken into the public ownership of the London metropolitan authority. But what made the debate extra-

George Robertson, A North View of the Cities of London and Westminster with part of Highgate, 1780.

ordinary was the insistence on the part of the campaigners that the great city *needed* a wilderness for its own civic health. London, of course, was already abundantly supplied with parks, not least Regent's Park, almost immediately to the southeast. But it was precisely the unkempt and uncultivated nature of the heath that was said to be its special gift to the people. Even its scrubby wastes, pockmarked by relentless digging so that the vales resembled a battlefield cratered by mortars, were lovingly represented as London's cherished wilderness. The Hampstead Heath Act of 1871 stipulated that the Metropolitan Board of Works "shall at all times preserve, as far as may be, the natural aspect

of the Heath and to that end protect the turf, gorse, heather, timber and other trees, shrubs and brushwood thereon."[5]

John Constable, *Branch Hill Pond, Hampstead,* 1824–25.

The urban context of this little drama is important. Arguably, *both* kinds of arcadia, the idyllic as well as the wild, are landscapes of the urban imagination, though clearly answering to different needs. It's tempting to see the two arcadias perennially defined against each other; from the idea of the park (wilderness or pastoral) to the philosophy of the front lawn (industrially kempt or

drifted with buttercups and clover); civility and harmony or integrity and unruliness? The quarrel even persists at the heart of debates within the environmental movement, between the deeper and paler shades of Greens. But as contentious as the battle often seems, and as irreconcilable as the two ideas of arcadia appear to be, their long history suggests that they are, in fact, mutually sustaining. Doubtless Thoreau was quite right to insist that "in Wildness is the preservation of the World." But he was also right to press his passions on the zealous Lyceums and sober academies of picket-fence New England.[6]

ii Primitives and Pastorals

You would never know it from the languid nymphs and shepherds that popu-
late the pastoral landscapes of the Renaissance, but the mark of the original
Arcadians was their bestiality. Their presiding divinity, Pan, copulated with
goats (as well as anything else that came his way) and betrayed his own animal
nature in his woolly thighs and cloven feet. Out of pity for his unrequited love
of the nymphs Echo and Syrinx he was taught how to masturbate by his father,
Hermes. Nor was he the only man-beast. For the crime of offering Zeus a child
sacrifice, Lykaon, the son of the first Arcadian ruler, Pelasgus, was transformed
into a wolf and driven from the table of the gods. Abstention from eating
human flesh for nine years would restore his original form. But the uncertainty
of Lykaon's conduct doomed him to a marginal existence between the world
of beasts and the world of men. As for the common run of Arcadians, they shel-

tered from the elements in
caves or the rudest huts,
and subsisted on acorns
and the meat and milk of
their goats. In these oral
traditions and myths, col-
lected by Pausanias,
the brutishness of the
Arcadians was explained by
their great antiquity. As
Philippe Borgeaud has
reminded us in a brilliant
study, they were consid-
ered *autochthons,* original
men sprung from the earth
itself, "pre-selenic," or
older than the moon.[7]

In an unexpected way,
then, the Greek myth of
Arcadian origins antici-

Aphrodite,
Eros and Pan,
sculpture group,
Delos.

pated the theory of evolution in its assumption of continuities between animals and men. The quality that softened the brutishness of Arcadian life was not so much language as music. But the music was that of Pan's pipes, the syrinx, and he could use its woodland and wilderness melodies to bewitch the hearer into states of pan-ic or pan-demonium. In this archaic tradition, though, the wildness of Arcadia and its creatures was not imagined as abhorrent. On the contrary, it was equated with the fecundity of nature. Pan's own name signified "everything." And on some occasions he was needed to stir life from barrenness. When Hades abducted Persephone into the underworld, her mother, Demeter, the corn goddess, went into grief-stricken seclusion in a cave. The fruits of the earth withered and the soil became sterile. It was Pan who broke the dearth by discovering Demeter in his rocky terrain and reporting her hiding place to Zeus. The result of the eventual reconciliation is that the earth, which was condemned to sterility, is once again able to bear fruit and grain.[8] The Arcadians themselves, though, are never imagined by the Greeks as farmers. Hunters and gatherers, warriors and sensualists, they inhabit a landscape notorious for its brutal harshness, trapped between arid drought and merciless floods.

This is not how we usually imagine the Arcadian landscape. It is much more likely to resemble the sort of place described by the Greek lyric poet Theocritus in the third century B.C. In the seventh of his bucolic poems the shepherd Lycidas takes the poet to a harvest festival where they lie on "deep green beds of fragrant reeds and fresh-cut vine-strippings."

> Many an aspen, many an elm bowed and rustled overhead, and hard by, the hallowed water welled purling forth of a cave of the Nymphs, while the brown cricket chirped busily amid the shady leafage, and the tree-frog murmured aloof in the dense thornbrake. Lark and goldfinch sang and turtle moaned, and about the spring the bees hummed and hovered to and fro. All nature smelt of the opulent summer-time, smelt of the season of fruit. Pears lay at our feet, apples on either side, rolling abundantly, and the young branches lay splayed upon the ground because of the weight of their damsons.[9]

Not all features of the primitive arcadia have been eliminated in Theocritus's idyll. Pan, the nymphs, and the goatherds are still in residence, but the wild notes of the syrinx have been replaced by melodious fluting and endless song contests. The goat-footed god still disports himself but has already gone a long way to becoming the custodian of flocks and amiable prankster the Romans would recognize. The lyrics are evidently the product of a sophisticated, even urbane taste. And since Theocritus was originally from Cos, spent much of his life in the Alexandria of the Ptolemies, and ended his days in Sicily,

it is no wonder that the landscape is a rich composite of Aegean olive groves, Egyptian cornfields, and Sicilian vineyards.

And it is in this ripely abundant southern earth that Virgil plants his drastically reinvented arcadia. Pan's indiscriminate insemination has now become the spontaneous fecundity of nature itself. In the climactic fourth eclogue the return of the age of gold is heralded as a time of effortless rustic prosperity. The soil produces fruit and grain without tillage; "uncalled, the goats . . . bring home their udders swollen with milk"; and wool changes hue while still on the backs of rams. From this perfect pastoral state, all savage things have been banished. Serpents have died and the herds are invulnerable against the lion.[10] And in the next eclogue the shepherd Daphnis is mourned as the strong softener, the man who "taught men to yoke Armenian tigers beneath the car."[11]

The *Georgics,* written by Virgil a little later, takes a much more austerely realistic view of the effort needed to produce this agrarian bounty. In its detailed descriptions of the soils suited to different husbandry, and the proper seasons for the various tasks of farming, the book resembles a farmer's calendar of work. But while the *Eclogues* and the *Georgics* offer contrasting views of the leisured and the laborious countryside, they both presuppose, not so very far away, the presence of state and city, the very world of human affairs, in fact, from which they are ostensibly in flight.

When he wrote the *Eclogues* the memory of dispossession must still have been sharp in Virgil's mind. Said to have been brought up "in bush and forest," he had seen his own estates confiscated as the penalty for choosing the wrong side in the civil war that followed the assassination of Caesar. He had, however, successfully appealed their restitution from Octavian (later Augustus). So it is hardly a surprise that the first eclogue takes the form of a dialogue between the bitter exile Meliboeus and the happy Tityrus, who blesses Augustus, "a god he shall ever be for me," for his good fortune. The outcast is offered "ripe apples, mealy chestnuts and pressed cheese" to console himself for the misery of having to part forever from his goats and vines.

The perfect *Georgic* scene is likewise conditional on a sense of order which is the social invention of humanity rather than the pure work of nature. After putting in the thankless hours, the husbandman is rewarded by a spectacle of domestic bliss:

> His dear children hang upon his kisses; his unstained home guards its purity; the kine droop milk-laden udders, and on the glad sward, horn to horn, the fat kids wrestle.[12]

This was the life, Virgil continues, that "the old Sabines" once lived: antique, in other words, but certainly not brutally archaic. And when he turns to the ideal rustic creatures in the following book, they turn out to be the cow

and the bee: the one placidly dutiful, the other a real paragon of social and even political virtue. Passing their lives "under the majesty of law," the bees alone "know a fatherland and fixed home, and in summer, mindful of the winter to come, spend toilsome days and garner their gains into a common store." Their division of labor is admirable: "Some watch over the gathering of food . . . some, within the confines of their homes, lay down the narcissus' tears and gluey gum from tree-bark as the first foundation of the comb. . . . To some it has fallen by lot to be sentries at the gates." The seniors take responsibility for the overall building of the hive; the juniors labor and return home, "their thighs freighted with thyme," to a well-earned rest "in their chambers."

We are at the very opposite pole from the pre-selenic original Arcadia, where there were men who looked, and behaved, like beasts. In Virgil's arcadia there are animals that, at their best, conduct themselves like citizens of a perfect political economy. And in the thinly disguised allegory (itself inherited

Elevation of Pliny's villa at Laurentinum from Robert Castell, *Ancient Villas*, 1728.

from Athenian fables) we can already see the elements of the landscape of Renaissance humanism: diligent labor, placid, meaty livestock, and bounteous fields and orchards, all overseen, politically and visually, by the hilltop fathers of the city-state.

The same mutuality between town and country was at work when the poetic oxymoron of a well-groomed arcadia took the form of a country villa.[13] Of course, the ancient ideal of country life as a corrective to the corruption, intrigue, and disease of the town was always a spur to rustication in a *locus amoenus,* a "place of delight." But it was not accidental that Pliny the Younger cited the closeness of his seaside villa at Laurentinum, seventeen miles from Rome, as one of its chief virtues. In the translation of Robert Castell, who reproduced Pliny's famous letters for the benefit of a new generation of eighteenth-century villa builders: "Having finished the Business of the City one may reach it [Laurentinum] with Ease and Safety by the Close of the Day."[14]

Laurentinum-by-the-sea was unapologetically a weekend place for Pliny, "large enough to afford a convenient though not sumptuous reception for my friends." It had a breezy atrium, hot tubs, a well-stocked library, figs and mulberries in the garden, terrific views over the water, and a steady supply of fresh

seafood. It was, in fact, perfectly equipped as a place of *otium*—leisure—through which one might refresh oneself for the next, inevitable round of *negotium*. And, as James Ackerman points out, it was criticized by more Georgic advocates of the rustic life, like Varro and Columella, as being altogether too suburban. Pliny's second villa in Tuscany would have answered their criticism by being more strictly organized around its farm estate. But virtually *all* Roman villas that we know of were places devoted to the productive ordering of nature, rather than the contemplation of its pristine beauty. Pliny presents his Tuscan house, tucked into the side of the Apennines (close to the modern Città di Castello), as a more remote and serious place than the opulent and seductive Laurentinum. Its climate was harsher in winter (when, evidently, its owner was seldom there), the terrain more rugged. These relatively bracing conditions were, however, merely a challenge to Georgic application. So the fields were submitted to "the largest oxen and the sturdiest ploughs." Vineyards and walking paths, lined with boxtrees, appeared from the stony ground. And though it made a serious effort to be a self-sustaining *villa rustica,* it was nonetheless as much a place of systematic cultivation as the more frankly epicurean resorts, a valley of fruit and wine shut off against the rigors of the wolf-run hills. And, just as at the *villa rustica* of another Latin gentleman farmer, Columella, there was, in all likelihood, gated security—custodians and dogs—to protect the house and farmyard from robbers.

Arcadia redesigned, then, was a product of the orderly mind rather than the playground of the unchained senses. When Vitruvius writes of paintings of "rivers, springs, straits, temples, groves, hills, cattle, shepherds," it is as wall decoration for the exedra—the portico or vestibule area meant for seated conversations.[15] "Satyric" landscapes, featuring caves, mountains, and woods, were on view as stage sets for the Roman theater. And the best recommendation that Pliny can think of for the hilltop view at his Tuscan villa is that the countryside around appears, from a height, "not as a real land but as an exquisite painting."[16] In all these instances there is a conscious element of artifice at work, simultaneously evoking natural forms but making sure they are corrected to eliminate the unsightly or disturbing. The ubiquitousness of temples in the pastoral was the sign of this aesthetic colonization (much like the clubhouse on the twentieth-century golf course). Such places were *not* required to represent natural forms except in the faintest and most abstracted echo. Vitruvius plainly loathes the corrupt fashion of embellishing columns or candelabra with slender stalks and tendrils since "such things neither are, nor can be, nor have been."[17] Buildings like temples or villas should correspond to nature only insofar as their ideal forms demonstrated the harmonies and symmetries governing the structure of the universe.

Once printed editions of Virgil became available after the middle of the fifteenth century, the scenery of the unbeastly pastoral became the model around

42. Theodore Rousseau, *The Forest of Fontainebleau.*

43. Narcise Diaz de la Peña, *The Forest of Fontainebleau.*

44. Nicolas Poussin, *Landscape with Man Being Killed by a Snake*, ca. 1648.

45. One of the dotards among the Burnham beeches.

which villa estates were designed. And by the time Sir Philip Sidney came to invent a poetic *Arcadia* for his sister, the countess of Pembroke, its original landscape and manners had become unrecognizably altered. "The countrey Arcadia" apparently had been singular among all the provinces of Greece not for its wildness and poverty but for the "sweetness of the ayre" and the "well-tempered mindes of the people." Being so fortunately provided for by nature, they were the least war-like of the Greeks, "giving neither cause nor hope to their neighbors to annoy them."[18] It was, in fact, England in perpetual Maytime.

The Renaissance prototype of these heavily sweetened pastorals was Jacopo Sannazaro's Italian-language *Arcadia,* first published in Venice in 1519. Sannazaro's fortunes, like his model's, had suffered from the vicissitudes of war and exile. His patron in Naples, King Frederick of Aragon, had been forced into exile and Sannazaro had himself been obliged to sell his estate (though not his villa). His poetic *Arcadia* recycled all the familiar themes of the *Eclogues:* of thwarted love in settings of impossible sweetness; the golden age when the fields were in common and plenty was invariable and there was no iron, war, or destruction. But to know what this arcadia was actually supposed to look like, Sannazaro has his shepherd Sincero approach a mysterious temple where the pediment is *painted,* like Vitruvius's exedra, with a landscape of "woods and hills, very beautiful and rich in leafy trees and a thousand kinds of flowers." Inside, instead of some satyrical devotee of Pan worshipping an ithyphallic statue of the goat-god, a pious old gentleman burns incense and lamb entrails and prays that "fell hunger be removed from us; may we have abundance always of grass and foliage and clear water for drinking and may we at all times abound in milk."[19]

It was not all birdsong, wild honey, and nosegays in the moonlight, though, in Sannazaro's *Arcadia.* Much of the appeal of his landscape was that, beside the more purely pastoral passages, he introduced a more sensational scenery to express darker emotions. There were the occasional waterfalls (invariably white-spumed) and precipices from which lovelorn shepherds threatened to hurl themselves. A mountain towered above Arcadia, "not very difficult to climb," on which giant cypresses and pines grew. There was the erotic landscape that appeared on the body of the nymph Amaranth, between whose budding breasts a path described a trail that descended toward deep and shady groves. So when recumbent nudes appear in the pastorals of Titian, Giorgione, and Domenico Campagnola, the swellings and hollows of their body become a further *locus amoenus,* a "place of delight." In one of his caves, "marvellously smoothed within," Sannazaro has a wooden image of the "forest Deity, leaning upon a great long staff . . . and on his head he had two horns, very straight and pointed toward heaven; with his face as ruddy as the ripened strawberry."[20] But whether he was meant to be Bacchus, Silvanus, or Pan himself, this creature was evidently more of a flirt than a rapist.

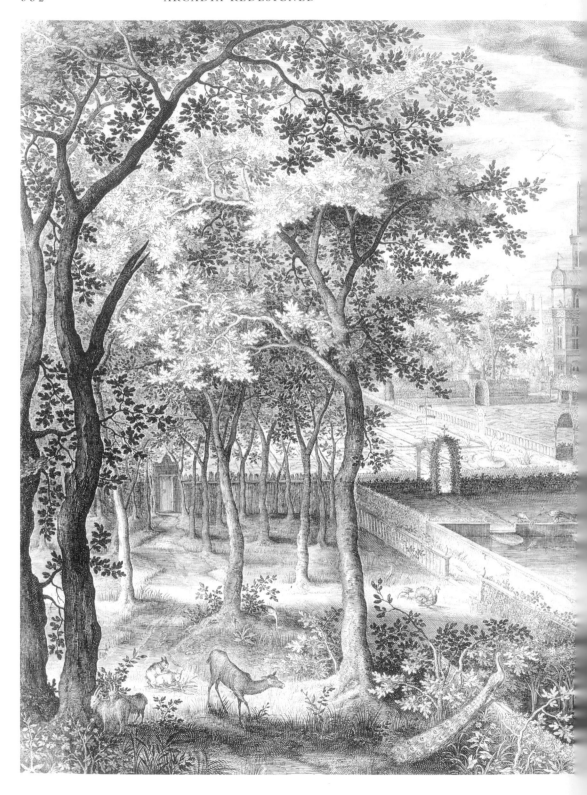

Jan van
Londerseel,
after David
Vinckboons,
*Susanna and
the Elders in
a Garden*,
engraving.

Renaissance humanists evidently enjoyed playing games with the teasingly indistinct boundary between the sacred and the profane. The Christian monastery "paradise garden" had been defined by its strong enclosing walls; the emblem both of Eden's prelapsarian self-sufficiency, and of the Virgin's immaculate conception: fertility without beasts or beastliness. Anne van Erp-Houtepan has traced the etymology of both *yard* and *garden* back to the Old English word for a wattle fence: *geard*. In the first instance the defense was against animals, but in medieval Europe the enclosed garden within an already walled and moated castle or manor became the most protected of all places.[21]

The piercing of this green *cordon sanitaire,* then, had serious implications for the separation of the wild and cultivated arcadias. When David Vinckboons, early in the seventeenth century, set the story of Susanna and the elders in a glorious garden ornamented in the late Renaissance style, with pergolas and formal terraces, the barriers to the wild animals were made deliberately flimsy (and in some places were actually pierced), the better to reinforce the heroine's naked vulnerability. And though the copulating rabbits and the pair of goats and peacocks remain just outside the garden, Susanna's victimization takes place by the side of a fountain supported by satyrs and surmounted by a pissing putto.[22]

Though the Vinckboons garden of lust was a fantasy, the boldest designs for villa gardens created places of wood, water, and rock that could be penetrated by straying from, or passing through, more formal areas. They might take the form of a *sacro bosco,* or "holy grove," not a forest but a carefully untended area on the fringe of the garden. The imprecise boundary between rough country and smooth would be marked by guardian herms: satyr-like heads and trunks, usually armless and mounted on square columns. (In the Vinckboons drawing they appear at the entrance and exit of the love arbor immediately behind Susanna.) Sometimes the figure was that of Pan's father, Hermes, and often it smiled in an intriguing expression of both deterrence and invitation.

Alternatively, the place of pagan pleasure might be a splashing nymphaeum, secreted at the rear of a house or park. For example, near Asolo, at the Villa Maser, where Caterina Cornaro, the Venetian aristocrat who had once been the "Queen of Cyprus," convened her own poetic arcadia, the visitor would walk past Veronese's frescoes extolling the robust virtues of the bucolic life, to the nymphaeum, where erotic sweetness poured from the fountain basins. And Venus herself would often be revealed in grottoes where the floors were made from polished pebbles and the walls glowed with iridescent shells. To discover any of these places was, in effect, to travel backward from the second, pastoral arcadia, to the first, archaic site of raw, unpredictable nature. And implicit in the journey was the comforting notion that the route could be immediately reversed.

There was one famous exception: the extraordinary *sacro bosco* at Bomarzo, near Viterbo, created, for once, in the midst of a genuine forest and where the ground was littered with monstrous heads, and figures either in tortured combat or threatened by wild beasts. It was the nightmare vision of Vicino Orsini, a member of an old Roman aristocratic family and a professional soldier. It has been recently argued that the grotesque stone figures, whose precise meaning has long eluded explanation, may all be connected with Ariosto's great epic poem, *Orlando Furioso,* in which the hero goes mad with unrequited love.[23] Impassioned debate has raged over the war elephant doing terrible things with his trunk to a Roman soldier, though Hannibal can hardly have been far from Orsini's mind. It seems most likely that this is a deliberately jumbled nightmare, with motifs picked and scrambled from the standard Renaissance anthologies of pagan lore and myth. But if it was meant to suggest civilization overrun by the demons, beasts, and monsters of the first world, the fantasy was meant to entertain as

Nicolas Poussin, *Bacchanalian Revels Before a Herm of Pan,* detail, early 1630s.

much as terrify. Visitors startled by the gaping mouth of hell might have noticed the significant amendment to Dante's "Abandon all hope, all ye who enter," which at Bomarzo has become "Abandon all *thought*." And this invitation to happy mindlessness became further apparent on entering, where a picnic table was thoughtfully set up so that visitors could enjoy a little cold collation in hell.

The same ambiguous effect, half playful, half mysterious, was evident in other projects for fantastic gardens, where the idea was to bring the elements of the primal world into the shelter of the garden. At the height of the French Wars of Religion in the late sixteenth century, Bernard Palissy (not merely a hydraulic engineer but a naturalist and chemist) designed a garden of "natural secrets" where adepts and initiates could comprehend the primordial structures of cration. The severely rectangular shape suggested the enclosed *hortus conclusus* of the Christ-

Sacro Bosco, Bomarzo, the mouth of hell.

Sacro Bosco, Bomarzo, interior of the mouth of hell, drawing, Giovanni Guerra.

ian garden. But in emulation of Eden's rivers, four hydraulically pumped streams were to course from grottoes situated at each corner. Inside, brick furnaces would melt enamel inserted into unpolished rocks so that the liquefied ceramic would then suggest primitive organic forms, wriggling their way through the stone. In the "green" cabinet, primitive tree columns would likewise suggest the sylvan origin of architecture, while in the marine grotto, ceramic salamanders and lizards would writhe inside the rocks which formed a salt pool for the real reptiles to crawl in and swim.[24]

Palissy was no wild man. On the contrary, he was a Protestant Platonist who thought that the whole world of creation conformed to sublimely interlocking but mysterious laws. The variety of natural form ought, if correctly discerned, to correspond to the many faces of God. So if the right formulae of inquiry were applied, those laws (and the countenance of Divinity) could be revealed to the learned. It might then be expressed in symbolic, exemplary form. His secret garden was a route to knowledge that was simultaneously scientific and mystical. But for that very reason it was also dangerous: a wizard's maze rather than a gardener's patch. No wonder, then, that Palissy's project went unrealized and that he himself (one of the most fascinating and universal minds of his generation) died in destitution during the days of carnage and cruelty that overran France at the end of the sixteenth century.

Bernard Palissy, lizard in enameled earthenware.

Palissy's master-plan was to create a garden where the totality of creation could be represented in its essentials, rather like the reduction of liquids to per-

fect crystals. But there was another way to gather in all the diversity of the natural world, the better to expose its underlying regularity. That was the botanical garden. Some years ago John Prest, in a beautiful and brilliant study, explained that the creators of those gardens were driven by the desire to re-create the botanical totality of Eden.[25] The walled-in paradise had, of course, been the standard form of the monastic garden, where Cistercian monks, for example, were each given their own little allotment of Eden to tend. But the exploration of the New World, with the discovery of a marvellous range of hitherto unknown species, had created a rich new topography of paradise. Eden, it was speculated, not least by Columbus himself, might be in the Southern Hemisphere. If these wonders of the tropics and the Orient could be shipped home, collected, named, and arranged within the confines of the botanical garden at Padua or Paris or Oxford, an exhaustive, living encyclopedia of creation could be assembled that would again testify to the stupendous ingenuity of the Creator.

The projectors of the botanical gardens were less sure about the zoology of Eden. Ideally, they reasoned, just as the affinities and relations between different species of herbs, flowers, and trees would be clarified in the encyclopedic garden, so the harmony that had reigned between beasts in the original Eden might also be re-established. The practical problem of wildness, though, remained daunting. The best that John Evelyn, a keen projector of a British Eden or "Ely-

sium," and an admirer of Turkish menageries of big cats, felt he could do, was a petting zoo of genteel English creatures like tortoises and squirrels.[26]

Eden-behind-walls was, then, the very opposite of Pan's Arcadia. It was, in fact, a way of bringing wildness to heel by sending it to school, making it understand its kinship with the tame and the temperate, making its medical *usefulness* apparent through the physick that could be drawn from its essence. To the universal optimists of this generation there was one power that could withstand all of the seductions and demons that Pan could mobilize, and that was the power of knowledge.

iii Rudeness and Confusion

When "rudeness" and "confusion" became terms of appreciation for landscapes, it was evident that old Arcadia was becoming visible again. It had never been completely effaced by the clipped formality of royal gardens like Versailles, merely banished to their outer edge and concealed by tall hedges. And when those topiary walls gave access, past the herms, to a "sacred grove," it was usually a carefully contained, and cosmetically preserved, form of wilderness. The only beasts that lurked amidst the elms were stone lions and panthers, carved for their heraldic nobility rather than their savagery.

A reaction against this stifling conformity was predictable. "When a Frenchman reads of the garden of Eden, I do not doubt but he concludes it was something approaching that of Versailles, with clipt hedges and trellis work," sneered Horace Walpole in his *History of the Modern Taste in Gardening*.[27] But much earlier in the eighteenth century, when Addison's *Spectator* began its campaign on behalf of pleasing irregularity and "horrid graces," it was English "Neatness and Elegancy" which were thought less "entertaining to the Fancy" than the "mixture of garden and forest" found in France and Italy.[28] A succession of remarkable landscape gardening books, beginning in 1700 with Timothy Nourse's *Campania Foelix* and continuing with Stephen Switzer's *Ichnographia Rustica* and Batty Langley's *New Principles of Gardening,* all extolled the virtues of what were designated as "rude wildernesses."[29] But when they were actually created, like the "Elysium" at Castle Howard, featuring a sixty-acre forest dotted with Ionic temples, it was the Virgilian, rather than the archaic, idea of arcadia that the gardeners had firmly in mind. It was wilder-

ness, up to a point, the sort of thing seen in paintings by Claude and Poussin, as the poem dedicated to Castle Howard prescribed:

> Buildings, the proper points of view adorn
> Of Grecian, Roman and Egyptian form
> Interspersed with woods and verdant plains
> Such as Possessd of Old Th'Arcadian Swains.[30]

So when the fences and walls that had closed off formal gardens from the rural estate were removed, the unbroken view enjoyed by the magnate was a very polite kind of rudeness. The patrons served by William Kent had all admired the rustic repose embodied in Robert Castell's *Ancient Villas* (1728), where the life enjoyed by Pliny at Tuscum was presented as a model for the Hanoverian country gentleman. Their new arcadias were really poetic lies about their relationship to land and labor, just like the sunken, brick-lined "ha-ha": the trench that made the garden and the park *seem* continuous while keeping animals off the lawn. Horace Walpole was only being true to his class and his political family when he celebrated William Kent as the obliterator of boundaries between garden and nature. It was what the English ruling elite liked to think of as freedom.

And since they also liked to imagine themselves to be the new Romans (with an expanding empire to match), their parks were packed with Virgilian structures—temples and obelisks—each of which, as John Dixon Hunt has reminded us, carried specific associations, mythic, literary, and historical. Temples of Worthies adorned lakesides and hilltops where Britannia's most august men of power and letters were figured as Roman senators (albeit usually, in Rysbrack's busts, betraying a certain degree of becoming Hanoverian plumpness).

Brought to perfection at estates like Stowe and Stourhead, British Virgilian became a truly international style, reproduced as far west as Virginia and as far east as Nieborów, where the gifted architect Szymon Bogumił Zug built a Polish arcadia for his patroness, Princess Helena Radziwiłł, complete with a flattering temple of Diana. For the next generation of sublimity-seekers, weaned on Burke and Rousseau, though, the studied counterpointing of copses, columns, and cupolas had become placidly formulaic. The Prince de Ligne, yawning behind his jabot, complained that English monotony had driven out French monotony: "They are all the same—a Greek temple, surrounded by a few trees, a hilltop. They bore me."[31]

The signposts to yet another reinvention of arcadia, though, did not all point the same way. There was an English way, advocated by Thomas Whately and adopted by Lancelot ("Capability") Brown, that wiped the landscape clean of all its allegorical clutter and classical quotation. Just as Alexander Cozens's *New Method* argued that intuitive impressions of bare rocks or heaped clouds

could themselves express particular moods, from terror to ecstasy, so Whately and Brown saw unembellished topography as the tool of emotive expression. So although Capability Brown allowed Lord Cobham to keep his Temple of Virtue and the Gothic Temple of Liberty (which was, after all, patriotically picturesque), the rest of William Kent's elaborately designed moral itinerary was done away with. Lake vistas were now purged of Palladian bridges, and meadows were made to sweep right up to the park facade of country houses without diversions into vales of Venus or temples of Diana.

Coplestone Warre Bamfylde, *A View of the Garden at Stourhead with the Temple of Apollo*, 1775.

For those, like the Prince de Ligne, who chose to follow another way, this affectation of naturalism was English hypocrisy at its most insolently self-deluding. For in order to achieve the effect of "pure" landscape, whole hills had to be levelled (or raised), lakes dug, and mountains of manure carted to the estate. If art and artifice had to be used, then why not revel in it? This was, after all, a time when the mechanical arts were being brought to the highest degree of ingenuity in the name of profit or pleasure. And the embellishment of landscape through mechanical devices and contrivances for a while became all the rage. As Monique Mosser has pointed out, the name *fabrique* given to the synthetic landscapes of terror and sublimity created by these spectacle-machines perfectly captured their air of unapologetic artificiality.[32]

By 1780 connoisseurs of the frightful and the terrific, if they had been so enterprising, could have constructed an entire Grand Tour around the arcadian theme parks of the *ancien régime*. They could have gone to see the mechanical volcano at Wörlitz, courtesy of Prince Leopold of Anhalt-Dessau, timing their trip to see a nighttime "eruption" so that, amidst the genuine fire and smoke, they would not notice that the "lava" pouring down its sides was actually water flowing over internally illuminated red glass panels. As the Prince de Ligne found to his delight, visitors were actually encouraged to enter the innards of the island volcano through a labyrinth of "caves, catacombs and scenes of fearsome horror."[33] If they were stirred by underground encounters they would certainly proceed on to Sir Francis Dashwood's estate at West Wycombe, where (if they had the right introduction) they could penetrate the subterranean hellfire caverns gouged from the chalk hill beneath the manorial church and follow the "river Styx" all the way to the "Cursing Well."[34] If they hankered after the erotic rather than the macabre, they could explore the Temple of Venus, ornamented with stone nymphs, satyrs, and monkeys, before passing into the cave below through an entrance fashioned as vagina.[35] Those with less libertine tastes might have preferred the lakeside grottoes of "pre-diluvian stone" (actually pockmarked tufa) built for Charles Hamilton at Painshill in Surrey or the cascade at Belton in Lincolnshire ornamented by Viscount Tyrconnel with handsome piles of giant rocks and boulders.

Not surprisingly, freemasons were in the forefront of both the admirers and the fabricators of these spectacles of awe and trembling. They could fantasize

Francis Vivares after Thomas Smith, *The Cascade at Belton House,* 1769.

initiation rites in the Egyptian rooms of the Mniejszy Palace at Warsaw before moving through chambers dedicated to "Horror, Pleasure and Hope."[36] Or if their orientalism was Far, rather than Near, Eastern, they could experience one of the Chinese gardens that had been inspired by Sir William Chambers's *Designs of Chinese Buildings,* published in 1757. There were pagodas, of course, not least the ten-roofed pavilion built for the princess Augusta at Kew. But the best Chinese gardens, like the duc de Choiseul's at Chanteloup, tried to realize Chambers's formula of "laughing," "enchanted," and "horrible" landscapes, using statuary of monstrous birds and dragons, and trees carefully

carved to appear as though they had been blasted by lightning. Just outside Paris there was even a park featuring an artificial thunderstorm machine which could produce downpours on demand, and where through the heavenly din could also be heard "the howls of ferocious animals" and "cries of men in torment."[37] For those who were more drawn to the enchanted than the horrible, there were Chinese gardens where the visitor could wander in a dream-like, shamanic state among waterfalls, bridges, and hanging rock faces beneath which lotus and lilies floated in carp-filled pools.

 Edmund Burke, the godfather of the aesthetic of awefulness, insisted that anything that threatened self-preservation was a source of the sublime. And sites like Hawkstone in Shropshire omitted nothing, mechanical or natural, in their assault on self-preservation.[38] Sir Richard Hill, the resident Pan, provided

"The Pagoda," from William Chambers, *Plans, Elevation . . . in the Gardens of Kew, Surrey,* 1763.

Louis Denys Camus, "The Pagoda, Chanteloup," 1773–78.

a ten-mile tour that included a figure of Neptune sitting between two whale ribs, a ravine called "The Dungeon," a "Gulph calculated to inspire solemnity," a "Scene in Switzerland" where a precarious Alpine bridge crossed a craggy pass, a heather hermitage, the (genuine) ruins of a red sandstone castle, and even a Tahitian scene modelled after Hodges's illustrations for Captain Cook's *Voyages.*

At the climax of the walk, visitors penetrated "Grotto Hill" by a pitch-black six-foot-high tunnel that gradually opened into a series of caverns and galleries, divided by pillars cut from the rock. At the end was a chamber where light, filtered through patches of colored glass in the roof, reflected off shells and spar set into the stone columns. In the midst of the glowing cave, a tall hermit bearing a magic wand would appear and greet the visitor "in a coarse voice" before bowing and disappearing into the Stygian gloom. Never mind that the figure was a wax effigy of one of Sir Richard Hill's ancestors, whose arm was moved by a lever from behind by the gardener who also provided the mysterious voice. As far as Dr. Johnson was concerned, "the effect was admirable." Not so admirable, as far as the doctor was concerned, was what happened next. The exit from the grotto, carved with a sandstone sphinx, sent the unsuspecting walker out onto the "Raven's Shelf," a perch on a cliff wall below which the crags dropped sheer away for hundreds of feet. Under the circumstances ravens nesting in the clumps of scrubby bushes clinging to the rock face were not ideal company for those whose "sense of self-preservation" may not have

been holding up too well. "He that mounts the precipice at Hawkstone," the doctor warned, "wonders how he came hither and doubts how he shall return."[39]

An elemental landscape produced by contrivance was bound, in the end, to collapse under the weight of its own contradictions. Just because of their whimsical nature ruins and follies have seemed to invite further ruin, inflicted on them by vandals. Several years ago the cave of the Druid at Hawkstone, for example, was badly trashed by a group of cyclists who had been refused tea at the local hotel, plainly not a company to be trifled with. But the harder such places worked at the wildness effect, the more likely they were to offend purists devoted to Rousseau, for whom nothing could possibly improve on nature's own sublimity. So when Rousseau's last patron and friend, the marquis René de Girardin, laid out his grounds at Ermenonville as a moral and spiritual promenade, he did his best to avoid the trickery of the most egregious *fabriques*. Nonetheless, Ermenonville ended up as an encyclopedia of all and every arcadia.[40] Wilderness was represented by a *désert* of rocks and sandy waste covered only with heather and broom. Ovid's golden world took the form of a specifically designated "Arcadian meadow." Virgilian sententiousness was provided with a Temple of Modern Philosophy, and other scenes within the park were picturesquely designed as living paintings by

Rock entrance to the "Desert de Retz," from George Louis le Rouge, *Détails de nouveaux jardins à la mode*, 1785.

Hermit of Hawkstone Park.

Claude and the Dutch landscapist Jacob van Ruisdael. And there was, of course, a tumulus that Girardin had always liked to think of as Celtic until, alas, workmen inadvertently dug it up and discovered remains considerably more recent.

Initially René de Girardin had meant to add Poussin to his living landscapes by re-creating, in the middle of the arcadian meadow, the tomb bearing the inscription *Et in Arcadia ego,* on which the tourists, like the shepherds, might soulfully meditate. He seems to have rejected the idea in favor of the reed hut of Philemon and Baucis, the aged couple who, according to Ovid, were the only inhabitants of Phrygia to offer hospitality to the disguised Jupiter and Mercury. For their kindness they were spared the flood that drowned their churlish neighbors, and were granted vegetable immortality by being transformed into trees at the moment of their death. Mortality, alas, came anyway. In December 1787, as France itself began to crack apart, a great storm that evidently paid no heed to Ovid destroyed the cottage of Philemon and Baucis and reduced the meadow to a muddy waste. Swept up in the Revolution, Girardin never did get around to restoring arcadia.

J. Merigot, "The Arcadian Meadow, Ermenonville," from René de Girardin, *Promenade ou itinéraire des jardins d'Ermenonville* (1788).

iv An Arcadia for the People: The Forest of Fontainebleau

From Virgil to Girardin all these arcadias, primitive or pastoral, had been lordly possessions. And even when the liberal marquis encouraged the public to visit his park, it was with the air of an aristocratic host providing an open-air Academy of Sensibility. It was ironic, then, that the first truly popular arcadia was created in the heart of the royal forest of Fontainebleau, a place saturated in memory. For centuries, through the reigns of Valois and Bourbon kings, it had been the greatest of the royal hunts. But, as painted by the artists of Barbizon— Corot, Diaz de la Peña, Millet, and Théodore Rousseau—its glades are realms away from the rout of kings (color illus. 42 and 43). The drowsy darknesses are unmistakably arcadian. Instead of nymphs and satyrs, Romany mule-drivers, itinerant herders, and light-flecked lovers move quietly through the dells; and instead of goats, dappled brindle cows slurp contentedly from woodland ponds. It is an arcadia that seems, somehow, to have been annexed by bohemia.

So it is right that the most bohemian of Pan's accomplices, Silvanus, is the *genius loci,* the "spirit of the place." He was an original, pelagic Arcadian, all right, even though he appears more often in Latin than Greek. The Romans had grafted him onto a cult associated with Mars and he had done service in their mythology as Custos, the protector of flocks, his dense trees sheltering the fat sheep and pigs of the *campagna*.[41] Transplanted by the legions to the wooded regions of the empire, Silvanus became less pastoral and more arboreal, a forest-god whose veneration was practiced from England to Dacia, but was especially revered in Gaul. Inscriptions proclaim him to be Silvanus the August, the Celestial, the Invincible. Boys were named Dendrophorus or Silvester in his honor. And if you went to the forest of Fontainebleau on a Sunday afternoon in the 1850s, according to Théophile Gautier and Auguste Luchet, you might actually catch a glimpse of him.

> At the top of a hill there would suddenly appear a little man, simply dressed, with a big hat and spectacles, holding the holly branch that serves him as a walking stick clambering down the slope taking care with his footing, his eyes to the sky, his nostrils flared, his breath robust, his manner that of a truly happy being.

If you looked more closely still, Gautier wrote, you would begin to notice that his coat was the color of wood, his trousers the hue of nutwood stain; his hands were ribbed like the trunk of an oak; his cheeks had the broken red veins of early autumn leaves; his feet bit the dirt like roots; his fingers divided like twigs; his hat was crowned with foliage—in short, he seemed altogether a vegetable presence.[42]

He had a mortal name, this faun of the oakwoods, and it was not Silvestre but Claude, Claude François Denecourt, *dit le Sylvain.* By 1855, when Gautier's impression of him was published, he had become adopted by the Romantics as the guardian spirit of the forest of Fontainebleau. The book that celebrated his life and the forest was a virtual Who's Who of Romanticism, with contributions in verse (some of it truly dreadful) and prose by Victor Hugo, Alfred de Musset, George Sand, Jules Janin, Gérard de Nerval, Alphonse de Lamartine, Arsène Houssaye, even the distinctly un-bucolic Charles Baudelaire!

For all of these arch-Romantics, Denecourt was the epitome of an anti-bureaucrat who had wrested the most famous woodland in all of France from both its royal history and the imperial state, and had given it back to the people. Not *the People,* of course, and certainly not the woodcutters, charcoal burners, and pig-grazers who fought pitched battles with the state foresters in the Vosges and the Pyrenees, but rather the Romantics' kind of people, the people who show up in Barbizon arcadian scenery: gypsies, fetchingly picturesque cottagers, the occasional herdsman. Above all, he had made it possible for themselves—urban bohemians—to escape he crushing *monde* of bourgeois Paris and rediscover their own nature and the world's, amidst the peace and solitude of the forest.[43]

Claude François Denecourt in 1867, photograph.

How had he done this? Why, by an extraordinary invention, all his very own: the woodland trail. For Claude François *le Sylvain* (as he himself stoutly believed) had a claim to immortality. He was The Man Who Invented Hiking.

There was not much in his background to suggest such originality. His family had been wooden-bowl vineyard laborers in the forested eastern uplands of the Haute-Saône. Denecourt's father had married into a family of waggoners and coachmen and produced eleven children, beginning with Claude François. His Romantic biographers liked to picture the unlettered boy being read to by his mother, his imagination stirring to tales from Perrault's *Mother Goose,* romances from the Bibliothèque Bleue, and even popular books about military strategy. As he drove the carts and coaches over the green hills of the Vosges,

his mind roamed afar and he learned, place by place, to read the only book that, in the end, counted: the book of nature.

There was one institution that could offer him both travel and instruction, but Claude's stature failed to meet the improved standards of Louis XVI's army. Napoleon Bonaparte seems to have looked more kindly on the short, for Denecourt was able to enlist in the Eighty-eighth Regiment of Light Infantry. So the *sergent-voltigeur* tramped from the Danube to the Tagus, and in 1809, at one of the most spectacular disasters of the Spanish Peninsula War, the battle of Merida, took a slice through a leg which left him with a permanent and marked limp.

Like thousands of Napoleon's *mutilés de guerre* who hobbled back to France, unrealistically proud of their livid gashes and cicatrices, Denecourt could not bear the thought of relinquishing the imperial colors. But the uniformed bureaucracy was expanding fast enough to accommodate these obstinate patriots, and Denecourt opted for a job in the imperial customs service, no sinecure at a time when Napoleon was attempting to seal off his continental empire from British manufactures. Though his childhood on France's forested eastern frontier (a famous smuggling route) should have suited him perfectly for the role, he seems to have made a halfhearted *douanier*. "His idea of himself as a free child of the mountains did not sit well with the duties of the customs-man," wrote Luchet.

It was probably in 1814 that Denecourt first saw the forest of Fontainebleau. The times were desperate enough that even the lame and the halt might be re-enlisted to defend France against the Coalition armies bearing down fast on what little remained of the Napoleonic Empire. Denecourt was wounded yet again at Verdun, and retreated westward along with his regiment to the wooded plains of the Brie. At what point he left active service is hard to say, but before his comrades could reach the château, Fontainebleau had already been occupied by Austrian troops. A regiment of Cossacks had taken up position on the heights overlooking the woods, and it was to the hamlet of Barbizon that local women and girls, terrified, it was said, of being raped or murdered by the Russians, had fled for safety. Bitter skirmishes broke out inside the woodland just coming into its Maytime leaf. Hot orange shells and sprays of shot sent traces of fire spitting through the ferny forest floor. After some weeks Fontainebleau reverted to the French, while the rest of the empire was giving up the ghost.

On a gray morning Napoleon announced his abdication in the very courtyard of the château and bade a tearful farewell to the imperial guard. Rather than surrender their colors, one regiment burned them, each soldier swallowing a draught of eau-de-vie in which the ashes of the flag had been dissolved.

For Denecourt, Fontainebleau was forever fixed as the site of this patriotic drama. But he had to live, somehow. After the first abdication he supported

himself as a jeweller, not of priceless but of artificial and semiprecious stones, the trinkets of ballroom glitter: marcasites and garnets pretending to be diamonds and rubies. He must have had some aptitude, as he employed a group of young journeymen and apprentices in his workshop. Hearing of the emperor's return in February 1815, he set out with his little band of bauble-makers for the barracks at Montereau, near Melun, hot and brilliant with imperial ardor. But before he could reach his Waterloo, the history of the empire written on his body betrayed him. The march was hard enough to open his wounds from the campaign of France, and Denecourt hobbled and oozed, grimly conceding his incapacity and watching his lads march off to their famous calamity.

Denecourt had done enough, though, to make himself suspect to the Restoration authorities in the painful years that followed the great fiasco of 1815. Threatened with legal proceedings, he wandered about the Ile de France, sometimes employing others, more often employed, until somebody or other who had caught him making indiscreetly Bonapartist remarks in a tavern would bring his name up with the police and force him to move on. His war wounds hurt him. His life seemed without point or purpose. He seemed doomed like tens of thousands of his old comrades-in-arms to drag out his days as a lame and shabby fugitive in his own country. For a while he managed to get work as janitor of the army barracks at Melun. But prudence required he change even this menial job every few years. So from Melun he went to Versailles and from Versailles to Fontainebleau.

The July Revolution of 1830 that brought the "citizen king," Louis-Philippe, to the throne seemed to promise better things. Yet the Orleanist governments, especially those run by ex-Napoleonic marshals, were even less hospitable to those classified on some police list as "dangerous Bonapartist" than the Bourbons. It was during the ministry of Marshal Soult, Denecourt's old commander in Spain, that in 1832 he was again ejected from his job.

In the celebratory anthology, Gautier and Luchet would claim it was this final, bitter blow that sent Denecourt to the forest. In fact, he seems to have made a tolerable, if not handsome, living for himself as a merchant of Cognac in the town of Fontainebleau. But Sylvanian apocryphas aside, it was certainly at this time that he began to spend a great deal of time wandering about the woods to what must have seemed, to his wife, no apparent purpose at all. Why had he gone there? What was he up to among the deer and the polecats, the charcoal burners and ruffians who frequented the ruins of ancient monasteries? None of his biographers offer much of an explanation and Denecourt was himself laconic, but the answer, surely, lay in a literary encounter. Denecourt, the boy-bookworm of the mountains, had discovered Senancour.

For it was in 1833 that Etienne Pivert de Senancour published a new edition of his epistolary pseudo-autobiography, *Oberman*. Senancour was a self-

conscious apostle of Rousseau and, like his model, in double revolt against both
the traditional authority of the classical and the Enlightenment rationality that
claimed to supersede it. Like Rousseau, his sources of truth and understanding
were to be nature and his own sentient self, preferably put into direct commu-
nion with each other, the better to grasp at the Infinite. But where Rousseau
had run away from Geneva toward France in search of revelation, Senancour
ran in the opposite direction. So in 1789, while the youth of France was on the
road to Paris to behold the birth of Liberty, Senancour escaped from his sem-
inary eastward to Switzerland, where he insisted on climbing, guideless, some
of the most daunting Alpine peaks (the Dents du Midi and the Great St.
Bernard).

Sure enough, the Infinite showed up at around fifteen thousand feet, and
Senancour attempted to describe the indescribable in the two volumes of *Ober-
man* which he published in 1804. The book enjoyed a modest success, but it
lacked the essential ingredient for Romantic popularity—a seriously tragic
hero—a flaw which doomed it to disparaging comparisons with Goethe's
Werther and Chateaubriand's *René*. Condescended to by the younger genera-
tion of writers, and habitually short of cash, Senancour lived on in Paris until
1846 in that worst of all possible Romantic twilights: acceptable mediocrity.[44]

Yet for all his disappointments, there must have been enough demand for
mountain epiphanies to warrant a reprinting. And there is no doubt that the
second coming of *Oberman* was more of an event than the first. It could boast
a preface by Sainte-Beuve. And it was Senancour's writing about the forest of
Fontainebleau, where he had spent adolescent summers, that attracted as much
attention as his Alpine threnodies. It may have been the woodland letters that
prompted George Sand, for example, to take her small son off to the forest for
several weeks in the summer of 1837. And it was surely the Fontainebleau let-
ters that gave Claude François Denecourt a model with whom to identify
(much as Senancour himself had obviously identified with the solitary
promeneur Jean-Jacques).

It is in Letter 9 that Senancour describes his first penetration of the forest:
his tingling sensation of "peace, freedom and wild joy," predictably mixed with
the balancing feeling of melancholy. He performs the obligatory Romantic rite
of entering the woods before dawn, where "I scrambled up the slopes that were
still covered in darkness; soaked myself in the dew-drenched heather, and when
the sun finally appeared I was saddened by the gathering brightness that pre-
cedes the dawn. I loved best the hollows, the dark valleys, the thickest woods."[45]

It was this determined retreat into the shadows that so appealed to the
Romantic generation. *Désert* (wilderness) is the word used by Senancour to
characterize the forest, echoing the peculiar affection King François I was said
to have had for his "chers déserts." It was not just the denseness and darkness
of the vegetation but the geology of the forest landscape which suited his tem-

per: sandstone outcrops and escarpments; loosely packed, sandy soil in which one's feet could slither and slip—a place that might be rugged or treacherous. "If scarcely picturesque," wrote Senancour, then the silence and the sterility sufficed, the "mute waste" corresponding nicely to the state of his soul.

No wilderness, of course, was complete without its arcadian hermit. And Senancour was led to his hermit, as if in a Mother Goose tale, by the appearance of two does pursued by a wolf. The deer seemed to make their escape through a dense patch of high bracken. When Senancour tried to follow them into one of the old, disused quarry-hollows, he found himself confronted by a dog guarding the mouth of a subterranean cave-dwelling. But this was not the Cerberus of Fontainebleau. "He looked at me silently and only barked when I walked away from him." Seemingly invited in, Senancour took a look at the strange abode. Its walls and roof were partly the result of the natural erosion of the soft rock, but their tenant had completed them by adding piles of stones, twigs, and branches of underbrush and clumps of turf and moss. Inside the cave was a crude bed and cupboard cut from forest timber but no table, for it was apparent that the lodger ate off a rock. Between the rocks was a scrawny but conscientiously tended patch that provided some vegetables to go with the ample game supplied by the forest.

Summoned by the barking (when Senancour tried to leave), the cave dweller turned out to be a retired quarry-worker who had lived in the woods for thirty years. Originally he had lived there with his long-suffering wife and two sons. But his obstinacy had been too much for them. The wife had died young, her life cut short, it was said, by her pitilessly austere subsistence. One son joined the army; another had drowned while trying to cross the Seine. Left alone, the hermit had decided to remain there in Jerome-like purity, dying amidst the scrub and sandstone rather than face the wretched humiliation of the Paris poorhouse.[46] "So there he lived with his cat and his dog, on bread, water and liberty. 'I have worked hard,' he told me, 'and I have had nothing, yet in the end I am content and I will die soon.' "[47]

The hermit may not have been a figment of Senancour's imagination, but he certainly belonged to Fontainebleau's well-established cast of fabulous characters. Some chroniclers thought the ancient forêt de Bière had been the site of ancient druidical rites, and that through the ages lords of the hunt had shared its woodlands with reclusive sages and holy men. Periodically kings would be unhorsed by an Intervening Hand and chastened toward a right and pious reform. Pursuing a stag, St. Louis had been thrown and was only rescued from certain death at the hands of robbers by a timely call on a hunting horn. In gratitude he built a chapel on the site of his rescue. A more emphatically correctional apparition suddenly loomed up in front of Henri IV in the huge, black, and forbidding form of the phantom "Grand Veneur" (also known as the "Chasseur noir") bellowing to the startled king, "Amendez-vous [Reform yourself]."[48]

Fontainebleau forest, then, was a contested place where the sport of princes and the culture of hermits and peasants jostled (albeit unequally) for space. What the people lacked in force they made up for in the aggressive richness of their woodland lore. The Mathurin monks, for example, established in the seventeenth century, had given some credence to the cult of La Roche-Qui-Pleure, "the weeping rock," out on the Gorges de Franchard, whose waters were said to cure afflictions of the sight. Every Pentecost saw a pilgrimage to the miraculous leak, which by the early eighteenth century had become a rowdy annual festival, altogether too much like the Maytime woodland bacchanals for the authorities' liking.

Their censure was complicated by the aristocratic fashion for rustic amusement. Rousseau's one-act opera, *Le Devin du village,* was rehearsed for Mme de Pompadour at Fontainebleau, and the "village soothsayer," who brought together a duet of star-crossed lovers, was evidently modelled on the woodland wizards reputed to live in the area. In his (admittedly self-serving) *Confessions* Rousseau casts himself as the contemptuous rebel, refusing to truckle to required politeness, showing up for the rehearsal with a growth of alienated stubble, and breaking off the charade to flee (into the woods?) in pursuit of freedom and self-respect. A generation later the Romantics would become obsessed with the landscape painter Simon Mathurin Lantara, who had grown up around the forest village of Oncy. Habitually in debt, reputed a great drinker, bartering his paintings for a glass and a crust, Lantara was adopted by the Romantics (long after his death in a Paris poorhouse) as a vanguard bohemian, yet another child of nature ruined by the city.[49]

On the eve of the Revolution, the forest served as backdrop scenery to imagined acts of defiance against polite culture. In fact, it was also home to a population that lived on (or over) the edge of the law: some thousands of poachers, woodcutters, charcoal burners, and any combination of the above, some of whom certainly supplemented their subsistence from plundering travellers or huntsmen who had strayed from the pack. Some, like the seventeenth-century *bande* Gautier, had become famous before their leader was caught, tortured, and hanged in front of the church at Fontainebleau.[50] Though the *maîtrise* of the Eaux et Forêts at Melun had sixteen guards patrolling the forest, eight on horse, eight on foot (by the standards of the old regime police, a sizable detachment), it was never enough to root out the tough and awesomely armed bands who camped in the ruins of old priories and convents. To take shortcuts away from the royal roads was to court peril. If the bandits didn't attack, the diamond-head vipers, said to populate the woodland floor in great swarms, surely would.

The royal state did not simply surrender the forest interior to the lawless. Between 1683 and his death in 1715, Louis XIV, that famous lover of state

geometry, had straightened the old winding forest avenues, and had new and broader paved roads constructed with side ditches and grass verges wide enough to thwart the sudden ambush of men appearing from the curtain of trees.[51] And the old network of stone and wooden crosses, marking directions and distances from village to village, was increased, with nobles of the court paying for their erection (and, naturally, marking the donation with their names engraved on the sign).

And Fontainebleau had the occasional loyal forester determined to subdue its many dangers. With a name like Bois d'Hyver, how could the royal forester at Melun *not* make it his mission to recover the woods for the king, and at least to curb the large-scale illegal cutting and selling of timber that went on with impunity? The Revolution saw him off, and the destruction of the woods (for profit and necessity) by gangs as large as two hundred men became serious enough in 1791 to require calling in troops from the Melun barracks. Like so many of the old forestry officials of the monarchy, Bois d'Hyver was restored to his old post during the Bonapartist consulate, defeating a brief challenge from an old enemy, a M. Noel, when it was discovered that the latter had made a large fortune in the Revolution trading the wood he was supposed to be protecting. Faced with public disgrace, the malefactor blew his brains out in the woods, and his accomplice, the "adjudicator" of brushwood, hanged himself. M. Bois d'Hyver returned in triumph.

In 1832 his son, Achille Marryer Bois d'Hyver, succeeded to the post of inspector-general of the forest, determined to restore the ragged woodlands to their ancient fame and glory. But in the same year, Denecourt entered the woods of Fontainebleau with quite a different notion in mind. What struck him was that no one except himself really *knew* the forest interior. There was the network of crosses, to be sure, and even maps and guides. But the maps were absurdly rudimentary, showing merely the main roads that cut through its center, running from Orléans to Paris, and occasionally the paths used by bird-hunters. And the few guides to the forest that had been published reflected the fact that their authors (like Charles Remard, librarian of the château, whose booklet appeared in 1820) were conventional, unimaginative antiquarians, for whom the woods were nothing much more than a rustic annex of the palace.

Moreover, these authors showed precious little evidence that they had actually walked through the forest. For on their plans it was charted indiscriminately with the scallop-edged green lines used to denote impenetrable woods. Denecourt had resolved that they would be penetrated, measured, surveyed, mapped. This would not be done statistically, as by the surveyors of the state who were interested only in an inventory of assets, but descriptively, even poetically. And in this task he did have one ally, the carpenter-poet Alexis Durand,

whose *Forêt de Fontainebleau* was published in 1836. An autodidact like Denecourt (though a more authentic artisan), Durand had been discovered by a local crown attorney, Clovis Michaux, while he was doing some woodwork on his house, and in no time at all had become a minor literary celebrity, the latest exemplar of the *honnête homme* of the woods.[52] And it was his friendship with Durand that led another local writer, Etienne Jamin, a clerk at the château, to launch his own little guide to "Four Promenades in the Forest of Fontainebleau."

Denecourt clearly drew inspiration both from Durand's odes to the oaks and from Jamin's initial excursion routes. But the scale of his own exploration was much more ambitious. He would give fresh names to rocks, hills, declivities; ponds and swamps; even the greatest and grandest of the trees. And enough classical French education had rubbed off on him for Denecourt to know that to name things was to possess them. From the shapeless, indeterminate mass of topography he would carve routes determined only by the pleasure it would give to the senses, the uplift it could supply for the spirit, jaded by the polluted vanities of the city. Had he known of Thoreau's definition of *sauntering*, with its etymological nostalgia for the medieval palmers who were walking to the "Saint-Terre," Denecourt would surely have approved. For he too, he thought, was a pilgrim.

So Claude François walked and walked and walked, winding his way through the densest and darkest areas, treading gingerly past the sleeping vipers, counting the much depleted population of deer and pig, laying down marks so that he could recognize the way back. For in one respect he did not mean to follow Senancour's euphoria at getting lost.[53] Perhaps he did not altogether believe it. At any rate *his* plan was to supply the maximum solitude consistent with guaranteed lack of terror, calculating, as if he were an engineer of the picturesque, how to produce the most strikingly various and pleasing prospects.

Sometimes he thought he could even improve on what nature offered. One night, as he lay on a sandstone ledge, the crumbly soil gave under him and he fell into a small cavern. Crawling along a narrow natural tunnel, he emerged into another space. The experience was at once frightening and, in a not disagreeable way, exciting. But would it not be more enthralling if the little hollows could be made more cavernous, in the proper Salvator Rosa manner? What would be wrong with taking up nature's suggestions and supplying, here and there, a little picturesque improvement? So Denecourt, with a friend, Bournet, who had joined him, took his pick and chisel and made crevices into caves and caves into splendid "grottoes" and caverns, wetting the walls to encourage moss and mushrooms, letting the perfectly sour smell of earth and leafmold fill the dank interior.

Gradually the activities of an eccentric ex-soldier tramping around the woods began to arouse the suspicions of M. Bois d'Hyver and his guards.

What exactly was this man up to? There was nothing he had done to infringe the forest laws. No one had seen him taking wood illegally or sneaking in and out with an unlawful pig or goat. But there were the painted blue arrows that kept mysteriously appearing on rocks and trees in different parts of the woods.

Those blue arrows were the syntax of Denecourt's grammar of woodland walks: what gave it direction and coherence. He would go out at night with a covered lamp, and a pot of blue paint beneath his coat, and apply them to the precise places where he anticipated his walkers would need direction. He was inventing the trail. It was simple enough. But no one had ever done it before.

Claude François Denecourt, ca. 1855, tinted photograph.

He published his first *indicateur* to Fontainebleau. The idea was to persuade those tourists who came to see the château (for which he provided an expert guide, room by room) to experiment with a brisk ten-kilometer walk along a path indicated by the first trail of blue arrows. Two years later the second *indicateur* had greatly expanded the menu of offerings to five walks. And for the first time he provided a detailed topographical map of the forest with his circuits inked in in different colors: green for Promenade Number One westward to the Apremont hill and the Gorges de Franchard; red, northward to the marshy reed-pond of the Mare aux Oevées (known colloquially as the Mare aux Fées, the "Fairy Bog") and the little "Calvary" hill; and orange, blue, and yellow, east, south, and southwest.

By 1837 Denecourt was ready to go public with his plan. Though, like Jamin, he called these walks *promenades,* they were anything but leisurely strolls through the glades. Each was between ten and fifteen kilometers long, and deliberately designed to offer the hiker the variations of dense woods: gentle

scrambles over rocky slopes, strolls in open meadows and beside brooks and streams. And on the analogy of a tour of ancient monuments, Denecourt was careful to break up the walk with "notable sights": spectacularly venerable trees which he renamed for celebrated writers, or kings, like the "Charlemagne" oak on the green walk, and the "Clovis" on the red, each with their own apocryphas set out in the little guide. Denecourt was already an unofficial one-man arboreal pantheon, bestowing honors on the heroes of his choice. The Bonapartist poet and balladeer Béranger (who had walked the woods with the carpenter-poet Durand) was thus rewarded for his Bonapartism with an oak, and like honors went to Voltaire and (to show his ideological neutrality) Chateaubriand.

Along with cultural celebrity went historical fable and myth, so that at the Gorges de Franchard, the courageous hiker could explore the "Druid's Cavern" (carefully excavated by Denecourt and made to look appropriately ancient-mystical). His poet friend Durand even made up a completely fictional tale of romance between the *chevalier* René and Queen Nemerosa, so that a particular glade could serve as the setting for rehearsals of the story. And the program was completed with moments of recent history, so that visitors could shudder in the grotto of the Barbizonnières as they imagined the terror of the women and girls from the village hiding from the horny hands of the rape-happy Cossacks.

During the first decade Denecourt's walks seem to have attracted a select group of enthusiasts: writers, poets, and artists as well as hangers-on from that social oxymoron, the Romantic bourgeoisie. And he astutely flattered their own sense of guild tradition by naming some oaks for their guild heroes, like Rubens and Primaticcio, with one specially Romantic specimen given to the figure they most venerated as the tree-painters' painter: Jacob van Ruisdael. The first of the landscape painters actually to live in the forest, Théodore Rousseau, arrived in 1846 and found himself a cottage at the hamlet of Barbizon near the Fontainebleau-Paris road. His paintings of the deep woods of the Bas Bréau and the oaks of Apremont (both features of Walk Number One), exhibited at the biennial salon in Paris, had the effect of bringing more enthusiasts of the *promenade solitaire* to the woods, among them George Sand's soi-disant secretary, Alexandre Damien Manceau, and Félix Saturnin Brissot de Warville, the son of a guillotined Girondin.[54] By the mid-1840s Denecourt was himself editing albums of lithographs that would publicize the charms of the forest to those who had not seen the first efforts of the Barbizon painters. In 1846 a group of painters and poets presented a verse bouquet to their "host and friend" M. Ganne, who was now advertising himself as "hôtelier des artistes." A year later the journal *L'Abeille de Fontainebleau* fulsomely praised the Denecourt trails that "call the *promeneur solitaire* to meditation and the poet to reverie."[55]

Everything changed in the last two years of the decade. The advent of the Second Republic in 1848 brought violence and a wave of random felling back

to the forest. It also brought the artist Millet, fleeing from both cholera and bloodshed in the capital. When the smoke cleared, Denecourt's program was brilliantly positioned to appeal to a whole new democracy of hikers. What was more, the Lyon-Paris railway was now able to bring to Fontainebleau a class of Sunday walkers for whom a private carriage had been prohibitively expensive and laborious. Denecourt shifted to a higher promotional gear, setting up a stall at the railway station to sell his guides. On the site of the ruined monastery of Franchard there was now a pleasant café run by the brothers Lapotaire ("confort, élégance, propreté") where those who took the most arduous walk could refresh themselves before pressing on. New editions of the *indicateur* appeared almost every year; some were specialized for artists, advising them just where the most picturesque vistas were located; others speeded up the vertical integration of forest tourism by actually making the artists and their haunts one of the prime spectacles of a visit! (M. Ganne was pleased.)

A special *petit-indicateur*, designed to slip into the pocket of a hacking coat, was more aggressively commercial, guiding tourists to the best cafés, patisseries, restaurants, and hotels (of which there were now nine in the little town, the grandest being the Grand Hôtel de la Ville de Lyon). Ancillary trades had begun to spring up around Denecourt's project, run, in particular, by Mme Cudot, whose stores sold anything and everything connected with Fontainebleau, from books, maps, and guides to juniper wood souvenirs, cigar boxes, ladies' nécessaires, appointment-book covers, visiting card holders, and even scented waters purporting to come from the purest forest brooks, *eau de Fontainebleau* and the more patently seductive *eau de Diane de Poitiers*.

Fontainebleau, juniper wood owl.

By the middle of the 1850s there were a hundred and fifty kilometers of twenty marked trails in the forest, guided and unguided, with over a thousand new "sites" identified and "explained" by the omnipresent *Sylvain*. And at last Denecourt was beginning to recoup some of the twenty thousand francs he had invested in his extraordinary enterprise. So that even as he was being eulogized by Gautier as the *genius loci* and guardian faun of the forest, Denecourt had become a rather different kind of phenomenon: the entrepreneur of seclusion.

That seclusion was becoming increasingly difficult to protect did not much bother him. A hundred thousand tourists a year were said to roll off the Sunday trains by 1860, and as the crowds grew, so Denecourt invented new ways to process them through the forest. For those who were ill-disposed to walk at all, horse- or open-carriage tours along selected forest routes could be arranged at modest rates. There was even an "all-in" tour providing a quick trot through the château before lunching (*vin à discrétion*) and being bundled into coaches to alight at selected three-star sites along the trail. Those who had even less time

could be taken directly to the viewing platform that Denecourt had erected on a two-storied tower, at the site where Louis XIV had provided a medieval folly for the queen to survey the hunt. It was high enough to take in the entire expanse of the trees, and on a clear day the western horizon would even reveal the Paris skyline. Since Louis-Napoléon had come to power there was nothing to stop Denecourt from calling it "La Tour de l'Empereur." Under his command Fontainebleau had exorcised the ghosts of 1814.

Not that the imperial foresters were any more well disposed toward *le Sylvain* than had been the officials of King Louis-Philippe. From a silvicultural point of view, he was a pest who had taken an entire forest that was supposed to be off limits to those not properly trained and licensed, and turned it into one enormous open-air resort of public amusement. It was the trespass to end all trespasses: a violation of the monopoly of public trust assumed by the classical forestry-state. Exception was also taken to his constant criticism of the state's efforts to establish coniferous plantations in the forest, trees that Denecourt deprecated as aesthetically and botanically inferior to his great hardwood monuments. And as Denecourt became virtually the unofficial *chef* of the park of his own invention, so the rumors and calumnies began to fly. He was accused by some of setting fires; by others of taking money from those who wanted a tree or a rock named after them; of, in effect, merchandising the forest.

But Denecourt survived both the official vexation of M. Bois d'Hyver and his foresters and the envy of frustrated competitors. Napoleon's sergeant had built himself a little empire; in the reign of "Napoléon le Petit" he had become an institution—even, as his guide became translated into English, an international institution. Painters from Holland, Germany, and America began to show up to work close to the Barbizons, and there was a constant traffic of English tourists in particular, from milords to stockbrokers. But for all this celebrity and despite dispatching personal petitions and addresses to Napoleon III, Denecourt was still denied the Légion d'honneur to which he felt wholly entitled, having in his view done far more for the woods than any of the state foresters in their blue coats and gold frogging. He had, after all, closed the area off to all but huntsmen and brigands and had given it back to the people of Paris. Had not Gautier himself described him as a man who had claimed a territory where there had been *un néant,* "a nothing," and made it instead *terre française.* It had been a true *mission civilisatrice,* an act of benign colonization, and he was compared to a Columbus of the woods, a Captain Cook, and even, in the fractured English verse of Théodore de Banville, a *Moses.*

> *Thine, Denecourt, was the chosen hand*
> *By whom each winding maze was traced*
> *As Moses to the promised land*
> *Led forth the Hebrews thro the waste.*[56]

Finally, however grudgingly, the government appointed him to an ad hominem curatorship, a *conservateur-en-chef* of the woods, with a nine-thousand-franc partial repayment for the expenses he had incurred in his enterprise. Denecourt immediately began to organize an entire *cadre* of rangers, and to design uniforms for them complete with coats, oakleaf badges, and képis.

This little act of official recognition, coming after years of hostility or grudging tolerance, must have pleased Denecourt enormously, perhaps even more than being celebrated as the Romantics' bosky hero. For *le Sylvain* had never thought of himself as a one-man opposition to the state foresters, much less as a Wild Man of the Woods. On the contrary, he was, in his way, as much part of the classical French culture of data collection, engineering, and strategic topography as any graduate of the Nancy college. To appropriate, name, classify, and map places and spaces, to produce an *order* among things, was Denecourt's great passion.

But he was also a promotional genius. He understood, intuitively, the need of the modern city dweller for designed excitement. His picturesque promenades were meant to be a tonic for urban enervation. They would supply just enough remoteness for the illusion of wilderness, without any of the danger of real disorientation. And this hunch about calculated exertion, protected exposure, even measured doses of alarm would prove to be the great business principle of mass popular recreation.

That Denecourt had a shrewd grasp of the psychology of protected terror is suggested by his presentation of The Man Who Kissed Vipers. His name was Guérigny, and before he had become famous ("Messieurs, je suis bien connu, j'ai été inscrit dans les journaux, moi!")[57] he had simply been one of the down-and-out local woodcutters who like so many others practiced other trades to keep himself in bread and wine. He painted houses and he also learned to catch vipers for the two-franc bounty that Louis-Philippe's regime offered in an effort to rid the woods of the pests. But he became so good at his special skill that he was able to sell surplus live specimens to the Jardin des Plantes in Paris and to the Venom Research Laboratory that had been established in Fontainebleau with the aim of producing effective antidotes.

When the railway came to Fontainebleau, Guérigny sold beer and spirits at the station, and Denecourt began to realize his potential as a major tourist attraction. Before long a special stop at the Gorges d'Apremont in a dark and scary cave, to watch the "Chasseur des Vipères," became a major feature of Walk Number One. Guérigny, dressed in a grimy shirt and oiled cap, would take the snakes from a box on his back and wind them around his neck. Dressed thus, he would tell cautionary tales of rash folk who presumed to gather the vipers without adequate understanding and paid the predictable penalty; even of his own snakebite histories en route to Paris asleep in a carriage when the basket opened and eight snakes slithered among the terrified passengers, bit-

ing him when he attempted to return them to safety. Finally he would reassure his audience that "if one doesn't bother them or impede them they are the most inoffensive and affectionate [*caressantes*] creatures in the world." The trick was to know how to hold them, not on a stick, but with the bare thumb and index finger secured firmly at the back and base of the neck. And Guérigny made his point by grasping a viper in each hand in the prescribed manner, smiling sweetly at them and planting a tender kiss on the tips of their snouts.

Applause was not advised, Guérigny told his thunderstruck tourists, since it made his reptiles *nerveux*, not just the vipers but the scores of lizards and grass snakes he kept in sacks around the cave. It was a perfectly calculated spectacle of horror and pleasure, drama and comedy, guaranteed to send the walkers on their way treading gingerly along the trail, cautious lest they ever stray from the path marked by the reassuring blue arrows. But Denecourt was Silvanus, not the great Lord of Panic, and he no more wanted his hikers to get lost in arcadia than he wanted them to die of fright when they saw a grimy, evil-smelling old man plant a kiss on the nose of a diamond-head. His woods were not trackless wastes, but ribboned with trails, like Ariadne's thread, that guaranteed to deliver the walker from savagery and get him back to the station in time for the next train to Paris.

v Arcadia under Glass

Poussin had posed the riddle. Poussin supplied the answer. To the curious who wondered just *what* form the mortal "ego" assumed in arcadia, a quick look at a painting in London's National Gallery would make this horribly clear (color illus. 44). In the midst of arcadia, the prostrate body of a man is being engulfed in the coils of an enormous serpent. But it is not just the victim that has been captured by a snaking form. At his most artful, Poussin has caught the eye of the beholder in a serpentine ribbon that winds its way through the painting, binding together the arcadia of light with the arcadia of darkness. From the serene obliviousness of the fishermen, the path of vision leads to the uncomprehending dismay of the woman in the middle ground, and onwards to the horrified consternation of the witness. Poussin had also painted a *Landscape with Man Pursued by Snake* in which the slithering reptile seems to be a viper, his head poised to strike another understandably terrified traveller. The histo-

rian and belletrist André Félibien, who knew Poussin well, had no hesitation in describing these scenes as representing "the effects of fear." And the retention of the usual features of the soft arcadia—umbrageous trees leaning over a glassy lake, towers and walls harmonizing with the gentle hills on which they stood— only enhances the sense of incongruous dread. Something has gone terribly wrong with the picture. Arcadia I has found a way into Arcadia II.

Almost exactly two hundred years after Poussin painted his picture, the situation had been completely reversed. Arcadia II had swallowed Arcadia I. It

Nicolas Poussin, *Landscape with Man Pursued by Snake.*

would take Londoners not much more than twenty minutes by hackney to go from the National Gallery to the brand-new Reptile House (the first of its kind in the world) at the Zoological Gardens in Regent's Park. With comforting sheets of glass separating them from the snakes, they could view not only boa constrictors even bigger than the one squeezing the life out of Poussin's unfortunate traveller but also pythons, puff adders, rattlesnakes, and poison frogs.[58] It had always been the mark of the habitable arcadia to banish wild creatures

from its territory; hence the peculiar horror of Poussin's scene, where these assumptions have collapsed. But the technology of imperial Britain had taken care of all that. Industrially heated piped water and plate glass made it possible for the exotic and the savage to be imported right into the midst of city life. Not only would the citizenry not be inconvenienced by this; they would actually throng to it as a *locus amoenus,* a resort of delight: a true zoological *garden.*

Nothing, in fact, could keep them away. When, in 1852, the first "keeper of serpents," one Edward Horatio Girling, succumbing to Pan's temptation, downed three pints of ale washed down by gin, and, blind drunk, began to wave a cobra about, it not unreasonably bit him. Two hours later, at the University College Hospital, he was dead. And while the sensational accident gave rise to a great deal of predictable sermonizing in the newspapers about the drinking habits of the working classes, it was, of course, phenomenally good for the turnstiles through which crowds passed, lining up to view the murderous reptile peacefully curled about his branch behind the glass.

Feeding time, every Friday, was another popular attraction. Live white mice and rabbits would be fed to the boa before appreciative crowds that included a large proportion of Victorian children. There were those (including Dickens) who were appalled by the public spectacle and said so in letters to *The Times.*[59] The unsentimental responded that it was hypocritical cant to complain about natural predators while men continued to fatten themselves off the meat of animals, and one correspondent even claimed that "the little victims" were not at all scared at the imminence of their painless end, the birds "flittering and fluttering all around." The only gesture that the head keeper, Bartlett, made to the agitation was (for reasons best known to himself) to substitute house mice for the white mice he had hitherto used. This turned out to be a serious mistake, since if not eaten right away, the house mice gnawed their way through the enclosure, providing a neat exit for the vipers and cobras.[60]

Sensationalism had certainly not been the idea behind the founding of the London Zoo in the 1820s. Like the Jardin des Plantes in Paris, it had begun as a learned enterprise, and originally admission was granted only to members of the Zoological Society. But just as the Renaissance botanical gardens were driven by the imperial desire to reconstitute the whole world in a walled enclosure, so the nineteenth-century zoos also owed their foundation to another dramatic

Decimus Burton, "Elephant Stables, London Zoo," in C. F. Partington *Natural History and Views of London,* 1835.

extension of imperial outreach. The two founders of the London Zoo were perfect exemplars of this alliance between geographical aggrandizement and technological invention. Stamford Raffles had been the conqueror of the East Indies, the source of many of the exotic species that were shipped by sail and steam to London. And his partner, Humphry Davy, the entrepreneurial engineer and inventor of the miner's helmet lamp, represented the industrial technology that made possible the heating systems, and the glazed and barred cages in which the animals were housed.

From its beginnings, though, the London Zoo seems to have wrapped the exoticism in cozy domesticity. The first generation of animal houses, built by Decimus Burton, as an ensemble resembled nothing so much as an eclectic English village, or gingerbread suburb, where (shades of Dr. Dolittle) the inhabitants just happened to have extremely long necks or ivory tusks. The first Elephant House was a little thatched pavilion with Gothic windows, and when it was eventually replaced, Anthony Salvin built for the rhinos and elephants something which from the outside looked like a terrace row of gabled country cottages: a sort of rustic almshouse for pachyderms. Burton's Camel House was an ornate villa surmounted by a clock tower, and the 1864 Monkey House was a Beaux Arts pavilion boasting ornamental arched windows. Only the Giraffe House, of necessity, was practical enough to have sixteen-foot doors, though they led into the type of Tuscan barn, complete with broken pediment, that the arcadian villa owners of the Venetian Renaissance would have immediately recognized.

Anthony Salvin, "Elephant and Rhinoceros House, London Zoo," *The Illustrated London News,* June 26, 1869.

The social treatment of the animals was also Victorian paternalism at its most unctuous. They were often given names like "Daisy" that belonged either to domesticated farm animals or to the bourgeois nursery. And when the apes, from the 1830s onward, were dressed up in nursery clothes and made to have tea parties, their kinship with humanity was simultaneously suggested and ridiculed. Queen Victoria, who saw the orangutan "Jenny" drink her Darjeeling like a good monkey in May 1842, could not forbear from adding in her diary, "He [*sic*] is frightful and painfully and disagreeably human."[61] A great one herself for family gatherings in the parlor, the queen took her own children

to the zoo many times, especially when any newborn animals were to be seen, like the infant giraffe born in May 1852.

It had been her uncle William IV who had given the Crown's menagerie at Windsor and the Tower of London (where a few beasts were kept in barbaric confinement) to the London Zoological Society. Nothing could be more elo-quent of the domestication of savage arcadia than the surrender of the royal beasts of Europe to metropolitan public gardens. When the first giraffe, pre-sented by Pasha Mehemet Ali of Egypt to King Charles X of France, arrived in its new country, it sported a cape embroidered with the fleur-de-lys and the crescent moon. But this was as much to protect it from the cold during the five-hundred-mile journey from Marseilles to Paris as for any lingering heraldic bravura. Charles X, Louis XVI's youngest brother and the last of the Bourbon kings, however, had all his life been romantically gallant and so insisted on feed-ing the giraffe rose petals from his own royal palm before the animal was taken to the Jardin des Plantes.

The bolder zoo-designers, in the middle of the nineteenth century, were not content merely with shipping and showing wild animals housed in various types of European domestic architecture. Their zoological imperialism aimed at reproducing tropical micro-environments, complete with running water, artifi-cial rock, and, above all, the vegetation that would give the displays an appear-ance of authenticity. And the most ambitious of all was Carl Hagenbeck, who at his own zoo in Stellingen, near Hamburg, adapted the pastoral ha-ha to create trenched enclosures and paddocks for the wild animals he had brought from the tropics. The effect was meant to be identical to Bridgeman's eighteenth-century country-house park, with an illusion of continuity established between the landowner (or in this case the European zoo spectator) and his herds (in this case wildebeest and leopards rather than sheep and cattle).[62] It was of a piece with this design of actually bringing whole savage landscapes into the world of bourgeois-imperial Germany that Hagenbeck also mounted displays of human savages, from Inuits to Hottentots, along with his animal paddocks.

The pseudo-naturalization of the zoos could only have happened with an ample supply of tropical plants. And what went for the fauna of the wild arca-dia certainly went for the flora. The difference between the attempts of the Renaissance botanists to encompass the world in a garden and the imperial tropical gardening of the nineteenth century was simply the industrial marriage of glass panes and iron ribs. Once these had been successfully fitted through the ridge-and-furrow engineering devised by John Claudius Loudun, the lim-its imposed by masonry or wooden-framed windows on the traditional conser-vatory disappeared in a great blaze of light. When forced hot-water heating was added, whole forests of exotic vegetation could luxuriate beneath the glass. And since iron columns could bear the load of the glass on relatively slender piers, the material could itself be cast or worked to disguise its own solidity.

Some columns even sprouted tendrils and garlands; others acted as trellises for creepers and vines. In 1842, a French designer of glasshouses, suggesting how far this illusion of a technologically produced Eden could go, urged gardeners to imitate "the rich disorder of the primeval forest." The miraculous space within would no longer simply be an arrangement of tropical plants but an entire landscape of wood, water, and rock: the original arcadia with its venom drained off. "In the midst of carefully chosen lighting a stream must meander, populated with tropical fish, murmuring its way between rocks, then spreading out placid and still into a wide stream bordered with sand and pebbles."[63]

Initially, such imperial arcadia were available only to the rich and aristocratic. It cost the duke of Devonshire thirty thousand pounds for his gardener

Decimus Burton and Richard Turner, Palm House, Kew Gardens, photograph, 1849.

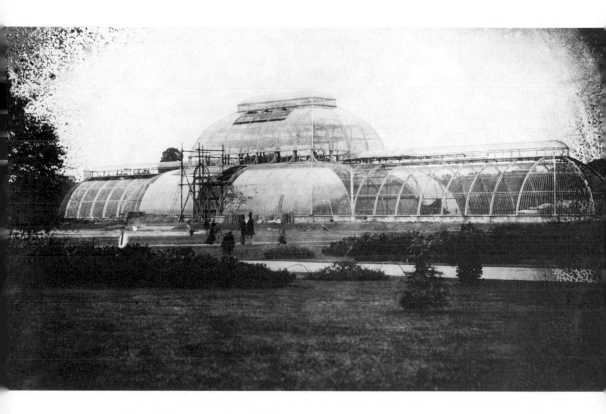

Joseph Paxton to build the "Great Stove," nearly three hundred feet long and sixty-seven feet high. This colossus of palm houses used eight coal-fired furnaces to send hot water through seven miles of pipes, all carefully concealed beneath a stone floor lest the illusion of paradise-come-to-Derbyshire be spoiled for the duke. Sub-tropicals like hibiscus and bougainvillea threw bombs of brilliant color within the dense greenery of palms and dracaena. Brilliant birds flew about in the steamy radiance. In the bleakest moment of the year, December 1843, Queen Victoria came to see both the Great Stove and the spe-

cial glasshouse that Paxton had built solely to house the duke's gigantic water lilies, obediently named the *Victoria regia*. Twelve thousand gas lamps lit the crystal; a fountain, driven by a concealed steam pump (the ultimate legacy of the great Salomon Caus), sent a spray fifty feet high, and the duke of Wellington pronounced the whole thing the most "magnificent *coup d'oeil*" he had ever seen.[64]

The Chatsworth conservatory was open to the public gratis. But even when railway travel shortened distances, access was still necessarily limited. And some of the most spectacular collections of palms and tropical plants, birds and fish were private reserves of the European monarchies, like the palm conservatory the king of Prussia, Frederick William III, built on the Pfaueninsel at the southern end of the Wannsee in 1830. Predictably, the most private of all was also the most fantastic: the realm of grottoes, jungles, and orchids built for Ludwig II of Bavaria, set (incongruously) in a painted setting of the Himalayas and accessible only through the king's private apart-

Palm House, Herrenhausen, Germany, 1879.

ments. There, beneath the peaks and palms, the king would sit dreaming on a rock, drifting his hand in the warm water while a servant dressed as Lohengrin (or possibly the Swan) would periodically cruise past.[65]

In 1845 the repeal of the glass tax in Britain dropped construction prices so steeply that grandiose glasshouses made from prefabricated units built expressly for the public became possible. The Regent's Park conservatory, built by the Royal Botanical Society, was completed in 1846. But the atmosphere inside was still that of a genteel botanical seminar. The Paris Winter Garden, the Jardin d'Hiver, all six hundred feet of it, was quite another matter. Built by Hector

Horeau during the Second Republic, in 1849, it was designed as an exotic pleasure garden, an arcadian palace for the people. So among the sixty-foot palms and the banks of camellias (two hundred thousand of them, for they were definitely the flower of the hour in Dumas's France) were also orchestras, several restaurants, bowling alleys, billiard rooms, dance floors, and a great swathe of lawn. At night, with the moonlight pouring through the glass (helped at strategic points by discretely placed gas lamps), the garden became a real Elysian Field (as the avenue outside was called), swimming in the perfumes of a perpetual spring.

At least eight thousand could be easily accommodated in the Jardin d'Hiver at one time. And the more learned jungle of Richard Turner and Decimus Burton's Palm House at Kew was visited by seventy thousand in 1841 and one hundred and eighty thousand thirty years later. They were, in effect, little empires, patrolled by white Europeans without the usual inconveniences of raging fevers and hostile indigens. In fact, the equation between glass-and-iron architecture and the extension of the tropics was so axiomatic that it deluded even experienced horticulturalists into supposing that all orchids, for example, would thrive in the hot and humid conditions of the greenhouse. The secretary of the Royal Horticultural Society, John Lindley, for example, expressly recommended such conditions in 1830 for orchid cultivation, with the result that hundreds of thousands of specimens that actually needed cool, relatively dry conditions perished after a few weeks in the greenhouses.[66]

None of these setbacks dampened the enthusiasms of the most determined zealots of the glazed arcadias. Not content with the staggering achievement of the Crystal Palace, built entirely of prefabricated parts for the Great Exhibition of 1851, Paxton dreamed up a Great Victorian Way winding around London, glazed over throughout its entire nine-mile route. Instead of weedy poplars and scabby sycamores, the road could be lined with palms as befitted a triumphal imperial boulevard.[67]

These visions of frond-brushed crystal danced in the mind of Andrew Jackson Downing, the greatest landscapist of his generation, when he considered the proposed park in New York. In *The Horticulturalist* for 1851 he imagined a site big enough to house a Crystal Palace "where the whole people could luxuriate in groves of the palms and spice trees of the tropics, at the same moment that sleighing parties glided swiftly and noiselessly over the snow covered surface of the country-like avenues of the wintry park."[68] Like Frederick Law Olmsted and Calvert Vaux, who, six years later, won the competition to design Central Park, Downing saw the project as therapy for the sickness, chaos, dirt, and violence of the modern metropolis. But his landscaped solution, set out in the article, was a peculiar mixture of modern entertainment and pastoral sentimentality. As well as the glasshouses to be set in the park, Downing envisaged shows of industrial arts, a glazed zoo, and a Virgilian pantheon to American worthies. The park would offer solitude to the Rousseaus of Manhattan who

might seek solitude, and gaiety to the gregarious. And "the thoughtful denizen of the town would go out there in the morning to hold converse with the whispering trees, and the wearied tradesmen in the evening, to enjoy an hour of happiness by mingling in the open spaces with 'all the world.' "[69]

One might have expected Olmsted to propose something like the standard English "pastoral," with its reputation for turning a brutalized working population into paragons of family morality. But he had also seen the municipal park at Birkenhead near Liverpool. And that suggested a different approach to park design than expanses of grass cut by straight avenues. Birkenhead's designer,

Lithograph by J. Bachmann, *Central Park, 1863.*

Joseph Paxton, had taken care to create a chain of irregularly shaped ponds, and paths that meandered around rocky outcrops, exposed during construction.[70] And this may have emboldened Olmsted and Vaux to create their own metropolitan arcadia in New York. His "Conception of the Plan," submitted to the commissioners (who would cause him so much grief), is still a document of startling independence and integrity. He begins with a principle: "The Park throughout is a single work of art, and as such subject to the primary law of every work of art, namely, that it shall be framed upon a single, noble motive." And then he proceeds to a prophecy: that "but for such a reservation,"

> the whole of the island of New York would . . . be occupied by buildings and paved streets; that millions upon millions of men were to live their lives upon this island, millions more to go out from it, or its immediate densely populated suburbs, only occasionally and at long intervals, and that all its inhabitants would assuredly suffer, in greater or lesser degree, according to their occupations and the degree of their confinement to it, from influences engendered by these conditions.

It was a brilliant, brave, anti-pastoral, *American* solution that Olmsted imagined. Summer recreation for those who could afford it already meant the wildernesses of the Adirondacks or the White Mountains of New Hampshire. But for the "hundreds of thousands of tired workers" who had no means and no time to enjoy such pleasures, something of New York's own original wilderness ought to be preserved.

> The time will come when New York will be built up, when all the grading and filling will be done, and when the picturesquely-varied, rocky formations of the Island will have been converted into formations for rows of monotonous straight streets, and piles of erect buildings. There will be no suggestion left of its present varied surface, with the single exception of the few acres contained in the Park. Then the priceless value of the present picturesque outlines of the ground will be more distinctly perceived. . . . It therefore seems desirable to interfere with its easy, undulating outlines, and picturesque, rocky scenery as little as possible.[71]

Exactly the features which would have led European landscapists to reject the site or to transform it into the standard civic pastoral—lawns and copses—challenged Olmsted to a more rugged and natural design. He rejected low meadows because the sight lines over the grass would be too brutally interrupted by the "Great Wall of China" of high buildings that already surrounded the park. Instead woods, little hills, and outcroppings would produce a local horizon with no definite sense of what might lie beyond it. And wherever pos-

sible he wanted to protect "picturesque" areas that would contrast with softer and more open scenery.

This is not to suggest that Olmsted was all wild arcadian, and that he wished to pretend that Central Park was some sort of urban Yosemite. Throughout his plan he was concerned to make carriage and pedestrian access as convenient as possible. But traffic was not to dominate the sovereign idea of the park, and he, too, used a modernized version of the ha-ha, to sink his roads, and enclose them with brick and stone, so that from the ground surface of the park they would be virtually invisible, offering no interruption of a single, continuous landscape. It was this uncompromisingly unified vision that produced inevitable quarrels over, for example, the zoo that the commissioners wished to install and which Olmsted fought tooth and nail to prevent, finally coming up with a plan so fantastically and expensively grandiose as to make it impractical.

By this time he had seen Yosemite for himself and had been instrumental in commending its protection to President Lincoln. One has the impression, reading his agitated protests against the low-budget park zoo, that what he most detested was the cheapening of the authentically natural landscape with ersatz wildness. His vision of the park was of a heroic urban arcadia, a place that would be grand as long as it was allowed to be true to its own native topography. (Though a trip to Panama in 1863 had him fantasizing about covering the island in the lake with banana plantains and subtropical creepers!) His repeated letters of resignation from the superintendence of the park always insisted that what he called his "creative fancy" had been violated by political compromises and wrangles that had eaten into the original design, turning the heroic into the merely prettified. But even when he had finally severed his relations with the commissioners, Olmsted still believed, with good reason, that he had created something as noble as any authentic American landscape. In its wilder aspects, along the Ramble, it was a place to scramble over mossy rocks or wander among wild flowers and ferns. In its more cultivated and open areas, children could kick balls or race along the paths.

Central Park was always supposed to answer to both arcadian myths that have survived in the modern memory: the wild and the cultivated; the place of unpredictable exhilaration and the place of bucolic rest. Olmsted could have had no inkling, of course, how the very features that made his park unique— the sunken roads, the gullies and hollows that closed off views to the streets— would shelter a savagery at which even Pan himself might have flinched. The woods and trails of Upper Manhattan are certainly not the only lair where ancient myths and demons, best forgotten, or left to academic seminars, have returned to haunt the modern polis. In fact Central Park divides its arcadian life by the hours of the clock. By day it is all nymphs and shepherds, cupids and *fêtes champêtres*. But at night it reverts to a more archaic place, the realm of Pelasgus where the wolf-men of Lykaon prowl, satyrs bide their time unsmiling, and feral men, hungry for wilding, postpone their music.

vi　The Wild, Hairy Huckleberry

Returning to the cabin in the woods by Walden Pond, a catch of fish tied to his pole, Henry David Thoreau was seized with an overwhelming urge to eat raw woodchuck. It was not that he was particularly hungry. And he already knew the taste of woodchuck, at least cooked woodchuck, for he had killed and eaten an animal that had been complacently dining off his bean field. It was simply the force of wildness he suddenly felt possessing his body like an ancient rage. "Once or twice . . . I found myself ranging the woods, like a half-starved hound, with a strange abandonment, seeking some kind of venison which I might devour, and no morsel could have been too savage for me."[72] So when the woodchuck shambled across his path, it was merely the "wildness which [it] represented" that tempted Thoreau to grab it and tear it apart. "I fear that we are such gods or demigods only as fauns or satyrs, the divine allied to beasts, the creatures of appetite."[73]

Thoreau *feared* the resurgence of the predator-animal in him because he was, in fact, deeply ambivalent about the primitive instinct within humanity. In *Walden* he agonized about the "animal in us, which awakens in proportion as our higher nature slumbers. It is reptile and sensual, and perhaps cannot be wholly expelled; like the worms which, even in life and health, occupy our bodies."[74] Drinking water from the brooks and eating berries, he was never pure enough for his own conscience; a virgin, he was never chaste enough for the content of his soul. As much as he fled from the conventional pieties of New England society, he was manifestly part of it in his remorseless attack on his own creature-instincts. And his direct encounter with a true wilderness, in the Maine woods around Mount Ktaadn in 1846, was a distinctly mixed experience. The forest was so damp and mossy he felt as though he were journeying through a perpetual swamp; the slopes of the mountain, pockmarked with bear dens, were "the most treacherous and porous country I ever travelled," the bare rock of the summit desolate and savage: "This was that Earth of which we have heard, made out of Chaos and Old Night. Here was no man's garden, but the unhandselled globe. . . . It was Matter, vast, terrific."[75]

When, however, he strode the boards of the Concord Lyceum to give his famous lecture entitled "Walking," Thoreau presented himself as an uncom-

promising wild man. To the assembled bonnets and whiskers he decreed that "in Wildness is the preservation of the World." To become tame, he cautioned, is to invite atrophy, for when the Roman descendants of Romulus and Remus were no longer "suckled by the wolf . . . they were conquered and displaced by the children of the northern forests who were." Since the skin of the antelope was said to emit perfume, he would have "every man so much like a wild antelope, so much a part and parcel of Nature, that his very person should thus sweetly advertise our senses of his presence, and remind us of those parts of Nature which he most haunts." And against the genteel tinkling of Spohr sonatas, Thoreau avowed his preference for "the sound of a bugle in a summer night," which reminded him "of the cries emitted by wild beasts in their native forests."[76]

In his public appearances, then, Thoreau found it necessary to repress his conflicted feelings about the coexistence of the savage and the social. The prophetic posture of the first generation of ecologists, especially in America, demanded a rejection of equivocation as so much moral slurry. For, like all revolutionaries, they rejoiced in seeing the world upside down, in proclaiming culture the whore and nature the

Frank Jesup Scott, *The Art of Beautifying Suburban Home Grounds,* 1881.

virgin. John Muir, the guardian-father of Yosemite, who could find his way through hundreds of miles of unmapped wilderness, professed to get lost in hotel corridors in San Francisco. When he was in New York, signs on the side of omnibuses made him want to see Olmsted's Central Park. But, "fearing that I might not be able to find my way back, I dared not make the adventure."[77] He was, of course, unfair to the park's landscape in supposing that he might be swallowed up by its urbanity, for Olmsted, as we have seen, had gone to great lengths to make such as Muir feel at home along the Ramble. (And Yosemite was actually only a third as large again as Central Park.) It was one of the bitterest disappointments of Muir's life that when Ralph Waldo Emerson came to Yosemite in 1871, he failed to persuade the old man to camp out overnight.

"You are a sequoia yourself," he told Emerson. "Stop and get acquainted with your big brothers."[78] But Emerson, at this late moment in his life, probably did not feel much like a sequoia and even less that he would rival their longevity. Muir would have better luck with the dauntless Teddy Roosevelt in 1903, digging him out of five-foot snowdrifts.

Battles over turf between wild men and gentlemen, hunters and gardeners, ancient Arcadians and Virgilian pastorals, wilderness forests and city parks, continued through the nineteenth century, becoming more serious as the world became more industrial. Turf, acre after acre after acre of it, became the landscape of settled civility: turf on the bowling greens of urban parks where working men who, said the city fathers, would otherwise have squandered their earnings on drink and lechery were made peaceable. Turf on the heavily rolled cricket pitches of the British Empire from the Caribbean to Singapore was the landscape on which class and racial divisions between Gentlemen and Players and Natives and Masters were supposed to be batted away with willow and leather.[79] And turf began its supremacy in the suburban yard in the middle of the nineteenth century, according to the dictates of Frank Jesup Scott, the categorical author of *The Art of Beautifying Suburban Home Grounds*.[80] A decent lawn, Scott insisted, must run down flush to the street, lest anything "unchristian and unneighborly . . . narrow our and our neighbor's views of the free graces of Nature."[81] But precisely because the grass occupied an unbroken space in front of the house, where it was also thought unseemly for the family to disport itself in public view, the lawn rapidly turned into a dead space, an empty green rug stretched before the dwelling.

It was this phantom suburban meadow, patrolled by relentless clipping, weeding, and mowing in the yards of America, that made the likes of Muir and Thoreau howl with chagrin and head for the woods. No amount of "wild gardening" of the sort proposed by William Robinson, with lawns freckled with randomly naturalized bulbs, could compensate for the fact that the *sacro bosco* had shrunk to the isolated maple or chestnut standing alone on the greensward, or that the ancient balm of Arcadia for tempers inflamed by city evils had become, in F. J. Scott's words, "our [suburban] panacea for the town-sick business man who longs for a rural home, whether from the ennui of business life or from the higher nature that is in him." Even this panacea, moreover, ought to be ladled out, Scott thought, in strictly rationed doses, lest the patient gag on an overdose of rustication. "One half to four or five acres will afford ground enough to give all the finer pleasures of rural life."[82]

If this was where historical sentimentality had brought us—to Ruskin's nightmare of cities draped in "pleasure parks" featuring pagodas and bastard Italianate bandstands; to row upon row of tasteful villas, each one a dwarfish parody of Gothic or Palladian style—then history be damned. "He is blessed over all mortals," declared Thoreau, "who loses no moment of the passing life in

remembering the past."[83] What he often urged was a sort of blessed amnesia, a liberation from the burden of the dead in order to see what was truly and naturally alive. To renounce transgression, of course, often requires that we unflinchingly survey our past and find it an unrelieved record of folly and infamy. Thoreau's rejection of history was based on the fierce conviction that it was irreconcilable with nature. Civilization's habitual way with the natural world, he thought, was to make it meek and compliant, a thing of herbaceous borders and bedding annuals rather than the "impervious and quaking swamp."

I have spent these many pages of *Landscape and Memory* begging to differ, attempting to piece together a different story. For it seems to me that neither the frontiers between the wild and the cultivated, nor those that lie between the past and the present, are so easily fixed. Whether we scramble the slopes or ramble the woods, our Western sensibilities carry a bulging backpack of myth and recollection. We walk Denecourt's trail; we climb Petrarch's meandering path. We should not support this history apologetically or resentfully. For within its bag are fruitful gifts—not only things that we have taken from the land but things that we can plant upon it. And though it may sometimes seem that our impatient appetite for produce has ground the earth to thin and shifting dust, we need only poke below the subsoil of its surface to discover an obstinately rich loam of memory. It is not that we are any more virtuous or wiser than the most pessimistic environmentalist supposes. It is just that we are more retentive. The sum of our pasts, generation laid over generation, like the slow mold of the seasons, forms the compost of our future. We live off it.

Thoreau lived off it, too. When he walked toward the "stately pine wood" by Spaulding's Farm, he saw that the "golden rays" of the setting sun had "straggled into the aisles of the wood as into some noble hall."[84] Consciously or not, he was remembering the ancient tradition that saw the forest roof as a holy, vaulted chamber. Throughout his writing he evoked memory, even when he believed himself to be dismissing it. He went to Concord to see "a panorama of the Rhine"—the sort of thing that Albert Smith popularized—and let himself be sweetly borne along,

> down its historic stream in something more than imagination, under
> bridges built by the Romans, and repaired by later heroes, past cities
> and castles whose very names were music to my ears, and each of which
> was the subject of a legend. There were Ehrenbreitstein and Roland-
> seck and Coblentz. . . . There seemed to come up from its waters and
> its vine-clad hills and valleys a hushed music as of Crusaders departing
> for the Holy Land. I floated along under the spell of enchantment, as
> if I had been transported to an heroic age, and breathed an atmo-
> sphere of chivalry.[85]

Even the fearsome bald dome of Mount Ktaadn put him in mind of "the creations of the old epic and dramatic poets, of Atlas, Vulcan, the Cyclops, and Prometheus. Such was Caucasus and the rock where Prometheus was bound. Aeschylus had no doubt visited such scenery as this."[86] And when he walked in the "universally stern and savage" woods of Maine, he conjured up, as if he were on an American Pook's Hill, the ghosts of "the Northmen, and Cabot, and Gosnold . . . and Raleigh" stumbling through the primeval forest.[87]

Herbert Gleason, *Walden Pond*, ca. 1906.

Myth, Thoreau readily acknowledged, could supply a library of nature's memory commensurate with its raw power and beauty. But, unorthodox as he

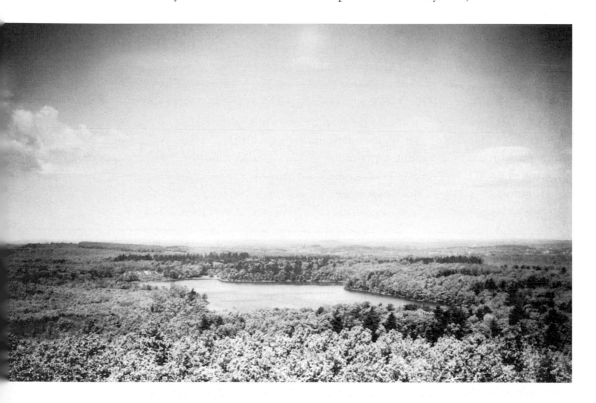

was in most things, he was entirely of his time in assuming history and culture to be sheared away from myth. "Mythology is the crop which the Old World bore before its soil was exhausted," he asserted, beginning a lament which continues to our own day. Yet he hoped that while "the valleys of the Ganges, the Nile, and the Rhine [had] yielded their crop," the great rivers of America—the Amazon, the Orinoco, and the Mississippi—might replenish the depleted stock of myth. "Perchance, when, in the course of ages, American liberty has become a fiction of the past,—as it is to some extent a fiction of the present,—the poets of the world will be inspired by American mythology."[88]

Archaeology was the enemy of mythology, for it presupposed a stale continuity of human habitation. The very idea of culture layered over culture on

the same site turned Thoreau's stomach, and he rejoiced that, as he imagined, the three acres Emerson had given him on Walden Pond had never seen any form of human settlement. Whether or not there had been Indian cultures by the deep, clear waters of the pond made no difference, since they were somehow exempt from the kind of social exploitation of nature he attributed to civilizations. Thoreau, like Muir, believed Indians to have led a life perfectly continuous with nature, with "the wolf and the beaver." "The wildness of the savage," he insisted, "is but a faint symbol of the awful ferity with which good men and lovers meet." So even if Indians had once lived by the pond, they could never have contaminated its innocence.

But what did *Walden* do to Walden? What did Thoreau expect would happen to his sanctuary of birch and pine should his book be successful? He never had the luxury of finding out, since it took five years to sell the two thousand copies of the first edition. Thoreau went to his early grave in 1862, bitterly grieved at its failure. His obituaries prompted a brief period of attention, but it was only in the 1880s that *Walden* became internationally known and a second American edition was finally published. Suppose, though, that it had been a success. Would that not have immediately turned the pond into a looking glass for Thoreau's celebrity? For there can be no question *now* of the loss of innocence of the place, since it is impossible to go there without being overwhelmingly aware of his ghostly presence.

But why should one want to avoid it? The archaeology of *his* habitation remains in the vestigial cairn of stones that represent his hearth, regularly added to by the countless pilgrims and devotees of his memory who have worn the path by the pond smooth with their homage. And whether Thoreau would actually have been displeased by their attention is moot. He was, as Edward Hoagland has pointed out, a more companionable and social person than his journals and books make him appear.[89] He would perhaps have flinched at the clatter and moan of the commuter train behind the sheltering rim of the hill that overlooks the pond, and the incessant rumble of freeway trucks barely a mile away would have been a torment. Worst of all, perhaps, might have been the joggers pounding the trails, for Thoreau often decreed that the best walking was a slow *saunter,* emulating the camel, the only beast, he thought, that could ruminate and walk at the same time.

Bathers splashing in the summer shallows, the occasional fisherman in a rowboat, might not have bothered him at all, nor the sense that *Walden* is less that "savage, howling mother of ours, Nature," than a suburban refuge—the two arcadias, wild and tender, folded together in the bowl of the same gentle landscape. For although we generally think of Thoreau as the guardian of wilderness, one of his most powerful passions was for the local and the intimate; hence the force of his wonderful oxymoron: "I have travelled a good deal in Concord." He had indeed, and it is from the close familiarity of those "trav-

els" that the unparalleled vividness and precision of his nature writing arises. In 1840, three years after graduating from Harvard, the pencil-maker's son pondered whether he ought not, like many of his contemporaries (Melville and Parkman, for example), satisfy his urge for the wild by undertaking a long journey in its pursuit. He perused the career of Sir Walter Ralegh upstream on the Orinoco. And on March 21 he daydreamed like a child. Might he be, he wondered in his journal,

> a mail carrier in Peru—or a South African planter—or a Siberian exile—or a Greenland whaler, or a settler on the Columbia river—or a Canton merchant—or a soldier in Florida—or a mackerel fisher off Cape Sable—or a Robinson Crusoe in the Pacific?

His answer was that he would do none of these things, for "our limbs indeed have room enough but it is our souls that rust in a corner. Let us migrate interiorly without intermission, and pitch our tent each day nearer the western horizon."[90] Even this urge toward the west was more a state of mind than a command to travel. For his grandest epiphanies always came locally. A year later he sat on his boat in the middle of the pond at twilight, playing the flute, watching the perch "and the moon travelling over the ribbed bottom—and feel[ing] that nothing but the wildest imagination [could] conceive of the manner of life we are living. Nature is a wizard. The Concord nights are stranger than the Arabian nights."[91]

In one sense at least, I have tried to keep faith with Thoreau's aversion to running after the esoteric, and with his conviction that the whole world can be revealed in our backyard if only we give it our proper attention. But the backyard I have walked through—*sauntered* through, Thoreau might exclaim—is the garden of the Western landscape imagination: the little fertile space in which our culture has envisioned its woods, waters, and rocks, and where the wildest of myths have insinuated themselves into the lie of our land. For that matter, there are places even within the boundaries of a modern metropolitan sprawl where the boundaries between past and present, wild and domestic, collapse altogether. Below the hilltop clearing where my house stands are drystone walls, the remains of a vanished world of sheep-farming and dairying, made destitute a century ago. The walls now trail across a densely packed forest floor, hidden from view by a second growth canopy of tulip trees, white ash, and chestnut-leaf oak. From the midst of this suburban wilderness, in the hours before dawn, barely a fairway away from the inevitably manicured country club, coyotes howl at the moon, setting off a frantic shrieking from the flocks of wild turkey hidden in the covers. This is Thoreau's kind of suburb.

He never changed his mind about the necessary intimacy of wildness. On August 30, 1856, six years before his death, he declared in his journal that he

had finally "reached a new world." He meant, of course, that he had stayed in the same place. But in that place he had discovered a spot so wild that the "huckleberries grew hairy and were inedible." The discovery made him shudder with pleasure, as if he had suddenly been transported to "Prince Rupert's Land" in Labrador. Holding the things in the palm of his hand, he began, suddenly, to be carried through time and space: "Here grows the hairy huckleberry as it did in Squaw Sachem's day and a thousand years before, and concerns me perchance more than it did her. I have no doubt that for a moment I experience exactly the same sensations as if I were alone in a bog in Rupert's Land, and it saves me the trouble of going there; for what in any case makes the difference between being here and being there but many such little differences of flavor and roughness put together? . . . I could be in Rupert's Land and supping at home within the hour! This beat the railroad."

Or the eco-trip to Belize. For this is what the unappetizing little fruit, finally, had to tell Thoreau, and us.

> It is in vain to dream of a wildness distant from ourselves. There is none such. It is the bog in our brain and bowels, the primitive vigor of Nature in us, that inspires that dream.[92]

NOTES

Introduction

1. For an extraordinary account of the fire-welcoming properties of the eucalyptus, see Stephen J. Pyne, *Burning Bush: A Firestick History of Australia* (New York, 1991), chap. 1.

2. For the Edenic associations of Yosemite, see John F. Sears, *Sacred Places: American Tourist Attractions in the Nineteenth Century* (Oxford, 1989), 133ff.

3. John Muir, *The Mountains of California* (New York, 1894), 3.

4. Ansel Adams, *On Our National Parks* (Boston, Toronto, and London, 1992), 113–17.

5. For a discussion of the etymology, see the essay by John Brinckerhoff Jackson in *Discovering the Vernacular Landscape* (New Haven, 1984), 3–8; also John R. Stilgoe, *Common Landscape of America, 1580–1845* (New Haven and London, 1982), 3–4. A sophisticated and persuasive account of the emergence of the idea of nature can be found in Neil Evernden, *The Social Creation of Nature* (Baltimore and London, 1992). A telling critique of the assumptions behind concepts of nature is offered in Luc Ferry, *Le Nouvel Ordre écologique: L'Arbre, l'animal et l'homme* (Paris, 1992). For a thoughtful, comparative view of the conceptualization of landscape, see Augustin Berque et al., "Au-delà du paysage moderne," *Le Débat* 65 (May–June 1991): 4–133.

6. Henry Peacham, *Minerva Britannia; or, A Garden of Heroical Devices, furnished and adorned with Emblemes and Impresas of sundry natures, Newly devised, moralised and published* (London, 1612).

7. Ibid., 185.

8. Cited in Sara Whitfield, *Magritte* (London, 1992), 62.

9. See the introductory essays by Simon Cutts and David Reason in *The Unpainted Landscape* (London, 1987).

10. David Reason, "A Hard Singing of Country," in op. cit., 24–34, recognizes the dilemma and, along with many of the artists represented in the exhibition, makes no pretense of a *total* absorption of the artist within the landscape.

11. Stephen J. Pyne, *The Ice: A Journey to Antarctica* (Ames, Iowa, 1986); William J. Cronon, *Changes in the Land: Indians, Colonists, and the Ecology of New England* (New York, 1978); Donald Worster, *Rivers of Empire: Water, Aridity and the Growth of the American West* (New York, 1986; Oxford, 1992). For a review of the principal issues moving environmental history as well as the problems of its methodology, see Donald Worster et al., "Environmental History: A Round Table," special number of *Journal of American History*, March 1990: 1087–1147.

12. On the scientific revolution and the environment, see Carolyn Merchant, *Radical Ecology: The Search for a Livable World* (New York and London, 1992), 41–59; idem, *Ecological Revolutions: Nature, Gender and Science in New England* (Chapel Hill, 1989). Victor Ferkiss, *Nature, Technology, and Society: Cultural Roots of the Current Environmental Crisis* (New York and London, 1993) is a more dispassionate history of the polarization between technology and nature. David Rothenberg, *Hand's End: Technology and the Limits of Nature* (Berkeley and Los Angeles, 1993) provides a persuasive and subtle criticism of the standard opposition between science and nature.

13. Lynn White, Jr., "The Historical Roots of Our Ecological Crisis," *Science* 155, no. 3767 (Mar. 10, 1967): 1203–1207. The classic, monumental account of the relationship between human self-perception and nature is Clarence J. Glacken, *Traces on the Rhodian Shore: Nature and Culture in Western Thought from Ancient Times to the End of the Eighteenth Century* (Berkeley and Los Angeles, 1967); see also the brilliant discussion in Keith Thomas, *Man and the Natural World: Changing Attitudes in England, 1500–1800* (London, 1983).

14. Max Oelschlaeger, *The Idea of Wilderness* (New Haven, 1991), 1–67 and passim.

15. David Middleton, *Ancient Forests* (San Francisco, 1992), 13.

16. The use of landscape in the creation of national mythologies has been at the heart of much recent writing in the field of cultural geography. See in particular Denis Cosgrove and Stephen Daniels, eds., *The Iconography of Landscape: Essays on the Symbolic Representation, Design and Use of Past Environments* (Cambridge, 1988); Stephen Daniels, *Fields of Vision: Landscape Imagery and National Identity in England and the United States* (Princeton, 1993); and essays by W. J. T. Mitchell, Ann Jensen Adams, Ann Bermingham, and Elizabeth Helsinger in W. J. T. Mitchell, ed., *Landscape and Power* (Chicago, 1994).

17. Alan Riding, "El Escorial Journal; Holy War: Virgin's Devotees vs. Doubting Mayor," *New York Times*, Mar. 15, 1994, A4.

18. See E. H. Gombrich, *Aby Warburg: An Intellectual Biography* (Chicago, 1970), 267. See also the preceding chapter, 239ff.

PART ONE: WOOD

Prologue: The Detour

1. Neal Ascherson has written a fine essay about the literary traditions and present realities of the *puszcza*, "Borderlands," originally published in *Granta* 20 (1990), and reprinted in *The Best of Granta Travel* (London, 1991), 305–27. Like Ascherson, I, too, met foresters at Białowieża who had found ancient military debris on the forest floor.

2. These are the opening lines, the famous "Invocation" of the greatest of all Polish epic poems, Adam Mickiewicz's *Pan Tadeusz*. The translation history of this extraordinary work is itself a vexed and fascinating topic, most Polish scholars pronouncing it definitively untranslatable. But an authoritative prose translation by George Noyes was published in 1884. The best modern verse rendering is by Kenneth Mackenzie (London, 1964) and this is the version I follow and cite. Some exceptionally lively and creative renderings of passages and fragments are anthologized in Clark Mills, ed., *Adam Mickiewicz, 1798–1855: Selected Poems* (New York, 1956). For an interesting comment on the Lithuanian idyll, see Jola Schabenbeck-Ebers (to whom I am personally grateful for help on this subject), "Lithuania as a Metaphor: The Case of Mickiewicz, Miłosz and Konwicki," *Baltisches Jahrbuch*, 1985: 122–30.

3. Mickiewicz, *Pan Tadeusz; or, The Last Foray in Lithuania,* 2.

4. Elzbieta Matynia of the New School is now preparing a detailed study of the Kosciuszko mound and its twentieth-century replica, the Piłsudski mound built a few miles further west from Kraków. I am most grateful to Ms. Matynia for drawing my attention to the mounds and for other generous help in the cultural history of Polish landscape.

5. See the brilliant and moving account of this relationship given by Aleksander Hertz, *The Jews in Polish Culture,* trans. Richard Lourie (Evanston, Ill., 1988). The biographical foreword by Czesław Miłosz makes it clear that Hertz could write so powerfully and subtly about this issue because his own self-consciousness was that of both a Polish patriot and an unequivocal Jew.

6. Ibid., 60ff.

7. The best account of Mickiewicz's relationship, domestic and literary, with the world of Polish Jews is in Joanna Rostropowice Clark, "Jews and Judaism in Polish Romantic Literature" (Ph.D. diss., University of Pennsylvania, 1990). I am most grateful to Dr. Clark for pointing me toward aspects of this issue that I had certainly overlooked. See also Hertz, op. cit., 29ff.

8. *Konrad Wallenrod and Other Writings of Adam Mickiewicz,* trans. Jewell Parish, Dorothea Prall Radin, and George Rapall Noyes (Berkeley, 1925), 167.

9. Astonishingly, the overt anti-semitism of the book did not preclude its translation into Hebrew by the Roman Jew Moise Ascarelli, who used Armand Levy's French edition as his text. See Abraham Duker, "Mickiewicz in Hebrew Translation," in Wacław Lednicki, ed., *Mickiewicz in World Literature* (Berkeley, 1956), 657 n. 25.

10. Mickiewicz, *Pan Tadeusz,* 80–81. For a fascinating discussion of the symbolic possibilities of the inn, and whether Mickiewicz meant it to have Masonic or Solomonic connotations, see Clark, op. cit., chap. 1, 40ff.

11. Mickiewicz, *Pan Tadeusz,* 276.

12. Ibid., 279.

13. See Adam Zamoyski, *The Polish Way: A Thousand-Year History of the Poles and Their Culture* (London, 1987), 256.

14. See Jadwiga Maurer, "Celina Szymanowski as a Frankist," *Polish Review* 34, no. 4 (1989).

15. See Adam Mickiewicz, *Cours de littérature slave, professé au Collège de France* (Paris, 1860); cited—and interestingly discussed—by Clark, op. cit., 38–39.

Chapter One: In the Realm of the Lithuanian Bison

1. See Baron J. von Brincken, *Mémoire descriptif sur la forêt impériale de Białowieża en Lithuanie* (Warsaw, 1828), a crucial source for the ecology, zoology, and folklore of Białowieża and the first book to publish engravings of the hunts.

2. Tacitus, *Germania,* trans. M. Hutton, rev. E. H. Warmington (Cambridge, Mass., 1980), chap. 46 (p. 213).

3. For a rich and learned discussion of these competing accounts of origins, see Norman Davies, *God's Playground: A History of Poland,* 2 vols. (New York, 1982), 1:38–45.

4. Nicolai Hussovianus, *Carmina,* ed. Jan Pelczar (Kraków, 1894), xiii–xiv.

5. Nicolaus Hussovianus, *Carmen N.H. de Statura feritate ac venatione Bisontis* (Kraków, 1523), lines 55–60 (p. 11).

6. Aristotle, *History of Animals,* trans. and ed. D. M. Balme (Cambridge, Mass., 1991), 8.45 (p. 391).

7. Caesar, *The Gallic War,* trans. H. J. Edwards (Cambridge, Mass., 1986), 6.28 (p. 353).

8. Conrad Celtis, *Pistorii Poloniae . . . ,* 1:168; see also Hussovianus, op. cit., "Praefatio" (p. xxi).

9. Davies, op. cit., 247, aptly compared Marcin Kromer's sixteenth-century account of an "enclosed" bison hunt to the ritual formalities of a Spanish corrida, not least because of

the use of a red cape to rouse exhausted animals to further exhibitions of savagery. See Marcin Kromer, *Poloniae; sive de situ, populis, moribus, magistratibus et republica regni Poloni libri duo,* 2 vols. (Cologne, 1578).

10. Hussovianus, op. cit., lines 885–900 (p. 41).

11. Sigismundus von Herberstein, *Rerum Moscovitarum Commentarius* (Basel, 1571); see also Kromer, op. cit., 1:489f.

12. See the letter from Sobieski to his wife, September 13, 1683, quoted in Davies, op. cit., 1:484–86.

13. Von Brincken, op. cit., 81.

14. The complete list of hunters is given in von Brincken, op. cit., 84–85.

15. Ibid., 84.

16. See Józef Broda and Antoni Zabko-Potopowicz, "Ewolucja lesnictwa w Polsce," in idem, eds., *W Gladu Lasu* (Warsaw, 1985), 16–17.

17. For a detailed history of the period of the partitions and the Napoleonic wars, see Davies, op. cit., vol. 2; also Adam Zamoyski, *The Polish Way: A Thousand-Year History of the Poles and Their Culture* (London, 1987), 223–87.

18. For Lithuanian tree cults, see J. G. Frazer, *The Golden Bough* (London and New York, 1950), 127–28.

19. See Monika M. Gardner, *Adam Mickiewicz, the National Poet of Poland* (New York, 1971), 80–83.

20. Ludwik Krzyżanowski, "Cooper and Mickiewicz, a Literary Friendship," in Manfred Kridl, ed., *Adam Mickiewicz, Poet of Poland* (New York, 1951), 245–57.

21. There is an enormous and distinguished literature on Cooper's use and definition of the forest landscape. See in particular H. Daniel Peck, *A World by Itself: The Pastoral Moment in Cooper's Fiction* (New Haven and London, 1977), esp. chaps. 3 and 5; Stephen Railton, *Fenimore Cooper: A Study of His Life and Imagination* (Princeton, 1978); R. W. B. Lewis, *The American Adam: Innocence, Tragedy, and Tradition in the Nineteenth Century* (Chicago, 1955); Blake Nevius, *Cooper's Landscapes: An Essay on the Picturesque Vision* (Berkeley, 1976).

22. Adam Mickiewicz, *Pan Tadeusz; or, The Last Foray in Lithuania,* trans. Kenneth Mackenzie (London, 1964), 76.

23. Ibid., 67.

24. Ibid., 68–69.

25. Ibid., 77.

26. Ibid., 90.

27. Ibid., 98.

28. Tadeusz Konwicki, *The Polish Complex,* trans. Richard Lourie (New York, 1982), 84–85.

29. I am grateful to my student Keith Crudgington for the information yielded by her rich research on Witkiewicz and the Zakopane school as well as on the influence of Ruskin in Poland.

30. Broda and Zabko-Potopowicz, op. cit., 24.

31. The annexation of Lithuania and the Niemen forest region including Grodno and Wilno, together with the creation of a satellite "Kingdom of Poland," was a firmly established feature of German war aims by 1916. See Fritz Fischer, *Germany's Aims in the First World War,* introduction by Hajo Holborn and James Joll (London and New York, 1967), 252–53, 278, and 313–16.

32. See letters from Lorenz Hagenbeck to Alarik Behn, Sept. 1915. I am most grateful to Nigel Rothfels, who is preparing a doctoral dissertation on the Hagenbecks and the imperial German zoos, for this information and archival sources.

33. Stefan Żeromski, *Puszcza Jodlowa* (Kraków, 1926), 28. I am grateful to Anna Popiel for helping me with the translation of Żeromski's extraordinary and haunting little book.

34. Waldemar Monkiewicz, *Białowieża w cieniu swastyki* (Białowieża in the Shadow of the Swastika) (Białystok, 1984), 36.

35. For the Third Reich's policy of remodelling the Polish landscape according to the principles of the German *Heimat,* see a series of articles by Gert Groning and Joachim Wolschke-Bulmahn, notably "1 September 1939, Der Überfall auf Polen also Ausgangspunkt 'totaler' Landespflege," *RaumPlanung* 46/47 (1989): 149–53; idem, "Politics, Planning and the Protection of Nature: Political Abuse of Early Ecological Ideas in Germany, 1933–1945," *Planning Perspectives* 2 (1987): 127–48; Joachim Wolschke-Bulmahn, "The Fear of the New Landscape: Aspects of the Perception of Landscape in the German Youth Movement Between 1900 and 1933 and Its Influence on Landscape Planning," *Journal of Architectural and Planning Research* 9, no. 1 (Spring 1992): 33–42. I am most grateful to my colleague John Czaplicka for bringing these important articles to my attention. For an astute discussion of the *deutsche Tierschutzrecht,* see Ferry, op. cit., 181–86.

36. Groning and Wolschke-Bulmahn, "Politics, Planning and the Protection of Nature," 133.

37. Interview with the Białowieża forester Włodek Piroznikow, June 5, 1992.

38. Avraham Tory, *Surviving the Holocaust: The Kovno Ghetto Diary,* trans. Jerzy Michałowicz, ed. Martin Gilbert (Cambridge, Mass., 1990), 497.

39. Ibid., 300.

40. Interview with Włodek Piroznikow, June 6, 1992.

Chapter Two: Der Holzweg: *The Track Through the Woods*

1. Franz Lichterfeld, "Der Auerochs," *Die Natur: Zeitung zur Verbreitung naturwissenschaftlicher Kenntnis und Naturanschauung für Leser aller Stände* (Organ des Deutschen Humboldt-Vereins), 1878: 527.

2. The narrative that follows is based on the account generously provided in conversations with Giovanni Baldeschi-Balleani and his sister, Francesca. I am deeply grateful to the Baldeschi-Balleani family for their help in reconstructing this story, as well as with descriptions of the palazzi in and near Iesi; to James Hankins and Ginny Brown for introducing me to the episode, and to Michael Sissons and Serena Palmer for putting me in contact with the family.

3. See Michael H. Kater, *Das "Ahnenerbe" der SS, 1933–1945: Ein Beitrag zur Kulturpolitik des Dritten Reiches* (Stuttgart, 1974).

4. Tacitus, *Germania,* trans. M. Hutton, rev. E. H. Warmington (Cambridge, Mass., 1980), chap. 37 (p. 189). For the passages that follow I have observed Hutton's translations except where they seem to me to gloss over the force of Tacitus's descriptions. Thus, for example, I translate *paludibus foeda* as "foul bogs" rather than the slightly more decorous "unhealthy marshes."

5. Ibid., chap. 13 (p. 151).

6. Ibid., chap. 14 (p. 153).

7. Ibid., chap. 22 (p. 165).

8. Ludwig Krapf, *Germanenmythus und Reichsideologie: Frühhumanistische Rezeptionsweisen der taciteischen "Germania"* (Tübingen, 1979), 4.

9. I am most grateful to Dr. Rosamund McKitterick of Newnham College, Cambridge, for her kind help in clarifying the complicated history of the codex. The version given in R. P. Robinson, *The Germania of Tacitus (A Critical Edition)* (Middletown, Conn., 1935), which insists that the Codex Aesinas could not be a direct copy of the Hersfeld manuscript, has now been seriously challenged by more recent scholarship. See, for example, C. E. Murgia and R. H. Rodgers, "A Tale of Two Manuscripts," *Classical Philology* 79 (1984): 145–53.

10. See the classic (though controversial) account of the *Rezeption* in Eduard Norden, *Die germanische Urgeschichte in Tacitus Germania* (Berlin, 1923), 3–4; also Krapf, op. cit.; Kenneth C. Schellhase, *Tacitus in Renaissance Political Thought* (Chicago, 1976), chaps. 2 and 3; J. Perret, *Recherches sur le texte de la Germanie* (Paris, 1950).

11. For this history, see Luciano Canfora, *La Germania di Tacito da Engels al nazismo* (Naples, 1979), 64–81.

12. Tacitus, *Germania*, chap. 4 (pp. 134–36).

13. On the founding of the Ahnenerbe, see Kater, op. cit., 11–37; and on the importance of natural history and topography in the project, idem, 211ff.

14. This edition is rare, certainly outside Germany, and I am most grateful to my Harvard colleague (and neighbor in Widener Library) Wendell Clausen for being so kind as to allow me to read his copy of the Till *Handschriftliche Untersuchungen zu Tacitus Agricola und Germania* (Berlin, 1943). For the detailed history of the Till edition, see Canfora, op. cit., 77–82.

15. The damage from water stains is happily confined to the opening folios of the *Germania*.

16. Tacitus, *Germania*, chap. 2 (p. 131). Norden, op. cit., 309–10, had also drawn attention to the relationship between the forest *Umwelt* of the Germans and their character as a race.

17. See, for example, Walther Schoenichen, *Urwaldwildnis in deutschen Landen* (Neudamm, 1934).

18. On Darré, see Anna Bramwell, *Blood and Soil: Richard Walther Darré and Hitler's "Green Party"* (Abbotsbrook, Bourne End, and Buckinghamshire, 1985).

19. Tacitus, *Germania*, chap. 2 (pp. 130–31).

20. Ibid., chap. 4 (pp. 135–37).

21. *The Epic of Gilgamesh*, trans. Maureen Gallery Kovacs (Stanford, 1989), 45.

22. Livy, *History*, trans. B. O. Foster (Cambridge, Mass., 1982), 9.25–36 (pp. 299–301).

23. Caesar, *De bello Gallico*. See the account of this and other classical texts on German primitivism including Seneca's *De providentia* in Arthur O. Lovejoy and George Boas, *Primitivism and Related Ideas in Antiquity* (Baltimore, 1935), 362ff.

24. Caesar, *The Gallic War*, trans. H. J. Edwards (Cambridge, Mass., 1986), 6.25 (pp. 350–51).

25. Pliny, *Natural History*, trans. H. Rackham (Cambridge, Mass., 1986), 3.10.67 (pp. 376–77).

26. Ibid., 16.2 (p. 391).

27. Seneca, *De providentia*, 14.15, in Lovejoy and Boas, op. cit., 364–65.

28. Tacitus, *Germania*, chap. 16 (pp. 154–55).

29. Ibid., p. 155.

30. The evidence of ritually killed bodies preserved in peat bogs does seem to bear out some of the Roman ethnographers' assertions about the practices of human sacrifices among the early Germans (as well as Celts). According to the geographer Strabo, the formidable northern Cimbri tribe, who invaded the Roman frontiers in the second century B.C., also practiced the tree-hanging sacrifice of prisoners taken in battle. See Malcom Todd, *The Early Germans* (Oxford and Cambridge, Mass., 1992), 112–13.

31. Tacitus, *Germania*, chap. 39 (p. 195).

32. Ibid., chap. 20 (p. 161).

33. Ibid., chap. 12 (p. 149).

34. Ibid., chap. 27 (p. 171).

35. See the introduction to the *Germania* by E. H. Warmington, p. 120.

36. Seneca, *De providentia* (*Dialogues*, book 1), cited also in Gerald Strauss, *Sixteenth-Century Germany, Its Topography and Topographers* (Madison, Wis., 1959), 156–57.

37. Velleius Paterculus, *Compendium of Roman History*, ed. and trans. John Selby Jackson (London, 1889), 536.

38. Tacitus, *Annals*, trans. John Jackson (Cambridge, Mass., and London, 1979), 1.51 (p. 329).

39. Ibid., 1.62 (p. 349).

40. Ibid., 1.65 (p. 355).

41. Ibid., 2.14 (pp. 403–4).

42. Ibid., 2.21 (pp. 413–15).

43. See Schellhase, op. cit., 32–33.

44. See Strauss, op. cit., 9.

45. "De Nocte et Osculo Hasilinae Erotice," in *Selections from Conrad Celtis, 1459–1508*, ed. Leonard Forster (Cambridge, 1948), 26–27. For the original version, and the many other poems devoted to Hasilina, see Conradus Celtes, *Conradis Celtis Protucij . . . quattuor libri amorum secundum quattuor latera Germaniae feliciter incipiunt* (Nuremberg, 1502).

46. On Celtis, see Lewis W. Spitz, *Conrad Celtis, The German Arch-Humanist* (Cambridge, Mass., 1957), esp. chap. 10; and Schellhase, op. cit., 35–40.

47. *Selections from Conrad Celtis*, ed. Forster, 47, 53.

48. Michael Baxandall, *The Limewood Sculptors of Renaissance Germany* (New Haven, 1980), 136.

49. See Schellhase, op. cit., 35–40; Spitz, op. cit., esp. chap. 10; Frank L. Borchardt, *German Antiquity in Renaissance Myth* (Baltimore and London, 1971), 106–9.

50. Schellhase, op. cit., 47.

51. *Conradis Celtis Protucij;* see also A. Werminghoff, *Conrad Celtis und sein Buch über Nurnberg* (Freiburg, 1921), 112.

52. Christopher S. Wood, *Albrecht Altdorfer and the Origins of Landscape* (Chicago, 1993), 128ff. Professor Wood and I have both been working on the relationship between German topography and the Tacitean revival and I am indebted to him for the rich scholarly insights he has generously shared with me over the years. A specific attempt to link the ancient Hercynian forest with contemporary geography can be found, for example, in Andreas Althamer's commentary on the *Germania, C. Cornelii Taciti: De Moribus et Populus Germanorum Liber* (1580), 140f.

53. Published in Munster, op. cit., 337–38. See the quotation in Strauss, op. cit., 130.

54. Sebastian Münster, *Cosmographey . . . bis auff das 1564 jar . . .* (Basel, 1564), 586–87.

55. I am most grateful to Nicholas Barker of the British Library for pointing this out. See Joachim Camerarius the Younger, *Hortus medicus et philosophicus: in quo plurimarum stirpium breues descriptiones, nouae icones . . . indicationes locorum natalium . . . nec non philologica quaedam continentur . . . Item Sylva Hercynia: sive catalogus planatarum sponte nascentium in montibus & locis plerisque Hercyniae Sylvae* (Frankfurt am Main, 1588).

56. Larry Silver, "Forest Primeval: Albrecht Altdorfer and the German Wilderness Landscape," *Simiolus* 13, no. 1 (1983): 4–43. It will be apparent how indebted I am to Silver's rich and important article.

57. The classic study is Richard Bernheimer, *Wild Men in the Middle Ages: A Study in Art, Sentiment and Demonology* (Cambridge, Mass., 1952). See also the excellent exhibition catalogue by Timothy Husband, with the assistance of Gloria Gilmore-House, *The Wild Man: Medieval Myth and Symbolism* (New York, 1980).

58. Conrad Celtis, *Libri Odarum Quattuor*, ed. F. Pindter (Leipzig, 1937), ode 1, 16.

59. As translated by Fred A. Childs in Husband, op. cit., appendix B, 204.

60. Johannes Boemus, *Omnium Gentium Mores . . .* (Augsburg, 1520), iv; also cited in Strauss, op. cit., 148.

61. Karl Oettinger makes the fascinating observation that during this period the word *Laub* signified both "foliage" and "tabernacle," or "holy sanctuary." See Oettinger, "Laube, Garten und Wald: Zu einer Theorie der süddeutschen Sakralkunst, 1470–1520," in idem, ed., *Festschrift für Hans Sedlmayr* (Munich, 1962), 201–28. I am grateful to Joseph Leo Koerner for bringing this important article to my attention.

62. Baxandall, op. cit., 31.

63. For an extraordinarily powerful and sensitive reading of the *St. George*, see Wood, op. cit., 138ff.

64. See Richard Kuehnemund, *Arminius; or, The Rise of a National Symbol in Literature, from Hutten to Grabbe* (Chapel Hill, 1953), 77ff.

65. For the implications of the Klopstock trilogy on the cult of the national woodland, see the exhibition catalogue edited by Bernd Weyergraf, *Waldungen: Die Deutschen und ihr Wald* (Berlin: Akademie der Kunste, 1987), 63.

66. For a thoughtful discussion of this sensibility, see Hubertus Fischer, "Dichter-Wald: Zeitsprünge durch Silvanien," in Weyergraf, ed., op. cit., 6–25. Many of the essays in this superb collection are essential reading for an understanding of the forest myth in the history of modern Germany.

67. R. E. Prutz, *Der Göttinger Dichterbund zur Geschichte der deutschen Literatur* (Leipzig, 1841), 227–28. I am most grateful to Professor Gerhard Brunn for this source, as well as further information on the "oak" cults of the eighteenth and nineteenth centuries.

68. On oak cults in this period, see the excellent essay by Annemarie Hurlimann, "Die Eiche, heiliger Baum der deutscher Nation," in Weyergraf, ed., op. cit., 62–73.

69. See Annedore Muller-Hofstede, *Der Landschaftsmaler Pascha Johann Friedrich Weitsch 1723–1803* (Braunschweig, 1973), 174–91.

70. See Hannelore Gartner, *Georg Friedrich Kersting* (Leipzig, 1988), 102–3; also Hurlimann, op. cit., 64–65. It can hardly be mere coincidence that *Am Vorposten*, the Kersting sentry painting, has been paid the ultimate compliment of being transformed into a postage stamp following the unification of the German Democratic Republic with the Federal Republic a few years ago. My thanks are due to Annette Schlagenhauff for showing me the stamp!

71. There is now a facsimile edition of the *Altdeutsche Wälder* in three volumes with an excellent introduction by Wilhelm Schoof (Darmstadt, 1966).

72. See Gabriele Seitz, *Die Brüder Grimm—Leben–Werk–Zeit* (Munich, 1984).

73. Jack Zipes, "The Enchanted Forest of the Brothers Grimm: New Modes of Approaching the Grimms' Fairy Tales," *Germanic Review* 62, no. 2 (Spring 1987): 66–74; see also Robert Pogue Harrison, *Forests: The Shadow of Civilization* (Chicago, 1992), 164–76.

74. For the history and iconography of the Detmold *Hermannsdenkmal* and its forerunners, see the excellent volume of essays *Ein Jahrhundert Hermannsdenkmal 1875–1975* (Detmold, 1975), esp. the brilliant essay by Thomas Nipperdey, "Zum Jubiläum des Hermannsdenkmals," 11–32; other contributions by Arno Forchert on Arminius operas; and Gerd Unverfehrt on the iconography of the von Bandel statue.

75. Erich Sandow, "Vorläufer des Detmolder Hermannsdenkmals," in *Ein Jahrhundert Hermannsdenkmal*, 107–8.

76. For the significance of the park, see Simon Schama, *Citizens: A Chronicle of the French Revolution* (New York, 1989), 156–59.

77. See H. E. Mittig, "Zu Joseph Ernst von Bandels Hermannsdenkmal im Teutoburger Wald," in *Lippische Mitteilungen aus Geschichte und Landeskunde* 37 (1968): 200ff.

78. W. Klinkenberg, ed., *Das Hermanns-Denkmal und der Teutoburger Wald* (Detmold, 1875).

79. See the illustrations and report in the journal *Die Gartenlaube*, 1875.

80. Tacitus, *Annals*, 2.88 (p. 519).

81. For details of the construction of the New Ulm monument, see *Hermann, from Legend to Symbol* (New Ulm, Minn.: Brown County Historical Society, n.d.); and Erich Sandow, *Das Hermannsdenkmal in New Ulm, Minnesota, USA: Ein Beitrag zum 80jarigen Bestehen des bandelschen Hermannsdenkmals* (Lippe, 1956).

82. An abridged and translated version has been published as *The Natural History of the German People,* ed. and trans. David J. Diephouse (Lampeter, Wales, 1990), with a useful biographical introduction by the translator.

83. Wilhelm Heinrich Riehl, *Land und Leute* (Stuttgart, 1861), 63.

84. See Josef Nikolaus Forster, "Die Bayerische Forstordnung von 1568," in *Wald, Mensch, Kultur* (Berlin and London, 1967), 100–12.

85. "Debates on the Law on Thefts of Wood," May 25, 1842, in Karl Marx and Frederick Engels, *Collected Works* (London, New York, and Moscow), vol. 1, *Karl Marx, 1835–1853,* 224–63. I am grateful to Professor Daniel Bell for reminding me of the lengths to which Marx went (including a citation from *The Merchant of Venice*) to press his attack on the replacement of customary by absolute property rights, and the criminalization of custom.

86. Riehl, op. cit., 59.

87. See Andrew Lees, *Revolution and Reflection: Intellectual Change in Germany During the 1850s* (The Hague, 1974).

88. Josef Nikolaus Forster, "Die Eingliederung der Forstwissenschaft in die Universität München," in op. cit., 166ff.

89. Johann Christian Hundeshagen, *Enzyklopädie der Forstwissenschaft* (Giessen, 1827).

90. For Benjamin's youthful engagement with the Wandervogel, see John McCole, *Walter Benjamin and the Antinomies of Tradition* (Ithaca, 1993). I am most grateful to Professor McCole for sharing his knowledge on this important issue with me.

91. See Joachim Wolschke-Bulmahn, "The Fear of the New Landscape: Aspects of the Perception of Landscape in the German Youth Movement Between 1900 and 1933 and Its Influence on Landscape Planning," *Journal of Architectural and Planning Research* 9, no. 1 (Spring 1992): 33–47.

92. See Peter Veddeler, "Nationale Feiern am Hermannsdenkmal in früherer Zeit," in *Ein Jahrhundert Hermannsdenkmal*, 177.

93. Otto Freucht, *Der Wald als Lebensgemeinschaft* (Ohringen, 1936); Kurt Hueck, *Mehr Schutzgebiet!* (Neudamm, 1936). For many other titles in the same vein, see the exhaustive bibliography compiled by Michael Glasmeier for Weyergraf, ed., op. cit., 312–20.

94. Alfred Döblin, *Der neue Urwald* (Amsterdam, 1938).

95. See Gert Groning and Joachim Wolschke-Bulmahn, "Politics, Planning and the Protection of Nature: Political Abuse of Early Ecological Ideas in Germany, 1933–1945," *Planning Perspectives* 2 (1987): 128–29.

96. See chap. 4.

97. See Chris Wickham, "European Forests in the Early Middle Ages: Landscape and Land Clearance," in *L'ambiente vegetale nell'alto medioevo* (Spoleto: Centro italiano di studi sull'alto medioevo, 1990), 515–20.

98. On the industrially generated phenomenon of *Waldsterben* in the German forests, see Karl Friedrich Wentzel, "Hat der Wald noch eine Zukunft?" in Weyergraf, ed., op. cit., 102–12.

99. For Kiefer's early career, see the excellent exhibition catalogue by Mark Rosenthal, *Anselm Kiefer* (Chicago and Philadelphia, 1987), 12–30.

100. The artist quoted in Gotz Adriani, *The Books of Anselm Kiefer* (New York, 1991), 28.

101. See Heiner Stachelhaus, *Joseph Beuys*, trans. David Britt (New York, 1991), 109–10.

102. Joseph Beuys, interview by Richard Demarco, "Art into Time: Conversations with Artists," *Studio International*, 195, no. 996 (Sept. 1982): 47.

103. See Richard Flood, "Wagner's Head," *ArtForum* 21 (Sept. 1982): 69–71.

104. For a serious and provocative discussion of Kiefer's interest in "cultural memory" and of his insistence on the importance of its mythic component, see John C. Gilmour, *Fire on the Earth: Anselm Kiefer and the Postmodern World* (Philadelphia, 1990), esp. chaps. 5 and 6. While Gilmour's discussion of Kiefer's place in postmodernism is always stimulating, it does seem to me that he is too determined to see his work as shaped by the "classical" line of postmodern theoreticians from Nietzsche to Heidegger and Lyotard. Kiefer's attitude toward many of these canonical figures, especially the unavoidable Heidegger, who actually appears as one of the wooden block-heads in the *Wege der Weltweisheit*, seems to me much more ambiguous and often downright hostile. Kiefer's sensibility is, it seems to me, original and interesting precisely because he forces a mutual address between theory and history in ways deliberately evaded by much (not all) poststructuralist argument.

105. Joseph Leo Koerner has some profoundly illuminating remarks on the theme of the *Holzweg* apropos of Caspar David Friedrich's woodland landscapes in *Caspar David Friedrich and the Subject of Landscape* (London, 1990), 159ff.

106. Anselm Kiefer, quoted in Rosenthal, op. cit., 55.

107. See Stephanie Barron et al., *German Expressionist Prints and Drawings* (Robert Gore Rifkind Center for Expressionist Studies, Los Angeles County Museum of Art, 1989).

108. I owe the account of Wagner's response to a performance of *Der Freischütz* to the kindness and scholarly generosity of Tim Blanning.

109. In this vein, see, for example, Arthur Danto's review of the 1989 American exhibitions of Kiefer's work in *The Nation,* Jan. 2, 1989, 26–28, where he accuses the artist of elaborate disingenuousness and perpetrating "Wagnerian war music . . . a heavy-handed compost of shallow ideas and foggy beliefs."

110. Mary Lefkowitz, "The Myth of Joseph Campbell," *American Scholar* 59, no. 3 (1990): 429–34.

111. See Norman Manea, "Happy Guilt," *New Republic,* Aug. 5, 1991, 27–36.

112. Carlo Ginzburg, "Germanic Mythology and Nazism: Thoughts on an Old Book by Georges Dumézil," in *Clues, Myths, and the Historical Method,* trans. John and Anne Tedeschi (Baltimore and London, 1989), 125–55.

113. The story comes to me from my friend Leon Wieseltier.

Chapter Three: The Liberties of the Greenwood

1. The account that follows is based on the biographical sketch in John Hutchins, *The History and Antiquities of the County of Dorset,* 2 vols. (London, 1774), 2:63–64.

2. Not surprisingly, a village with this name no longer exists. But for the history of the farm and its sequestration, see Hutchins, op. cit., 1:489.

3. Ibid., 2:63.

4. William Gilpin, *Remarks on Forest Scenery and Other Woodland Views,* 2 vols., 3d ed. (London, 1808), 2:26.

5. Ibid., 217.

6. Ibid., 44.

7. Ibid., 47.

8. Ibid., 218.

9. For the importance of George III, especially toward the end of the eighteenth century, as an emblem figure of patriotic popularity, see the brilliant account given by Linda Colley, *Britons: Forging the Nation, 1707–1837* (New Haven, 1992), in particular chap. 5.

10. See Frank Barlow, *William Rufus* (London, 1983), 121.

11. Ibid., 429.

12. See Charles Young, *The Royal Forests of Medieval England* (Philadelphia, 1979), 7.

13. Cited in Brian Vesey Fitzgerald, *Portrait of the New Forest* (London, 1966), 79.

14. *As You Like It,* act 5, scene 4.

15. Oliver Rackham, *Trees and Woodlands in the British Landscape* (London, 1990), 48. "Reading the Anglo-Saxon charters, one has the impression that England . . . was definitely not a very wooded place. . . . The great survey of 1086 makes it clear that England was not very wooded." See also idem, *Ancient Woodland: Its History, Vegetation and Uses in England* (London, 1980); Peter Marren, *Britain's Ancient Woodland* (London, 1990), 53, also concludes that "by Roman times, three quarters of the wildwood had gone."

16. H. C. Darby, "The Anglo-Scandinavian Foundations" and "Domesday England," in idem, ed., *A New Historical Geography of England before 1600* (Cambridge, 1976), 34–35 and 53ff.; also Charles Higounet, "Les Forêts de l'Europe occidentale du Ve au XIe siècle," in *Agricultura e mondo rurale in occidente nell'alto medioevo* (Spoleto: Centro italiano di studi sull'alto medioevo, 1966), 353.

17. Rackham, *Trees and Woodlands,* 183.

18. For a useful account of the medieval forest in France as well as England, see Roland Bechmann, *Trees and Man: The Forest in the Middle Ages,* trans. Katharyn Dunham (New York, 1990). In comparison with the most recent work, Bechmann perhaps overemphasizes the starkness of the contrast (rather than the continuities) between cultivated agriculture and the forest habitat. See also the two important articles by Charles Higounet, "Les Forêts de

l'Europe occidentale du Ve siècle à l'an mil," in *Agricultura e mondo rurale,* and "Les Forêts de l'Europe occidentale."

19. See Rackham, *Trees and Woodlands.*

20. William Ellis, *The Timber-Tree Improved; or, The Best Practical Methods of Improving Lands with Timber,* 2 vols. in 1, 3d ed. (London, 1742), 2:26.

21. This is a point very well made in a superb article by Chris Wickham, "European Forests in the Early Middle Ages: Landscape and Land Clearance," in *L'ambiente vegetale nell'alto medioevo* (Spoleto: Centro italiano di studi sull'alto medioevo, 1990), 480–548. Wickham does draw attention to the differing degrees of separation or connection between forested and non-forested economies in different areas of Europe. (The Odenwald, for example, emerges as an area where the opposition between the two societies was more abruptly delineated.)

22. The best account of the institutions and administration of the forest is Young, op. cit.

23. See Matt Cartmill, *A View to a Death in the Morning: Hunting and Nature through History* (Cambridge, Mass., 1993), 30–31. Cartmill's brilliant study appeared too late for me to integrate its rich insights into my own account, but I am still indebted to the book for its suggestive reading of hunting lore as a way of understanding cultural ambivalence toward the natural world.

24. See Barbara Hanawalt, "Men's Games, King's Deer: Poaching in Medieval England," *Journal of Medieval and Renaissance Studies* 18, no. 2 (Fall 1988): 175–93, for the initiatory aspects of the hunt. Hanawalt's article principally concerns evidence on poaching and is drawn from case histories presented in the forest courts, but many of its insights could equally well be applied to the licit practices of the royal hunt. See also Cartmill, op. cit., 64.

25. *The Anglo-Saxon Chronicle,* ed. and trans. Dorothy Whitelock (London, 1961), 164–65.

26. For details of their respective jurisdiction, see N. D. G. James, *A History of English Forestry* (Oxford, 1981), 18ff.; Young, op. cit., 18–59.

27. John Manwood, *A treatise of the laws of the forest; wherein is declared not only those laws as they are now in force, but also the original and beginning of forests and what a forest is in its own proper nature . . .* (London, 1598).

28. See James, op. cit., 17.

29. Manwood (abridgement), in Nicholas Cox, *The gentleman's recreation . . . to which is now added a perfect abstract of all the forest-laws* (London, 1697), 35.

30. See G. J. Turner, *Selected Pleas of the Forest* (London, 1901).

31. See the introduction by J. F. Stagg to *New Forest Documents,* 2 vols. (Hampshire County Council Records Series, 1979) 1:ix; see also Young, op. cit., 30–31.

32. Stagg, op. cit., 1:98.

33. The operation of these profitable loopholes is described in Young, op. cit., 37, 116ff.

34. J. C. Holt, *Robin Hood* (London, 1982), 62–63; see also Maurice Keen, *The Outlaws of Medieval Legend* (1961; London, 1977), though Keen differs sharply from Holt in his argument that the Robin Hood tales are an authentic product of popular culture and represent the real stirring of social rebellion.

35. *The Greenwood Tree* (n.p., n.d.).

36. Ibid.

37. See David Wiles, *The Early Plays of Robin Hood* (Cambridge, 1981).

38. There is now a vast literature on the "world turned upside down" rituals of the Renaissance and especially on carnival. For an introduction to many of these issues, see Emmanuel Le Roy Ladurie, *Carnival in Romans,* trans. Mary Feeney (New York, 1979).

39. Quoted in Holt, op. cit., 161; see also Wiles, op. cit., 17.

40. Wiles, op. cit., 48.

41. See the excellent account of these developments given in John Perlin, *A Forest Journey: The Role of Wood in the Development of Civilization* (New York, 1989), 167.

42. Cited in F. V. Emery, "England about 1600," in Darby, ed., op. cit., 273.

43. Cited in James, op. cit., 139.

44. Robert Greenhalgh Albion, *Forests and Sea Power: The Timber Problem of the Royal Navy, 1652–1852* (Cambridge, Mass., 1926), 107; see also Perlin, op. cit., 208.

45. The principle of the "General Plantation" was to set aside forty of every thousand acres of the realm for replanting, with trees set at ten-yard intervals for optimal growth.

46. See George Hammersley, "The Revival of the Forest Laws under Charles I," *History* 45, no. 154 (June 1960): 85–102. I am most grateful to Mark Kishlansky for this source.

47. See Buchanan Sharp, *In Contempt of All Authority: Rural Artisans and Riot in the West of England, 1586–1660* (Berkeley and Los Angeles, 1980), 249 and passim.

48. For details of the publishing history of *Silva*, see Blanche Henrey, *British Botanical and Horticultural Literature before 1800* (Oxford and New York, 1975), 1:102ff.

49. Cited in Henrey, op. cit., 1:103.

50. Letter of Evelyn, July 11, 1679, at the time of the third edition, cited in Henrey, op. cit., 1:106.

51. John Evelyn, *Silva*, 5th ed., ed. Alexander Hunter (York, 1776), 147.

52. Ibid., "Epistle Dedicatory," n.p.

53. Ibid., 617.

54. John Milton, "Comus, A Mask Presented at Ludlow Castle, 1634, Before the Earl of Bridgewater, Then President of Wales," in Douglas Bush, ed., *The Portable Milton* (London, 1977), 92, lines 534–35.

55. Ibid., 616.

56. Ibid., 643, 577.

57. Cited in Henrey, op. cit., 1:106.

58. The most exhaustive scholarly account of this perennial problem is still Albion, op. cit.

59. Evelyn, op. cit., 634.

60. Ibid., 633.

61. *The Poems of Alexander Pope: A Reduced Version of the Twickenham Text*, ed. John Butt (New Haven and London, 1963), 209.

62. John Charnock, *An History of Marine Architecture*, 3 vols. (London, 1800–2), 3:171.

63. Batty Langley, *A Sure Method of Improving Estates* (London, 1728), i–ii.

64. Cited in Fitzgerald, op. cit., 97.

65. E. P. Thompson, *Whigs and Hunters* (New York, 1975).

66. Cited in Henrey, op. cit., 2:559–60.

67. Fisher's book and his correspondence with shipwrights was reprinted in 1771 by special order of the House of Commons committee of inquiry, who had also called him as an expert witness. For a discussion of arboreal patriotism, see Stephen Daniels, "The Political Iconography of the Woodland in Later Georgian England," in Denis Cosgrove and Stephen Daniels, eds., *The Iconography of Landscape: Essays on the Symbolic Representation, Design and Use of Past Environments* (Cambridge, 1988), 43–81.

68. Roger Fisher, *Heart of Oak: The British Bulwark* (n.p., 1772), chap. 37.

69. See Sir Henry Wood, *A History of the Royal Society of Arts* (London, 1912), 143–51.

70. See Andrew Emmerich, *The Culture of Forests; with an appendix in which the state of the royal forests is considered, and a system for their proposed improvement* (London, 1789).

71. Alexander Hunter, in Evelyn, op. cit., 111.

72. Ibid., 557.

73. The subscription list is printed with the frontispiece to the Hunterian edition. For some other sources of aristocratic tree enthusiasm in the latter half of the century, see Keith Thomas, *Man and the Natural World: Changing Attitudes in England, 1500–1800* (London, 1983), 220–23.

74. See the subscription list printed with Hunter's edition of *Silva*, preface, n.p.

75. Ibid., 101.

76. William Cowper, "Yardley Oak," in *Selected Poems,* ed. Nick Rhodes (Manchester, 1984), 72.

77. Ellis, op. cit., 2:23.

78. William Marshall, *Planting and Ornamental Gardening* (London, 1785).

79. Albion, op. cit., 395–96.

80. Ibid., 396.

81. His report is printed in Cyril E. Hart, *Royal Forest: A History of Dean's Woods as Producers of Timber* (Oxford, 1966), 312–14.

82. For the operation of the ring (and its unbreakability), see Albion, op. cit., 58ff.

83. See the account given in Louis Badré, *Histoire de la forêt française* (Paris, 1983), 60–64. A beautiful series of panels illustrating the ceremonies, painted for a timber merchant in the eastern forests of the Vosges, are preserved in the *mairie* of Raon-l'Etape.

84. The exhaustive history of forestry in old regime France is a superlative monograph by Andrée Corvol, *L'Homme et l'arbre sous l'Ancien Régime* (Paris, 1984). The most important manual for the training of French foresters was Duhamel du Monceau, *De l'Exploitation des bois,* 2 vols. (Paris, 1964).

85. Vitruvius, *De architectura,* trans. F. Granger (Cambridge, Mass., and London, 1983), 2.1 (p. 81).

86. Louis Badré, *Les Eaux et les forêts du 12e au 20e siècle* (Paris, 1987), 91.

87. John Croumbie Brown, *The French Forest Ordinance of 1669* (Edinburgh, 1883), 33; see also Badré, *Histoire de la forêt française,* 73.

88. See Corvol, op. cit.

89. See Serge Benoît, "Les Forges de Buffon," in the commemorative volume *Buffon* (Paris, 1988), 136–57.

90. See Daniel Solakian, "De la multiplication des chèvres sous la Révolution," in D. Woronoff, ed., *Révolution et espaces forestiers* (Paris, 1988), 53–62. This volume is indispensable for an understanding of the effects of the French Revolution on forests.

91. Paul Walden Bamford, *Forests and French Sea Power, 1660–1789* (Toronto, 1956), 112.

92. For one (unflattering) description of the Jewish timber trade, see Robert Johnston, *Travels through Part of the Russian Empire and Poland* (New York, 1876), 68, 368f.

93. *The Dictionary of National Biography* (London, 1917), 16:1125.

94. For the complete text, see Maurice Buxton-Forman, ed., *Letters of John Keats* (Oxford, London, and Toronto, 1947), 95, n. 1.

95. *Poems by John Keats,* ed. Walter Raleigh (London, 1897), 295–96.

Chapter Four: The Verdant Cross

1. The story is told in James Hutchings's *Scenes of Wonder and Curiosity in California,* 3d ed. (New York and San Francisco, 1875), 10–12.

2. See Alfred Runte, *Yosemite: The Embattled Wilderness* (Lincoln, Neb., and London, 1990), 8–9; also Elizabeth Godfrey, *Yosemite Indians,* rev. James Snyder and Craig Bates (Yosemite National Park: Yosemite Natural History Association, 1977), 3.

3. Hutchings, op. cit., 45.

4. For the initial reception of the news, see the account given in J. D. Whitney, *The Yosemite Book* (San Francisco, 1868), 102ff. Whitney was the state geologist appointed under the terms of California's reservation of the valley in 1864 to conduct a thorough geological and topographical survey.

5. Ibid., 103.

6. Cited in Thomas Starr King, *A Vacation among the Sierras,* ed. John A. Hussey (San Francisco, 1962), 31. The text was also printed in one of Starr King's articles on Yosemite sent to the *Boston Evening Transcript* in 1861.

7. Horace Greeley, *An Overland Journey from New York to San Francisco in the Summer of 1859* (New York, 1964), 264.

8. Hutchings, op. cit., 43. For more details on the commercialization of the trees, see the excellent essay by Nancy K. Anderson "The Kiss of Enterprise," in William H. Truettner, ed., *The West as America: Reinterpreting Images of the Frontier, 1820–1920* (Washington and London, 1991), 268–77.

9. For nineteenth-century landscape tourism in America, see the excellent book by John F. Sears, *Sacred Places: American Tourist Attractions in the Nineteenth Century* (Oxford, 1989). Chapter 5 is devoted to the Big Trees.

10. See Arnold Crompton, *Apostle of Liberty: Starr King in California* (Boston, 1950).

11. King, op. cit., 32.

12. Whitney, op. cit., 41.

13. Cited in William Day Simonds, *Starr King in California* (San Francisco, 1917), 84–85.

14. Ibid., 35.

15. *Boston Daily Advertiser,* Nov. 3, 1869; also cited in John K. Howat et al., *American Paradise: The World of the Hudson River School* (New York: Metropolitan Museum of Art, 1987), 297 n. 9.

16. See, for example, John Muir's comment to this effect in his essay "The Sequoia and General Grant National Parks," in *Our National Parks* (San Francisco, 1991), 207; on the "immortality" of the trees, see Muir, *The Mountains of California* (New York, 1894), 181–82. "The Holy of Holies of the Woods" occurs in *Afoot to Yosemite* (1874; reprint, San Francisco, 1924), 10.

17. See Pauline Grenbeaux, "Before Yosemite Art Gallery: Watkins' Early Career," *California History,* special issue (Carleton E. Watkins) 57, no. 3 (Fall 1978): 220–41.

18. For Olmsted's report and his part in the Yosemite reservation, see Laura Roper, *FLO: A Biography of Frederick Law Olmsted* (Baltimore, 1973), 233–90.

19. Cited in the extraordinarily learned and perceptive book by Michael Williams, *Americans and Their Forests: A Historical Geography* (Cambridge, 1989), 144.

20. For the chronology and documentation of Bierstadt's journeys, see Gordon Hendricks, "The First Three Western Journeys of Albert Bierstadt," *Art Bulletin* 46, no. 3 (Sept. 1964), 333–67.

21. For more details of his career and an extremely helpful chronology and documentation, see the superb exhibition catalogue by Nancy K. Anderson and Linda S. Ferber, *Albert Bierstadt: Art and Enterprise* (Brooklyn Museum, 1990), esp. 146–244.

22. Fitz Hugh Ludlow, "Seven Weeks in the Great Yo-Semite," *Atlantic Monthly* 13 (June 1864): 745.

23. Ibid.

24. See the inventory compiled by Hendricks, op. cit., 354–65. Not all of these paintings have, however, survived and they are of widely varying size.

25. Quoted in Roper, op. cit., 265–66.

26. Ludlow, op. cit., 744.

27. Clarence King, *Mountaineering in the Sierra Nevada* (Boston, 1872), 43.

28. Quoted in Roderick Nash, *Wilderness and the American Mind* (New Haven, 1967), 73–74.

29. Barbara Novak, *Nature and Culture: American Landscape and Painting, 1825–1875* (New York, 1980), 266–71.

30. Asher Durand, "Letters on Landscape Painting," no. 2, *The Crayon,* Jan. 17, 1855, 34.

31. Bryant's address was subsequently published by the National Academy of Design as *A Funeral Oration Occasioned by the Death of Thomas Cole, Delivered before the National Academy of Design, New-York, May 4th, 1848.*

32. William Cullen Bryant, "The Antiquity of Freedom," in *Poems, Collected and Arranged by the Author* (New York, 1849), 227.

33. Bryant, "A Forest Hymn," in *Poems,* 88.

34. See pages 226–40.

35. James Fenimore Cooper, *The Pathfinder* (New York: Signet Classic, 1981), 11.

36. For more on this subject, see the classic survey by Roderick Nash, *Wilderness and the American Mind*.

37. Cole had, in fact, been experimenting with ruins overrun by greenery in a number of paintings and drawings made during his stay in Italy.

38. Thomas Cole to Henry Pratt, cited in Ellwood C. Parry III, *The Art of Thomas Cole: Ambition and Imagination* (Cranbury, N.J.; London; and Mississauga, Ont., 1988), facing plate 17, n.p. For a brief discussion of the painting, see 313–14.

39. Rudolf Wittkower, "The Interpretation of Visual Symbols," in *Allegory and the Migration of Symbols* (London, 1977), 186.

40. Robert Ackerman, *J. G. Frazer: His Life and Work* (Cambridge, England, and New York, 1987). For more penetrating criticism, see Mary Douglas, "Judgements on James Frazer," *Daedalus* (Generations) 107, no. 4 (Fall 1978): 151–64.

41. On Trevelyan's mystical communions with landscape, see the brilliant biography by David Cannadine, *G. M. Trevelyan* (London and New York, 1993).

42. On Warburg, see E. H. Gombrich, *Aby Warburg: An Intellectual Biography* (Chicago, 1970), esp. chap. 13, "The Theory of Social Memory"; also the extremely important essay by Carlo Ginzburg, "From Aby Warburg to E. H. Gombrich: A Problem of Method," in *Clues, Myths, and the Historical Method*, trans. John and Anne Tedeschi (Baltimore and London, 1989), 17–59. Ginzburg is himself much interested in the eloquence of peculiarity and has profound things to say of its value for the historian in the introduction to *Ecstasies: Deciphering the Witches' Sabbath*, trans. Raymond Rosenthal (New York, 1991).

43. Gombrich, op. cit., 123–24.

44. For an account of the trip, see Ron Chernow, *The Warburgs* (New York, 1993), 64–66.

45. Felix Gilbert, "From Art History to the History of Civilization: Aby Warburg," in *History: Choice and Commitment* (Cambridge, Mass., 1977), 434.

46. Cited in Chernow, op. cit., 176.

47. For an account of Warburg's sickness, see the version by Warburg's student Carl Georg Heise, *Persönliche Erinnerungen an Aby Warburg* (New York, 1947); also Chernow, op. cit., 203–6, 254–61.

48. On the original trip, see Gombrich, op. cit., 88ff.; on the lecture, 216–27.

49. Chernow, op. cit., 286–87.

50. Pliny, *Natural History*, trans. H. Rackham (Cambridge, Mass., 1986), book 16. For a discussion of the phoenix-palm, see also Jacques Brosse, *Mythologie des arbres* (Paris, 1989), 163ff.

51. See Wittkower, op. cit., 90.

52. See Chiara Frugoni, "Alberi (in paradiso voluptatis)," in *L'ambiente vegetale nell'alto medioevo* (Spoleto: Centro italiano di studi sull'alto medioevo, 1990), 762–63, illus. 14.

53. For the attacks on forest cults and the subsequent assimilation of sacred groves to the Christian tradition, see Réginald Grégoire, "La foresta come esperienza religiosa," in *L'ambiente vegetale*, 662–703.

54. Cited in Valerie Flint, *The Rise of Magic in Medieval Europe* (Princeton, 1991). Flint's richly documented book makes a wholly persuasive case for the conscious co-option of pagan cults and rites in the service of Christian conversion.

55. Lisa M. Bitel, *Isle of the Saints: Monastic Settlement and Christian Community in Early Ireland* (Ithaca, 1990), esp. 36ff.; see also Susan Power Bratton, "Oaks, Wolves, and Love: Celtic Monks and Northern Forests," *Journal of Forest History* 33, no. 1 (Jan. 1989), 4–20.

56. Flint, op. cit., 76.

57. Brosse, op. cit., 143–44.

58. J. G. Frazer, *The Golden Bough,* Part IV, *Adonis, Attis, Osiris: Studies in the History of Oriental Religion,* 2 vols. (London, 1914), 1, 268ff. It strikes me as possible that the eventual popularity of evergreens as Christmas trees (from the Renaissance onward) may also have transferred elements of the cult of Atys not just from paganism to Christianity but from the season of Hilary to that of the winter Saturnalia.

59. *The Life of St. Boniface by Willibald,* trans. George W. Robinson (Cambridge, Mass., 1916), 63–64. See also David Keep, *St. Boniface and His World* (Exeter, 1979).

60. William Anderson, *The Green Man* (London and San Francisco, 1990), 48.

61. Ibid., 85.

62. Besides Frazer and Mannhardt, there is a huge literature on tree mythology. The most recent and comprehensive guide to the whole subject is Jacques Brosse, *Mythologie des arbres* (Paris, 1989). See also Alexander Porteous, *Forest, Folklore, Mythology and Romance* (London, 1928).

63. Lambert, of Saint-Omer, *Liber floridus* (Ghent); see Anderson, op. cit., 92. For this and other examples of the iconographic evolution, see Frugoni, op. cit.

64. See Stephen J. Reno, "The Sacred Tree as an Early Christian Literary Symbol: A Phenomenological Study," in *Forschungen zur Anthropologie und Religionsgeschichte,* vol. 4 (Saarbrücken, 1978); also Jean Daniélou, "Das Leben das am Holz hangt," in *Kirche und Überlieferung* (Freiburg, 1960); and a typically learned and beautifully crafted essay by Marina Warner, "Signs of the Fifth Element" in the exhibition catalogue *The Tree of Life: New Images of an Ancient Symbol* (London: South Bank Arts Centre, 1989), 7–47.

65. Genesis 4.24 (King James Version).

66. *The Dream of the Rood* in *The Poems of Synewulf,* trans. Charles W. Kennedy (New York, 1949), 307–08. See also Michael Swarton, ed., *The Dream of the Road* (Exeter, 1987), for a discussion of its authorship and cultural context.

67. Rab Hatfield, "The Tree of Life and the Holy Cross: Franciscan Spirituality in the Trecento and the Quattrocento," in Timothy Verdon and John Henderson, eds., *Christianity and the Renaissance: Image and Religious Imagination in the Quattrocento* (Syracuse, 1990), 135–36, points out that the most famous version of the legend, Jacopo Varagine's *Golden Legend,* has the seed drop from the Tree of the Knowledge of Good and Evil, not the Tree of Life; an oddly incongruous variation. But some versions of the story have survived which sustain the more theologically coherent myth.

68. See Kurt Kallensee, *Der Baum des Lebens* (Berlin, 1985), 104–5; see also Otto Mazal, *Der Baum: Ein Symbol des Lebens in der Buchmalerei* (Graz, 1988); Gabrielle Dufour-Kowalska, *L'Arbre de vie et la croix: Essai sur l'imagination visionnaire* (Geneva, 1985).

69. J. H. Philpot, *The Sacred Tree* (London, 1897), 167.

70. See Chris Wickham, "European Forests in the Early Middle Ages: Landscape and Land Clearance," in *L'ambiente vegetale nell'alto medioevo,* 515–20.

71. Grégoire, op. cit., 697.

72. On forest hermitages, see Grégoire, op. cit., 677–92; Etienne Delaruelle, "Les ermites et la spiritualité populaire," in *L'eremitismo in Occidente nei secoli XIe XII* (Milan, 1965); Jean Heuclin, *Aux origines monastiques de la Gaule du Nord: Ermites et reclus du Ve au XIe siècle* (Lille, 1988).

73. Grégoire, op. cit., 689.

74. Karl Oettinger, "Laube, Garten und Wald: Zu einer Theorie der süddeutschen Sakralkunst, 1470–1520," in idem, ed., *Festschrift für Hans Sedlmayr* (Munich, 1962), 201–28; see also Gerhard Ladner, "Vegetation Symbolism and the Concept of Renaissance," in Millard Meiss, ed., *De Artibus Opuscula* 40, no. 1 (Essays in Honor of Erwin Panofsky).

75. See Jurgen Baltrusaitis, *Aberrations* (Paris, 1983), 101.

76. For a brilliant account of this tradition in architectural writing and practice, see Joseph Rykwert, *On Adam's House in Paradise: The Idea of the Primitive Hut in Architectural History* (Cambridge, Mass., 1981). On the Vulcan and Aeolus, see Sharon Fermor, *Piero di Cosimo: Fiction, Invention and Fantasia* (London, 1993), 62–63.

77. See Paul Frankl, *The Gothic: Literary Sources and Interpretations through Eight Centuries* (Princeton, 1964), 273ff.

78. Ibid., 100.

79. Cited in Sir James Hall, *Essay on the Origins, History and Principles of Gothic Architecture* (London, 1813), 6.

80. See the discussion on these wooden shrines and chapels in Michael Baxandall, *The Limewood Sculptors of Renaissance Germany* (New Haven, 1980), and Christopher S. Wood, *Albrecht Altdorfer and the Origins of Landscape* (Chicago, 1993).

81. See Karsten Harries, *The Bavarian Rococo Church: Between Faith and Asceticism* (New Haven and London, 1983), 190–92.

82. William Warburton, "An Epistle to Lord Burlington," in Alexander Pope, *Collected Works* (London, 1751), 3:267–68.

83. See Rykwert, op. cit., 43–47.

84. On Hall, see Rykwert, op. cit., 82–87; also an excellent discussion in Jurgen Baltrusaitis's brilliantly suggestive book, *Aberrations,* 96–97.

85. Cited in Hall, op. cit., 18.

86. On this meeting, see Nicholas Boyle, *Goethe: The Poet and the Age,* vol. 1, *The Poetry of Desire* (Oxford, 1991), 92ff.

87. Johann Wolfgang von Goethe, *Gedenkausgabe der Werke,* ed. Ernst Beutler, 24 vols. (Zurich, 1948–1954), 13:19–20. See also Rykwert, op. cit., 89. For a discussion of Goethe's eulogy, see Harald Keller, *Goethe's Hymnus auf den Strasburger Münster und die Wiederweckung der Gotikim 18 Jahrhundert 1772–1972* (Munich, 1974).

88. Friedrich von Schlegel, *Grundzüge der gothischen baukunst: Auf einer Reise durch die Niederlände, Rheingegenden, die Schweiz und einer Teil von Frankreich in der Jahren 1804 und 1805,* in *Poetisches Taschenbuch auf den Jahr 1806* (Berlin, 1806), 177–78. See the discussions in Frankl, op. cit., 460, and W. D. Robson Scott, *The Literary Background of the Gothic Revival in Germany: A Chapter in the History of Taste* (Oxford, 1965), 134.

89. For an excellent discussion of the painting, see the essay by John Leighton in the exhibition catalogue *Caspar David Friedrich: Winter Landscape* (London: National Gallery, 1990), 34–51.

PART TWO: WATER

Chapter Five: Streams of Consciousness

1. Barlow's notebooks, letter books, and memoranda from the spring of 1796, when he sailed for Algiers, to the winter of 1797, when he returned to Paris, are preserved in the Houghton Library, Harvard University. They make up a rich and fascinating collection of sources on an extraordinary episode. The chronology of these observations is far from definitively established since a number of his memoranda and articles on sundry matters are undated. But I have tried to reconstruct their order through entries that follow directly from his notes on Algiers, commentaries that were certainly made during his diplomatic residency there, or immediately afterward in the *lazaret* at Marseilles. I am immensely grateful to Carla Mulford for first pointing me toward Barlow's *Genealogy of the Liberty Tree.* Her excellent article on Barlow's politics and poetry, "Radicalism in Joel Barlow's *The Conspiracy of Kings* (1792)," is published in Leo Lemay, ed., *Deism, Masonry and the Enlightenment: Essays Honoring Alfred Owen Aldridge* (Newark, Del., 1987), 137–57. Ms. Mulford also believes, on the strength of the internal evidence of the notebooks, that the *Genealogy* was written around the time of the Algiers mission. Barlow's correspondence on various Algerian matters with the Abbé Grégoire, who had also written a tract on the Liberty Tree, makes this even more likely.

2. Pierre Perrault, "Traité de l'origine des fontaines," in idem, *Oeuvres divers de physique et de mécanique,* 2 vols. (Paris, 1721), 2:717–848.

3. Athanasius Kircher, *Mundus subterraneus in quo universae naturae majestas et divitiae demonstrantur in XII libros digestus* (Amsterdam, 1665).

4. For Barlow's career, see Samuel Bernstein, *Joel Barlow: A Connecticut Yankee in an Age of Revolution* (Cliff Island, Maine, 1985); M. Ray Adams, "Joel Barlow: Political Romanticist," *American Literature* 9, no. 2 (May 1937): 113–52; James Woodress, *A Yankee's Odyssey: The Life of Joel Barlow* (Philadelphia, 1958).

5. For a discussion of Barlow's *Conspiracy of Kings* and *Advice to the Privileged Orders,* see Mulford, op. cit.

6. Constantin Volney, *Les Ruines; ou, Méditation sur les révolutions des empires* (Paris, 1791). Barlow's translation appeared in 1802.

7. Charles François Dupuis, *L'Origine de tous les cultes; ou, La Religion universelle* (Paris, 1794).

8. Barlow Papers, Houghton Library, Harvard University.

9. Grégoire, *Essai historique et patriotique sur les arbres de la liberté* (Paris, 1794). On Grégoire, see Ruth Necheles, *The Abbé Grégoire, 1787–1831: The Odyssey of an Egalitarian* (Westport, Conn., 1971).

10. Barlow's Algerian and Marseilles diaries mention Diodorus in other connections, as well as the poem of Osiris by Nonnus. The relevant passages in Diodorus Siculus, trans. C. H. Oldfather (Cambridge, Mass., 1970–1989), are books 1 and 14–23.

11. *Genealogy of the Liberty Tree,* Barlow Papers.

12. Ibid.

13. On the Baron d'Hancarville, see Francis Haskell, "The Baron d'Hancarville: An Adventurer and Art Historian in Eighteenth-Century Europe," in idem., *Past and Present in Art and Taste: Selected Essays* (New Haven and London, 1987), 30–45.

14. On Payne Knight, see G. S. Rousseau, "The Sorrows of Priapus: Anticlericalism, Homosocial Desire and Richard Payne Knight," in idem and Roy Porter, eds., *The Sexual Underground of the Enlightenment* (Chapel Hill, 1988), 101–53. See also the forthcoming book by John Brewer.

15. See, for example, John Gwyn Griffiths, *The Origins of Osiris and His Cult* (Leiden, 1980); also Walter Burkert, *Ancient Mystery Cults* (Cambridge, Mass., 1987), 82–88. E. A. Wallis Budge, *The Gods of the Egyptians: Studies in Egyptian Mythology,* 2 vols. (London, 1904); idem, *Osiris and the Egyptian Resurrection,* 2 vols. (London and New York, 1912).

16. A typical example is A. Wiedemann, *Religion of the Ancient Egyptians* (trans. 1897). I am extremely grateful to Dr. David McKittrick, the librarian of Trinity College, for allowing me this extraordinary vision of the encyclopedic Frazer at his most compulsive, and for many generous and learned suggestions on the themes of this chapter and book.

17. Frazer, op. cit.

18. See, for example, the evidence cited in the important monography by Vivian A. Hibbs, *The Mendes Maze: A Libation Table for the Inundation of the Nile (I–III A.D.)* (New York and London, 1985), 121–22.

19. See Burkert, op. cit., 105; M. P. Nilsson, *Geschichte der griechischen Religion* (Munich, 1961), 2:590–94.

20. Seneca, *Naturales quaestiones,* trans. T. H. Corcoran (Cambridge, Mass., 1971), 2.27.

21. Ibid., 31–32.

22. Wiedemann, op. cit.

23. Plutarch, in fact, opens his account as if it were an anthropological explanation of customs like the abstention from eating the *oxyrhynchus* and other fish. *Moralia,* trans. Frank Babbitt, vol. 5 (Cambridge, Mass., 1984), chap. 7 (p. 19). For an astute critical commentary, see John Gwyn Griffiths, ed., *Plutarch's De Iside et Osiride* (Cardiff, Wales, 1970).

24. Plato, *Timaeus* and *Critias,* trans. and ed. Desmond Lee (London, 1965), 30–31 (pp. 42–43). For further discussion, see Burkert, op. cit., 84ff.

25. Herodotus, *Histories,* trans. A. D. Godley (London and Cambridge, Mass., 1920), 2.19–34 (pp. 297ff.).

26. See, for example, *Plutarch's De Iside et Osiride,* chaps. 35 (p. 81) and 39 (p. 95).

27. Ibid.

28. Budge, *Osiris,* 2:387–88.

29. See Yi-Fu Tuan, *Landscapes of Fear* (New York, 1979), 58; for the Tammuz myth and other related Near Eastern myths, see Eleanor Follansbee, "The Story of the Flood in the Light of Comparative Semitic Mythology," in Alan Dundes, ed., *The Flood Myth* (Berkeley and Los Angeles, 1988), 75–88.

30. Hesiod, *Theogony,* 335–40.

31. Plato, *Timaeus and Critias,* trans. Desmond Lee (London and New York, 1977), 39 (pp. 53–54).

32. Ibid., 22 (p. 35).

33. I am indebted to the complete account given in Hibbs, op. cit.

34. Hibbs, op. cit., 182.

35. George Sandys, *A Relation of a Journey Begun in A.D. 1610* (London, 1637), 99.

36. See Karl Butzer, *Early Hydraulic Civilization in Egypt* (Chicago, 1976), 54.

37. See Barbara Bell, "The First Dark Age in Egypt," *American Journal of Archaeology* 75:1–26.

38. Hibbs, op. cit., 61.

39. See Butzer, op. cit., 33.

40. Karl Wittfogel, *Oriental Despotism* (New Haven, 1957; New York, 1981). For an excellent discussion of the implications of Wittfogel's "thesis" for the history of American rivers and water resources, see Donald Worster, *Rivers of Empire: Water, Aridity and the Growth of the American West* (New York, 1986; Oxford, 1992), 22–48.

41. On the Three Gorges Dam, see the report by Nicholas D. Kristoff in *The New York Times,* June 22, 1993.

42. Lucan, *The Civil War,* trans. J. D. Duff (London and Cambridge, Mass., 1988), 10.104–331 (pp. 597–615).

43. Ibid., 10.130–93 (pp. 603–5).

44. Ibid., 10.263–67 (pp. 609–11).

45. For what follows I have relied on the edition translated and edited by Jacques Masson, S.J., *Le Voyage en Egypte de Felix Fabri* (Cairo, 1975).

46. Fabri, op. cit., 640.

47. Ibid., 621.

48. Wyman H. Herendeen, *From Landscape to Literature: The River and the Myth of Geography* (Pittsburgh, 1986), a superb book in general and one to which I am much indebted for methodology, is particularly good on the Nile Jordan antithesis in medieval typologies; see esp. pp. 31–34.

49. For a powerful discussion of the dichotomy between linear and circular concepts of historical time, see Stephen Jay Gould, *Time's Arrow, Time's Cycle: Myth and Metaphor in the Discovery of Geological Time* (Cambridge, Mass., 1987). I should also record here my great debt to Professor Gould for any number of insights into the relationship between the history of nature and the history of culture, not least his important and ongoing discussion of contingency. On the issue of circularity in fluvial and hydrological history, see also Yi-Fu Tuan, *The Hydrological Cycle and the Wisdom of God* (Toronto, 1968), passim.

50. Per Lundberg, *La Typologie baptismale dans l'ancienne église* (Leipzig and Uppsala, 1942), 167. Jean Daniélou, *Primitive Christian Symbols,* trans. Donald Attwater (Baltimore, 1964).

51. For a full discussion, see Lundberg, op. cit.; also E. O. James, *Christian Myth and Ritual* (Gloucester, Mass., 1973).

52. See the introduction to J. R. Harris, ed., *The Legacy of Egypt* (Oxford, 1971), 4. This volume has many valuable essays on the transmission of Egyptian antiquities to Western culture.

53. Seneca, op. cit., 1.263.

54. Fabri, op. cit., 631–32.

55. Petrarch, *Epistolae familiares,* Aachen, June 21, 1333.

56. Fabri, op. cit., 645.

57. Ibid., 611 (for the four rivers) and 635 (for Fabri's conclusion).

58. See Jean Seznec, *The Survival of the Pagan Gods,* trans. Barbara Sessions (Princeton, 1972).

59. See Elisabeth B. MacDougall and Naomi Miller, *Fons Sapientiae: Garden Fountains in Illustrated Books, from the Sixteenth to the Eighteenth Centuries* (Washington, D.C., and Dumbarton Oaks, 1977); for watercourses in Renaissance gardens, M. Fagiolo, "Il significato dell'acqua e la dialettica del giardino," in idem, ed., *Natura e artificio* (Rome, 1981), 144–53. See also on this subject Terry Comito, "The Humanist Garden," in Monique Mosser and Georges Teyssot, eds., *The Architecture of Western Gardens* (Cambridge, Mass., 1991), 42; for the Villa Lante program, Claudia Lazzaro-Bruno, "The Villa Lante at Bagnaia: An Allegory of Art and Nature," *Art Bulletin* 4, no. 59 (1977): 553–60; and for the place of the gardens in Renaissance culture, David Coffin, *The Villa in the Life of Renaissance Rome* (Princeton, 1979).

60. Claire Préaux, "Graeco-Roman Egypt," in Harris, ed., op. cit., 340–41, classes the Praeneste mosaic as an "escapist" landscape, similar to the Nile mosaic at Ain Tabgha on the shore of Lake Tiberias. See also Hibbs, op. cit., 91, 107; Iversea, op. cit., 340; Herendeen, op. cit., 52.

61. See Emanuela Kretzulesco-Quaranta, *Les Jardins du songe: Poliphile et la mystique de la Renaissance* (Paris, 1986).

62. On the hieroglyphic tradition, see A. A. Barb, "Mystery, Myth and Magic," and Erik Iversen, "The Hieroglyphic Tradition," both in J. R. Harris, ed., op. cit., 138–97.

63. The identity of the author of the *Hypnerotomachia* has been hotly disputed, not least because there were, in fact, *two* Francesco Colonnas, the other being an elderly friar (1433–1527). On internal grounds and the strongly pagan color of the poem, both Kretzulesco-Quaranta and Maurizio Calvesi, *Il Sogno di Polifilo Prenestino* (Rome, 1983), argue for the younger Colonna's authorship, the view embodied in my account.

64. On these gardens and the importance of fountains and "water-chains" and basins, see the essays by Terry Comito, Lionello Puppi, and Gianni Venturi in Mosser and Teyssot, eds., op. cit.; also Coffin, op. cit.; T. Comito, *The Idea of the Garden in the Renaissance* (New Brunswick, 1978). On the role of water in particular, see Fagiolo, op. cit.

65. On the progression from wildness to order, see Lazzaro-Bruno, op. cit.; on Pratolino, see David Wright, "Villa Medici at Pratolino," *I Tatti Studies* (Essays in Honor of Craig Smythe), 1985.

66. See Roy Strong, *The Renaissance Garden in England* (London, 1979), 71–76.

67. Bernard Palissy, *Discours admirables, de la nature des eaux et fontaines, tant naturelles qu'artificielles, des metaux, des sels et salines, des pierres, des terres, du feu et des émaux* (Paris, 1580).

68. There is still no major study of the Caus family in the detail their career certainly deserves. The best discussion is in Strong, op. cit., 73ff.; and there is a brief biography by C. S. Maks, *Salomon de Caus* (Paris, 1935). For Isaac de Caus, see the short but helpful introduction by John Dixon Hunt in his facsimile edition of I. de Caus, *Wilton Garden: New and Rare Inventions of Water-Works* (London and New York, 1982).

69. See Ruth Rubinstein, "The Renaissance Discovery of Antique River God Personifications," in *Scritti di storia dell'arte in onore di Roberto Salvini* (Florence, 1984), 257–63; also Francis Haskell and Nicholas Penny, *Taste and the Antique: The Lure of Classical Sculpture* (New Haven, 1982).

70. See Herendeen, op. cit., 147–48.

71. Iversen, op. cit., 183.

72. Domenico Fontana, *Della trasportatione dell'obelisco Vaticano et delle fabriche di Nostro Signore Papa Sisto V* (Rome, 1590).

73. See Peter A. Clayton, *The Rediscovery of Ancient Egypt: Artists and Travellers in the Nineteenth Century* (London, 1982), 11.

74. Pliny, *Natural History*, trans. H. Rackham (Cambridge, Mass., 1986), 36.24.

75. See Sextus Julius Frontinus, *The Strategems* and *The Aqueducts of Rome*, trans. Charles Bennett, ed. Mary B. McElwain (Cambridge, Mass., 1980).

76. See, for example, the discussion in John Baptist Knipping, *Iconography of the Counter-Reformation in the Netherlands: Heaven on Earth* (Nieuwkoop, 1974).

77. For a commentary on this extraordinary painting, see Knipping, op. cit., 2:468.

78. See Franco Borsi, *Bernini architetto* (Milan, 1980), 174.

79. All of which is lost in the august silence of the Victoria and Albert Museum's display. What is needed is at least the *sound* of the original if it is to be remotely true to Bernini's intentions.

80. For the Roman fountains, see C. d'Onofrio, *Le fontane di Roma* (Rome, 1962).

81. Howard Hibbard, *Bernini* (London, 1965), 23.

82. See Sergio Bosticco et al., *Piazza Navona: Isola dei Pamphilj* (Rome, 1978).

83. I must thank my colleague Joseph Connors for suggesting this explanation for Borromini's superficially conservative response to the commission, as well as for drawing the Algardi designs to my attention.

84. Jennifer Montagu, *Alessandro Algardi* (New Haven, 1985), 87–90.

85. For the evolution of the designs in the drawings, see Heinrich Brauer and Rudolf Wittkower, *Die Zeichnungen des Gianlorenzo Bernini* (Berlin, 1931), 47ff.

86. Domenico Bernini, *Vita del Cavaliere Gio.Lorenzo Bernino* (Rome, 1713), 86–88.

87. On the obelisk (and its predecessors), see Cesare d'Onofrio, *Gli obelisci di Roma* (Rome, 1967), 222–29.

88. Irving Lavin, *Bernini and the Unity of the Visual Art* (New York, 1980).

89. See, for example, Wittkower, op. cit.

90. See Iversen, op. cit., 189–90. The works in question were M. Mercati, *De gli obelischi di Roma* (Rome, 1589); L. Pignoria, *Vetustissimae Tabulae Aeneae . . . Explicatio* (Venice, 1605); and in this archaeological spirit, Johannes Georgius Herwart ab Hohenburg, *Thesaurus Hieroglyphicorum* (Munich, 1610).

91. In particular, the three-volume *Oedipus Aegyptiacus* (1652–54), *Ad Alexandrum VII Obelisci Aegyptiaci* (1666), and *Sphinx Mystagoga* (1676).

92. Iversen, op. cit., 191.

93. On the specific symbolic program of the fountain, see Norbert Huse, *Gianlorenzo Bernini's Vierströmebrennen* (Munich, 1967); and Hans Kauffmann, *Giovanni Lorenzo Bernini: Die figürlich Kompositionen* (Berlin, 1970), 174–89.

Chapter Six: Bloodstreams

1. The episode is narrated by Robert Lacey in his outstanding biography, *Sir Walter Ralegh* (London and New York, 1974), 46.

2. Walter Ralegh, *Works* (London, 1829), book 1, chap. 2, sec. 5; see also the discussion in Wyman H. Herendeen, *From Landscape to Literature: The River and the Myth of Geography* (Pittsburgh, 1986), 135ff.; also Yi-Fu Tuan, *The Hydrological Cycle and the Wisdom of God* (Toronto, 1968), 29–30.

3. For the development of Ralegh's colonial adventures, see D. B. Quinn, *Ralegh and the British Empire* (New York, 1962).

4. See Joyce Lorimer, *English and Irish Settlements on the River Amazon, 1550–1646* (London, 1989) 10 n. 3.

5. John Hemming's *Search for El Dorado* (New York, 1978) is a beautiful and gripping account of these adventures. See also V. S. Naipaul, *The Loss of El Dorado* (London, 1969).

6. Ibid., 151–59.

7. Published in London, 1596.

8. Walter Ralegh, *The Discoverie . . .* , 48.

9. Ibid., 54.

10. Ibid., 51–52.

11. Ibid., 63.

12. Walter Ralegh, *The History of the World* (London, 1687). The first edition was published in 1614 and at frequent intervals thereafter. Ralegh's long and fascinating disquisitions on the rivers of Genesis occur principally in chaps. 2 and 3.

13. *The Life of Sir Walter Ralegh,* bound together with *The History of the World,* 40.

14. *The Praise of Hemp-Seed with the Voyage of Mr. Roger Bird and the Writer Hereof, in a boat of browne paper from London to Quinborough in Kent . . . ,* in *Works of John Taylor, The Water-Poet* (1630; Spenser Society facsimile ed., London, 1869), 544–59.

15. Surprisingly little has been written on John Taylor. One of the few vivid impressions of him is in Wallace Notestein, *Four Worthies: John Chamberlain, Anne Clifford, John Taylor, Oliver Heywood* (London, 1956), 169–208.

16. Preface to *Thames-Isis,* 4.

17. See Josephine Ross, *The Winter Queen: The Story of Elizabeth Stuart* (London, 1979), 41.

18. Ibid., 46.

19. *The Praise of the Element of Water,* 18.

20. *A very merry Wherry voyage from London to Yorke with a Pair of Oares.*

21. *John Taylor's Last Voyage* (1641).

22. *The Great Eater of Kent; or, Part of the Admirable Teeth and Stomacks Exploits of Nicholas Wood, of Harrison in the county of Kent.*

23. Giovanni Botero, *A Treatise Concerning the Causes of the Magnificencie and Greatness of Cities,* trans. Robert Peterson (London, 1606), 22.

24. Ibid., 23.

25. Ibid., 22.

26. Michael Drayton, *Poly-Olbion; or, A Chorographicall Description of Tracts, Rivers, Mountaines, Forests, and other Parts of this renowned Isle of Great Britaine* (London, 1613), in *Michael Drayton, His Works,* 10 vols., ed. J. W. Hebel (Oxford, 1933), 4:1.

27. John Nichols, *The Progresses and Public Processions of Queen Elizabeth,* 3 vols. (London, 1823), 1:67–69.

28. See Jack B. Oruch, "Spenser, Camden and the Poetic Marriage of Rivers," *Studies in Philology* 64, no. 4 (July 1967): 606–24; for further discussion of Spenser and Camden, see the excellent account given in Herendeen, op. cit., 203–9.

29. Edmund Spenser, *Epithalamion Tamesis;* William Camden, *De Connubio Tamae et Isis,* later incorporated into his monumental topographical-historical poem, *Britannia.*

30. Ibid., 208.

31. On Denham, see James Turner, *The Politics of Landscape* (Oxford, 1979), esp. chap. 4, which emphasizes the myths of the "happy land" in topographical poetry.

32. Drayton, op. cit., 331–32.

33. Taylor, *Thames-Isis,* 25.

34. Ibid., 27.

35. See Basil Cracknell, *Canvey Island: The History of a Marshland Community* (Leicester, 1959), 21.

36. Ibid., 23.

37. Cited in P. G. Rogers, *The Dutch in the Medway* (Oxford, 1970), 121.

38. This account of the floating island on the Bidassoa, the "conference," and the marriage of Louis XIV and Maria Theresa of Spain is based on [Colletet], *La Suitte du voyage des deux roys de France et d'Espagne et leur rendez-vous dans l'Isle de la Conférence . . .* (Paris, 1660); also *La Pompe et magnificence faite au mariage du roy et de l'infante de l'Espagne . . .* (Paris, 1660).

39. See Daniel Nordman, "Des Limites d'état aux frontières nationales," in Pierre Nora, ed., *Les Lieux de mémoire,* vol. 2, *La Nation* (Paris, 1986), 35–61. For the evolution of the

concept of "natural frontiers" and the river frontier in particular, see the fascinating and well-argued article by Peter Sahlins, "Natural Frontiers Revisited: France's Boundaries Since the Seventeenth Century," *American Historical Review* 95, no. 5 (December 1990): 1423–1452.

40. See Jean Tronçon, *L'Entrée triomphante de Leurs Majestés Louis XIV, roy de France et de Navarre, et Marie Thérèse d'Austriche son espouse, dans la ville de Paris* (Paris, 1662).

41. Vincent Scully, *Architecture: The Natural and the Man-made* (New York, 1991), 226–66. It will be apparent that I owe much not just to Scully's discussion of the use of water in French gardens, but to his central thesis concerning the conscious and unconscious relationship between topography and human design.

42. See Hélène Verin, "Technology in the Park: Engineers and Gardeners in Seventeenth-Century France," in Monique Mosser and Georges Teyssot, eds., *The Architecture of Western Gardens* (Cambridge, Mass., 1991), 135–201.

43. *Essay des merveilles de nature et de plus nobles artifices* (Rouen, 1629), cited in Verin, op. cit., 136–37. For more in this vein, see also Jacques Boyceau de Baraudière, *Traité du jardinage selon les raisons de la nature et de l'art* (Paris, 1638).

44. For a persuasive and eloquent reading of the fountain, see Nathan Whitman, "Myth and Politics: Versailles and the Fountain of Latona," in John C. Rule, ed., *Louis XIV and the Craft of Kingship* (Columbus, Ohio, 1969), 286–301.

45. See Edouard Pommier, "Versailles, l'image du souverain," in Nora, ed., op. cit., 215.

46. George L. Hersey, *Architecture, Poetry, and Number in the Royal Palace at Caserta* (Cambridge, Mass., 1983). The account which follows is heavily indebted to Hersey's superlative reading, esp. chap. 5, pp. 98–141.

47. Ovid, *The Metamorphoses,* trans. Horace Gregory (New York, 1978), book 6 (p. 173).

48. See Simon Lacordaire, *Les Inconnus de la Seine* (Paris, 1985), 292–94.

49. Ibid., 241ff.

50. Bernard Forest de Belidor, *Architecture hydraulique; ou, L'Art de conduire d'élever et de ménager les eaux pour les différens besoins de la vie,* 3 vols. (Paris, 1737). For Belidor's account of divining rods and their lore, see vol. 2, book 4, pp. 341ff.

51. Charles Dickens, *Dictionary of the Thames* (London, 1893), 64.

52. It was Macaulay's biographer, my friend the late John Clive, who told me about the historian's lasting passion for whitebait, as we ourselves enjoyed them at the Trafalgar on a summer evening in 1979.

53. Thomas Babington Macaulay, "A Conversation between Mr. Abraham Cowley and Mr. John Milton touching the Great Civil War," in *Works,* 11:310–22; the essay is discussed in John Clive, *Macaulay: The Shaping of the Historian* (New York, 1974), 82ff.

54. Sir George Otto Trevelyan, *The Life and Letters of Lord Macaulay,* 2 vols. (New York, 1877), 2:23–24.

55. See Philippe Barrier, *La Mémoire des fleuves de France* (Paris, 1989), 95–96.

56. *Thomson's Poetical Works, with Life, Critical Dissertation and Explanatory Notes,* ed. George Gilliam (Edinburgh, 1853), 80.

57. Thomas Love Peacock, *The Genius of the Thames: A Lyrical Poem in Two Parts* (London, 1810), n.p.

58. James Barry, *An Account of a Series of Pictures in the Great Room of the Society of Arts . . .* (London, 1783). The formal composition of Barry's painting was based on Francis Hayman's earlier *Triumph of Britannia* (1769), executed for the Vauxhall Gardens.

59. Ibid., 63.

60. William L. Pressly, *James Barry: The Artist as Hero* (London, 1983), 83.

61. For a superbly detailed and perceptive account of Turner's Thames paintings, see David Hill, *Turner on the Thames: River Journeys in the Year 1805* (New Haven and London, 1993).

62. Hill, op. cit., chap. 2 ("Imagination Flowing"), pp. 24–51.

63. For a perceptive commentary, see John Gage, *J. M. W. Turner: "A Wonderful Range of Mind"* (New Haven, 1987), 178; see also Hill, op. cit., 150–51.

64. For the latter view, see the essay by Stephen Daniels, "Turner and the Circulation of State," in his *Fields of Vision: Landscape Imagery and National Identity in England and the United States* (Princeton, 1993), where Daniels draws attention to Turner's earlier renderings of the industrial city of Leeds. See also the richly learned monograph by John Gage, *Turner: Rain, Steam and Speed* (London, 1972).

65. Barrier, op. cit., 250.

66. See Claudio Magris, *Danube*, trans. Patrick Creagh (New York, 1989).

67. Julien Tiersot, *Smetana* (Paris, 1926), 24.

68. Alexandre Dumas, *Excursions sur les bords du Rhin*, ed. Dominique Fernandez (Paris, 1991), 239–40.

69. Eric Shanes, ed., *Les Fleuves de la France* (Paris, 1990).

70. This is a point well made by Stephen Daniels in his essay "Thomas Cole and the Course of Empire," in op. cit., 151.

71. Cited in *American Paradise: The World of the Hudson River School* (New York: Metropolitan Museum of Art, 1988), 127.

72. See the catalogue note by Oswaldo Rodriguez Roque in ibid., 125.

73. Henry Adams, "A New Interpretation of Bingham's *Fur Traders Descending the Missouri*," *Art Bulletin,* 1983: 675–80, makes some important points about the relationship of Bingham's river genres to the trajectory of America's national and economic development. But I still find it difficult to find the anxieties and insecurities that Adams sees in Bingham's paintings with the imperturbably arrogant flatboatmen.

74. Yellow fever is, of course, spread by mosquitoes rather than tainted water, but the provision of fresh water to Philadelphia certainly did the city no harm. On Rush, see the exhibition catalogue *William Rush: American Sculptor* (Philadelphia: Pennsylvania Academy of Fine Arts, 1982), esp. 19–21 and 115–17; and on the city's water, see John L. Cotter, Daniel G. Roberts, and Michael Parrington, *The Buried Past: An Archaeological History of Philadelphia* (Philadelphia, 1992), 53ff.

75. There is a considerable literature on Eakins's painting and on his motives for the meaningful anachronism of the nude model, but very little on the relationship between the discarded clothes and the hydraulic themes of the painting and Rush's own fountain-statue. See Elizabeth Johns, *Thomas Eakins: The Heroism of Modern Life* (Princeton, 1983), 82–113; William Innes Homer, *Thomas Eakins: His Life and Art* (New York, London, and Paris, 1992), 93–97; Lloyd Goodrich, *Thomas Eakins,* 2 vols. (Cambridge, Mass., 1982), 1:145–57. The most perceptive of all analyses of Eakins is to be found in Michael Fried, *Realism, Writing, Disfiguration: On Thomas Eakins and Stephen Crane* (Chicago, 1987), and while Fried does not discuss the Rush paintings, it is impossible not to be carried from his account of the extension of the river landscape in Courbet's *Studio of the Artist* toward a comparable instance in Eakins.

76. Michael Fried, *Courbet's Realism* (Chicago, 1990), chaps. 8 and 9.

77. For a discussion of *The Origin of the World,* see the exhibition catalogue *Courbet Reconsidered* (Brooklyn Gallery of Art, 1988), 176–78. Other discussions of the relationship between the paintings of the source of the Loue and the image of female genitalia may be found in Neil Hertz, *The End of the Line: Essays on Psychoanalysis and the Sublime* (New York, 1985), 209–14. On Khalil Bey, see Francis Haskell, "A Turk and His Pictures in Nineteenth-Century Paris," in *Rediscoveries in Art* (Ithaca, 1976).

78. John Hanning Speke, *Journal of the Discovery of the Source of the Nile* (Edinburgh and London, 1863), 357.

79. See R. A. Hayward, *Cleopatra's Needles* (London, 1978), 15.

80. *Illustrated London News,* Sept. 21, 1878; also cited in Hayward, op. cit., 126.

81. Amelia Edwards, *A Thousand Miles up the Nile* (London, 1877), 124.

82. Florence Nightingale, *Letters from Egypt: A Journey on the Nile, 1849–1850,* ed. Anthony Sattin (London, 1987), 114. Philae had, in fact, been the object of long and passionate interest by Western travellers. Richard Pococke, later bishop of Ossory and Heath, went there in 1737 and wrote up his account for the king of Denmark ten years later. See

Peter A. Clayton, *The Rediscovery of Egypt: Artists and Travellers in the Nineteenth Century* (London, 1982), 13–14. Philae appears prominently in the great *Description de l'Egypte,* published by the scholars and engineers of Napoleon's expedition in 1798–99. See Charles C. Gillispie and Michel de Wachter, *Monuments of Egypt,* 2 vols. (Princeton, 1987), vol. 1, plates 3–28.

83. Nightingale, op. cit., 114.

84. Lucie Duff Gordon, *Letters from Egypt* (London, 1983), 170.

85. Cited in Anthony Sattin, *Lifting the Veil: British Society in Egypt, 1768–1956* (London, 1988), 259.

PART THREE: ROCK

Chapter Seven: Dinocrates and the Shaman: Altitude, Beatitude, Magnitude

1. R.A.P. to Eleanor Roosevelt, Mar. 28, 1934, Rose Arnold Powell Papers, Schlesinger Library, Harvard University.

2. See "Notes on the Mount Rushmore Struggle," the autobiographical essay by R.A.P. in the Powell Papers, p. 1.

3. Ibid.

4. The description is from his son and daughter-in-law, Lincoln Borglum and June Culp Zeitner, *Borglum's Unfinished Dream* (Aberdeen, S. Dak., 1976), 101.

5. R.A.P., "Notes on the Mount Rushmore Struggle," Powell Papers, p. 3.

6. Gutzon Borglum to Eleanor Roosevelt, May 13, 1936, copy to R.A.P., Powell Papers.

7. Cited in Rex Alan Smith, *The Carving of Mount Rushmore* (New York, 1985), 31.

8. Albert Boime, "Patriarchy Fixed in Stone: Gutzon Borglum's Mount Rushmore," *American Art* 5, nos. 1–2 (Winter–Spring 1991): 147.

9. Quoted in Borglum and Zeitner, op. cit., 107.

10. In 1931 he wrote to his friend Lester Barlow that only someone "with guts" who had "vision and courage" and the power to carry it out like Mussolini could take charge of government and make the American presidency work. Borglum to Barlow, Aug. 29, 1931, Borglum Papers, Library of Congress. Cited in Boime, op. cit., 153.

11. On Borglum's association with, and later membership in, the Ku Klux Klan and his deep-seated anti-semitism, see Howard and Audrey Karl Shaff, *Six Wars at a Time* (Sioux Falls, S. Dak., 1985), 103ff. See also Alex Heard, "Mount Rushmore: The Real Story," *New Republic,* July 15 and 22, 1991, 16–18.

12. Quoted in Borglum and Zeitner, op. cit., 111.

13. Gutzon Borglum to Eleanor Roosevelt, May 13, 1936, copy to R.A.P., Powell Papers.

14. Ibid.

15. Cited in Boime, op. cit., 153.

16. Don Terry, "Columbus Divides Ohio's Capital City," *New York Times,* Dec. 26, 1993, pp. 1 and 20.

17. Sir Francis Younghusband, *The Epic of Mount Everest* (London, 1926), 19.

18. William Gilpin, *The Mission of the North American People; Geographical, Social, and Political* (Philadelphia, 1873). On Gilpin, see the interesting discussion in connection with land surveying in the Rockies and Thomas Moran's painting of the Mountain of the Holy Cross, Linda Hults, "Pilgrim's Progress in the West, Moran's Mountain of the Holy Cross," *American Art* 5, nos. 1–2 (Winter–Spring 1991): 74.

19. Quoted in Borglum and Zeitner, op. cit., 28.

20. Borglum and Zeitner, op. cit., 26.

21. According to Borglum, Frank Lloyd Wright had agreed to work with him on the design of the Hall of Records. Borglum and Zeitner, op. cit., 68.

22. Quoted in Donald Dale Jackson, "Gutzon Borglum's Odd and Awesome Portraits in Granite," *Smithsonian* 23, no. 5 (Aug. 1992): 64–77.

23. Smith, op. cit., 371.

24. Quoted in ibid., 388.

25. *Washington Herald,* Mar. 19, 1934, p. 3.

26. Vitruvius, *De architectura,* trans. F. Granger (Cambridge, Mass., and London, 1983), book 2 (pp. 73–77). Dinocrates is also mentioned in Plutarch's *Moralia* and Pliny's *Natural History* as the architect of Alexandria and perhaps of the wondrous temple of Diana at Ephesus.

27. Ibid., 75.

28. Pliny, *Natural History,* book 7, mentions the same architect, known under the variable name of "Dinochares," as the surveyor of Alexandria. He was also reputed by less reliable authorities to have been the designer of the tomb of Diana at Ephesus.

29. This is my translation, since Granger's version, translating, for example, *deformavit* as "uncomely," seems somewhat demure.

30. On this tradition, see the article by Werner Oechslin, "Dinokrates—Legende und Mythos megalomaner Architektusstiftung," *Daidalos* 4 (July 1982): 7–26.

31. Quoted in Ascanio Condivi, *The Life of Michelangelo,* trans. Alice Sedgwick, ed. Helmut Wohl (Baton Rouge, 1976), 29–30.

32. J. B. Fischer von Erlach, *Entwurff einer historischen Architektur in Abbildung unterscheidener berühmten Gebäude, des Altertums und fremder Völker* (Vienna, 1721), 1:18. On the Pietro da Cortona drawing, see Richard Krautheimer, *The Rome of Alexander VII, 1655–1667* (Princeton, 1985), 10.

33. See the catalogue entry in *Claude to Corot: The Development of Landscape Painting in France* (New York, 1990), 256–58.

34. For a brief discussion of these figures, see the excellent introductory book by Maggie Keswick, *The Chinese Garden: History, Art and Architecture* (London, 1978), 175.

35. Lao Tzu, *Tao Te Ching,* trans. D. C. Lau (London and New York, 1963), 82; see also Kyohiko Munikata, *Sacred Mountains in Early Chinese Art* (Illinois, 1991), esp. 4–39.

36. For the fantastic rocks of the Han and Sung gardens, see Keswick, op. cit., 155–62.

37. Ulrich Christoffel, *La Montagne dans la peinture* (Geneva, 1963), 19.

38. See Francis Gribble, *The Early Mountaineers* (London, 1899), 14–16; see also (and for many other accounts of early mountain narratives) John Grand-Carteret, *La Montagne à travers les ages* (Grenoble-Moutiers, 1900–1904), 1:111.

39. See Gribble, op. cit., 15.

40. J. J. Scheuchzer, *Helveticus, sive Itinera per Helvetiae Alpinas Regiones Facta Annis 1702–1711* (Lucerne, 1711).

41. Scheuchzer in turn relied on Wagner's *Historia Naturalibus Helvetiae Curiosa* (1680).

42. John Wilkinson, ed., with Joyce Hill and W. F. Ryan, *Jerusalem Pilgrimage, 1099–1185* (London, 1988), 8.

43. Ibid.

44. Ibid., 186–87.

45. Ibid., 186.

46. Ibid.

47. Ibid., 186–87.

48. On the creation of Shangri-La myths from the eighteenth century onward, see the fascinating book by Peter Bishop, *The Myth of Shangri-La: Tibet, Travel Writing, and the Western Creation of Sacred Landscape* (Berkeley and Los Angeles, 1989).

49. For a further discussion of the Jeromes and other "mountain prospect, world paintings," see Walter Gibson, *Mirror of the Earth: The World Landscape in Sixteenth-Century Flemish Painting* (Princeton, 1989), 7ff.

50. See George Williams, *Wilderness in Christian Thought: The Biblical Experience of the Desert in the History of Christianity* (New York, 1962).

51. See Gibson, op. cit., 27.

52. Ibid., 21.

53. Wilfred Noyce, *Scholar Mountaineers* (London, 1950), 25.

54. Dante, *Purgatorio*, cantos 27–28.

55. The full text is reproduced in David Thompson, ed. and trans., *Petrarch: A Humanist among Princes: An Anthology of Petrarch's Letters and of Selections from His Other Works* (New York, Evanston, and London, 1971), 27–36. It is taken from Petrarch, *Epistolae familiares*, 50.4.1, Petrarch to Dionigi da Borgo San Sepolcro. The letter is said by Thompson and others to have been "ostensibly written from Malaucène on April 26, 1336," but the dating has proved contentious.

56. For a discussion of the status of the letter as the report of an event, and of its problematic dating, see Hans Baron, *From Petrarch to Leonardo Bruni: Studies in Humanistic and Political Literature* (Chicago and London, 1968), 17–20.

57. See the brilliant reading of mountain iconography offered by Jacek Wozniakowski, *Die Wildnis: Zur Deutungsgeschichte des Berges in der europäischen Neuzeit* (Frankfurt am Main, 1987), 78–79.

58. See the documents printed in Gribble, op. cit., 29–35.

59. Ibid., 37.

60. E. H. Gombrich, "The Renaissance Theory of Art and the Rise of Landscape," in *Norm and Form: Studies in the Art of the Renaissance* (London, 1966), 107–21.

61. A. Richard Turner, *Inventing Leonardo* (New York, 1993), 162–63.

62. See, for example, Christoffel, op. cit.; and Christopher S. Wood, *Albrecht Altdorfer and the Origins of Landscape* (Chicago, 1993), 22.

63. See Wozniakowski, op. cit., 95.

64. For more of these views, see the interesting iconographic anthology compiled by Alfred Steinitzer, *Der Alpinismus in Bildern* (Munich, 1924).

65. On early Alpine cartography, see the brief discussion in Philippe Joutard, *L'Invention du Mont Blanc* (Paris, 1986), 63.

66. See Gribble, op. cit., 59; the original source is Gesner, *Descriptio Montis Fracti sive Montis Pilati, iuxta Lucernam in Helvetia* (Zurich, 1555).

67. Ibid., 51.

68. Josias Simler, *Vallesiae Descriptio et de Alpibus Commentarius* (Zurich, 1574).

69. The best study of these images is Gibson, op. cit.

70. Gribble, op. cit., 55–56.

71. Gibson, op. cit., 70.

72. Klaus Ertz, *Josse de Momper der Jungere, 1564–1635* (Freren, 1986), 43.

73. Quoted in the important article by William Hood, "The *Sacro Monte* of Varallo: Renaissance Art and Popular Religion," in T. Verdon, ed., *Monasticism and the Arts* (Syracuse, 1984), 305. My argument here is indebted to Hood and to the generous help of Geraldine Johnson of Harvard University, who first alerted me to the rich sources on the tradition of the *sacro monte*.

74. See George Kubler, "Sacred Mountains in Europe and America," in Timothy Verdon and John Henderson, eds., *Christianity and the Renaissance: Image and Religious Imagination in the Quattrocento* (Syracuse, 1990), 413–41.

75. Lino Moroni, *Descrizione del Sacro Monte della Verna* (n.p., n.d.; Florence/Venice, ca. 1620). For a commentary on the book, see Lucilla Conigliello, *Jacopo Ligozzi: Le vedute del Sacro Monte della Verna, i dipinti di Poppi e Bibbiena* (Poppi, 1992).

76. See Kubler, op. cit., 418–22.

77. I am grateful to Annette Schlagenhauff for personally investigating the modern fate of Mont Valérien and for unearthing a great trove of documents on its history. See, for reference, Edouard Fournier, *Suresnes: Notes historiques* (Paris, 1890); Jacques Hérissay, *Le Mont-Valérien: Les Pèlerinages de Paris révolutionnaire* (Paris, 1934); and summary in Germain Bazin, *Aleijadinho et la sculpture baroque en Brésil* (Paris, 1963), 200–202.

78. See Fournier, op. cit., 73–74.

79. I am most grateful to Cristina Mathews for permission to consult and quote from her fascinating 1991 Senior Essay for the Department of Religious Studies at Yale University, and

to Virginia Blaisdell for a selection of photographs from the portfolio she made to illustrate Ms. Mathews's study.

80. Ibid., 8–9.

Chapter Eight: Vertical Empires, Cerebral Chasms

1. Horace Walpole to Richard West, Nov. 11, 1739, *The Correspondence of Gray, Walpole, West and Ashton, 1734–1771*, ed. Paget Toynbee (Oxford, 1915), 255–56. For another account of the incident, see Gray's letter to his mother, Nov. 7, 1739, *Correspondence of Thomas Gray*, eds. Paget Toynbee and Leonard Whibley (Oxford, 1935), 125–26. The dog had been given to Walpole by Lord Conway during his stay in Paris and was named "Tory" after a die-hard Tory relative. It presumably amused the son of the great Whig prime minister to have a Tory in his lap. A nineteenth-century editor of Walpole's letters adds, rather unfeelingly, how apt it would have been for Gray to have composed an ode on the dog's untimely death seeing as he would write a poem on a pet cat drowned in a goldfish bowl. The poetic immortalization of Tory would have to wait for the much lesser talent of Edward Burnaby Greene in 1775.

2. James Thomson, "Winter," from *The Seasons,* in *Thomson's Poetical Works,* ed. George Gilfillan (Edinburgh, 1853), 145.

3. Gray to West, Nov. 16, 1739, *Correspondence of Thomas Gray,* 128.

4. Walpole to West, Nov. 11, 1739, *Correspondence,* 254–55.

5. Gray to West, Nov. 16, 1739, *Correspondence,* 259.

6. Cited in Marjorie Hope Nicolson, *Mountain Gloom, Mountain Glory* (Ithaca, 1959), 277.

7. Thomas Gray, *Journal;* also cited in *Correspondence of Thomas Gray,* 122 n. 1.

8. Gray to West, Nov. 16, 1739, *Correspondence of Thomas Gray,* 128.

9. See note 6 above.

10. See Yi Fu-Tuan, *The Hydrological Cycle and the Wisdom of God* (Toronto, 1968).

11. Stephen Jay Gould, *Time's Arrow, Time's Cycle: Myth and Metaphor in the Discovery of Geological Time* (Cambridge, Mass., 1987), 32. The literature on Thomas Burnet is considerable. See in particular Don Cameron Allen, "Science and the Universality of the Flood," in Alan Dundes, ed., *The Flood Myth* (Berkeley and Los Angeles, 1988), 357–82.

12. Gilbert Burnet, *Some Letters Containing an Account of what seemed Most Remarkable in travelling through Switzerland, Italy . . . and Germany in the years 1685 and 1686* (London, 1724), 15.

13. Cited in Malcolm Andrews, *The Search for the Picturesque Landscape: Aesthetics and Tourism in Britain, 1760–1800* (Stanford, 1989), 44.

14. Cited in Nicolson, op. cit., 305.

15. Walpole to West, Sept. 28, 1739, *Correspondence,* 244.

16. Horace Walpole, *Aedes Walpolianae* (London, 1743), xxvii. See also Elizabeth W. Manwaring, *Italian Landscape in Eighteenth-Century England* (1925; New York, 1965).

17. William Gilpin, *Essay on Prints* (London, 1792), 2:44.

18. Salvator to Ricciardi, May 13, 1662, *Lettere inedite di Salvator Rosa a G. B. Ricciardi,* ed. Aldo de Rinaldis (Rome, 1939), 135. See also the introductory essay by Michael Kitson in the exhibition catalogue *Salvator Rosa* (London: Hayward Gallery, 1973), 15; and Francis Haskell, *Patrons and Painters: A Study in the Relations Between Italian Art and Society in the Age of the Baroque* (New Haven and London, 1980), 144–45 and passim.

19. See Richard A. Wallace, *Salvator Rosa in America* (Wellesley, Mass., 1979), 90–91.

20. Walpole to West, Sept. 30, 1739, *Correspondence,* 246–47.

21. West to Walpole, *Correspondence,* 251.

22. For a discussion of its effects on travel writing, see the thoughtful essay by Chloë

Chard, "Rising and Sinking on the Alps and Mount Etna: The Topography of the Sublime in Eighteenth-Century England," *Journal of Philosophy and the Visual Arts* 1, no. 1 (1989): 61–69.

23. Gray's own copy is now preserved in the Houghton Library, Harvard University.

24. This is the dismissive summary offered by the translator and editor J. D. Duff in his 1933 Loeb Library edition.

25. Silius Italicus, *Punica*, trans. J. D. Duff (Cambridge, Mass., 1933), 3.494 (p. 151).

26. For a discussion of the circumstances surrounding the lost *Hannibal* and an excellent critical monograph on the Cozenses, see Kim Sloan, *Alexander and John Robert Cozens: The Poetry of Landscape* (New Haven and London, 1986), 110–11.

27. There is still a surprisingly scanty literature on the Cozenses. A. P. Oppé's *Alexander and John Robert Cozens* (Cambridge, Mass., 1954) is now seriously out of date, and the introduction by Andrew Wilton to his exhibition *The Art of Alexander and John Robert Cozens* (New Haven: Yale Center for British Art, 1981) is tantalizingly brief. It also argues against a close stylistic connection between the work of father and son, a position disputed by Kim Sloan (see n. 26 above).

28. Thomas Grimston to his father, John, May 11, 1776, cited in Sloan, op. cit., 109.

29. Cited in Sloan, op. cit., 56.

30. The text is reproduced in John Gage, *J. M. W. Turner: "A Wonderful Range of Mind"* (New Haven, 1987), 192.

31. Cited in Sloan, op. cit., 109.

32. Francis Gribble, *The Early Mountaineers* (London, 1899), 123. For the full account, see William Windham, *An account of the Glacieres or Ice Alps of Savoy in two Letters* (London, 1744).

33. Windham's account was published in 1744 and is reproduced in many histories of early Alpinism, for example, G. R. De Beer, *Early Travellers in the Alps* (London, 1930), 99–114.

34. Ibid., 100.

35. Ibid., 107.

36. Ibid., 109.

37. Ibid., 111.

38. For Sandby's role in Scotland, as well as for a survey of the beginnings of "Scottish taste" in England, see James Holloway and Lindsay Errington, *The Discovery of Scotland* (Edinburgh, 1978), 33ff.

39. Linda Colley, *Britons* (New Haven and London, 1992), 117–32.

40. Holloway and Errington, op. cit., 37.

41. See Andrews, op. cit., 109–51. I am indebted to Dr. Andrews's superb account of Welsh tourism for my interpretation.

42. Cited in Andrews, op. cit., 130. See also Joseph Cradock, *Letters from Snowdon: Descriptives of a Tour through the Northern Counties of Wales* (Dublin, 1770).

43. See Fiona J. Stafford, "The Sublime Savage: A Study of James Macpherson and the Poems of Ossian in Relation to the Cultural Context in Scotland in the 1750s and 1760s" (D.Phil. diss., Oxford University, 1986).

44. James Boswell, *Journal of a Tour to the Hebrides with Samuel Johnson, LLD* (London, 1785).

45. Thomas Pennant, *A Tour in Scotland and Voyage to the Hebrides* (1774).

46. For Bourrit, see Philippe Joutard, *L'Invention du Mont Blanc* (Paris, 1986).

47. Cited in Andrews, op. cit., 113.

48. Marc Théodore Bourrit, *Description des glacières et amas de glace du duché de Savoye* (Geneva, 1773).

49. Mary Shelley and P. B. Shelley, *History of a Six Weeks' Tour through a Part of France, Switzerland, Germany, and Holland* (1817; reprint, Oxford, 1989), 151.

50. Joseph Addison, *Tatler*, no. 161, Apr. 20, 1710.

51. Gribble, op. cit., 116.

52. Jean-Jacques Rousseau, *Oeuvres complètes* (Paris, 1826); *La Nouvelle Héloïse*, 1: 131–45.

53. On the cult of Rousseau's posterity, see my *Citizens: A Chronicle of the French Revolution* (New York, 1989), 156–61.

54. Shelley's account of the voyage is in his letter to Thomas Love Peacock, July 12, 1816. It was printed in full in Shelley and Shelley, op. cit., 106–39. For the story of this extraordinary Romantic summer, see Claire Eliane Engel, *Byron et Shelley en Suisse et en Savoie* (Chambéry, 1930).

55. Shelley and Shelley, op. cit., 116.

56. Cited in Cuthbert Girdlestone, *Louis François Ramond de Carbonnières, 1755–1820* (Paris, 1968), 66.

57. William Coxe [and Louis Ramond de Carbonnières], *Travels in Switzerland . . .*, 2 vols. (Paris, 1802), 1:60.

58. Ibid., 1:58.

59. Cited in Girdlestone, op. cit., 460.

60. Louis Ramond de Carbonnières, *Voyages au Mont-Perdu* (Paris, 1802), 113–14. For Ramond's more uninhibitedly romantic writing on Pyrenean desolation, including spectacular descriptions of mountain storms, see his *Observations faites aux Pyrénées* (Lourdes and Paris, 1789).

61. Ibid., 235.

62. Percy Bysshe Shelley, "Mont Blanc: Lines Written in the Vale of Chamouni," *Poems* (New York, 1993), 112–17.

63. Horace Bénédict de Saussure, *Journal d'un voyage à Chamouni et à la cime du Mont Blanc* (1787; reprint, Lyon, 1926), 26.

64. See Paul Payot, *Au royaume du Mont Blanc* (Chamonix, 1950), 238.

65. On the successor climbs, see Claire Eliane Engel, *Histoire de l'alpinisme des origines à nos jours* (Paris, 1950), 55.

66. John Auldjo, *A Narrative of an Ascent to the Summit of Mont Blanc on the 8th and 9th of August, 1827* (London, 1830), 67–68.

67. Payot, op. cit., 41.

68. M. J. G. Ebel, *The Traveller's Guide through Switzerland,* supplement by Daniel Wall (London, 1818).

69. Marianna Starke, *Travels in Europe for the Use of Travellers on the Continent* (Paris, 1836), 35–36.

70. Ebel, op. cit., 44.

71. For her biography, see Emile Gaillard, *Une Ascension romantique en 1838: Henriette d'Angeville au Mont Blanc* (Chambéry, 1947).

72. Henriette d'Angeville, *My Ascent of Mont Blanc,* preface by Dervla Murphy, trans. Jennifer Barnes (London, 1992), 32.

73. Cited in Gaillard, op. cit., 42ff.

74. Albert Smith, *The Story of Mont Blanc* (London, 1853), 159.

75. Ibid., 30.

76. Ibid., 33.

77. Ibid., 33–34.

78. Ibid., 198–99.

79. Edmund Swinglehurst, *The Romantic Journey: The Story of Thomas Cook and Victorian Travel* (New York and London, 1974), 49–64.

80. For a close study of the membership of the Alpine Club as well as an important interpretation of the social and imperial history of British mountaineering, see the 1993 Harvard Ph.D. dissertation by Peter Hansen on Victorian Alpinism. I am immensely grateful to the author for the many insights on this subject which he has shared during our discussions of this topic during his years as a graduate student at Harvard. His forthcoming book will take his historical insights further into the "Himalayan" period of British climbing.

81. Leslie Stephen, *The Playground of Europe* (London, 1924), 68.

82. Cited in R. L. G. Irving, *The Mountain Way* (London, 1938), 85.

83. Reprinted in Irving, op. cit., 497.

84. Ronald William Clark, *The Victorian Mountaineers* (London, 1953), 61.

85. The atmosphere of competitive dauntlessness on the mid-Victorian climbs is wonderfully conveyed in the anthologies published by the Alpine Club as *Peaks, Passes, and Glaciers* (London, 1859).

86. Stephen, op. cit., 195.

87. Ibid., 192–93.

88. Ibid., 328.

89. Ibid., 321.

90. Ibid., 336–37.

91. For an excellent account of Alpine Club aesthetics, see Hansen, op. cit.

92. John Ruskin, *Sesame and Lilies: Two Lectures delivered at Manchester in 1864* (New York, 1865), 53–54.

93. John Ruskin, *Praeterita*, introduction by Kenneth Clark (London, 1949), 103.

94. See Paul H. Walton, *The Drawings of John Ruskin* (Oxford, 1972), 15.

95. John Ruskin, *Modern Painters*, 5 vols. (Boston, 1875), 4:427.

96. Ibid., 246.

97. Cited in Clark, op. cit., 38.

98. On the dispute, see the brilliant article by Robin Middleton, "Viollet-le-Duc et les Alpes: La Dispute de Mont Blanc," in the catalogue of the exhibition *Viollet-le-Duc: Centenaire de sa mort à Lausanne* (Lausanne, 1979), 100–110. See also, in the same catalogue, Jacques Gubler, "Architecture et géographie: Excursions de lecture, ainsi que deux manifestes de Viollet-le-Duc," 91–108. See also the essays in Pierre A. Frey, ed., *E. Viollet-le-Duc et le massif du Mont Blanc, 1868–1879* (Lausanne, 1988).

99. Ruskin, *Modern Painters*, 4:486–87.

100. Ibid., 133–34.

Chapter Nine: Arcadia Redesigned

1. Erwin Panofsky, "Et in Arcadia Ego: Poussin and the Elegiac Tradition," in idem., *Meaning in the Visual Arts* (New York, 1955), 295–320.

2. Henry Peacham, *Graphice; or, The Most Ancient and Excellent Art of Drawing and Limning* (London, 1612), 44.

3. *Morning Herald*, July 8, 1789; cited in Alan Farmer, *Hampstead Heath* (New Barnet, 1984), 47.

4. Farmer, op. cit., 132.

5. Ibid., 104.

6. The famous phrase is from his essay "Walking," delivered as a lecture to the Concord Lyceum, and reprinted in Ralph Waldo Emerson, *Nature*, and Henry David Thoreau, *Walking* (Boston, 1991).

7. Philippe Borgeaud, *The Cult of Pan in Ancient Greece*, trans. Kathleen Atlass and James Redfield (Chicago, 1988), 9–10 and passim.

8. Ibid., 57–58.

9. Theocritus, in *The Greek Bucolic Poets*, trans. J. M. Edmonds (Cambridge, Mass., 1977), 105.

10. Virgil, *Eclogues* and *Georgics*, trans. H. Rushton Fairclough (Cambridge, Mass., 1986), 31.

11. Ibid., 37.

12. Ibid., 153.

13. See the important discussion of these issues in James S. Ackerman, *The Villa: Form and Ideology of Country Houses* (Princeton, 1990), chap. 1. I am altogether much in debt to

this book, as well as to conversations with Professor Ackerman on the themes of this and other chapters.

14. See Robert Castell, *Ancient Villas* (London, 1728).

15. Vitruvius, *De architectura*, trans. F. Granger (Cambridge, Mass., and London, 1983), 7.100.5.2 (p. 103). For his classification of stage landscapes, see idem, 5.100.6.9.

16. See Castell, op. cit.

17. Vitruvius, op. cit., 7.100.5.4 (p. 105).

18. Philip Sidney, *The Countess of Pembroke's Arcadia* (1633), 9.

19. Jacopo Sannazaro, *Arcadia*, trans. Ralph Nash (Detroit, 1966), 42–44.

20. Ibid., 102.

21. See Anne van Erp-Houtepan, "The Etymological Origin of the Garden," *Journal of Garden History* 6, no. 3 (1986): 227–31. I am also most grateful to Dr. Erp-Houtepan for her great kindness in letting me read chapters of her thesis on changing attitudes to fences and boundaries in landscape gardening. On the implications of these definitions, see the brilliant and provocative discussion in Simon Pugh's reading of William Kent's garden at Rousham, *Garden, Nature, Language* (Manchester, 1988), esp. chap. 5.

22. See the catalogue note on the engraving after Vinckboons by Jan van Lonserdeel, in Kahren Jones Hellerstedt, *Gardens of Earthly Delight: Sixteenth and Seventeenth Century Netherlandish Gardens* (Pittsburgh: Frick Art Museum, 1986), 34–35.

23. Margaretta Darnall and Mark S. Weil, "Il sacro bosco di Bomarzo: Its Sixteenth-Century Literary and Antiquarian Context," *Journal of Garden History* 4, no. 1 (1984): 1–94; but see also the critical review essay by J. B. Bury, "Bomarzo Revisited," *Journal of Garden History* 5, 2 (April–June 1985): 213–23.

24. See Anne-Marie Lecoq, "The Garden of Wisdom of Bernard Palissy," in Monique Mosser and Georges Teyssot, eds., *The Architecture of Western Gardens* (Cambridge, Mass., 1991), 69–80.

25. John Prest, *The Garden of Eden: The Botanic Garden and the Re-Creation of Paradise* (New Haven and London, 1981), passim.

26. Ibid., 52.

27. Horace Walpole, *The History of the Modern Taste in Gardening,* in *Anecdotes of Painting in England,* 5 vols., 2d ed., (London, 1782), 4:235.

28. Cited in John Dixon Hunt, *The Figure in the Landscape: Poetry, Painting and Gardening during the Eighteenth Century* (Baltimore and London, 1989), 65.

29. There is a huge literature on these revolutionary developments in English landscape gardening. The guiding light in the debate, for many years, has been John Dixon Hunt, among whose many richly learned and perceptive books *The Figure in the Landscape, Gardens and the Picturesque: Studies in the History of Landscape Architecture* (Cambridge, Mass., 1992), and his biography of William Kent, *William Kent: Landscape Garden Designer; An Assessment and Catalogue of His Ideas* (London, 1987), may be especially recommended. My debt to him throughout this chapter will be evident.

30. Christopher Hussey, *The Picturesque: Studies in a Point of View* (Hamden, Conn., 1967).

31. Cited in Monique Mosser, "Paradox in the Garden: A Brief Account of *Fabriques,*" in Mosser and Teyssot, eds., op. cit., 266–67.

32. Ibid.

33. For the "Stein" at Wörlitz, see Christopher Thacker, "The Volcano: Culmination of the Landscape Garden," in Robert P. Maccubbin and Peter Martin, eds., *British and American Gardens in the Eighteenth Century* (Williamsburg, 1984), 74–82.

34. See Barbara Jones, *Follies and Grottoes* (London, 1989), 101–6.

35. See the catalogue note by Gervase Jackson-Stops, *An English Arcadia: Designs for Gardens and Garden Buildings in the Care of the National Trust, 1600–1990* (London, 1992), 94.

36. See Mosser, op. cit., 269–70.

37. See Dora Wiebenson, *The Picturesque Garden in France* (Princeton, 1978).

38. See Malcolm Andrews, "The Sublime as Paradigm: Hafod and Hawkstone," in Mosser and Teyssot, eds., op. cit., 323–26.

39. Ibid., 325; see also A. Oswald, "Beauties and Wonders of Hawkstone," *Country Life*, July 3, 1958, p. 18; see also Jones, op. cit., 78–85; T. Rodenhurst, *A Description of Hawkstone, the Seat of Sir Richard Hill, Bart.* (London, 1784).

40. See Antoinette Le Normand Romain, "The 'Ideas' of René de Girardin at Ermenonville," in Mosser and Teyssot, eds., op. cit., 336–39.

41. Louis Ferdinand Alfred Maury, *Les Forêts de la France dans l'antiquité et au Moyen Age* (Paris: Académie des Inscriptions et Belles-Lettres, 1843), 13.

42. These extracts are taken from Auguste Luchet, ed., *Fontainebleau: Paysages, légendes, fantômes; Hommage à Denecourt* (Paris, 1855), 5 and 346.

43. See Nicholas Green, *The Spectacle of Nature: Landscape and Bourgeois Culture in Nineteenth-Century France* (Manchester, 1990), 84–120.

44. For Senancour, see the hagiography by Jules Levallois, *Un Précurseur, Senancour* (Paris, 1897), and the better, critical study of the works by Marcel Raymond, *Senancour: Sensations et révélations* (Paris, 1965).

45. Senancour, *Oberman* (Brussels, 1837), 1:87–88.

46. In the version of this encounter that prefaced Senancour's *Libres méditations* (Paris, 1819) he records the actual fate of the old man, desperately sick, taken from his forest cell by friends, and dying before he could be brought safely to the town.

47. Ibid., 94.

48. Some accounts of the story maintained that what the Grand Veneur said was "Entendez-vous [Do you hear/understand me]," but the sense of admonishment was the same.

49. Emile Bilier de la Chavignerie, *Recherches historiques, biographiques et littéraires sur le peintre Lantara* (Paris, 1852).

50. This, in 1645; see Paul Domet, *Histoire de la forêt de Fontainebleau* (Paris, 1873), 86.

51. Ibid., 244ff.

52. On Durand, see Green, op. cit., 162ff.

53. See in particular the passage in *Oberman*, p. 92, where Senancour specifically rejects orientation: "I try to retain no information whatsoever; *not* to know the forest, so as always to have something else to discover."

54. For a list of the earliest denizens of Barbizon, see Félix Herbet, *Dictionnaire historique et artistique de la forêt de Fontainebleau* (Fontainebleau, 1903), 19–22.

55. Cited in Green, op. cit., 3.

56. Théodore de Banville, in Luchet, ed., op. cit.

57. Charles Vincent, "Le Chasseur des vipères," in Luchet, ed., op. cit., 232–42.

58. For the building of the Reptile House and its successor in the 1880s, see Peter Guillery, *The Buildings of London Zoo* (London, 1993), 5–9; for the reptiles and their perils, see Wilfrid Blunt, *The Ark in the Park: The Zoo in the Nineteenth Century* (London, 1976), 220–31.

59. See Blunt, op. cit., 224–25.

60. Ibid., 226.

61. Ibid., 38.

62. For Hagenbeck, see Nigel Rothfels, "Bring 'Em Back Alive: Carl Hagenbeck and the Exotic Animal and People Trade in Germany, 1848–1914" (Ph.D. diss., Harvard University, 1994).

63. Cited in Georg Kohlmaier and Barna von Sartory, *Houses of Glass: A Nineteenth-Century Building Type* (Cambridge, Mass., 1986), 27–28. This is a rich account of the implications of iron and glass technology for the realization of ancient dreams of verdant utopias. See also May Woods and Arete Warren, *Glass Houses: A History of Greenhouses, Orangeries and Conservatories* (London, 1990), 112–36.

64. Ibid., 124–25.

65. Ibid., 31.

66. See Jack Kramer, *The World Wildlife Fund Book of Orchids* (New York, 1989).

67. Kohlmaier and von Sartory, op. cit., 34.

68. See Frederick Law Olmsted, Jr., and Theodora Kimball, eds., *Forty Years of Landscape Architecture: Central Park* (Cambridge, Mass., 1973), 27.

69. Ibid.

70. See Hazel Conway, *People's Parks: The Design and Development of Victorian Parks in Britain* (Cambridge, 1991), 89–90. The debate between advocates of a more "urban" designed place of entertainment and supporters of the "naturalist," "Greensward" approach is vividly discussed in the superb history by Roy Rosenzweig and Elizabeth Blackmar, *The Park and the People* (New York, 1993), esp. 95–150.

71. Olmsted and Kimball, eds., op. cit., 46.

72. Henry David Thoreau, *Walden* (Princeton, 1973), 210.

73. Ibid., 220.

74. Ibid., 219.

75. Henry David Thoreau, *The Maine Woods,* introduction by Edward Hoagland (New York, 1988), 94.

76. Thoreau, "Walking," 96 and 106.

77. Cited in Walter L. Creese, *The Crowning of the American Landscape* (Princeton, 1985), 102.

78. Ibid., 126.

79. On the social and imperial implications of cricket, nothing has ever improved on C. L. R. James's wonderful *Beyond a Boundary* (London, 1963).

80. On the empire of the lawn, see Kenneth T. Jackson, *Crabgrass Frontier: The Suburbanization of the United States* (New York and Oxford, 1985).

81. F. J. Scott, *The Art of Beautifying Suburban Home Grounds* (New York, 1870), 61.

82. Ibid., 29.

83. Thoreau, "Walking," 119–20.

84. Ibid., 116.

85. Ibid., 93–94.

86. Thoreau, *The Maine Woods,* 85.

87. Ibid., 109.

88. Thoreau, "Walking," 105.

89. Edward Hoagland, introduction to *The Maine Woods,* xxv.

90. Henry David Thoreau, *Journal,* ed. John C. Broderick (Princeton, 1981), vol. 1, *1837–1844,* pp. 118–19.

91. Ibid., 37 (May 27, 1841).

92. Robert L. Rothwell, ed., *Henry David Thoreau: An American Landscape* (New York, 1991), 126–27.

A BIBLIOGRAPHIC GUIDE

(For primary sources, see the notes and references in individual chapters.)

One Landscape history, methods and approaches

All paths to landscape history must lead through two enduringly important and powerful works, very different in their scope and goals but alike in their intense sensitivity to the relationship between civilization and nature: Clarence J. Glacken, *Traces on the Rhodian Shore: Nature and Culture in Western Thought from Ancient Times to the End of the Eighteenth Century* (Berkeley and Los Angeles, 1967), and Raymond Williams, *The Country and the City* (London, 1973). Of great significance to this perennial debate is Keith Thomas, *Man and the Natural World: Changing Attitudes in England, 1500–1800* (London, 1983). My own approach to the subject has been shaped, though not, I hope, determined, by two important French texts—Gaston Bachelard, *La Poétique de l'espace* (Paris, 1957), and the classic work of Maurice Halbwachs, *La Mémoire collective* (Paris, 1968)—and encouraged by the convergence of history, geography, and iconology embodied in the remarkable series of volumes edited by Pierre Nora, *Les Lieux de mémoire* (Paris, 1985–1992). An important collection of essays on changing cultural definitions of landscape (including a major contribution by John Dixon Hunt on the distinctions between European and American landscape norms) is offered in a special number of *Le Débat* 65 (May–August 1991): 3–128. A similar discussion (including articles by John Dixon Hunt, Robert Rosenblum, and J. B. Jackson) is collected in Stuart Wrede and William Howard Adams, eds., *Denatured Visions: Landscape and Culture in the Twentieth Century* (New York, 1988).

The interpretation of landscape was revolutionized by the work of John Brinckerhoff Jackson. See in particular his *Landscapes: A Choice of Texts,* ed. E. H. Zube (Amherst, 1970), and *Discovering the Vernacular Landscape* (New Haven, 1984). Jackson's former pupil John R. Stilgoe has become an extraordinary interpreter of landscape in his own right. See, for example, *Common Landscape of America, 1580–1845* (New Haven, 1982) and *Borderland: Origin of the American Suburb, 1820–1939* (New Haven and London, 1988). There is an excellent account of the importance of Jackson's work by D. Meinig in idem, ed., *The Interpretation*

of Ordinary Landscapes (Oxford and New York, 1979); see also his essay "The Beholding Eye" in the same volume. The other patriarch of landscape history and interpretation is Yi-Fu Tuan, to whose elegant synthesis of psychology and natural and architectural history I owe a great deal. See in particular his *Space and Place: The Perspective of Experience* (Minneapolis, 1977) and *Landscapes of Fear* (New York, 1979). The indissoluble connection between the lay of the land and the hand of man is the fundamental motif of much of the work of Vincent Scully, in particular his *Architecture: The Natural and the Man-made* (New York, 1991). Tony Hiss, *The Experience of Place* (New York, 1990), also while primarily concerned with the contemporary American landscape, has valuable insights into the relationship between social habit and natural habitat.

That cultural geography is once again thriving in Britain as a field of inquiry owes a great deal to two scholars in particular (who, however, have quite distinct and even opposite methodologies): Jay Appleton and Denis Cosgrove. See Appleton, *The Experience of Landscape* (London and New York, 1975), *The Poetry of Habitat* (Hull, 1978), and *The Symbolism of Habitat: An Interpretation of Landscape and the Arts* (Seattle and London, 1990). See Cosgrove, *Social Formation and Symbolic Landscape* (London and Sydney, 1984). See also the exceptionally interesting volume of essays edited by Cosgrove and Stephen Daniels, *The Iconography of Landscape: Essays on the Symbolic Representation, Design and Use of Past Environments* (Cambridge, 1988); and Stephen Daniels, *Fields of Vision: Landscape Imagery and National Identity in England and the United States* (Princeton, 1993). Scholars whose work has recently enriched landscape history through the insights of literary and critical studies include Simon Pugh, *Garden, Nature, Language* (Manchester, 1988) and *Reading Landscape: Country, City, Capital* (Manchester, 1990); and Stephen Bann, whose articles on landscape form and meaning have appeared in the *Journal of Garden History* 1, no. 2, and in Monique Mosser and Georges Teyssot, eds., *The Architecture of Western Gardens* (Cambridge, Mass., 1991), 522–24. The peculiar importance of landscape for twentieth-century German politics and culture is perceptively discussed in a series of articles by Joachim Wolschke-Bulmahn (for specific references, see the notes to chapter 2).

Though my concerns in this book go beyond two-dimensional representations of landscape, it goes without saying that the approach offered here has been fundamentally guided by the long and rich tradition of art historical literature on the concept and practice of landscape art. Works on individual artists are listed in the appropriate notes, but works that have been particularly important include E. H. Gombrich's classic essay "The Renaissance Theory of Art and the Rise of Landscape," in *Norm and Form: Studies in the Art of the Renaissance* (London, 1966), 107–21. Gombrich's argument, as well as that of Kenneth Clark, *Landscape into Art* (London, 1949), on the evolution of landscape is challenged by W. J. T. Mitchell ed., *Landscape and Power* (Chicago, 1994). For important examples of a more self-consciously historically grounded approach to the subject, see the essays of Ann Jensen Adams on Dutch landscapes, Ann Bermingham on eighteenth-century English landscape drawings, and Elizabeth Helsinger on Turner and "the representation of England" in the same volume. The most innovative study of all recent interpretations of English landscape painting is John Barrell, *The Dark Side of the Landscape* (Cambridge, 1980); and see also Ann Bermingham, *Landscape and Ideology: The English Rustic Tradition, 1740–1860* (Berkeley, 1986).

American art history is especially rich in thoughtful discussions of the evolving forms and objects of landscape painting and I am especially indebted to the brilliant work of Barbara Novak, *Nature and Culture: American Landscape and Painting, 1825–1875* (New York, 1980). Angela Miller's *Empire of the Eye: Landscape, Representation and American Cultural Politics, 1825–1875* (Ithaca, 1993) is an important recent addition to this literature, and major discussions of American landscape can be found in Franklin Kelly, *Frederic Edwin Church and the National Landscape* (Washington, D.C., 1988), and the essays in three exhibition catalogues: *American Paradise: The World of the Hudson River School;* John Wilmerding et al., *American Light: The Luminist Movement, 1850–1875* (Princeton and Washington D.C., 1989); and William H. Truettner et al., *The West as America: Reinterpreting Images of the Frontier* (Wash-

ington, D.C., 1991). See also Mick Gidley and Robert Lawson-Peebles, eds., *Views of American Landscapes* (Cambridge, 1989). John F. Sears, *Sacred Places: American Tourist Attractions in the Nineteenth Century* (Oxford, 1989) is a vivid and engaging study of the religiosity of American landscape. Many of these works themselves owe a debt to Leo Marx's classic study, *The Machine in the Garden: Technology and the Pastoral Ideal in America* (Oxford, 1964).

The literature on the history and prospects of the environmental movement is, of course, abundant and growing. For works of particular interest to the argument made here, see the notes to the Introduction.

Two The history and culture of the forest

Robert Pogue Harrison, *Forests: The Shadow of Civilization* (Chicago, 1992) is a landmark in the cultural interpretation of the forest. While it appeared as I was completing my own work on forest mythologies, my own understanding of the topic has been enriched by Harrison's brilliant discussion of Vico's historical mythology and Dante's treatment of the sylvan motif. The anthropological fascination with woodland imagery inherited from Vico produced two classic texts of nineteenth-century ethnography: Wilhelm Mannhardt's *Wald- und Feldkulte*, 2 vols. (Berlin, 1875–1877), and Sir James George Frazer's *The Golden Bough: A Study in Comparative Religion* (London, 1890).

For the cultural history of the German forest, see the essays in Bernd Weyergraf et al., *Waldungen: Die Deutschen und ihr Wald* (Berlin, 1987), and Josef Nikolaus Forster, *Wald, Mensch, Kultur* (Berlin and London, 1967). Two extraordinary works of art history are of paramount importance in understanding the resonance of forest imagery in German culture: Christopher S. Wood, *Albrecht Altdorfer and the Origins of Landscape* (Chicago, 1993), and Joseph Leo Koerner, *Caspar David Friedrich and the Subject of Landscape* (London, 1990). Also important in the discussion of Friedrich's forest iconography, sacred and patriotic, is H. Borsch-Supan, "L'Arbre aux corbeaux de Caspar David Friedrich," *Revue du Louvre* 26, no. 4 (1976): 275–90; and C. J. Bailey, "Religious Symbolism in Caspar David Friedrich," in *Bulletin of the John Rylands Library* 71, no. 3 (1989): 5–20; and idem (with John Leighton), *Caspar David Friedrich: Winter Landscape* (London, 1990). On the history of the wild man, see Richard Bernheimer, *Wild Men in the Middle Ages: A Study in Art, Sentiment and Demonology* (Cambridge, Mass., 1952); Timothy Husband (with the assistance of Gloria Gilmore-House), *The Wild Man: Medieval Myth and Symbolism* (New York, 1980); and Larry Silver, "Forest Primeval: Albrecht Altdorfer and the German Wilderness Landscape," *Simiolus* 13, no. 1 (1983): 4–43. On German topographical writing, see Gerald Strauss, *Sixteenth-Century Germany, Its Topography and Topographers* (Madison, Wis., 1959); and for an understanding of the continuing traditions of sacred arborealism in Germany, see Michael Baxandall, *The Limewood Sculptors of Renaissance Germany* (New Haven, 1980); and Karl Oettinger, "Laube, Garten und Wald: Zu einer Theorie der süddeutschen Sakralkunst, 1470–1520," in idem, ed., *Festschrift für Hans Sedlmayr* (Munich, 1962), 201–28. On verdant crosses see Stephen J. Reno, "The Sacred Tree as an Early Christian Literary Symbol: A Phenomenological Study," in *Forschungen zur Anthropologie und Religionsgeschichte*, vol. 4 (Saarbrücken, 1978); and Rab Hatfield, "The Tree of Life and the Holy Cross: Franciscan Spirituality in the Trecento and the Quattrocento," in Timothy Verdon and John Henderson, eds., *Christianity and the Renaissance: Image and Religious Imagination in the Quattrocento* (Syracuse, 1990).

For the sustained fascination in Western culture with the "arboreal" origins of the Gothic, see in particular the brilliant study by Joseph Rykwert, *On Adam's House in Paradise: The Idea of the Primitive Hut in Architectural History* (Cambridge, Mass., 1981); and Jurgen Baltrusaitis, *Aberrations: Légendes des formes* (Paris, 1983), 90–113. See also Paul Frankl, *The Gothic: Literary Sources and Interpretations through Eight Centuries* (Princeton, 1960).

There is an exceptionally rich and important collection of essays on the sacred iconography of the forest in *L'ambiente vegetale nell'alto medioevo* (Spoleto: Centro italiano di studi

sull'alto medioevo, 1990). For other important contributions to the medieval history of the forest, see Charles Higounet, "Les Forêts de l'Europe occidentale du Ve au XIe siècle," in *Agricultura e mondo rurale in occidente nell'alto medioevo* (Spoleto: Centro italiano di studi sull'alto medioevo, 1966), 343–97; and Chris Wickham, "European Forests in the Early Middle Ages: Landscape and Land Clearance," in *L'ambiente vegetale* (as above), 479–548. For an excellent general account of medieval forest culture (principally French), see Roland Bechmann, *Trees and Man: The Forest in the Middle Ages,* trans. Katharyn Dunham (New York, 1990). John Perlin, *A Forest Journey: The Role of Wood in the Development of Civilization* (New York, 1989) is an excellent historical narrative on the material history of Western forests from antiquity to the nineteenth century.

For more specialized histories of the forest, see, on England: N. D. G. James, *A History of English Forestry* (Oxford, 1981); Oliver Rackham, *Trees and Woodlands in the British Landscape* (London, 1990); and Charles Young, *The Royal Forests of Medieval England* (Philadelphia, 1979). The great oak panic of the eighteenth century is still best treated in Robert Greenhalgh Albion, *Forests and Sea Power: The Timber Problem of the Royal Navy, 1652–1852* (Cambridge, Mass., 1926). See also Stephen Daniels, "The Political Iconography of the Woodland in Later Georgian England," in Cosgrove and Daniels, *The Iconography of Landscape,* 43–81.

On France: the field is dominated by two monumental studies by Andrée Corvol, *L'Homme et l'arbre sous l'Ancien Régime* (Paris, 1984) and *L'Homme aux bois: Histoire des relations de l'homme et de la forêt, XIIe XXe siècles* (Paris, 1987). See also the useful study by Louis Badré, *Histoire de la forêt française* (Paris, 1983) and *Les Eaux et les forêts du 12e au 20e siècle* (Paris, 1987). For the Colbert regime, see John Croumbie Brown, *The French Forest Ordinance of 1669* (Edinburgh, 1883). The French side of the oak panic is covered in Paul Walden Bamford, *Forests and French Sea Power, 1660–1789* (Toronto, 1956). For the revolutionary history of the French forests, see Denis Woronoff, ed., *Révolution et espaces forestiers* (Paris, 1988); and on the relationship between the Barbizon artists and the forest of Fontainebleau, see the excellent study by Nicholas Green, *The Spectacle of Nature: Landscape and Bourgeois Culture in Nineteenth-Century France* (Manchester, 1990). The *Groupe d'Histoire des Forêts Françaises* (45 rue d'Ulm, 75005 Paris) regularly publishes important research results on the history of the French forest.

For the material and cultural history of the American forests, see the encyclopedic work by Michael Williams, *Americans and Their Forests: A Historical Geography* (Cambridge, 1989). Many of the works that have dealt with the wilderness passion in American life also, of course, discuss the cultural issues involved in America's long, ambivalent relationship with its forests. See in particular Roderick Nash, *Wilderness and the American Mind* (New Haven, 1967). *Forest and Conservation History,* the excellent journal of the Forest History Society of the United States, is a wonderful source of scholarly and research data on one of the liveliest and most fascinating of all fields of environmental history.

Three Rivers and hydraulic history

The two most imaginative works on fluvial culture also represent opposite poles of methodology: the numinous essay of Gaston Bachelard, *L'Eau et les rêves: Essai sur l'imagination de la matière* (Paris, 1942), and Karl Wittfogel's ambitious typology of the hydraulic cultures of antiquity, *Oriental Despotism* (New Haven, 1957). Of fundamental importance in understanding the perennial debate in Western culture on the origin of rivers is Yi-Fu Tuan, *The Hydrological Cycle and the Wisdom of God* (Toronto, 1968). Denis Cosgrove and Geoff Petts, eds., *Water, Engineering and Landscape* is an important recent collection of essays on the history and cultural geography of water, including a brilliant essay by Cosgrove, "Platonism and Practicality: Hydrology, Engineering and Landscape in Sixteenth-Century Venice," 35–53. A work that transcends in significance its immediate topic of the Renaissance river poem and to which I am much indebted is Wyman H. Herendeen, *From Landscape to Literature: The River and the Myth of Geography* (Pittsburgh, 1986).

On ancient Egyptian hydraulics, see Karl Butzer, *Early Hydraulic Civilization in Egypt* (Chicago, 1976); and Vivian A. Hibbs, *The Mendes Maze: A Libation Table for the Inundation of the Nile (I–III A.D.)* (New York and London, 1985). E. A. Wallis Budge, *Osiris and the Egyptian Resurrection*, 2 vols. (London and New York, 1912), and *From Fetish to God in Ancient Egypt* (London, 1934), though much criticized, still remain fundamental for any understanding of the relationship between cults of sacrifice, immortality, and the topography of the Nile. For a critical view of Plutarch's version of the Isis and Osiris myth, see John Gwynn Griffiths, *Plutarch's De Iside et Osiride* (Cardiff, Wales, 1970). For related versions of inundation myths, see the collection of essays edited by Alan Dundes, *The Flood Myth* (Berkeley and Los Angeles, 1988). For the transmission of Egyptian culture through the centuries, see J. R. Harris, ed., *The Legacy of Egypt* (Oxford, 1971); Erik Iversen, *The Myth of Egypt and Its Hieroglyphs in European Tradition* (Copenhagen, 1961); and idem, *Obelisks in Exile*, vol. 1, *The Obelisks of Rome* (Copenhagen, 1968). The spectacular exhibition catalogue *Egyptomania: L'Egypte dans l'art occidental, 1770–1930* unfortunately appeared too late for me to take advantage of its wealth of insights but is essential reading on this topic. On the fateful journey of the barge *Cleopatra*, see R. A. Hayward, *Cleopatra's Needles* (London, 1978).

For Renaissance hydraulics, fountains, and grottoes, see M. Fagiolo, "Il significato dell'acqua e la dialettica del giardino," in Fagiolo, ed., *Natura e artificio* (Rome, 1981), 144–53 and 176–89; Claudia Lazzaro-Bruno, "The Villa Lante at Bagnaia: An Allegory of Art and Nature," *Art Bulletin* 4, no. 59 (1977): 553–60; David Coffin, *The Villa in the Life of Renaissance Rome* (Princeton, 1979); Elisabeth B. MacDougall and Naomi Miller, *Fons Sapientiae: Garden Fountains in Illustrated Books, from the Sixteenth to the Eighteenth Centuries* (Washington, D.C., and Dumbarton Oaks, 1977); and essays by Terry Comito, Lionello Puppi, Bruno Adorni, and Anne-Marie Lecoq in Monique Mosser and Georges Teyssot, eds., *The Architecture of Western Gardens*. There is an intense debate over the identity and career of the author of the *Hypnerotomachia Poliphili*. I have followed, I hope, with a critical eye, the historical reconstruction of Emanuela Kretzulesco-Quaranta, *Les Jardins du songe: Poliphile et la mystique de la Renaissance* (Paris, 1986), and Maurizio Calvesi, *Il Sogno di Polifilo Prenestino* (Rome, 1983), though I certainly don't subscribe to the notion that Francesco Colonna was, in fact, Leon Battista Alberti. The only full length study on the prodigious Salomon Caus is by C. S. Maks, *Salomon de Caus* (Paris, 1935), but the career of the Caus family is discussed in detail in Roy Strong, *The Renaissance Garden in England* (London, 1979).

The literature on Bernini and his fountains is copious. For the specific history of the Fountain of the Four Rivers, see the notes to chapter 5.

On the importance of the river as a vehicle of political and national identity, see Herendeen (above) and James Turner, *The Politics of Landscape* (Oxford, 1979). On the French tradition, see Philippe Barrier, *La Mémoire des fleuves de France* (Paris, 1989); and for the extraordinary river-road of the Bourbon king of Naples, see George L. Hersey, *Architecture, Poetry, and Number in the Royal Palace at Caserta* (Cambridge, Mass., 1983), a work that also includes one of the most interesting discussions of the "New Science" of Giambattista Vico. One of the most remarkable works ever written about the importance of the Rhine for German nationalism was by Alexandre Dumas, *Excursions sur les bords du Rhin*, introduction by Dominique Fernandez (Paris, 1991). From the abundant literature on Turner's river pieces, see in particular David Hill, *Turner on the Thames: River Journeys in the Year 1805* (New Haven and London, 1993); Stephen Daniels, "J. M. W. Turner and the Circulation of State," in *Fields of Vision*, 112–45; Eric Shanes, *Turner's Human Landscapes* (London, 1989); and John Gage, *J. M. W. Turner: "A Wonderful Range of Mind"* (New Haven, 1987). The literature on Eakins is also substantial. The most acute commentary on his painting of Rush carving the allegorical figure of the Schuylkill is Elizabeth Johns, *Thomas Eakins: The Heroism of Modern Life* (Princeton, 1983), 82–114. And I am as always in debt to the brilliant insights of Michael Fried, in this case in his *Courbet's Realism* (Chicago, 1990), as well as to essays by Linda Nochlin and others in the exhibition catalogue *Courbet Reconsidered* (Brooklyn, 1988).

Four Mountains

The most powerful and profound cultural history of mountain sensibility and representations is Jacek Wozniakowski, *Die Wildnis: Zur Deutungsgeschichte des Berges in der europäischen Neuzeit* (Frankfurt am Main, 1987). It shares the eminence with another work of enduring brilliance and sophistication: Marjorie Hope Nicolson, *Mountain Gloom, Mountain Glory* (Ithaca, 1959). Recently there has been a revived interest in art historical scholarship in the issues of altitude and omniscience. See, for example, Walter Gibson, *Mirror of the Earth: The World Landscape in Sixteenth-Century Flemish Painting* (Princeton, 1989), and the enormously stimulating work by Albert Boime, *The Magisterial Gaze: Manifest Destiny and American Landscape Painting, c. 1830–1865* (Washington, D.C., 1991). An important essay on American views of mountains, including the anthropomorphic "Stone Face" of New Hampshire, has been written by Gray Sweeney, "The Nude of Landscape Painting: Emblematic Personification in the Art of the Hudson River School," *Smithsonian Studies in American Art* (Fall 1989): 43–65. See also the typically suggestive essay by Yi-Fu Tuan, "Mountains, Ruins and the Sentiments of Melancholy," *Landscape* (Autumn 1964): 27–30. At the other extreme of mountainous comprehensiveness is the encyclopedic John Grand-Carteret, *La Montagne à travers les âges* (Grenoble-Moutiers, 1900–1904). On the iconography of mountains, see Ulrich Christoffel, *La Montagne dans la peinture* (Geneva, 1963), and Alfred Steinitzer, *Der Alpinismus in Bildern* (Munich, 1924). For the oriental tradition, see Kyohiko Munikata, *Sacred Mountains in Early Chinese Art* (Illinois, 1991); and for a different perspective on the relationship between Western and Eastern representations of mountain scenery, see James Cahill, *The Compelling Image: Nature and Style in Seventeenth-Century Chinese Painting* (Cambridge, Mass., 1982), esp. 1–69.

There is a substantial literature on Mount Rushmore, but the extraordinary subject and the career of its amazing sculptor have not at all been exhausted. Albert Boime has done much to rekindle critical interest in the monument in, for example, "Patriarchy Fixed in Stone: Gutzon Borglum's Mount Rushmore," *American Art* (Winter–Spring 1991); and two studies of Borglum are important: Rex Alan Smith, *The Carving of Mount Rushmore* (New York, 1985), and Howard and Audrey Karl Shaff, *Six Wars at a Time: The Life and Times of Gutzon Borglum, Sculptor of Mount Rushmore* (Sioux Falls, S. Dak., 1985). The essential sources for a full history of the project and its creator are the Borglum Papers in the Library of Congress, Manuscript Division, and for his correspondence with Rose Arnold Powell, the Schlesinger Library, Harvard University. On the "Dinocratic tradition," see Werner Oechslin, "Dinokrates—Legende und Mythos megalomaner Architektusstiftung," *Daidalos* 4 (July 1982): 7–26. For Michelangelo's fantasy and Pietro da Cortona's, see, respectively, Ascanio Condivi, *The Life of Michelangelo,* trans. Alice Sedgwick (Baton Rouge, 1976); and Richard Krautheimer, *The Rome of Alexander VII: 1655–1667* (Princeton, 1985), 10–11. There is an interesting discussion of Leonardo's mountain drawings in A. Richard Turner, *Inventing Leonardo* (New York, 1993). Sacred mountains are discussed in two important articles, George Kubler, "Sacred Mountains in Europe and America," in Verdon and Henderson, eds., *Christianity and the Renaissance,* 413–41; and William Hood, "The *Sacro Monte* of Varallo: Renaissance Art and Popular Culture," in T. Verdon, ed., *Monasticism and the Arts* (Syracuse, 1990). On the Monte Verna prints, see Lucilla Conigliello, ed., *Jacopo Ligozzi: Le vedute del Sacro Monte della Verna, i dipinti di Poppi e Bibbiena* (Poppi, 1992), 47–56. For Renaissance accounts of climbs, see G. R. de Beer, *Early Travellers in the Alps* (London, 1930), and Francis Gribble, *The Early Mountaineers* (London, 1899).

On the taste for Salvator Rosa, the important study is still Elizabeth W. Manwaring, *Italian Landscape in Eighteenth-Century England* (New York, 1925), though a full study of the English prints after Rosa is desperately needed. Salvator's letters on savage beauty may be found in *Lettere inedite di Salvator Rosa a G. B. Ricciardi* (Rome, 1939), ed. Aldo de Rinaldis; and there is a helpful introduction by Michael Kitson to the 1973 exhibition "Salvator Rosa" at the Hayward Gallery, London. For the authentically pre-Romantic connec-

tions between Salvator's sense of artistic isolation and his scenery of isolation, see Francis Haskell, *Patrons and Painters: A Study in the Relations Between Italian Art and Society in the Age of the Baroque* (New Haven and London, 1980).

The budding enthusiasm for mountain scenery in eighteenth-century Britain is superbly analyzed by Malcolm Andrews, *The Search for the Picturesque Landscape: Aesthetics and Tourism in Britain, 1760–1800* (Stanford, 1989); and the change in perceptions of Scottish scenery from revulsion to adoration is neatly charted in James Holloway and Lindsay Errington, *The Discovery of Scotland* (Edinburgh, 1978). The most detailed account of sublime aesthetics is Walter J. Hipple, Jr., *The Beautiful, the Sublime and the Picturesque in Eighteenth-Century British Aesthetic Theory* (Carbondale, Ill., 1957). On the growing French appreciation of mountain sublimity, see D. G. Charlton, *New Images of the Natural in France: A Study in European Cultural History, 1750–1800* (Cambridge, 1984); the classic study by Daniel Mornet, *Le Sentiment de la nature en France de J-J Rousseau à Bernardin de Saint-Pierre* (Paris, 1907); and Numa Broc, *Les Montagnes vues par les geographes et les naturalistes de langue française au XVIIe siècle* (Paris, 1969).

Arguably, no demonstrably great English artist has been more neglected than John Robert Cozens, perhaps a consequence of the fact that his most powerful works were executed in what is still thought of as the weak genre of watercolor. The best monograph on his work and that of his father is Kim Sloan, *Alexander and John Robert Cozens: The Poetry of Landscape* (New Haven and London, 1986). There is also an exhibition catalogue with an introduction by Andrew Wilton, *The Art of Alexander and John Robert Cozens* (New Haven, 1981); and interesting anecdotal evidence of the sketchily documented life appears in A. P. Oppé, *Alexander and John Robert Cozens* (Cambridge, Mass., 1954).

There is an expanding and abundant literature on eighteenth- and nineteenth-century Alpinism, much of it written by the climbers themselves and to a surprising degree (to a non-mountaineering reader) colored with great poetic intensity. On some general themes coloring the taste for sublimity, see the stimulating essay by Chloë Chard, "Rising and Sinking on the Alps and Mount Etna: The Topography of the Sublime in Eighteenth-Century England," *Journal of Philosophy and the Visual Arts* 1, no 1 (1989): 61–69; and the exhibition catalogue *Découverte et sentiment de la montagne, 1740–1840* (Annecy, 1986). An exemplary work of the new Helvetomania is Jean-Benjamin de Laborde, *Tableaux topographiques . . . de la Suisse,* 2 vols. (Paris, 1780–1786). Saussure is most accessible in his *Journal d'un voyage à Chamouni à la cime du Mont Blanc* (1787; reprint, Lyon, 1926). I must thank Alix Cooper for allowing me to see her unpublished paper on Déodat de Dolomieu: "From the Alps to Egypt (and Back Again): Dolomieu, Scientific Voyaging and the Construction of the Field in Late Eighteenth-Century France."

For Ramond, see Cuthbert Girdlestone, *Louis François Ramond de Carbonnières, 1755–1820* (Paris, 1968), a detailed work that also offers rich samples of Ramond's own many writing styles, from the drily scientific to the ecstatically Romantic. The Romantic poets' engagement with Switzerland is treated in Claire Eliane Engel, *Byron et Shelley en Suisse et en Savoie* (Chambéry, 1930). Engel has also written many volumes on the Alpine aesthetic, in particular *La Littérature alpestre en France et en Angleterre au XVIII et au XIXe siècles* (Chambéry, 1930), necessarily omitting, however arguably, the greatest of all Romantic Alpine novels, Adalbert Stifter's *Bergkristall* (1852), but available in an excellent new edition (Frankfurt am Main, 1980). It should be read together with the extraordinary outpouring of the non-climbing Romantic historian Jules Michelet, *La Montagne* (Paris, 1868). For an example of Alpine tourist literature, see John Murray, *A Glance at Some of the Beauties and Sublimities of Switzerland* (London, 1829).

Claire Eliane Engel has also written an excellent *Histoire de l'alpinisme des origines à nos jours* (Paris, 1950). More recent accounts include Philippe Joutard, *L'Invention du Mont Blanc* (Paris, 1986), and Yves Ballu, *A la conquête du Mont-Blanc* (Paris, 1986). For Henriette d'Angeville, see Emile Gaillard, *Une Ascension romantique en 1838: Henriette d'Angeville au Mont Blanc* (Chambéry, 1947). There is also a recent translation of Henriette's account

of the climb, *My Ascent of Mont Blanc,* trans. Jennifer Barnes (London, 1992). There are many studies of Victorian climbing, for example, Ronald William Clark, *The Victorian Mountaineers* (London, 1953), but the literature is dominated by two immensely important works, the first popular, the second profound: Edward Whymper, *Scrambles amongst the Alps in the Years 1860–1869* (London and Edinburgh, 1871), and Leslie Stephen, *The Playground of Europe* (London, 1924). Surprisingly, there is as yet no major study of Albert Smith, one of the most extraordinary of all Victorians and who is best approached through his wonderful *Story of Mont Blanc* (London, 1853). Peter Hansen's outstandingly important work discusses the career of Smith in detail and is the best analysis of the social world of Victorian Alpinism, "British Mountaineering, 1850–1914" (Ph.D. diss., Harvard University, 1993).

The literature on Ruskin is, of course, as immense as his own output. Among the more recent studies of particular interest with respect to Ruskin's perception of mountains is Elizabeth K. Helsinger, *Ruskin and the Art of the Beholder* (Cambridge, Mass., 1982), and Robert Hewison, *John Ruskin: The Argument of the Eye* (Princeton, 1976). See also the excellent study by Paul H. Walton, *The Drawings of John Ruskin* (Oxford, 1972). For Viollet-le-Duc's Alpine cartography and geology as well as Ruskin's argument with him, see Pierre A. Frey, *E. Viollet-le-Duc et le massif du Mont Blanc, 1868–1879* (Lausanne, 1988); and Robin Middleton, "Viollet-le-Duc et les Alpes: La Dispute de Mont Blanc," in the exhibition catalogue *Viollet-le-Duc: Centenaire de sa mort à Lausanne* (Lausanne, 1979).

Five Arcadia

It would be redundant (and hopelessly invidious) to make a selection from the enormous literature on the pastoral tradition in poetry and the visual arts. I list here only those works I have found helpful in considering the shifting boundary between the wild and the ordered in arcadian landscapes, gardens, and parks.

For the original arcadian myths, see the brilliant work by Philippe Borgeaud, *The Cult of Pan in Ancient Greece,* trans. Kathleen Atlass and James Redfield (Chicago, 1988). A number of essays in Mosser and Teyssot, eds., *The Architecture of Western Gardens,* are expressly concerned with the paradox of designed wildness; see in particular Lionello Puppi, "Nature and Artifice in the Sixteenth-Century Garden," 47–58; Anne-Marie Lecoq, "The Garden of Wisdom of Bernard Palissy," 69–80; Luigi Zangheri, "The Gardens of Buontalenti," 96–99; Simon Pugh, "Received Ideas on Pastoral," 253–60; and the superb essay by Monique Mosser, "Paradox in the Garden: A Brief Account of *Fabriques,*" 263–80. The *sacro bosco* at Bomarzo has been exhaustively and ingeniously read by Margaretta Darnall and Mark S. Weil as a program representing Ariosto's *Orlando Furioso,* "Il sacro bosco di Bomarzo: Its Sixteenth-Century Literary and Antiquarian Context," *Journal of Garden History* 4, no. 1 (1984): 1–94; but this view has been challenged by J. B. Bury, "Bomarzo Revisited," *Journal of Garden History* 5, no. 2 (1985): 213–23. The botanical garden is the subject of the extraordinary book by John Prest, *The Garden of Eden: The Botanic Garden and the Re-Creation of Paradise* (New Haven and London, 1981).

On pastoral painting and the arcadian tradition, see David Rosand, "Giorgione, Venice and the Pastoral Vision," in Robert C. Cafritz, ed., *Places of Delight: The Pastoral Landscape* (Washington, D.C., 1988), 21–83. On Sannazaro, see William J. Kennedy, *Jacopo Sannazaro and the Uses of Pastoral* (Hanover, N.H., and London, 1983). On Poussin's arcadian paintings, see Erwin Panofsky, "Et in Arcadia Ego: Poussin and the Elegiac Tradition," in *Meaning in the Visual Arts* (New York, 1955), 295–320.

The great authority on eighteenth-century gardens and their relationship to literary sources and conventions is the prolific John Dixon Hunt. See in particular *The Figure in the Landscape: Poetry, Painting and Gardens during the Eighteenth Century* (Baltimore and London, 1989). On Anglo-Chinese taste and other eighteenth-century fantastic designs, see Baltrusaitis, *Aberrations,* 97–126; Eleanor von Erdberg, *Chinese Influence on European Structures* (New York, 1985); Barbara Jones, *Follies and Grottoes* (London, 1953). The only attention

that has been paid to Denecourt has been by Nicholas Green, *The Spectacle of Nature*. The anthology of essays for and about him is Auguste Luchet, ed., *Fontainebleau: Paysages, légendes, fantômes; Hommage à Denecourt* (Paris, 1855). See also Paul Domet, *Histoire de la forêt de Fontainebleau* (Paris, 1873).

On greenhouses and winter gardens, see May Woods and Arete Warren, *Glass Houses: A History of Greenhouses, Orangeries and Conservatories* (London, 1990), and the superb exhibition catalogue edited by Georg Kohlmaier and Barna von Sartory, *Houses of Glass: A Nineteenth-Century Building Type* (Cambridge, Mass., 1986). On the ironies and ecstasies of "wild" and "tame" gardening in the contemporary world, there is nothing better than Michael Pollan's wonderful book *Second Nature: A Gardener's Education* (New York, 1991). On the history of the lawn, see Kenneth T. Jackson, *Crabgrass Frontier: The Suburbanization of the United States* (New York and Oxford, 1985); and F. Herbert Bormann, Diana Balmori, and Gordon T. Geballe, *Redesigning the American Lawn* (New Haven and London, 1993).

Six Myths and memories

In the vast literature on nature myths and their persistence, the following were especially helpful in clarifying the principal themes of this book:

Walter Burkert, *Ancient Mystery Cults* (Cambridge, Mass., 1987); E. H. Gombrich, "Icones Symbolicae," in *Symbolic Images* (London and New York, 1972), 123–95; Sir James George Frazer, *The Worship of Nature* (London, 1926); Arthur O. Lovejoy and George Boas, *Essays on Primitivism and Related Ideas in the Middle Ages* (Baltimore and London, 1930); Mircea Eliade, "Mythologies of Memory and Forgetting," in *Myth and Reality* (New York, 1963), 114–38; idem, *Myths, Dreams and Mysteries* (New York, 1960); Elaine Pagels, *Adam, Eve and the Serpent* (London, 1988); and George L. Hersey, *The Lost Meaning of Classical Architecture* (Cambridge, Mass., 1988). Of all presently practicing historians, Carlo Ginzburg has written most imaginatively, courageously, and rigorously on the opportunities and perils of tracking the evidence of social memory, and on the intellectual history of that methodology. See in particular "Clues: Roots of an Evidential Paradigm," in Ginzburg, *Clues, Myths, and the Historical Method*, trans. John and Anne Tedeschi (Baltimore and London, 1989), 96–125; also in the same volume, "From Aby Warburg to E. H. Gombrich: A Problem of Method," 17–59. On Warburg, see also E. H. Gombrich, *Aby Warburg: An Intellectual Biography* (Chicago, 1970). For Warburg's career and personality, see the introduction by Gertrud Bing to Warburg, *Gesammelte Schriften*, 2 vols. (Leipzig and Berlin, 1932), and revised in the *Journal of the Warburg and Courtauld Institutes* 28 (1965): 299–313; Carl Georg Heise, *Persönliche Erinnerungen an Aby Warburg* (New York, 1947). There is a good deal of new and candid information about Warburg's breakdown in Ron Chernow, *The Warburgs* (New York, 1993); an interesting discussion in Peter Burke, "Aby Warburg as Historical Anthropologist" in Horst Bredekamp et al., *Aby Warburg, Akten des Internationalen Symposions Hamburg 1990* (Hamburg, 1991), 39–44; and a characteristically acute and humane sketch by Felix Gilbert, "From Art History to the History of Civilization: Aby Warburg," in *History: Choice and Commitment* (Cambridge, Mass., 1977), 423–40.

ACKNOWLEDGEMENTS

Landscape and Memory is an expanded version of lectures delivered, in one form, as the Christian Gauss Seminars on Criticism at Princeton University in the spring of 1991, and in another form as the George Macaulay Trevelyan Lectures at Cambridge University in the winter of 1993—on the latter occasion, a text colored by Trevelyan's own deep belief in the communion between landscape and history. I must thank my host at Princeton, Professor Victor Brombert, and at Cambridge, Professor Patrick Collinson and the Faculty of History, for making those occasions so rewarding. Versions of some chapters have also been delivered as lectures and seminars at the New School, Boston University, Pennsylvania State University, and the Ecole des Hautes Etudes en Sciences Sociales in Paris. My thanks are due to Professor Jacques Revel for his intellectual and personal hospitality in Paris in 1992, to Professor Pierre Nora for his warm encouragement and constructive comments on the project, and to Mme Gabrielle van Zuylen for her kindness during my stay in Paris.

Of all the research projects I have undertaken in the past twenty-five years, none has benefited more from the extraordinary generosity and unselfish help of innumerable colleagues and friends who refrained from vocal disbelief at the scale of the task I set myself and instead gave so freely of their counsel and learning. In particular I want to thank Ann Jensen Adams, Daniel Bell, Mirka Benes, Tom Bisson, Tim Blanning, Ginny Brown, Gerhard Brunn, Peter Burke, Joan Cashin, Wendell Clausen, Joseph Connors, John Czaplicka, Norman Davies, Caroline Ford, Michael Fried, James Hankins, Peter Hansen, Bill Harris, Patrice Higonnet, Geraldine Johnson, Mark Kishlansky, Joseph Leo Koerner, Lisbet Koerner, Michael McCormick, David McKitterick, Rosamund McKitterick, Charles Maier, Elzbieta Matynia, Andrew Motion, Carla Mulford, Susan Pedersen, Sir John Plumb, Rosamund Purcell, Tadeusz Rolke, Peter Sahlins, Elaine Scarry, Yola Schaberbeck-Ebers, Trudie Schama, Quentin Skinner, Naomi Wittes, Christopher Wood, and Marina van Zuylen.

I am deeply grateful to Giovanni Baldeschi-Balleani for his account of the ordeals of the Codex Aesinas 8 during 1943 and for allowing me to publish the story.

The Polish chapters of the book could not have been written without research help from Keith Crudgington, translation assistance from Anna Popiel, and the photographic flair and historical memory of Tadeusz Rolke, to whom I am also grateful for permission to publish his photographic record of our journey to Białowieża and Punsk. The Prologue was originally published in a slightly different form in *The New Republic*.

My thanks are also due to an extraordinary group of research assistants. Beth Daugherty took on the Herculean task of locating and acquiring permissions for the illustrations, with the help of Peter Lindseth and Anne Woollett. Maia Rigas has been a rigorous tracker of fugitive references and citations, and any that have somehow eluded her scrupulous attention are certainly my responsibility. For three years Annette Schlagenhauff was much more than merely my best and most enterprising research assistant; she was also a fundamental and inexhaustible source of ideas, a true partner in the making of the book. I also owe her a special debt of gratitude for a research trip to Suresnes in pursuit of a phantom sacred mountain haunting the suburbs of Paris.

Landscape and Memory has also been made into a series of five television programs for BBC 2. It is impossible to overemphasize just how richly rewarding the experience of writing and presenting these programs has been. For the pleasure and exhilaration of creating an original form of the arguments in this book I must thank the producers Jane Alexander and Tony Cash, who had, from the beginning, unwavering faith in the project; Kim Evans, director of music and arts at BBC 2, for sharing that faith and seeing it through; and the directors Geoff Dunlop and Frank Hanly for finding brilliantly original visual forms in which to communicate both the ideas and the passions of this work.

Through the years of research and writing this book I have as usual shamelessly exploited the love and good cheer of my closest friends as I marched, meandered, or staggered through the landscapes of the Western mind. For their sustained belief in the whole project and their contributions to its unapologetic peculiarity I want to thank especially Svetlana Boym, John Brewer, Tanya Luhrmann, Richard Sennett, Stella Tillyard, and Leon Wieseltier. Over endless cups of tea and vats of happy claret, Robert and Jill Slotover have calmed me down or cheered me as occasion required. Jill, who read the manuscript, countered my waves of doubt and kvetcherei with a delight so stubborn and so infectious that she always gave me renewed heart to see the enterprise through.

As usual, my agents and dear friends, Peter Matson and Michael Sissons, have astonished me by never wavering in their belief not only that this book could be written but that I was actually the historian to write it. My friends at Alfred A. Knopf—Nancy Clements, Iris Weinstein, and Robin Swados—have all been, as always, pillars of strength whenever signs of tottering were detected in the author, and inspired colleagues in the design and production of the book. My editors, Stuart Proffitt at HarperCollins and Carol Brown Janeway at Alfred A. Knopf, have been everything an author could want: exacting, perfectionist in their demand for clarity, tireless in their attention to the meaning, texture, and idiosyncrasies of this book. To Carol, with whom I first mooted the idea of *Landscape and Memory* over a bowl of broth in Munich, I owe a debt difficult to register in the conventional pieties of author's acknowledgements. Through all the stages of its research and writing, she has been a constant and devoted guardian of its progress; a creative partner in its revision and an unshakeable believer in its fruition.

For five years, my wife, Ginny, and my children, Chloë and Gabriel, have endured a great deal more than the regulation dose of authorial petulance, self-absorption, and generally impossible temper. They have somehow soaked up the seasonal storms and stresses that came with a book rooted in the cultural psychology of nature. In return for all this heavy weather they have given me only patience, succor, and sweetness. More than anything else this book is meant as an offering to my wife for our shared passion for the landscapes we have together seen, tended, and remembered. And to my children to whom it is dedicated, I must apologize for giving them a present bulkier than the most cumbersome of their school textbooks. But they, too, are children of nature, and perhaps one day, when the rain is drumming against the windows, they will find some pleasure in it and read the full measure of their father's love.

Index

Black and white (by page number)

Achenbach Kunsthandel, Düsseldorf, Germany: 125.

A.C.L., Brussels, Belgium: 288.

Ansel Adams Publishing Rights Trust, Carmel, California: 9.

Alinari/Art Resource, New York: 221, 224 (top), 276, 282, 283, 302, 303 (top and bottom), 304, 341, 344.

Amis de la Forêt de Fontainebleau: 547, 557.

Arti Doria Pamphilj: 295.

Art Institute of Chicago: 128 (Anselm Kiefer, German, b.1945, *Paths of the Wisdom of the World: Herman's Battle,* woodcut, additions in acrylic and shellac, 1980, 344.8 x 528.3 cm, Restricted gift of Mr. and Mrs. Noel Rothman, Mr. and Mrs. Douglas Cohen, Mr. and Mrs. Thomas Dittmer, Mr. and Mrs. Ralph Goldenberg, Mr. and Mrs. Lewis Manilow, and Mr. and Mrs. Joseph R. Shapiro; Wirt D. Walker Fund, 1986.112. Photograph by courtesy of the artist. Photograph © 1994, The Art Institute of Chicago, All Rights Reserved.)

Art Resource, New York: 222 (top).

Ashmolean Museum, Oxford, England: 294, 471, 473, 510.

Herzog August Bibliothek, Wolfenbüttel, Germany: 93.

Author's collection: ii, 224 (bottom. Photo © Anthony Holmes).

Avery Library, Columbia University, New York: 231–5, 544.

Bancroft Library, University of California, Berkeley, California: 188.

Bayerisches Staatsbibliothek, Munich, Germany: 410.

Bayerische Staatsgemäldesammlungen, Munich, Germany: 427 (bottom).

Bibliothèque Nationale, Paris: 215 (bottom), 439–40, 442–3.

Birmingham City Art Gallery, Birmingham, England: 476.

Virginia Blaisdell: 445 (all).

Borough of Camden, Local History Library, London: 524.

British Library, London: 310, 317, 467, 468 (bottom).

British Museum, London: 403, 470, 474, 477.

Collection of the Eli Broad Family Foundation: 126 (Photo © Douglas M. Parker).

Brown County Historical Museum, New Ulm, Minnesota: 111.

Parrochia di S. Giovanni Battista, Museo del Duomo, Monza, Italy: 215 (top).

Cleveland Museum of Art: 525 (Leonard C. Hanna, Jr., Fund).

Columbia University, New York: 542 (Photo: Drawings & Archives, Avery Library, Columbia University).

Concord Free Public Library, Concord, Massachusetts: 575 (Photo © Herbert Gleason).

Electa Books, Milan, from Franco Borsi, *Bernini Architetto* (1980): 293 (Photo © Bruno Balestrini).

Fairmount Park Art Association/Philadelphia Museum of Art, Pennsylvania: 368 (bottom).

Russ Finley, National Parks Service, Mount Rushmore National Monument: 396.

The Forward Association, New York: 28 (from *The Vanished World,* New York: 1947).

Fratelli Alinari, 1993/Art Resource, New York: 270–1.

Galinetta Fotographica, Rome: 519.

Germanisches Nationalmuseum, Nürnberg, Germany: 94.

Giraudon/Art Resource, New York: 287, 337 (top and bottom), 342, 543.

Greater London Photographic Library: 520.

Harvard College Library, Cambridge, Massachusetts: 38, 63, 90, 117, 164, 166, 176, 222, 223, 241, 243, 274 (left and right), 290 (bottom), 299, 306, 349, 379, 437–8, 503.

By permission of the Houghton Library, Harvard University, Cambridge, Massachusetts: 10, 84, 85, 86, 96, 101, 150, 153, 171, 172, 182, 184, 272, 273, 280, 281, 285, 300, 301, 305, 348, 405 (top and bottom), 413 (top and bottom), 429, 452, 453, 458, 513, 530, 545 (bottom), 562, 578.

The Luton Hoo Foundation (The Wernher Collection): 521.

Imperial War Museum, London: 11.

Independence National Historical Park, Philadelphia, Pennsylvania: 368 (top).

Institut Royal du Patrimone Artistique, Brussels, Belgium: 40.

Istituto Centrale per il Catalogo et la Documentazione, Milan, Italy: 297.

Kenney Galleries, New York: 204 (top).

Maggie Keswick: 406, 408.

Kunstsammlungen zu Weimar, Weimar, Germany: 206 (bottom; Photo: Louis Held, Weimar).

Kunsthalle, Hamburg, Germany: 122 (Photo: Elke Walford, Hamburg).

Kunsthaus, Zürich, Switzerland: 372.

Kunsthistorisches Museum, Vienna, Austria: 428, 432, 434–5.

Kurpfälzisches Museum, Heidelberg, Germany: 279.

Library of the Gray Herbarium, Harvard University, Cambridge, Massachusetts: 192–3.

Metropolitan Museum of Art, New York: 8 (bottom; The Elisha Whittelsey Collection, The Elisha Whittelsey Fund, 1922), 97 (top; Harris Brisbane Dick Fund, 1928), 198 (Gift in memory of Jonathan Sturges by his children, 1895), 225, 258 (Purchase, 1969, Gift of Dulaney Logan, 1967–69), 365 (Gift of Mrs. Russell Sage, 1908), 366 (bottom; Morris K. Jessup Fund, 1933), 400 (Gift of James Stillman, 1906), 408 (left; Gift of Ernest Erickson Foundation, Inc., 1985), 454 (Charles B. Curtis Fund, 1934), 532–3 (The Elisha Whittelsey Collection, The Elisha Whittelsey Fund, 1949).

MIT Press, Cambridge, Massachusetts: 275.

Musée Carnavalet, Paris: 537.

Musée d'art et d'histoire, Geneva, Switzerland: 427 (top), 463 (Depot Fondation Gottfried Kneller; Photo: M. Aesehim).

Musée de la Forêt de Fontainebleau, Fontainebleau, France: 555.

Musée de Loraine, Nancy, France: 224.

Musée d'Orsay, Paris: 371 (Photo © Agence Photographique de la Réunion des Musées Nationaux).

Musée du Louvre, Paris (Réunion des Musées Nationaux): 416, 518.

Musée Mickiewicz, Paris: 55 (Photo: Félix Nadar).

Museo di Roma, Italy: 292.

Museum d. bildenen Künste, Leipzig, Germany: 296 (bottom).

Museum of Fine Arts, Boston, Massachusetts, Department of Prints and Drawings, Sargent Fund: 131, 132 (top and bottom), 418.

Museum of Fine Arts, Montreal, Canada: 561.

National Archaeological Museum, Athens, Greece: 526.

National Gallery of Canada, Ottawa: 229.

National Gallery, London: 157, 168, 448 (top and bottom), 535.

National Gallery of Scotland, Edinburgh: 475.

National Gallery of Wales, Cardiff: 468 (top), 469.

National Museum, Naples/Alinari, Art Resource, New York: 269.

National Palace Museum, Taiwan, Republic of China: 409.

National Park Service: 386 (top), 387.

National Portrait Gallery, London: 308.

National Portrait Gallery, Smithsonian Institution/Art Resource, New York: 246.

National Trust, England: 540 (Hoare Collection, Stourhead, Wiltshire), 541 (Brownlow Collection, Belton House, Lincolnshire).

Gemäldegalerie Neue Meister, Dresden, Germany: 206 (above left and right).

New-York Historical Society: 202 (top and bottom), 568.

New York Public Library, Print Collection: 189 (Miriam and Ira D. Wallach Division of Art, Prints and Photographs, Astor, Lenox and Tilden Foundations).

Niederdeutscher Verband für Volks- und Altertumskunde Lüneberg Museum: 110.

Oakland Museum, Oakland, California: 8 (top).

Palazzo Pitti, Florence, Italy: 455.

Patrimonial Nacional, Madrid, Spain: 335.

Philadelphia Academy of Fine Arts, Philadelphia, Pennsylvania: 369 (Pennsylvania Academy Purchase from the Estate of Paul Beck, Jr.).

Philadelphia Museum of Art, Philadelphia, Pennsylvania: 370 (Given by Mrs. Thomas Eakins and Miss Mary Adeline Williams).

Pierpont Morgan Library, New York: 507.

Powell Papers, Schlesinger Library, Harvard University, Cambridge, Massachusetts: 386 (bottom).

Prado Museum, Madrid, Spain: 334.

Private collection: 121, 123, 130, 483, 493.

Private collection, Paris: 373 (Photo © Musée Gustav Courbet, Ornans).

Research Libraries, New York Public Library: 199.

Reynolda House, Museum of American Art, Winston Salem, North Carolina: 203.

Royal Botanical Gardens, Kew Gardens, London: 565.

Royal Collection, Windsor Castle, London, England: 296 (top), 424–5 (© Her Majesty Queen Elizabeth II).

Royal Geographic Society, London, England: 375 (top and bottom).

Royal Society of Arts, London: 358 (Photo: Courtesy of the Paul Mellon Center for Studies in British Art).

Shropshire Records Research, England: 545 (top).

Smithsonian Institution, Washington, D.C.: 407–8 (bottom; courtesy of the Freer Gallery of Art, Washington, D.C.).

Spencer Society Publications, London: 323 (from *All the Workes of John Taylor*, 1630. Butler Library, Columbia University. Photo: Anthony Holmes).

Staatliche Kunstsammlungen, Schlossmuseum, Weimar, Germany: 108 (Photo: Fotoatelier Louis Held, Weimar).

Staatliche Kunsthalle, Karlsruhe, Germany: 104 (top).

Staatliche Museen zu Berlin: 97 (bottom; Preußischer Kulturbesitz Kupferstichkabinett (Photo: Jörg P. Anders Photoatelier, Berlin), 105 (Preußischer Kulturbesitz Nationalgalerie; Photo: Jörg P. Anders Photoatelier, Berlin), 196 (Preußischer Kulturbesitz Nationalgalerie).

Städtisches Museum, Braunschweig, Germany: 104 (bottom).

Joseph Szeszfai: 200.

Tate Gallery, London/Art Resource, New York: 359, 360.

Courtesy Museo Thyssen-Bornemisza, Madrid: 204 (bottom).

A NOTE ON THE TYPE

This book was set in Galliard, a typeface drawn by Matthew Carter for the Mergenthaler Linotype Company in 1978. Carter, one of the foremost type designers of the twentieth century, studied and worked with historic hand-cut punches before designing typefaces for Linotype, film, and digital composition. He based his Galliard design on sixteenth-century types by Robert Granjon. Galliard has the classic feel of the old Granjon types as well as a vibrant, dashing quality that marks it as a contemporary typeface and makes its name so apt.

Composed by North Market Street Graphics, Lancaster, Pennsylvania

Designed by Iris Weinstein